The

Photography

Reader
History and Theory

Second Edition

Edited by

Liz Wells

Routledge
Taylor & Francis Group
LONDON AND NEW YORK

Second edition published 2019
by Routledge
2 Park Square, Milton Park, Abingdon, Oxon, OX14 4RN

and by Routledge
711 Third Avenue, New York, NY 10017

Routledge is an imprint of the Taylor & Francis Group, an informa business

First edition published by Routledge 2003

British Library Cataloguing-in-Publication Data
A catalogue record for this book is available from the British Library

Library of Congress Cataloging-in-Publication Data
Names: Wells, Liz, 1948– editor.
Title: The photography reader : history and theory / edited by Liz Wells.
Description: Second edition. | London ; New York : Routledge, 2019. |
 Includes bibliographical references and index.
Identifiers: LCCN 2018013725 | ISBN 9780415749176 (hardback : alk. paper) |
 ISBN 9780415749183 (pbk. : alk. paper)
Subjects: LCSH: Photographic criticism. | Photography—History.
Classification: LCC TR187 .P56 2019 | DDC 770—dc23
LC record available at https://lccn.loc.gov/2018013725

ISBN: 978-0-415-74917-6 (hbk)
ISBN: 978-0-415-74918-3 (pbk)

Typeset in Perpetua and Akzidenz-Grotesk Pro
by Apex CoVantage LLC

MIX
Paper from
responsible sources
FSC™ C013985
www.fsc.org

Printed in the United Kingdom
by Henry Ling Limited

The Photography Reader

Following on from its hugely successful first edition, *The Photography Reader: History and Theory* provides deeper insight into the critical discussions around photography – its production, its uses and its effects. Presenting both the historical ideas and the continuing theoretical debates within photography and photographic study, this second edition contains essays by photographers including Edward Weston and László Moholy-Nagy, and key thinkers such as Walter Benjamin, Roland Barthes and Susan Sontag.

Along with its companion text – *The Photography Cultures Reader: Representation, Agency and Identity* – this is the most comprehensive introduction to photography and photographic criticism.

This new edition features:

- Over 50 additional photographs
- New essays from photographers and academics
- Revised introductions, setting ideas and debates in their historical and theoretical context
- Sections on Art photography, Documentary and Photomedia.

Includes essays by: Jan Baetens, Roland Barthes, Geoffrey Batchen, David Bate, André Bazin, Walter Benjamin, Lynn Berger, Matthew Biro, Osip Brik, Victor Burgin, Hubert Damisch, Edmundo Desnoes, Umberto Eco, Elizabeth Edwards, Steve Edwards, Andy Grundberg, Lisa Henderson, Estelle Jussim, Sarah Kember, Siegfried Kracauer, Rosalind Krauss, Martin Lister, Lev Manovich, Christian Metz, W. J. T. Mitchell, Tina Modotti, László Moholy-Nagy, Wright Morris, Darren Newbury, Daniel Palmer, Marjorie Perloff, Fred Ritchin, Martha Rosler, Steven Skopik, Abigail Solomon-Godeau, Susan Sontag, Lucy Soutter, John Szarkowski, John Tagg, Hilde Van Gelder, Ian Walker, Liz Wells, Edward Weston, Peter Wollen.

Liz Wells, curator and writer, is Professor in Photographic Culture, Faculty of Arts and Humanities, University of Plymouth, UK. She edited *Photography: A Critical Introduction*, (2015, 5th ed.) and co-edits *photographies*. Publications on landscape include *Land Matters: Landscape Photography, Culture and Identity* (2011). She is series editor for *Photography, Place, Environment*.

Contents

Illustrations

Contributors

Jan Baetens is a professor in literary theory and cultural studies at the University of Leuven, Belgium.

Roland Barthes (1915–1980), essayist and semiologist, taught at the *Ecole des Hautes Etudes en Sciences Sociales*, Paris. His critical writings ranged widely; key writings on photographs include *Mythologies* (1957/1972 English), 'The Photographic Message' and 'The Rhetoric of the Image' in *Image, Music, Text* (1977), *Camera Lucida* (1981/1984 English).

Geoffrey Batchen is the author of *Burning with Desire: The Conception of Photography* (1997), *Each Wild Idea: Writing, Photography, History* (2001), editor, *Photography Degree Zero: Reflections on Roland Barthes's Camera Lucida* (2009), and co-editor, *Picturing Atrocity: Photography in Crisis* (2012). He is a professor in art history and photography at Victoria University, Wellington, New Zealand.

David Bate, artist and writer, is Professor of Photography, University of Westminster, UK. Publications include *Photography and Surrealism: Sexuality, Colonialism and Social Dissent* (2002), *Art Photography* (2015) and *Photography: Key Concepts* (2016, 2nd ed.).

André Bazin (1918–1958), film critic and theorist, co-founder of *Cahiers du Cinema* in 1951. Publications include *What is Cinema?* Eng. trans. Vol. 1 (1967), Vol. 2 (1971).

Walter Benjamin (1892–1940), Marxist cultural critic, was associated with 'Frankfurt School' theorists including Adorno and Marcuse, and with the playwright

Bertolt Brecht. His essays encompass a range of issues, from history and criticism to literature, theatre and photography; from collecting and connoisseurship to authorship.

Lynn Berger, independent scholar, completed a PhD at Columbia University, New York in 2016. She has worked in documentary film, TV and print journalism, as well as the Museum of Modern Art's Department of Photography.

Matthew Biro is Professor of Modern and Contemporary Art, University of Michigan, USA. Recent publications include, *Dada Cyborg: Visions of the New Human in Weimar Berlin* (2009).

Osip Brik (1888–1945), Soviet activist and theorist, contributed to *Lef* and *Novy Lef*, journals which carried debates about the revolutionary potential of the arts.

Victor Burgin has published and exhibited widely; books include *Thinking Photography* (1982), *The End of Art Theory: Criticism and Postmodernity* (1986), *In/Different Spaces* (1996) and *The Remembered Film* (2004). From 2001 to 2006 he was Millard Professor of Fine Art, Goldsmiths College, University of London, UK.

Hubert Damisch (1928–2017) was on the faculty of the *Ecole des Hautes Etudes in Sciences Sociales* in Paris, 1975–1996. His many publications include *The Origin of Perspective* (1994, Eng. trans.) and *Skyline: The Narcissistic City* (2001).

Edmundo Desnoes, born in Havana in 1930, is the author of *Memories of Underdevelopment* and the sequel, *Memories of Development* (2008). He lives and writes in New York City and is a professor emeritus at New York University.

Umberto Eco (1932–2016) is known for his novels, *The Name of the Rose* (1983) and *Foucault's Pendulum* (1989), as well as his academic publications. He was Professor of Semiotics at the University of Bologna, Italy.

Elizabeth Edwards is a visual and historical anthropologist and Professor Emerita of Photographic History at De Montfort University, Leicester, UK. Publications include *Photographs, Museums, Collections: Between Art and Information* (ed. with C. Morton) (2015), *Uncertain Images: Museums and the Work of Photographs* (ed. with S. Lien) (2014) and *Camera as Historian: Amateur Photographers and Historical Imagination 1885–1912* (2012).

Steve Edwards is Professor in the History and Theory of Photography, Birkbeck College, University of London and a visiting professor in art history at The Open University, UK. He has published widely on photography including *Photography, A Very Short Introduction* (2006), *The Making of English Photograph Allegories* (2006) and *Martha Rosler, The Bowery in Two Inadequate Descriptive Systems* (2012).

Andy Grundberg, critic, curator and a former professor at the Corcoran School of Art, George Washington University, Washington DC, USA, organised the travelling exhibition 'In Response to Place: Photographs from The Nature Conservancy's Last Great Places' (2001). Publications include *Visons from America* (2002) and *The Crisis of the Real* (1999, expanded edition).

Lisa Henderson is Professor of Communication at the University of Massachusetts, Amherst (USA), where she works on cultural production and sexual representation. Publications include *Love and Money: Queers, Class, and Cultural Production* (2013).

Estelle Jussim (1927–2004) was a professor in the history of photography at Simmons College, Massachusetts. Her publications include *Landscape as Photograph* (1985) with Elizabeth Lindquist-Cock, *Decade by Decade: Twentieth-century American Photography from the Collection of the Center for Creative Photography* (1989) and *The Eternal Moment* (1989).

Sarah Kember is the author of *Virtual Anxiety*: *Photography, New Technologies and Subjectivity* (1998), *Cyberfeminism and Artificial Life* (2002) and *Life after New Media: Mediation as a Vital Process* (2012) with Joanna Zylinska. She is Professor of New Technologies of Communications at Goldsmiths College, University of London, UK, and Director of Goldsmiths Press.

Siegfried Kracauer (1889–1966), German writer, critic and editor at Frankfurter Zeitung (1927–1933) emigrated to New York (1941) where he worked at institutions including MoMA and Columbia University. He is best known as a film theorist with interests in Realism. Publications include *Theory of Film: The Redemption of Physical Reality* (1960).

Rosalind Krauss is an American art theorist and critic, and professor in 20th Century Art and Theory at Columbia University in New York City. Publications include *The Originality of the Avant-Garde and Other Modernist Myths* (1986, MIT Press) and *Perpetual Inventory* (2010).

Martin Lister has lectured and published widely on visual culture and the digital image. He is editor of *The Photographic Image in Digital Culture* (1995; 2013), and co-author of *New Media: A Critical Introduction* (2002; 2009). He is Professor Emeritus in Visual Culture at the University of the West of England, Bristol, UK.

Lev Manovich writes on new media. Publications include *The Language of New Media* (2001), *Instagram and Contemporary Image* (2016) and, co-edited with Rasa Smite and Raitis Smits, *Data Drift: Archiving Media and Data Art in the 21st Century* (2015). He lectures in the Visual Arts Department at the University of California, San Diego. He is Professor of Computer Science, City University of New York Graduate Center.

Christian Metz (1931–1993) contributed founding work on cinesemiotics and psychoanalytic film theory. Publications included *Film Language* (1974) and *The Imaginary Signifier* (1982). He was a director of research at the Ecole des Hautes Etudes en Science Sociales, Paris.

W. J. T. Mitchell has been editor of *Critical Inquiry* since 1978 and is the author of numerous articles and books on the visual arts, literature and media, including *Iconology* (1986), *Picture Theory* (1994), *The Last Dinosaur Book* (1998), *What Do Pictures Want? Essays on the Lives and Loves of Images* (2005) and *Image Science: Iconology, Media Aesthetics, and Visual Culture* (2015). He is Professor in English and Art History at the University of Chicago.

Tina Modotti (1896–1942) was an Italian-born photographer and political activist based in San Francisco and, from 1925 to 1929, in Mexico City.

László Moholy-Nagy (1895–1946), Hungarian artist, designer, photographer, film-maker and broadcaster, was a central figure in the German Bauhaus design movement of the 1920s, (and later founded the Chicago Institute of Design).

Wright Morris (1910–1998), author and photographer, documented middle America on film and in his many novels and short stories. He was Professor of English at San Francisco State College.

Darren Newbury is Professor of Photographic History at University of Brighton, UK. Publications include *Defiant Images: Photography and Apartheid South Africa* (2009), *People Apart: 1950s Cape Town Revisited* (2013) and *The African Photographic Archive: Research and Curatorial Strategies* (2015) co-edited with Christopher Morton.

Daniel Palmer is Professor and Associate Dean of Research and Innovation in the School of Art at RMIT University, Melbourne, Australia. He edited *Photogenic: Essays/Photography/CCP 2000–2004* (2005) and co-authored *Twelve Australian Photo Artists* (2009) with Blair French.

Marjorie Perloff's publications include *Wittgenstein's Ladder: Poetic Language and the Strangeness of the Ordinary* (1996), *Poetry On Off the Page* (1998), *Twenty First Century Modernism* (2001) and *Poetics in a New Key: Interviews and Essays* (2014). She is Professor Emerita of English at Stanford University, USA.

Fred Ritchin writes on photography and new media. Since 2014 he has been Dean of the School at the International Center of Photography, New York, and previously was Professor in Photography and Digital Imaging, Tisch School of the Arts, New York University. Publications include *In Our Own Image: The Coming Revolution in Photography* (1990, 1999, 2010), *After Photography* (2008) and *Bending the Frame: Photojournalism, Documentary, and the Citizen* (2013),

Martha Rosler is a New York-based artist who works with video, photography and installation and has taught photography and media since the mid-1970s. Publications include *Decoys and Disruptions, selected writings, 1975–2001* (2004) and *Culture Class* (2013). Artist books include *Martha Rosler: Passionate Signals* (2005) and *Martha Rosler: 3 Works* (2006).

Steven Skopik, art photographer and writer, is Professor and Chair, Media Arts, Sciences and Studies, Ithaca College, USA. His articles, essays and reviews have appeared in *Exposure* and *Afterimage*, as well as in *History of Photography*.

Abigail Solomon-Godeau has written widely on postmodernism, feminist theory and nineteenth-century and contemporary art. She is the author of *Photography at the Dock: Essays on Photographic History, Institutions and Practices* (1991), *Male Trouble: A Crisis in Representation* (1997) and *Photography after Photography: Gender, Genre, History* (2017). She is Emeritus Professor of Art History, University of California, Santa Barbara.

Susan Sontag (1933–2004), writer, film-maker and activist, is author of a number of collections, including *On Photography* (1973), *Against Interpretation and Other Essays* (1987) and *Regarding the Pain of Others* (2004). She wrote the introductions to a selection of writings by Roland Barthes, published in the USA as *The Barthes Reader* (1982) and in Britain as *Barthes: Selected Writings* (1983), and to *One Way Street and Other Writings by Walter Benjamin* (1979).

Lucy Soutter is course leader for MA Photography Arts, University of Westminster, UK, and a former tutor at the Royal College of Art, London. Publications include *Why Art Photography?* (2013).

John Szarkowski (1925–2007), photographer, photography historian and critic was director of the Department of Photography at the New York Museum of Modern Art, late 1960s to 1991 and organised several exhibitions and publications on American photography.

John Tagg is Professor and Chair of Art History at Binghamton University, State University of New York. His books include *The Burden of Representation* (1988, 1992; Spanish version 2005), *Grounds of Dispute* (1992) and *The Disciplinary Frame: Photographic Truths and the Capture of Meaning* (2009).

Hilde Van Gelder is a professor in art history at the University of Leuven, Belgium. She co-authored *Photography Theory in Historical Perspective: Case Studies from Contemporary Art* (2011) with Helen Westgeest. She is series editor, with Alexander Streitberger, for Lieven Gevaert publications on photography, Leuven University Press, Belgium.

Ian Walker, freelance writer and artist based in London, was formerly Professor of the History of Photography, University of South Wales, UK. Publications include

City Gorged with Dreams: Surrealism and Documentary Photography in Interwar Paris (2002), *So Exotic, So Homemade: Surrealism, Englishness and Documentary Photography* (2007) and *Surrealism and Photography in Czechoslovakia: On the Needles of Days* (2013) co-written with Krzysztof Fijalkowski and Michael Richardson.

Edward Weston (1886–1958), painter turned photographer, was a founder member of the f.64 West Coast group (that included Imogen Cunningham and Ansel Adams); he worked in Mexico and California.

Peter Wollen, former Professor of Film Studies at the University of California, Los Angeles, is a film-maker and has published extensively on photography, modern art, Godard and on the semiotics of cinema including *Paris/Manhattan: Writings on Art* (2004) and *Raiding the Icebox: Reflections on Twentieth-Century Culture* (1993, 2008).

All information correct at time of printing.

Acknowledgements

The publishers have made every effort to contact authors/copyright holders of works reprinted in *The Photography Reader, 2nd edition: History and Theory* to obtain permission to publish extracts. This has not been possible in every case, however, and we would welcome correspondence from those individuals/companies whom we have been unable to trace. Any omissions brought to our attention will be remedied in future editions.

Roland Barthes, excerpts from "Specialty of the Photograph," "The Photograph Unclassifiable," "Operator, Spectrum and Spectator," "He Who Is Photographed," "Studium," "To Inform," "One Evening . . .," "History as Separation," "To Recognize," and "The Winter Garden Photograph" from *Camera Lucida: Reflections on Photography* by Roland Barthes, translated by Richard Howard. Translation copyright © 1981 by Farrar, Straus & Giroux, Inc. Reprinted by permission of Hill & Wang, a division of Farrar, Straus and Giroux, LLC. From *Camera Lucida* by Roland Barthes. Published by Jonathan Cape. Reprinted by permission of The Random House Group Limited.

'Rhetoric of the Image', *Image Music Text*, London: HarperCollins, Copyright Roland Barthes 1977. English translation copyright © 1977 by Stephen Heath. Reprinted by permission of HarperCollins Publishers Ltd © 1964 Roland Barthes.

Geoffrey Batchen, 'Photogenics' in *History of Photography*, 22/1 (1998), pp. 18–26. Copyright © 1998 Routledge. Reprinted by permission of the publisher and the author (Taylor & Francis Ltd, www.tandfonline.com).

David Bate, Sarah Kember, Martin Lister and Liz Wells, 'Editorial Statement', *Photographies* (Routledge Taylor and Francis journals), 2008 Vol. 1:1.

Copyright © 2008 Routledge. Reprinted by permission of the authors and publisher (Taylor & Francis Ltd, www.tandfonline.com).

André Bazin, 'The Ontology of the Photographic Image'. Translated by Hugh Gray, *Film Quarterly*, Vol. 13, No. 4. (Summer, 1960), pp. 4–9. Copyright © 1960, The Regents of the University of California.

Walter Benjamin, 'The Work of Art in the Age of Mechanical Reproduction' from *ILLUMINATIONS* by Walter Benjamin, translated by Harry Zohn. Copyright © 1955 by Suhrkamp Verlag, Frankfurt A M, English translation copyright © 1968 and renewed 1996 by Houghton Mifflin Harcourt Publishing Company. Reprinted by permission of Houghton Mifflin Harcourt Publishing Company and Writers House LLC. All rights reserved.

Lynn Berger, 'The Authentic Amateur and the Democracy of Collecting Photographs', 2009, *Photography and Culture*, 2:1, pp. 31–50. Reprinted by permission of the author and publisher (Taylor & Francis Ltd, www.tandfonline.com).

Matthew Biro, 'From Analogue to Digital Photography: Bernd and Hilla Becher and Andreas Gursky', *History of Photography,* Routledge Journals, 2012 Vol. 36:3 pp. 353–366. Copyright © 2012 Routledge. Reprinted by permission of the author and publisher (Taylor & Francis Ltd, www.tandfonline.com).

Osip Brik, 'What the Eye Does Not See' in Christopher Phillips, *Photograph in the Modern Era* (New York, Metropolitan Museum of Art and Aperture, 1989). Reprinted by permission of the Metropolitan Museum of Art, New York.

Victor Burgin, 'Looking at Photographs', first published in *Screen Education*, No. 24 (1977), pp. 17–24. Rights on *Screen Education* are administered by Screen.
 'Conversation with Hilde van Gelder' is from *Parallel Texts: Interviews and Interventions about Art*. (London, Reaktion Books, 2011), pp. 207–226. Reprinted by permission of the author and Reaktion Books.

Hubert Damisch, 'Five Notes for a Phenomenology of the Photographic Image', *October,* 5 (Summer, 1978), pp. 70–72. Originally published in *L'Arc*, Paris, 1963. Reprinted by permission of MIT Press Journals.

Edmundo Desnoes, 'Cuba Made me So' in Marshall Bionsky (ed.) *On Signs* (Oxford, Basil Blackwell, 1985). Reprinted by permission of the author.

Umberto Eco, 'A Photograph' From *Faith in Fakes*. Published by Martin Secker & Warburg, 1986. Reprinted by permission of The Random House Group Limited.

Elizabeth Edwards, 'Objects of Affect: Photography Beyond the Image', by Elizabeth Edwards, 2012. *The Annual Review of Anthropology* 41:221-34-0.

Steve Edwards, 'Snapshooters of History: passages on the postmodem argument' in *Ten 8*, No. 32 (1989). Reprinted by permission of the author.

Andy Grundberg, 'The Crisis of the Real: Photography and Postmodernism' in Daniel P. Younger (ed.), *Multiple Views* (Albuquerque, University of New Mexico. 1991). Reprinted by permission of the University of New Mexico Press.

Lisa Henderson, 'Access and Consent in Public Photography' by Henderson in *Image Ethics: The Moral Rights of Subjects in Photographs, Film, and Television*, Larry Gross, John Stuart Katz and Jay Ruby (eds.), © 1988 by Oxford University Press, Inc., pp. 91–108. Reprinted by permission of Oxford University Press, USA.

Estelle Jussim, 'The Eternal Moment: Photography and Time', NY: Aperture, 1989.

Sarah Kember, 'The Shadow of the Object: photography and realism' in *Textual Practice*, 10/1 (1996) pp. 145–63. Copyright © 1996 Routledge. Reprinted by permission of the author and Taylor & Francis Ltd. www.tandf.co.uk.

Siegfried Kracauer, 'Photography'. Translated by Thomas Y. Levin, *Critical Inquiry*, Vol. 19, No. 3 (Spring, 1993), pp. 421–436. Published by The University of Chicago Press. Reprinted with permission of University of Chicago Press and Thomas Y. Levin.

Rosalind Krauss, 'Photography's Discursive Spaces', *Art Journal*, Vol. 42: 4, *The Crisis in the Discipline*. (Winter, 1982), pp. 311–319. (Reprinted in Richard Bolton ed. 1989 *The Contest of Meaning*, Cambridge, Mass.: MIT, pp. 286–301). Copyright © 1982 Routledge. Reprinted by permission of the author and Taylor & Francis Ltd. www.tandf.co.uk.

Martin Lister, 'Introduction to The Photographic Image' in *Digital Culture*, 2nd ed. (London, Routledge, 2013.) Reprinted by permission of Taylor & Francis Ltd. www.tandf.co.uk

Lev Manovich, 'The Paradoxes of Digital Photography' in V. Amelunxen, Stefan Iglhaut, Florian Rotzer (eds.) *Photography After Photography*, (Munich, Verlag der Kunst, 1993). Reprinted by permission of the author.

Christian Metz, 'Photography and Fetish', *October,* 34 (Fall, 1985), pp. 81–90. © 1985 by *October Magazine*, Ltd. and the Massachusetts Institute of Technology. Reprinted by permission of MIT Press Journals.

W. J. T Mitchell, 'Benjamin and the Political Economy of the Photograph' in *Iconology: Image, Text, Ideology* (Chicago, University of Chicago, 1986). Reprinted by permission of the author and the University of Chicago.

Tina Modotti, 'Manifesto: on photography' in Modotti, *A New Vision*, 1929. Jesús Nieto Sotelo and Elisa Lozano Alvarez (eds.). Published by Centro de la Imagen and Universidad Autónoma del Estado de Morelos.

Laszlo Moholy-Nagy, 'A New Instrument of Vision' extract from 'From Pigment to Light' in *Telebar* Vol. 1/2 (1936).

Wright Morris, 'In Our Image' by Wright Morris reprinted by permission of the University of Nebraska Press.

Darren Newbury, 'Photography and the Visualisation of Working-Class Lives in Britain'. Reproduced by permission of the author and American Anthropological Association from *Visual Anthropology Review*, volume 15, Issue I, pp. 3–20, March 1999. Not for sale or further reproduction.

Daniel Palmer, 'Redundancy in Photography', *Philosophy of Photography*, Vol. 3:1 (2012), pp. 36–44, doi: 10.1386/pop.3.1.36_1. Reprinted with permission of the author. Reproduced with permission of Intellect Limited via PLSclear.

Marjorie Perloff, from 'What has occurred only once: Barthes's Winter Garden/ Boltanski's Archives of the Dead' in Jean-Michel Rabate (ed.) *Writing the Image after Roland Barthes*, pp. 35–58. Copyright © 1997 University of Pennsylvania Press. Reprinted with permission of the University of Pennsylvania Press.

Fred Ritchin, 'On Pixels and Paradox' from *After Photography*, Copyright © 2009 by Fred Ritchin. Used by permission of W. W. Norton & Company, Inc.

Martha Rosler, 'In, around, and afterthoughts (on documentary photography)' from *Decoys and Disruptions: Selected Writings, 1975–2001*, pp. 152–206, © 2004 Massachusetts Institute of Technology. Reprinted by permission of The MIT Press.

Steven Skopik, 'Digital Photography: Truth, Meaning, Aesthetics', *History of Photography,* 2003, Vol. 27:3, pp. 264–271. Copyright © 2003 Routledge. Reprinted by permission of the author and publisher (Taylor & Francis Ltd, www.tandfon line.com).

Abigail Solomon-Godeau, 'Photography after Art Photography and Postmodernism', *Photography at the Dock: Essays on Photographic History, Institutions and Practices* (University of Minnesota Press, 1991), pp. 103–124. Originally published in *Art After Modernism: Rethinking Representation* edited by Brian Wallis (New Museum of Contemporary Art, 1984).

Susan Sontag, 'Photography within the Humanities'. Copyright © Susan Sontag 1977, used by permission of The Wylie Agency (UK) Limited.

Lucy Soutter, *'Why Art Photography?'* Source, Winter 2007, Issue 53, reprinted as the introduction to Soutter, *Why Art Photography?'*, Routledge, 2013. Reprinted by permission of the author and Routledge.

John Szarkowski, 'Introduction' from *The Photographer's Eye* (New York, MoMA, 1966). Reprinted by permission of the Museum of Modern Art. © 1966, 1980, 2007 The Museum of Modern Art, New York.

John Tagg, 'Evidence, Truth and Order: Photographic Records and the Growth of the State' in *Ten 8*, No. 13 (1984), reprinted in *The Burden of Representation: Essays on Histories and Photographies* (London: Macmillan, 1988). Reprinted by permission of the author.

Hilde Van Gelder and Jan Baetens, 'A Note on Critical Realism Today' in Van Gelder & Baetens, *Critical Realism in Contemporary Art,* Leuvan University Press, 2010. Reprinted by permission of Leuvan University Press.

Ian Walker, 'Through the Picture Plane: On Looking into Photographs' *Image and Imagination,* ed. Martha Langford. Montreal: MQUP, 2005. Print. Reprinted by permission of McGill-Queen's University Press.

Edward Weston, 'Seeing Photographically' from The Encyclopedia of Photography Vol. 18 (1964). Text by Edward Weston. © Center for Creative Photography, Arizona Board of Regents.

Peter Wollen, 'Fire and Ice' in John Berger and Olivier Richon, *Other than Itself* (Manchester, Cornerhouse, 1984). Reprinted by permission of the author.

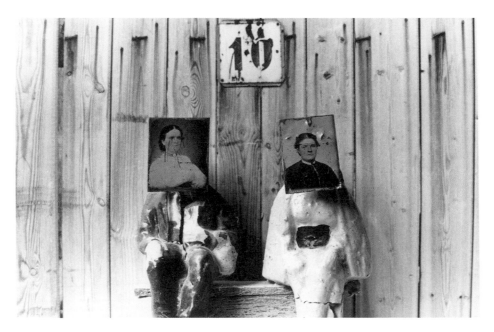

Frontispiece Mari Mahr, *About Photography*, 1985. Courtesy of the artist.

General introduction

The photograph

What is a photograph? Photography and the nature of photographic communication attracted debate throughout the twentieth century. The photograph was viewed by most critics as a particular sort of image, one that operates through freezing a moment in time, portraying objects, people and places as they appeared within the view of the camera at that instant. Photography thus contributed to the dislocation of time and space, enlightening and enlivening history and geography. As such, it attracted scrutiny from philosophers concerned with its semiotic structure and its phenomenological impact.

In an early work (first published in 1940), Jean-Paul Sartre examined the phenomenon of the photograph. Taking the example of a portrait of a friend whom he called Peter, he commented that:

> The relationship between the image and its object is still very obscure. We said that the image was a consciousness of an object. The object of the image of Peter, we said, is the Peter of flesh and bone, who is actually in Berlin. But, on the other hand, the image I now have of Peter shows him to be at his home, in his room in Paris, seated in a chair well known to me. Consequently the question can be raised whether the object of the image is the Peter who actually lives in Berlin or the Peter who lived last year in Paris. And if we persist in affirming that it is the Peter who lives in Berlin, we must explain the paradox: why and how the imaginative consciousness aims at the Peter of Berlin through the Peter who lived last year in Paris?[1]

Here Sartre mused not on the image itself but on the use of photographs, for instance, as tokens of family or friendship relations.

Likewise discussing the character of the photograph and the experience of looking at photographs, John Berger suggested that photography is rather like memory. To be precise, he stated this in relation not to the single image but to a whole system of photography. He noted that:

> memory is normally embedded in an ongoing experience of a person who is remembering. . . . If the photograph isn't 'tricked' in one way or another, it is authentic like a trace of an event: the problem is that an event, when it is isolated from all the other events that come before it and which go after it, is in another sense not very authentic because it has been seized from that ongoing experience which is the true authenticity. Photographs are both authentic and not authentic; whether the authentic side of photographs can be used authentically or not depends upon how you use them.[2]

Thus, Berger's interest in photographs seems based on a notion of the photo as a sort of *aide-memoire*, but one that falsifies experience.

Both Berger and Sartre assume personal familiarity or involvement with the subject of the image. The status and use of a photograph changes according to the viewer's relation with the subject or circumstances. For instance, the same image of 'Peter' might be of interest to social historians, not because of personal familiarity, but as evidence of clothing and furniture from the period and place. Photographs often do not activate individual memory directly, but operate through soliciting identification with needs, desires and circumstances. Obvious instances of this include advertising, fashion or travel imagery which may mobilise memories − from childhood, of romantic interludes, of family events, or whatever − but the links articulated are more indirect.

Photography encompasses a range of differing types of social and artistic practices engaging various audiences in a wide variety of contexts. As critical photo readers, we need to link considerations about the photograph as a particular sort of artefact with questions of the uses of photography and its effects. Through such discussions, we can consider how and in what circumstances we use photographs. As photographers, curators or critics, we can move from thinking about photography to thinking about the world differently, and, indeed, reconsidering our place and contribution. Not only do we want to ask how photographs operate, we also want to ask how photography can be used to resist dominant structures and practices.

Criticism

Prior to asking what we need to know about photography we might also ask why criticism is of interest to us; how it helps practitioners, curators, historians and media analysts. Discussing the function of criticism, Terry Eagleton (1984) linked criticism with political and social empowerment. He suggested that the European bourgeoisie of the seventeenth and eighteenth centuries began to carve out a

public arena wherein debate about literature featured as one element within more general discussions and judgements. Social groups thus emerged, in effect challenging the aristocratic and absolutist state.

> A polite, informed public opinion pits itself against the arbitrary diktats of autocracy; within the translucent space of the public sphere it is supposedly no longer social power, privilege and tradition which confer upon individuals the title to speak and judge, but the degree to which they are constituted as discoursing subjects by sharing in a consensus of universal reason.[3]

Crucial here is the (implicit) link between public debate, education, literacy and empowerment. Of course, Eagleton was referencing a relatively privileged group, one that was predominately professional and, although he did not remark on this, male. But the key point here is that engagement with criticism, that is, analysis and discussion of artefacts, including images, contributes to our sophistication as rational and sentient citizens. Given the inter-relation of theory and practice, critical skills inform and support artistic development as well as contributing to more general involvement with ideas and cultural processes. To lack the analytic skills, knowledge and confidence in judgement involved in critical engagement is, in effect, to be disempowered.

Essentially, we are concerned not so much with a history of photography as with histories of ideas about photography. Given the range of different global situations, relations and developments that have characterised and impacted on ways of thinking about photography, no singular notion of 'history' could ever encompass the range of contexts and uses of photography that beg analysis and discussion. Of course, histories overlap and inter-sect in curious and interesting ways. Ideas and positions do not supersede one another, or inter-act and synthesise in clear dialectical fashion. Rather we witness an accumulation of models and critical perspectives which fold into one another, re-emerging in shifted formations. For instance, the formal and political concerns of the 1920s in Europe involving questions of class and political power were re-articulated in the 1970s, certainly in Britain, but in a new radical context more specifically incorporating issues of representation. Similarly, the debates about identity and multi-culturalism which figured in the 1970s and 1980s, in Western Europe and in North America, roll over into the issues of self, otherness and global connectivity that seem central now. The point is that history is culturally formative. Aside from fascination with history in its own right, study of histories allows us to better understand the references, ideological legacies and sociopolitical inheritances in relation to which we negotiate the contemporary.

Of course, history, as a project, is not neutral; ideas about the photograph and about photographic practices are contested. Differing social and political concerns offer up varying positions from which critical projects are constructed and pursued. The parameters of any project reflect the interests of the historian, both in the priorities and fascinations anchoring any project and in terms of whatever institutional constraints frame it. History may tell us as much about the historian as it does about the place, period, circumstances and activity under scrutiny!

Here, we need to be alert to developments and changes in the focus, purpose and theoretical assumptions central to the work of particular critics. Critics may publish over several decades; not only do their own positions shift, but intellectual fashions also move on as, indeed, do aesthetic, technological and social circumstances. To read one piece of work by a particular writer is not enough if what is sought is understanding of their place within debates. For instance, Roland Barthes was one of the most prominent twentieth-century writers on photography. However, there are at least two and arguably three 'Barthes', spanning a writing period of over twenty years. His first book, *Mythologies* (1957, French; English version 1972), was concerned with semiology (systems of signs) and analysis of visual communications. Later, in his essays 'The Rhetoric of the Image' and 'The Photographic Message', he focused more specifically on the paradoxes of the photograph and its nature, which, at this stage, controversially, he wished to argue is a medium without a code. His final publication on photography, *La Chambre claire* (1981; English version, *Camera Lucida*, 1984), is unashamedly personal in its focus on a picture of his mother and, perhaps more importantly, is concerned with the affective impact of the image. His discussion of the subjective response to particular elements in the image (punctum/studium) may be understood as a re-working and broadening of concerns addressed a few years earlier in his analysis of responses to literature, *The Pleasure of the Text* (1973; English version 1975).

The example of Barthes reminds us that no one book or essay adequately represents the significance of the contribution of a critic of stature; also, that writers rarely focus only on one subject. Their contribution to the history of debates on a specific medium may be illuminated through reading other discussions in which they have engaged. Indeed, figures such as Walter Benjamin and Susan Sontag, whose essays on photography held central places in twentieth-century debates, are known for the breadth of their cultural engagement. Furthermore, there are a number of philosophers and cultural critics who never themselves wrote specifically on photography but without whose contribution this field of study would be notably poorer. For instance, Michel Foucault's discussion of systems of surveillance, his insights on the socially specific nature of knowledge and his linking of knowledge, power and subjectivity have been influential. Likewise, there has been extensive reference to Lacanian psychoanalytic models by those who interpret photographs symptomatically, that is, as indicating something about the photographer or the circumstances of the making of the image as well as in terms of subjective readings and responses to images, for instance, of family or self. Thus, although we are particularly concerned with photographic practices, the pertinent histories of ideas and debates are broader. We need to explore widely in order to forge links that should, on occasion, be courageous in challenging knowledge parameters and other assumptions.

Contexts

Writings come from somewhere, are motivated, exist in specific historical circumstances and contexts. The British cultural critic, Raymond Williams, used the

phrase 'structure of feeling' to refer to 'certain common characteristics in a group of writers, but also of others, in a particular historical situation'.[4] He drew our attention to 'tendencies' in formal structure, and content or theme, evident in particular sets of historical circumstances and social relations, noting the inter-play of public/political and individual/subjective (un)consciousness. Similarly, the German revolutionary writer, Bertolt Brecht, argued that as reality changes, the means of representation also have to change if art is to retain potential for radical impact. The overall point is that artistic form is not independent of social change. It is productive to analyse art movements in these terms. For instance, Soviet constructivism and the German Bauhaus were both concerned with the relation between aesthetic form and sociopolitical function; their critical objectives can best be understood through taking into account the respective historical circumstances not as context in the sense of a 'backdrop' for photographic and other practices but as a productive influence contributing to the shaping of subjectivity and of artistic sensibilities.

The context in which images are encountered and the organisation of photographs within particular institutional or everyday settings also beg discussion. As a number of critics have commented, collections of photographs in public or private archives are not neutral, but rather reflect the interests and curiosities of the collector.[5] This is equally applicable to family albums, national collections of photography as art, posters selected for putting on walls (for instance in student dormitories) or local history archives. The front cover of this edition offers an example. The picture is one of a number from the late nineteenth century that were recently re-discovered, having remained unnoticed in what is now the Hulton Archive/Getty Images collection, an international commercial institution that has grown over the decades through amalgamation of various smaller collections. This finding led to a project, *Black Chronicles*, led by Autograph ABP,[6] that critically investigated archives in order to further illuminate debates relating to ideology and Black subjectivity in Britain. Core to the research was the premise that ethnicity acted as a discriminator within the archive, thereby contributing to obscuring specific visual histories.

Here, the notion of 'institution' with characteristic ideological positions, preoccupations, practices and rituals encompasses not only the institutions of photography – archives, photographers' associations, photography education, and so on – but also the institutions in relation to which photography occurs, wherein specific photographic conventions have emerged, for instance, the family, advertising agencies, journalism and social media and the international art market. Furthermore, the gallery, magazine, hoarding, website or the family album offer rather different sorts of viewing experiences. When thinking about the meaning and significance of images we need to take account of the import of the way they are organised and the effects of their setting; also, of the degree of purposefulness of our engagement. For instance, idly spotting an image when Googling or flicking through a magazine with the telly on, possibly distracted by children and tired at the end of a long day, is very different to purposefully looking at the same photograph, perhaps on a larger scale and in higher quality reproduction, in a gallery.

Contributions to debates

This selection of essays is not all-inclusive for a number of reasons. First, a great deal has been written about photography and no single volume could do justice to the number of academically rigorous, playful or provocative pieces of work which both delight and inform. Second, whilst most academics would agree on the centrality of certain contributions and contributors (Benjamin, Barthes, Sontag, . . .), aside from a handful of essays which regularly appear on university reading lists there is no clear 'canon' of contributions or, indeed, writers on the subject. As I remarked in *Photography: A Critical Introduction*[7] this is partly due to the ubiquity of photography and to its diversity of professional and everyday uses and contexts. As Victor Burgin argued some years ago:

> Photography theory has no methodology peculiarly its own. Equally clearly, the wide range of types of photographic practices across a variety of disparate institutions – advertising, amateur art, journalism, etc. – means that photography theory has an object of its own only in the very minimal sense that it is concerned with signifying practices in which still images are used by an instrumentality more automatic than had been previous ways of producing images. . . . Photography theory therefore is not, nor is it ever destined to be, an autonomous discipline. It is rather an emphasis within a general history and theory of representations.[8]

And, one might add, an emphasis within communications theory.

Of course, no discipline is autonomous in terms of its concerns and field of knowledge. However, some academic disciplines have established specific histories of debate and methodological conventions. This collection is emphatically not an attempt to establish a similar canon of writings and methods for photography theory. Rather, it demonstrates a diversity of discussions and of contexts within which debates have been pursued, as well as varying styles of engagement, from the polemical to the playful, from detailed academic analysis to the more journalistic.

This diversity invites us to consider what methods of analysis help us to understand the operations and affects of photographs. As Dudley Andrew has remarked:

> Technology has flooded us with representations such that we need to develop reflexes of reading in order to cope with a superabundance of signification. Semiotics might be thought of as a critical strategy responding directly to the technology of image production in the modern age. But photographs, because they are in part auto-generated, present enormous problems for those who would control the reading of them. Everything in the photo is potentially significant, even and especially, that which has escaped the control of the photographer pointing the camera. Here the indexical function of the photo comes to the fore, outweighing its iconic function. The photographic plate is etched with

experience, like the unconscious; and like the unconscious, it invites
a symptomatic reading of the images that escape from it to reach the
surface. As was the case with psychoanalysis, the structural study of
latent meaning had eventually to give way to strategies of reading that
are stimulated by excessive signification – in other words, poststructural
reading strategies.[9]

By extension, it is productive to situate ideas about photography within what has
come to be termed visual cultural studies wherein a diversity of methodological
issues and critical strategies may be articulated. Here, the emphasis is on bringing
a range of questions and methods of analysis to bear upon images and practices
in order to accumulate complex understanding of their cultural operations. As Irit
Rogoff notes:

> In the arena of visual culture the scrap of an image connects with a
> sequence of film and with the corner of a billboard or the window dis-
> play of a shop we have passed by, to produce a new narrative formed
> out of both our experienced journey and our unconscious. Images do
> not stay within discrete disciplinary fields such as 'documentary film' or
> 'Renaissance painting', since neither the eye nor the psyche operates
> along or recognizes such divisions.[10]

It follows that we may productively draw upon a range of academic arenas
including semiotics, psychoanalysis, art history, social history, the history of media
technologies, aesthetics, philosophy and the sociology of culture in relation to spe-
cific images and photographic practices. Thus, we may want to consider method
and methodology in relation to specific fields of practice – documentary, personal
photography, art photography, and so on. To do so is productive. This involves tak-
ing into account more general questions associated with each particular field. For
instance, in examining portraiture of children – whether within the family album or
as a more formal public commission – we would want to discuss the concept of
childhood relating this to particular historical circumstances and cultural under-
standings. However, journeys down this path risk distracting us from that which is
peculiar to photography as an act and as medium (whether chemical or digital) in
terms of contexts of making images and, more particularly, processes of interpreta-
tion. We have to balance more general contextual and methodological concerns
with more immediate investigation of the photographic.

The Photography Reader was first published in 2003, with the intention of
bringing together a number of key contributions within twentieth-century debates
on photographs, their uses, impact and contexts. Since then, there has been a bur-
geoning of writings on photographic practices (photography and digital imaging),
on the global flow of images, on what is photographed and how and on what is left
out of the picture. The first edition of this collection was comprehensive, bringing
together historical, theoretical and cultural texts that were wide-ranging in their

compass. In order to update and extend the compilation, *The Photography Reader* has been expanded across two new volumes: *The Photography Reader: History and Theory* and, a companion volume, *The Photography Culture Reader: Representation, Agency and Identity*. The books are intended primarily for undergraduate students, although I hope they continue to prove more widely useful. This first collection brings into focus aspects of twentieth-century and early twenty-first-century debates relating to photography; this includes issues pertaining to aesthetics, theories of knowledge and the immanent characteristics of the photograph, as well as to uses of photography: images and contexts. This mapping takes place through the reproduction of essays which have made substantial contributions to ideas about photography and to photography criticism.

Criteria for selection of essays in this collection were varied; given the extensive amount that has been written about photography in differing contexts, the final selection was difficult. In some cases, I have included essays because of their renowned influence, for instance, Benjamin's 'artworks' essay. I have also tried to include essays that 'speak' to each other through cross-reference or debate. Sections are organised historically and thematically. Thus, the first section is concerned more broadly with reflections on photographs; the following three sections, on photographic seeing, on meaning and interpretation and on photography and art are more-or-less chronological in terms of ideas and debates; the following two sections, document and photomedia, engage continuing contemporary concerns relating to the status of images in an era of digital fluidity. Some essays are illustrated. However, due to copyright restrictions, availability and, in some instances, space, it has not been possible to include all relevant images. A number of threads run through the book, across and between sections, for instance, questions of the power of the photographic gaze or of affects of photographs. In addition, I wanted to represent as great a range of authors as possible, well-known and less celebrated. This led to some difficult decisions. In many instances, I had to choose between several excellent pieces of writing by the same author; as I have already remarked, to select one essay from a body of work inevitably risks misrepresenting the overall position and diversity of explorations of the writer.

Given the range of potential material, with regret, I had to eliminate some considerations, for instance, there is little reference to photo-narrative, although there are some interesting debates on the subject; additionally, there is no direct address to historiography. In theorising photography, we need to take into account specificities of purpose and context but also to transcend these. Several of the essays included reference specific fields of photographic practice but have broader implications in terms of theory and methods of analysis. The contributions obviously reflect debates and assumptions of their era. A number of the authors have moved on from the positions, concerns and methods of analysis represented here. Nonetheless, fundamental questions about the nature and status of photographs and the act of photography echoed through much of the twentieth century and remain pertinent now.

For a substantial bibliography of publications on photography, students are advised to consult *Photography: A Critical Introduction* (Wells (ed.) 2015), to which this is something of a companion volume.

This book would not have been possible without the contributions of many people. First, I should like to thank all the writers, and their publishers, for allowing their work to be reproduced. Attempts were made to contact each of the contributors to check for any comments or amendments they wished to propose; particular thanks to those who responded with suggestions. It goes without saying that without the essays this collection could not exist. Second, I would like to thank Kate Isherwood for an extensive library journal search through which she identified, annotated and brought to my attention a number of key articles published since 2000. Third, I thank Routledge, in particular Natalie Foster and Jennifer Vennall, for entrusting me with the challenge of extending the reader into two volumes. Finally, acknowledgement is due to Mandy Russell, arts librarian at University of Plymouth, for her unfailing support. Draft versions of this introduction, first written over fifteen years ago, were given as papers in research seminars at University of Plymouth at Exeter, at the Society for Photographic Education annual conference, 2001, and at the symposium 'Why Pictures Now?' in Krakow, 2001. My grateful thanks to colleagues at the university and elsewhere, for their many helpful comments and suggestions.

Notes

1 Jean-Paul Sartre (1972) *The Psychology of Imagination*, London: Methuen & Co., p. 16, first published in French in 1940, Eng. trans. 1948, New York: Philosophical Library Inc.
2 Interviewed in 'The Authentic Image', *Screen Education* No. 32/33 Autumn/Winter 1979/80.
3 Terry Eagleton (1984) *The Function of Criticism*, London: Verso, p. 9.
4 Raymond Williams (1980) 'Literature and Sociology' in *Problems in Materialism and Culture*, London: Verso, p. 22.
5 Cf, in particular, Allan Sekula 'Reading an Archive: Photography Between Labour and Capital', included in this collection.
6 Autograph ABP (formerly the Association of Black Photographers) is an international arts agency concerned with photography, film, representation, cultural identity and human rights that has its roots in supporting and promoting the work of Black and Minority Ethnic British photographers. www.autograph-abp.co.uk
7 Liz Wells (ed.) (1997, 2000, 2004, 2009, 2015) *Photography: A Critical Introduction*, London: Routledge. An introduction to key debates in photographic histories and theory.
8 Victor Burgin (1984) 'Something About Photography Theory', *Screen* Vol. 25 No. 1 p. 65.
9 Dudley Andrew (1997) *The Image in Dispute*, Austin: University of Texas pp. x/xi.
10 Irit Rogoff (1998) 'Studying Visual Culture' in Nicholas Mirzoeff (ed.) *The Visual Culture Reader*, London and New York: Routledge, p. 16.

PART ONE

Reflections on photography

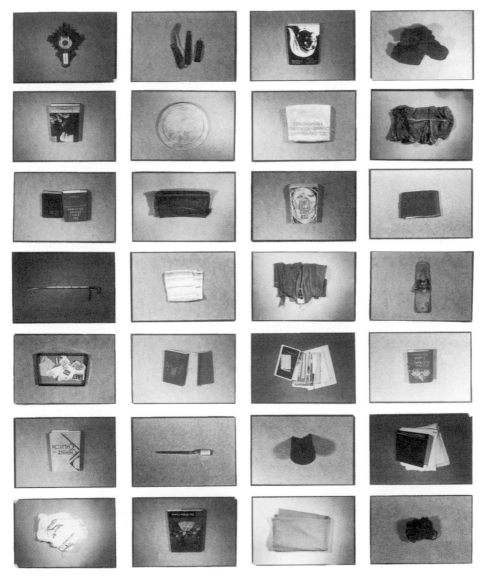

Christian Boltanski, *Inventaire des objets ayant appartenu á un habitant d'Oxford*, 1973. Courtesy of the artist and the Marian Goodman Gallery. © ADAGP, Paris and DACS, London 2018.

Introduction

WHAT DISTINGUISHES PHOTOGRAPHY from other means of visual representation? How do photographs acquire meaning? How do we use them? Such questions have proved perplexing ever since the inception of photography.

In the nineteenth century such debates generally assumed that photography had characteristics which made it a more accurate method of recording and representing than previously existing methods (such as painting or observational drawing). Language reflects attitudes to artefacts and experiences. In French, the camera lens is called the 'objectif', a term that twins defining what we see as the 'object' of vision, and the idea of 'objectivity', in the sense of impartial observation. In Spanish, the camera is called a 'machina', a term which implies the mechanical. As with other machinery, it is possible to use the camera to make images without understanding the technical mechanisms involved. We don't have to analyse and comprehend either the physical 'machinery' or the properties of 'vision' to make an image. However, discussion of ideas and experiments in the construction and interpretation of images can take us into the realms of chemistry, optics and physics, as well as those of aesthetics and visual communication (see, for instance, Aumont 1997).

Many historians have noted the coincidence of early photography with realism in painting in the mid-nineteenth century. Realism emphasised painting from observation, as opposed, for instance, to picturing narratives from history, or to religious iconography. Realism was thus seated in empirical aesthetics. Photographer and photo-historian, Giselle Freund, suggested that this

> aesthetic equation of visual reality with the reality of nature was also the premise of the photographer, for whom reality in nature was defined only by the optical image of nature. . . . Imagination had little role in his work, which consisted only in choosing the subject matter, evaluating the best way to frame it, and selecting the pattern of light and shadow. His work ended there, even before the shutter clicked.
>
> (Freund 1980: 71)

On the other hand, there was emphasis on the expressive properties of the photograph and the creativity of the photographer. This reflected experiments in use of light and chemicals, including contact printing; also, staging of dramatic scenarios (for instance, by Julia Margaret Cameron) or the framing and titling of images to suggest the metaphoric (for instance, H. P. Robinson). Such imagery allowed 'pictorialists' towards the end of the nineteenth century to claim photography as an art practice. Thus, at the turn of the twentieth century, theoretical investigations and speculations as to the constitution of photographs were influenced by a tension between realist and expressive aesthetics, which to some extent correlated with different intentions and uses of the medium.

By the end of the nineteenth century, photography was being used within a very great range of spheres of activity, from the anthropological and the medical to

the domestic, everyday; from street photography to explicitly poetic imagery. Possibilities for photography burgeoned as firms such as Kodak, Eastman and Lumières Bros. set out to invent new, relatively portable and easy-to-use cameras. Indeed, by the end of the 1880s both hand-held cameras and sensitised paper (replacing glass plates) were available. Kodak advertising carried the tag line 'you press the button, we do the rest' (the whole camera was returned for a reel of film to be processed). As manufacturers, their motives were in part profit-driven, but this interest in expanding entrepreneurial possibilities led to cameras becoming more widely accessible.

For theorists the implications of 'fixing a shadow' remained puzzling. In Latin, 'camera' refers to a vault or arched chamber. The mediaeval camera obscura was thus a darkened, contained space. Susan Sontag's opening essay 'In Plato's Cave' in *On Photography* (Sontag 1979) references this idea of letting light reflect shadows within a dark space. Classical Greek philosopher, Plato, talked of a cave within which light through a hole reflected images from outside of the cave. Sontag's title reminds us that shadow play and the transient effects of the reflection of light have long been a source of fascination. But once the image could be fixed it became an agent of disruption, changing our sense of space and time – of geography and history – as we became able to view images of people and places otherwise unseen.

The debates about the photograph included in this section (and, indeed, throughout this Reader and its companion) focus upon the sociocultural. What impact does photography, which literally means 'writing with light', have on our ways of seeing, experiencing and making sense of experience? How do we use photographs? In what ways might photographs be said to 'frame' vision or pre-empt interpretation, for instance, when we see photographs of people or places in advance of actually meeting or visiting? What can photographs reveal that would otherwise be imperceptible? Walter Benjamin argued that photography draws attention to the 'optical unconscious':

> Whereas it is a commonplace that, for example, we have some idea what is involved in the act of walking, if only in general terms, we have no idea at all what happens during the fraction of a second when a person *steps out*. Photography, with its devices of slow motion and enlargement, reveals the secret. It is through photography that we first discover the existence of this optical unconscious, just as we discover the instinctual unconscious through psychoanalysis.
>
> (Benjamin 1931: 243)

Photographs, in this respect, can offer explicit evidence of aspects of behaviour (human, animal, plant, environmental) that otherwise would not be available for comment or analysis. Through photography, information is brought 'into the picture'.

In the late twentieth century, some philosophers questioned whether we can distinguish between the world as experienced directly, whether consciously acknowledged or unconsciously taken into account, and the world as represented to us. For instance, semiotician, Umberto Eco, notoriously made a visit to New Orleans (the city) in order to check whether it lived up to its simulation in Disneyland. Likewise, the

postmodern rhetoritician, Jean Baudrillard, asserted that "the Gulf War did not take place", not because he thought that nothing had actually occurred, but because he wanted to draw attention to the fact that for most people this experience was one of photographic/televisual representation and mediation (Baudrillard 1995). So how can we best understand the inter-relation of image, experience and comprehension? In what ways has photography changed the social world?

Such questions were central to the concerns of a number of key twentieth-century philosopher-critics whose contemplations on photography have contributed to defining the parameters of theoretical debates. Such contributions have often taken the form of discussion of photography or of photographs within broader phenomenological considerations, as for instance, in Jean-Paul Sartre's musings (see p. 1 of this volume). Others have written more specifically about photographs and about photography. A number question the relation between the image and the world of objects and appearances which it references. For instance, Max Kosloff, in trying to define something of the fascination of photographs, suggested that photos 'witness' events, whilst Susan Sontag referred to photographs as 'traces' or 'stencils' imprinted from actuality, whereas John Berger suggested that photographs can best be understood as quotations from actuality (Berger 1982; Kosloff 1979; Sontag 1979). Such terminology is not only indicative of a suggested relation with the world of appearances but also of uses of images; for instance, to conceptualise the photograph as 'witness' is to suggest that photographs offer evidence, that they are testimonials; extending the analogy, Kosloff commented that images can offer false or partial witness. Furthermore, a term such as 'witness' will always imply documentary concerns. By contrast, terms such as 'trace' or 'stencil' or 'quotation' suggest references which become detached from their source, circulating in new contexts but with something of their origins continuing to adhere. Such terminology invites us to consider the slippage between specific histories and experiences and more general historical contexts and circumstances.

Roland Barthes, Susan Sontag and Walter Benjamin are among the preeminent twentieth-century critics who have specifically examined photography; hence the inclusion of their essays or extracts in this section. In each case, their writing is 'paired' with a response or related piece which in some way engages, places and develops from their contribution.

Camera Lucida was Roland Barthes' final book and therefore, in effect, his last word on the photograph. It is in two parts, composed of forty-eight sections. The first part deals primarily with the nature of the photograph as a phenomenon with a particular sort of relation to history, and echoes some of the concerns engaged a couple of decades earlier by Jean-Paul Sartre (to whom *Camera Lucida* is dedicated) in *L'Imaginaire* (1940). The second part stands as a meditation on photography as a marker of the passage of time. He centrally addresses the image as a courier of emanations from the past, asking what particularly arrests attention. The poignancy of the image is emphasised through his starting point: a photograph of his (deceased) mother. The title of the book, in French *La Chambre claire* sets up a series of resonances around photography, the empty but illuminated ('clair') chamber, being, like Plato's Cave, a space of inscription.

Barthes' final meditation upon photographs has attracted wide-ranging debate. Here, Marjorie Perloff responds in particular to the second half of the book, Barthes' elegy to his dead mother, which centres on the autobiographical. Perloff explores Barthes' contribution through the 'filter' of the work of artist Christian Boltanski, in particular his installations based on the Holocaust. Through this comparative analysis, the nature and status of the image and its relation to history, as conceptualised by Barthes, is brought into question. Boltanski's work invites us to think about photographs as markers of absence and to question everyday images, appearances and events. His approach echoes Barthes' own lack of concern with the authoring of the image. Barthes' interest was in everyday imagery, in the photograph as a carrier of meaning, both as a semiotic artefact (the focus of his earlier work) and as a phenomenon with psychological and autobiographical implications (emphasised in his later work).

European photography in the modern era was characterised by a sense of change. It was not alone in this. In particular, after the First World War in Europe and after the Soviet Revolution, there was a sense of a need for reconstruction which linked the artistic, the social and the political. In Germany, the group of philosophers and critics, retrospectively labelled 'Frankfurt School', were concerned, amongst other things, with the relation between public spheres of debate and activity and the private, and also with the social role of art. Within this group, Walter Benjamin paid particular attention to photography, to questions of authorship and to collecting, including the construction of archives. His famous essay on 'The Work of Art in an Age of Mechanical Reproduction' is frequently reproduced and cited in twentieth-century writings on the impact and implications of photography. The essay, first published in 1936, centrally considers two issues: first, the nature of photography as a creative act, one which differs in its immediacy and in its relation to actuality from other forms of activity; second, what he views as the democratising effects of the mass reproducibility of images. Although photography had been widespread since the mid-nineteenth century, it was only at the turn of the twentieth century that developments in lithography allowed for mass reproduction and publication of photo-images. The original German title for the essay literally translates as 'The Work of Art in an Era of Technical *Reproducibility*', emphasising the expanding potential for mass duplication. This essay acquired new life in the 1990s through frequent reference by those concerned to analyse the impact and implications of digital imaging and cyberspace networks.

William J. T. Mitchell's contextualisation of Benjamin's essays on photography helps locate them within Marxist criticism, emphasising the materialist – or economic – foundations of Benjamin's discussion. For Marxism there is a distinction within Capitalism between the cost of production (involving investment in raw materials, machinery and labour) and the exchange value which a product can command in the market place as a socially valued or 'fetishised' commodity. Fetishisation is a consequence of attributes projected onto the commodity – hence Mitchell's reference to the fetishism of aesthetics. The extract is from a much longer publication in which Mitchell's principal concern is to investigate ideas about imagery.

Siegfried Kracauer was writing in the same historical context as Walter Benjamin; indeed, Benjamin's essay, 'A Short History of Photography' (1931), along with his 'Artworks' essay extracted here, can be seen as responses to Kracauer's initial musings on 'Die Photographie' (1927). His contribution is significant for interrogating the faith that we invest in historical photographs as stand-ins for memory that reach out to those not originally present and therefore lacking actual memory of specific people, places or occasions. His reflections rest on an assumption of photography as directly representing that in front of the camera, and thus anchored in specific circumstances. He proposes that photographs are simultaneously bound to time (the moment of making) yet reach out through time (subsequent viewings), and that, in transcending their specific context, any stability of meaning is disrupted. In common with Kracauer, the French critic, André Bazin, stressed the ontological relationship of photography to reality. Both writers were interested in photographic realism in relation to cinema. Bazin also wrote on documentary and on neo-realist film. He argued that the authority of photographic imagery stems from the camera as an automatic means of representation (by contrast with drawing or painting wherein the expressive interpretation of the artist is integral). For Bazin photographs are simultaneously 'hallucinations' and 'facts', although at the end of his essay he also acknowledges the role of 'language', reminding us of the role played by visual form or structures within meaning and interpretation and also aesthetic impact.

Issues, ideas and practices age, especially as information, knowledge, understandings and technologies change and develop. Richard Bolton has remarked that:

> The disruptions and challenges posed by modernist invention have been assimilated into the status quo; once-radical methods for producing alternative reality have become apolitical means for reproducing dominant reality. Despite the utopian and anarchic desires that fueled modern art, its lasting impact seems to have been on commodity production, mass media, and other means of social control. Its greatest accomplishment can be found in the public's adjustment to the new productive and reproductive apparatuses of twentieth-century life.
>
> (Bolton 1989: xi)

Likewise, writings reflect contemporary concerns and debates. Philosophical contributions should be considered both in terms of their significance at the time and in terms of their helpfulness in illuminating critical enquiry now.

The final pairing of Susan Sontag and Wright Morris is more indirect, based upon the manner of the critical process rather than upon direct engagement by the one critic with the work of the other. Sontag wrote six essays on photography that were collected as a book in 1973 (and also made into a television discussion under the title *It's Stolen Your Face*, BBC, UK). According to her own account, she wrote the essays in sequence, each pushing her central investigation further. Overall, she questions the moral implications of the making and distribution of photographs. Two years later she was invited to lecture at Jewett Arts Center, Wellesley College, Massachusetts, within a series of ten talks, mostly by photographers, and to contribute to

an accompanying exhibition. Her lecture reproduced here, in effect summarises her position on the nature and uses of photography, thereby complementing the essays collected in *On Photography* (a publication that remains widely available).

Photographs record surface perceptions in a detailed manner; this allows that which might be known through the optical unconscious, but not previously articulated, to become explicit. Writing at around the same time as Sontag, Morris is likewise concerned with the implications and effects of the ubiquity and proliferation of photographic images and what he views as the 'rise in status' of the photograph. He distinguishes between the 'image', consequent upon the eye and vision of the photographer as artist; and the 'photograph', which he sees as fixed by the camera. He emphasises the everyday, the pleasure of looking at anonymous, vernacular images and speculates on the interaction of photographs, history and myth.

This section comprises twentieth-century writings, published after the First World War in Europe. This should not be taken to suggest that questions of the ontology of photographs were ignored in the nineteenth and early twentieth centuries. On the contrary, there were extensive debates, particularly between pictorialists, and those who emphasised the naturalist (realist) properties of the medium. Such debates remain of historical interest but are less immediately pertinent to us as they did not directly contribute to framing the conceptual questions and parameters of current debates that rest in many respects on re-thinking that which was earlier taken to characterise the effects, affects and import of photographs.

References and selected further reading

Aumont, J. (1997) *The Image*. London: British Film Institute. First published in French in 1990.

Baudrillard, J. (1983) *Simulations*. New York: Semiotext.

——— (1995) *The Gulf War Did Not Take Place*. Sydney: Power Publications.

Bazin, A. (1967) 'The Ontology of the Photographic Image' in *What Is Cinema*? Vol. 1. Berkeley: University of California Press. Original French publication, 1945.

Benjamin, W. (1931) 'A Short History of Photography' included in Benjamin, W. (1979) *One Way Street*. London: New Left Books. Also in A. Trachtenberg (1980) *Classic Essays on Photography*. New Haven: Leete's Island Books.

Berger, J. (1980) 'Uses of Photography' in his *About Looking*. London: Writers and Readers.

——— (1982) 'Appearances' in *Another Way of Telling*: London: Writers and Readers.

Bolton, R. (ed.) (1989) *The Contest of Meaning*. Cambridge, MA: MIT Press. American critical essays reappraising photo-histories.

Buck Morse, S. (1992) 'Aesthetics and Anaesthetics: Walter Benjamin's Artwork Essay Reconsidered' *October*, No. 62, Fall, pp. 3–41.

Coleman, A. L. (1979) *Light Readings*. New York: Oxford University Press.

——— (1995) *Critical Focus: Photography in the International Image Community*. Munich: Nazraeli Press. Collections of reviews and essays, mostly written for U.S. magazines and catalogues.

Eco, U. (1990) *Travels in Hyperreality*. San Diego: Harcourt Brace.

Freund, G. (1980) *Photography and Society*. London: Gordon Fraser. Originally published in French, 1974.

Goldberg, V. (ed.) (1981) *Photography in Print: Writings from 1816 to the Present*. Albuquerque: University of New Mexico Press. Organised chronologically in terms of

debates and practitioners, the final ten essays dating from the 1970s, indicate some-thing of then contemporary concerns. Aside from one contribution (from Barthes), these particularly reflect American perspectives.

Kosloff, M. (1979) *Photography and Fascination*. Danbury, New Hampshire: Addison House. Collections of his essays and reviews published variously in magazines such as *Artforum*, *Art in America*, *Village Voice*.

———— (1987) *The Privileged Eye*. Albuquerque: University of New Mexico Press.

Lomax, Y. (2000) *Writing the Image*. London: I. B. Taurus. Speculation on the nature and uses of photography.

Petruck, P. R. (1979) *The Camera Viewed*: *writings on twentieth-century photography*. New York: Dutton. Useful collection, including writings by Barthes, Man Ray, Sontag, Duane Michals.

Sartre, J.-P. (1948) *The Psychology of the Imagination*. New York: Philosophical Library. First published in French in 1940 as *L'Imaginaire*, Paris: Éditions Gallimard. A broad phenomenological discussion which includes a section on 'The Image Family'.

Sontag, S. (1979) *On Photography*. Harmondsworth: Penguin. New edition, 2002, with introduction by John Berger. Essays first published in *The New York Review of Books*, 1973, 1974, 1977. First published as a collection, 1977.

Bibliography of essays in part one

Barthes, R. (1984) *Camera Lucida: Reflections on Photography*. London: Flamingo (Fontana). Originally published, 1980.

Bazin, A. (1960) 'The Ontology of the Photographic Image' translated by Hugh Gray. *Film Quarterly*, Vol. 13, No. 4, Summer. Originally published, 1945.

Benjamin, W. (1973) 'The Work of Art in the Age of Mechanical Reproduction' in H. Arendt (ed.) *Illuminations*. London: Fontana. Originally published, 1936.

Kracauer, S. (1993) 'Photography' *Critical Inquiry*, Vol. 19, No. 3, Spring, pp. 421–436. Chicago: University of Chicago Press. Originally published, 1927.

Mitchell, W. J. T. (1986) 'Benjamin and the Political Economy of the Photograph' in *Iconology: Image, Text, Ideology*. Chicago, University of Chicago.

Morris, W. (1978) 'In Our Image' *The Massachusetts Review*, Vol. XIX, No. 4. The Massachusetts Review Inc. pp. 534–545. Reprinted in Goldberg, V. (ed.) (1981) *Photography in Print*. Albuquerque: University of New Mexico.

Perloff, M. (1994) 'What Has Occurred Only Once: Barthes's Winter Garden/Boltanski's Archives of the Dead' in Jean-Michel Rabate (ed.) *Writing the Image After Roland Barthes*. Philadelphia: University of Pennsylvania Press.

Sontag, S. (1975) 'Photography Within the Humanities' in Eugenia Parry Janis and Wendy MacNeil (ed.) *Photography Within the Humanities*. Danbury, New Hampshire: Addison House Publishers.

Roland Barthes

EXTRACTS FROM *CAMERA LUCIDA*

1

ONE DAY, QUITE SOME TIME AGO, I happened on a photograph of Napoleon's youngest brother, Jerome, taken in 1852. And I realized then, with an amazement I have not been able to lessen since: 'I am looking at eyes that looked at the Emperor.' Sometimes I would mention this amazement, but since no one seemed to share it, nor even to understand it (life consists of these little touches of solitude), I forgot about it. My interest in Photography took a more cultural turn. I decided I liked Photography *in opposition* to the Cinema, from which I nonetheless failed to separate it. This question grew insistent. I was overcome by an 'ontological' desire: I wanted to learn at all costs what Photography was 'in itself,' by what essential feature it was to be distinguished from the community of images. Such a desire really meant that beyond the evidence provided by technology and usage, and despite its tremendous contemporary expansion, I wasn't sure that Photography existed, that it had a 'genius' of its own.

2

Who could help me?

From the first step, that of classification (we must surely classify, verify by samples, if we want to constitute a corpus), Photography evades us. The various distributions we impose upon it are in fact either empirical (Professionals/Amateurs), or rhetorical (Landscapes/Objects/Portraits/Nudes), or else aesthetic (Realism/Pictorialism), in any case external to the object, without relation to its essence, which can only be (if it exists at all) the New of which it has been the advent; for these classifications might very well be applied to other, older forms of representation. We might say that Photography is unclassifiable. Then I wondered what the source of this disorder might be.

The first thing I found was this. What the Photograph reproduces to infinity has occurred only once: the Photograph mechanically repeats what could never be repeated existentially. In the Photograph, the event is never transcended for the sake of something else: the Photograph always leads the corpus I need back to the body I see; it is the absolute Particular, the sovereign Contingency, matte and somehow stupid, the *This* (this photograph, and not Photography), in short, what Lacan calls the *Tuché*, the Occasion, the Encounter, the Real, in its indefatigable expression. In order to designate reality, Buddhism says *sunya*, the void; but better still: *tathata*, as Alan Watts has it, the fact of being this, of being thus, of being so; *tat* means *that* in Sanskrit and suggests the gesture of the child pointing his finger at something and saying: *that, there it is, lo!* but says nothing else; a photograph cannot be transformed (spoken) philosophically, it is wholly ballasted by the contingency of which it is the weightless, transparent envelope. Show your photographs to someone – he will immediately show you his: 'Look, this is my brother; this is me as a child,' etc.; the Photograph is never anything but an antiphon of 'Look,' 'See,' 'Here it is;' it points a finger at certain *vis-à-vis*, and cannot escape this pure deictic language. This is why, insofar as it is licit to speak of *a* photograph, it seemed to me just as improbable to speak of *the* Photograph.

A specific photograph, in effect, is never distinguished from its referent (from what it represents), or at least it is not *immediately* or *generally* distinguished from its referent (as is the case for every other image, encumbered – from the start, and because of its status – by the way in which the object is simulated): it is not impossible to perceive the photographic signifier (certain professionals do so), but it requires a secondary action of knowledge or of reflection. By nature, the Photograph (for convenience's sake, let us accept this universal, which for the moment refers only to the tireless repetition of contingency) has something tautological about it: a pipe, here, is always and intractably a pipe. It is as if the Photograph always carries its referent with itself, both affected by the same amorous or funereal immobility, at the very heart of the moving world: they are glued together, limb by limb, like the condemned man and the corpse in certain tortures; or even like those pairs of fish (sharks, I think, according to Michelet) which navigate in convoy, as though united by an eternal coitus. The Photograph belongs to that class of laminated objects whose two leaves cannot be separated without destroying them both: the window-pane and the landscape, and why not: Good and Evil, desire and its object: dualities we can conceive but not perceive (I didn't yet know that this stubbornness of the Referent in always being there would produce the essence I was looking for).

This fatality (no photograph without *something* or *someone*) involves Photography in the vast disorder of objects – of all the objects in the world: why choose (why photograph) this object, this moment, rather than some other? Photography is unclassifiable because there is no reason to *mark* this or that of its occurrences; it aspires, perhaps, to become as crude, as certain, as noble as a sign, which would afford it access to the dignity of a language: but for there to be a sign there must be a mark; deprived of a principle of marking, photographs are signs which don't *take,* which *turn,* as milk does. Whatever it grants to vision and whatever its manner, a photograph is always invisible: it is not it that we see.

In short, the referent adheres. And this singular adherence makes it very difficult to focus on Photography. The books which deal with it, much less numerous moreover than for any other art, are victims of this difficulty. Some are technical; in order to

'see' the photographic signifier, they are obliged to focus at very close range. Others are historical or sociological; in order to observe the total phenomenon of the Photograph, these are obliged to focus at a great distance. I realized with irritation that none discussed precisely the photographs which interest me, which give me pleasure or emotion. What did I care about the rules of composition of the photographic landscape, or, at the other end, about the Photograph as family rite? Each time I would read something about Photography, I would think of some photograph I loved, and this made me furious. Myself, I saw only the referent, the desired object, the beloved body; but an importunate voice (the voice of knowledge, of *scientia*) then adjured me, in a severe tone: 'Get back to Photography. What you are seeing here and what makes you suffer belongs to the category "Amateur Photographs," dealt with by a team of sociologists; nothing but the trace of a social protocol of integration, intended to reassert the Family, etc.' Yet I persisted; another, louder voice urged me to dismiss such sociological commentary; looking at certain photographs, I wanted to be a primitive, without culture. So I went on, not daring to reduce the world's countless photographs, any more than to extend several of mine to Photography: in short, I found myself at an impasse and, so to speak, 'scientifically' alone and disarmed.

[. . .]

4

So I make myself the measure of photographic 'knowledge.' What does my body know of Photography? I observed that a photograph can be the object of three practices (or of three emotions, or of three intentions): to do, to undergo, to look. The *Operator* is the Photographer. The *Spectator* is ourselves, all of us who glance through collections of photographs — in magazines and newspapers, in books, albums, archives. . . . And the person or thing photographed is the target, the referent, a kind of little simulacrum, any *eidolon* emitted by the object, which I should like to call the *Spectrum* of the Photograph, because this word retains, through its root, a relation to 'spectacle' and adds to it that rather terrible thing which is there in every photograph: the return of the dead.

One of these practices was barred to me and I was not to investigate it: I am not a photographer, not even an amateur photographer: too impatient for that: I must see right away what I have produced (Polaroid? Fun, but disappointing, except when a great photographer is involved). I might suppose that the *Operator's* emotion (and consequently the essence of Photography-according to-the-Photographer) had some relation to the 'little hole' (*stenope*) through which he looks, limits, frames, and perspectivizes when he wants to 'take' (to surprise). Technically, Photography is at the intersection of two quite distinct procedures; one of a chemical order: the action of light on certain substances; the other of a physical order: the formation of the image through an optical device. It seemed to me that the *Spectator's* Photograph descended essentially, so to speak, from the chemical revelation of the object (from which I receive, by deferred action, the rays), and that the *Operator's* Photograph, on the contrary, was linked to the vision framed by the keyhole of the *camera obscura*. But of that emotion (or of that essence) I could not speak, never having experienced it; I could not join the troupe of those (the majority) who deal with Photography-according-to-the-Photographer. I possessed only two experiences: that of the observed subject and that of the subject observing . . .

5

It can happen that I am observed without knowing it, and again I cannot speak of this experience, since I have determined to be guided by the consciousness of my feelings. But very often (too often, to my taste) I have been photographed and knew it. Now, once I feel myself observed by the lens, everything changes: I constitute myself in the process of 'posing,' I instantaneously make another body for myself, I transform myself in advance into an image. This transformation is an active one: I feel that the Photograph creates my body or mortifies it, according to its caprice (apology of this mortiferous power: certain Communards paid with their lives for their willingness or even their eagerness to pose on the barricades: defeated, they were recognized by Thiers's police and shot, almost every onc).

Posing in front of the lens (I mean: knowing I am posing, even fleetingly), I do not risk so much as that (at least, not for the moment). No doubt it is metaphorically that I derive my existence from the photographer. But though this dependence is an imaginary one (and from the purest image-repertoire), I experience it with the anguish of an uncertain filiation: an image – my image – will be generated: will I be born from an antipathetic individual or from a 'good sort'? If only I could 'come out' on paper as on a classical canvas, endowed with a noble expression – thoughtful, intelligent, etc.! In short, if I could be 'painted' (by Titian) or drawn (by Clouet)! But since what I want to have captured is a delicate moral texture and not a mimicry, and since Photography is anything but subtle except in the hands of the very greatest portraitists, I don't know how to work upon my skin from within. I decide to 'let drift' over my lips and in my eyes a faint smile which I mean to be 'indefinable,' in which I might suggest, along with the qualities of my nature, my amused consciousness of the whole photographic ritual: I lend myself to the social game, I pose, I know I am posing, I want you to know that I am posing, but (to square the circle) this additional message must in no way alter the precious essence of my individuality: what I am, apart from any effigy. What I want, in short, is that my (mobile) image, buffeted among a thousand shifting photographs, altering with situation and age, should always coincide with my (profound) 'self'; but it is the contrary that must be said: 'myself' never coincides with my image; for it is the image which is heavy, motionless, stubborn (which is why society sustains it), and 'myself' which is light, divided, dispersed; like a bottle-imp, 'myself' doesn't hold still, giggling in my jar: if only Photography could give me a neutral, anatomic body, a body which signifies nothing! Alas, I am doomed by (well-meaning) Photography always to have an expression: my body never finds its zero degree, no one can give it to me (perhaps only my mother? For it is not indifference which erases the weight of the image – the Photomat always turns you into a criminal type, wanted by the police – but love, extreme love).

To see oneself (differently from in a mirror): on the scale of History, this action is recent, the painted, drawn, or miniaturized portrait having been, until the spread of Photography, a limited possession, intended moreover to advertise a social and financial status – and in any case, a painted portrait, however close the resemblance (this is what I am trying to prove) is not a photograph. Odd that no one has thought of the *disturbance* (to civilization) which this new action causes. I want a History of Looking. For the Photograph is the advent of myself as other: a cunning dissociation of consciousness from identity. Even odder: it was *before* Photography that men had the most

to say about the vision of the double. Heautoscopy was compared with an hallucinosis; for centuries this was a great mythic theme. But today it is as if we repressed the profound madness of Photography: it reminds us of its mythic heritage only by that faint uneasiness which seizes me when I look at 'myself' on a piece of paper.

This disturbance is ultimately one of ownership. Law has expressed it in its way: to whom does the Photograph belong? Is landscape itself only a kind of loan made by the owner of the terrain? Countless cases, apparently, have expressed this uncertainty in a society for which being was based on having. Photography transformed subject into object, and even, one might say, into a museum object: in order to take the first portraits (around 1840) the subject had to assume long poses under a glass roof in bright sunlight; to become an object made one suffer as much as a surgical operation; then a device was invented, a kind of prosthesis invisible to the lens, which supported and maintained the body in its passage to immobility: this headrest was the pedestal of the statue I would become, the corset of my imaginary essence.

The portrait-photograph is a closed field of forces. Four image-repertoires intersect here, oppose and distort each other. In front of the lens, I am at the same time: the one I think I am, the one I want others to think I am, the one the photographer thinks I am, and the one he makes use of to exhibit his art. In other words, a strange action: I do not stop imitating myself, and because of this, each time I am (or let myself be) photographed, I invariably suffer from a sensation of inauthenticity, sometimes of imposture (comparable to certain nightmares). In terms of image-repertoire, the Photograph (the one I *intend*) represents that very subtle moment when, to tell the truth, I am neither subject nor object but a subject who feels he is becoming an object: I then experience a micro-version of death (of parenthesis): I am truly becoming a specter. The Photographer knows this very well, and himself fears (if only for commercial reasons) this death in which his gesture will embalm me. Nothing would be funnier (if one were not its passive victim, its *plastron*, as Sade would say) than the photographers' contortions to produce effects that are 'lifelike': wretched notions: they make me pose in front of my paintbrushes, they take me outdoors (more 'alive' than indoors), put me in front of a staircase because a group of children is playing behind me, they notice a bench and immediately (what a windfall!) make me sit down on it. As if the (terrified) Photographer must exert himself to the utmost to keep the Photograph from becoming Death. But I – already an object, I do not struggle. I foresee that I shall have to wake from this bad dream even more uncomfortably; for what society makes of my photograph, what it reads there, I do not know (in any case, there are so many readings of the same face); but when I discover myself in the product of this operation, what I see is that I have become Total-Image, which is to say, Death in person; others – the Other – do not dispossess me of myself, they turn me, ferociously, into an object, they put me at their mercy, at their disposal, classified in a file, ready for the subtlest deceptions: one day an excellent photographer took my picture; I believed I could read in his image the distress of a recent bereavement: for once Photography had restored me to myself, but soon afterward I was to find this same photograph on the cover of a pamphlet; by the artifice of printing, I no longer had anything but a horrible disinternalized countenance, as sinister and repellent as the image the authors wanted to give of my language. (The 'private life' is nothing but that zone of space, of time, where I am not an image, an object. It is my *political* right to be a subject which I must protect.)

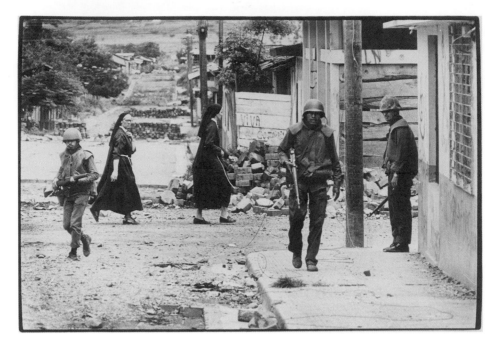

Figure 1.1 Koen Wessing, *Nicaragua*, 1979. Courtesy of the artist.

Ultimately, what I am seeking in the Photograph taken of me (the 'intention' according to which I look at it) is Death: Death is the *eidos* of that Photograph. Hence, strangely, the only thing that I tolerate, that I like, that is familiar to me, when I am photographed, is the sound of the camera. For me, the Photographer's organ is not his eye (which terrifies me) but his finger: what is linked to the trigger of the lens, to the metallic shifting of the plates (when the camera still has such things). I love these mechanical sounds in an almost voluptuous way, as if, in the Photograph, they were the very thing – and the only thing – to which my desire clings, their abrupt click breaking through the mortiferous layer of the Pose. For me the noise of Time is not sad: I love bells, clocks, watches – and I recall that at first photographic implements were related to techniques of cabinetmaking and the machinery of precision: cameras, in short, were clocks for seeing, and perhaps in me someone very old still hears in the photographic mechanism the living sound of the wood.

[. . .]

9

I was glancing through an illustrated magazine. A photograph made me pause. Nothing very extraordinary: the (photographic) banality of a rebellion in Nicaragua: a ruined street, two helmeted soldiers on patrol; behind them, two nuns. Did this photograph please me? Interest me? Intrigue me? Not even. Simply, it existed (for me). I understood at once that its existence (its 'adventure') derived from the co-presence of two discontinuous elements, heterogeneous in that they did not belong to the same world (no need to proceed to the point of contrast): the soldiers and the nuns. I foresaw a structural rule (conforming to my own observation), and I immediately tried to verify

it by inspecting other photographs by the same reporter (the Dutchman Koen Wess-ing): many of them attracted me because they included this kind of duality which I had just become aware of. Here a mother and daughter sob over the father's arrest (Baudelaire: 'the emphatic truth of gesture in the great circumstances of life'), and this happens *out in the countryside* (where could they have learned the news? for whom are these gestures?). Here, on a torn-up pavement, a child's corpse under a white sheet; parents and friends stand around it, desolate: a banal enough scene, unfortunately, but I noted certain interferences: the corpse's one bare foot, the sheet carried by the weep-ing mother (why this sheet?), a woman in the background, probably a friend, holding a handkerchief to her nose. Here again, in a bombed-out apartment, the huge eyes of two little boys, one's shirt raised over his little belly (the excess of those eyes disturb the scene). And here, finally, leaning against the wall of a house, three Sandinists, the lower part of their faces covered by a rag (stench? secrecy? I have no idea, knowing nothing of the realities of guerrilla warfare); one of them holds a gun that rests on his thigh (I can see his nails); but his other hand is stretched out, open, as if he were explaining and demonstrating something. My rule applied all the more closely in that other pic-tures from the same reportage were less interesting to me; they were fine shots, they expressed the dignity and horror of rebellion, but in my eyes they bore no mark or sign: their homogeneity remained cultural: they were 'scenes,' rather *à la* Greuze, had it not been for the harshness of the subject.

10

My rule was plausible enough for me to try to name (as I would need to do) these two elements whose co-presence established, it seemed, the particular interest I took in these photographs.

The first, obviously, is an extent, it has the extension of a field, which I perceive quite familiarly as a consequence of my knowledge, my culture; this field can be more or less stylized, more or less successful, depending on the photographer's skill or luck, but it always refers to a classical body of information: rebellion, Nicaragua, and all the signs of both: wretched un-uniformed soldiers, ruined streets, corpses, grief, the sun, and the heavy-lidded Indian eyes. Thousands of photographs consist of this field, and in these photographs I can, of course, take a kind of general interest, one that is even stirred sometimes, but in regard to them my emotion requires the rational intermedi-ary of an ethical and political culture. What I feel about these photographs derives from an *average* affect, almost from a certain training. I did not know a French word which might account for this kind of human interest, but I believe this word exists in Latin: it is *studium*, which doesn't mean, at least not immediately, 'study,' but application to a thing, taste for someone, a kind of general, enthusiastic commitment, of course, but without special acuity. It is by *studium* that I am interested in so many photographs, whether I receive them as political testimony or enjoy them as good historical scenes: for it is culturally (this connotation is present in *studium*) that I participate in the fig-ures, the faces, the gestures, the settings, the actions.

The second element will break (or punctuate) the *studium*. This time it is not I who seek it out (as I invest the field of the *studium* with my sovereign consciousness), it is this element which rises from the scene, shoots out of it like an arrow, and pierces

me. A Latin word exists to designate this wound, this prick, this mark made by a pointed instrument: the word suits me all the better in that it also refers to the notion of punctuation, and because the photographs I am speaking of are in effect punctuated, sometimes even speckled with these sensitive points; precisely, these marks, these wounds are so many *points*. This second element which will disturb the *studium* I shall therefore call *punctum*; for *punctum* is also: sting, speck, cut, little hole — and also a cast of the dice. A photograph's *punctum* is that accident which pricks me (but also bruises me, is poignant to me).

Having thus distinguished two themes in Photography (for in general the Photographs I liked were constructed in the manner of a classical sonata), I could occupy myself with one after the other.

11

Many photographs are, alas, inert under my gaze. But even among those which have some existence in my eyes, most provoke only a general and, so to speak, *polite* interest: they have no *punctum* in them: they please or displease me without pricking me: they are invested with no more than *studium*. The *studium* is that very wide field of unconcerned desire, of various interest, of inconsequential taste: *I like / I don't like*. The *studium* is of the order of *liking*, not of *loving*; it mobilizes a half desire, a demi-volition; it is the same sort of vague, slippery, irresponsible interest one takes in the people, the entertainments, the books, the clothes one finds 'all right.'

To recognize the *studium* is inevitably to encounter the Photographer's intentions, to enter into harmony with them, to approve or disapprove of them, but always to understand them, to argue them within myself, for culture (from which the *studium* derives) is a contract arrived at between creators and consumers. The *studium* is a kind of education (knowledge and civility, 'politeness') which allows me to discover the *Operator*, to experience the intentions which establish and animate his practices, but to experience them 'in reverse,' according to my will as a *Spectator*. It is rather as if I had to read the Photographer's myths in the Photograph, fraternizing with them but not quite believing in them. These myths obviously aim (this is what myth is for) at reconciling the Photograph with society (is this necessary? — Yes, indeed: the Photograph is *dangerous*) by endowing it with *functions*, which are, for the Photographer, so many alibis. These functions are: to inform, to represent, to surprise, to cause to signify, to provoke desire. And I, the *Spectator*, I recognize them with more or less pleasure: I invest them with my *studium* (which is never my delight or my pain).

12

Since the Photograph is pure contingency and can be nothing else (it is always *something* that is represented) — contrary to the text which, by the sudden action of a single word, can shift a sentence from description to reflection — it immediately yields up those 'details' which constitute the very raw material of ethnological knowledge. When William Klein photographs 'Mayday, 1959' in Moscow, he teaches me how Russians dress (which after all I don't know): I *note* a boy's big cloth cap, another's necktie, an old

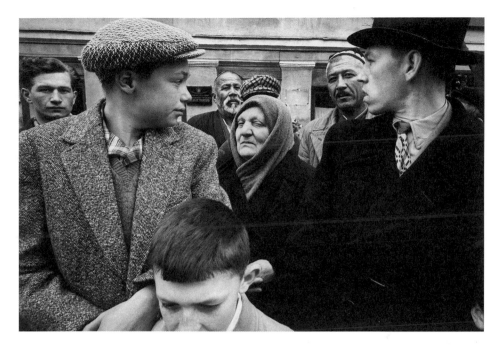

Figure 1.2 Klein, *Mayday, Moscow*, 1959. © William Klein.

woman's scarf around her head, a youth's haircut, etc. I can enter still further into such details, observing that many of the men photographed by Nadar have long fingernails: an ethnographical question: how long were nails worn in a certain period? Photography can tell me this much better than painted portraits. It allows me to accede to an infra-knowledge; it supplies me with a collection of partial objects and can flatter a certain fetishism of mine: for this 'me' which likes knowledge, which nourishes a kind of amorous preference for it. In the same way, I like certain biographical features which, in a writer's life, delight me as much as certain photographs; I have called these features 'biographemes'; Photography has the same relation to History that the biographeme has to biography.

[. . .]

25

Now, one November evening shortly after my mother's death, I was going through some photographs. I had no hope of 'finding' her, I expected nothing from these 'photographs of a being before which one recalls less of that being than by merely thinking of him or her' (Proust). I had acknowledged that fatality, one of the most agonizing features of mourning, which decreed that however often I might consult such images, I could never recall her features (summon them up as a totality). No, what I wanted – as Valéry wanted, after his mother's death – was 'to write a little compilation about her, just for myself' (perhaps I shall write it one day, so that, printed, her memory will last at least the time of my own notoriety). Further, I could not even say about these Photographs, if we except the one I had already published (which shows my mother as a

young woman on a beach of Les Landes, and in which I 'recognized' her gait, her health, her glow — but not her face, which is too far away), I could not even say that I loved them: I was not sitting down to contemplate them, I was not engulfing myself in them. I was sorting them, but none seemed to me really 'right': neither as a photographic performance nor as a living resurrection of the beloved face. If I were ever to show them to friends I could doubt that these photographs would *speak*.

26

With regard to many of these Photographs, it was History which separated me from them. Is History not simply that time when we were not born? I could read my nonexistence in the clothes my mother had worn before I can remember her. There is a kind of stupefaction in seeing a familiar being dressed *differently*. Here, around 1913, is my mother dressed up — hat with a feather, gloves, delicate linen at wrists and throat, her 'chic' belied by the sweetness and simplicity of her expression. This is the only time I have seen her like this, caught in a History (of tastes, fashions, fabrics): my attention is distracted from her by accessories which have perished; for clothing is perishable, it makes a second grave for the loved being. In order to 'find' my mother, fugitively alas, and without ever being able to hold on to this resurrection for long, I must, much later, discover in several photographs the objects she kept on her dressing table, an ivory powder box (I loved the sound of its lid), a cut-crystal flagon, or else a low chair, which is now near my own bed, or again, the raffia panels she arranged above the divan, the large bags she loved (whose comfortable shapes belied the bourgeois notion of the 'handbag').

 Thus the life of someone whose existence has somewhat preceded our own encloses in its particularity the very tension of History, its division. History is hysterical: it is constituted only if we consider it, only if we look at it — and in order to look at it, we must be excluded from it. As a living soul, I am the very contrary of History, I am what belies it, destroys it for the sake of my own history (impossible for me to believe in 'witnesses'; impossible, at least, to be one; Michelet was able to write virtually nothing about his own time). That is what the time when my mother was alive *before me* is — History (moreover, it is the period which interests me most, historically). No anamnesis could ever make me glimpse this time starting from myself (this is the definition of anamnesis) — whereas, contemplating a photograph in which she is hugging me, a child, against her, I can waken in myself the rumpled softness of her crêpe de Chine and the perfume of her rice powder.

27

And here the essential question first appeared: did I *recognize* her?
 According to these Photographs, sometimes I recognized a region of her face, a certain relation of nose and forehead, the movement of her arms, her hands. I never recognized her except in fragments, which is to say that I missed her *being*, and that therefore I missed her altogether. It was not she, and yet it was no one else. I would have recognized her among thousands of other women, yet I did not 'find' her. I recognized

her differentially, not essentially. Photography thereby compelled me to perform a painful labor; straining toward the essence of her identity, I was struggling among images partially true, and therefore totally false. To say, confronted with a certain photograph, 'That's *almost* the way she was!' was more distressing than to say, confronted with another, 'That's not the way she was at all.' The *almost*: love's dreadful regime, but also the dream's disappointing status – which is why I hate dreams. For I often dream about her (I dream only about her), but it is never quite my mother: sometimes, in the dream, there is something misplaced, something excessive: for example, something playful or casual – which she never was; or again I *know* it is she, but I do not *see* her features (but do we *see,* in dreams, or do we *know*?): I dream about her, I do not dream *her*. And confronted with the Photograph, as in the dream, it is the same effort, the same Sisyphean labor: to reascend, straining toward the essence, to climb back down without having seen it, and to begin all over again.

Yet in these Photographs of my mother there was always a place set apart, reserved and preserved: the brightness of her eyes. For the moment it was a quite physical luminosity, the photographic trace of a color, the blue-green of her pupils. But this light was already a kind of mediation which led me toward an essential identity, the genius of the beloved face. And then, however imperfect, each of these Photographs manifested the very feeling she must have experienced each time she 'let' herself be photographed: my mother 'lent' herself to the photograph, fearing that refusal would turn to 'attitude'; she triumphed over this ordeal of placing herself in front of the lens (an inevitable action) *with discretion* (but without a touch of the tense theatricalism of humility or sulkiness); for she was always able to replace a moral value with a higher one – a civil value. She did not struggle with her image, as I do with mine: she did not *suppose* herself.

28

There I was, alone in the apartment where she had died, looking at these pictures of my mother, one by one, under the lamp, gradually moving back in time with her, looking for the truth of the face I had loved. And I found it.

The Photograph was very old. The corners were blunted from having been pasted into an album, the sepia print had faded, and the picture just managed to show two children standing together at the end of a little wooden bridge in a glassed-in conservatory, what was called a Winter Garden in those days. My mother was five at the time (1898), her brother seven. He was leaning against the bridge railing, along which he had extended one arm; she, shorter than he, was standing a little back, facing the camera; you could tell that the Photographer had said, 'Step forward a little so we can see you'; she was holding one finger in the other hand, as children often do, in an awkward gesture. The brother and sister, united, as I knew, by the discord of their parents, who were soon to divorce, had posed side by side, alone, under the palms of the Winter Garden (it was the house where my mother was born, in Chennevières-sur-Marne).

I studied the little girl and at last rediscovered my mother. The distinctness of her face, the naïve attitude of her hands, the place she had docilely taken without either showing or hiding herself, and finally her expression, which distinguished her, like Good from Evil, from the hysterical little girl, from the simpering doll who plays at being a grownup – all this constituted the figure of a sovereign *innocence* (if you

will take this word according to its etymology, which is: 'I do no harm'), all this had transformed the photographic pose into that untenable paradox which she had none-theless maintained all her life: the assertion of a gentleness. In this little girl's image I saw the kindness which had formed her being immediately and forever, without her having inherited it from anyone; how could this kindness have proceeded from the imperfect parents who had loved her so badly – in short: from a family? Her kindness was specifically *out-of-play*, it belonged to no system, or at least it was located at the limits of a morality (evangelical, for instance); I could not define it better than by this feature (among others): that during the whole of our life together, she never made a single 'observation.' This extreme and particular circumstance, so abstract in relation to an image, was nonetheless present in the face revealed in the photograph I had just discovered. 'Not a just image, just an image,' Godard says. But my grief wanted a just image, an image which would be both justice and accuracy – *justesse*: just an image, but a just image. Such, for me, was the Winter Garden Photograph.

For once, photography gave me a sentiment as certain as remembrance, just as Proust experienced it one day when, leaning over to take off his boots, there suddenly came to him his grandmother's true face, 'whose living reality I was experiencing for the first time, in an involuntary and complete memory.' The unknown photographer of Chennevières-sur-Marne had been the mediator of a truth, as much as Nadar making of his mother (or of his wife – no one knows for certain) one of the loveliest photo-graphs in the world; he had produced a supererogatory photograph which contained more than what the technical being of photography can reasonably offer. Or again (for I am trying to express this truth) this Winter Garden Photograph was for me like the last music Schumann wrote before collapsing, that first *Gesang des Frühe* which accords with both my mother's being and my grief at her death; I could not express this accord except by an infinite series of adjectives, which I omit, convinced however that this photograph collected all the possible predicates from which my mother's being was constituted and whose suppression or partial alteration, conversely, had sent me back to these Photographs of her which had left me so unsatisfied. These same photographs, which phenomenology would call 'ordinary' objects, were merely analogical, provoking only her identity, not her truth; but the Winter Garden Photograph was indeed essen-tial, it achieved for me, utopically, *the impossible science of the unique being*.

Original publication

Extracts from *Camera Lucida: Reflections on Photography* (1984).
[Originally published 1980]

Marjorie Perloff

WHAT HAS OCCURRED ONLY ONCE

Barthes's Winter Garden/Boltanski's Archives of the Dead

I BEGIN WITH TWO PHOTOGRAPHS, both of them family snapshots of what are evidently a young mother and her little boy in a country setting. Neither is what we would call a 'good' (i.e., well-composed) picture. True, the one is more 'expressive,' the anxious little boy clinging somewhat fearfully to his mother, whereas the impassive woman and child look straight ahead at the camera.

The second pair of photographs are class pictures: The first, an end-of-the-year group photo of a smiling high-school class with their nonsmiling male teacher in the first row, center; the second, a more adult (postgraduate?) class, with their teacher (front row, third from the left) distinguished by his white hair, and smiling ever so slightly in keeping with what is evidently the collegial spirit of the attractive young group.

Both sets may be used to illustrate many of the points Barthes makes about photography in *Camera Lucida*. First, these pictures are entirely ordinary – the sort of photographs we all have in our albums. Their appeal, therefore, can only be to someone personally involved with their subjects, someone for whom they reveal the 'that-has-been' (*ça a été*) that is, for Barthes, the essence or *noème* of photography. 'The photographic referent,' we read in #32, '[is] not the *optionally* real thing to which an image or a sign refers but the *necessarily* real thing which has been placed before the lens, without which there would be no photograph. [. . .] [I]n Photography I can never deny that *the thing has been there*' (*CL*, 76). And again, 'The photograph is literally an emanation of the referent' (*CL*, 80). In this sense, 'every photograph is a certificate of presence' (*CL*, 87).

But 'presence' in this instance, goes hand in hand with death. 'What the Photograph reproduces to infinity has occurred only once: the Photograph mechanically repeats what could never be repeated existentially' (*CL*, 4). As soon as the click of the shutter has taken place, what was photographed no longer exists; subject is transformed into object, 'and even,' Barthes suggests, 'into a museum object' (*CL*, 13). When

we look at a photograph of ourselves or of others, we are really looking at the return of the dead. 'Death is the *eidos* of the Photograph' (*CL*, 15).

Christian Boltanski, whose photographs I have paired with two of the illustrations in *Roland Barthes by Roland Barthes*, shares Barthes's predilection for the ordinary photograph, the photograph of everyday life. Like Barthes, he dislikes 'art photography,' photography that approaches the condition of painting. For him, too, the interesting photograph provides the viewer with testimony that the thing seen *has been*, that *it is thus*. In Barthes's words, 'the Photograph is never anything but an antiphon of "Look," "See," "Here it is"; it points a finger at certain *vis-à-vis*, and cannot escape this pure deictic language' (*CL*, 5). But, in Boltanski's oeuvre, as we shall see, this pure deictic language, this pointing at 'what has occurred only once,' takes on an edge unanticipated in the phenomenology of *Camera Lucida*.

Consider the mother-and-child snapshots above. Both foreground the 'real' referent of the image, the outdoor scene that the camera reproduces. But in what sense are the photographs 'certificates of presence'? [The first] portrays Roland Barthes, age five or six, held by his mother, who stands at some distance from a house (her house?) in a non-specifiable countryside. The mother's clothes and hairdo place the photograph somewhere in the 1920s; the long-legged boy in kneesocks, shorts, and sweater seems rather big to be held on his mother's arm like a baby. The caption on the facing page accounts for this phenomenon: it reads, 'The demand for love [*la demande d'amour*]' (*RB* 5).

The second photograph is part of a work (similarly published in the early 1970s) called *Album de photos de la famille D, 1939–64*, which depicts a 'family' (are they a family?) Boltanski did not know. He borrowed several photo albums from his friend Michel Durand-Dessert (hence the *D*), reshot some one hundred fifty snapshots from these albums, and tried to establish their chronology as well as the identities of their subjects using what he called an ethnological approach: for example, 'the older man who appeared only at festive occasions must be an uncle who did not live in the vicinity.'[1] But the sequence he constructed turned out to be incorrect: 'I realized,' the artist remarked, 'that these images were only witnesses to a collective ritual. They didn't teach us anything about the Family D. [. . .] but only sent us back to our own past.'[2] And, since the snapshots in the sequence date from the French Occupation and its immediate aftermath, the viewer begins to wonder what this bourgeois provincial family was doing during the war. Were these men on the battlefield? Were they Nazi collaborators or resistance fighters? Did these women have to harbor the enemy? And so on. What, in short, is it that *has been* in the snapshot of the young woman and small boy resting in a shady meadow?

Similar questions are raised by the second Boltanski photograph. Again, the two class pictures make an interesting pair. We have one of the 'S' entries in *Roland Barthes by Roland Barthes*: a photograph of Barthes's seminar, taken some time in the 1970s. The caption reads: 'The space of the seminar is phalansteric, i.e., in a sense, fictive, novelistic. It is only the space of the circulation of subtle desires, mobile desires; it is, within the artifice of a sociality whose consistency is miraculously extenuated, according to a phrase of Nietzsche's: "the tangle of amorous relations"' (*RB*, 171). The 'real,' 'referential' photograph thus becomes an occasion for pleasurable erotic fantasy.

In contrast, the other class photograph is a picture Boltanski came across by chance. It portrays the 1931 graduating class of the Lycée Chases (Chases Gymnasium), the Jewish high school in Vienna, which was shut down shortly after this end-of-the-year

group photograph was taken. If, as Barthes posits, the photograph is coterminal with
its referent, here the 'death' of its subjects produced by the camera may well have fore-
shadowed their real death in the camps. For his 1986 installation *Lycée Chases*, Boltanski
rephotographed the individual smiling faces in this 'ordinary' class photograph, enlarg-
ing them until they lost any sense of individuality and began to look like skeletal X
rays or, better yet, death masks. Yet this version is no more 'real' than the other, since
Boltanski never learned what actually happened to the members of the class of 1931.
When *Lycée Chases* was shown in New York in 1987, one of the students in the photo-
graph, now in his late sixties, came forward and identified himself to Boltanski. But
this Chases graduate, who had emigrated to the United States in the early 1930s, knew
nothing of the fate of the other students.[3]

 'Every photograph,' says Barthes, 'is somehow co-natural with its referent' (*CL*,
76). But what is the referent of the Chases graduation picture? What 'evidential force'
does it possess and for whom? To answer this question, we might begin with Barthes's
famed Winter Garden photograph, the photograph whose *punctum* (the prick, sting, or
sudden wound that makes a particular photograph epiphanic to a particular viewer) is
so powerful, so overwhelming, so implicated in Barthes's anticipation of his own death
that he simply cannot reproduce it in *La Chambre clair*.

> I cannot reproduce the Winter Garden Photograph. It exists only for me.
> For you, it would be nothing but an indifferent picture, one of the thou-
> sand manifestations of the 'ordinary'; it cannot in any way constitute the
> visible object of a science; it cannot establish an objectivity, in the positive
> sense of the term; at most it would interest your *studium*: period, clothes,
> photogeny; but in it, for you, no wound.
>
> (*CL*, 73)

The Winter Garden photograph thus becomes the absent (and hence more potent) ref-
erent of Barthes's paean to presence, a paean that takes the form of an elegiac *ekphrasis*.

 'One November evening, shortly after my mother's death,' Barthes recalls, 'I was
going through some photographs. I had no hope of "finding" her. I expected nothing
from these "photographs of a being before which one recalls less of that being than
by merely thinking of him or her"' (*CL*, 63). And Barthes puts in parentheses follow-
ing the quote the name of the writer who is the tutelary spirit behind his own lyric
meditation – Proust. Like the Proust of *Les Intermittences du coeur*, Barthes's narrator
has learned, from the repeated disillusionments of life, to expect nothing. The mood
is autumnal, sepulchral, and the image of the dead mother cannot be recovered – at
least not by the voluntary memory. Different photographs capture different aspects of
her person but not the 'truth of the face I had loved': 'I was struggling among images
partially true and therefore totally false' (*CL*, 66).

 As in Proust, the miraculous privileged moment, the prick of the *punctum*, comes
when least expected. The uniqueness of the Winter Garden photograph – an old, faded,
album snapshot with 'blunted' corners – is that it allows Barthes to 'see' his mother,
not as he actually saw her in their life together (this would be a mere *studium* on his
part), but as the child he had never known in real life, a five-year-old girl standing with
her seven-year-old brother 'at the end of a little wooden bridge in a glassed-in con-
servatory' (*CL*, 67). We learn that brother and sister are united 'by the discord of their

parents, who were soon to divorce' (*CL*, 69). But in Barthes's myth, this little girl is somehow self-born. 'In this little girl's image I saw the kindness which had formed her being immediately and forever, without her having inherited it from anyone; how could this kindness have proceeded from the imperfect parents who had loved her so badly – in short, from a family?' (*CL*, 69). In an imaginative reversal, the mother-as-child in the Winter Garden photograph now becomes his child: 'I who had not procreated, I had, in her very illness, engendered my mother' (*CL*, 72). The tomblike glass conservatory thus becomes the site of birth.

'The unknown photographer of Chennevières-sur-Marne,' Barthes remarks, 'had been a mediator of a truth' (*CL*, 70) – indeed, of *the* truth. His inconsequential little snapshot 'achieved for me, utopically, *the impossible science of the unique being*' (*CL*, 71) – impossible because the uniqueness of that being is, after all, only in the eye of the beholder. Like Proust's Marcel, the Barthesian subject must evidently purge himself of the guilt prompted by the unstated conviction that his own 'deviation' (sexual or otherwise) from the bourgeois norms of his childhood world must have caused his mother a great deal of pain. Like Marcel, he therefore invents for himself a perfect mother, her goodness and purity deriving from no one (for family is the enemy in this scheme of things). Gentleness is all: 'during the whole of our life together,' writes Barthes in a Proustian locution, 'she never made a single "observation"' (*CL*, 69). Thus perfected, the mother must of course be dead; the very snapshot that brings her to life testifies to the irreversibility of her death.

Barthes understands only too well that the *punctum* of this photograph is his alone, for no one else would read the snapshot quite as he does. The 'emanation of the referent,' which is for him the essence of the photograph, is thus a wholly personal connection. The intense, violent, momentary pleasure (*jouissance*) that accompanies one's reception of the photograph's 'unique Being' is individual and 'magical,' for unlike all other representations, the photograph is an image without a code (*CL*, 88), the eruption of the Lacanian 'Real' into the signifying chain, a '*satori* in which words fail' (*CL*, 109).

As an elegy for his mother and as a kind of epitaph for himself, *Camera Lucida* is intensely moving. But what about Barthes's insistence on the 'realism' of the photograph, his conviction that it bears witness to what has occurred only once? 'From a phenomenological viewpoint,' says Barthes, 'in the Photograph, the power of authentication exceeds the power of representation' (*CL*, 89). Authentication of what and for whom? Here Boltanski's photographic representations of everyday life raise some hard questions. Indeed, the distance between Barthes's generation and Boltanski's – a distance all the more remarkable in that such central Boltanski photo installations as *La Famille D*, *Le Club Mickey*, and *Détective* date from the very years when Barthes was composing *Roland Barthes by Roland Barthes*, *A Lover's Discourse*, and *Camera Lucida* – can be measured by the revisionist treatment Boltanski accords to the phenomenology of authentication practiced by the late Barthes.

Roland Barthes was born in the first year of World War I (26 October 1915); Christian Boltanski, in the last year of World War II, specifically on the day of Paris's liberation (6 September 1944) – hence his middle name, Liberté. Barthes's Catholic father was killed in October 1916 in a naval battle in the North Sea; the fatherless child was brought up in Bayonne by his mother and maternal grandmother in an atmosphere he described as one of genteel poverty and narrow Protestant bourgeois rectitude. Boltanski's father, a prominent doctor, was born a Jew but converted to Catholicism;

his mother, a writer, was Catholic, and young Christian was educated by the Jesuits. To avoid deportation in 1940, the Boltanskis faked a divorce and pretended the doctor had fled, abandoning his family, whereas in reality he was hidden in the basement of the family home, in the center of Paris, for the duration of the Occupation. The death of Barthes's father, an event his son understood early on as being only too 'real,' may thus be contrasted to the simulated 'death' of Dr. Boltanski at the time of his son's birth. Indeed, this sort of simulation, not yet a central issue in World War I when battlelines were drawn on nationalistic rather than ideological grounds, became important in the years of the resistance, when simulation and appropriation became common means of survival. For example, in his fictionalized autobiography *W or the Memory of Childhood*, Georges Perec (a writer Boltanski greatly admires and has cited frequently) recalls that his widowed mother, who was to die at Auschwitz, got him out of Paris and into the Free Zone by putting him on a Red Cross convoy for the wounded en route to Grenoble. 'I was not wounded. But I had to be evacuated. So we had to pretend I was wounded. That was why my arm was in a sling.'[4]

Under such circumstances, *authentication* becomes a contested term. How does one document what has occurred only once when the event itself is perceived to be a simulation? And to what extent has the experience of *studium* versus *punctum* become collective, rather than the fiercely personal experience it was for Barthes? In a 1984 interview held in conjunction with the Boltanski exhibition at the Centre Pompidou in Paris, Delphine Renard asked the artist how and why he had chosen photography as his medium. 'At first,' he replied, 'what especially interested me was the property granted to photography of furnishing the evidence of the real [*la preuve du réel*]: a scene that has been photographed is experienced as being true. [. . .] If someone exhibits the photograph of an old lady and the viewer tells himself, today, she must be dead, he experiences an emotion which is not only of an aesthetic order.'[5]

Here Boltanski seems to accept the Barthesian premise that the 'photographic referent' is 'not the *optionally* real thing to which an image or a sign refers but the *necessarily* real thing which has been placed before the lens, without which there would be no photograph. [. . .] [I]n Photography I can never deny that *the thing has been there*.' But for Boltanski, this 'reasonable' definition is not without its problems:

> In my first little book, *Tout ce qui reste de mon enfance* of 1969, there is a photograph that supplies the apparent proof that I went on vacation to the seashore with my parents, but it is an unidentifiable photograph of a child and a group of adults on the beach. One can also see the photograph of the bed I slept in when I was five years old; naturally, the caption orients the spectator, but the documents are purposely false. [. . .] In most of my photographic pieces, I have utilized this property of the proof one accords to photography to expose it or to try to show that *photography lies, that it doesn't speak the truth but rather the cultural code*.
>
> (*BOL*, 75; emphasis added)

Such cultural coding, Boltanski argues, characterizes even the most innocent snapshot (say, the Winter Garden photograph). The amateur photograph of the late nineteenth century was based on a preexisting image that was culturally imposed – an image derived from the painting of the period. Even today the amateur photographer

'shows nothing but images of happiness, lovely children running around on green meadows: he reconstitutes an image he already knows' (*BOL*, 76). Tourists in Venice, for example, who think they are taking 'authentic' photographs of this or that place, are actually recognizing the 'reality' through the lens of a set of clichés they have unconsciously absorbed; indeed, they want these pictures to resemble those they already know. So Boltanski creates an experiment. Together with Annette Messager he produces a piece called *Le Voyage de noces à Venise* (1975), composed of photographs taken elsewhere (*BOL*, 76). And in another book, *10 portraits photographiques de Christian Boltanski, 1946–1964* (1972), the temporal frame (the boy is depicted at different ages) is a pure invention; all the photographs were actually taken the same day. 'This little book,' says the artist, 'was designed to show that Christian Boltanski had only a collective reality . . . [that of] a child in a given society' (*BOL*, 79). In a related book, *Ce dont ils se souviennent*, we see what looks like an updated version of a Proustian scene in which the narrator and Gilberte play together in the Champs-Elysées; here, ostensibly, are young Christian's friends playing on the seesaw in the park. This simple little photograph is enormously tricky. There are actually three seesaws, as evident from the three horizontal shadows stretching across the ground in the bottom of the frame.[6] The two little girls next to one another on parallel seesaws on the left look normal enough, but what is happening at the other end? The slightly crouching boy in the center (his legs straddling a third seesaw) seems to be staring at what looks like an extra leg, its knee bent on the board opposite – a leg that suggests a body on the rack rather than a child at play. The impression is created by the photograph's odd lighting: the figure on the far right, who is evidently holding down one seesaw in balance, blocks the second figure (feet dangling) and the head and torso of the third. Moreover, the ropelike thin line of the third seesaw extends from that bent leg on the right to the head of the little girl at its opposite pole, creating the illusion that she is chained to it. Thus the little playground scene takes on an aura of isolation and imprisonment. Is it winter (the white area could be snow) or a scorchingly sunny summer? The more one looks at this 'ordinary' photograph (actually, Boltanski tells us, a found photograph taken from the album of a young woman), the less clear the 'emanation of the referent' becomes.

But Boltanski's is by no means a simple reversal of the Barthesian *noème*. For the paradox is that, like Barthes and even more like Perec, he finds nothing as meaningful as the ordinary object, the trivial detail. Photography for him is a form of ethnography. Boltanski has spoken often of his early fascination with the displays in the Musée de l'Homme, not so much the displays of large pieces of African sculpture but of everyday objects – Eskimo fishhooks, arrows from the Amazon valley, and so on:

> I saw large metal boxes in which there were little objects, fragile and without signification. In the corner of the case there was often a small faded photograph representing a 'savage' in the middle of handling these little objects. Each case presented a world that has disappeared: the savage of the photograph was no doubt dead, the objects had become useless, and, anyway, no one knew how to use them any more. The Musée de l'Homme appeared to me as a great morgue. Numerous artists have here discovered the human sciences (linguistics, sociology, archeology); here there is still the 'weight of

time' which imposes itself on artists. . . . Given that we have all shared the same cultural references, I think we will all finish in the same museum.

(BOL, 71)

Does this mean that art discourse can be no more than a cultural index, that the individual artwork is no longer distinguished from its family members? On the contrary. For whereas Barthes posits that what he calls 'the impossible science of the unique being' depends on a given spectator's particular reading of an 'ordinary' photograph, Boltanski enlarges the artist's role: it is the artist who creates those images 'imprecise enough to be as communal as possible' – images each viewer can interpret differently. The same holds true, the artist posits, for captions, the ideal situation being one, for example, in which a picture from an elementary school history book every child has used is reproduced, bearing a caption like 'Ce jour-là, le professeur entra avec le directeur [That day, the teacher entered with the principal]' *(BOL, 79)*.

One of Boltanski's favorite genres is thus the inventory. If many of his albums use 'fake' photos to tell what are supposedly 'true' stories, the *Inventaire* series work the other way. Consider, for example, the *inventaire des objets ayant appartenus à un habitant d'Oxford* of 1973 (see section frontispiece to Part I).

Boltanski had read of the untimely death of an Oxford student and wrote to his college asking if his personal effects, 'significant' or otherwise, could be sent to him. Photographed against a neutral background, these objects take on equal value: the pope's photograph, a folded shirt, a suit jacket on a hanger, a set of pamphlets, a toothbrush. The question the inventory poses is whether we can know someone through his or her things. If the clothes make the man, as the adage has it, can we recreate the absent man from these individual items? Or does the subject fragment into a series of metonymic images that might relate to anyone? Is there, in other words, such a thing as identity?

Here again Barthes offers an interesting *point de repère*. One of the sections in *Roland Barthes by Roland Barthes* is called '*Un souvenir d'enfance* – A Memory of Childhood' and goes like this:

> When I was a child, we lived in a neighborhood called Marrac; this neighborhood was full of houses being built, and the children played in the building sites; huge holes had been dug in the loamy soil for the foundations of the houses, and one day when we had been playing in one of these, all the children climbed out except me – I couldn't make it. From the brink up above, they teased me: lost! alone! spied on! excluded! (to be excluded is not to be outside, it is to be *alone in the hole*, imprisoned under the open sky; *precluded*); then I saw my mother running up; she pulled me out of there and took me far away from the children – against them.
>
> *(RB, 121–2)*

We could obviously submit this text to a psychosexual reading and discuss its Freudian symbolism. But what interests me here is less the content than Barthes's assumption that the *souvenir d'enfance* has meaning; that memory can invoke the past, revive the fear, panic, and sense of release the boy felt when his mother rescued him. However

painful the memory, the little filmic narrative implies, it relates past to present and creates Barthes's sense of identity.

Memory plays no such role in Boltanski's work. 'I have very few memories of childhood,' he tells Delphine Renard, 'and I think I undertook this seeming autobiography precisely to blot out my memory and to protect myself. I have invented so many false memories, which were collective memories, that my true childhood has disappeared' (*BOL*, 79). Again, Perec's *W or the Memory of Childhood* comes to mind: 'I have no childhood memories. Up to my twelfth year or thereabouts, my story comes to barely a couple of lines.' For writers and artists born in World War II France, and especially for Jewish artists like Perec and Boltanski, the Proustian or Barthesian *souvenir d'enfance* seems to have become a kind of empty signifier, a site for assumed identities and invented sensations.

Take the installation *Détective* (a first version was mounted in 1972, a more extensive one in 1987), which consists of four hundred black-and-white photographs, one hundred ten metal boxes with magazine articles, and twenty-one clamp-on desk lamps. 'These photographs,' we read in the headnote, 'originally appeared in the magazine *Détective*. A weekly specializing in news items, it presents an indiscriminate blend of assassins and victims, the unintentional heroes of forgotten dramas.'[7] The immediate occasion, Boltanski explains, was the 1987 trial in Lyons of the Nazi war criminal Klaus Barbie. 'Barbie has the face of a Nobel Peace Prize Winner,' Boltanski remarked. 'It would be easier if a terrible person had a terrible face' (see *LE*, 81). And in an interview for *Parkett* called 'The White and the Black,' Boltanski explains that his ideas of original sin and grace stem from his Christian upbringing even as his longing for a lost Jerusalem is part of Jewish mythology. 'My work is caught between two cultures as I am.'[8]

The mystery of *Détective* is that one cannot tell the criminals from the victims. Inevitably, when told that this is the case, one tries to rise to the challenge by distinguishing between the two. The bald man whose head and cheeks have been cropped (top row, third from the left) is surely a killer, isn't he? Or could he be an innocuous person, the local butcher or pharmacist, perhaps, who is one of the murdered? Is he a mental patient? And what about the little boy with blond curls (second row, third from the right); surely he is an innocent victim? Or is it a baby picture of someone who turned out to be an ax murderer? The pictures do not reveal anything. Each and every photograph can be read both ways and there are all sorts of metonymic linkages: compare the woman (if it is a woman) with glasses (bottom row, second from the right) to the man in the top row referred to above. The cropping, lighting, and pose are similar. One wears glasses, the other does not. One is probably female, the other definitely male. Throughout the sequence, each person looks a bit like someone else (e.g., the young girls in bathing suits). Just so, the sequence implies, the middle-class Nazis and Jews of prewar Berlin, for example, were quite indistinguishable.

What sort of evidence, then, does the photograph supply? I have already mentioned the students of *Lycée Chases*, whose faces Boltanski cropped, enlarged, and placed under transparent paper so that they resembled death masks. But the same phenomenon can be found much closer to home: in 1973, in the foyer of a junior high school in Dijon, Boltanski installed the portrait photographs of each of the students attending the school who were then between the ages of ten and thirteen. Thirteen years later he produced an installation using the same photographs, which had been supplied by the children's parents. As Günter Metken explains, '[Boltanski] tightened the format, closing in on the subject, so that the clothing, hairstyle and background disappeared, and only the faces, standardized by their identical presentation remained' (*COL*, 155). In

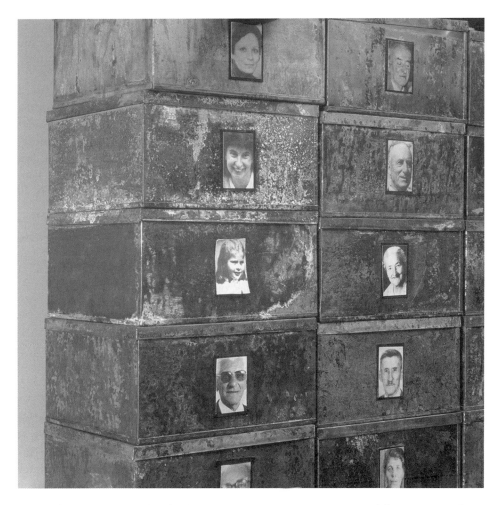

Figure 2.1 Christian Boltanski, from *Les Suisses morts*, 1991. Courtesy of the Marian Goodman Gallery, New York. © ADAGP, Paris and DACS, London 2018.

the case of the girl in question, Boltanski enhanced the black-and-white contrast and added glasses – a logical development for a woman now in her mid-twenties. As in the case of *Lycée Chases*, the artist merely brings out what is already there.

The figurative 'death' of the Dijon schoolgirl, reborn a plain woman in glasses, prefigures death itself, which is for Boltanski, as for Barthes, the very essence of photography. In 1991 Boltanski produced a piece called *Les Suisses morts* (see Figure 2.1) that can be read as an interesting public counterpart to Barthes's very private Winter Garden. The 'subjects' are some three thousand dead Swiss citizens as depicted in the obituary announcements published in the Swiss regional newspaper *Le Nouvelliste du Valais*. Why Swiss? 'Because,' Boltanski explains, 'Switzerland is neutral. There is nothing more neutral than a dead Swiss. Before, I did pieces with dead Jews but "dead" and "Jew" go too well together. It's too obvious. There is nothing more normal than the Swiss. There is no reason for them to die, so they are more terrifying in a way. They are us' (*PAR*, 36). The 'normalcy' of the three thousand Swiss is further heightened by the conventions of the obituary photograph: 'The thing about pictures of dead people

Walter Benjamin

EXTRACTS FROM *THE WORK OF ART IN THE AGE OF MECHANICAL REPRODUCTION*

1

IN PRINCIPLE A WORK OF ART has always been reproducible. Man-made artefacts could always be imitated by men. Replicas were made by pupils in practice of their craft, by masters for diffusing their works, and, finally, by third parties in the pursuit of gain. Mechanical reproduction of a work of art, however, represents something new. Historically, it advanced intermittently and in leaps at long intervals, but with accelerated intensity. The Greeks knew only two procedures of technically reproducing works of art: founding and stamping. Bronzes, terra cottas, and coins were the only art works which they could produce in quantity. All others were unique and could not be mechanically reproduced. With the woodcut graphic art became mechanically reproducible for the first time, long before script became reproducible by print. The enormous changes which printing, the mechanical reproduction of writing, has brought about in literature are a familiar story. However, within the phenomenon which we are here examining from the perspective of world history, print is merely a special, though particularly important, case. During the Middle Ages engraving and etching were added to the woodcut; at the beginning of the nineteenth century lithography made its appearance.

With lithography the technique of reproduction reached an essentially new stage. This much more direct process was distinguished by the tracing of the design on a stone rather than its incision on a block of wood or its etching on a copper-plate and permitted graphic art for the first time to put its products on the market, not only in large numbers as hitherto, but also in daily changing forms. Lithography enabled graphic art to illustrate everyday life, and it began to keep pace with printing. But only a few decades after its invention, lithography was surpassed by photography. For the first time in the process of pictorial reproduction, photography freed the hand of the most important artistic functions which henceforth devolved only upon the eye looking into a lens. Since the eye perceives more swiftly than the hand can draw, the process

of pictorial reproduction was accelerated so enormously that it could keep pace with speech. A film operator shooting a scene in the studio captures the images at the speed of an actor's speech. Just as lithography virtually implied the illustrated newspaper so did photography foreshadow the sound film. The technical reproduction of sound was tackled at the end of the last century. These convergent endeavours made predictable a situation which Paul Valéry pointed up in this sentence: 'Just as water, gas, and electricity are brought into our houses from far off to satisfy our needs in response to a minimal effort, so we shall be supplied with visual or auditory images, which will appear and disappear at a simple movement of the hand, hardly more than a sign.'[1] Around 1900 technical reproduction had reached a standard that not only permitted it to reproduce all transmitted works of art and thus to cause the most profound change in their impact upon the public; it also had captured a place of its own among the artistic processes. For the study of this standard nothing is more revealing than the nature of the repercussions that these two different manifestations – the reproduction of works of art and the art of the film – have had on art in its traditional form.

2

Even the most perfect reproduction of a work of art is lacking in one element: its presence in time and space, its unique existence at the place where it happens to be. This unique existence of the work of art determined the history to which it was subject throughout the time of its existence. This includes the changes which it may have suffered in physical condition over the years as well as the various changes in its ownership. The traces of the first can be revealed only by chemical or physical analyses which it is impossible to perform on a reproduction; changes of ownership are subject to a tradition which must be traced from the situation of the original.

The presence of the original is the prerequisite to the concept of authenticity. Chemical analyses of the patina of a bronze can help to establish this, as does the proof that a given manuscript of the Middle Ages stems from an archive of the fifteenth century. The whole sphere of authenticity is outside technical – and, of course, not only technical – reproducibility.[2] Confronted with its manual reproduction, which was usually branded as a forgery, the original preserved all its authority; not so *vis à vis* technical reproduction. The reason is twofold. First, process reproduction is more independent of the original than manual reproduction. For example, in photography, process reproduction can bring out those aspects of the original that are unattainable to the naked eye yet accessible to the lens, which is adjustable and chooses its angle at will. And photographic reproduction, with the aid of certain processes, such as enlargement or slow motion, can capture images which escape natural vision. Secondly, technical reproduction can put the copy of the original into situations which would be out of reach for the original itself. Above all, it enables the original to meet the beholder halfway, be it in the form of a photograph or a phonograph record. The cathedral leaves its locale to be received in the studio of a lover of art; the choral production, performed in an auditorium or in the open air, resounds in the drawing room.

The situations into which the product of mechanical reproduction can be brought may not touch the actual work of art, yet the quality of its presence is always depreciated. This holds not only for the art work but also, for instance, for a landscape which

work of art designed for reproducibility.[7] From a photographic negative, for example, one can make any number of prints; to ask for the 'authentic' print makes no sense. But the instant the criterion of authenticity ceases to be applicable to artistic production, the total function of art is reversed. Instead of being based on ritual, it begins to be based on another practice – politics.

5

Works of art are received and valued on different planes. Two polar types stand out: with one, the accent is on the cult value; with the other, on the exhibition value of the work. Artistic production begins with ceremonial objects destined to serve in a cult. One may assume that what mattered was their existence, not their being on view. The elk portrayed by the man of the Stone Age on the walls of his cave was an instrument of magic. He did expose it to his fellow men, but in the main it was meant for the spirits. Today the cult value would seem to demand that the work of art remain hidden. Certain statues of gods are accessible only to the priest in the cella; certain Madonnas remain covered nearly all year round; certain sculptures on mediaeval cathedrals are invisible to the spectator on ground level. With the emancipation of the various art practices from ritual go increasing opportunities for the exhibition of their products. It is easier to exhibit a portrait bust that can be sent here and there than to exhibit the statue of a divinity that has its fixed place in the interior of a temple. The same holds for the painting as against the mosaic or fresco that preceded it. And even though the public presentability of a mass originally may have been just as great as that of a symphony, the latter originated at the moment when its public presentability promised to surpass that of the mass.

 With the different methods of technical reproduction of a work of art, its fitness for exhibition increased to such an extent that the quantitative shift between its two poles turned into a qualitative transformation of its nature. This is comparable to the situation of the work of art in prehistoric times when, by the absolute emphasis on its cult value, it was, first and foremost, an instrument of magic. Only later did it come to be recognized as a work of art. In the same way today, by the absolute emphasis on its exhibition value the work of art becomes a creation with entirely new functions, among which the one we are conscious of, the artistic function, later may be recognized as incidental. This much is certain: today photography and the film are the most serviceable exemplifications of this new function.

6

In photography, exhibition value begins to displace cult value all along the line. But cult value does not give way without resistance. It retires into an ultimate retrenchment: the human countenance. It is no accident that the portrait was the focal point of early photography. The cult of remembrance of loved ones, absent or dead, offers a last refuge for the cult value of the picture. For the last time the aura emanates from the early photographs in the fleeting expression of a human face. This is what constitutes their melancholy, incomparable beauty. But as man withdraws from the photographic image, the exhibition value for the first time shows its superiority to the ritual value.

To have pinpointed this new stage constitutes the incomparable significance of Atget, who, around 1900, took photographs of deserted Paris streets. It has quite justly been said of him that he photographed them like scenes of crime. The scene of a crime, too, is deserted; it is photographed for the purpose of establishing evidence. With Atget, photographs become standard evidence for historical occurrences, and acquire a hidden political significance. They demand a specific kind of approach; free-floating contemplation is not appropriate to them. They stir the viewer; he feels challenged by them in a new way. At the same time picture magazines begin to put up signposts for him, right ones or wrong ones, no matter. For the first time, captions have become obligatory. And it is clear that they have an altogether different character than the tide of a painting. The directives which the captions give to those looking at pictures in illustrated magazines soon become even more explicit and more imperative in the film where the meaning of each single picture appears to be prescribed by the sequence of all preceding ones.

7

The nineteenth-century dispute as to the artistic value of painting versus photography today seems devious and confused. This does not diminish its importance, however; if anything, it underlines it. The dispute was in fact the symptom of a historical transformation the universal impact of which was not realized by either of the rivals. When the age of mechanical reproduction separated art from its basis in cult, the semblance of its autonomy disappeared forever. The resulting change in the function of art transcended the perspective of the century; for a long time it even escaped that of the twentieth century, which experienced the development of the film.

Earlier much futile thought had been devoted to the question of whether photography is an art. The primary question – whether the very invention of photography had not transformed the entire nature of art – was not raised. Soon the film theoreticians asked the same ill-considered question with regard to the film. But the difficulties which photography caused traditional aesthetics were mere child's play as compared to those raised by the film. Whence the insensitive and forced character of early theories of the film. Abel Gance, for instance, compares the film with hieroglyphs: 'Here, by a remarkable regression, we have come back to the level of expression of the Egyptians . . . Pictorial language has not yet matured because our eyes have not yet adjusted to it. There is as yet insufficient respect for, insufficient cult of, what it expresses.'[8] Or, in the words of Séverin-Mars: 'What art has been granted a dream more poetical and more real at the same time! Approached in this fashion the film might represent an incomparable means of expression. Only the most high-minded persons, in the most perfect and mysterious moments of their lives, should be allowed to enter its ambience.'[9] Alexandre Arnoux concludes his fantasy about the silent film with the question: 'Do not all the bold descriptions we have given amount to the definition of prayer?'[10] It is instructive to note how their desire to class the film among the 'arts' forces these theoreticians to read ritual elements into it – with a striking lack of discretion. Yet when these speculations were published, films like *L'Opinion publique* and *The Gold Rush* had already appeared. This, however, did not keep Abel Gance from adducing hieroglyphs for purposes of comparison, nor Séverin-Mars from speaking of the film as one might speak of paintings by Fra Angelico. Characteristically, even

today ultrareactionary authors give the film a similar contextual significance – if not an outright sacred one, then at least a supernatural one. Commenting on Max Reinhardt's film version of *A Midsummer Night's Dream*, Werfel states that undoubtedly it was the sterile copying of the exterior world with its streets, interiors, railroad stations, restaurants, motorcars, and beaches which until now had obstructed the elevation of the film to the realm of art. 'The film has not yet realized its true meaning, its real possibilities . . . these consist in its unique faculty to express by natural means and with incomparable persuasiveness all that is fairylike, marvellous, supernatural.'[11]

[. . .]

11

The shooting of a film, especially of a sound film, affords a spectacle unimaginable anywhere at any time before this. It presents a process in which it is impossible to assign to a spectator a viewpoint which would exclude from the actual scene such extraneous accessories as camera equipment, lighting machinery, staff assistants, etc. – unless his eye were on a line parallel with the lens. This circumstance, more than any other, renders superficial and insignificant any possible similarity between a scene in the studio and one on the stage. In the theatre one is well aware of the place from which the play cannot immediately be detected as illusionary. There is no such place for the movie scene that is being shot. Its illusionary nature is that of the second degree, the result of cutting. That is to say, in the studio the mechanical equipment has penetrated so deeply into reality that its pure aspect freed from the foreign substance of equipment is the result of a special procedure, namely, the shooting by the specially adjusted camera and the mounting of the shot together with other similar ones. The equipment-free aspect of reality here has become the height of artifice; the sight of immediate reality has become an orchid in the land of technology.

Even more revealing is the comparison of these circumstances, which differ so much from those of the theatre, with the situation in painting. Here the question is: How does the cameraman compare with the painter? To answer this we take recourse to an analogy with a surgical operation. The surgeon represents the polar opposite of the magician. The magician heals a sick person by the laying on of hands; the surgeon cuts into the patient's body. The magician maintains the natural distance between the patient and himself; though he reduces it very slightly by the laying on of hands, he greatly increases it by virtue of his authority. The surgeon does exactly the reverse; he greatly diminishes the distance between himself and the patient by penetrating into the patient's body, and increases it but little by the caution with which his hand moves among the organs. In short, in contrast to the magician – who is still hidden in the medical practitioner – the surgeon at the decisive moment abstains from facing the patient man to man; rather, it is through the operation that he penetrates into him.

Magician and surgeon compare to painter and cameraman. The painter maintains in his work a natural distance from reality, the cameraman penetrates deeply into its web. There is a tremendous difference between the pictures they obtain. That of the painter is a total one, that of the cameraman consists of multiple fragments which are assembled under a new law. Thus, for contemporary man the representation of reality by the film is incomparably more significant than that of the painter, since it

offers, precisely because of the thoroughgoing permeation of reality with mechanical equipment, an aspect of reality which is free of all equipment. And that is what one is entitled to ask from a work of art.

12

Mechanical reproduction of art changes the reaction of the masses toward art. The reactionary attitude toward a Picasso painting changes into the progressive reaction toward a Chaplin movie. The progressive reaction is characterized by the direct, intimate fusion of visual and emotional enjoyment with the orientation of the expert. Such fusion is of great social significance. The greater the decrease in the social significance of an art form, the sharper the distinction between criticism and enjoyment by the public. The conventional is uncritically enjoyed, and the truly new is criticized with aversion. With regard to the screen, the critical and the receptive attitudes of the public coincide. The decisive reason for this is that individual reactions are predetermined by the mass audience response they are about to produce, and this is nowhere more pronounced than in the film. The moment these responses become manifest they control each other. Again, the comparison with painting is fruitful. A painting has always had an excellent chance to be viewed by one person or by a few. The simultaneous contemplation of paintings by a large public, such as developed in the nineteenth century, is an early symptom of the crisis of painting, a crisis which was by no means occasioned exclusively by photography but rather in a relatively independent manner by the appeal of art works to the masses.

Painting simply is in no position to present an object for simultaneous collective experience, as it was possible for architecture at all times, for the epic poem in the past, and for the movie today. Although this circumstance in itself should not lead one to conclusions about the social role of painting, it does constitute a serious threat as soon as painting, under special conditions and, as it were, against its nature, is confronted directly by the masses. In the churches and monasteries of the Middle Ages and at the princely courts up to the end of the eighteenth century, a collective reception of paintings did not occur simultaneously, but by graduated and hierarchized mediation. The change that has come about is an expression of the particular conflict in which painting was implicated by the mechanical reproducibility of paintings. Although paintings began to be publicly exhibited in galleries and salons, there was no way for the masses to organize and control themselves in their reception. Thus the same public which responds in a progressive manner toward a grotesque film is bound to respond in a reactionary manner to surrealism.

13

The characteristics of the film lie not only in the manner in which man presents himself to mechanical equipment but also in the manner in which, by means of this apparatus, man can represent his environment. A glance at occupational psychology illustrates the testing capacity of the equipment. Psychoanalysis illustrates it in a different perspective. The film has enriched our field of perception with methods which can be illustrated by those of Freudian theory. Fifty years ago, a slip of the tongue passed more or less unnoticed. Only exceptionally may such a slip have revealed dimensions of

depth in a conversation which had seemed to be taking its course on the surface. Since the *Psychopathology of Everyday Life* things have changed. This book isolated and made analyzable things which had heretofore floated along unnoticed in the broad stream of perception. For the entire spectrum of optical, and now also acoustical, perception the film has brought about a similar deepening of apperception. It is only an obverse of this fact that behaviour items shown in a movie can be analysed much more precisely and from more points of view than those presented on paintings or on the stage. As compared with painting, filmed behaviour lends itself more readily to analysis because of its incomparably more precise statements of the situation. In comparison with the stage scene, the filmed behaviour item lends itself more readily to analysis because it can be isolated more easily. This circumstance derives its chief importance from its tendency to promote the mutual penetration of art and science. Actually, of a screened behaviour item which is neatly brought out in a certain situation, like a muscle of a body, it is difficult to say which is more fascinating, its artistic value or its value for science. To demonstrate the identity of the artistic and scientific uses of photography which heretofore usually were separated will be one of the revolutionary functions of the film.

By close-ups of the things around us, by focusing on hidden details of familiar objects, by exploring commonplace milieus under the ingenious guidance of the camera, the film, on the one hand, extends our comprehension of the necessities which rule our lives; on the other hand, it manages to assure us of an immense and unexpected field of action. Our taverns and our metropolitan streets, our offices and furnished rooms, our railroad stations and our factories appeared to have us locked up hopelessly. Then came the film and burst this prison-world asunder by the dynamite of the tenth of a second, so that now, in the midst of its far-flung ruins and debris, we calmly and adventurously go travelling. With the close-up, space expands; with slow motion, movement is extended. The enlargement of a snapshot does not simply render more precise what in any case was visible, though unclear: it reveals entirely new structural formations of the subject. So, too, slow motion not only presents familiar qualities of movement but reveals in them entirely unknown ones 'which, far from looking like retarded rapid movements, give the effect of singularly gliding, floating, supernatural motions.'[12] Evidently a different nature opens itself to the camera than opens to the naked eye – if only because an unconsciously penetrated space is substituted for a space consciously explored by man. Even if one has a general knowledge of the way people walk, one knows nothing of a person's posture during the fractional second of a stride. The act of reaching for a lighter or a spoon is familiar routine, yet we hardly know what really goes on between hand and metal, not to mention how this fluctuates with our moods. Here the camera intervenes with the resources of its lowerings and likings, its interruptions and isolations, its extensions and accelerations, its enlargements and reductions. The camera introduces us to unconscious optics as does psychoanalysis to unconscious impulses.

Original publication

Extracts from 'The Work of Art in the Age of Mechanical Reproduction' in *Illuminations* (1973).

Notes

1 Paul Valéry, *Aesthetics*, trans. Ralph Mannheim. New York: Pantheon Books, 1964. Bollingen Series originally published as Pièces sur l'Art, Paris, 1934.

2 Precisely because authenticity is not reproducible, the intensive penetration of certain (mechanical) processes of reproduction was instrumental in differentiating and grading authenticity. To develop such differentiations was an important function of the trade in works of art. The invention of the woodcut may be said to have struck at the root of the quality of authenticity even before its late flowering.

3 Abel Gance, 'Le Temps de l'image est venu,' *L'Art cinématographique*, Vol. 2, pp. 94f, Paris, 1927.

4 To satisfy the human interest of the masses may mean to have one's social function removed from the field of vision. Nothing guarantees that a portraitist of today, when painting a famous surgeon at the breakfast table in the midst of his family, depicts his social function more precisely than a painter of the seventeenth century who portrayed his medical doctors as representing this profession, like Rembrandt in his 'Anatomy Lesson.'

5 The definition of the aura as a 'unique phenomenon of a distance however close it may be' represents nothing but the formulation of the cult value of the work of art in categories of space and time perception. Distance is the opposite of closeness. The essentially distant object is the unapproachable one. Unapproachability is indeed a major quality of the cult image. True to its nature, it remains 'distant, however close it may be.' The closeness which one may gain from its subject matter does not impair the distance which it retains in its appearance.

6 To the extent to which the cult value of the painting is secularised the ideas of its fundamental uniqueness lose distinctness. In the imagination of the beholder the uniqueness of the phenomena which hold sway in the cult image is more and more displaced by the empirical uniqueness of the creator or of his creative achievement. To be sure, never completely so; the concept of authenticity always transcends mere genuineness. (This is particularly apparent in the collector who always retains some traces of the fetishist and who, by owning the work of art, shares in its ritual power.) Nevertheless, the function of the concept of authenticity remains determinate in the evaluation of art; with the secularization of art, authenticity displaces the cult value of the work.

7 In the case of films, mechanical reproduction is not, as with literature and painting, an external condition for mass distribution. Mechanical reproduction is inherent in the very technique of film production. This technique not only permits in the most direct way but virtually causes mass distribution. It enforces distribution because the production of a film is so expensive that an individual who, for instance, might afford to buy a painting no longer can afford to buy a film.

8 Abel Gance, *op. cit.*, pp. 100–1.

9 Séverin-Mars, quoted by Abel Gance, *op. cit.*, p. 100.

10 Alexandre Arnoux, *Cinéma pris*, 1929, p. 28.

11 Franz Werfel, 'Ein Sommernachtstraum, Ein Film von Shakespeare und Reinhardt,' *Neues Wiener Journal*, cited in *Lu* 15, November 1935.

12 Rudolf Arnheim, *Film als Kunst*, Berlin, 1932, p. 138.

W. J. T. Mitchell

BENJAMIN AND THE POLITICAL ECONOMY OF THE PHOTOGRAPH

Each wondrous work of thine excites Surprize;
And, as at Court some fall, when others rise;
So, if thy magick Pow'r thou deign to shew;
The High are humbled, and advanc'd the Low;

[. . .]

Instructive Glass! here human Pride may trace,
Diminish'd Grandeur, and inverted Place.
> Anonymous, *Verses Occasion'd by the*
> *Sight of a Chamera Obscura* (1747)[1]

I MENTIONED EARLIER A CURIOUS asymmetry in Marxist writing about photography. In spite of the fact that photography was *the* revolutionary medium of the nineteenth century, invented during the years when Marx produced his major writings, he never mentions it except as another kind of 'industry'.[2] It is not hard to see, nevertheless, why photography would take on a special status for later Marxist criticism. The assumption that photography is an inherently realistic medium is very congenial with Marx's own expressed preference for realism in literature and painting. Marx and Engels resisted the notion that literature and art should be merely didactic instruments of socialist propaganda, preferring the realism of a nostalgic royalist like Balzac to the *Tendenzroman*.[3] And in the visual arts, Engels suggested that the leaders of the revolution should not be glorified but should

> be finally depicted in strong Rembrandtian colors, in all their living quali-
> ties. Hitherto these people have never been pictured in their real form;
> they have been presented as official personalities, wearing buskins and
> with aureoles around their heads. In these apotheoses of Raphaelite beauty
> all pictorial truth is lost.[4]
>
> (Marx and Engels 1947: 40)

'Rembrandtian' was, as it happens, one of the terms applied to the daguerreotype; Samuel Morse called the new images 'Rembrandt perfected' in 1839.[5] The 'realism' celebrated here is not, however, an optical, scientific reconstruction of vision – Vermeer would have been the right analogy for that sort of realism. And it is not 'historical' in the sense of traditional history painting ('apotheoses of Raphaelite beauty'), but an image of *real* history, of flesh-and-blood creatures in their material circumstances. This image replaces the traditional 'aureole' around the figure with a new sort of aura – the 'living qualities' of the subject.

These 'living qualities' are what, notoriously, the camera captures under the right conditions, so that it seems to come equipped with a historical, documentary claim built in to its mechanism: this really happened, and it really looked this way, at this time. This is more than the claim to merely optical fidelity, a correct transcription of visual appearances; it is a claim to have captured a piece of the 'historical life-process' as well as the 'physical life-process.' Perhaps we can now see some of the reasons for the Marxist fascination with photography and cinema, and also understand its ambivalence. The camera duplicates the ambiguous status of the camera obscura and raises it to a new power, for its images, in their permanence, can become material objects of exchange, and its overcoming of the transience of the 'fairy images' of the camera obscura means that it really can capture the historical process in a way that was only figuratively possible for the camera obscura.

Walter Benjamin's essays on photography provide the most fully developed expression of the Marxist ambivalence about the camera. Benjamin treats the camera as a kind of two-handed engine wielded at the gateway to the revolutionary millennium. The camera is, on the one hand, the epitome of the destructive, consumptive political economy of capitalism; it dispels the 'aura' of things by reproducing them in a leveling, automatic, statistically rationalized form: 'that which withers in the age of mechanical reproduction is the aura of the work of art. . . . To pry an object from its shell, to destroy its aura, is the mark of a perception whose "sense of the universal equality of things" has increased to such a degree that it extracts it even from a unique object by means of reproduction.'[6] Benjamin's camera does to the visible world what Marx said (in the *Communist Manifesto*) that capitalism was doing to social life in general: capitalism, like the pitiless eye of the camera, 'strips of its halo every occupation,' and replaces all the traditional forms of life 'veiled by religious and political illusions' with 'naked, shameless, direct, brutal exploitation.'[7] On the other hand, Benjamin also echoes Marx's faith in the dialectical inversion and redemption of these evils by the cunning of historical development: capitalism must run its course, unveil its contradictions and produce a new class that will be so nakedly dispossessed that a complete social revolution will be inevitable. In a similar fashion, Benjamin hails the invention of photography as 'the first truly revolutionary means of production' ('Work of Art,' 224), a medium that was invented 'simultaneously with the rise of socialism' and that is capable of revolutionizing the whole function of art, and of the human senses as well. If Marx thought of ideology as a camera obscura, Benjamin regarded the camera as both the material incarnation of ideology and as a symbol of the 'historical life-process' that would bring an end to ideology.

Benjamin was not the only one to express ambivalence about the camera, of course. The endless battles over the artistic status of photography and the larger question of whether the photographic image has a special 'ontology' reflect similar contradictory

feelings. Is photography a fine art or a mere industry? Is it 'Rembrandt perfected,' as Samuel Morse thought, or a new distraction for the 'idolatrous multitude,' as Baudelaire characterized it? ('An avenging God has heard the prayers of this multitude; Daguerre was his messiah.')[8] Does the camera provide a material incarnation of objective, scientific representation by mechanizing the system of perspective, as Gombrich argues? Or is it an instrument of 'contemplative materialism,' 'a purely ideological apparatus' whose 'monocular' vision ratifies 'the metaphysical centering on the subject' in bourgeois humanism, as Marcel Pleynet contends?[9]

Benjamin finesses all these kinds of disputes by treating them as 'contradictions' in the Marxist-Hegelian sense: they are symptoms of contradictions within capitalism that find their resolution in a historical narrative that foresees a synthesis in the future. Thus, Benjamin can mimic both sides of these debates while criticizing them. He can echo Baudelaire's distaste for the leveling effect of photography as an idol of mass culture, and yet see this leveling as an omen of the classless society. He can absorb the dispute between the 'scientific' and 'ideological' views of the photograph in the same way that Marx absorbed the debate between idealism and empiricism in the metaphor of the camera obscura, by treating them as equally partial, equally deluded options in the dialectic of history. He can rise above the argument over the artistic status of photography by dismissing it as a 'futile' debate that ignores the 'primary question – whether the very invention of photography had not transformed the entire nature of art' ('Work of Art,' 227). The argument that photography is a fine art is denounced as reactionary idolatry:

> Here, with all the weight of its dullness, enters the philistine's concept of *art*, to which any technical development is totally foreign, which with the provocative challenge of the new technology, feels its own end nearing. Nevertheless it was this fetishistic, fundamentally anti-technological concept of art with which the theoreticians of photography sought for almost a hundred years, naturally without coming to the slightest result.[10]

On the other hand, the dismissal of photography as mere technology is, in Benjamin's view, equally involved in fetishism and idolatry, the sort that tries to exclude the photographic image from the circle of sacred (i.e., artistic) objects. Benjamin quotes the Leipzig *City Advertiser* to illustrate this sort of reaction:

> 'To fix fleeting reflections,' it was written there, 'is not only impossible, as has been shown by thoroughgoing German research, but to wish to do it is blasphemy. Man is created in the image of God and God's image cannot be held fast by a human machine. At the most the pious artist – enraptured by heavenly inspiration – may at the higher command of his genius dare to reproduce those divine/human features in an instant of highest dedication, without mechanical help.'
>
> ('Short History' 1931; 1977: 200)

Photography, for Benjamin, is neither art nor nonart (mere technology): it is a new form of production that transforms the whole nature of art. To hold on to the view of photography as *either* art or as nonart in the traditional sense of the word is

to fall into some sort of fetishism, a charge which Benjamin can substantiate simply by quoting the antagonists against one another. One thing Benjamin does not really try to explain, however, is why one version of this fetishism won out. Why did assimilation of the machine-made image into the fine arts by the 'philistine' (recall here that the legendary Philistines were not simply idolaters but also the legendary thieves who stole the Ark of the Covenant from the Israelites; see I Samuel 5:1) overcome the reactionary pieties about man-made images? One answer is that there were certain historical exceptions: early photographs, with their predominance of shadows and oval images have about them the 'aura' or 'halo' that Benjamin sees photography as ultimately destroying ('Short History,' 207). In these early 'pre-industrial' photographs, the 'photographer was on the highest level of his instrument' ('Short History,' 205), and thus occupies, in Benjamin's view, a kind of prophetic or patriarchal status in the history of the medium: 'there seems to have been a sort of Biblical blessing on those first photographers: Nadar, Stelzner, Pierson, Bayard all lived to ninety or a hundred' ('Short History,' 205). Another answer is that there are two ways to dispel the aura around objects in the photographic process: one is the merely technical, vulgar clarity that comes with mass production and improved lighting: 'The conquest of darkness by increased illumination . . . eliminated the aura from the picture as thoroughly as the increasing alienation of the imperialist bourgeoisie had eliminated it from reality' ('Short History,' 208). The other is the 'liberation of the object from the aura' that one sees first in Atget, and which prefigures the 'healthy alienation' Benjamin sees in surrealist photography ('Short History,' 208–10).

Neither of these examples, however, really answers the question about the absorption of photography by traditional notions of fine art. When Benjamin praises the production of aura in Nadar, and the destruction of aura in Atget, he is praising them as moments in the formation of a new, revolutionary conception of art that bypasses all the philistine twaddle about creative genius and beauty. And yet it is precisely these traditional notions of aesthetics, with all their attendant claims about craftsmanship, formal subtlety and semantic complexity, that have sustained the case for the artistic status of photography. Some photographs just happen to be beautiful, by some criterion or other; some have a lot to say, or they present novel, moving, or otherwise interesting subject-matter. If the photograph really has the revolutionary character that Benjamin ascribes to it, one would expect more resistance to its appropriation by traditional aesthetic norms, more inertia in its status as a mere industry, and more unequivocal evidence of its tendency to transform all the other arts – to shift our attention, as it were, from 'photography as a form of art' to 'art as a form of photography' ('Short History,' 211).

The Marxist tradition has an answer to the question of why photography was assimilated to the fine arts, but it does not fit very well with Benjamin's idealization of it as a revolutionary art. Bernard Edelman suggests that the aesthetic idealization of photography is purely an economic and legal matter. The photographer had to gain recognition as a creative artist in order for the law to find grounds for ownership of photographic images. Before the invention of photography, Edelman argues,

> the law recognised only 'manual' art – the paintbrush, the chisel – or 'abstract' art – writing. The irruption of modern techniques of the (re)production of the real – photographic apparatuses, cameras – surprises the

> law in the quietude of its categories. . . . Photographer and film maker must
> become creators, or the industry will lose the benefit of legal protection.[11]

Edelman suggests, like Benjamin, that the 'pre-industrial' phase of photography is somehow a special moment: 'The photographer of 1860 is the *proletarian of creation*; he and his tool form one body.'[12] But this pre-industrial phase is also preaesthetic, and Edelman musters a large number of legal opinions to suggest that the rise of the aesthetic justification – the 'creative subjectivity' of the photographer in particular – is a legal fiction devised to secure property rights.

Edelman is completely silent about Benjamin, an astonishing omission in a Marxist analysis of photography and cinema. But the reason may not be so difficult to see. There is no suggestion in Edelman's account that some photography (except perhaps the earliest) escapes the political economy of capitalism. Edelman presents no sensitive analyses of Agtet or the surrealists, no discoveries of the revolutionary destruction of aura and 'healthy alienation' as Benjamin does: In fact he never discusses a single photograph. He is interested only in photography as a 'legal fiction' and in the photographer as a 'subject in law' under capitalist jurisprudence. In his way, Edelman's version of photography is as idealized as Benjamin's; the difference is that he has some empirical evidence to suggest that his particular idealization (for which he has nothing but contempt) has had the force of law. Benjamin's, we might say, has the force of desire: he wants photography to transform the arts into a revolutionary force; he wants the question of photography as a fine art (or perhaps as just another technique of picture-making) to be bypassed by history. The one place where these two accounts converge is in their agreement that the aestheticizing of photography is a kind of fetishism. For Benjamin, it is the quasi-religious fetishism that tries to reproduce the 'aura' in photography by tricking it up or imitating painterly styles; for Edelman, it is the fetishism of the commodity, the photograph as something that has exchange value. The 'idols of the mind' that Marx saw projected in the camera obscura take their material, incarnate form in the legal and aesthetic status of the photograph as a capitalist fetish. This conclusion fulfills the logic of Marx's thought, but it also produces certain problems for the application of that thought to photography, and to art in general, problems which are centered in the figure of the fetish.

Original publication

'Benjamin and the Political Economy of the Photograph' in *Iconology: Image, Text, Ideology*, 1986.

Notes

1 These verses were printed for the noted optician, John Cuff, who probably wrote them. See Heinrich Schwarz, 'An Eighteenth Century English Poem on the Camera Obscura,' in *One Hundred Years of Photographic History: Essays in Honor of Beaumont Newhall*, ed. Van Deren Coke (Albuquerque: University of New Mexico Press, 1975), 128–35. I am grateful to Joel Snyder for leading me to this text.

2 *Capital* (1867), ed. Frederick Engels, trans. from the third German edition (1883) by Samuel Moore and Edward Aveling, 3 vols. (New York: International Publishers, 1967), 1:445. All references to *Capital* will be from this edition, hereafter indicated by C.

3 See Marx and Engels, *Literature and Art* (New York: International Publishers, 1947), 42. A strong argument for placing Marx's aesthetic theory with the Saint-Simonist avant garde is made by Margaret A. Rose in *Marx's Lost Aesthetic* (New York: Cambridge University Press, 1984).

4 *Literature and Art*, 40.

5 *One Hundred Years of Photographic History*, 23.

6 'The Work of Art in the Age of Mechanical Reproduction,' first published in *Zeitschrift für Socialforschung* V, I (1936). Reference here and throughout is to the translation in *Illuminations*, ed. Hannah Arrendt (New York: Shocken, 1969), 221, 223, hereafter cited as 'Work of Art.'

7 See 1:397, for capitalism as a leveler, the 'halo' and 'veil' images occur in *The Communist Manifesto* (1848), ed. Samuel H. Beer (Arlington Heights, IL: Harlan Davidson, 1955), 12.

8 Trachtenberg, *Classic Essays on Photography* (New Haven, CT: Leete's Island Books, 1980), 86.

9 See chapter 3 in the original publication of this article for a discussion of Gombrich on the scientific status of photography; Pleynet is quoted in Bernard Edelman, *The Ownership of the Image* (London: Routledge & Kegan Paul, 1979), 63–4.

10 Benjamin, 'A Short History of Photography,' originally published in *Literarische Welt* (1931); reprinted from *Artforum* (February, 1977), Phil Patton, trans., in Trachtenberg, 201. Hereafter cited as 'Short History.'

11 *The Ownership of the Image*, 44.

12 Ibid., 45.

Siegfried Kracauer[1],
Translated by Thomas Y. Levin[2]

PHOTOGRAPHY

Forced to leave fascist Germany in 1933, Siegfried Kracauer (1889–1966) began a period of exile that would last the rest of his life. It was thus in Paris and then, after 1941, in New York that he would write the works for which he is known in the Anglo-American realm: a "social biography" of Jacques Offenbach (Orpheus in Paris, 1937), a study of Weimar film (From Caligari to Hitler, 1947), an aesthetics of cinema (Theory of Film, 1960), and a meditation on the philosophy of history (History: The Last Things before the Last, 1969). What Kracauer abandoned in Frankfurt and Berlin was not only his native language but also a career as one of the major cultural critics of the Weimar Republic. Trained as both an architect and a sociologist, in the mid-1920s Kracauer became one of the editors of the feuilleton (arts and culture) section of the important, left-liberal Frankfurter Zeitung, a paper in which he eventually published nearly two thousand articles on a remarkably wide range of subjects. While many of these were more or less incidental journalistic pieces, others, such as "Photography," were sustained philosophical reflections. It was in these pages that Kracauer effectively pioneered the genre of sociological film criticism, undertook a pathbreaking series of analyses of the new "employee-class" (collected in 1930 in a book entitled Die Angestellten), and published major essays on Kafka, Benjamin, Weber, Scheler, the Buber-Rosenzweig translation of the Bible, the genre of biography, to name just a few. Together with his friends Adorno, Benjamin, and Bloch, whose work he published regularly in the feuilleton section, Kracauer also wrote philosophical and sociological analyses of daily-life phenomena in the tradition of his teacher Georg Simmel. In these quotidian micrologies focusing, for example, on the architecture of cinema palaces, unemployment offices and arcades, on travel and dance troupes, best-sellers and boredom, on neon-light displays and mass sports events, Kracauer developed a genre motivated by the following

programmatic insight: "One must rid oneself of the delusion that it is the major events which have the most decisive influence on people. They are much more deeply and continuously influenced by the tiny catastrophes which make up daily life."[3] The publication in translation of a collection of these essays from the Weimar period entitled The Mass Ornament will finally make available this important and until recently largely unknown facet of Kracauer's work.

(Thomas Y. Levin)

In the days of cock-a-doodle I went and saw Rome and the Lateran hanging from a silk thread. I saw a man without feet outrunning a swift horse and a sharp, sharp sword cutting a bridge in two.

(Brothers Grimm, "The Tale of a Cock-a-Doodle")

1

THIS IS WHAT THE *FILM DIVA* LOOKS LIKE. She is twenty-four years old, featured on the cover of an illustrated magazine, standing in front of the Hotel Excelsior on the Lido. The date is September. If one were to look through a magnifying glass one could make out the grain, the millions of little dots that constitute the diva, the waves and the hotel. The picture, however, does not refer to the dot matrix but to the living diva on the Lido. Time: the present. The caption calls her demonic: our demonic diva. Still, she does not lack a certain look. The bangs, the seductive position of the head, and the twelve lashes right and left – all these details, diligently recorded by the camera, are in their proper place, a flawless appearance. Everyone recognizes her with delight since everyone has already seen the original on the screen. It is such a good likeness that she cannot be confused with anyone else, even if she is perhaps only one twelfth of a dozen Tiller girls.[4] Dreamily she stands in front of the Hotel Excelsior, which basks in her fame, a being of flesh and blood, our demonic diva, twenty-four years old, on the Lido. The date is September.

Is that what *Grandmother* looked like? The photograph, over sixty years old and already a photograph in the modern sense, depicts her as a young girl of twenty-four. Since photographs are likenesses, this one must have been a likeness as well. It was carefully produced in the studio of a court photographer. But were it not for the oral tradition, the image alone would not have sufficed to reconstruct the grandmother. The grandchildren know that in her later years she lived in a narrow little room with a view onto the old part of town and that, to give pleasure to the children, she would make soldiers dance on a glass plate;[5] they also know a nasty story about her life and two confirmed utterances, which change a bit from generation to generation. One has to believe the parents – who claim to have gotten it from Grandmother herself – that this photograph depicts the very same grandmother about whom one has retained these few details that may also in time be forgotten. Yet such testimonies are unreliable. It might turn out that the photograph does not depict the grandmother after all but rather a girlfriend that resembled her. None of her contemporaries are still alive – and the question of likeness? The ur-image has long since decayed. But the now-darkened

appearance has so little in common with the traits still remembered that the grand-children are amazed when urged to believe that it is the fragmentarily remembered ancestor whom they encounter in the photograph. All right, so it is Grandmother, but in reality it is any young girl in 1864. The girl smiles continuously, always the same smile, the smile is arrested yet no longer refers to the life from which it has been taken. Likeness has ceased to be any help. The smiles of plastic manikins in beauty parlours are just as rigid and perpetual. This manikin does not belong to our time; it could be standing with others of its kind in a museum, in a glass case labelled "Traditional Costumes 1864." There the manikins are displayed solely for the historical costumes, and the grandmother in the photograph is also an archeological manikin that serves to illustrate the costumes of the period. So that's how one dressed back then: with a chignon, the waist tightly tied, in a crinoline and a Zouave jacket.[6] The grandmother dissolves into fashionably old-fashioned details before the very eyes of the grandchildren. They are amused by the traditional costume that, following the disappearance of its bearer, remains alone on the battlefield – an external decoration that has become autonomous. They are irreverent, and today young girls dress differently. They laugh and at the same time they feel a shudder. For through the ornamentation of the costume from which the grandmother has disappeared they think they glimpse a moment of time past, a time that passes without return. While time is not part of the photograph like the smile or the chignon, the photograph itself, so it seems to them, is a representation of time. If it is only the photograph that endows these details with duration, it is not at all they who outlast mere time, but, rather, it is time that makes images of itself out of them.

2

"From the early days of the friendship between Goethe and Karl August." "Karl August and the 1787 coadjutor election in Erfurt." "A visit of a Bohemian in Jena and Weimar" (1818). "Recollections of a Weimar high school student" (1825 to 1830). "A contemporary account of the Goethe celebration on November 7, 1825." "A rediscovered bust of Wieland by Ludwig Klauer." "Plan for a national monument to Goethe in Weimar." The herbarium for these and other investigations is provided by the Goethe Society yearbooks, a series that in principle can never come to an end. It would be superfluous to ridicule the Goethe philology that deposits its specimens in these volumes, all the more so since it is as ephemeral as the items it processes. The pseudolustre of the numerous monumental works on Goethe's stature, being, personality, and so on, on the other hand, has hardly begun to be questioned. The fundamental principle of Goethe philology is that of *historicist* thinking, which emerged at about the same time as did modern photographic technology. On the whole the advocates of such historicist thinking believe that they can explain any phenomenon purely in terms of its genesis.[7] That is, they believe at the very least that they can grasp historical reality by reconstructing the series of events in their temporal succession without any gaps. Photography presents a spatial continuum; historicism seeks to provide the temporal continuum. According to historicism the complete mirroring of a temporal sequence simultaneously contains the meaning of all that occurred within that time. Thus, if the connecting links of the Erfurt coadjutant election or the recollections of the Weimar

high school student were missing in the presentation of Goethe, for the historicist, such an account would be lacking reality. Historicism is concerned with the photography of time. The equivalent of its temporal photography would be a giant film depicting the temporally interconnected events from every vantage point.[8]

3

Memory encompasses neither the entire spatial appearance nor the entire temporal course of an event. Compared to photography memory's records are full of gaps. The fact that the grandmother was at one time involved in a nasty story that is being recounted time and again because one really doesn't like to talk about it – this doesn't mean much from the photographer's perspective. He knows the first little wrinkles on her face and has noted every date. Memory does not pay much attention to dates; it skips years or stretches temporal distance. The selection of traits that it assembles must strike the photographer as arbitrary. The selection may have been made this way rather than another because disposition and purposes required the repression, falsification, and emphasis of certain parts of the object; a virtually endless number of reasons determine the remains to be filtered. No matter which scenes a person remembers, they all mean something that is relevant to him or her without his or her necessarily knowing what they mean. Memories are retained because of their significance for that person. Thus they are organized according to a principle that is essentially different from the organizing principle of photography. Photography grasps what is given as a spatial (or temporal) continuum; memory-images retain what is given only insofar as it has significance. Since what is significant is not reducible to either merely spatial or merely temporal terms, memory-images are at odds with photographic representation. From the latter's perspective, memory-images appear to be fragments but only because photography does not encompass the meaning to which they refer and in relation to which they cease to be fragments. Similarly, from the perspective of memory, photography appears as a jumble that consists partly of garbage.

The meaning of memory-images is linked to their truth content. As long as they are embedded in the uncontrolled life of the drives they are inhabited by a demonic ambiguity; they are opaque like frosted glass that hardly a ray of light can penetrate. Their transparency increases to the extent that insights thin out the vegetation of the soul and limit the compulsion of nature. Truth can only be found by a liberated consciousness that assesses the demonic nature of the drives. The traits that consciousness recollects stand in a relationship to what has been perceived as true, the latter being either manifest in these traits or shut out by them. The image in which these traits are to be found is distinguished from all other memory-images, for unlike the latter it preserves not a multitude of opaque recollections but instead elements that touch upon what has been recognized as true. All memory-images are bound to be reduced to this type of image, which may rightly be called the last image, since in it alone does the unforgettable persevere. The last image of a person is that person's actual "*history.*" In this history, all characteristics and determinations that do not relate in a significant sense to the truth intended by a liberated consciousness drop out. How a person represents this history does not depend purely on his or her natural constitution nor on the pseudo-coherence of his or her individuality; thus only fragments of these assets are

included in his or her history. This history is like a *monogram* that condenses the name into a single graphic figure that is meaningful as an ornament. Eckart's monogram is fidelity.[9] Great historical figures survive in legends that, however naive they may be, strive to preserve their actual history. In authentic fairy tales, the imagination has intuitively deposited typical monograms. In a photograph a person's history is buried as if under a layer of snow.

4

In his description of a Rubens landscape presented to him by Goethe, Eckermann notices to his surprise that the light in the painting comes from two opposing directions, "which is quite contrary to nature."[10] Goethe responds: "This is how Rubens proves his greatness, and shows to the world that he stands *above* nature with a free spirit, fashioning it according to his higher purposes. The double light is indeed violent and you could even say that it is contrary to nature. But if it is contrary to nature, I still say that it is *higher* than nature; I say that it is the bold hand of the master whereby he demonstrates in a brilliant way that art is not entirely subject to natural necessity but rather has laws of its own." A *portrait painter* who submitted entirely to "natural necessity" would at best create photographs. During a particular period, which began with the Renaissance and may now be approaching its end, the "artwork" is indeed faithful to nature whose specificity reveals itself more and more during this period. But by penetrating this nature the artwork orients itself toward "higher purposes." There is cognition in the material of colours and contours, and the greater the artwork the more it approaches the transparency of the final memory-image in which the features of "history" converge. A man who had his portrait painted by Trübner asked the artist not to forget the wrinkles and folds on his face. Trübner pointed out the window and said: "Cross the way there's a photographer. If you want to have wrinkles and folds then you'd better hire him, he'll put 'em all in; me, I paint history."[11] In order for history to present itself the mere surface coherence offered by photography must be destroyed. For in the artwork the meaning of the object takes on spatial appearance, whereas in photography the spatial appearance of an object is its meaning. The two spatial appearances – the "natural" one and that of the object permeated by cognition – are not identical. By sacrificing the former for the sake of the latter the artwork also negates the *likeness* achieved by photography. This likeness refers to the look of the object, which does not immediately divulge how it reveals itself to cognition; the artwork, however, conveys nothing but the transparency of the object. In so doing it resembles a magic mirror that does not reflect those who consult it as they appear but instead as they wish to be or as they fundamentally are. The artwork too disintegrates over time, but its meaning arises out of its crumbled elements, whereas photography merely stockpiles the elements.

 Until well into the second half of the nineteenth century the practice of photography was often in the hands of former painters. The not yet entirely depersonalized technology of this transition period corresponded to a spatial environment in which traces of meaning could still be trapped. With the increasing independence of the technology and the simultaneous evacuation of meaning from the objects, *artistic photography* loses its justification; it does not grow into an artwork but into its

imitation. Images of children are Zumbusches,[12] and the godfather of photographic landscape impressions was Monet. These pictorial arrangements – which do not go beyond a skilful emulation of familiar styles – fail precisely to undertake the representation of the remnants of nature of which, to a certain extent, the advanced technology would be capable. Modern painters have composed their images out of photographic fragments in order to highlight the side-by-side existence of reified appearances as they manifest themselves in spatial relations. This artistic intention is diametrically opposed to that of artistic photography. The latter does not explore the object assigned to photographic technology but rather wants to hide the technological essence by means of style. The artistic photographer is a dilettante artist who apes an artistic manner minus its substance instead of capturing the very lack of substance. Similarly, rhythmical gymnastics wants to incorporate the soul about which it knows nothing. It shares with artistic photography the ambition to lay claim to a higher life in order to elevate an activity that is actually at its most elevated when it finds the object appropriate to its technology. The artistic photographers function like those social forces that are interested in the semblance of the spiritual because they fear the real spirit; it might explode the material base that the spiritual illusion serves to disguise. It would be well worth the effort to expose the close ties between the prevailing social order and artistic photography.

5

The photograph does not preserve the transparent aspects of an object but instead captures it as a spatial continuum from any one of a number of positions. The last memory-image outlasts time because it is unforgettable; the photograph, which neither refers to nor encompasses such a memory-image, must be essentially associated with the moment in time at which it came into existence. Referring to the average film whose subject matter is the normal photographable environment, E. A. Dupont remarked in his book on film that "the essence of film is, to a certain extent, the essence of time."[13] If photography is a *function of the flow of time*, then its substantive meaning will change depending upon whether it belongs to the domain of the present or to some phase of the past.

Current event photography, which portrays phenomena familiar to *contemporary* consciousness, provides access, of a limited sort, to the life of the original. In each case it registers an exterior that, at the time of its reign, is a means of expression as generally intelligible as language. The contemporaneous beholder believes that he or she sees the film diva herself in the photograph, not only her bangs or the pose of her head. Naturally, he or she cannot imagine her on the basis of the photograph alone. But luckily the diva numbers among the living, and the cover of the illustrated magazine functions as a reminder of her corporeal reality. This means that present-day photography performs a mediating function; it is an optical sign for the diva who is meant to be recognized. One may have one's doubts in the end as to whether her decisive trait is really the demonic. But even the demonic is less something conveyed by the photograph than it is the impression of the cinemagoers who experience the original on the screen. They recognize it as the representation of the demonic – so be it. The image denounces the demonic not because of but

rather *despite* its resemblance. For the time being the demonic belongs to the still-vacillating memory-image of the diva to which the photographic resemblance does not refer. However, the memory-image drawn from the viewing of our celebrated diva breaks through the wall of resemblance into the photograph and thereby lends the latter a modicum of transparency.

Once a photograph ages, the immediate reference to the original is no longer possible. The body of a deceased person appears smaller than the living figure. An *old* photograph also presents itself as the reduction of a contemporaneous one. The old photograph has been emptied of the life whose physical presence overlay its merely spatial configuration. In inverse proportion to photographs, memory-images enlarge themselves into monograms of the remembered life. The photograph is the sediment that has settled from the monogram, and from year to year its semiotic value decreases. The truth content of the original is left behind in its history; the photograph captures only the residuum that history has discharged.

If one can no longer encounter the grandmother in the photograph, the image taken from the family album necessarily disintegrates into its particulars. In the case of the diva, one's gaze may wander from her bangs to her demonic quality; from the nothingness of the grandmother the gaze is thrown back onto the chignon: it is the fashion details that hold it tight. Photography is bound to time in precisely the same way as *fashion*. Since the latter has no significance other than as current human garb, it is translucent when modern and abandoned when old. The tightly corsetted dress in the photograph protrudes into our time like a mansion from earlier days that has been marked for destruction because the city centre has been moved to another part of town. Usually members of the lower class settle in such buildings. It is only the very old traditional dress, a dress that has lost all contact with the present, that can attain the beauty of a ruin. The effect of an outfit that was still worn only recently is *comical*. The grandchildren are amused by the grandmotherly crinoline of 1864, which provokes the thought that it might hide the legs of a modern girl. The recent past that claims to be alive is more outdated than that which existed long ago and whose meaning has changed. The comic quality of the crinoline is due to the powerlessness of its claim. In the photograph, the grandmother's costume is recognized as a cast-off remnant that wants to continue to hold its ground. It is reduced to the sum of its details like a corpse yet stands tall as if full of life. Even the landscape and all other concrete objects become costumes in an old photograph. For what is retained in the image are not the features envisaged by a liberated consciousness. The representation captures contexts from which such consciousness has departed, that is, it encompasses orders of existence that have shrivelled without wanting to admit it. The more consciousness withdraws from natural bonds, the more nature diminishes. In old etchings whose fidelity is photographic the hills of the Rhine look like mountains. Due to technological development they have in the meantime been reduced to tiny slopes and the grandiosity of those aged views seems a bit ridiculous.

Ghosts are simultaneously comic and terrifying. Laughter is not the only response provoked by antiquated photography. It represents what is utterly past and yet this refuse was once the present. Grandmother was once a person and to this person belonged the chignon and the corset as well as the High Renaissance chair with its turned pillars, a ballast that did not weigh her down but was just carried along as a matter of fact. Now the image wanders ghostlike through the present like the lady

of the haunted castle. Spooky apparitions occur only in places where a terrible deed has been committed. The photograph becomes a ghost because the costumed manikin was once alive. The image proves that the alien trappings were incorporated into life as accessories. These trappings, whose lack of transparency one experiences in the old photograph, were formerly inseparably meshed with the transparent aspects. This bad association that persists in the photograph provokes a shudder. Such a shudder is provoked in drastic fashion by the pre-World War I films screened in the avant-garde cinema Studio des Ursulines in Paris – film images that show how the features stored in the memory-image are embedded in a reality that has long since disappeared. Like the photographic image, the playing of an old hit song or the reading of letters written long ago also conjures up anew a disintegrated unity. This ghostlike reality is *unredeemed*. It consists of elements in space whose configuration is so far from necessary that one could just as well imagine a different organization of these elements. Those things once clung to us like our skin, and this is how our property still clings to us today. We are contained in nothing and photography assembles fragments around a nothing. When Grandmother stood in front of the lens she was present for one second in the spatial continuum that presented itself to the lens. But it was this aspect and not the grandmother that was eternalized. A shudder runs through the beholder / viewer of old photographs. For they do not make visible the knowledge of the original but rather the spatial configuration of a moment; it is not the person who appears in his or her photograph, but the sum of what can be deducted from him or her. It annihilates the person by portraying him or her, and were person and portrayal to converge, the person would cease to exist. An illustrated newspaper recently put together photographs of famous personalities as children and as grown-ups and published them under the heading, "The Faces of Famous People: This Is How They Once Were – And This Is How They Are Today!" Marx as a youth and Marx as leader of the Center party, Hindenburg as a lieutenant and our Hindenburg. The photographs are aligned beside each other like statistical reports, and one can neither guess the later image from the earlier one nor reconstruct the earlier image from the later. One has to take it on faith that the optical inventories belong together. The features of human beings are retained only in their "history."

6

The daily papers are illustrating their texts more and more, and what would a magazine be without pictures? The striking proof of photography's extraordinary validity today is provided above all by the increase in the number of *illustrated newspapers*. In them one finds assembled everything from the film diva to anything within reach of the camera and the audience. Infants are of interest to mothers and young gentlemen are captivated by the legs of beautiful girls. Beautiful girls like to behold sports and stage celebrities standing on gangways of ocean liners when embarking on voyages to distant lands. In distant lands there are battles of conflicting interests. But the focus of interest is not on them but on the cities, the natural catastrophes, the cultural heroes, and the politicians. In Geneva the League of Nations is meeting; it serves as a pretext for showing Mr. Stresemann and Mr. Briand in conversation in front of the entrance of the hotel.[14] The new fashions also must be disseminated or else in the summer the

beautiful girls will not know who they are. Fashion beauties attend high-society events accompanied by young gentlemen, earthquakes take place in distant lands, Mr. Stresemann is seated on a terrace with potted palms, and for the mothers we have the little tots.

The aim of the illustrated newspapers is the complete reproduction of the world accessible to the photographic apparatus; they record the spatial outlines of people, conditions, and events from every possible perspective. Their method corresponds to that of the weekly newsreel, which is nothing but a collection of photographs, whereas an authentic film employs photography merely as a means. Never before has an age been so informed about itself, if being informed means having an image of objects that resembles them in a photographic sense. Most of the images in the illustrated magazines are topical photographs that, as such, refer to existing objects. The reproductions are thus basically signs that may remind one of the original object that was supposed to be understood. The demonic diva. In reality, however, the weekly photographic ration does not intend at all to refer to these objects or ur-images. If it were offering itself as an aid to memory, then memory would have to determine the selection. But the flood of photos sweeps away the dams of memory. The assault of this mass of images is so powerful that it threatens to destroy the potentially existing awareness of crucial traits. Artworks suffer this fate through their reproductions. The phrase "lie together, die together" applies to the multiply reproduced original; rather than coming into view through the reproductions, it tends to disappear in its multiplicity and to live on as art photography. In the illustrated magazines people see the very world that the illustrated magazines prevent them from perceiving. The spatial continuum from the camera's perspective predominates the spatial appearance of the perceived object; the likeness that the image bears to it effaces the contours of the object's "history." Never before has a period known so little about itself. In the hands of the ruling society, the invention of illustrated magazines is one of the most powerful means of organizing a strike against understanding. Even the colorful arrangement of the images provides a not insignificant means to successfully implement such a strike. The *contiguity* of these images systematically excludes their contextual framework available to consciousness. The "image-idea" drives away the idea; the blizzard of photographs betrays an indifference toward what the things mean. It would not have to be this way; but, in any case, the American illustrated magazines – which the publications of other countries emulate to a large degree – equate the world with the quintessence of the photographs. This equation is not made without good reason. For the world itself has taken on a "photographic face"; it can be photographed because it strives to be completely reducible to the spatial continuum that yields to snapshots. It can sometimes depend on that fraction of a second required for the exposure of an object whether or not a sportsman will become so famous that photographers are commissioned by illustrated magazines to give him exposure. The camera can also capture the figures of the beautiful girls and young gentlemen. That the world devours them is a sign of the *fear of death*. What the photographs by their sheer accumulation attempt to banish is the recollection of death, which is part and parcel of every memory-image. In the illustrated magazines the world has become a photographable present, and the photographed present has been entirely eternalized. Seemingly ripped from the clutch of death, in reality it has succumbed to it all the more.

7

The series of pictorial representations of which photography is the last historical stage begins with the *symbol*. The symbol, in turn, arises out of the "natural community" in which man's consciousness was still entirely embedded in nature.

> Just as the history of individual words always begins with the sensuous, natural meaning and only progresses to abstract, figurative uses in the later stages of its development, one can observe the same progression from sub-stance and matter to the spiritual and the intellectual in religion, in the development of the human individual and of mankind in general. Like-wise the symbols in which the earliest mankind customarily deposited its views of the nature of their surrounding world have a fundamental mean-ing which is purely physical and material. Symbolism, like language, sat in nature's lap.

This statement is taken from *Bachofen's* study of the rope-twisting Ocnus in which he shows that the spinning and weaving depicted in the image originally referred to the activity of the creative power of nature.[15] As consciousness becomes more and more aware of itself and in the process the originary "identity of nature and man" dissolves, the meaning of the image becomes increasingly abstract and immaterial.[16] But even if, as Bachofen puts it, the image progresses to the point of designating "the spiritual and the intellectual," the meaning is nevertheless so much a part of the image that it cannot be separated from it. For long stretches of history imagistic representations remain symbols. As long as human beings need them they remain dependent in practice on natural conditions, a dependence that determines the visible and corporeal expression of consciousness. It is only with the increasing domination of nature that the image loses its symbolic power. Consciousness, which disengages itself from nature and stands over against it, is no longer naively enveloped in its mythological shell; it thinks in con-cepts that, of course, can still be used in an altogether mythological way. In certain epochs the image retains its power; the symbolic presentation becomes allegory. "The latter signifies merely a general concept or an idea which is distinct from it; the former is the sensuous form, the incorporation of the idea itself " – this is how old Creuzer defines the difference between the two types of images.[17] At the level of the symbol what is thought is contained in the image; at the level of allegory thought maintains and employs the image as if consciousness were hesitating to throw off its shell. This schematization is crude. Yet it suffices to illustrate the transformation of representa-tions that is the sign of the departure of consciousness from its natural contingency. The more decisively consciousness frees itself from this contingency in the course of the historical process, the more purely does its natural foundation present itself to consciousness. What is meant no longer appears to consciousness in images; rather, this meaning goes toward and through nature. To an ever-increasing degree, European painting during the last few centuries has represented nature stripped of symbolic and allegorical meanings. This certainly does not imply that the human features it depicts are therefore bereft of meaning. Even at the time of the old daguerreotypes conscious-ness is so imbricated in nature that the faces bring to mind meanings that cannot be

separated from natural life. Since nature changes in exact correspondence with the respective state of consciousness of a period, the foundation of nature devoid of meaning arises with modern photography. No different from earlier modes of representation, photography too is assigned to a particular developmental stage of practical and material life. It is a secretion of the capitalist mode of production. The same mere nature that appears in photography flourishes in the reality of the society produced by this capitalist mode of production. One can well imagine a society that has succumbed to mute nature that has no meaning no matter how abstract its silence. The contours of such a society emerge in the illustrated journals. Were it to last, the consequence of the emancipation of consciousness would be its own eradication; nature that consciousness failed to penetrate would sit down at the very table that consciousness had abandoned. Were this society not to prevail, however, then liberated consciousness would be given an incomparable opportunity. Less enmeshed in the natural bonds than ever before, it can prove its power in dealing with them. The turn to photography is the *go-for-broke game* of history.

8

Even if the grandmother has disappeared, the crinoline has nonetheless remained. The totality of all photographs must be understood as the *general inventory* of a nature that cannot be further reduced, as the comprehensive catalogue of all manifestations that present themselves in space to the extent that they are not constructed out of the monogram of the object but from a natural perspective that the monogram does not capture. Corresponding to this spatial inventory is historicism's temporal inventory. Instead of preserving the "history" that consciousness reads out of the temporal succession of events, historicism records the temporal succession of events whose linkage does not contain the transparency of history. The barren self-presentation of spatial and temporal elements belongs to a social order that regulates itself according to economic laws of nature.

A consciousness still caught up in nature is unable to see its own material base. It is the task of photography to disclose this previously unexamined *foundation of nature*. For the first time in history, photography brings to the fore the entire natural shell; or the first time the inert world presents itself in its independence from human beings. Photography shows cities in aerial shots, brings crockets and figures down from the Gothic cathedrals; all spatial configurations are incorporated into the central archive in unusual combinations that distance them from human proximity. Once the grandmother's costume has lost its relationship to the present it will no longer be funny, but peculiar like a submarine octopus. One day the diva will lose her demonic quality and her bangs will go the same way as the chignon. This is how the elements crumble since they are not held together. The photographic archive assembles in effigy the last elements of a nature alienated from meaning.

This warehousing of nature promotes the confrontation of consciousness with nature. Just as consciousness finds itself confronting the unabashedly displayed mechanics of industrial society, it also faces, thanks to photographic technology, the reflection of the reality that has slipped away from it. To have provoked the decisive confrontation in every field – this is precisely the go-for-broke game of the historical process. The

images of the stock of nature disintegrated into its elements are offered up to consciousness to deal with as it pleases. Their original order is lost; they no longer cling to the spatial context that linked them with an original out of which the memory-image was selected. However, if the remnants of nature are not oriented toward the memory-image, then the order they assume through the image is necessarily provisional. It is therefore incumbent on consciousness to establish the *provisional status* of all given configurations and, perhaps, even to awaken an inkling of the right order of the inventory of nature. In the works of Franz Kafka, a liberated consciousness absolves itself of this responsibility by destroying natural reality and jumbling the fragments against each other. The disorder of the detritus reflected in photography cannot be elucidated more clearly than through the suspension of every habitual relationship between the elements of nature. The capacity to stir up the elements of nature is one of the possibilities of film. This possibility is realized whenever film combines parts and segments to create strange constructs. If the disarray of the illustrated newspapers is simply confusion, the game that film plays with the pieces of disjointed nature is reminiscent of *dreams* in which the fragments of daily life become jumbled. This game indicates that the valid organization of things is not known, an organization that would designate how the remains of the grandmother and the diva stored in the general inventory will some day have to appear.

Original publication

Extracts from 'Photography', in *Critical Inquiry*, vol. 19 no. 3 (1993).
[Originally published 1927]

Notes

1 "Die Photographie" was first published in the *Frankfurter Zeitung*, 28 Oct. 1927. It was first reprinted in Siegfried Kracauer, *Das Ornament der Masse* (Frankfurt am Main, 1963), pp. 21–39, a collection of his essays that the author himself edited. See also Kracauer, vol. 5, pt. 2 of *Schriften*, ed. Inka Mülder-Bach (Frankfurt am Main, 1990), pp. 83–97. The present text will appear in *The Mass Ornament* (Cambridge, Mass., 1993). All footnotes are the translator's.

2 Thomas Y. Levin is assistant professor in the department of Germanic languages and literatures at Princeton University. He has edited *Siegfried Kracauer: Eine Bibliographie seiner Schriften, Siegfried Kracauer: Neue Interpretationen* (with Michael Kessler) and has translated and edited Kracauer's essay collection *The Mass Ornament* (1993).

3 Siegfried Kracauer, *Die Angestellten* (Frankfurt am Main, 1971), p. 252.

4 A group of militarily trained dancing girls named after the Manchester choreographer John Tiller. Introduced in the late nineteenth century, the troupe was hired in Germany by Eric Charell, the director of Berlin's Großes Schauspielhaus theater from 1924 to 1931 whose revues and operetta productions were the forerunners of the "musicals." See Derek Parker and Julia Parker, *The Natural History of the Chorus Girl* (London, 1975).

5 In the autobiographical novel *Georg*, which Kracauer completed in 1934 during his exile in Paris, the main character at one point recalls his childhood delight at "the glass battle fields of former times" filled with tin soldiers. "His grandmother," so we learn, "had occasionally set them up on a glass plate and then tapped on the surface from underneath

with her finger, in order to bring the ranks into disorder" (Siegfried Kracauer, *Georg*, in *Schriften* [Frankfurt am Main, 1973], 7:251).

6 A fashionable woman's jacket from the 1860s, modelled after the uniform of the Zou-ave, a French colonial troop composed of Berber tribes and *Europeans* and recruited in Algiers in 1830–31.

7 In the first publication of the essay in the *Frankfurter Zeitung*, Kracauer here explicitly names Wilhelm Dilthey as an exemplary advocate of such historical thinking.

8 Kracauer refers to this passage in his introduction to *History: The Last Things Before the Last* (New York, 1969) when describing his surprising realization of the continuity between the work he had done on film and his present concern with history: "I realized in a flash the many existing parallels between history and the photographic media, historical reality and camera-reality. Lately I came across my piece on 'Photography' and was com-pletely amazed at noticing that I had compared historicism with photography already in this article of the 'twenties'" (pp. 3–4).

9 The German mythological hero, faithful protector, and counselor Eckart warns the Nibelungen at the border of the Rüdegers Mark of the threatening Hunn danger. Kra-cauer here plays on the association of Eckart and fidelity as manifest in Ludwig Tieck's 1799 fable "Tannenhäuser and the Faithful Eckart" and Goethe's 1811 text entitled "The Faithful Eckart."

10 Johann Peter Eckermann (1792–1854), Goethe's private secretary, in a discussion with Goethe on 18 April 1827, *Gespräche mit Goethe in den letzten Jahren seines Lebens* (Wies-baden, 1955), p. 578; trans. John Oxenford, under the title *Conversations of Goethe With Eckermann and Soret* (London, 1874), p. 248; trans. mod. Compare also Eckermann, *Con-versations With Goethe*, trans. Gisela C. O'Brien (New York, 1964).

11 Wilhelm Trübner (1851–1917), a German "naturalist" painter best known for his early, sober, Courbet-inspired "realistic" portraits. Following a period in the 1870s during which Trübner produced large historical and mythological scenes, he became a member of the Munich Secession in the 1890s and adopted an impressionist idiom in which he painted a large corpus of landscape works. For his views on photography, rendered in Bavarian dialect in the original German quotation, compare for example the sections on "Die photographische Darstellung" and "Die Grenzen zwischen produktiver und repro-ductiver Thätigkeit" in Wilhelm Trübner, *Die Verwirrung der Kunstbegriffe* (Frankfurt am Main, 1900), pp. 44–6.

12 Ludwig von Zumbusch (1861–1927) was a German painter of naive canvases, portraits, and pastel landscapes.

13 Ewald André Dupont, *Wie ein Film geschrieben wird und wie man ihn verwertet* (Berlin, 1919); quoted in Rudolf Harms, *Philosophie des Films: Seine ästhetischen und metaphysischen Grundlagen* (1926; Zurich, 1970), p. 142. Shortly after its publication Kracauer reviewed Harms's study. See *Frankfurter Zeitung*, 10 July 1927, p. 5.

14 Aristide Briand, foreign minister of France (1925–32), and Gustav Stresemann, foreign minister of Germany (1923–29), shared the 1926 Nobel Peace Prize and were instru-mental in gaining acceptance of the Kellogg-Briand Pact.

15 Johann Jakob Bachofen, "Oknos der Seilflechter," *Versuch über die Gräbersymbolik der Alten*, vol 4. of *Gesammelte Werke* (1923; Basel, 1954), p. 359; trans. Ralph Manheim, under the title "Ocnus the Rope Plaiter," *Myth, Religion, and Mother Right: Selected Writings of J. J. Bachofen* (Princeton, 1967), pp. 54–5; trans. mod.

16 Karl Marx and Frederick Engels, *The German Ideology*, ed. C. J. Arthur (New York, 1970), p. 51.

17 Georg Friedrich Creuzer, *Symbolik und Mythologie der alten Völker, besonders der Griechen*, 4 vols. (Leipzig, 1836–42).

André Bazin,
Translated by Hugh Gray

THE ONTOLOGY OF THE PHOTOGRAPHIC IMAGE

Before his untimely death in 1958 André Bazin began to review and select for publication his post-World War II writings on the cinema. Of the planned four volumes, one was published in 1958, and a second in 1959; the remainder await some competent selective hand. The first volume centers on the theme of the ontological basis of cinema or, as Bazin also puts it, "in less philosophical terms: the cinema as the art of reality." The second discusses the relations between the cinema and those arts with which it has things in common – the theater, the novel, and painting. A third volume was to have discussed the relations of cinema and society; the fourth would have dealt with neorealism. What follows is a translation of the first chapter of volume one. To those not yet familiar with the writings of a man who might be described with justice as the Sainte-Beuve of film criticism, it should serve to reveal the informed clarity and perceptiveness of his mind, shining through the inevitable awkwardnesses and compressions of writing under pressure as a journalist. It is difficult to estimate fully, as yet, the loss to the cinema of a man who was counsellor as well as critic.

IF THE PLASTIC ARTS WERE PUT UNDER PSYCHOANALYSIS, the practice of embalming the dead might turn out to be a fundamental factor in their creation. The process might reveal that at the origin of painting and sculpture there lies a mummy-complex. The religion of ancient Egypt, aimed against death, saw survival as depending on the continued existence of the corporeal body. Thus, by providing a defence against the passage of time it satisfied a basic psychological need in man, for death is but the victory of time. To preserve, artificially, his bodily appearance is to snatch it from the flow of time, to stow it away neatly, so to speak, in the hold of life. It was natural, therefore, to keep up appearances in the face of the reality of death by preserving flesh and bone. The first Egyptian statue, then, was a mummy, tanned and

petrified in sodium. But pyramids and labyrinthine corridors offered no certain guarantee against ultimate pillage.

Other forms of insurance were therefore sought. So, near the sarcophagus, alongside the corn that was to feed the dead, the Egyptians placed terra cotta statuettes, as substitute mummies which might replace the bodies if these were destroyed. It is this religious use, then, that lays bare the primordial function of statuary, namely, the preservation of life by a representation of life. Another manifestation of the same kind of thing is the arrow-pierced clay bear to be found in prehistoric caves, a magic identity-substitute for the living animal, that will ensure a successful hunt. The evolution, side by side, of art and civilization has relieved the plastic arts of their magic role. Louis XIV did not have himself embalmed. He was content to survive in his portrait by Lebrun. Civilization cannot, however, entirely cast out the bogy of time. It can only sublimate our concern with it to the level of rational thinking. No one believes any longer in the ontological identity of model and image, but all are agreed that the image helps us to remember the subject and to preserve him from a second spiritual death. Today the making of images no longer shares an anthropocentric, utilitarian purpose. It is no longer a question of survival after death, but of a larger concept, the creation of an ideal world in the likeness of the real, with its own temporal destiny. "How vain a thing is painting" if underneath our fond admiration for its works we do not discern man's primitive need to have the last word in the argument with death by means of the form that endures. If the history of the plastic arts is less a matter of their aesthetic than of their psychology then it will be seen to be essentially the story of resemblance, or, if you will, of realism.

Seen in this sociological perspective photography and cinema would provide a natural explanation for the great spiritual and technical crisis that overtook modern painting around the middle of the last century. André Malraux has described the cinema as the furthermost evolution to date of plastic realism, the beginnings of which were first manifest at the Renaissance and which found a limited expression in baroque painting.

It is true that painting, the world over, has struck a varied balance between the symbolic and realism. However, in the fifteenth century Western painting began to turn from its age-old concern with spiritual realities expressed in the form proper to it, towards an effort to combine this spiritual expression with as complete an imitation as possible of the outside world.

The decisive moment undoubtedly came with the discovery of the first scientific and already, in a sense, mechanical system of reproduction, namely, perspective: the camera obscura of Da Vinci foreshadowed the camera of Niepce. The artist was now in a position to create the illusion of three-dimensional space within which things appeared to exist as our eyes in reality see them.

Thenceforth painting was torn between two ambitions: one, primarily aesthetic, namely the expression of spiritual reality wherein the symbol transcended its model; the other, purely psychological, namely to duplicate the world outside. The satisfaction of this appetite for illusion merely served to increase it till, bit by bit, it consumed the plastic arts. However, since perspective had only solved the problem of form and not of movement, realism was forced to continue the search for some way of giving dramatic expression to the moment, a kind of psychic fourth dimension that could suggest life in the tortured immobility of baroque art.[1]

The great artists, of course, have always been able to combine the two tendencies. They have allotted to each its proper place in the hierarchy of things, holding reality at their command and melding it at will into the fabric of their art. Nevertheless, the fact remains that we are faced with two essentially different phenomena and these any objective critic must view separately if he is to understand the evolution of the pictorial. The need for illusion has not ceased to trouble the heart of painting since the sixteenth century. It is a purely mental need, of itself nonaesthetic, the origins of which must be sought in the proclivity of the mind towards magic. However, it is a need the pull of which has been strong enough to have seriously upset the equilibrium of the plastic arts.

The quarrel over realism in art stems from a misunderstanding, from a confusion between the aesthetic and the psychological; between true realism, the need that is to give significant expression to the world both concretely and in its essence, and the pseudorealism of a deception aimed at fooling the eye (or for that matter the mind); a pseudorealism content in other words with illusory appearances.[2] That is why medieval art never passed through this crisis; simultaneously vividly realistic and highly spiritual, it knew nothing of the drama that came to light as a consequence of technical developments. Perspective was the original sin of Western painting.

It was redeemed from sin by Niepce and Lumière. In achieving the aims of baroque art, photography has freed the plastic arts from their obsession with likeness. Painting was forced, as it turned out, to offer us illusion and this illusion was reckoned sufficient unto art. Photography and the cinema on the other hand are discoveries that satisfy, once and for all and in its very essence, our obsession with realism.

No matter how skilful the painter, his work was always in fee to an inescapable subjectivity. The fact that a human hand intervened cast a shadow of doubt over the image. Again, the essential factor in the transition from the baroque to photography is not the perfecting of a physical process (photography will long remain the inferior of painting in the reproduction of colour); rather does it lie in a psychological fact, to wit, in completely satisfying our appetite for illusion by a mechanical reproduction in the making of which man plays no part. The solution is not to be found in the result achieved but in the way of achieving it.[3]

This is why the conflict between style and likeness is a relatively modern phenomenon of which there is no trace before the invention of the sensitized plate. Clearly the fascinating objectivity of Chardin is in no sense that of the photographer. The nineteenth century saw the real beginnings of the crisis of realism of which Picasso is now the mythical central figure and which put to the test at one and the same time the conditions determining the formal existence of the plastic arts and their sociological roots. Freed from the "resemblance complex," the modern painter abandons it to the masses who, henceforth, identify resemblance on the one hand with photography and on the other with the kind of painting which is related to photography.

Originality in photography as distinct from originality in painting lies in the essentially objective character of photography. [Bazin here makes a point of the fact that the lens, the basis of photography, is in French called the "objectif," a nuance that is lost in English. — TR.] For the first time, between the originating object and its reproduction there intervenes only the instrumentality of a nonliving agent. For the first time an image of the world is formed automatically, without the creative intervention of man. The personality of the photographer enters into the proceedings only in his selection of the object to be photographed and by way of the purpose he has in mind. Although

the final result may reflect something of his personality, this does not play the same role as is played by that of the painter. All the arts are based on the presence of man, only photography derives an advantage from his absence. Photography affects us like a phenomenon in nature, like a flower or a snowflake whose vegetable or earthly origins are an inseparable part of their beauty.

This production by automatic means has radically affected our psychology of the image. The objective nature of photography confers on it a quality of credibility absent from all other picture-making. In spite of any objections our critical spirit may offer, we are forced to accept as real the existence of the object reproduced, actually *re*-presented, set before us, that is to say, in time and space. Photography enjoys a certain advantage in virtue of this transference of reality from the thing to its reproduction.[4]

A very faithful drawing may actually tell us more about the model but despite the promptings of our critical intelligence it will never have the irrational power of the photograph to bear away our faith.

Besides, painting is, after all, an inferior way of making likenesses, an *ersatz* of the processes of reproduction. Only a photographic lens can give us the kind of image of the object that is capable of satisfying the deep need man has to substitute for it something more than a mere approximation, a kind of decal or transfer. The photographic image is the object itself, the object freed from the conditions of time and space that govern it. No matter how fuzzy, distorted, or discoloured, no matter how lacking, in documentary value the image may be, it shares, by virtue of the very process of its becoming, the being of the model of which it is the reproduction; it *is* the model.

Hence the charm of family albums. Those grey or sepia shadows, phantomlike and almost undecipherable, are no longer traditional family portraits but rather the disturbing presence of lives halted at a set moment in their duration, freed from their destiny; not, however, by the prestige of art but by the power of an impassive mechanical process: for photography does not create eternity, as art does, it embalms time, rescuing it simply from its proper corruption.

Viewed in this perspective, the cinema is objectivity in time. The film is no longer content to preserve the object, enshrouded as it were in an instant, as the bodies of insects are preserved intact, out of the distant past, in amber. The film delivers baroque art from its convulsive catalepsy. Now, for the first time, the image of things is likewise the image of their duration, change mummified as it were. Those categories of *resemblance* which determine the species *photographic image* likewise, then, determine the character of its aesthetic as distinct from that of painting.[5]

The aesthetic qualities of photography are to be sought in its power to lay bare the realities. It is not for me to separate off, in the complex fabric of the objective world, here a reflexion on a damp sidewalk, there the gesture of a child. Only the impassive lens, stripping its object of all those ways of seeing it, those piled-up preconceptions, that spiritual dust and grime with which my eyes have covered it, are able to present it in all its virginal purity to my attention and consequently to my love. By the power of photography, the natural image of a world that we neither know nor can know, nature at last does more than imitate art: she imitates the artist.

Photography can even surpass art in creative power. The aesthetic world of the painter is of a different kind from that of the world about him. Its boundaries enclose a substantially and essentially different microcosm. The photograph as such and the object in itself share a common being, after the fashion of a fingerprint. Wherefore,

photography actually contributes something to the order of natural creation instead of providing a substitute for it. The surrealists had an inkling of this when they looked to the photographic plate to provide them with their monstrosities and for this reason. The surrealist does not consider his aesthetic purpose and the mechanical effect of the image on our imaginations as things apart. For him, the logical distinction between what is imaginary and what is real tends to disappear. Every image is to be seen as an object and every object as an image. Hence photography ranks high in the order of surrealist creativity because it produces an image that is a reality of nature, namely, an hallucination that is also a fact. The fact that surrealist painting combines tricks of visual deception with meticulous attention to detail substantiates this.

So, photography is clearly the most important event in the history of the plastic arts. Simultaneously a liberation and an accomplishment, it has freed Western painting, once and for all, from its obsession with realism and allowed it to recover its aesthetic autonomy. Impressionist realism, offering science as an alibi, is at the opposite extreme from eye-deceiving trickery. Only when form ceases to have any imitative value can it be swallowed up in colour. So, when form, in the person of Cézanne, once more regains possession of the canvas there is no longer any question of the illusions of the geometry of perspective. The painting, being confronted in the mechanically produced image with a competitor able to reach out beyond baroque resemblance to the very identity of the model, was compelled into the category of object. Henceforth Pascal's condemnation of painting is itself rendered vain since the photograph allows us on the one hand to admire in reproduction something that our eyes alone could not have taught us to love, and on the other, to admire the painting as a thing in itself whose relation to something in nature has ceased to be the justification for its existence.

On the other hand, of course, cinema is also a language.

New periodicals

Definition: Quarterly Journal of Film Criticism. 33 Electric Avenue, London S.W.9, England. 2s. 6d. A new journal edited by former students and staff members of the London School of Film Technique, aiming at a more responsible "new criticism" of films. The editors note that since Lindsay Anderson's famous article, "Stand Up! Stand Up!" in *Sight & Sound* three years ago, "the cry has been repeated, the thesis elaborated and the case restated with increasing showmanship; so that those who began as isolated prophets can now find reward in the satisfactions of preaching to the converted. But criticism has not noticeably changed."

The first issue contains "Towards a Theory," by Dai Vaughan, who points out that "*any* criticism assumes an aesthetic, even though this aesthetic may not be made conscious or explicit," and suggests certain basic lines for a committed aesthetic theory. Stuart Hall compares *Look Back in Anger* and *Room at the Top* in what is probably the best piece yet done on these films. Mr. Vaughan also contributes "Complacent Rebel" on Robert Flaherty, and the issue includes as well an interview with François Truffaut by Fernando Lopes, pieces on film schools by David Naden and Boleslaw Sulik, a curious pair of notes for and on films by John Irvin and "Two Lost Generations?" by Arnold Wesker. We hope that *Definition* survives the economic perils of a new independent magazine.

For Film is the publication of the rejuvenated American Federation of Film Societies, Box 2607, Grand Central Station, New York 17, N.Y. Founded in 1955, the AFFS is a nonprofit organization with the basic aim of assisting existing film societies and encouraging the formation of new ones. The first issue of *For Film*, which is the successor to the *AFFS Newsletter*, contains an editorial by Gideon Bachmann, new AFFS President, notes on films newly available for film societies, several book reviews, an interview with Rod Steiger and news notes of various kinds. To be published approximately four times a year; $1.00 a year.

Original publication

'The Ontology of the Photographic Image', in *Film Quarterly*, vol. 13, no. 4 (1960). [Originally published 1945]

Notes

1 It would be interesting, from this point of view, to study in the illustrated magazines of 1890–1910, the rivalry between photographic reporting and the use of drawings. The latter, in particular, satisfied the baroque need for the dramatic. A feeling for the photographic document developed only gradually.

2 Perhaps the Communists, before they attach too much importance to expressionist realism, should stop talking about it in a way more suitable to the eighteenth century, before there were such things as photography or cinema. Maybe it does not really matter if Russian painting is second-rate provided she gives us first-rate cinema. Eisenstein is her Tintoretto.

3 There is room, nevertheless, for a study of the psychology of the lesser plastic arts, the molding of death masks, for example, which likewise involves a certain automatic process. One might consider photography, in this sense as a molding, the taking of an impression, by the manipulation of light.

4 Here one should really examine the psychology of relics and souvenirs which likewise enjoy the advantages of a transfer of reality stemming from the "mummy-complex." Let us merely note in passing that the Holy Shroud of Turin combines the features alike of relic and photograph.

5 I use the term *category* here in the sense attached to it by M. Gouhier in his book on the theater in which he distinguishes between the dramatic and the aesthetic categories. Just as dramatic tension has no artistic value, the perfection of a reproduction is not to be identified with beauty. It constitutes rather the prime matter, so to speak, on which the artistic fact is recorded.

Susan Sontag

PHOTOGRAPHY WITHIN THE HUMANITIES[1]

I AM A WRITER AND A FILMMAKER. I don't consider myself a critic, and I am above all not a critic of photography. But it's from that strictly independent and freelance position that I am saying my say; it's not as a member of the photography establishment or photography anti-establishment, but as an educated outsider.

It has occurred to me, however, that because of my special status in relation to the other people whom you have invited to talk before me that I might be in a better position than some of them to comment on the subject of this series. Obviously, to say 'Photography within the Humanities' is to name two things which raise a whole series of problems. The question is: What is photography? Then there is the other big word with the little ones in between – Humanities, which makes us think of a very particular set of values that refers back to certain cultural and educational ideas, so that Humanities is a term that comes up in, above all, university curricula. But that is a kind of condensation or synthesis or anthology of the most valuable cultural experiences and ideas and works of the imagination or creation within, I say, *a* given culture. But just to catch up with it in its relatively modern form, it does have to do with a notion of curriculum.

Now if anyone would think to suggest as a title for a series of experiences or lectures or discussions, *Photography within the Humanities*, he's probably not mainly thinking of the humanities as being the subject under question but photography, because one of the first things to say about photography is that it is a relatively recent activity. Whether you consider it an art form or not, it is an activity over which people have debated (and) whose status has been under question. A lot of people in the early decades of photography tried to treat it as if it were simply some kind of copying machine, as an aid in reproducing or dispensing a certain kind of visual information, but not itself as an independent source of seeing or of material that would fundamentally change our visual sensibility, as, in fact, it has. And the history of taste and argument about photography has roughly consisted, to speak in broad terms, of the continuous upgrading of this activity.

One continues to have a great many debates, needless to say: 'Is photography an art or isn't it?' This very nourishing, if phony, debate has been going on for a century about

whether photography is an art or not. I say it's phony not because there are not some real questions, but because I think that the questions – at that level – are oversimplified and fundamentally opaque. But it has been, if it is a form of mystification, an immensely creative mystification. The literature about photography by professional photographers is incredibly defensive. It is both aggressive and defensive, two stances that usually go together. One can sense, under all these exalted claims that are being made for photography, a very interesting and fruitful pressure on the photographer which has been this problematic status of the very activity itself.

By asking about the situation of photography within the humanities, one is covertly raising that old query: Is photography an art? – is it really a serious activity or a serious art; does it really have a proper place in the university curriculum, as a department in museums; is it different from the other art forms? In another sense, it is as I suggested before, a phony debate, because there is no doubt the battle has been won.

The question is rather, if photography is an art and is socially or sociologically accepted, is it an art like any other? It isn't exactly an art, like painting, and perhaps that may explain something about its current influence. In some way I would suggest that photography is not so much an art as a meta-art. It's an art which devours other art. It is a creation, a creation in the form of some certain kind of visual image, but it also cannibalizes and very concretely reproduces other forms of art; there is a creation of images, images which would not exist if we did not have the camera. But there is also a sense in which photography takes the whole world as its subject, cannibalizes all art forms, and converts them into images. And in that sense it seems a peculiarly modern art. It may be the art that is most appropriate to the fundamental terms and concerns of an industrial consumer society. It has the capacity to turn every experience, every event, every reality into a commodity or an object or image. One of the fundamental axes of modern thought is this contrast between image and reality. It doesn't seem wrong to say that our society is rooted or centered in a certain proliferation of images in a way that no other society has been.

To return to the point of departure, if photography has a place within the humanities, it might very well have a kind of central place, because it is not only a form of art under certain restrictions, but it also has a place where all kinds of sociological and moral and historical questions can be raised.

My purpose is not to evaluate the work of particular photographers, but rather to discuss the problems raised by the presence of photography, and these include moral issues as well as aesthetic issues. I think it's a perfectly good idea to study photography. I'm not talking about studying making photographs, but studying looking at them, and learning how to see, because the way in which you learn to see is a general education of sight, and its results can be extended to other ways of seeing. Another point should be made that there is such a thing as photographic seeing. If you think of people actually going out and looking for photographs as a kind of freelance artistic activity, what people have more and more learned to value is something they get in the camera that they don't get ordinarily, that they can see by means of the camera, and so they are changing their own way of seeing, in the very process of becoming habitual camera users. The world becomes a series of events that you transform into pictures, and those events have reality, so far as you have the pictures of them.

Most people in this society have the idea that to take a picture is to say, among other things: 'this is worth photographing.' And to appraise an event as valuable or

interesting or beautiful is to wish to have a photograph of it. It has gotten built into our very way of perceiving things, that we have a fundamentally appropriative relationship to reality. We think that the properly flattering contact with anything is to want to photograph it. And the camera has indeed become part of our sensibility. So when Christopher Isherwood said, 'I am a Camera,' what he really meant was 'I see. I see. I perceive. I am storing this up.'

One of the reasons I don't take pictures is that there are a lot of other people taking them and that's for the moment enough for me; and I feel I already do see photographically. Perhaps I see too much photographically and don't wish to indulge this way of seeing any further. It is a very particular specialization of one's sensibility.

How did you first become involved with photography from the critical point of view?

I've always been a photograph junkie. That is, I've always been very interested in photographs – I cut them out of magazines and collect, not originals, but copies, reproductions of photographs. The only difference is that recently I decided to write about some of the ideas that I've had over the last twenty years. So I embarked on what I thought would be one essay and has turned out to be six. But I'm not, as I told the people who invited me to Wellesley, a photographer; I do not take photographs; I don't like to take photographs; I don't own a camera; and I'm not a photography critic. But my writing about photography represents the expression, and in a certain sense, the liquidation of a very long-term interest. It's precisely because I've been thinking about this for twenty years that I think I can write about it now. Somebody asked me what I thought I was going to do by writing these essays, and I said I'm going to cure myself of my addiction. That hasn't happened, however.

In your opinion, is the normal everyday photographer any more aggressive, cannibalistic towards the world around him or her than a normal, everyday prose writer?

There are an unlimited number of photographs to take, every photographer feels that. There are not an unlimited number of things to write, except in a very cerebral sense, which no writer really feels. Every writer has to reach and is constantly aware of how basically it comes from inside; it all has to be transformed in the homemade laboratory that you have got in your guts and your brain. Whereas, for the photographer, the world is really there; it is an incredible thing, it is all interesting and in fact, more interesting when seen through the camera than when seen with the naked eye or with real sight. The camera is this thing which can capture the world for you. It is not like a gun; it is not like doing people in, but it is a way of bringing something back. It enables you to transform the world, to miniaturize it. And photographs have a special status for us as icons and as magical objects that other visual images such as paintings and other forms of representational art such as literature do not have. I do not think that any other way of creating image systems has the same kind of obsessional power behind it.

Of course, the word 'cannibalize' is loaded and provocative and is perhaps overly strong, but I do not consider it to be a key part of my argument. My primary point is not to speculate about what picture taking does to people, but to consider the impact of looking at photographs and having this kind of information or experience of the picture. It is the consumption of photographs rather than the taking of them which concerns me and why pictures have become a regular nutriment of our sensibility and a source of information.

I think there are moral issues that are worth talking about, and one shouldn't be afraid of them. I get kind of sad when I realize that what people seem to want is to be told whether photography is okay or not. I mean it's part of the world. Let me give you an example. I'm probably being very indiscreet, but I don't think he would mind – I had a call the other day from Richard Avedon, whom I had gotten to know as a result of these essays for the *New York Review of Books*. In fact, I didn't know him before. I don't think I would have written about photography if I had known any photographers. Any-way, we had become friends and we had a lot of discussion about the ideas of the essays, some of which he agreed with and some of which he didn't. He said, 'I want to know your opinion.' He had spent seven weeks in Saigon in the early seventies and he took a great many photographs of the napalm victims, victims of American bombings of the Vietnamese. He did this on his own, with his own money. He was not sent by anybody. He set up a studio in a hotel in Saigon and among other things he photographed dozens and dozens of people without faces, without hands, bodies covered with scar tissue. He was asked by a major and very commercial magazine a couple of days ago to print these photographs. He's never printed them. He's never published them. He called me up and said, 'What do you think? I don't know what to do. It seems to me a terrible thing to do, and it also seems to me a good thing to do. I mean, I just don't know.' We talked for an hour about it. Was it an exploitation of these people? Are these photo-graphs aesthetic? He had only shown me one, and I haven't seen all of them. He said the photographs were beautiful. In some ways, they're beautiful and in others they are absolutely horrifying. He said, 'I don't know what to do,' and I said, 'I don't know what you should do either; after calling me up to ask my opinion I think I'm just as puzzled as you are. I can think of very good arguments for not doing it, and I can think of very good arguments for doing it.'

This is a tremendous, messy, moral problem. It doesn't start with that phone call either; it starts all the way back when one does it. If you don't publish them, you'll have some regrets; if you do publish them, you'll have some regrets. He agreed. I haven't heard the news, so I do feel a little indiscreet about telling you the story, but it's not a real secret and you may very well see these photographs in the next few weeks. But the problems are real. The complexity is real. He's very objective about his work, and he's very smart. He said they looked like Avedon pictures, and yet they are of those people. He said he was crying when he took the photographs, and yet they looked like Avedon photographs, very straight-on, white background. He said, now I don't know what to do with them. I wonder if I should have taken them, and yet I know if I had to do it all over again I would still have taken them. It's very interesting; it put his whole activity into question. I do think that people understand this. I don't think I invented these problems, and I think that a lot of photographers are aware of them. These are the real moral and aesthetic questions that are raised by this enterprise.

Do you wish that photography wasn't as ubiquitous as it is? Do you resent that kind of intrusion into your consciousness that you described as happening at age twelve when you first saw photographs of Dachau?[2]

Well, it changed my life. But I don't know that I would say I resent it. A lot of people have seen photographs that have, whether they know it or not, changed their consciousness. It's not a question of my reaction personally; it's a question of naming it – naming this phenomenon which is very formative for us . . . this shock experience. . . . It's not that I want to say that you can't be shocked by anything but a photograph, but here is this object, this image, which you can stumble or come upon inadvertently by opening the pages of a magazine. It's not like a painting; you know where the paintings are – they're in museums and galleries and if you want to go that's a special experience; you go to it, so to speak. But photographs come to you because they're all over the place.

The nature of the imagery, in which the imagery is very shocking and painful, is certainly more common now, steadily more common than it was. There was a photograph, you must have seen it, it was on the cover of both *Newsweek* and *Time* magazines a few weeks ago, of a Vietnamese mother holding a child that was wounded probably, or dying, or was already dead in her arms, facing the camera. Now this is a photograph which you would not have seen on the cover of any news magazine several years ago. I am not saying that people were not shocked by the photograph; I am sure some people cancelled their subscriptions to those magazines. But that kind of image would not have been acceptable, would have been thought too shocking by the editors of those magazines a few years ago. I think there is a process of becoming inured. I do not know if people become that much more tolerant of the real thing because the imagery becomes that much more acceptable, but inevitably there is a process of dissociation. So that often when people for the first time are confronted in reality with anything like the level of cruelty in the images they have seen, what they think is, 'It's like the photograph' or 'It's like the movie.' They refer back to the images in order to have a direct experience of the reality because they have been prepared, in some very dissociated way, by the images and not by real experience. If you see a lot of images like that, the ante is being raised; the image has to be even more shocking to be really upsetting.

In a way you are not present, you are passive when you look at the photograph. Perhaps that is the disturbing thing. If you are standing watching an operation, next to the operating table, you can change your focus, you can still look different ways, you can change your attention – make the close-ups and the long shots for yourself. There are also the surgeons and the nurses, but you are there. You are not there in a picture, and that is where some of the anxiety comes in; there is nothing you can do when you look at a photograph.

Photographs give us information; it seems that they give us information that is very packaged and they give us the information that we are already prepared to recognize obviously. It's as if the words don't have the weight they should have, so that one of the statements being made by any photograph is: 'This really exists.' The photograph is a kind of job for the imagination to do something that we should have been able to do if we were not so disturbed by so many different kinds of information that are not really absorbed. Photographs have this authority of being testimony, but almost as if you have

some direct contact with the thing, or as if the photograph is a piece of the thing; even though it's an image, it really is the thing.

Do you feel that photography has promoted a new kind of seeing?

Oscar Wilde said that the way you see is largely determined by art, in the larger sense. Though people have always seen, now there is a process of framing or selection which is guided by the kinds of things that we see reproduced. Photography is an art form which is basically and fundamentally connected with technology and a technology whose virtues are its simplicity and its rapidity.

Cartier-Bresson has recently said that he wants to stop photographing. He has always painted a little bit, but now he wants to devote himself completely to painting, and the reason he gave is that photography promotes 'fast seeing,' and, having spent a lifetime seeing fast, he now wants to slow down. So he'd rather paint. The existence of the camera does promote habits of seeing which are rapid, and part of their value is how much you can get out of this rapid seeing.

Technologically, the whole history of the development of cameras has been to shorten the exposure time. Beginning a few decades ago, you got virtually instantaneous development. That means there is an increasing enlargement of the scope of the photographic project. Thus, anything can be caught by the camera, and the whole world is material to be photographed. There's no doubt that the reigning taste is for the photograph that makes the thing interesting. It isn't interesting in itself, it's interesting because it's in a photograph. One of the many tendencies is to reduce the subject matter or have a kind of throw-away subject matter in photography. There's nothing that wouldn't make a good picture. I don't think that presumption exists in the history of the other arts or – if it does – it is only recently, and partly because photography has become a model for our consciousness. When you have seen something extraordinary it goes with the telling afterwards that you want to have the photographic record of it; the notion of an event or situation or person being privileged and you're taking a camera to record it are intertwined for us.

I was in China a year and a half ago and wherever I went, the Chinese said to me, 'Where is your camera?' I was apparently the first person to ever come to China in the past few years (since foreigners have started going again) who hadn't gone with a camera. They understood, of course, that to get to go to China was a big thing for us foreigners and that what those foreigners did when they came to an event that was particularly interesting was to take a picture of it. I was very interested to see what people do with cameras in China, because it is the one country in the world where there is a conscious effort on the part of the Chinese leadership not to be a consumer society. Wherever I went in China, everybody had photographs of relatives: in wallets, on the glass under desks in offices, on the side of the lathe or the machine in factories. And they'd say, 'That's my aunt so-and-so, or my cousin so-and-so; he lives a thousand miles away, and I haven't seen him in two years; those are my children, those are my parents.' Or you'd see, less often, photographs of famous holy places or important monuments. Those are the only photographs you see. When a foreigner comes to China and takes a picture of an appealing door, the Chinese say, 'What would you want to take a picture

of that for?' And the person says, 'Well, it's beautiful.' 'That door is beautiful? It needs a coat of paint.' And you say, 'No, it's beautiful.' The Chinese do not have that idea that objects can disclose some kind of aesthetic value simply when they are reproduced, or that particularly casual, vernacular, off-hand, deteriorated, throw-away objects have a kind of poetry that a camera can reveal.

The point that I make in a number of the essays is that there is a kind of surrealist sensibility in photography which is very important, i.e., the casual ordinary thing is able to reveal its beauties when photographed. There is a whole tradition in photography, and I do not mean necessarily the so-called surrealist photographers, but precisely the people who are doing very straight-on stuff, like Weston photographing toilets and artichokes. One of the great traditions in photography is taking the neglected, homely object, the corner of something, the interesting surface, preferably a bit deteriorated or decayed with some kind of strange pattern on it. That is a way of seeing which is very much promoted by photography and has influenced people's way of seeing – whether they use cameras or not.

Is there a difference in impact between still photographs and film?

The photographs change, depending on the context in which they are seen. One could say there is something exploitative; they become items, visual commodities to be flipped through as you move on to something else. It is perhaps a way of denigrating the subject. For example, I have seen those Minamata photographs, that are downstairs, many times. I have seen them in books and all kinds of magazines, and now I am seeing them in a college art museum; each time they have looked different to me. And they are different. Photographs are these portable objects which are changed by their context. You could say, of course, that that is also true of films. To some extent, under what circumstances you see a film does change it, but the photograph is more changed by its context, especially the still photograph, because it is such a compact and portable object. This is why I tend to favor films over photographs on this question; the film establishes a proper context for the use of those images, and perhaps still photographs, in fact, are more vulnerable. I certainly think in some way a still image is and always will be more memorable. You can really remember a photograph and you can really describe it, in a way that you cannot describe two or three minutes of film.

What kinds of photographs do you find pleasing or good?

I do not know what it really means to talk about one's favorite or preferred photographs. It is funny, I learned something about my taste this afternoon that I had not seen; the people who organized this set of events asked for us to suggest ten photographs to be put in the exhibit downstairs in the museum. I sent in a list of nine photographs that meant something to me, that I had meditated about. One of the nine pictures could not be obtained, so another photograph by the same photographer was substituted. That photograph stuck out so much for me as not belonging with the

others. It seemed quite clear to me that it had a different aesthetic — that anyone who had eyes could have seen that I would not have chosen that photograph, though I could have and did choose the other eight. I chose a very straight, tough, hard edged portrait photograph by Brassaï called 'Rome-Naples Express.' For some reason they could not get it and put this soft-focus, sentimental, touristy Brassaï photograph of a Paris book-stall on the Seine. Seeing the eight I had chosen I realized that they — in contrast with the one I had not — had something in common, even aesthetically. They all had a hard edge quality and a very high definition. All of them are upsetting, for one thing. It is funny since I have never tried to understand what makes me like one photograph over another.

Original publication

Photography Within the Humanities (1975).

Notes

1 A speech delivered at a Wellesley College photographic symposium on April 21, 1975.
2 Susan Sontag, 'On Photography,' *New York Review of Books*, October 18, 1973.

Wright Morris

IN OUR IMAGE

L ET US IMAGINE A TOURIST FROM ROME, on a conducted tour of the provinces, who takes snapshots of the swarming unruly mob at Golgotha, where two thieves and a rabble rouser are nailed to crosses. The air is choked with dust and the smoke of campfires. Flames glint on the helmets and spears of the soldiers. The effect is dramatic, one that a photographer would hate to miss. The light is bad, the foreground is blurred, and too much is made of the tilted crosses, but time has been arrested, and an image recorded, that might have diverted the fiction of history. What we all want is a piece of the cross, if there was such a cross. However faded and disfigured, this moment of arrested time authenticates, for us, time's existence. Not the ruin of time, nor the crowded tombs of time, but the eternal present in time's every moment. From this continuous film of time the camera snips the living tissue. So that's how it was. Along with the distortions, the illusions, the lies, a specimen of the truth.

That picture was not taken, nor do we have one of the flood, or the crowded ark, or of Adam and Eve leaving the garden of Eden, or of the Tower of Babel, or the beauty of Helen, or the fall of Troy, or the sacking of Rome, or the landscape strewn with the debris of history – but this loss may not be felt by the modern film buff who might prefer what he sees at the movies. Primates, at the dawn of man, huddle in darkness and terror at the mouth of a cave: robots, dramatizing the future, war in space. We see the surface of Mars, we see the moon, we see planet earth rising on its horizon. Will this image expand the consciousness of man or take its place among the ornaments seen on T-shirts or the luncheon menus collected by tourists? Within the smallest particle of traceable matter there is a space, metaphorically speaking, comparable to the observable universe. Failing to see it, failing to grasp it, do we wait for it to be photographed?

There is a history of darkness in the making of images. At Peche Merle and Altamira, in the recesses of caves, the torchlit chapels of worship and magic, images of matchless power were painted on the walls and ceilings. These caves were archival museums. Man's faculty for image-making matched his need for images. What had been seen in the open, or from the cave's mouth, was transferred to the interior, the lens

in the eye of man capturing this first likeness. The tool-maker, the weapon-maker, the sign-maker, is also an image-maker. In the fullness of time man and images proliferate. Among them there is one God, Jehovah, who looks upon this with apprehension. He states his position plainly.

> Thou shalt not make unto thee any
> graven image, or any likeness of
> any thing that is in heaven above,
> or that is in the earth beneath, or
> that is in the water under the earth:
> . . . for I the Lord thy God am a jealous
> God. . . .

Did Jehovah know something the others didn't, or would rather not know? Did he perceive that images, in their kind and number, would exceed any likeness of anything seen, and in their increasing proliferation displace the thing seen with the image, and that one day, like the Lord himself, we would see the planet earth orbiting in space, an image, like that at Golgotha, that would measurably change the course of history, and the nature of man.

Some twenty years ago, in San Miguel Allende, Mexico, I was standing on a corner of the plaza as a procession entered from a side street. It moved slowly, to the sombre beat of drums. The women in black, their heads bowed, the men in white, hatless, their swarthy peasant faces masks of sorrow. At their head a priest carried the crucified figure of Christ. I was moved, awed, and exhilarated to be there. For this, surely, I had come to Mexico, where the essential rituals of life had their ceremony. This was, of course, not the first procession, but one that continued and sustained the tradition. I stood respectfully silent as it moved around the square, in the direction of the church. Here and there an impoverished Indian, clutching a baby, looked on. The pathetic masquerade of a funeral I had observed in the States passed through my mind. Although a photographer, I took no photographs. At the sombre beat of the drums the procession approached the farther corner, where, in the shadow of a building, a truck had parked, the platform crowded with a film crew and whirring cameras. The director, wearing a beret, shouted at the mourners through a megaphone. This was a funeral, not a fiesta, did they understand? They would now do it over, and show a little feeling. He wrung his hands, he creased his brows. He blew a whistle, and the columns broke up as if unravelled. They were herded back across the square to the street where they had entered. One of the mourners, nursing a child, paused to ask me for a handout. It is her face I see through a blur of confusing emotions. In my role as a gullible tourist, I had been the true witness of a false event. Such circumstances are now commonplace. If I had been standing in another position or had gone off about my business, I might still cherish this impression of man's eternal sorrow. How are we to distinguish between the real and the imitation? Few things observed from one point of view only can be considered *seen*. The multifaceted aspect of reality has been a commonplace since cubism, but we continue to see what we will, rather than what is there. Image-making is our preference for what we imagine, to what is then to be seen.

With the camera's inception an *imitation of life* never before achieved was possible. More revolutionary than the fact itself, it might be practiced by anybody. Intricately

part of the dawning age of technology, the photographic likeness gratified the viewer in a manner that lay too deep for words. Words, indeed, appeared to be superfluous. Man, the image-maker, had contrived a machine for making images. The enthusiasm to take pictures was surpassed by the desire to be taken. These first portraits were daguerreotypes, and the time required to record the impression on a copper plate profoundly enhanced the likeness. Frontally challenged, momentarily 'frozen,' the details rendered with matchless refinement, these sitters speak to us with the power and dignity of icons. The eccentrically personal is suppressed. A minimum of animation, the absence of smiles and expressive glances, enhances the aura of suspended time appropriate to a timeless image. There is no common or trivial portrait in this vast gallery. Nothing known to man spoke so eloquently of the equality of men and women. Nor has anything replaced it. With a strikingly exceptional man the results are awesome, as we see in the portraits of Lincoln: the exceptional, as well as the common, suited the heroic mould of these portraits. Fixed on copper, protected by a sheet of glass, the miraculous daguerreotype was a unique, one-of-a-kind creation. No reproductions or copies were possible. To make a duplicate one had to repeat the sitting.

Although perfect of its kind, and never surpassed in its rendering of detail, once the viewer's infatuation had cooled, the single, unique image aroused his frustration. Uniqueness, in the mid-nineteenth century, was commonplace. The spirit of the age, and Yankee ingenuity, looked forward to inexpensive reproductions. The duplicate had about it the charm we now associate with the original. In the decade the daguerreotype achieved its limited perfection, its uniqueness rendered it obsolete, just as more than a century later this singularity would enhance its value on the market.

After predictable advances in all areas of photographic reproduction, it is possible that daguerreotype uniqueness might return to photographic practice and evaluation. This counter-production aesthetic has its rise in the dilemma of overproduction. Millions of photographers, their number increasing hourly, take billions of pictures. This fact alone enhances rarity. Is it beyond the realm of speculation that single prints will soon be made from a negative that has been destroyed?

Considering the fervour of our adoption it is puzzling that some ingenious Yankee was not the inventor of the camera. It profoundly gratifies our love for super gadgets, and our instinct for facts. This very American preoccupation had first been articulated by Thoreau:

> If you stand right fronting and face to face to a fact, you will see the sun glimmer on both its surfaces, as if it were a cimiter, and feel its sweet edge dividing you through the heart and marrow, and so you will happily conclude your mortal career. Be it life or death, we crave only reality.

This might serve many photographers as a credo. At the midpoint of the nineteenth century a new world lay open to be seen, inventoried, and documented. It has the freshness of creation upon it, and a new language to describe it. Whitman has the photographer's eye, but no camera:

> Wild cataract of hair; absurd, bunged-up felt hat, with peaked crown; velvet coat, all friggled over with gimp, but worn; eyes rather staring, look upward. Third rate artist.

Or the commonplace, symbolic object:

> Weapon shapely, naked, wan,
> Head from the mother's bowels drawn

Soon enough the camera will fix this image, but its source is in the eye of the image-maker. Matthew Brady and staff are about to photograph the Civil War. In the light of the camera's brief history, does this not seem a bizarre subject? Or did they intuit, on a moment's reflection, that war is the camera's ultimate challenge? These photographers, without precedent or example, turned from the hermetic studio, with its props, to face the facts of war, the sun glimmering on all of its surfaces. Life or death, what they craved was reality.

A few decades later Stephen Crane stands face to face to a war of his imagination:

> He was being looked at by a dead man who was seated with his back against a columnlike tree. The corpse was dressed in a uniform that once had been blue, but was now shaded to a melancholy shade of green. The eyes, staring at the youth, had changed to the dull hue to be seen on the side of a dead fish. The mouth was open. Its red had changed to an appalling yellow. Over the gray skin of the face ran little ants. One was trundling some sort of bundle along the upper lip.

Crane had never seen war, at the time of writing, and relied heavily on the photographs of Brady and Gardner for his impressions. A decade after Crane this taste for what is real will flower in a new generation of writers. The relatively cold war of the depression of the 1930s will arouse the passions of the photographers of the Farm Security Administration, Evans, Lee, Lange, Vachon, Rothstein, Russell, and others. They wanted the facts. Few facts are as photographic as those of blight. A surfeit of such facts predictably restored a taste for the bizarre, the fanciful, the fabled world of fashion, of advertising, of self-expression, and of the photo as an *image*.

Does the word image flatter or diminish the photographs of Brady, Sullivan, Atget, and Evans? Would it please Bresson to know that he had made an 'image' of Spanish children playing in the ruins of war? Or the photographers unknown, numbering in the thousands, whose photographs reveal the ghosts of birds of passage, as well as singular glimpses of lost time captured? Does the word image depreciate or enhance the viewer's involvement with these photographs? In the act of refining, does it also impair? In presuming to be more than what it is, does the photograph risk being less? In the photographer's aspiration to be an 'artist' does he enlarge his own image at the expense of the photograph?

What does it profit the photograph to be accepted as a work of art? Does this dubious elevation in market value enhance or diminish what is intrinsically photographic? There is little that is new in this practice but much that is alien to photography. The photographer, not the photograph, becomes the collectible.

The practice of 'reading' a photograph, rather than merely looking at it, is part of its rise in status. This may have had its origin in the close scrutiny and analysis of aerial photographs during the war, soon followed by those from space. Close readings of this sort result in quantities of disinterested information. The photograph lends itself to

this refined 'screening,' and the screening is a form of evaluation. In this wise the 'reading' of a photograph may be the first step in its critical appropriation.

A recent 'reading' of Walker Evans 'attempted to disclose a range of possible and probable meanings.' As these meanings accumulate, verbal images compete with the visual – the photograph itself becomes a point of referral. If not on the page, we have them in mind. 'The Rhetorical Structure of Robert Frank's Iconography' is the title of a recent paper. To students of literature, if not to Robert Frank, this will sound familiar. The ever expanding industry of critical dissertations has already put its interest in literature behind it, and now largely feeds on criticism. Writers and readers of novels find these researches unrewarding. Fifty years ago Laura Riding observed, 'There results what has come to be called Criticism. . . . More and more the poet has been made to conform to literature instead of literature to the poet – literature being the name given by criticism to works inspired or obedient to criticism.'

Is this looming in photography's future? Although not deliberate in intent, the apparatus of criticism ends in displacing what it criticizes. The criticism of Pauline Kael appropriates the film to her own impressions. The film exists to generate those impressions. In order to consolidate and inform critical practice, agreement must be reached, among the critics, as to what merits critical study and discussion. These figures will provide the icons for the emerging pantheon of photography. Admirable as this must be for the critic, it imposes a misleading order and coherence on the creative disorder of image-making. Is it merely ironic that the rise of photography to the status of art comes at a time the status of art is in question? Is it too late to ask what photographs have to gain from this distinction? On those occasions they stir and enlarge our emotions, arousing us in a manner that exceeds our grasp, it is as photographs. Do we register a gain, or a loss, when the photographer displaces the photograph, the shock of recognition giving way to the exercise of taste?

In the anonymous photograph, the loss of the photographer often proves to be a gain. We see only the photograph. The existence of the visible world is affirmed, and that affirmation is sufficient. Refinement and emotion may prove to be present, mysteriously enhanced by the photographer's absence. We sense that it lies within the province of photography to make both a personal and an impersonal statement. Atget is impersonal. Bellocq is both personal and impersonal.

In photography we can speak of the anonymous as a genre. It is the camera that takes the picture; the photographer is a collaborator. What we sense to be wondrous, on occasion awesome, as if in the presence of the supernatural, is the impression we have of seeing what we have turned our backs on. As much as we crave the personal, and insist upon it, it is the impersonal that moves us. It is the camera that glimpses life as the Creator might have seen it. We turn away as we do from life itself to relieve our sense of inadequacy, of impotence. To those images made in our own likeness we turn with relief.

Photographs of time past, of lost time recovered, speak the most poignantly if the photographer is missing. The blurred figures characteristic of long time exposures is appropriate. How better to visualize time in passage? Are these partially visible phantoms about to materialize, or dissolve? They enhance, for us, the transient role of humans among relatively stable objects. The cyclist crossing the square, the woman under the parasol, the pet straining at the leash, are gone to wherever they were off to. On these ghostly shades the photograph confers a brief immortality. On the horse in the snow, his breath smoking, a brief respite from death.

These photographs clarify, beyond argument or apology, what is uniquely and intrinsically photographic. The visible captured. Time arrested. Through a slit in time's veil we see what has vanished. An unearthly, mind-boggling sensation: commonplace yet fabulous. The photograph is paramount. The photographer subordinate.

As a maker of images I am hardly the one to depreciate or reject them, but where distinctions can be made between images and photographs we should make them. Those that combine the impersonality of the camera eye with the invisible presence of the camera holder will mingle the best of irreconcilable elements.

The first photographs were so miraculous no one questioned their specific nature. With an assist from man, Nature created pictures. With the passage of time, however, man predictably intruded on Nature's handiwork. Some saw themselves as artists, others as 'truth seekers.' Others saw the truth not in what they sought, but in what they found. Provoked by what they saw, determined to capture what they had found, numberless photographers followed the frontier westward, or pushed on ahead of it. The promise and blight of the cities, the sea-like sweep and appalling emptiness of the plains, the life and death trips in Wisconsin and elsewhere, cried to be taken, pleaded to be reaffirmed in the teeth of the photographer's disbelief. Only when he saw the image emerge in the darkness would he believe what he had seen. What is there in the flesh, in the palpable fact, in the visibly ineluctable, is more than enough. Of all those who find more than they seek the photographer is preeminent.

In his diaries Weston speaks of wanting 'the greater mystery of things revealed more clearly than the eyes see —' but that is what the observer must do for himself, no matter at what he looks. What is there to be seen will prove to be inexhaustible.

Compare the photographs of Charles van Schaik, in Michael Lesy's *Wisconsin Death Trip*, with the pictures in *Camera Work* taken at the same time. What is intrinsic to the photograph we recognize, on sight, in van Schaik's bountiful archive. What is intrinsic to the artist we recognize in Stieglitz and his followers. In seventy years this gap has not been bridged. At this moment in photography's brief history, the emergence and inflation of the photographer appears to be at the expense of the photograph, of the miraculous.

If there is a common photographic dilemma, it lies in the fact that so much has been seen, so much has been 'taken,' there appears to be less to find. The visible world, vast as it is, through overexposure has been devalued. The planet looks better from space than in a close-up. The photographer feels he must search for, or invent, what was once obvious. This may take the form of photographs free of all pictorial associations. This neutralizing of the visible has the effect of rendering it invisible. In these examples photographic revelation has come full circle, the photograph exposing a reality we no longer see.

The photographer's vision, John Szarkowski reminds us, is convincing to the degree that the photographer hides his hand. How do we reconcile this insight with the photo-artist who is intent on maximum self-revelation? Stieglitz took many portraits of Georgia O'Keefe, a handsome unadorned fact of nature. In these portraits we see her as a composition, a Stieglitz arrangement. Only the photographer, not the camera, could make something synthetic out of this subject. Another Stieglitz photograph, captioned 'Spiritual America,' shows the rear quarter of a horse, with harness. Is this a photograph of the horse, or of the photographer?

There will be no end of making pictures, some with hands concealed, some with hands revealed, and some without hands, but we should make the distinction, while it

is still clear, between photographs that mirror the subject, and images that reveal the photographer. One is intrinsically photographic, the other is not.

Although the photograph inspired the emergence and triumph of the abstraction, freeing the imagination of the artist from the tyranny of appearances, it is now replacing the abstraction as the mirror in which we seek our multiple selves. A surfeit of abstractions, although a tonic and revelation for most of this century, has resulted in a weariness of artifice that the photograph seems designed to remedy. What else so instantly confirms that the world exists? Yet a plethora of such affirmations gives rise to the old dissatisfaction. One face is the world, but a world of faces is a muddle. We are increasingly bombarded by a Babel of conflicting images. How long will it be before the human face recovers the aura, the lustre, and the mystery it had before TV commercials – the smiling face a debased counterfeit.

Renewed interest in the snapshot, however nondescript, indicates our awareness that the camera, in itself, is a picture-maker. The numberless snapshots in existence, and the millions still to be taken, will hardly emerge as art objects, but it can be safely predicted that many will prove to be 'collectibles.' Much of what appears absurd in contemporary art reflects this rejection of romantic and aesthetic icons. The deployment of rocks, movements of earth, collections of waste, debris, and junk, Christo's curtains and earthbound fences, call attention to the spectacle of nature, the existence of the world, more than they do the artist. This is an oversight, needless to say, the dealer and collector are quick to correct. Among the photographs we recognize as masterly many are anonymous. Has this been overlooked because it is so obvious?

If an automatic camera is mounted at a window, or the intersection of streets, idle or busy, or in a garden where plants are growing, or in the open where time passes, shadows shorten and lengthen, weather changes, it will occasionally take exceptional pictures. In these images the photographer is not merely concealed, he is eliminated. Numberless such photos are now commonplace. They are taken of planet earth, from space, of the surface of the moon, and of Mars, of the aisles of stores and supermarkets, and of much we are accustomed to think of as private. The selective process occurs later, when the photographs are sorted for specific uses. The impression recorded by the lens is as random as life. The sensibility traditionally brought to 'pictures,' rooted in various concepts of 'appreciation,' is alien to the impartial, impersonal photo image. It differs from the crafted art object as a random glance out the window differs from a painted landscape. But certain sensibilities, from the beginning, have appreciated this random glance.

The poet, Rilke, snapped this:

> In the street below there is the following composition: a small wheelbarrow, pushed by a woman; on the front of it, a hand-organ, lengthwise. Behind that, crossways, a baby-basket in which a very small child is standing on firm legs, happy in its bonnet, refusing to be made to sit. From time to time the woman turns the handle of the organ. At that the small child stands up again, stamping in its basket, and a little girl in a green Sunday dress dances and beats a tambourine up toward the windows.

This 'image' is remarkably photogenic. Indeed, it calls to mind one taken by Atget. The poet is at pains to frame and snap the picture, to capture the look of life. His

description is something more than a picture, however, since the words reveal the presence of the writer, his 'sensibility.' This very sensitivity might have deterred him from taking the snapshot with a camera. Describe it he could. But he might have been reluctant to take it. In his description he could filter out the details he did not want to expose. From its inception the camera has been destined to eliminate *privacy*, as we are accustomed to conceive it. Today the word describes what is held in readiness for exposure. It is assumed that privacy implies something concealed.

The possibility of filming a life, from cradle to the grave, is now feasible. We already have such records of laboratory animals. If this film were to be run in reverse have we not, in our fashion, triumphed over time? We see the creature at the moment of death, gradually growing younger before our eyes. I am puzzled that some intrepid avant garde film creator has not already treated us to a sampling, say the death to birth of some short-lived creature. We have all shared this illusion in the phenomenon of 'the instant replay.' What had slipped by is retrieved, even in the manner of its slipping. Life lived in reverse. Film has made it possible. The moving picture, we know, is a crick that is played on our limited responses, and the refinement of the apparatus will continue to outdistance our faculties. Perhaps no faculty is more easily duped than that of sight. Seeing is believing. Believing transforms what we see.

If we were to choose a photographer to have been at Golgotha, or walking the streets of Rome during the sacking, who would it be? Numerous photographers have been trained to get the picture, and many leave their mark on the picture they get. For that moment of history, or any other, I would personally prefer that the photograph was stamped *Photographer Unknown*. This would assure me, rightly or wrongly, that I was seeing a fragment of life, a moment of time, as it was. The photographer who has no hand to hide will conceal it with the least difficulty. Rather than admiration, for work well done, I will feel the awe of revelation. The lost found, the irretrievable retrieved.

Or do I sometimes feel that image proliferation has restored the value of the non-image. Perhaps we prefer Golgotha as it is, a construct of numberless fictions, filtered and assembled to form the uniquely original image that develops in the darkroom of each mind.

Images proliferate. Am I wrong in being reminded of the printing of money in a period of wild inflation? Do we know what we are doing? Are we able to evaluate what we have done?

Original publication

In Our Image (1978).

PART TWO

Photographic seeing

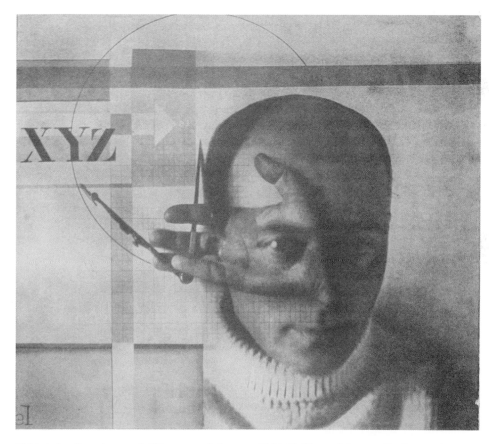

El Lissitzky, *Draughtsman: Self-Portrait with Compass*, 1924. © Christie's Images/Bridgeman Images.

Introduction

THIS SECTION EXAMINES IDEAS about *photographic* seeing discussed in Europe in the 1920s and 1930s (and in North America slightly later). The writings focus on form and aesthetics, although, as will be seen, the European examples link aesthetic experimentation with social change. Artists, ideas and works of art crossed the Atlantic so debates on the two continents did not develop in isolation. However, the historic circumstances which obtained in Europe through much of the twentieth century (Soviet Revolution; two World Wars; partition between East and West Europe) provoked emphasis on the social role and significance of photography; this is reflected in the writings included here.

In his 'A Short History of Photography', Walter Benjamin suggested that a medium comes of age when it starts to be interrogated, rather than being greeted in terms of the excitement of the new and faith in progress (Benjamin 1931). In terms of aesthetics, towards the end of the nineteenth century 'pictorialist' photographers in Europe and North America had attempted to legitimate photography as fine art, typically taking allegorical themes, using soft focus and deploying light lyrically. In sharp contrast, by the 1920s in Europe such poetics had been superseded by emphasis upon the mechanical and objective characteristics of the 'photo-eye'. As Lucia Moholy-Nagy commented:

> photographers, after having been made over-conscious of tone values and balance, began to be more object-conscious than ever-before. The object in the picture became self-assertive; and so did the details of the object. Nothing was without significance. The minuteness of detail became essential. Impressionist texture of paper surface and technique were rejected. The texture of the object, its own surface, were emphasised. Cuttings and unusual angles were in favour. . . . It was the beginning of modern object photography, sometimes called 'straight' photography.
>
> (Moholy-Nagy 1939: 164)

For artists and designers this 'modern era' was a period of optimism and experiment.

The avant-garde was not unified; rather, explorations ranged from formal experimentation to concern with the social implications of new technologies and new visualities, from subjective existential pre-occupations to, for example, commercial or political photomontage. As Herbert Marcuse later noted:

> Art can be called revolutionary in several senses. In a narrow sense, art may be revolutionary if it represents a radical change in style and technique. Such change may be the achievement of a genuine avant-garde, anticipating or reflecting substantial changes in the society at large. Thus, expressionism and surrealism anticipated the destructiveness of monopoly capitalism and the emergence of new goals of radical change. But the merely 'technical' definition of revolutionary art says nothing about the quality of the work, nothing about its authenticity and truth.

Beyond this, a work of art can be called revolutionary if, by virtue of the aesthetic transformation, it represents, in the exemplary fate of individuals, the prevailing unfreedom and the rebelling forces, thus breaking through the mystified (and petrified) social reality, and opening the horizon of change (liberation).

(Marcuse 1977: x)

Social and technological change had heralded widespread use of cameras and the mass circulation of imagery. Creative experimentation encouraged new ways of seeing in terms of camera angle, focus, geometry of the image and, by extension, perception and cultural understanding. Furthermore, photography was seen as a part of the new machine age, essentially a modern mode of seeing. Photography, thus, had come to seem socially progressive, not confined by the precepts and preoccupations of more traditional fine arts, especially as aesthetic experimentation interacted with sociopolitical concerns.

Thus, for instance, Osip Brik, writing in the context of the early years of the Soviet Revolution, discusses how camera technologies might be used to further aesthetic revolution – and, by extension, social change. The essay first appeared in a Moscow magazine, 'Soviet cinema' (*Sovetskoe kino*). Likewise, in Germany, László Moholy-Nagy, who was associated with the Bauhaus movement, argued that photography had unique potential for drawing attention to social experience in terms of time and space, in effect, extending human perception. In this extract he links analysis of the characteristics of photography with educational possibilities established through emphasis on a new mode of vision.

In North America, with the establishment of a photography section at the Museum of Modern Art, New York, in 1940, the photograph seemed accepted as art. By contrast with Europe, aesthetic experimentation was not immediately connected to social change. As Abigail Solomon-Godeau has noted:

The radical formalism that structured the new Soviet photography had little to do with the Anglo-American variety that propelled the photography of Alfred Stieglitz, Paul Strand, *et al.* toward a fully articulated modernist position, although there were common grounds in the two formalisms – shared convictions, for example, that the nature of the medium must properly determine its aesthetic and that photography must acknowledge its own specific characteristics. Deriving ultimately from Kantian aesthetics, Anglo-American formalism insisted above all on the autonomy, purity and self-reflexivity of the work of art. As such it remained throughout its modernist permutations an essentially idealist stance.

(Solomon-Godeau 1989: 86)

Many of the photographs in the MoMA collection had originally been conceived as social document rather than as images for museums or galleries, so museum acquisition gave status to images originally made for other purposes. Given the

dominance of modernist pre-occupation with form and materiality within the art establishment of the period, the changing status of the photograph invited analysis of that specific to the medium. For instance, Italian-American photographer, Tina Modotti, who made much of her work when living in Mexico City (1925–29), explored light and composition, producing images that remain highly acclaimed in terms of formal precision and experiments in new ways of seeing. As is clear from her manifesto, she eschewed the painterly, emphasising the photographic as a distinct, direct means of representing people and circumstances. In the piece included at the end of this section, Edward Weston likewise argues for the specificity of photographic seeing, for imagery which transcends painterly conventions. However, implicitly distancing himself from documentary photography, he also emphasises pre-conceptualisation of the image and an experimental approach to composition, exposure, developing and printing. For Weston, photography has the potential to reveal and offer emotional insight into the nature of the world.

Although agreeing with Weston that photography needs to find its own particular way of making meaning, John Szarkowski, director of photography at MoMA from 1960 to 1991, emphasised the historical inter-relation of fine art photography and documentary (in his words, 'functional' photography). His approach is analytic. In the essay included here, Szarkowski identified five characteristics of the medium which, he argued, are key to its specificity. As the introduction to the catalogue for the exhibition 'The Photographer's Eye', the essay was intended to support the contention that there exists a shared photographic vocabulary despite diversity of themes, contexts and artistic intentions, that 'the vision (the photographers) share belongs to no school or aesthetic theory, but to photography itself'. (Szarkowski 1966: no page numbers).

The concern to discuss photography in terms of the specificity of the medium is in itself characteristic of modernism in art in North America, with its emphasis on personal expressivity and on exploration of the nature of a particular medium. North American modernism's self-reflexivity has been criticised subsequently for the narrowness of its concerns; yet the writings remain pertinent as they invite focus both on photography as a specific means of communication, and, to the extent to which it is valid to seek to comprehend photography in all its diverse forms and contexts, in terms of a defined set of characteristics.

Hence, this section opens with an essay first published in *L'Arc* magazine, Paris, in 1963, at a time when a number of writers, including Jean-Paul Sartre, were attempting to comprehend photographs as a particular type of phenomenon. Hubert Damisch draws attention to the fundamental meaning and processes of 'photography' and argues that the camera is neither neutral nor impartial but was constructed to reproduce established image conventions. He also argues that photography creates nothing of 'use' in terms of basic social utility. Rather, he sees the photograph in terms of 'exchange value', the price for which it can be sold or marketed, and implies that the mechanical nature of photography renders image-making essentially industrial and irrefutably seated within the capitalist system. This essay invites us to consider the relation between camera technology, visuality and specific socioeconomic arrangements.

References and selected further reading

Benjamin, W. (1931) 'A Short History of Photography', included in Benjamin, W. (1979) *One Way Street*. London: New Left Books. Also in A. Trachtenberg (1980) *Classic Essays on Photography*. New Haven: Leete's Island Books.

Enzensberger, M. (1974) 'Introduction, Osip Brik: Selected Writings', *Screen* 15/3.

Goldberg, V. (ed.) (1981) *Photography in Print: Writings From 1816 to the Present*. Albuquerque: University of New Mexico Press. Includes a number of writings from or about the modern period.

Harrison, C. and Wood, P. (eds.) (1992) *Art in Theory 1900–1990*. Oxford: Blackwell. Collection of extracts relating to the idea of a modern world and to modernism in the visual arts; not specifically about photography.

Kracauer, S. (1965) 'Photography', first section in his *Theory of Film*. New York: Oxford University Press. On photographic aesthetics and the affinities of photographs.

Marcuse, H. (1979) *The Aesthetic Dimension*. London: Macmillan. Original German publication, 1977.

Moholy-Nagy, L. (1939) *A Hundred Years of Photography*. Harmondsworth: Penguin.

Petruck, P.R. (ed.) (1979) *The Camera Viewed: Writings on Twentieth-Century Photography*, Vol. 1. New York: Dutton. Volume 1 includes writings from before the Second World War.

Phillips, C. (1989) *Photography in the Modem Era: European Documents and Critical Writings, 1913–1940*. New York: Metropolitan Museum of Art and Aperture. Comprehensive collection of documents on photography from France, Germany, Russia and elsewhere which indicates how debates developed through articles and correspondence in journals (as well as retaining, in translation, what now seems a rather ponderous style in which discussions were conducted).

Solomon-Godeau, A. (1989) 'The Armed Vision Disarmed: Radical Formalism From Weapon to Style', in *The Contest of Meaning*. Cambridge, MA: MIT Press. Originally published in January 1983 in *Afterimage* 11/6. Reprinted in Richard Bolton (1989).

Taylor, B. (1991/92) *Art and Literature Under the Bolsheviks*, Vols. 1 and 2. London: Pluto Press. Comprehensive account of events from 1917–32 including discussion of constructivist art, Vol. 1, section 3.

Wells, L. (2018) 'Camera-Eye: Photography and Modernism', in Pam Meecham (ed.) *A Companion to Modern Art*. Oxford: John Wiley and Sons Inc.

Willett, J. (1978) 'The Camera Eye: New Photography, Russian and Avant-Garde Films', Chapter 15 of his *The New Sobriety, Art and Politics in the Weimar Period, 1917–33*. London: Thames and Hudson. Progressive uses of photography discussed in the context of critical analysis of the politics of visual arts and design in the inter-war period in Germany and Russia.

Bibliography of essays in part two

Brik, O. (1926) 'What the Eye Does Not See', in Christopher Phillips (1989) *Photography in the Modem Era*. New York: Metropolitan Museum of Art and Aperture.

Damisch, H. (1978) 'Five Notes for a Phenomenology of the Photographic Image', in *October 5, Photography: A Special Issue*, Summer. Original French publication, 1963, *L'Arc*, Paris, reprinted in Alan Trachtenberg (ed.) (1980) *Classic Essays on Photography*. New Haven: Leete's Island Books.

Modotti, T. (1929) 'Manifesto; On Photography', in Jesús Nieto Sotelo and Elisa Lozano Alvarez (eds.) (2000) *Tina Modotti: A New Vision*. Mexico City: Centro de la Imagen and Universidad Autónoma del Estado de Morelos.

Moholy-Nagy, L. (1936) 'A New Instrument of Vision', extract from 'From Pigment to Light', original publication, *Telehor* Vol. 1/2. Reprinted in Nathan Lyons (ed.) (1966) *Photographers on Photography*. New Jersey: Prentice Hall.

Szarkowski, J. (1966) 'Introduction', to *The Photographer's Eye*. New York: MoMA. Reprinted (1980) London: Secker & Warburg.

Weston, E. (1943) 'Seeing Photographically', from Willard D. Morgan (ed.) (1964) *The Encyclopedia of Photography*, Vol. 18. New York: Greystone Press. Reprinted in Alan Trachtenberg *Classic Essays*, *op. cit.*

Hubert Damisch

FIVE NOTES FOR A PHENOMENOLOGY OF THE PHOTOGRAPHIC IMAGE

1

THEORETICALLY SPEAKING, PHOTOGRAPHY is nothing other than a process of recording, a technique of *inscribing*, in an emulsion of silver salts, a stable image generated by a ray of light. This definition, we note, neither assumes the use of a camera, nor does it imply that the image obtained is that of an object or scene from the external world. We know of prints obtained from film directly exposed to a light source. The prime value of this type of endeavor is to induce a reflection on the nature and function of the photographic image. And insofar as it successfully eliminates one of the basic elements of the very idea of 'photography' (the camera obscura, the camera), it produced an experimental equivalent of a phenomenological analysis which purports to grasp the essence of the phenomenon under consideration by submitting that phenomenon to a series of imaginary variations.

2

The reluctance one feels, however, in describing such images as photographs is a revealing indication of the difficulty of reflecting phenomenologically – in the strict sense of an eidetic experience, a reading of essences – on a *cultural* object, on an essence that is historically constituted. Moreover, the full purview of a photographic document clearly involves a certain number of 'theses' which, though not of a transcendental order, appear nevertheless as the conditions for apprehending the photographic image as such. To consider a document of this sort like any other image is to claim a bracketing of all knowledge – and even, as we shall see, of all prejudice – as to its genesis and empirical functions. It therefore follows that the photographic situation cannot be defined *a priori*, the division of its fundamental components from its merely contingent aspects cannot be undertaken in the absolute.

The photographic image does not belong to the natural world. It is a product of human labor, a cultural object whose being – in the phenomenological sense of the term – cannot be dissociated precisely from its historical meaning and from the necessarily datable project in which it originates. Now, this image is characterized by the way in which it presents itself as the result of an objective process. Imprinted by rays of light on a plate or sensitive film, these figures (or better perhaps, these signs?) must appear as the very *trace* of an object or a scene from the real world, the image of which inscribes itself, without direct human intervention, in the gelatinous substance covering the support. Here is the source of the supposition of 'reality,' which defines the photographic situation. A photograph is this paradoxical image, without thickness or substance (and, in a way, entirely unreal), that we read without disclaiming the notion that it retains something of the reality from which it was somehow released through its physiochemical make-up. This is the constitutive deception of the photographic image (it being understood that every image, as Sartre has shown, is in essence a deceit). In the case of photography, however, this ontological deception carries with it a *historical* deceit, far more subtle and insidious. And here we return to that object which we got rid of a little too quickly: the black box, the photographic camera.

3

Niepce, the successive adepts of the daguerreotype, and those innumerable inventors who made photography what it is today, were not actually concerned to create a new type of image or to determine novel modes of representation; they wanted, rather, to fix the images which 'spontaneously' formed on the ground of the camera obscura. The adventure of photography begins with man's first attempts to retain that image he had long known how to make. (Beginning in the eleventh century, Arab astronomers probably used the camera obscura to observe solar eclipses.) This long familiarity with an image so produced, and the completely objective, that is to say automatic or in any case strictly mechanical, appearance of the recording process, explains how the photographic representation generally appeared as *a matter of course*, and why one ignores its highly elaborated, arbitrary character. In discussions of the invention of film, the history of photography is most frequently presented as that of a *discovery*. One forgets, in the process, that the image the first photographers were hoping to seize, and the very *latent image* which they were able to reveal and develop, were in no sense naturally given; the principles of construction of the photographic camera – and of the camera obscura before it – were tied to a conventional notion of space and of objectivity whose development preceded the invention of photography, and to which the great majority of photographers only conformed. The lens itself, which had been carefully corrected for 'distortions' and adjusted for 'errors,' is scarcely as objective[1] as it seems. In its structure and in the ordered image of the world it achieves, it complies with an especially familiar though very old and delapidated system of spatial construction, to which photography belatedly brought an unexpected revival of current interest.

(Would the art, or rather the craft, of photography not consist partly in allowing us to forget that the black box is not 'neutral' and that its structure is not impartial?)

4

The retention of the image, its development and multiplication, form an ordered succession of steps which composed the photographic act, taken as a whole. History determined, however, that this act would find its goal in reproduction, much the way the point of film as spectacle was established from the start. (We know that the first inventors worked to fix images and simultaneously to develop techniques for their mass distribution, which is why the process perfected by Daguerre was doomed from the very outset, since it could provide nothing but a *unique* image.) So that photography's contribution, to use the terms of classical economy, is less on the level of *production*, properly speaking, than on that of *consumption*. Photography creates nothing of 'use' (aside from its marginal and primarily scientific applications); it rather lays down the premises of an unbridled destruction of utility. Photographic activity, even though it generally takes the form of craft, is nonetheless, in principle, industrial; and this implies that of all images the photographic one – leaving aside its documentary character – wears out the most quickly. But it is important to note that even when it gives us, through the channels of publishing, advertising, and the press, only those images which are already half consumed, or so to speak, 'predigested,' this industry fulfills the initial photographic project: the capturing and restoration of an image already worn beyond repair, but still, through its physical nature, unsuited to mass consumption.

5

Photography aspires to art each time, in practice, it calls into question its essence and its historical roles, each time it uncovers the contingent character of these things, soliciting in us the producer rather than the consumer of images. (It is no accident that the most *beautiful* photograph so far achieved is possibly the first image Nicéphore Niepce fixed in 1822, on the glass of the camera obscura – a fragile, threatened image, so close in its organization, its granular texture, and its emergent aspect, to certain Seurats – an incomparable image which makes one dream of a photographic *substance* distinct from subject matter, and of an art in which light creates its own metaphor.)

Original publication

'Five Notes for a Phenomenology of the Photographic Image', in *October*, 5 (1978). [Originally published 1963]

Note

1 The play here is on the French word for lens: *objectif*.

Osip Brik,
Translated by John E. Bowlt

WHAT THE EYE DOES NOT SEE

V ERTOV IS RIGHT. The task of the cinema and of the camera is not to imitate the human eye, but to see and record what the human eye normally does not see.

The cinema and the photo-eye can show us things from unexpected viewpoints and in unusual configurations, and we should exploit this possibility.

There was a time when we thought it was enough just to photograph objects at eye level, standing with both feet firmly on the ground. But then we began to move around, to climb mountains, to travel on trains, steamships, and automobiles, to soar in airplanes and drop to the bottom of the sea. And we took our camera with us everywhere, recording whatever we saw.

So we began to shoot from more complex angles which became increasingly diverse, even though the link with the human eye and its usual optical radius remained unbroken.

However, that link is not really needed. Beyond that, it actually limits and impoverishes the possibilities of the camera. The camera can function independently, can see in ways that man is not accustomed to – can suggest new points of view and demonstrate how to look at things differently.

This is the kind of experiment that Comrade Rodchenko undertook when he photographed a Moscow house from an unusual viewpoint.

The results proved extremely interesting: that familiar object (the house) suddenly turned into a never-before-seen structure, a fire escape became a monstrous object, balconies were transformed into a tower of exotic architecture.

When you look at these photos it is easy to imagine how a cinematic sequence could be developed here, what great visual potential it could have – much more effective than the usual shots on location.

The monotony of form in the cinematic landscape has inspired some people to seek an answer in movie decorations, props, and displacements, or to prevail upon

the artist to 'invent an interesting slice of life,' to build 'fantasy houses' and construct a 'nonexistent nature.'

A hopeless task. The camera does not tolerate props, and mercilessly exposes any cardboard theatricality offered instead of the real thing.

That's not the answer, and there's only one way out of the dilemma: we must break out beyond the customary radius of the normal human eye, we must learn to photograph objects with the camera outside the bounds of that radius, in order to obtain a result other than the usual monotony. Then we will see our concrete reality rather than some kind of theater prop, and we will see it as it has never been seen before.

The cinema and the photo-eye must create their own point of view, and use it. They must expand – not imitate – the ordinary optical radius of the human eye.

Original publication

'What the Eye Does Not See' in *Photograph in the Modern Era* (1989).
[Originally published 1926]

László Moholy-Nagy

A NEW INSTRUMENT OF VISION

IN PHOTOGRAPHY WE POSSESS AN extraordinary instrument for repro-duction. But photography is much more than that. Today it is in a fair way to bringing (optically) something entirely new into the world. The specific elements of photography can be isolated from their attendant complications, not only theoretically, but tangibly, and in their manifest reality.

The unique quality of photography

The photogram, or camera-less record of forms produced by light, which embodies the unique nature of the photographic process, is the real key to photography. It allows us to capture the patterned interplay of light on a sheet of sensitized paper without recourse to any apparatus. The photogram opens up perspectives of a hitherto wholly unknown morphosis governed by optical laws peculiar to itself. It is the most com-pletely dematerialized medium which the new vision commands.

What is optical quality?

Through the development of black-and-white photography, light and shadow were for the first time fully revealed; and thanks to it, too, they first began to be employed with something more than a purely theoretical knowledge. (Impressionism in painting may be regarded as a parallel achievement.) Through the development of reliable artificial illumination (more particularly electricity), and the power of regulating it, an increas-ing adoption of flowing light and richly gradated shadows ensued; and through these, again a greater animation of surfaces, and a more delicate optical intensification. This manifolding of gradations is one of the fundamental 'materials' of optical formalism: a

fact which holds equally well if we pass beyond the immediate sphere of black-white-grey values and learn to think and work in terms of coloured ones.

When pure colour is placed against pure colour, tone against tone, a hard, poster-like decorative effect generally results. On the other hand, the same colours used in conjunction with their intermediate tones will dispel this poster-like effect, and create a more delicate and melting impression. Through its black-white-grey reproductions of all coloured appearances photography has enabled us to recognize the most subtle differentiations of values in both the grey and chromatic scales: differentiations that represent a new and (judged by previous standards) hitherto unattainable quality in optical expression. This is, of course, only one point among many. But it is the point where we have to begin to master photography's inward properties, and that at which we have to deal more with the artistic function of expression than with the reproductive function of portrayal.

Sublimated technique

In reproduction – considered as the objective fixation of the semblance of an object – we find just as radical advances and transmogrifications, compared with prevailing optical representation, as in direct records of forms produced by light (photograms). These particular developments are well known: bird's-eye views, simultaneous interceptions, reflections, elliptical penetrations, etc. Their systematic co-ordination opens up a new field of visual presentation in which still further progress becomes possible. It is, for instance, an immense extension of the optical possibilities of reproduction that we are able to register precise fixations of objects, even in the most difficult circumstances, in a hundredth or thousandth of a second. Indeed, this advance in technique almost amounts to a psychological transformation of our eyesight,[1] since the sharpness of the lens and the unerring accuracy of its delineation have now trained our powers of observation up to a standard of visual perception which embraces ultra-rapid snapshots and the millionfold magnification of dimensions employed in microscopic photography.

Improved performance

Photography, then, imparts a heightened, or (in so far as our eyes are concerned) increased, power of sight in terms of time and space. A plain, matter-of-fact enumeration of the specific photographic elements – purely technical, not artistic, elements – will be enough to enable us to divine the power latent in them, and prognosticate to what they lead.

The eight varieties of photographic vision

1. Abstract seeing by means of direct records of forms produced by light: the photogram which captures the most delicate gradations of light values, both chiaroscuro and coloured.

2. Exact seeing by means of the normal fixation of the appearance of things: reportage.

3. Rapid seeing by means of the fixation of movements in the shortest possible time: snapshots.

4. Slow seeing by means of the fixation of movements spread over a period of time: e.g., the luminous tracks made by the headlights of motor cars passing along a road at night: prolonged time exposures.

5. Intensified seeing by means of:

 a) micro-photography;

 b) filter-photography, which, by variation of the chemical composition of the sensitized surface, permits photographic potentialities to be augmented in various ways – ranging from the revelation of far-distant landscapes veiled in haze or fog to exposures in complete darkness: infrared photography.

6. Penetrative seeing by means of X-rays: radiography.

7. Simultaneous seeing by means of transparent superimposition: the future process of automatic photomontage.

8. Distorted seeing: optical jokes that can be automatically produced by:

 a) exposure through a lens fitted with prisms, and the device of reflecting mirrors; or

 b) mechanical and chemical manipulation of the negative after exposure.

What is the purpose of the enumeration?

What is to be gleaned from this list? That the most astonishing possibilities remain to be discovered in the raw material of photography, since a detailed analysis of each of these aspects furnishes us with a number of valuable indications in regard to their application, adjustment, etc. Our investigations will lead us in another direction, however. We want to discover what is the essence and significance of photography.

The new vision

All interpretations of photography have hitherto been influenced by the aesthetic-philosophic concepts that circumscribed painting. These were long held to be equally applicable to photographic practice. Up to now, photography has remained in rather rigid dependence on the traditional forms of painting; and like painting it has passed through the successive stages of all the various art 'isms'; though in no sense to its advantage. Fundamentally new discoveries cannot for long be confined to the mentality and practice of bygone periods with impunity. When that happens all productive activity is arrested. This was plainly evinced in photography, which has yielded no results of any value except in those fields where, as in scientific work, it has been employed without artistic ambitions. Here alone did it prove the pioneer of an original development, or of one peculiar to itself.

 In this connection it cannot be too plainly stated that it is quite unimportant whether photography produces 'art' or not. Its own basic laws, not the opinions of

art critics, will provide the only valid measure of its future worth. It is sufficiently unprecedented that such a 'mechanical' thing as photography, and one regarded so contemptuously in an artistic and creative sense, should have acquired the power it has, and become one of the primary objective visual forms, in barely a century of evolution. Formerly the painter impressed his own perspective outlook on his age. We have only to recall the manner in which we used to look at landscapes and compare it with the way we perceive them now! Think, too, of the incisive sharpness of those camera por-traits of our contemporaries, pitted with pores and furrowed by lines. Or an air-view of a ship at sea moving through waves that seem frozen in light. Or the enlargement of a woven tissue, or the chiselled delicacy of an ordinary sawn block of wood. Or, in fact, any of the whole gamut of splendid details of structure, texture and 'factor' of whatever objects we care to choose.

The new experience of space

Through photography, too, we can participate in new experiences of space, and in even greater measure through the film. With their help, and that of the new school of archi-tects, we have attained an enlargement and sublimation of our appreciation of space, the comprehension of a new spatial culture. Thanks to the photographer, humanity has acquired the power of perceiving its surroundings, and its very existence, with new eyes.

The height of attainment

But all these are isolated characteristics, separate achievements, not altogether dis-similar to those of painting. In photography we must learn to seek, not the 'picture,' not the aesthetic of tradition, but the ideal instrument of expression, the self-sufficient vehicle for education.

Series (photographic image sequences of the same object)

There is no more surprising, yet, in its naturalness and organic sequence, simpler form than the photographic series. This is the logical culmination of photography. The series is no longer a 'picture,' and none of the canons of pictorial aesthetics can be applied to it. Here the separate picture loses its identity as such and becomes a detail of assembly, an essential structural element of the whole which is the thing itself. In this concatenation of its separate but inseparable parts a photographic series inspired by a definite purpose can become at once the most potent weapon and the tenderest lyric. The true significance of the film will only appear in a much later, less confused and groping age than ours. The prerequisite for this revelation is, of course, the realization that a knowledge of photography is just as important as that of the alphabet. The illiterate of the future will be ignorant of the use of camera and pen alike.

Original publication

'A New Instrument of Vision' extract from 'From Pigment to Light' in *Telebar* Vol. 1/2 (1936).

Note

1 Helmholtz used to tell his pupils that if an optician were to succeed in making a human eye, and brought it to him for his approval, he would be bound to say: 'this is a clumsy job of work.'

Tina Modotti

MANIFESTO BY TINA MODOTTI "SOBRE LA FOTOGRAFÍA" (ON PHOTOGRAPHY)

Technique will become a much more powerful inspiration in artistic production; later, it will find its solution in a higher synthesis of the contrast existing between technique and nature.

(Leon Trotzky)

WHENEVER THE WORDS "ART" OR "ARTISTIC" are used with respect to my photographic work, I have an unpleasant reaction, most surely because of the improper, abusive use of those words. I consider myself a photographer and nothing more. If my photographs are different from those generally produced, it is precisely because I try to produce not art, but rather, honorable photographs – without any tricks or manipulations. Most photographers, however, are still looking for "artistic effects" or an imitation of other types of graphic expression. These tendencies lead to a hybrid product and do not achieve the most valuable feature that a work should have: PHOTOGRAPHIC QUALITY. There has been a great deal of discussion in recent years regarding whether photography can be considered a work of art comparable to other plastic art creations. Naturally, opinions vary between those who accept photography as a medium of expression just as any other, and others – those who are shortsighted – who continue to look at the twentieth century with eyes from the tenth or even the eighth century. They are, therefore, incapable of accepting the manifestations of our mechanical civilization. But, those of us who use the camera as a tool, just as a painter uses a brush, are not bothered by opposing ideas. We have the approval of persons who recognize the merit of photography in its many functions, and accept it as the most eloquent, direct medium for capturing and registering the present time. It is not important to know whether or not photography is an art. What is important is to distinguish between good and bad photography. What should be understood by good photography is that which accepts the limitations inherent in photographic technique, and which takes advantage of all the possibilities and characteristics offered by this medium. Bad photography should be understood as that which

is produced, one could say, with a kind of inferiority complex, without valuing what photography has to offer as its very own. In this latter case, all kinds of imitations are used, giving the idea that the one producing the work is almost embarrassed by making photographs and tries to hide everything that has to do with photography from the work, using tricks and falsifications that can only be pleasing to someone with a pervasive taste. Photography, because of the single fact that it can only be produced in the present and based on what objectively exists in front of the camera, is clearly the most satisfactory medium for registering objective life in all its manifestations. For that reason, it has documentary value. If we add to all of this some sensitivity and understanding of the matter, and above all, a clear orientation of the place photography should hold in history, I believe the result is something which deserves a place in social production, something to which all of us should contribute.

Original publication

Manifesto; on photography (2000).
[Originally published 1929]

John Szarkowski

INTRODUCTION TO *THE PHOTOGRAPHER'S EYE*

THE INVENTION OF PHOTOGRAPHY provided a radically new picture-making process – a process based not on synthesis but on selection. The difference was a basic one. Paintings were *made* – constructed from a storehouse of traditional schemes and skills and attitudes – but photographs, as the man on the street put it, were *taken*.

The difference raised a creative issue of a new order: how could this mechanical and mindless process be made to produce pictures meaningful in human terms – pictures with clarity and coherence and a point of view? It was soon demonstrated that an answer would not be found by those who loved too much the old forms, for in large part the photographer was bereft of the old artistic traditions. Speaking of photography Baudelaire said: 'This industry, by invading the territories of art, has become art's most mortal enemy.'[1] And in his own terms of reference Baudelaire was half right; certainly the new medium could not satisfy old standards. The photographer must find new ways to make his meaning clear.

These new ways might be found by men who could abandon their allegiance to traditional pictorial standards – or by the artistically ignorant, who had no old allegiances to break. There have been many of the latter sort. Since its earliest days, photography has been practiced by thousands who shared no common tradition or training, who were disciplined and united by no academy or guild, who considered their medium variously as a science, an art, a trade, or an entertainment, and who were often unaware of each other's work. Those who invented photography were scientists and painters, but its professional practitioners were a very different lot. Hawthorne's daguerreotypist hero Holgrave in *The House of the Seven Gables* was perhaps not far from typical:

> Though now but twenty-two years old, he had already been a country schoolmaster; salesman in a country store; and the political editor of a country newspaper. He had subsequently travelled as a peddler of cologne

water and other essences. He had studied and practiced dentistry. Still more recently he had been a public lecturer on mesmerism, for which science he had very remarkable endowments. His present phase as a daguerreotypist was of no more importance in his own view, nor likely to be more perma-nent, than any of the preceding ones.[2]

The enormous popularity of the new medium produced professionals by the thousands — converted silversmiths, tinkers, druggists, blacksmiths, and printers. If photography was a new artistic problem, such men had the advantage of having noth-ing to unlearn. Among them they produced a flood of images. In 1853 the *New York Daily Tribune* estimated that three million daguerreotypes were being produced that year.[3] Some of these pictures were the product of knowledge and skill and sensibility and invention; many were the product of accident, improvisation, misunderstanding, and empirical experiment. But whether produced by art or by luck, each picture was part of a massive assault on our traditional habits of seeing.

By the latter decades of the nineteenth century the professionals and the serious amateurs were joined by an even larger host of casual snapshooters. By the early eight-ies the dry plate, which could be purchased ready-to-use, had replaced the refractory and messy wet plate process, which demanded that the plate be prepared just before exposure and processed before its emulsion had dried. The dry plate spawned the hand camera and the snapshot. Photography had become easy. In 1893 an English writer complained that the new situation had

> created an army of photographers who run rampant over the globe, photo-graphing objects of all sorts, sizes and shapes, under almost every condition, without ever pausing to ask themselves, is this or that artistic? . . . They spy a view, it seems to please, the camera is focused, the shot taken! There is no pause, why should there be? For art may err but nature cannot miss, says the poet, and they listen to the dictum. To them, composition, light, shade, form and texture are so many catch phrases.[4]

These pictures, taken by the thousands by journeyman worker and Sunday hobby-ist, were unlike any pictures before them. The variety of their imagery was prodigious. Each subtle variation in viewpoint or light, each passing moment, each change in the tonality of the print, created a new picture. The trained artist could draw a head or a hand from a dozen perspectives. The photographer discovered that the gestures of a hand were infinitely various, and that the wall of a building in the sun was never twice the same.

Most of this deluge of pictures seemed formless and accidental, but some achieved coherence, even in their strangeness. Some of the new images were memorable, and seemed significant beyond their limited intention. These remembered pictures enlarged one's sense of possibilities as he looked again at the real world. While they were remembered they survived, like organisms, to reproduce and evolve.

But it was not only the way that photography described things that was new; it was also the things it chose to describe. Photographers shot 'objects of all sorts, sizes and shapes . . . without ever pausing to ask themselves, is this or that artistic?' Painting was difficult, expensive, and precious, and it recorded what was known to be important.

Photography was easy, cheap, and ubiquitous, and it recorded anything: shop windows and sod houses and family pets and steam engines and unimportant people. And once made objective and permanent, immortalized in a picture, these trivial things took on importance. By the end of the century, for the first time in history, even the poor man knew what his ancestors had looked like.

The photographer learned in two ways: first, from a worker's intimate understanding of his tools and materials (if his plate would not record the clouds, he could point his camera down and eliminate the sky); and second he learned from other photographs, which presented themselves in an unending stream. Whether his concern was commercial or artistic, his tradition was formed by all the photographs that had impressed themselves upon his consciousness. . . .

It should be possible to consider the history of the medium in terms of photographers' progressive awareness of characteristics and problems that have seemed inherent in the medium. Five such issues are considered below. These issues *do not* define discrete categories of work; on the contrary they should be regarded as interdependent aspects of a single problem – as section views through the body of photographic tradition. As such, it is hoped that they may contribute to the formulation of a vocabulary and a critical perspective more fully responsive to the unique phenomena of photography.

The thing itself

The first thing that the photographer learned was that photography dealt with the actual; he had not only to accept this fact, but to treasure it; unless he did, photography would defeat him. He learned that the world itself is an artist of incomparable inventiveness, and that to recognize its best works and moments, to anticipate them, to clarify them and make them permanent, requires intelligence both acute and supple.

But he learned also that the factuality of his pictures, no matter how convincing and unarguable, was a different thing than the reality itself. Much of the reality was filtered out in the static little black and white image, and some of it was exhibited with an unnatural clarity, an exaggerated importance. The subject and the picture were not the same thing, although they would afterwards seem so. It was the photographer's problem to see not simply the reality before him but the still invisible picture, and to make his choices in terms of the latter.

This was an artistic problem, not a scientific one, but the public believed that the photograph could not lie, and it was easier for the photographer if he believed it too, or pretended to. Thus he was likely to claim that what our eyes saw was an illusion, and what the camera saw was the truth. Hawthorne's Holgrave, speaking of a difficult portrait subject said:

> 'We give [heaven's broad and simple sunshine] credit only for depicting the merest surface, but it actually brings out the secret character with a truth that no painter would ever venture upon, even could he detect it . . . the remarkable point is that the original wears, to the world's eye . . . an exceedingly pleasant countenance, indicative of benevolence, openness of heart, sunny good humor, and other praiseworthy qualities of that cast. The

sun, as you see, tells quite another story, and will not be coaxed out of it, after half a dozen patient attempts on my part. Here we have a man, sly, subtle, hard, imperious, and withal, cold as ice.'[5]

In a sense Holgrave was right in giving more credence to the camera image than to his own eyes, for the image would survive the subject, and become the remembered reality. William M. Ivins, Jr. said 'at any given moment the accepted report of an event is of greater importance than the event, for what we think about and act upon is the symbolic report and not the concrete event itself.'[6] He also said: 'The nineteenth century began by believing that what was reasonable was true and it would end up by believing that what it saw a photograph of was true.'[7]

The detail

The photographer was tied to the facts of things, and it was his problem to force the facts to tell the truth. He could not, outside the studio, pose the truth; he could only record it as he found it, and it was found in nature in a fragmented and unexplained form – not as a story, but as scattered and suggestive clues. The photographer could not assemble these clues into a coherent narrative, he could only isolate the fragment, document it, and by so doing claim for it some special significance, a meaning which went beyond simple description. The compelling clarity with which a photograph recorded the trivial suggested that the subject had never before been properly seen, that it was in fact perhaps *not* trivial, but filled with undiscovered meaning. If photographs could not be read as stories, they could be read as symbols.

The decline of narrative painting in the past century has been ascribed in large part to the rise of photography, which 'relieved' the painter of the necessity of storytelling. This is curious, since photography has never been successful at narrative. It has in fact seldom attempted it. The elaborate nineteenth-century montages of Robinson and Rejlander, laboriously pieced together from several posed negatives, attempted to tell stories, but these works were recognized in their own time as pretentious failures. In the early days of the picture magazines the attempt was made to achieve narrative through photographic sequences, but the superficial coherence of these stories was generally achieved at the expense of photographic discovery. The heroic documentation of the American Civil War by the Brady group, and the incomparably larger photographic record of the Second World War, have this in common: neither explained, without extensive captioning, what was happening. The function of these pictures was not to make the story clear, it was to make it *real*. The great war photographer Robert Capa expressed both the narrative property and the symbolic power of photography when he said, 'If your pictures aren't good, you're not close enough.'

The frame

Since the photographer's picture was not conceived but selected, his subject was never truly discrete, never wholly self-contained. The edges of his film demarcated what he thought most important, but the subject he had shot was something else; it had

extended in four directions. If the photographer's frame surrounded two figures, isolating them from the crowd in which they stood, it created a relationship between those two figures that had not existed before.

The central act of photography, the act of choosing and eliminating, forces a concentration on the picture edge – the line that separates in from out – and on the shapes that are created by it.

During the first half-century of photography's lifetime, photographs were printed the same size as the exposed plate. Since enlarging was generally impractical, the photographer could not change his mind in the darkroom and decide to use only a fragment of his picture, without reducing its size accordingly. If he had purchased an eight by ten inch plate (or worse, prepared it), had carried it as part of his back-bending load, and had processed it, he was not likely to settle for a picture half that size. A sense of simple economy was enough to make the photographer try to fill the picture to its edges.

The edges of the picture were seldom neat. Parts of figures or buildings or features of landscape were truncated, leaving a shape belonging not to the subject, but (if the picture was a good one) to the balance, the propriety, of the image. The photographer looked at the world as though it was a scroll painting, unrolled from hand to hand, exhibiting an infinite number of croppings – of compositions – as the frame moved onwards.

The sense of the picture's edge as a cropping device is one of the qualities of form that most interested the inventive painters of the latter nineteenth century. To what degree this awareness came from photography, and to what degree from oriental art, is still open to study. However, it is possible that the prevalence of the photographic image helped prepare the ground for an appreciation of the Japanese print, and also that the compositional attitudes of these prints owed much to habits of seeing which stemmed from the scroll tradition.

Time

There is in fact no such thing as an instantaneous photograph. All photographs are time exposures, of shorter or longer duration, and each describes a discrete parcel of time. This time is always the present. Uniquely in the history of pictures, a photograph describes only that period of time in which it was made. Photography alludes to the past and the future only in so far as they exist in the present, the past through its surviving relics, the future through prophecy visible in the present.

In the days of slow films and slow lenses, photographs described a time segment of several seconds or more. If the subject moved, images resulted that had never been seen before: dogs with two heads and a sheaf of tails, faces without features, transparent men, spreading their diluted substance half across the plate. The fact that these pictures were considered (at best) as partial failures is less interesting than the fact that they were produced in quantity; they were familiar to all photographers, and to all customers who had posed with squirming babies for family portraits.

It is surprising that the prevalence of these radical images has not been of interest to art historians. The time-lapse painting of Duchamp and Balla, done before the First World War, has been compared to work done by photographers such as Edgerton

and Mili, who worked consciously with similar ideas a quarter-century later, but the accidental time-lapse photographs of the nineteenth century have been ignored — presumably *because* they were accidental.

As photographic materials were made more sensitive, and lenses and shutters faster, photography turned to the exploration of rapidly moving subjects. Just as the eye is incapable of registering the single frames of a motion picture projected on the screen at the rate of twenty-four per second, so is it incapable of following the positions of a rapidly moving subject in life. The galloping horse is the classic example. As lovingly drawn countless thousands of times by Greeks and Egyptians and Persians and Chinese, and down through all the battle scenes and sporting prints of Christendom, the horse ran with four feet extended, like a fugitive from a carousel. Not till Muybridge successfully photographed a galloping horse in 1878 was the convention broken. It was this way also with the flight of birds, the play of muscles on an athlete's back, the drape of a pedestrian's clothing, and the fugitive expressions of a human face.

Immobilizing these thin slices of time has been a source of continuing fascination for the photographer. And while pursuing this experiment he discovered something else: he discovered that there was a pleasure and a beauty in this fragmenting of time that had little to do with what was happening. It had to do rather with seeing the momentary patterning of lines and shapes that had been previously concealed within the flux of movement. Cartier-Bresson defined his commitment to this new beauty with the phrase *the decisive moment*, but the phrase has been misunderstood; the thing that happens at the decisive moment is not a dramatic climax but a visual one. The result is not a story but a picture.

Vantage point

Much has been said about the clarity of photography, but little has been said about its obscurity. And yet it is photography that has taught us to see from the unexpected vantage point, and has shown us pictures that give the sense of the scene, while withholding its narrative meaning. Photographers from necessity choose from the options available to them, and often this means pictures from the other side of the proscenium, showing the actors' backs, pictures from the bird's view, or the worm's, or pictures in which the subject is distorted by extreme foreshortening, or by none, or by an unfamiliar pattern of light, or by a seeming ambiguity of action or gesture.

Ivins wrote with rare perception of the effect that such pictures had on nineteenth-century eyes: 'At first the public had talked a great deal about what it called photographic distortion. . . . [But] it was not long before men began to think photographically, and thus to see for themselves things that it had previously taken the photograph to reveal to their astonished and protesting eyes. Just as nature had once imitated art, so now it began to imitate the picture made by the camera.'[8]

After a century and a quarter, photography's ability to challenge and reject our schematized notions of reality is still fresh. In his monograph on Francis Bacon, Lawrence Alloway speaks of the effect of photography on that painter: 'The evasive nature of his imagery, which is shocking but obscure, like accident or atrocity photographs, is arrived at by using photography's huge repertory of visual images. . . . Uncaptioned

news photographs, for instance, often appear as momentous and extraordinary. . . . Bacon used this property of photography to subvert the clarity of pose of figures in traditional painting.'[9]

The influence of photography on modern painters (and on modern writers) has been great and inestimable. It is, strangely, easier to forget that photography has also influenced photographers. Not only great pictures by great photographers, but *photography* – the great undifferentiated, homogeneous whole of it – has been teacher, library, and laboratory for those who have consciously used the camera as artists. An artist is a man who seeks new structures in which to order and simplify his sense of the reality of life. For the artist photographer, much of his sense of reality (where his picture starts) and much of his sense of craft or structure (where his picture is completed) are anonymous and untraceable gifts from photography itself.

The history of photography has been less a journey than a growth. Its movement has not been linear and consecutive, but centrifugal. Photography, and our understanding of it, has spread from a centre; it has, by infusion, penetrated our consciousness. Like an organism, photography was born whole. It is in our progressive discovery of it that its history lies.

Original publication

Introduction from *The Photographer's Eye* (1966).

Notes

1 Charles Baudelaire, 'Salon de 1859,' translated by Jonathan Mayne for *The Mirror of Art, Critical Studies by Charles Baudelaire*. London: Phaidon Press, 1955. (Quoted from *On Photography: A Source Book of Photo History in Facsimile*, edited by Beaumont Newhall. Watkins Glen: Century House, 1956, p. 106.)

2 Nathaniel Hawthorne, *The House of the Seven Gables*. New York: Signet Classics edition, 1961, pp. 156–7.

3 A. C. Willers, 'Poet and Photography,' in *Picturescope*, Vol. XI, No. 4. New York: Picture Division, Special Libraries Association, 1963, p. 46.

4 E. E. Cohen, 'Bad Form in Photography,' in *The International Annual of Anthony's Photographic Bulletin*. New York and London: E. and H. T. Anthony, 1893, p. 18.

5 Hawthorne, op. cit., p. 85.

6 William M. Ivins, Jr., *Prints and Visual Communication*. Cambridge, MA: Harvard University Press, 1953, p. 180.

7 Ibid., p. 94.

8 Ibid., p. 138.

9 Lawrence Alloway, *Francis Bacon*. New York: Solomon II. Guggenheim Foundation, 1963, p. 22.

Edward Weston

SEEING PHOTOGRAPHICALLY

Each medium of expression imposes its own limitations on the artist – limitations inherent in the tools, materials, or processes he employs. In the older art forms these natural confines are so well established they are taken for granted. We select music or dancing, sculpture or writing because we feel that within the *frame* of that particular medium we can best express whatever it is we have to say.

The photo-painting standard

Photography, although it has passed its hundredth birthday, has yet to attain such familiarization. In order to understand why this is so, we must examine briefly the historical background of this youngest of the graphic arts. Because the early photographers who sought to produce creative work had no tradition to guide them, they soon began to borrow a ready-made one from the painters. The conviction grew that photography was just a new kind of painting, and its exponents attempted by every means possible to make the camera produce painter-like results. This misconception was responsible for a great many horrors perpetrated in the name of art, from allegorical costume pieces to dizzying out-of-focus blurs.

But these alone would not have sufficed to set back the photographic clock. The real harm lay in the fact that the false standard became firmly established, so that the goal of artistic endeavour became photo-painting rather than photography. The approach adopted was so at variance with the real nature of the medium employed that each basic improvement in the process became just one more obstacle for the photo-painters to overcome. Thus the influence of the painters' tradition delayed recognition of the real creative field photography had provided. Those who should have been most concerned with discovering and exploiting the new pictorial resources were ignoring them entirely and, in their preoccupation with producing pseudopaintings, departing more and more radically from all photographic values.

As a consequence, when we attempt to assemble the best work of the past, we most often choose examples from the work of those who were not primarily concerned with aesthetics. It is in commercial portraits from the daguerreotype era, records of the Civil War, documents of the American frontier, the work of amateurs and professionals who practiced photography for its own sake without troubling over whether or not it was art, that we find photographs that will still stand with the best of contemporary work.

But in spite of such evidence that can now be appraised with a calm, historical eye, the approach to creative work in photography today is frequently just as muddled as it was eighty years ago, and the painters' tradition still persists, as witness the use of texture screens, handwork on negatives, and ready-made rules of composition. People who wouldn't think of taking a sieve to the well to draw water fail to see the folly in taking a camera to make a painting.

Behind the photo-painter's approach lay the fixed idea that a straight photograph was purely the product of a machine and therefore not art. He developed special technics to combat the mechanical nature of his process. In this system the negative was taken as a point of departure — a first rough impression to be 'improved' by hand until the last traces of its unartistic origin had disappeared.

Perhaps if singers banded together in sufficient numbers, they could convince musicians that the sounds they produced through *their machines* could not be art because of the essentially mechanical nature of their instruments. Then the musician, profiting by the example of the photo-painter, would have his playing recorded on special discs so that he could unscramble and rescramble the sounds until he had transformed the product of a good musical instrument into a poor imitation of the human voice!

To understand why such an approach is incompatible with the logic of the medium, we must recognize the two basic factors in the photographic process that set it apart from the other graphic arts: the nature of the recording process and the nature of the image.

Nature of the recording process

Among all the arts photography is unique by reason of its instantaneous recording process. The sculptor, the architect, the composer all have the possibility of making changes in, or additions to, their original plans while their work is in the process of execution. A composer may build up a symphony over a long period of time; a painter may spend a lifetime working on one picture and still not consider it finished. But the photographer's recording process cannot be drawn out. Within its brief duration, no stopping or changing or reconsidering is possible. When he uncovers his lens every detail within its field of vision is registered in far less time than it takes for his own eyes to transmit a similar copy of the scene to his brain.

Nature of the image

The image that is thus swiftly recorded possesses certain qualities that at once distinguish it as photographic. First there is the amazing precision of definition, especially

in the recording of fine detail; and second, there is the unbroken sequence of infinitely subtle gradations from black to white. These two characteristics constitute the trademark of the photograph; they pertain to the mechanics of the process and cannot be duplicated by any work of the human hand.

The photographic image partakes more of the nature of a mosaic than of a drawing or painting. It contains no *lines* in the painter's sense, but is entirely made up of tiny particles. The extreme fineness of these particles gives a special tension to the image, and when that tension is destroyed – by the intrusion of handwork, by too great enlargement, by printing on a rough surface, etc. – the integrity of the photograph is destroyed.

Finally, the image is characterized by lucidity and brilliance of tone, qualities which cannot be retained if prints are made on dull-surface papers. Only a smooth, light-giving surface can reproduce satisfactorily the brilliant clarity of the photographic image.

Recording the image

It is these two properties that determine the basic procedure in the photographer's approach. Since the recording process is instantaneous, and the nature of the image such that it cannot survive corrective handwork, it is obvious that the *finished print must be created in full before the film is exposed.* Until the photographer has learned to visualize his final result in advance, and to predetermine the procedures necessary to carry out that visualization, his finished work (if it be photography at all) will present a series of lucky – or unlucky – mechanical accidents.

Hence the photographer's most important and likewise most difficult task is not learning to manage his camera, or to develop, or to print. It is learning to *see photographically* – that is, learning to see his subject matter in terms of the capacities of his tools and processes, so that he can instantaneously translate the elements and values in a scene before him into the photograph he wants to make. The photo-painters used to contend that photography could never be an art because there was in the process no means for controlling the result. Actually, the problem of learning to see photographically would be simplified if there were fewer means of control than there are.

By varying the position of his camera, his camera angle, or the focal length of his lens, the photographer can achieve an infinite number of varied compositions with a single, stationary subject. By changing the light on the subject, or by using a colour filter, any or all of the values in the subject can be altered. By varying the length of exposure, the kind of emulsion, the method of developing, the photographer can vary the registering of relative values in the negative. And the relative values as registered in the negative can be further modified by allowing more or less light to affect certain parts of the image in printing. Thus, within the limits of his medium, without resorting to any method of control that is not photographic (i.e., of an optical or chemical nature), the photographer can depart from literal recording to whatever extent he chooses.

This very richness of control facilities often acts as a barrier to creative work. The fact is that relatively few photographers ever master their medium. Instead they allow the medium to master them and go on an endless squirrel cage chase from new lens to new paper to new developer to new gadget, never staying with one piece of equipment long enough to learn its full capacities, becoming lost in a maze of technical information that is of little or no use since they don't know what to do with it.

Only long experience will enable the photographer to subordinate technical considerations to pictorial aims, but the task can be made immeasurably easier by selecting the simplest possible equipment and procedures and staying with them. Learning to see in terms of the field of one lens, the scale of one film and one paper, will accomplish a good deal more than gathering a smattering of knowledge about several different sets of tools.

The photographer must learn from the outset to regard his process as a whole. He should not be concerned with the 'right exposure,' the 'perfect negative,' etc., such notions are mere products of advertising mythology. Rather he must learn the kind of negative necessary to produce a given kind of print, and then the kind of exposure and development necessary to produce that negative. When he knows how these needs are fulfilled for one kind of print, he must learn how to vary the process to produce other kinds of prints. Further he must learn to translate colours into their monochrome values, and learn to judge the strength and quality of light. With practice this kind of knowledge becomes intuitive; the photographer learns to see a scene or object in terms of his finished print without having to give conscious thought to the steps that will be necessary to carry it out.

Subject matter and composition

So far we have been considering the mechanics of photographic seeing. Now let us see how this camera-vision applies to the fields of subject matter and composition. No sharp line can be drawn between the subject matter appropriate to photography and that more suitable to the other graphic arts. However, it is possible, on the basis of an examination of past work and our knowledge of the special properties of the medium, to suggest certain fields of endeavour that will most reward the photographer, and to indicate others that he will do well to avoid.

Even if produced with the finest photographic technic, the work of the photo-painters referred to could not have been successful. Photography is basically too honest a medium for recording superficial aspects of a subject. It searches out the actor behind the make-up and exposes the contrived, the trivial, the artificial, for what they really are. But the camera's innate honesty can hardly be considered a limitation of the medium, since it bars only that kind of subject matter that properly belongs to the painter. On the other hand it provides the photographer with a means of looking deeply into the nature of things, and presenting his subjects in terms of their basic reality. It enables him to reveal the essence of what lies before his lens with such clear insight that the beholder may find the recreated image more real and comprehensible than the actual object.

It is unfortunate, to say the least, that the tremendous capacity photography has for revealing new things in new ways should be overlooked or ignored by the majority of its exponents – but such is the case. Today the waning influence of the painter's tradition has been replaced by what we may call *Salon Psychology*, a force that is exercising the same restraint over photographic progress by establishing false standards and discouraging any symptoms of original creative vision.

Today's photographer need not necessarily make his picture resemble a wash drawing in order to have it admitted as art, but he must abide by 'the rules of composition.'

That is the contemporary nostrum. Now to consult rules of composition before making a picture is a little like consulting the law of gravitation before going for a walk. Such rules and laws are deduced from the accomplished fact; they are the products of reflection and after-examination, and are in no way a part of the creative impetus. When subject matter is forced to fit into preconceived patterns, there can be no freshness of vision. Following rules of composition can only lead to a tedious repetition of pictorial clichés.

Good composition is only the strongest way of seeing the subject. It cannot be taught because, like all creative effort, it is a matter of personal growth. In common with other artists the photographer wants his finished print to convey to others his own response to his subject. In the fulfilment of this aim, his greatest asset is the directness of the process he employs. But this advantage can only be retained if he simplifies his equipment and technic to the minimum necessary, and keeps his approach free from all formula, art-dogma, rules, and taboos. Only then can he be free to put his photographic sight to use in discovering and revealing the nature of the world he lives in.

Original publication

'Seeing Photographically' in *The Encyclopedia of Photography*, vol. 18 (1964). [Originally published 1943]

PART THREE

Meaning and interpretation

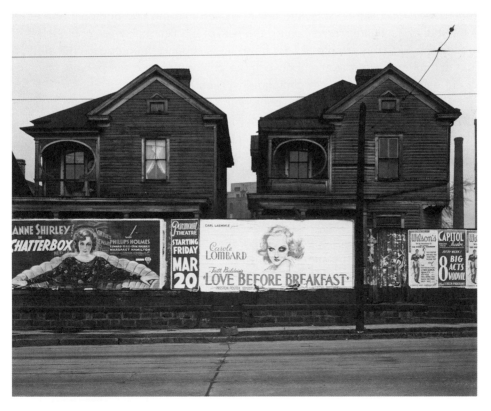

Walker Evans, *Billboards and Frame Houses, Atlanta, Georgia*, 1936. Courtesy of Bridgeman.

Introduction

THE IDEA OF SEMIOTICS, the science of signs, was proposed in 1916 by Ferdinand de Saussure, but it was only in the 1950s and 1960s that theorists, including Roland Barthes (France) and C. S. Pierce (USA), set about examining the structure of non-verbal systems of communication. The aim was to comprehend how meaning is produced. In linguistics there is a distinction between grammar, the rules or system of any particular language, and words, specific units of expression. The relation between words and the objects or events to which they refer is generally arbitrary, resulting from convention (even when onomatopoeic). Meaning emerges from the inter-relation of words and their organisation into phrases, sentences and paragraphs in accordance with particular rules. Thus, language is a coded system (like Morse code) within which comprehension relies upon the familiarity of the reader with the codes and conventions in play, on the ability to 'decode.'

In photography, the question of codification has seemed complex, principally because of direct resemblance between the image and the object of the photograph. In an early essay, Roland Barthes argued that the photographic image in itself is not coded; in effect, photos are 'transparent' renderings of that which they record. Likewise, film critic, André Bazin, argued that the photographic was at its most authentic when intervention on the part of the film-maker (or photographer) was minimised. (See chapter 6.) Such positions support the proposition that there is a natural and direct relation between the photograph and the person, place or occurrence recorded (the pro-photographic event).

Others have characterised the photograph in terms of imprint, or trace, or physical correspondence, but draw attention to what Umberto Eco defines as 'codes of transmission' (associated with technical processes) and to photographic codes (use of light, focus and so on). Such codes are conventional in that they are contrived, but they tend to operate unnoticed, having become taken-for-granted constituents of the 'good' photograph. This model accepts that something of the object, person or place adheres to the image, and that this trace is motivated (a direct effect of the pro-photographic) rather than arbitrary. However, it proposes that the operations of particular coded systems immanently influence interpretation. Various code systems are inter-layered within the image so that we simultaneously see, for instance, clusters of silver on paper (the technical) constituting tonal contrast, which contributes to precision and clarity organised through depth of field (photographic coding), and the formal organisation of the image in terms of aesthetic conventions (art historical).

Semioticians initially proposed that the reader was 'positioned' by the image in ways which constructed specific interpretation. Emphasis was laid upon the power of the image as a text, rather than upon processes of interpretation, although the influence of particular cultural knowledge on 'reading' was acknowledged. Later, attention was paid to effects of differences between social groups and individuals on meaning and interpretation. In early writings on the semiotics of the image, the photographer as producer of meaning was also sidelined when Barthes, and others, proposed (rhetorically) 'the death of the author,' arguing that meaning emerged

through symbolic convention and, by extension, that the image-maker was merely an agent for the recirculation of conventional imagery. This appears borne out in everyday circulation of imagery wherein we seem to repeatedly see the same sorts of news picture, advertisement or domestic narrative. (German artist, Joachim Schmid, advertised for people to send in their family photographs, which he used to demonstrate that we all make similar images (Schmid, 1993).) However, relegation of authorship means that we do not take into account the effects of individual style, specialist subject-matter and commitment of particular image-makers, historically and now, working within various contexts including the gallery and social documentary.

Here, the rhetorical may be paramount; the image may seem to provide evidence or support a particular point of view. As Susan Sontag has remarked, 'A photograph passes for incontrovertible proof that a given thing happened. The picture may distort; but there is always a presumption that something exists, or did exist, which is like what's in the picture' (Sontag, 1979: 5). The image in itself may tell us little about the specific sociohistorical context of its making. Captions are commonly used for further information, and, as is evident in Barthes' essay on 'Rhetoric of the Image,' one of the concerns of semiotics has been to investigate the relation between the image and the written text. This essay was originally published in French in 1964 in *Communications* to accompany – and, in effect, as a case study for – his 'Elements of Semiology.' It extended and consolidated some of the methodological techniques first proposed in *Mythologies* (1957), in which he commented on a range of everyday cultural phenomena in order to analyse the workings of language (the text of a message) and myth (ideas and references invoked). Subsequently, in 'The Photographic Message' (1961), he problematised the photographic, defining the photograph as an analogue of reality and, thus, as a 'message without a code.' There he noted a distinction between the activities of semiotics and questions to do with the making and with the reception of the message, which he viewed as properly belonging to sociology. He proceeded to focus on ways in which elements within the image, such as pose or photogenic effects, may provoke connotative responses. Here, he invites us to analyse images in terms of the complex layering of signification.

By contrast, Umberto Eco suggests that the rhetorical function of the image emerges principally from iconographic emphasis. Analysing the operations of film, Eco has argued that a combination of codes is complexly articulated in the photographic. As already indicated, these include technical codes associated with optics and perception or seated in the mode of transmission (for instance, the concentrations of dots that form newsprint or the arithmetical system underlying the digital). They also include broader cultural codes of recognition, representation and iconography, inter-related with aesthetics; stylistic and rhetorical conventions. Here, Eco explores the symbolic power of the (photojournalistic) image. Its inclusion both remarks the force of photojournalism and acknowledges the status of Eco as, alongside Barthes, a key figure in visual semiotic analysis.

Semiotics was part of a broader concern to analyse and comprehend cultures in terms of integral structures of meaning; this was developed in particular within anthropology, by Claude Lévi-Strauss. Early semiotics was criticised for formalism, in particular for failure to take into account audience reception and interpretation.

As we see from several of the chapters, semiotics now tends to be used in conjunction with other disciplines within visual cultural studies. As such, what might otherwise have been dismissed as an over-rigid structuralist discipline has had lasting academic influence.

Psychoanalysis was increasingly drawn upon in conjunction with semiotics in order to analyse photographic effects in relation to ideological operations. Victor Burgin's contribution, written when he was teaching photography students at the Polytechnic of Central London (now University of Westminster), employs semiotic and psychoanalytic models in order to investigate the structure of representation of the image and the position offered to the viewer in terms of ideology and subjectivity. It is one of three essays by him included in his edited collection, *Thinking Photography*, that, in its era, constituted a key contribution towards a materialist analysis of photography. (His introduction to the collection remains worth noting for its succinct definitional discussion of the Marxist debates about ideology and culture which influenced academic enquiry in Britain at the time.)

Ian Walker likewise reflects on the space within the image, and ways in which our eyes enter into the picture. He extends questions of reading and interpretation through addressing the specific context and circumstances of viewing not only in terms of the scale or an image and where it is situated, but also what is going on for the spectator, whether staring at a computer screen, handling an editioned print in an archive or gallery, or travelling to see a picture in a destination museum. Estelle Jussim asks parallel questions relating to time and place, remarking on the extent to which present assumptions and experiences re-inflect our readings of pictures from the past. For both writers, meaning is not fixed; rather it is negotiated in part through the circumstances of our encounter with an image and what we bring into play in order to interpret what we think we are seeing. Elizabeth Edwards introduces a further element into these discussions, reminding us that any such encounter is an embodied experience, and that photographic prints are tactile objects, that we might handle and discuss, drawing upon sensibilities other than the visual. All three writers emphasise that meaning does not reside in the image; rather it is a matter of teasing out an interpretation based not only on what we see, but also on the circumstances of our encounter with images and our relation to them in terms of time, place, previous or assumed knowledge and personal histories. In order to analyse processes of interpretation we have to acknowledge the effects and affects of complex and fluid social and historical relations.

Taking psychoanalysis as a theoretical touchstone, Christian Metz explores photography in everyday contexts through contrasting film and photography. Drawing upon Freud, Metz considers the photograph as a 'fetish' in the twin sense that it stands in for and thereby comes to symbolise that to which it refers and it also, in psychoanalytic terms, displaces difficulties associated with the referent. His final point qualifying psychoanalytic theory as influential *through suggestion* remains pertinent when considering theoretical models and methods in visual studies.

Metz references Peter Wollen who, in the late 1980s, explored distinctions between the still and the moving image. Through contrasting the time-based nature of film with the 'frozen moment' that is the photograph, Peter Wollen speculates on the defining characteristics of each medium. He suggests that film has an

immediacy, a 'here and newness', and an ability to carry us along in fascination; this contrasts with the 'there and thenness' of the photograph. Written originally for a collection focussed on postmodernity and photography, this essay suggests slippages which refuse the possibility of making definitive statements either about distinctions between the time-based and the still or, indeed, about the conceptual nature and affects of photographs. His contribution remains prescient, especially given contemporary camera technologies whereby the still and moving imagery have become inter-changeable.

References and selected further reading

Bignell, J. (1997) *Media Semiotics: An Introduction*. Manchester: Manchester University Press. Includes discussion of the work of Roland Barthes and sections analysing words and images in advertising, newspapers, and women's magazines.

Freud, S. (1927) [1977] 'Fetishism' in *On Sexuality*, Vol. 7, *The Pelican Freud Library*. Harmondsworth: Penguin.

Hariman, R. and Lucaites, J.L. (2007) *No Logo Needed*. Chicago: University of Chicago Press. On iconic photographs, public culture, memory and civic identity.

Hawkes, T. (1991) *Structuralism and Semiotics*. London: Methuen; revised edition. Introduction to models and debates.

Lister, M. and Wells, L. (2000) 'Seeing Beyond Belief: Cultural Studies as an Approach to Analysing the visual' in Carey Jewitt and Theo van Leeuwen (eds.) *Handbook of Visual Analysis*. London: Sage. Semiotics deployed as one of a range of approaches to visual analysis.

Schmid, J. (1993) *Taking Snapshots. Amateur Photography in Germany from 1900 to the Present*. The Queen's Hall, Edinburgh: Fotofeis (International tour 1993–1998: York, New Delhi, Kecskemét, Warsaw, Plovdiv, Bratislava, Belgrad, Skopje, Bandung, Singapur, Manila, Bangkok, San Francisco, Yaoundé, Lomé, Addis Abeba, London, Edinburgh).

Sontag, S. (1979) *On Photography*. Harmondsworth: Penguin. New edition, 2002, with introduction by John Berger. Essays first published in *The New York Review of Books*, 1973, 1974, 1977. First published as a collection, 1977.

Bibliography of essays in part three

Barthes, R. (1977) 'Rhetoric of the Image' in Stephen Heath (trans. and ed.) *Image-Music-Text*. London: Fontana. Originally published, 1964.

Burgin, V. (1982) 'Looking at Photographs' in Burgin (ed.) *Thinking Photography*. London: Macmillan.

Eco, U. (1986) 'A Photograph' in *Faith in Fakes*. London: Secker & Warburg. Originally published, 1977.

Edwards, E. (2012) 'Objects of Affect: Photography Beyond the Image'. *Annual Review of Anthropology*, 41, pp. 221–34.

Jussim, E. (1989) 'The Eternal Moment: Photography and Time' in *The Eternal Moment, Essays on the Photographic Image*. New York: Aperture.

Metz, C. (1985) 'Photography and Fetish' in *October 34*. Cambridge, MA: MIT Press. Reprinted in Carol Squires (ed.) (1990) *The Critical Image*. Seattle: Bay Press/London: Lawrence and Wishart.

Walker, I. (2005) 'Through the Picture Plane: On Looking into Photographs' in Martha Langford (ed.) *Image and Imagination*. Montreal: McGill-Queens University.

Wollen, P. (1984) 'Fire and Ice' in John Berger and Olivier Richon (eds.) *Other than Itself*. Manchester: Cornerhouse.

Roland Barthes

RHETORIC OF THE IMAGE

ACCORDING TO AN ANCIENT ETYMOLOGY, the word *image* should be linked to the root *imitari*. Thus we find ourselves immediately at the heart of the most important problem facing the semiology of images: can analogical representation (the 'copy') produce true systems of signs and not merely simple agglutinations of symbols? Is it possible to conceive of an analogical 'code' (as opposed to a digital one)? We know that linguists refuse the status of language to all communication by analogy – from the 'language' of bees to the 'language' of gesture – the moment such communications are not doubly articulated, are not founded on a combinatory system of digital units as phonemes are. Nor are linguists the only ones to be suspicious as to the linguistic nature of the image; general opinion too has a vague conception of the image as an area of resistance to meaning – this in the name of a certain mythical idea of Life: the image is re-presentation, which is to say ultimately resurrection, and, as we know, the intelligible is reputed antipathetic to lived experience. Thus from both sides the image is felt to be weak in respect of meaning: there are those who think that the image is an extremely rudimentary system in comparison with language and those who think that signification cannot exhaust the image's ineffable richness. Now even – and above all if – the image is in a certain manner the *limit* of meaning, it permits the consideration of a veritable ontology of the process of signification. How does meaning get into the image? Where does it end? And if it ends, what is there *beyond*? Such are the questions that I wish to raise by submitting the image to a spectral analysis of the messages it may contain. We will start by making it considerably easier for ourselves: we will only study the advertising image. Why? Because in advertising the signification of the image is undoubtedly intentional; the signifieds of the advertising message are formed *a priori* by certain attributes of the product and these signifieds have to be transmitted as clearly as possible. If the image contains signs, we can be sure that in advertising these signs are full, formed with a view to the optimum reading: the advertising image is *frank*, or at least emphatic.

The three messages

Here we have a Panzani advertisement: some packets of pasta, a tin, a sachet, some tomatoes, onions, peppers, a mushroom, all emerging from a half-open string bag, in yellows and greens on a red background.[1] Let us try to 'skim off' the different messages it contains.

The image immediately yields a first message whose substance is linguistic; its supports are the caption, which is marginal, and the labels, these being inserted into the natural disposition of the scene, 'en abyme'. The code from which this message has been taken is none other than that of the French language; the only knowledge required to decipher it is a knowledge of writing and French. In fact, this message can itself be further broken down, for the sign *Panzani* gives not simply the name of the firm but also, by its assonance, an additional signified, that of 'Italianicity'. The linguistic message is thus twofold (at least in this particular image): denotational and connotational. Since, however, we have here only a single typical sign,[2] namely that of articulated (written) language, it will be counted as one message.

Putting aside the linguistic message, we are left with the pure image (even if the labels are part of it, anecdotally). This image straightaway provides a series of discontinuous signs. First (the order is unimportant as these signs are not linear), the idea that what we have in the scene represented is a return from the market. A signified which itself implies two euphoric values: that of the freshness of the products and that of the essentially domestic preparation for which they are destined. Its signifier is the half-open bag which lets the provisions spill out over the table, 'unpacked'. To read this first sign requires only a knowledge which is in some sort implanted as part of the habits of a very widespread culture where 'shopping around for oneself' is opposed to the hasty stocking up (preserves, refrigerators) of a more 'mechanical' civilization. A second sign is more or less equally evident; its signifier is the bringing together of the tomato, the pepper, and the tricoloured hues (yellow, green, red) of the poster; its signified is Italy or rather *Italianicity*. This sign stands in a relation of redundancy with the connoted sign of the linguistic message (the Italian assonance of the name *Panzani*) and the knowledge it draws upon is already more particular; it is a specifically 'French' knowledge (an Italian would barely perceive the connotation of the name, no more probably than he would the Italianicity of tomato and pepper), based on a familiarity with certain tourist stereotypes. Continuing to explore the image (which is not to say that it is not entirely clear at the first glance), there is no difficulty in discovering at least two other signs: in the first, the serried collection of different objects transmits the idea of a total culinary service, on the one hand as though Panzani furnished everything necessary for a carefully balanced dish and on the other as though the concentrate in the tin were equivalent to the natural produce surrounding it; in the other sign, the composition of the image, evoking the memory of innumerable alimentary paintings, sends us to an aesthetic signified: the 'nature morte' or, as it is better expressed in other languages, the 'still life';[3] the knowledge on which this sign depends is heavily cultural. It might be suggested that, in addition to these four signs, there is a further information pointer, that which tells us that this is an advertisement and which arises both from the place of the image in the magazine and from the emphasis of the labels (not to mention the caption). This last information, however, is co-extensive with the

scene; it eludes signification insofar as the advertising nature of the image is essentially functional; to utter something is not necessarily to declare *I am speaking,* except in a deliberately reflexive system such as literature.

Thus there are four signs for this image and we will assume that they form a coherent whole (for they are all discontinuous), require a generally cultural knowledge, and refer back to signifieds each of which is global (for example, *Italianicity*), imbued with euphoric values. After the linguistic message, then, we can see a second, iconic message. Is that the end? If all these signs are removed from the image, we are still left with a certain informational matter; deprived of all knowledge, I continue to 'read' the image, to 'understand' that it assembles in a common space a number of identifiable (nameable) objects, not merely shapes and colours. The signifieds of this third message are constituted by the real objects in the scene, the signifiers by these same objects photographed, for, given that the relation between thing signified and image signifying in analogical representation is not 'arbitrary' (as it is in language), it is no longer necessary to dose the relay with a third term in the guise of the psychic image of the object. What defines the third message is precisely that the relation between signified and signifier is quasi-tautological; no doubt the photograph involves a certain arrangement of the scene (framing, reduction, flattening) but this transition is not a *transformation* (in the way a coding can be); we have here a loss of the equivalence characteristic of true sign systems and a statement of quasi-identity. In other words, the sign of this message is not drawn from an institutional stock, is not coded, and we are brought up against the paradox (to which we will return) of a *message without a code.*[4] This peculiarity can be seen again at the level of the knowledge invested in the reading of the message; in order to 'read' this last (or first) level of the image, all that is needed is the knowledge bound up with our perception. That knowledge is not nil, for we need to know what an image is (children only learn this at about the age of four) and what a tomato, a string bag, a packet of pasta are, but it is a matter of an almost anthropological knowledge. This message corresponds, as it were, to the letter of the image and we can agree to call it the literal message, as opposed to the previous symbolic message.

If our reading is satisfactory, the photograph analysed offers us three messages: a linguistic message, a coded iconic message, and a non-coded iconic message. The linguistic message can be readily separated from the other two, but since the latter share the same (iconic) substance, to what extent have we the right to separate them? It is certain that the distinction between the two iconic messages is not made spontaneously in ordinary reading: the viewer of the image receives *at one and the same time* the perceptual message and the cultural message, and it will be seen later that this confusion in reading corresponds to the function of the mass image (our concern here). The distinction, however, has an operational validity, analogous to that which allows the distinction in the linguistic sign of a signifier and a signified (even though in reality no one is able to separate the 'word' from its meaning except by recourse to the metalanguage of a definition). If the distinction permits us to describe the structure of the image in a simple and coherent fashion and if this description paves the way for an explanation of the role of the image in society, we will take it to be justified. The task now is thus to reconsider each type of message so as to explore it in its generality, without losing sight of our aim of understanding the overall structure of the image, the final interrelationship of the three messages. Given that what is in question is not a 'naive' analysis but a structural description[5] the order of the messages will be modified a little by the

inversion of the cultural message and the literal message; of the two iconic messages, the first is in some sort imprinted on the second: the literal message appears as the *support* of the 'symbolic' message. Hence, knowing that a system which takes over the signs of another system in order to make them its signifiers is a system of connotation,[6] we may say immediately that the literal image is *denoted* and the symbolic image *connoted*. Successively, then, we shall look at the linguistic message, the denoted image, and the connoted image.

The linguistic message

Is the linguistic message constant? Is there always textual matter in, under, or around the image? In order to find images given without words, it is doubtless necessary to go back to partially illiterate societies, to a sort of pictographic state of the image. From the moment of the appearance of the book, the linking of text and image is frequent, though it seems to have been little studied from a structural point of view. What is the signifying structure of 'illustration'? Does the image duplicate certain of the informations given in the text by a phenomenon of redundancy or does the text add a fresh information to the image? The problem could be posed historically as regards the classical period with its passion for books with pictures (it was inconceivable in the eighteenth century that editions of La Fontaine's *Fables* should not be illustrated) and its authors such as Menestrier who concerned themselves with the relations between figure and discourse.[7] Today, at the level of mass communications, it appears that the linguistic message is indeed present in every image: as title, caption, accompanying press article, film dialogue, comic strip balloon. Which shows that it is not very accurate to talk of a civilization of the image – we are still, and more than ever, a civilization of writing,[8] writing and speech continuing to be the full terms of the informational structure. In fact, it is simply the presence of the linguistic message that counts, for neither its position nor its length seem to be pertinent (a long text may only comprise a single global signified, thanks to connotation, and it is this signified which is put in relation with the image). What are the functions of the linguistic message with regard to the (twofold) iconic message? There appear to be two: *anchorage* and *relay*.

As will be seen more clearly in a moment, all images are polysemous; they imply, underlying their signifiers, a 'floating chain' of signifieds, the reader able to choose some and ignore others. Polysemy poses a question of meaning and this question always comes through as a dysfunction, even if this dysfunction is recuperated by society as a tragic (silent, God provides no possibility of choosing between signs) or a poetic (the panic 'shudder of meaning' of the Ancient Greeks) game; in the cinema itself, traumatic images are bound up with an uncertainty (an anxiety) concerning the meaning of objects or attitudes. Hence in every society various techniques are developed intended to fix the floating chain of signifieds in such a way as to counter the terror of uncertain signs; the linguistic message is one of these techniques. At the level of the literal message, the text replies – in a more or less direct, more or less partial manner – to the question: *what is it?* The text helps to identify purely and simply the elements of the scene and the scene itself; it is a matter of a denoted description of the image (a description which is often incomplete) or, in Hjelmslev's terminology, of an *operation* (as opposed to connotation).[9] The denominative function corresponds exactly to an

anchorage of all the possible (denoted) meanings of the object by recourse to a nomen-clature. Shown a plateful of something (in an *Amieux* advertisement), I may hesitate in identifying the forms and masses; the caption ('*rice and tuna fish with mushrooms*') helps me to choose *the correct level of perception*, permits me to focus not simply my gaze but also my understanding. When it comes to the 'symbolic message', the linguistic message no longer guides identification but interpretation, constituting a kind of vice which holds the connoted meanings from proliferating, whether towards excessively individual regions (it limits, that is to say, the projective power of the image) or towards dysphoric values. An advertisement (for *d'Arcy* preserves) shows a few fruits scattered around a ladder; the caption ('*as if from your own garden*') banishes one possible signified (parsimony, the paucity of the harvest) because of its unpleasantness and orientates the reading towards a more flattering signified (the natural and personal character of fruit from a private garden); it acts here as a counter-taboo, combatting the disagreeable myth of the artificial usually associated with preserves. Of course, elsewhere than in advertising, the anchorage may be ideological and indeed this is its principal function; the text *directs* the reader through the signifieds of the image, causing him to avoid some and receive others; by means of an often subtle *dispatching*, it remote-controls him towards a meaning chosen in advance. In all these cases of anchorage, language clearly has a function of elucidation, but this elucidation is selective, a metalanguage applied not to the totality of the iconic message but only to certain of its signs. The text is indeed the creator's (and hence society's) right of inspection over the image; anchorage is a control, bearing a responsibility – in the face of the projective power of pictures – for the use of the message. With respect to the liberty of the signifieds of the image, the text has thus a *repressive* value[10] and we can see that it is at this level that the morality and ideology of a society are above all invested.

Anchorage is the most frequent function of the linguistic message and is commonly found in press photographs and advertisements. The function of relay is less common (at least as far as the fixed image is concerned); it can be seen particularly in cartoons and comic strips. Here text (most often a snatch of dialogue) and image stand in a complementary relationship; the words, in the same way as the images, are fragments of a more general syntagm and the unity of the message is realized at a higher level, that of the story, the anecdote, the diegesis (which is ample confirmation that the diegesis must be treated as an autonomous system).[11] While rare in the fixed image, this relay-text becomes very important in film, where dialogue functions not simply as elucidation but really does advance the action by setting out, in the sequence of messages, meanings that are not to be found in the image itself. Obviously, the two functions of the linguistic message can co-exist in the one iconic whole, but the dominance of the one or the other is of consequence for the general economy of a work. When the text has the diegetic value of relay, the information is more costly, requiring as it does the learning of a digital code (the system of language); when it has a substitute value (anchorage, control), it is the image which detains the informational charge and, the image being analogical, the information is then 'lazier': in certain comic strips intended for 'quick' reading the diegesis is confided above all to the text, the image gathering the attributive informations of a paradigmatic order (the stereotyped status of the characters); the costly message and the discursive message are made to coincide so that the hurried reader may be spared the boredom of verbal 'descriptions', which are entrusted to the image, that is to say to a less 'laborious' system.

The denoted image

We have seen that in the image properly speaking, the distinction between the literal message and the symbolic message is operational; we never encounter (at least in advertising) a literal image in a pure state. Even if a totally 'naive' image were to be achieved, it would immediately join the sign of naivety and be completed by a third – symbolic – message. Thus the characteristics of the literal message cannot be substantial but only relational. It is first of all, so to speak, a message by eviction, constituted by what is left in the image when the signs of connotation are mentally deleted (it would not be possible actually to remove them for they can impregnate the whole of the image, as in the case of the 'still life composition'). This evictive state naturally corresponds to a plenitude of virtualities: it is an absence of meaning full of all the meanings. Then again (and there is no contradiction with what has just been said), it is a sufficient message, since it has at least one meaning at the level of the identification of the scene represented; the letter of the image corresponds in short to the first degree of intelligibility (below which the reader would perceive only lines, forms, and colours), but this intelligibility remains virtual by reason of its very poverty, for everyone from a real society always disposes of a knowledge superior to the merely anthropological and perceives more than just the letter. Since it is both evictive and sufficient, it will be understood that from an aesthetic point of view the denoted image can appear as a kind of Edenic state of the image; cleared utopianically of its connotations, the image would become radically objective, or, in the last analysis, innocent.

This utopian character of denotation is considerably reinforced by the paradox already mentioned, that the photograph (in its literal state), by virtue of its absolutely analogical nature, seems to constitute a message without a code. Here, however, structural analysis must differentiate, for of all the kinds of image only the photograph is able to transmit the (literal) information without forming it by means of discontinuous signs and rules of transformation. The photograph, message without a code, must thus be opposed to the drawing which, even when denoted, is a coded message. The coded nature of the drawing can be seen at three levels. Firstly, to reproduce an object or a scene in a drawing requires a set of *rule-governed* transpositions; there is no essential nature of the pictorial copy and the codes of transposition are historical (notably those concerning perspective). Secondly, the operation of the drawing (the coding) immediately necessitates a certain division between the significant and the insignificant: the drawing does not reproduce *everything* (often it reproduces very little), without its ceasing, however, to be a strong message; whereas the photograph, although it can choose its subject, its point of view and its angle, cannot intervene *within* the object (except by trick effects). In other words, the denotation of the drawing is less pure than that of the photograph, for there is no drawing without style. Finally, like all codes, the drawing demands an apprenticeship (Saussure attributed a great importance to this semiological fact). Does the coding of the denoted message have consequences for the connoted message? It is certain that the coding of the literal prepares and facilitates connotation since it at once establishes a certain discontinuity in the image: the 'execution' of a drawing itself constitutes a connotation. But at the same time, insofar as the drawing displays its coding, the relationship between the two messages is profoundly modified: it is no longer the relationship between a nature and a culture (as with the photograph) but that between two cultures; the 'ethic' of the drawing is not the same as that of the photograph.

In the photograph – at least at the level of the literal message – the relationship of signifieds to signifiers is not one of 'transformation' but of 'recording', and the absence of a code clearly reinforces the myth of photographic 'naturalness': the scene *is there*, captured mechanically, not humanly (the mechanical is here a guarantee of objectivity). Man's interventions in the photograph (framing, distance, lighting, focus, speed) all effectively belong to the plane of connotation; it is as though in the beginning (even if utopian) there were a brute photograph (frontal and clear) on which man would then lay out, with the aid of various techniques, the signs drawn from a cultural code. Only the opposition of the cultural code and the natural non-code can, it seems, account for the specific character of the photograph and allow the assessment of the anthropological revolution it represents in man's history. The type of consciousness the photograph involves is indeed truly unprecedented, since it establishes not a consciousness of the *being-there* of the thing (which any copy could provoke) but an awareness of its *having-been-there*. What we have is a new space-time category: spatial immediacy and temporal anteriority, the photograph being an illogical conjunction between the *here-now* and the *there-then*. It is thus at the level of this denoted message or message without code that the *real unreality* of the photograph can be fully understood: its unreality is that of the *here-now*, for the photograph is never experienced as illusion, is in no way a *presence* (claims as to the magical character of the photographic image must be deflated); its reality that of the *having-been-there*, for in every photograph there is the always stupefying evidence of *this is how it was*, giving us, by a precious miracle, a reality from which we are sheltered. This kind of temporal equilibrium (*having-been-there*) probably diminishes the projective power of the image (very few psychological tests resort to photographs while many use drawings): the *this was so* easily defeats the *it's me*. If these remarks are at all correct, the photograph must be related to a pure spectatorial consciousness and not to the more projective, more 'magical' fictional consciousness on which film by and large depends. This would lend authority to the view that the distinction between film and photograph is not a simple difference of degree but a radical opposition. Film can no longer be seen as animated photographs: the *having-been-there* gives way before a *being-there* of the thing; which omission would explain how there can be a history of the cinema, without any real break with the previous arts of fiction, whereas the photograph can in some sense elude history (despite the evolution of the techniques and ambitions of the photographic art) and represent a 'flat' anthropological fact, at once absolutely new and definitively unsurpassable, humanity encountering for the first time in its history *messages without a code*. Hence the photograph is not the last (improved) term of the great family of images; it corresponds to a decisive mutation of informational economies.

At all events, the denoted image, to the extent to which it does not imply any code (the case with the advertising photograph), plays a special role in the general structure of the iconic message which we can begin to define (returning to this question after discussion of the third message): the denoted image naturalizes the symbolic message, it innocents the semantic artifice of connotation, which is extremely dense, especially in advertising. Although the *Panzani* poster is full of 'symbols', there nonetheless remains in the photograph, insofar as the literal message is sufficient, a kind of natural *being-there* of objects: nature seems spontaneously to produce the scene represented. A pseudo-truth is surreptitiously substituted for the simple validity of openly semantic systems; the absence of code disintellectualizes the message because it seems to find in

nature the signs of culture. This is without doubt an important historical paradox: the more technology develops the diffusion of information (and notably of images), the more it provides the means of masking the constructed meaning under the appearance of the given meaning.

Rhetoric of the image

It was seen that the signs of the third message (the 'symbolic' message, cultural or connoted) were discontinuous. Even when the signifier seems to extend over the whole image, it is nonetheless a sign separated from the others: the 'composition' carries an aesthetic signified, in much the same way as intonation although suprasegmental is a separate signifier in language. Thus we are here dealing with a normal system whose signs are drawn from a cultural code (even if the linking together of the elements of the sign appears more or less analogical). What gives this system its originality is that the number of readings of the same lexical unit or *lexia* (of the same image) varies according to individuals. In the *Panzani* advertisement analysed, four connotative signs have been identified; probably there are others (the net bag, for example, can signify the miraculous draught of fishes, plenty, etc.). The variation in readings is not, however, anarchic; it depends on the different kinds of knowledge — practical, national, cultural, aesthetic — invested in the image and these can be classified, brought into a typology. It is as though the image presented itself to the reading of several different people who can perfectly well co-exist in a single individual: *the one lexia mobilizes different lexicons.* What is a lexicon? A portion of the symbolic plane (of language) which corresponds to a body of practices and techniques.[12] This is the case for the different readings of the image: each sign corresponds to a body of 'attitudes' — tourism, housekeeping, knowledge of art — certain of which may obviously be lacking in this or that individual. There is a plurality and a co-existence of lexicons in one and the same person, the number and identity of these lexicons forming in some sort a person's *idiolect.*[13] The image, in its connotation, is thus constituted by an architecture of signs drawn from a variable depth of lexicons (of idiolects); each lexicon, no matter how 'deep', still being coded, if, as is thought today, the *psyche* itself is articulated like a language; indeed, the further one 'descends' into the psychic depths of an individual, the more rarified and the more classifiable the signs become — what could be more systematic than the readings of Rorschach tests? The variability of readings, therefore, is no threat to the 'language' of the image if it be admitted that that language is composed of idiolects, lexicons, and sub-codes. The image is penetrated through and through by the system of meaning, in exactly the same way as man is articulated to the very depths of his being in distinct languages. The language of the image is not merely the totality of utterances emitted (for example at the level of the combiner of the signs or creator of the message), it is also the totality of utterances received:[14] the language must include the 'surprises' of meaning.

Another difficulty in analysing connotation is that there is no particular analytical language corresponding to the particularity of its signifieds — how are the signifieds of connotation to be named? For one of them we ventured the term *Italianicity*, but the others can only be designated by words from ordinary language (*culinary preparation, still life, plenty*); the metalanguage which has to take charge of them at the moment of

the analysis is not specialized. This is a difficulty, for these signifieds have a particular semantic nature; as a seme of connotation, 'plenty' does not exactly cover 'plenty' in the denoted sense; the signifier of connotation (here the profusion and the condensation of the produce) is like the essential cypher of all possible plenties, of the purest idea of plenty. The denoted word never refers to an essence for it is always caught up in a contingent utterance, a continuous syntagm (that of verbal discourse), oriented towards a certain practical transitivity of language; the seme 'plenty', on the contrary, is a concept in a pure state, cut off from any syntagm, deprived of any context and corresponding to a sort of theatrical state of meaning, or, better (since it is a question of a sign without a syntagm), to an *exposed* meaning. To express these semes of connotation would therefore require a special metalanguage and we are left with barbarisms of the *Italianicity* kind as best being able to account for the signifieds of connotation, the suffix *-icity* deriving an abstract noun from the adjective: *Italianicity* is not Italy, it is the condensed essence of everything that could be Italian, from spaghetti to painting. By accepting to regulate artificially – and if needs be barbarously – the naming of the semes of connotation, the analysis of their form will be rendered easier.[15] These semes are organized in associative fields, in paradigmatic articulations, even perhaps in oppositions, according to certain defined paths or, as A. J. Greimas puts it, according to certain semic axes:[16] *Italianicity* belongs to a certain axis of nationalities, alongside Frenchicity, Germanicity, or Spanishicity. The reconstitution of such axes – which may eventually be in opposition to one another – will clearly only be possible once a massive inventory of the systems of connotation has been carried out, an inventory not merely of the connotative system of the image but also of those of other substances, for if connotation has typical signifiers dependent on the different substances utilized (image, language, objects, modes of behaviour) it holds all its signifieds in common: the same signifieds are to be found in the written press, the image, or the actor's gestures (which is why semiology can only be conceived in a so to speak total framework). This common domain of the signifieds of connotation is that of *ideology*, which cannot but be single for a given society and history, no matter what signifiers of connotation it may use.

To the general ideology, that is, correspond signifiers of connotation which are specified according to the chosen substance. These signifiers will be called *connotators* and the set of connotators a *rhetoric*, rhetoric thus appearing as the signifying aspect of ideology. Rhetorics inevitably vary by their substance (here articulated sound, there image, gesture, or whatever) but not necessarily by their form; it is even probable that there exists a single rhetorical *form*, common for instance to dream, literature, and image.[17] Thus the rhetoric of the image (that is to say, the classification of its connotators) is specific to the extent that it is subject to the physical constraints of vision (different, for example, from phonatory constraints) but general to the extent that the 'figures' are never more than formal relations of elements. This rhetoric could only be established on the basis of a quite considerable inventory, but it is possible now to foresee that one will find in it some of the figures formerly identified by the Ancients and the Classics,[18] the tomato, for example, signifies *Italianicity* by metonymy and in another advertisement the sequence of three scenes (coffee in beans, coffee in powder, coffee sipped in the cup) releases a certain logical relationship in the same way as an asyndeton. It is probable indeed that among the metabolas (or figures of the substitution of one signifier for another),[19] it is metonymy which furnishes the image with

the greatest number of its connotators, and that among the parataxes (or syntagmatic figures), it is asyndeton which predominates.

The most important thing, however, at least for the moment, is not to inventorize the connotators but to understand that in the total image they constitute *discontinuous* or better still *scattered traits*. The connotatators do not fill the whole of the lexia, reading them does not exhaust it. In other words (and this would be a valid proposition for semiology in general), not all the elements of the lexia can be transformed into connotators; there always remaining in the discourse a certain denotation without which, precisely, the discourse would not be possible. Which brings us back to the second message or denoted image. In the *Panzani* advertisement, the Mediterranean vegetables, the colour, the composition, the very profusion rise up as so many scattered blocks, at once isolated and mounted in a general scene which has its own space and, as was seen, its 'meaning': they are 'set' in a syntagm *which is not theirs and which is that of the denotation*. This last proposition is important for it permits us to found (retroactively) the structural distinction between the second or literal message and the third or symbolic message and to give a more exact description of the naturalizing function of the denotation with respect to the connotation. We can now understand that *it is precisely the syntagm of the denoted message which 'naturalizes' the system of the connoted message*. Or again: connotation is only system, can only be defined in paradigmatic terms; iconic denotation is only syntagm, associates elements without any system: the discontinuous connotators are connected, actualized, 'spoken' through the syntagm of the denotation, the discontinuous world of symbols plunges into the story of the denoted scene as though into a lustral bath of innocence.

It can thus be seen that in the total system of the image the structural functions are polarized: on the one hand there is a sort of paradigmatic condensation at the level of the connotators (that is, broadly speaking, of the symbols), which are strong signs, scattered, 'reified'; on the other a syntagmatic 'flow' at the level of the denotation — it will not be forgotten that the syntagm is always very close to speech, and it is indeed the iconic 'discourse' which naturalizes its symbols. Without wishing to infer too quickly from the image to semiology in general, one can nevertheless venture that the world of total meaning is torn internally (structurally) between the system as culture and the syntagm as nature: the works of mass communications all combine, through diverse and diversely successful dialectics, the fascination of a nature, that of story, diegesis, syntagm, and the intelligibility of a culture, withdrawn into a few discontinuous symbols which men 'decline' in the shelter of living speech.

Original publication

'Rhetoric of the Image' in *Image Music Text* (1977).
[Originally published 1964]

Notes

1 The *description* of the photograph is given here with prudence, for it already constitutes a metalanguage.

2 By *typical sign* is meant the sign of a system insofar as it is adequately defined by its substance: the verbal sign, the iconic sign, the gestural sign are so many typical signs.

3 In French, the expression *nature morte* refers to the original presence of funereal objects, such as a skull, in certain pictures.

4 Cf. 'The photographic message', in *Image-Music-Text*, ed. Stephen Heath, 1977, pp. 15–31.

5 'Naive' analysis is an enumeration of elements, structural description aims to grasp the relation of these elements by virtue of the principle of the solidarity holding between the terms of a structure: if one term changes, so also do the others.

6 Cf. R. Barthes, *Eléments de sémiologie*, *Communications* 4, 1964, p. 130 [trans. *Elements of Semiology*, London 1967 and New York 1968, pp. 89–92].

7 Menestrier, *L'Art des emblèmes*, 1684.

8 Images without words can certainly be found in certain cartoons, but by way of a paradox; the absence of words always covers an enigmatic intention.

9 *Eléments de sémiologie*, pp. 131–2 [trans. pp. 90–4].

10 This can be seen clearly in the paradoxical case where the image is constructed according to the text and where, consequently, the control would seem to be needless. An advertisement which wants to communicate that in such and such a coffee the aroma is 'locked in' the product in powder form and that it will thus be wholly there when the coffee is used depicts, above this proposition, a tin of coffee with a chain and padlock round it. Here, the linguistic metaphor ('locked in') is taken literally (a well-known poetic device); in fact, however, it is the image which is read first and the text from which the image is constructed becomes in the end the simple choice of one signified among others. The repression is present again in the circular movement as a banalization of the message.

11 Cf. Claude Bremond, 'Le message narratif', *Communications* 4, 1964.

12 Cf. A. J. Greimas, 'Les problèmes de la description mécanographique', *Cahiers de Lexicologie* 1, 1959, p. 63.

13 Cf. *Eléments de sémiologie*, p. 96 [trans. pp. 21–2].

14 In the Saussurian perspective, speech (utterances) is above all that which is emitted, drawn from the language-system (and constituting it in return). It is necessary today to enlarge the notion of language [*langue*], especially from the semantic point of view: language is the 'totalizing abstraction' of the messages emitted *and received*.

15 *Form* in the precise sense given it by Hjelmslev (cf. *Eléments de sémiologie*, p. 105 [trans. pp. 39–41]), as the functional organization of the signifieds among themselves.

16 A. J. Greimas, *Cours de Sémantique*, 1964 (notes roneotyped by the Ecole Normale Supérieure de Saint-Cloud).

17 Cf. Emile Benveniste, 'Remarques sur la fonction du langage dans la découverte freudienne', *La Psychanalyse* 1, 1956, pp. 3–16 [reprinted in E. Benveniste, *Problèmes de linguistique généale*, Paris 1966, Chapter 7; translated as *Problems of General Linguistics*, Coral Gables, Florida 1971].

18 Classical rhetoric needs to be rethought in structural terms (this is the object of a work in progress); it will then perhaps be possible to establish a general rhetoric or linguistics of the signifiers of connotation, valid for articulated sound, image, gesture, etc. See 'L'ancienne Rhétorique (Aide-mémoire)', *Communications* 16, 1970.

19 We prefer here to evade Jakobson's opposition between metaphor and metonymy, for if metonymy by its origin is a figure of contiguity, it nevertheless functions finally as a substitute of the signifier, that is as a metaphor.

Umberto Eco

A PHOTOGRAPH

THE READERS OF *L'ESPRESSO* will recall the tape of the last minutes of
Radio Alice,[1] recorded as the police were hammering at the door. One thing that
impressed many people was how the announcer, as he reported in a tense voice what
was happening, tried to convey the situation by referring to a scene in a movie. There
was undoubtedly something singular about an individual going through a fairly trau-
matic experience as if he were in a film.

There can be only two interpretations. One is the traditional: life is lived as a work
of art. The other obliges us to reflect a bit further: it is the visual work (cinema, video
tape, mural, comic strip, photograph) that is now a part of our memory. Which is quite
different, and seems to confirm a hypothesis already ventured, namely that the younger
generations have absorbed as elements of their behavior a series of elements filtered
through the mass media (and coming, in some cases, from the most impenetrable areas
of our century's artistic experimentation). To tell the truth, it isn't even necessary to
talk about new generations: If you are barely middle-aged, you will have learned per-
sonally the extent to which experience (love, fear, or hope) is filtered through 'already
seen' images. I leave it to moralists to deplore this way of living by intermediate com-
munication. We must only bear in mind that mankind has never done anything else, and
before Nadar and the Lumières, it used other images, drawn from pagan carvings or
the illuminated manuscripts of the Apocalypse.

We can foresee another objection, this time not from cherishers of the tradition:
Isn't it perhaps an unpleasant example of the ideology of scientific neutrality, the way,
when we are faced by active behavior and searing, dramatic events, we always try again
and again to analyze them, define them, interpret them, dissect them? Can we define
that which by definition eludes all defining? Well, we must have the courage to assert
once more what we believe in: Today more than ever political news itself is marked,
motivated, abundantly nourished by the symbolic. Understanding the mechanisms of
the symbolic in which we move means being political. Not understanding them leads
to mistaken politics. Of course, it is also a mistake to reduce political and economic
events to mere symbolic mechanisms; but it is equally wrong to ignore this dimension.

There are unquestionably many reasons, and serious ones, for the outcome of Luciano Lama's intervention[2] at the University of Rome, but one particular reason must not be overlooked: the opposition between two theatrical or spatial structures. Lama presented himself on a podium (however makeshift), thus obeying the rules of a frontal communication characteristic of trade-union, working-class spatiality, facing a crowd of students who have, however, developed other ways of aggregation and interaction, decentralized, mobile, apparently disorganized. Theirs is a different way of organizing space and so that day at the University there was the clash also between two concepts of perspective, the one we might call Brunelleschian and the other cubist. True, anyone reducing the whole story to these factors would be mistaken, but anyone trying to dismiss this interpretation as an intellectual game would be mistaken, too. The Catholic Church, the French Revolution, Nazism, the Soviet Union, and the People's Republic of China, not to mention the Rolling Stones and soccer clubs, have always known very well that the deployment of space is religion, politics, ideology. So let's give back to the spatial and the visual the place they deserve in the history of political and social relations.

And now to another event. These past months, within that variegated and shifting experience that is called 'the movement,' the men carrying .38's have emerged. From various quarters the movement has been asked to denounce them as an alien body; and there were forces exerting pressure both from outside and from within. Apparently this demand for rejection encountered difficulties, and various elements came into play. Synthetically, we can say that many belonging to the movement didn't feel like labeling as outsiders forces that, even if they revealed themselves in unacceptable and tragically suicidal ways, seemed to express a reality of social protest that couldn't be denied. I am repeating discussions that all of us have heard. Basically what was said was this. They are wrong, but they are part of a mass movement. And the debate was harsh, painful.

Now, last week, there occurred a kind of precipitation of all the elements of the debate previously suspended in uncertainty. Suddenly, and I say suddenly because decisive statements were issued in the space of a day, the gunmen were cut off. Why at that moment? Why not before? It's not enough to say that recent events in Milan[3] made a deep impression on many people, because similar events in Rome had also had a profound effect. 'What happened that was new and different?' We may venture a hypothesis, once again recalling that an explanation never explains everything, but becomes part of a landscape of explanations in reciprocal relationship. A photograph appeared.

Many photographs have appeared, but this one made the rounds of all the papers after being published in the *Corriere d'Informazione*. As everyone will recall, it was the photograph of a young man wearing a knitted ski-mask, standing alone, in profile, in the middle of a street, legs apart, arms outstretched horizontally, with both hands grasping a pistol. Other forms can be seen in the background, but the photograph's structure is classical in its simplicity: the central figure, isolated, dominates it.

If it is licit (and it is necessary) to make aesthetic observations in such cases, this is one of those photographs that will go down in history and will appear in a thousand books. The vicissitudes of our century have been summed up in a few exemplary photographs that have proved epoch-making: the unruly crowd pouring into the square during the 'ten days that shook the world'; Robert Capa's dying *miliciano*; the marines planting the flag on Iwo Jima; the Vietnamese prisoner being executed with a shot in the temple; Che Guevara's tortured body on a plank in a barracks. Each of these images has become a myth and has condensed numerous speeches. It has surpassed the individual circumstance that produced it; it no longer speaks of that single character

or of those characters, but expresses concepts. It is unique, but at the same time it refers to other images that preceded it or that, in imitation, have followed it. Each of these photographs seems a film we have seen and refers to other films that had seen it. Sometimes it isn't a photograph but a painting, or a poster.

What did the photograph of the Milanese gunman 'say'? I believe it abruptly revealed, without the need for a lot of digressive speeches, something that has been circulating in a lot of talk, but that words alone could not make people accept. That photograph didn't resemble any of the images which, for at least four generations, had been emblems of the idea of revolution. The collective element was missing; in a traumatic way the figure of the lone hero returned here. And this lone hero was not the one familiar in revolutionary iconography, which when it portrayed a man alone always saw him as victim, sacrificial lamb: the dying *miliciano* or the slain Che, in fact. This individual hero, on the contrary, had the pose, the terrifying isolation of the tough guy of gangster movies or the solitary gunman of the West – no longer dear to a generation who consider themselves metropolitan Indians.

This image suggested other worlds, other figurative, narrative traditions that had nothing to do with the proletarian tradition, with the idea of popular revolt, of mass struggle. Suddenly it inspired a syndrome of rejection. It came to express the following concept: revolution is elsewhere and, even if it is possible, it doesn't proceed via this 'individual' act.

The photograph, for a civilization now accustomed to thinking in images, was not the description of a single event (and, in fact, it makes no difference who the man was, nor does the photograph help in identifying him): it was an argument. And it worked.

It is of no interest to know if it was posed (and therefore faked), whether it was the testimony of an act of conscious bravado, if it was the work of a professional photographer who gauged the moment, the light, the frame, or whether it virtually took itself, was snapped accidentally by unskilled and lucky hands. At the moment it appeared, its communicative career began: once again the political and the private have been marked by the plots of the symbolic, which, as always happens, has proved producer of reality.

Original publication

'A Photograph' in *Faith in Fakes* (1986).
[Originally published 1977]

Notes

1 An independent radical radio station closed down by the police after the Bologna student riots of 1977, on the grounds that the station had incited the rioters and given them information about police movements.
2 Luciano Lama, leader of the Communist-oriented General Confederation of Labor, was violently rejected when he tried to speak to students occupying the University of Rome. The incident confirmed the rupture between the Communist Party and the student movement of 1977.
3 During a confrontation between rioters and police, a policeman was shot.

Victor Burgin

LOOKING AT PHOTOGRAPHS

I T IS ALMOST AS UNUSUAL to pass a day without seeing a photograph as it is to miss seeing writing. In one institutional context or another – the press, family snapshots, billboards, etc. – photographs permeate the environment, facilitating the formation/reflection/inflection of what we 'take for granted'. The daily instrumentality of photography is clear enough, to sell, inform, record, and delight. Clear, but only to the point at which photographic representations lose themselves in the ordinary world they help to construct. Recent theory follows photography beyond where it has effaced its operations in the 'nothing-to-explain'.

It has previously been most usual (we may blame the inertia of our educational institutions for this) to view photography in the light of 'art' – a source of illumination which consigns to shadow the greater part of our day-to-day experience of photographs. What has been most often described is a particular nuancing of 'art history' brought about by the invention of the camera, a story cast within the familiar confines of a succession of 'masters', 'masterworks' and 'movements' – a *partial* account which leaves the social fact of photography largely untouched.

Photography, sharing the static image with *painting*, the camera with *film*, tends to be placed 'between' these two mediums, but it is encountered in a fundamentally different way from either of them. For the majority, paintings and films are only seen as the result of a voluntary act which quite clearly entails an expenditure of time and/or money. Although photographs may be shown in art galleries and sold in book form, most photographs are not seen by deliberate choice, they have no special space or time allotted to them, they are *apparently* (an important qualification) provided free of charge – photographs offer themselves *gratuitously*; whereas paintings and films readily present themselves to critical attention as objects, photographs are received rather as an environment. As a free and familiar coinage of meaning, largely unremarked and untheorised by those amongst whom it circulates, photography shares an attribute of language. However, although it has long been common to speak, loosely, of the 'language of photography', it was not until the 1960s that any systematic investigation of forms

of communication outside of natural language was conducted from the standpoint of linguistic science; such early 'semiotic' studies, and their aftermath, have radically reorientated the theory of photography.

Semiotics, or semiology, is the study of signs, with the object of identifying the systematic regularities from which meanings are construed. In the early phase of 'structuralist' semiology (Roland Barthes's *Elements of Semiology* first appeared in France in 1964)[1] close attention was paid to the analogy between 'natural' language (the phenomenon of speech and writing) and visual 'languages'. In this period, work dealt with the codes of analogy by which photographs denote objects in the world, the codes of connotation through which denotation serves a secondary system of meanings, and the 'rhetorical' codes of juxtaposition of elements within a photograph and between different but adjacent photographs.[2] Work in semiotics showed that there is no 'language' of photography, no single signifying system (as opposed to technical apparatus) upon which all photographs depend (in the sense in which all texts in English ultimately depend upon the English language); there is, rather, a heterogeneous complex of codes upon which photography may draw. Each photograph signifies on the basis of a plurality of these codes, the number and type of which varies from one image to another. Some of these are (at least to first analysis) peculiar to photography (e.g. the various codes built around 'focus' and 'blur'), others are clearly not (e.g. the 'kinesic' codes of bodily gesture). Further, importantly, it was shown that the putatively autonomous 'language of photography' is never free from the determinations of language itself. We rarely see a photograph *in use* which does not have a caption or a title, it is more usual to encounter photographs attached to long texts, or with copy superimposed over them. Even a photograph which has no actual writing on or around it is traversed by language when it is 'read' by a viewer (for example, an image which is predominantly dark in tone carries all the weight of signification that darkness has been given in social use; many of its interpretants will therefore be linguistic, as when we speak metaphorically of an unhappy person being 'gloomy').

The intelligibility of the photograph is no simple thing; photographs are *texts* inscribed in terms of what we may call 'photographic discourse', but this discourse, like any other, engages discourses beyond itself, the 'photographic text', like any other, is the site of a complex 'intertextuality', an overlapping series of previous texts 'taken for granted' at a particular cultural and historical conjuncture. These prior texts, those *presupposed* by the photograph, are autonomous; they serve a role in the actual text but do not appear in it, they are latent to the manifest text and may only be read across it 'symptomatically' (in effect, like the dream in Freud's description, photographic imagery is typically *laconic* – an effect refined and exploited in advertising). Treating the photograph as an object-text, 'classic' semiotics showed that the notion of the 'purely visual' *image* is nothing but an Edenic fiction. Further to this, however, whatever specificity might be attributed to photography at the level of the 'image' is inextricably caught up within the specificity of the social acts which intend that image and its meanings: news photographs help transform the raw continuum of historical flux into the product 'news', domestic snapshots characteristically serve to legitimate the institution of the family, and so on. For any photographic practice, given materials (historical flux, existential experience of family life, etc.) are transformed into an identifiable type of product by men and women using a particular technical method and working within particular social institutions. The significant 'structures' which early semiotics

found in photography are not spontaneously self-generated, they originate in determinate modes of human organisation. The question of meaning therefore is constantly to be referred to the social and psychic formations of the author/reader, formations existentially simultaneous and coextensive but theorised in separate discourses; of these, Marxism and psychoanalysis have most informed semiotics in its moves to grasp the determinations of history and the subject in the production of meaning.

In its structuralist phase, semiotics viewed the text as the objective site of more or less determinate meanings produced on the basis of what significant systems were empirically identifiable as operative 'within' the text. Very crudely characterised, it assumed a coded message and authors/readers who knew how to encode and decode such messages while remaining, so to speak, 'outside' the codes – using them, or not, much as they might pick up and put down a convenient tool. This account was seen to fall seriously short in respect of this fact: as much as we speak language, so language 'speaks' us. All meaning, across all social institutions – legal systems, morality, art, religion, the family, etc. – is articulated within a network of *differences,* the play of presence and absence of conventional significant features which linguistics has demonstrated to be a founding attribute of language. Social practices are structured *like* a language, from infancy, 'growing up' is a growing *into* a complex of significant social practices including, and founded upon, language itself. This general symbolic order is the site of the determinations through which the tiny human animal becomes a social human being, a 'self' positioned in a network of relations to 'others'. The structure of the symbolic order channels and moulds the social and psychic formation of the individual subject, and it is in this sense that we may say that language, in the broad sense of symbolic order, speaks *us*. The subject inscribed in the symbolic order is the product of a channelling of predominantly sexual basic drives within a shifting complex of heterogeneous cultural systems (work, the family, etc.): that is to say, a complex interaction of a *plurality* of subjectivities presupposed by each of these systems. This subject, therefore, is not the fixed, innate entity assumed in classic semiotics but is itself a function of textual operations, an unending process of *becoming* – such a version of the subject, in the same movement in which it rejects any absolute discontinuity between speaker and codes, also evicts the familiar figure of the *artist* as autonomous *ego*, transcending his or her own history and unconscious.

However, to reject the 'transcendental' subject is not to suggest that either the subject or the institutions within which it is formed are caught in a simple mechanistic determinism; the institution of photography, while a product of the symbolic order, also *contributes* to this order. Some earlier writings in semiology, particularly those of Barthes, set out to uncover the language-like organisation of the dominant myths which command the meanings of photographed appearances in our society. More recently, theory has moved to consider not only the structure of appropriation to ideology of that which is 'uttered' in photographs but also to examine the ideological implications inscribed within the *performance* of the utterance. This enquiry directs attention to the object/subject constructed within the technical apparatus itself.[3] The signifying system of photography, like that of classical painting, at once depicts a scene *and the gaze of the spectator*, an object *and* a viewing subject. The two-dimensional analogical signs of photography are formed within an apparatus which is essentially that of the *camera obscura* of the Renaissance. (The *camera obscura* with which Niépce made the first photograph in 1826 directed the image formed by the lens via a mirror on to

a ground-glass screen – precisely in the manner of the modern single-lens reflex camera.) Whatever the object depicted, the manner of its depiction accords with laws of geometric projection which imply a unique 'point-of-view'. It is the position of point-of-view, occupied in fact by the camera, which is bestowed upon the spectator. To the point-of-view, the system of representation adds the *frame* (an inheritance which may be traced through easel painting, via mural painting, to its origin in the convention of post and lintel architectural construction); through the agency of the frame the world is organised into a coherence which it actually lacks, into a parade of tableaux, a succession of 'decisive moments'.

The structure of representation – point-of-view and frame – is intimately implicated in the reproduction of ideology (the 'frame of mind' of our 'points-of-view'). More than any other textual system the photograph presents itself as 'an offer you can't refuse'. The characteristics of the photographic apparatus position the subject in such a way that the object photographed serves to conceal the textuality of the photograph itself – substituting passive receptivity for active (critical) *reading*. When confronted with puzzle photographs of the 'What is it?' variety (usually, familiar objects shot from unfamiliar angles) we are made aware of having to select from sets of possible alternatives, of having to supply information the image itself does not contain. Once we have discovered what the depicted object *is*, however, the photograph is instantly transformed for us – no longer a confusing conglomerate of light and dark tones, of uncertain edges and ambivalent volumes, it now shows a 'thing' which we invest with a full identity, a *being*. With most photographs we see, this decoding and *investiture* takes place instantaneously, unselfconsciously, 'naturally'; but it does take place – the wholeness, coherence, identity, which we attribute to the depicted scene is a projection, a refusal of an impoverished reality in favour of an imaginary plenitude. The imaginary object here, however, is not 'imaginary' in the usual sense of the word, it is *seen*, it has projected an image. An analogous imaginary investiture of the real constitutes an early and important moment in the construction of the self, that of the 'mirror stage' in the formation of the human being, described by Jaques Lacan:[4] between its sixth and eighteenth month, the infant, which experiences its body as fragmented, uncentred, projects its potential unity, in the form of an ideal self, upon other bodies and upon its own reflection in a mirror; at this stage the child does not distinguish between itself and others, it *is* the other (separation will come later through the knowledge of sexual *difference*, opening up the world of language, the symbolic order); the idea of a unified body necessary to the concept of self-identity has been formed, but only through a rejection of reality (rejection of incoherence, of separation).

Two points in respect of the mirror-stage of child development have been of particular interest to recent semiotic theory: first, the observed correlation between the formation of identity and the formation of *images* (at this age the infant's powers of vision outstrip its capacity for physical co-ordination), which led Lacan to speak of the 'imaginary' function in the construction of subjectivity; second, the fact that the child's recognition of itself in the 'imaginary order', in terms of a reassuring coherence, is a *misrecognition* (what the eye can see for its-*self* here is precisely that which is not the case). Within the context of such considerations the 'look' itself has recently become an object of theoretical attention. To take an example – *General Wavell watches his gardener at work*, made by James Jarché in 1941;[5] it is easy enough today to read the immediate connotations of paternalistic imperialism inscribed in this 35-year-old picture and

anchored by the caption (the general watches *his* gardener). A first analysis of the object-text would unpack the connotational oppositions constructing the ideological message. For example, primarily and obviously, *Western/Eastern*, the latter term of this opposition engloblng the marks of a radical 'otherness'; or again, the placing of the two men within the implied opposition *capital/labour*. Nevertheless, even in the presence of such obviousness another obviousness asserts itself – the very 'natural' casualness of the scene presented to us disarms such analysis, which it characterises as an *excessive* response. But excess production is generally on the side of ideology, and it is precisely in its apparent ingenuousness that the ideological power of photography is rooted – our conviction that we are free to choose what we make of a photograph hides the complicity to which we are recruited in the very act of *looking*. Following recent work in film theory,[6] and adopting its terminology, we may identify four basic types of look in the photograph: the look of the camera as it photographs the 'pro-photographic' event; the look of the viewer as he or she looks at the photograph; the 'intradiegetic' looks exchanged between people (actors) depicted in the photograph (and/or looks from actors towards objects); and the look the actor may direct to the camera.

In the reading implied by the title to Jarché's photograph, the general looks at the gardener, who receives this look with his own gaze cast submissively to the ground. In an additional reading, the general's look may be interpreted as directed at the camera, that is to say, to the viewing subject (representation identifies the camera's look with that of the subject's point-of-view). This full-frontal gaze, a posture almost invariably adopted before the camera by those who are not professional models, is a gaze commonly received when we look at ourselves in a mirror, we are invited to return it in a

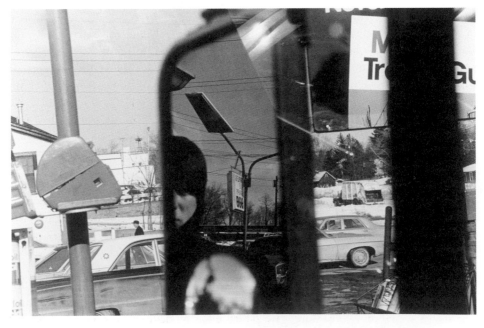

Figure 17.1 Lee Friedlander, *Hillcrest, NY,* 1970. © Lee Friedlander. Courtesy of the artist and the Fraenkel Gallery, San Francisco.

gaze invested with narcissistic identification (the dominant alternative to such identification *vis-à-vis* photographic imagery is voyeurism). The general's look returns our own in direct line, the look of the gardener intersects this line. Face hidden in shadow (labour here is literally featureless) the gardener *cuts off* the general (our own power and authority in imaginary identification) from the viewing subject; the sense of this movement is amplified via the image of the mower – instrument of amputation – which condenses references to scythe and, through its position (still photographs are texts built upon *coincidences*), penis (the correlates: white fear of black sexuality/fear of castration). Even as we turn back (as we invariably must) from such an excess of reading to the literal 'content' of this picture we encounter the same figure: the worker 'comes between' the general and the peace of his garden, the black man literally *disturbs*. Such overlaying determinations, which can be only sketchily indicated here, act in concert with the empirically identifiable connotators of the object-text to show the gardener as out-of-place, a threat, an intruder in what presumably is his own land – material considerations thus go beyond the empirical in the overdetermination of ideology.

The effect of representation (the recruitment of the subject in the production of ideological meaning) requires that the stage of the represented (that of the photograph as object-text) meet the stage of the representing (that of the viewing subject) in a 'seamless join'. Such an integration is achieved within the system of Jarché's picture where the inscribed ideology is read from a subject position of founding centrality; in the photograph *Hillcrest, New York,* by Lee Friedlander (1970) (see Figure 17.1) this position itself is under threat. The attack comes from two main sources: first, the vanishing-point perspective system which recruits the subject in order to complete itself has here been partially subverted through ambiguous figure/ground relationships – it is only with some conscious effort that what is seen in this photograph may be organised in terms of a coherent and singular site/(sight); second, the device of the minor central to the picture here generates a fundamental ambivalence. A bisected head and shoulders rises from bottom-centre frame; the system of representation has accustomed us to identifying our own point-of-view with the look of the camera, and therefore a full-frontal mirror reflection with the self; here, however, there is no evidence (such as the reflection of the camera) to confirm whether we are looking at the reflection of the photographer or at that of some other person – the quartered figure has unresolved '(imaginary) self'/'other' status. In Friedlander's picture, the conjunction of technical photographic apparatus and raw phenomenological flux has almost failed to guarantee the subjective *effect* of the camera – a coherence founded in the unifying gaze of a unified, punctual, subject. Almost, but not quite – the picture (and therefore the subject) remains 'well composed' (in common with Jarché's picture, albeit differently from it). We know very well what 'good' composition is – art schools know how to teach it – but not *why* it is; 'scientific' accounts of pictorial composition tend merely to reiterate *what* it is under a variety of differing descriptions (e.g. those of Gestalt psychology). Consideration of our *looking* at photographs may help illuminate this question, and return us to the topic of our characteristic use of photographs, with which we began.

To look at a photograph beyond a certain period of time is to court a frustration; the image which on first looking gave pleasure has by degrees become a veil behind which we now desire to see. It is not an arbitrary fact that photographs are deployed so that we do not look at them for long; we use them in such a manner that we may

play with the coming and going of our *command* of the scene/(seen) (an official of a national art museum who followed visitors with a stop-watch found that an average of ten seconds was devoted by an individual to any single painting – about the average shot-length in classic Hollywood cinema). To remain long with a single image is to risk the loss of our imaginary command of the look, to relinquish it to that absent other to whom it belongs by right – the camera. The image then no longer receives *our* look, reassuring us of our founding centrality, it rather, as it were, avoids our gaze, confirming its allegiance to the other. As alienation intrudes into our captivation by the image we can, by averting our gaze or turning a page, reinvest our looking with authority. (The 'drive to master' is a component of scopophilia, sexually based pleasure in looking.)

The awkwardness which accompanies the over-long contemplation of a photograph arises from a consciousness of the monocular perspective system of representation as a systematic deception. The lens arranges all information according to laws of projection which place the subject as geometric point of origin of the scene in an imaginary relationship with real space, but facts intrude to deconstruct the initial response: the eye/(I) cannot move within the depicted space (which offers itself precisely to such movement), it can only move *across* it to the points where it encounters the frame. The subject's inevitable recognition of the *rule* of the frame may, however, be postponed by a variety of strategies which include 'compositional' devices for moving the eye from the framing edge. 'Good composition' may therefore be no more or less than a set of devices for prolonging our imaginary command of the point-of-view, our *self*-assertion, a device for retarding recognition of the autonomy of the frame, and the authority of the *other* it signifies. 'Composition' (and indeed the interminable discourse *about* composition – formalist criticism) is therefore a means of prolonging the imaginary force, the real power to please, of the photograph, and it may be in this that it has survived so long, within a variety of rationalisations, as a criterion of value in visual art generally. Some recent theory[7] has privileged film as the *culmination* of work on a 'wish-fulfilling machine', a project for which photography, in this view, constitutes only a historical moment; the darkness of the cinema has been evinced as a condition for an artificial 'regression' of the spectator; film has been compared with hypnosis. It is likely, however, that the apparatus which desire has constructed for itself incorporates *all* those aspects of contemporary Western society for which the Situationists chose the name *spectacle*: aspects forming an integrated specular regime, engaged in a mutual exchange of energies, not strung out in mutual isolation along some historicist progress; desire needs no material darkness in which to stage its imaginary satisfactions; day-dreams, too, can have the potency of hypnotic suggestion.

Precisely because of its real role in constructing the imaginary, the misrecognitions necessary to ideology, it is most important that photography be recovered from its own appropriation to this order. Counter to the nineteenth-century aesthetics which still dominate most teaching of photography, and most writings on photography, work in semiotics has shown that a photograph is not to be reduced to 'pure form', nor 'window on the world', nor is it a gangway to the presence of an author. A fact of primary social importance is that the photograph is a *place of work*, a structured and structuring space within which the reader deploys, and is deployed by, what codes he or she is familiar with in order to *make sense*. Photography is one signifying system among others in society which produces the ideological subject in the same movement

in which they 'communicate' their ostensible 'contents'. It is therefore important that photography theory take account of the production of this subject as the complex totality of its determinations are nuanced and constrained in their passage through and across photographs.

Original publication

'Looking at Photographs' in *Screen Education*, no. 24 (1977).

Notes

1 Published in English by Jonathan Cape, 1967.
2 For an overview of this work, in its application to photography, see Victor Burgin, 'Photographic Practice and Art Theory', *Studio International*, July–August 1975.
3 See Jean-Louis Baudry, 'Ideological Effects of the Basic Cinematographic Apparatus', *Film Quarterly*, Winter 1974–5.
4 Published in English as 'The Mirror-Phase as Formative of the Function of the I', *New Left Review*, September–October 1968.
5 Unfortunately it has not been possible to obtain this photograph for reproduction here. See Burgin, *Thinking Photography* (1982) for the illustration. (ed.)
6 Anyone familiar with recent film theory will recognise the extent to which my remarks here are indebted to it. The English language locus of this work is *Screen* magazine (see particularly Laura Mulvey, 'Visual Pleasure and Narrative Cinema', *Screen*, Vol. 16, no. 3, Autumn 1975).
7 See particularly Jean-Louis Baudry, 'The Apparatus', *Camera Obscura*, Autumn 1976.

Ian Walker

THROUGH THE PICTURE PLANE: ON LOOKING INTO PHOTOGRAPHS

A S I W R I T E , I have propped up next to the computer screen a photograph by Walker Evans. You probably know it. It shows a row of movie posters in front of two frame houses, and it was taken in Atlanta, Georgia, in March 1936 (Figure 18.1). My eyes are flicking back and forth between the words scrolling across this glowing screen and the stillness of the photograph. I scrutinize it for a few seconds and start to type again.

The space in the photograph is complex. Both the posters and the house fronts lie parallel to the picture plane, almost pushing themselves up onto it, but at the edges and in the centre between the two houses, the space punches back towards factory chimneys and a larger building in the distance. This tension between flatness and depth within the photograph parallels the relationship between the flat surface of the image and its presentation of a reality beyond that surface, between the picture as object in itself and the picture as window on the world. At the same time, though, another tension is played out laterally. For the street is on a slope that pulls down on the foursquare evenness of houses, posters, and, not least, the frame of the picture itself. The symmetry in the picture is not static but precariously balanced.

How have I been looking at the picture? What process has enabled me to describe it in this way? I'm not sure, because looking at a photograph is such a familiar activity that it's hard to analyse what happens when you do it. Certainly, my eyes have been constantly active, darting in to examine details and out again to see the whole picture. But when I say "in" and "out," do I mean that I am able to enter the space and, in some meaningful sense, go back to where the chimneys are? Or am I really just looking at grey shapes on the surface of the paper – shapes that I read as "chimneys"?

On one level, reading the space – or reading into it – is a problem of visual perception: how we interpret spatial distance through gradients of texture, overlapping objects, and so forth.[1] But reading the space also encompasses the memory of our own lived experience. "Entering" the picture is something I do imaginatively by extrapolating from my previous experience of walking up and down roads and imagining what

it would feel like to walk up this road and enter these houses. Our visual examination of a photograph cannot be disengaged from the associations we invest in it. Cognition and imagination elide.

This is one way we might relate the space in the world of the picture to our own sense of space in the actual world. But if I am looking at a photograph in a book or on a gallery wall, how will the literal and immediate three-dimensional space that I occupy influence my response to the "other" space of the photograph? The room I am in may be full or empty; I may be alone or with friends. The picture itself may be big or small, on its own, or with other pictures. Outside, it may be winter or summer, sunny or raining. All these factors – and many more besides – can affect the way I look at the picture, the way I look into it.

We are most aware of this variability when we have travelled to see the picture. I remember a winter's day in Paris, the light grey and limpid. In a gallery behind the Beaubourg, there was an exhibition by Lynne Cohen. The space was an empty, white, post-industrial cube, and the frigid symmetries of Cohen's pictures felt at one with their surroundings. Then I walked across to the Marais, entered a rather grand townhouse, and went upstairs to see a show of Thomas Struth's pictures from China. The melancholy of their Fujicolour precision seemed to shimmer across the Parisian rooftops outside, lit by a pale sun. Whenever I see those photographs by Cohen or Struth now, they carry with them a memory of that afternoon which has settled into their fabric.[2]

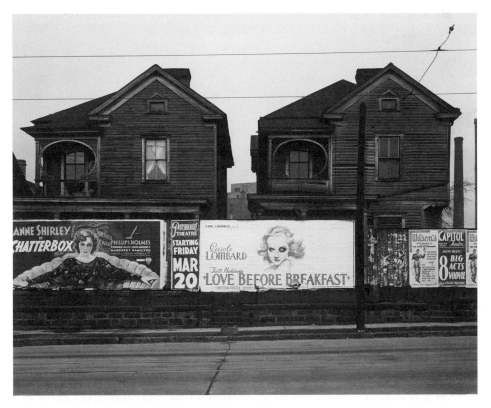

Figure 18.1 Walker Evans, *Billboards and Frame Houses, Atlanta, Georgia, March 1936*. Courtesy of Bridgeman.

I don't need to go to Paris to experience the process whereby a photograph is changed by its context. On my desk I have three different versions of Walker Evans's Atlanta photograph. One of them is a postcard, about 4 by 6 inches, with the photograph surrounded by a thin white border. Next to it is propped my copy of Evans's book *American Photographs,* open on the page with this picture, about halfway through.[3] Looking at the postcard, all its connotations of cheapness, democracy, and disposability come to mind, while the placement of the picture in Evans's own historical arrangement of his work gives the version in the book a certain gravitas. And, in turn, those qualities affect my close scrutiny of the picture itself – emphasizing either its humorous affirmation of popular culture or its value as an icon of modern photography.

My third version is different yet again. About thirty years ago a friend bought me another book by Walker Evans – the catalogue of his negatives held in the Library of Congress in Washington.[4] It gave details on how to order a print from that collection for just $3.50. I decided I wanted the Atlanta Picture, negative no. LC-USF342-8057A, so I sent off my cheque and, a few weeks later, the print arrived.[5] Even though it was made by an anonymous technician and probably printed to a predetermined formula, it still retains – much as I hate to be fetishistic about this – that aura of originality that comes from its contact with the negative itself.

Is this one photograph in different versions, transmitted through various physical media, essentially the same? Or are these different images, with a common source, but so transformed as to make the differences greater than the similarities? Again, to what extent is it a material question, depending on the physicality of the image and its context? Or does it depend, rather, on how I imaginatively and intellectually respond to its different forms? Can I set aside the quality of postcard, book, or print as I try to "enter" the picture, or is it constantly affecting my response in ways I don't immediately recognize?

I could continue the search for this image by Walker Evans in different sites, beginning with all the other books where it might appear, always subtly changing in relation to the images and text around it. I could switch away from these words for a few minutes to go searching on the Internet, where I would surely find the picture floating somewhere out there. Or I could pursue the search for origination. I could book myself into the Erna and Victor Hasselblad Photography Study Research Center at the Museum of Modern Art in New York, put on white gloves, and look at the print they own, made by Evans himself. Or I could go to the Library of Congress, where I might, with a good deal of wheedling, get to see the negative itself – the ur-form of the image that is in itself not yet the image.[6]

But would I then be looking at the photograph? Does it exist before the positive print is made? Does it indeed "exist" before it is looked at? The questions we need to ask here are not only about the decisions made by the picture's maker (the photographer, of course, but maybe also the editor, the curator, the institution) but ultimately about the process whereby the picture is seen by a viewer. How much do we make the picture what it is in the act of looking at it and making it part of our own visual culture? In 1957 Marcel Duchamp delivered a lecture in which he argued that "the creative act is not performed by the artist alone; the spectator brings the work in contact with the external world by deciphering and interpreting its inner qualifications."[7] Keen to contradict a Modernist purism that would see the artwork as self-sufficient, Duchamp proposed that a picture does not really mean anything – even really exist – until someone is looking at it.

I want to consider how Duchamp's argument might be applied to photography, where there are particular elements that make his proposition both intriguing and problematic. But first it's useful to examine the conventions of painting, the medium that set the agenda for the way we look at flat, rectangular images. And it is in painting, specifically in Western post-Renaissance easel painting, that we primarily encounter the notion that we can enter a picture and move through its space. As Brian O'Doherty put it, "the easel picture is like a portable window that, once set on the wall, penetrates it with deep space."[8]

One of the most brilliantly condensed analyses of the ways in which post-Renaissance culture has engaged with pictorial space is Martin Jay's essay "Scopic Regimes of Modernity."[9] He begins by describing the dominant visual model, which he terms "Cartesian perspectivalism." The spectator here was placed at the centre of the picture, a position that was "static, unblinking and fixated . . . producing a visual take that was eternalised, reduced to one 'point of view' and disembodied."[10] The scene is laid for us, and we can "enter" it directly, straight up that central line towards the vanishing point.

In fact, few paintings after the Renaissance (and even then) work quite so smoothly, but still there is something very seductive about the notion that we can walk into a painting. In 1906 Herbert Winckworth Tompkins published a book about the paintings of John Constable – one of the earliest attempts to find the sources of Constable's art in his native country. At one point in the book, though, Tompkins seeks to find Constable's landscape in his art, specifically in his most famous painting *The Hay Wain* (Figure 18.2). "Go into the National Gallery," he writes, "view that landscape steadily and sympathetically from a sufficient distance, and presently the frame, the wall, the Gallery itself is

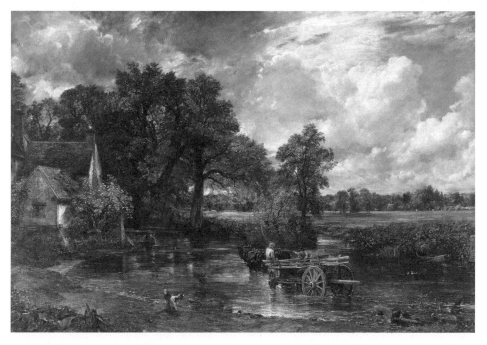

Figure 18.2 John Constable, *The Hay Wain*, 1821 [original in colour]. © Classicpaintings / Alamy Stock Photo.

gone and you are looking, not upon *The Hay Wain* by Constable, but upon a scene by the riverside, in the full light of noonday, a scene truly typical of the England you love so well."[11]

The picture will work so powerfully, then, that the viewer will be transported through the frame into the space on the other side. But Tompkins's move through the picture plane is not based in the cool, clear logic of perspectival illusion. It is affected by an emotional attachment to the place depicted – by a desire to be there. And the picture need not be particularly realistic to create that desire. Indeed, given that it is a dream world we often seek, it may be better if it is not. In Kurosawa's film *Dreams,* a young Japanese art student enters the world of Van Gogh, where he deliriously wanders through both the paintings and the actual landscape of northern France, and he meets and talks with Vincent himself (played by Martin Scorsese!).[12]

"Cartesian perspectivalism" has undoubtedly been central to Western picture making, but Jay himself suggests that it has not gone unchallenged. He outlines two other models of vision that, though they derive from the Renaissance model, also oppose it. One he adopts from Svetlana Alpers's book *The Art of Describing,* where she characterizes Dutch seventeenth-century painting in opposition to Italian art of the period: "attention to many small things versus a few large ones . . . the surface of objects, their colours and textures, dealt with rather than their placement in a legible space; an unframed image versus one that is clearly framed; one with no clearly situated viewer compared to one with such a viewer."[13] Finally, Jay introduces a third model, which he identifies with the Baroque; it is, by contrast to both of the above, "dazzling, disorientating, ecstatic," seeking to overwhelm the viewer's sense of his or her own position.[14]

It's interesting to map Jay's discussion onto photography – something he himself does rather briefly. The camera is, of course, an extension of the machines used ever since the Renaissance to order vision, and the way we are invited to enter a photograph by Atget has many points of similarity with the way we might enter a painting by Piero della Francesca.[15] But the other models are useful as well. Both Alpers and Jay link "the art of describing" to Peter Galassi's argument that photography was built on a model of topographical sketching.[16] More precisely, Walker Evans's fascination with surfaces – the weathered frontage of a building or the well-used objects on a mantelpiece – can be interestingly read in this way. We are often invited to scan across his pictures rather than penetrate their space. Finally, a sort of baroque vision – excessive and disorientating – might be found in the use of photographic distortion, not only in the Surrealist photography that Jay (following Rosalind Krauss) cites but also in documentary, in the use of wide-angle lenses by Bill Brandt or the tipping of a crowded frame by Garry Winogrand.

It's rather obvious, but not often remarked, that the Albertian concept of the picture as a window on a world beyond the wall works fully only if the picture is actually hanging on that wall, vertically, opposite the viewer. That tends to exclude pictures which we see in other ways – prints in a portfolio or illustrations in a book, for example. And of course, it's unlikely that our first viewing of a photograph by Atget, Evans, Brandt, or Winogrand is going to be on a wall, but, rather, on the page. How does perspective work when we see it like that? In the Renaissance, there were volumes with illustrations of its principles so large that readers had to look at them flat on a table. Do our brains imaginatively tip them back up to the vertical in order to enter

their space? Or – an idea closer to that baroque vision referred to earlier – do we fall forward and plunge into them, really somewhat out of control?

That's one way in which looking at and imaginatively entering a photograph will often differ from an easel painting. But we need to set this difference alongside another, more fundamental, one. However much we may gasp at the space we are offered in a painting by Van Eyck, Piero, or Vermeer, we know it is an illusion – that's partly what we are gasping at. But photography is different, and no matter how much some may want to release the medium from its basic indexicality, photographs are tied to the reality from which they came. The space depicted in a painting has been filtered through the painter's working of the material surface, but in a photograph, we seem to – we want to – connect with the original reality that made the picture in the first place. Indeed, it can seem as though we are making a return journey into the space beyond the picture. Straight or documentary photography, however complex and constructed it may be, offers us that space – a space that is at once physical, social, and imaginative.

But what happens when documentary photography leaves the page and enters the gallery, asking to be seen in the same way that paintings are? How do issues around size, framing, and installation affect our response to the image? Indeed, how does the physical situation we find ourselves in – walking around the communal space of the gallery, moving bodily towards and away from the images – affect our imaginative response in ways that are radically different from our usually solitary and sedentary response to the picture on the page? A contemporary photograph can be more or less any size, framed or unframed, glazed, unglazed, on aluminium or board or simply pinned to the wall. But one significant thing that has happened as photographs have entered the gallery is that they have got bigger, sometimes very big. It might seem that the bigger a picture is – the closer it is to our own bodily scale – the easier it should be to enter it. But if our experience is now more physically direct, it may in other ways be rendered problematic.

I want to recall here my experience of a recent exhibition – the set of photographs by Luc Delahaye called *History,* which I saw in the National Museum of Photography, Film and Television in Bradford in April 2004.[17] I'd seen some of these pictures in reproduction before – for example, in the Mois de la Photo à Montréal catalogue from 2003 – but they were quite small and, because of their extreme horizontal shape, they often had a gutter running up the middle of them.[18] Still, I was impressed by their sophisticated take on what a history picture might be today – both a picture *of* history as it happens and a modern revision of the nineteenth-century history paintings that hang in the Louvre. In the gallery, with perhaps just ten or twelve images around a darkened, cavernous, somewhat labyrinthian space, they were epic, their size indicative of the sweep of history they embodied.

Then, of course, I wanted to move in, to interrogate the details of the pictures, to look at all the tiny events that are going on in them. But as I came closer, I was stopped in my tracks by the realization that I was actually looking at the surface of the image, at the grain of the film, which was acting as a screen between me and the scene in the picture (and I don't mean that in any Lacanian sense, but more like the sort of screen you use to keep mosquitoes out).[19] Suddenly aware of the physicality of the photograph itself, I took a few steps back to a point where I could re-engage with the scene in the picture – not as far back as I might sit to watch a movie, but nowhere near as close as I might get to a smaller photo.

In one view, of course, this isn't a problem but rather part of the picture's condition. And in making so transparent the photograph's physicality, it can be argued that this interference reveals more openly the nature of the medium. But is the excessive presence of the photographic grain itself a problem with pictures where we want to read all the detail, where what is happening in the detail is often the point? In Delahaye's case, I'm thinking of sweeping panoramas, such as the views of the press hotel in Baghdad or the September 11 memorial service, rather than pictures of a single central subject such as the dead Taliban soldier (Figure 18.3). What is gained by the epic scale – and much is gained – is threatened by the lack of precision. By evoking History, do we run the danger of losing sight of a specific historical moment?

But what struck me most was how very different this experience was from the way I look at my Walker Evans photograph – almost as though I'm no longer experiencing the same medium. Standing with my arms crossed or walking back and forth in front of the picture, I am suddenly aware that I am reacting as much with my body as I am with my eye. Yet I cannot touch the photograph. I cannot pick it up and hold it, and when I try to get close, it throws me back. Perhaps that is appropriate when faced with the great events and distant lands that Delahaye's pictures show. I can't pretend I am there and still less that I understand what is happening. Yet, equally, how can I connect with working-class life in the southern United States during the Depression? I may feel the desire to enter the physical space of a photograph, but that will of necessity take me into a social space from which it cannot be separated.

After walking round the Delahaye show for a while, I returned to my main purpose in the museum – looking through the archive of the English photographer Tony Ray-Jones. It was a strange shift – yet altogether symptomatic of the condition of photography – to go from those huge pictures up in the gallery to the thousands of small images on Ray-Jones's contact sheets down in the archive.[20] Then I opened one of his notebooks and read the comments he made after seeing the paintings of Giorgio de Chirico in the Museum of Modern Art, New York: "One doesn't seem capable of entering the photographic image – Is it the machine finish of the surface – no human

Figure 18.3 Luc Delahaye, *September 11 Memorial*, 2002 [original in colour]. From the series *History*. Courtesy Luc Delahaye & Nathalie Obadia Gallery.

Figure 18.4 Aaron Siskind, *Chicago 10*, 1948. Courtesy of the Aaron Siskind Foundation.

flaws? The painting on the other hand often absorbs one – draws the eye beyond the overt image. In de Chirico one loses oneself in endless shadows – the depths are incredible."[21] Ray-Jones was, of course, talking about glossy black and white photographs of a modest scale, but his point about "machine finish" is acute. It is what both attracts and in some ways also repels us as we try to look into a photograph.

This flattened lack of surface differentiation is very far from the knobbly, bumpy surface of most paintings, but that painterly surface ought equally to prevent our entry into the space of a picture. Thinking back to my own experience in front of Constable's *Hay Wain,* I have never managed to find that "sufficient distance" that Tompkins evokes. Sitting on the leather banquette in the middle of the gallery, I am too far away, too aware of the wallpaper, the rope barrier, the ornate gold frame. But as I get up and move towards the picture, I find myself suddenly studying the surface of the paint. Yet it's that surface that allows me the sensation of the experience that lies beyond the painting. As Elizabeth Helsinger has observed, "Touch – the marks of the painter's touch on the canvas – for Constable seems to be a direct translation of the physical feel of air and water."[22] In other words, I don't find myself looking at some sort of actuality but rather at a miraculous analogy conjured up between a swirl of white paint and water gushing through a dam, and I read one through the other.

Photography offers its own miracle, of course. As I gaze into my Walker Evans Atlanta print, I realize that I cannot really tell what is photograph and what is tarmac, wall, poster, or wood. The guarantee offered by the index is complex, sometimes treacherous, and always ambiguous, but it's the lynchpin that holds the photographic effect together. The interlocking duality of "picture as object in itself" and "picture as window on the world" is pitched differently in Evans's photographs and Delahaye's history pictures, but it's crucial to both. One aspect may dominate, but it never completely overcomes the other. This tension between the materiality of the photograph itself and the intimation it holds of a somehow accessible reality on the other side of the picture plane is common to all photographs.

Yet the relationship can be easily misread. In his essay "What the Spectator Sees," the philosopher Richard Wollheim coined the term "seeing-in" to describe a situation where "I am visually aware of the surface I look at, and I discern something standing out in front of, or (in certain cases) receding behind, something else." This innate ability to see at the same time both the surface and the space depicted within it is, Wollheim argues, fundamental to representational art. The primary example he gives is a simple one. Looking at the surface of a stained wall, "at one and the same time I am visually aware of the wall, and I recognize a naked boy in front of a darker ground (see Plate 20)."[23]

Intrigued by this description, I turn the page to look at plate 20, only to find that Wollheim wasn't in fact looking at an actual wall. He is, rather, describing a photograph of a wall, one, moreover, taken some forty years earlier by Aaron Siskind in Chicago in 1948 (Figure 18.4). It seems that even such a subtle reader of images as Wollheim can fail to see (or at least acknowledge as significant) the surface of the photograph itself, the surface *through* which he sees the surface of the wall *in* which he sees the boy. Perhaps this was because of the nature of this particular picture, where it is easy to elide the flatness of the photograph and the flatness of the wall. Indeed, his description raises some more questions about the nature of photographic space and our ability to enter it. Where is the surface of the wall in relation to the surface of the photograph? Is that a space we can enter and explore as we do the space in a more perspectival image?

It is, then, a picture which poses from a different angle the question that has been circling throughout this essay: Do I look at the photograph or do I look through it? Is it an "object in itself" or is it a "window on the world" (albeit one without much of a view)? But perhaps we have to resist making that choice, for Wollheim argues that we have an innate ability when looking at an image to see at one and the same time both the surface and the space that it holds within it. They are "two aspects of a single experience that I have, and the two aspects are distinguishable but also inseparable."[24] We stay on the surface *and* we enter the space; we see the gloss of the print and the texture of the poster peeling off the hoarding.

For Charles Baudelaire, writing in 1859, imagination was "the Queen of the Faculties" – "It touches all the others; it rouses them and sends them into combat" – and it was because he thought photography lacked an imaginative dimension that he condemned its pretensions to art.[25] It will be obvious from this essay that I am interested in a somewhat cooler version of "imagination," one that, moreover, is thoroughly embedded in our apprehension of photographs. Walker Evans's picture from Atlanta doesn't need a spectator to validate its existence, but the process of imaginative engagement which we undertake when we look at it is integral to its meaning. It may be hard to define exactly what part our eyes and our brain, our sense of sight and our sense of touch, our knowledge and our imagination each contribute to this process, but it's evident that we understand photographs only by bringing all those faculties into play.

Original publication

'Through the Picture Plane: On Looking into Photographs' in *Image and Imagination* (2005).

Notes

1 A rich tradition of discussion exists about how we read visual space. Two classic studies are Gibson, *The Perception of the Visual World,* and Gombrich, *Art and Illusion.* More recently, see Morgan *The Space between Our Ears.*
2 The date was 9 February 1996. The Lynne Cohen show was in the Galerie des Archives, 4 Impasse Beauborg; the Thomas Struth show in the Marian Goodman Gallery, 7 rue Debelleyme. There is little written on the contextual experience of viewing photographs, but I discuss my own experience of seeing Sophie Ristelhueber's post-Gulf War photographs in the Imperial War Museum in "Desert Stories or Faith in Facts?" in Lister, ed., *The Photographic Image in Digital Culture,* 236-54.
3 This is not, alas, the original edition of 1938, but the reprint produced by the Museum of Modern Art, New York, on the book's fiftieth anniversary in 1988. Despite the emphasis in this text on the experience of seeing photographs in galleries, there is no doubt that the book has been the major historical vehicle for serious photography; see Parr and Badger, *The Photo Book,* vol. 1. Evans, though, was also very interested in postcards; see Rosenheim and Eklund, *Unclassified,* 200-7.
4 *Walker Evans: Photographs for the Farm Security Administration, 1935-1938.*
5 You can still take advantage of this remarkable service, though a 10x8 print now costs $22 and is made from a digital copy.

6 See Loengard, *Celebrating the Negative,* for an array of famous negatives and some interesting questions about their status. On pages 32-33 he reproduces another Evans 10x8 negative from the Library of Congress — a picture of Bud Fields and his family taken inside their shack — with the comment: "The negative retains an eerie sense of being present in the 'square pine room' where it was made."

7 Duchamp's paper on "The Creative Act" was originally presented at the Convention of the American Federation of Arts, Houston, Texas, 1957. It has been printed in a number of books, including Sanouillet and Peterson, eds., *The Essential Writings of Marcel Duchamp,* 138-140.

8 O'Doherty, *Inside the White Cube,* 18.

9 First given as a paper at the Dia Art Foundation, New York, 1988, and subsequently published in Foster, ed. *Vision and Visuality,* 3-23.

10 Ibid., 7.

11 Tompkins, *In Constable's Country,* 44.

12 Released in 1990, the film was simply called *Dreams* in Japan, while its English title was expanded to *Akira Kurosawa's Dreams.*

13 Alpers, *The Art of Describing,* 44.

14 Martin Jay, "Scopic Regimes of Modernity," in Foster, ed., *Vision and Visuality,* 16.

15 The camera's "unblinking, fixated" gaze has also been crucial to the use of photography as an instrument of power, most recently through surveillance.

16 Galassi, *Before Photography.*

17 The Luc Delahaye exhibition was at the museum from 5 February to 3 May 2004. For an account by the exhibition's curator, see Henry, "Luc Delahaye Photographs," 10-15. For a comparison with the work in book form, see Luc Delahaye's *History,* with an essay by Eugenia Parry.

18 Are these versions on the page variant forms of the work (as a print version of a Walker Evans is) or are they reproductions like those we might see of a painting (which is the case with some exponents of the large photograph such as Gursky or Wall)? For Delahaye, with his background in photojournalism, it seems the answer would be more indeterminate.

19 Roland Barthes wrote of his attempt to enlarge the photograph of his mother to "reach my mother's very being," but found himself defeated by the grain of the image: "I undo the image for the sake of the substance," *Carmera Lucida,* 99-100. But, of course, the actual pucture that Barthes was viewing remained quite small. Nowadays, I am likely (especially in a large print) to be looking at pixels rather than the photographic grain per se. But one interesting result of the increasing refinement of digital printing is that it can hide its own process to offer us a resolution that is little different from a print produced by traditional means.

20 My work in the Insight Collections and Research Centre resulted in the essay "Summer of Love: A Photograph by Tony Ray-Jones," an exploration of what his contact sheets tell us about about one of his pictures.

21 In the notebook, these comments are dated 19 April, but with no indication of the year. It was probably either 1964 or 1965, when Ray-Jones was living in New York.

22 Helsinger, "Constable: The Making of a National Painter," 266-7.

23 Richard Wollheim, "What the Spectator Sees," in Bryson, Holly, and Moxey, eds., *Visual Theory,* 103.

24 Ibid., 105.

25 Baudelaire writes about both imagination and photography in "The Salon of 1859."

Estelle Jussim

THE ETERNAL MOMENT[1]
Photography and time

A FREQUENT THEME in popular culture fantasies, especially in motion pic-
tures like *Back to the Future,* is the reversal of time, where we are magically trans-
ported to past decades. One such fantasy, the first *Superman* movie starring muscular
Christopher Reeves, featured a truly spectacular time transformation, the progress
of which the audience was allowed to see. After a gigantic earthquake had smothered
the hero's beloved Lois Lane under an avalanche of rocks and dirt, Superman was so
overcome that he did what his father Jor-El had explicitly forbidden: he intervened in
human affairs.

At a speed and with strength incalculable to mere mortals, Superman reversed
the spinning of the planet earth, asking the audience to believe that this action could
reverse time. The hours shot back, the avalanche hurled itself uphill, spunky Lois Lane
rose up from her buried car and was, amazingly, alive again. But in saving her, by revers-
ing the supposedly inexorable march of time, Superman did more than intervene in
human affairs. He did what we all know to be impossible. Only in human imagination
can time be reversed, or so common sense tells us.

Common sense, or what Albert Einstein is credited with calling "that set of clichés
you collect by the time you are eighteen," tells us that time moves forward and never
can be stopped or reversed. Yet we talk about photography's stopping of time, and per-
haps we need to determine what that might mean. Besides the presumed "stopping" of
time, we should try to discover if there are any other aspects of time revealed to us by
those peculiar objects we call photographs.

Photography (along with its progeny, film, and television) is the only visual medium
we know that provides us with a record of something that was actually *there* in front
of the camera, so we turn with sometimes misguided confidence to photographs to
show us what existed in the past. Clues like haircuts and fashions, housing and horse-
drawn carriages, paternal poses and studio props, all indicate that we are looking at the
then of history. Yet we are looking at those clues *now,* with the intellectual apparatus of

today. Our vision of *then* is perforce screened through our accumulated perceptions, misconceptions, and assumptions concerning the past; more important, the photographic *then,* paradoxically, can only be experienced in the *now*. Any historian worth his or her salt would agree, since we can only know the past through evidence available in the present. When we hold a photograph in our hands, we are looking at it *now*. But how long is *now*? William James called it *the thickened present* and suggested that it lasted three seconds. A student of his claimed it lasted for twelve seconds. What *is* "now"? When do we think "now" is over? What takes its place, another "now"?

Marcus Aurelius wrote in the second century of our era, "Time is a sort of river of passing events, and so strong is its current, no sooner is a thing brought into sight than it is swept by and another takes its place, and this too shall be swept away." Heraclitus put it more simply: "You cannot step twice into the same river." To that idea should be added the observation that *you* are changing also, not just the river.

There are continuing arguments about this notion of time as a ceaselessly changing river, with philosophers and scientists insisting that there is also *duration*, a duration of identity. The Mississippi River remains the Mississippi River. Ah, but does it? Mark Twain described the evershifting banks and sandbars of that mighty stream, and I have seen rivers in the Southwest that in the dry season were not rivers at all. The prime proselytizer for the notion of duration, Henri Bergson, argued that to call time a river was to spatialize it, thereby misrepresenting what he called real, concrete time (*durée*), which can be experienced only by the inner consciousness. Surely this notion, as his many critics aver, is metaphysical, subjective, and idealistic. Yet there may be merit in regarding time as a metaphor reflecting the difficulty of expressing in language a complex set of experiences concerning past, present, and future.

A photograph is presumably constant, however, despite what we know about the ongoing alterations in its chemistry, particularly in colour. It is the notion that a photograph stops time – through a brief exposure of light-sensitive emulsions to the actinic rays of the sun reflected from real objects in the phenomenological world – that may make us overlook a more global concept: photography may have altered our very ideas about time.

What if photography does not *stop time* but rather lets us see *through* time? What if photography somehow makes time transparent? In 1932, André Kertész climbed a tower to aim his camera through the face of a giant town clock down to the populated square below; the picture is the perfect metaphor for seeing through time.

The grand chaos

When I suggested that photography may have altered our sense of what time is, I was playing with a rather wild possibility, yet a possibility that photographic archivists and curators encounter every day. Imagine, if you will, an enormous flat field out in bright sunshine. To this field a mysterious power has transported all the photographs that have ever been taken, all the daguerreotypes, ambrotypes, albumen prints, ivorytypes, tintypes, platinum prints, gum bichromates, gelatin silver prints – all of the billions and billions of images on paper, metal, ivory, glass, that photographers have taken since the third decade of the nineteenth century. The field is piled high with this stupefying

aggregate of images, higgledy-piggledy, without order, a genuine chaos. If you happened to be standing to one side of this monstrous aggregate and shut your eyes, extended your hands, and plucked forth two pictures totally at random, what might you come up with? Quite possibly two images as absurdly disconnected as an 1850s Francis Frith photograph of the pyramids and a 1970s Garry Winogrand photograph of a pair of chimpanzees waving hello. Or you might find a prim and proper Queen Victoria and her consort Prince Albert looking askance from the 1850s at the shocking sexual mores of the 1970s as seen in a Danny Lyon photograph of two teenagers kissing on a bed. Or you could simultaneously look at John Thomson's picture of a Chinese execution of the 1860s and Nick Ut's horrifying record of the execution of a Vietcong prisoner over a hundred years later. Whatever you find in this aggregate, you can only look at these images *now*. You can see the 1850s simultaneously with the 1970s. In that sense, photography has not stopped time. It has obliterated time.

Just as André Malraux called the condition of contemporary arts a "Museum without Walls" because photography could reproduce any art object and present it in a book, so we might call our imaginary field overflowing with photographs "History without Time." For we are being overwhelmed by the simultaneity of photographic images from all decades and from all countries. We see everything and anything we want and see it *now*.

We may try to hold fast to our notions of *then* and *now*, but we can only look at an 1860s picture in the *now*. We cannot go back in time. We can scarcely go to another culture without losing ourselves. Superman cannot help us as we look at the mid-nineteenth century through late twentieth-century eyes and judge what we see only by what we ourselves, in the present, in the *now* have learned to see. Even though pairs of photographs taken a century apart may urge us to think *then* and *now*, we are forced to acknowledge that we are looking at them in the *now*.

The poet-seer-artist William Blake believed that all time is present in each moment: "I see the Past, Present & Future existing all at once / Before me." The psychologist Joost Meerloo agreed, for he said, "Every present contains the past, but also looks ahead to the future." J. W. Dunne, in his *An Experiment with Time*, stated it unequivocally: "Past, present, and future exist simultaneously." This may be a hard concept to grasp, even when propounded so directly by poet, psychologist, and scientist. It may be even harder to grasp when we turn to consider a statement ascribed to Albert Einstein: "The universe is an aggregate of nonsimultaneous and only partially overlapping events."

Einstein was, of course, thinking about what we see when we look at the distant galaxies of the universe. It is old light, light emitted from the stars millions or even billions of years ago, arriving in our planet's neighbourhood only after traversing mind-staggering spaces. George Kubler stressed this fact in his book *The Shape of Time,* reminding us that the light we see from the stars is, to put it mildly, ancient indeed.

Photographs, too, let us see old light, light captured a century and a half ago. That enormous pile of photographs we have imagined lying in chaotic dispersal across a wide field is quite similar to Einstein's universe. It, too, is an aggregate of nonsimultaneous and only partially overlapping events. Time has become relative in Einstein's world. It is impossible any longer to think of time as an absolute in Newton's terms. *Whose* time? *Which* time? *Where* time? When we say that photography *stops time*, does that phrase

represent a misconception about the nature of time? As Martin Heidegger insisted, we do not live *in* time; rather, we *live time*. How can time therefore be "stopped"?

Henri Cartier-Bresson wrote and talked a good deal about what he called "the Decisive Moment." To me, his remarkable photograph of a man leaping a puddle behind a railway station in Paris is the quintessence of our problem. Cartier-Bresson wrote, "Photography implies the recognition of a rhythm in the world of real things," and "We work in unison with movement as though it were a presentiment of the way in which life unfolds. . . . But inside movement there is one moment at which the elements in motion are held in balance. Photography must seize upon this moment and hold immobile the equilibrium of it."

If photography is supposed to stop time, it has always struck me as odd that Cartier-Bresson stressed rhythm, movement, elements of motion, immobility, equilibrium, and only twice uses the word *moment,* moment as an element of time. Here is this leaping fellow who in the rhythm of the world of real things was about to go kerplash into a major puddle. The photographer foresaw the consequences of the leap in the real world but chose to record the moment of high drama.

Obviously, what interested Cartier-Bresson more than the moment of time with its real consequences was the geometry of the moment, the perfect equilibrium of the man with his reflection in the puddle balancing his reality, and, just as important, the

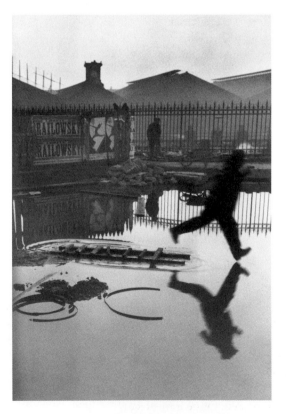

Figure 19.1 Henri Cartier-Bresson, *Behind the Gare St. Lazare, Paris,* 1932. © Henri Cartier-Bresson/Magnum Photos.

rhythm of the dancer in the posters behind him – a dancer in much the same pose and balanced by much the same type of reflection. Surely we know that in the immediate past the man executing this improbable jeté must have been hurrying to grab a taxi or catch a train, and in his immediate future there would have been a considerable wetness of the lower trousers and shoes. Past and future and present in the now.

Or has Cartier-Bresson in his "decisive moment" somehow abstracted this fellow from all time? Since, in the photograph, he can never move forward, is he not in the now at all, but rather in what we call *eternity*? That idea requires much thought.

The poet John Keats rhapsodized on the eternity of men and maidens captured in paint on a clay vessel, and wrote these lines in his "Ode on a Grecian Urn": "O Attic shape! Fair attitude! with brede / Of marble men and maidens overwrought, / With forest branches and the trodden weed; / Thou, silent form, dost tease us out of thought / As doth eternity. . . ." As that other poet, William Blake, is said to have believed, "Eternity is not the endless duration of time. It is the absence of time." As an absence of time, eternity is a concept that needs to be reckoned with in terms of photography. But first, perhaps, we need to think about other aspects of time.

Visually, to understand that the past and future are implicit in the present, it helps to look at sequential photographs of nature. The same scene in summer and winter can remind us that the changing of the seasons has always been a primary time teller relating us to the solar year. Few of us in the late twentieth century doubt that spring will surely follow winter and that summer will follow spring. In that sense, every landscape holds within it the now that enfolds past and future.

Of the many types of time, the one that photographs seem to excel at depicting is the before and after. Take, for example, a sequence of two photographs by Robert Doisneau: the picture on the left is of a wedding party arranged on raised platforms; the picture on the right is the same scene emptied of people. The presumption is that the wedding party posed first and the empty scene occurred afterward. The only trouble is that nothing in logic can persuade us that this sequence by Robert Doisneau is the only one possible. It would be just as easy to place the empty benches on the left and the full wedding group on the right. The primary reason we "read" this as "before and after" is that we read our written language from left to right, and therefore tend to read series of images in the same left-to-right sequence. Readers of Hebrew, for example, or any other language read from right to left, might easily see the empty bench as the "before" and the wedding group portrait as the "after." Perceptions of time sequences in photographic images may be as culture-derived as our written languages.

Language itself speaks in many photographs. At one point in his photographic perambulations, Nathan Lyons came upon an irresistible billboard that read READY OR NOT . . . JESUS IS COMING! Lyons likes to photograph messages that embody past, present, and implications of the future. That particular message is a kind of threat of an imminent event whose precise time we cannot foretell. But clearly, the Jesus who is coming is that dire figure of Michelangelo's *Last Judgment,* else why threaten us, why warn us? The past contains our sins, our unreadiness; the present is the warning; and the future is heaven or hell. Quite a message!

In terms of the medium itself being the message, daguerreotypes and ambrotypes seem to carry time with them as part of the processes now seemingly abandoned

forever. We tend to trust images recorded in these processes as representative not only of their technologies but of a certain time in the history of photography. Unfortunately, identifying process alone can no longer help us ascertain the time frame of a photograph. At Faneuil Hall in Boston, for example, you can yourself pose today for a daguerreotype. However, we do consider that photographs portray discrete moments of time that we can examine in the now as reliable guides to past information.

Not only the documentarians, but even the aesthetic pictorialists were interpreted in capturing the evanescent moments of reality. In a charming image by Pierre Dubreuil, a shuttlecock flies between two upper-class children bathed in the warm glow of orange-tinted gum bichromate as they play a game of badminton. Obviously, such depictions of suspended action were made possible by the increasing speed of light-sensitive emulsions as well as by camera shutters that could control the length of exposure. The two children in the Dubreuil seem poised in eternity, brushed by the wings of their own time, yet removed from the world of cause and effect, removed from the terrors of onrushing time. Dubreuil has encapsulated them forever.

In another Dubreuil image, a puffing railroad engine roars on the tracks heading straight for us, but he photographed it in such a way that it seems suspended forever so that we might contemplate the formal geometry of the image. The train will never move forward. The steam will never dissipate. Even the most active subject can be deactivated by stress on formally beautiful composition. By this means, Dubreuil asked that we contemplate the symbolic meaning of the train, not its speed on the tracks nor its plunge forward. It is not the "decisive moment" we are asked to admire, but rather the long-term significance of an event. The "decisive moment" belongs to the photographer, not to the viewer. When we engage in contemplation, we are outside time, and we begin to be able to define eternity.

But when Dubreuil composes a picture in such a way as to imply ongoing motion, then we are forced to draw conclusions about past and future action. Even if we know intellectually that the tiny toy carousel horses in one of his pictures could never actually move, the gestural implication of those prancing hooves pushes us towards a non-verbal acceptance of the idea of motion. It takes only a few seconds for our eyes to travel from the top right corner to the bottom left and to rush back around again to the top, but those few seconds are enough to make us imagine swift movement on the part of the stationary creatures. Photographs are certainly *still* in the sense of being silent, but sometimes they are not at all still in the sense of being without movement. And movement takes place through our sense of time.

From Muybridge and Marey to Edgerton

The need for stopping time in smaller and smaller increments has increased relentlessly since the experiments of Eadweard Muybridge in the 1870s. To capture the movement of racing horses, Muybridge set up a sequence of cameras rigged with electrically controlled shutters at about 1/1000th of a second, undoubtedly the fastest photographs taken up to that time. But a French contemporary of his, Étienne-Jules Marey, was dissatisfied because he wanted to show the continuity of motion rather than the

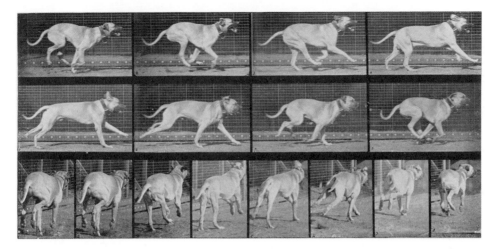

Figure 19.2 Eadward Muybridge, *Dog, Galloping; Mastiff "Dread"*, 1886. © Int Museum Photography Chronicle / Alamy Stock Photo.

separate movements Muybridge succeeded in capturing. Ingeniously, Marey devised ways of recording a sequence of motion on a single plate. A man wearing a black suit with a white strip painted on it was recorded as he ran past Marey's camera. Marey called his work chronophotography, literally the photography of time.

Marey also invented a single large photographic plate that was exposed to light only through the slits of a revolving wheel. The Marey wheel, as it came to be known, contained twelve slits through which fairly rapid exposures could be made. This wheel was a true stroboscope, a word meaning "whirling watcher," and was a forerunner of the astonishing accomplishments of Dr. Harold Edgerton at MIT in the 1930s. Edgerton, an electrical engineering professor, was at first interested primarily in studying the action of rotary engines. He soon discovered, however, that his invention of the electronic stroboscope and what we today know as electronic flash photography would alter forever how we see things.

Edgerton's strobe was used to capture the sequences of motions made by tennis players, girls skipping rope, dogs hurdling benches, and a wide variety of sports activities, including boxers and ice skaters, these usually at sixty multiflash exposures per second. Each moment of the action could be captured, yet Edgerton prefers to speak of "events" being stopped rather than time alone being stopped. A true son of the Einstein era, Edgerton does not separate time and space, but considers them together as an inseparable continuum.

Edgerton sought the perfect combination of timing and motion that would astonish viewers in pictures like *Milk-Drop Coronet* and *Shooting the Apple*. The visual surprise in the latter startling image is that entry of the supersonic bullet was as violent as its exit. A moment later the apple disintegrated, making it possible for Edgerton to title one of his lectures, "How to Make Apple-sauce at M.I.T." Joke or not, a .30 caliber bullet traveling 2,800 feet per second required an exposure of less than 1 / 1,000,000th of a second to capture its passage. We might with justice call *this* stopping time.

Timely news

There is another sense of time being addressed when we talk of a picture being
"timely." Newspaper publishers are rapaciously competitive about the timeliness of
news photographs, and it became an urgent matter in the late nineteenth and early
twentieth century to cut as much time as possible from the interval between taking
the picture and seeing it in print. Photojournalists like Jimmy Hare became daredevils
as they dodged bullets to capture battle scenes. Thanks to progress in rotogravure
and other printing processes aided by photographic technologies, the cameramen of
World War I had their photographs, including stills from motion pictures, published in
millions of newspaper editions. Even the great gray lady, *The New York Times,* published
special gravure sections and urged the public to collect them as specimens of "beauti-
ful" photographs. What wonderful memories they were supposed to evoke is difficult
to imagine, but it seems obvious that the newspapers marketed their pictures not just
as excitements for the present, but as potential memories in an undefined future. Thus,
what was timely was also expected to retain value over time.

Sometimes "before and after" news pictures yield most peculiar sensation. *Time*
magazine, for example, published two photographs of the German city Cologne, plac-
ing them side by side: the demolished city in 1945, after the heavy bombardments
during the last days of World War II; then Cologne as was in the 1980s, successfully
revived and completely rebuilt. Looking at the picture of bustling Cologne, you may
have an uncanny feeling as if certain things really had not happened. The time frame
of any picture may be meaningless without an understanding and an acceptance of the
context of the pictures.

Mortality and time

Yet another type of time recorded in photographs is the passage of time implicit in a
single still subject. Was it Walker Evans Minor White or Aaron Siskind who first began
to record the destruction of painted surfaces and postered walls by the wrath of the
elements over periods of time? Siskind, like Evans before him, saw in the deterioration
of posters' signs of mortality, the wreck left behind in time's wake. While he commu-
nicates far more than the simple passage of time as evinced by the tearing and layering
of posters, he is clearly obsessed with their loss of solidity and longevity. Despite the
fact that time seems embedded in Siskind's evocative fragments, we cannot tell which
time is involved, how much time elapsed between the posting of a paper message on an
outdoor wall and the last flapping pieces of paper detritus. Siskind's imagery, therefore,
is more a symbol of the *ideal time* rather than a specific time of any kind.

The idea of time and its inexorable passage finds eloquent embodiment in por-
traits, especially in Anne Noggle's records of her aging mother's face, body, hands, taken
through the last decade of Agnes's life. Who was it who said the human face is a clock?
Discovering the human clock in his own visage, William Butler Yeats wanted to "spit
into the face of Time/that has transfigured me." In a picture called *Artifact,* Noggle
relentlessly recorded her mother's gnarled and furrowed hands holding in her lap

nothing less than her upper dental plate. As Shakespeare put it, old age will deprive us of everything from hearing to sight, until at last we will be "*sans* teeth, *sans* everything." Noggle calls aging "the saga of the fallen flesh," but managed to endow her mother's last portraits with sublime dignity.

Time passes, bringing with it mortality. But *times* change, and sometimes bring improvements in social conditions. It seems to be difficult for still photographs to depict the changing of certain types of social conditions, and they may have to rely upon text to define their content. There may be no visual equivalent to verbal ideas about time, but anyone sensitive to changing mores would have to reject something like Bertrand Russell's epigrams on the "ages of man": "The child lives in the minute. / The boy in the day. / The instinctive man in the year. / The man imbued with history lives in the epoch. / The true philosopher lives in eternity." Today such statements would be deemed sexist, since they seem to be excluding the female of the species. But even making Russell's statement about time less sexist does not necessarily make it possible for such abstractions to be photographed. Could we take photographic portraits of boy, man, or, for that matter, girl or woman, that could express the relationship of a person to a year, or an epoch? For expressing abstractions like "epoch," even a series of photographs may prove less accurate than language. Words best convey abstractions even if we interpret those abstractions according to our individual ideologies.

Photographic collages treat time uniquely, as the work of Vaughn Sills demonstrates. Sills has combined her own portrait with that of her mother, her grandmother, her early childhood. A comment by the psychologist Joost Meerloo may help to understand such an approach: "Temporality – awareness of the point of time – and duration – moving in time – are the keynotes in human self-awareness and existence, the beginning of comprehension. They involve an inner effort to go beyond the immediate data toward the continuity of the self."

Sills felt very close to her grandmother and tried to express her feelings diaristically as well as photographically. In looking at her composites of images coalesced in the now but representing stages of her own development, I find an image history that has some relationship to cubism. At one point in that style's evolution, the painter Jean Metzinger observed that the cubists had abolished the rule that commanded painters "to remain motionless in front of the object, at a fixed distance. . . . They have allowed themselves to move around the object, in order to give . . . a concrete representation of it, made up of successive aspects. Formerly a picture took possession of space, now reigns also in time." Stephen Kern's marvellous book, *The Culture of Time and Space 1880–1918*, discloses many such observations. Rereading it helped me conclude that, like her teacher Wendy Snyder MacNeil, Vaughn Sills did not seek to make photography stop time. On the contrary, she wants to show us many aspects of time in relation to each other.

Movements of time

Like the portrait collage, the diptych or triptych formats manage to display aspects of time in relation to each other. In Carl Chiarenza's diptych of 1982 called *Menotomy,* he manipulated light to communicate the passage of time not in this world but in some mysterious universe beyond our ken. Yet we do not know how much time or on what

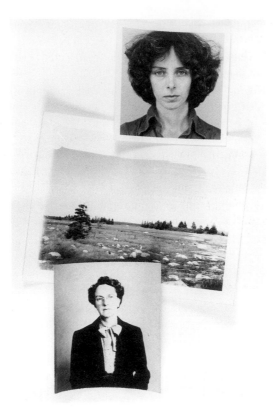

Figure 19.3 Vaughn Sills, *Self, Nova Scotia Landscape, Grandmother*, 1985. (© Sills)

planet the conditions might be operative. Chiarenza typically transforms fabrications made to be photographed into poetic fantasies, and fantasies, as we all know, must exist outside of common sense time. Encounters with art tend to lift us outside time; perhaps that is why Nietzsche said that art is what keeps you from going crazy. In Chiarenza's art, his intense blacks and silvers proceed like music chords, a progression in time and rhythm that moves the soul.

In music, we are expected to hear time moving. On television, we see time moving: history passes before our eyes too rapidly to comprehend. Michael McKeen invented sequences culled from the evening news that he calls "Mock TV." He is convinced that we are going to smother in images that we are not permitted time to understand. The evening news consists of twenty-two minutes of "news" and eight minutes of advertising. The "news" sometimes consists of one sentence with a visual background to fill in the space around the anchorperson's head. The eight minutes of advertising is visually far more exciting than the news. Therefore newscasters attempt to liven up the news by speeding it up. What would take a leisurely column of explication in, say, *The New York Times,* flashes by in seconds on the tube. It has become impossible to tell the difference between newscasts and other forms of entertainment. We have become frenzied consumers of visual messages that speed by at what used to be intolerably quick rates for the human eye and brain. We may have become so accustomed to glancing at pictures

that we rush by still photographs without granting them time for comprehension, enjoyment, or evaluation.

Human gestures, human actions, involve time. We move through time, we live time, we are creatures of time. Photography retrieves for us small shards of time, and we should relish our astonishment at this fact. Photography juggles time. Yet we can only know these shards and other simulacra of times gone by in the present, in the now. The longer we contemplate a photographic image, the longer we stay in the now. Staying in the now, instead of furiously rushing towards the future, has psychological advantages, and profound reverberations in our lives. As Ludwig Wittgenstein observed somewhere in the *Tractatus,* those of us who live in the present live in eternity. That is, we remain outside of time even while clocks tick their artificial minutes away. Perhaps the real measure of a photograph's greatness is that in its presence we experience a priceless relief from mortality, we engage in such intense thought that we have a sense of being outside ourselves, even for the eternity of a moment.

Original publication

The Eternal Moment (1989).

Note

1 Based on a presentation at the University of Rochester's "Rochester Conference: *On Time,"* January 13, 1987. Previously unpublished.

Elizabeth Edwards

OBJECTS OF AFFECT
Photography beyond the image

The shape of the question

IN HIS ESSAY ON THE MATERIAL SIGN, Keane (2005) asks, "What do material things make possible?" (p. 191). I use this question as a springboard to consider the impact and efficacy of material thinking in anthropological studies of photography, photographs, and photographic practices: What does material thinking make possible? Central to this discussion are questions of what people do with photographs, or what "work" is expected of photographs as objects – in albums, on walls, at shrines, in political protest, as gift exchange. Under which material conditions are photographs seen? In which ways are they things that demand embodied responses and emotional affects?

This is a field of inquiry that has established itself strongly in the past two decades, with notable studies of both historical and contemporary photography in India, Indonesia, Vanuatu, and Australia, for example (Pinney 1997, 2004, 2008; Lydon 2005; Deger 2006; Geismar 2009; Strassler 2010; Geismar and Herle 2010), all of which address the material and affective dynamics of photographs in some form or other. Although the emergence of such an approach has a longer history (see, for instance, Bourdieu 1965), it is no coincidence that the rise of a newly figured and newly theorized, Marxist-derived material culture studies in the 1970s and 1980s, which provided "a powerful critique of the role of objects in symbolic systems and social structures" (Buchli 2002, pp. 10–11), emerged at the same time as the increasing recognition of the work of photographs. Although the first engagements with photographs were in relation to anthropology's own history framed largely through a politics of representation and a disquiet with anthropology's own claims to authority (see Edwards 1992, 2011; Pinney 1992, 2011) … of the anthropology of visual systems, and in particular of photographic practices, had emerged strongly by the 1990s (Banks and Morphy 1997; Poole 1997; Pinney and Peterson 2003). In their varying ways, such studies brought the material practices of photography into the center of the analysis. As part of that broader material

turn, anthropologists recognized the constitutive importance, agency, and affective qualities of things in social relations. These approaches placed the photographic image centrally within the complex relations between humans and nonhumans, people and things (Latour 2005). This position was complicated in intellectually important ways by the fact that photographs, especially in their global consumption, are often of people, thus blurring the distinction between person and thing, subject and object, photograph and referent in significant ways. These relations circumscribe the interlinked dynamics of the photograph's social use, material performance, and patterns of affect as they are put to work through their material substance (Belting 2011, p. 11).

This complex relationship is grounded in the laminated quality of the nature of photography itself and photographs as objects, and the consequent analytical positions on the circulation and use of, and engagement with, the material qualities and perfor- mances of photographs are premised on this lamination. Two key and related models have framed the field, models that continue to have resonance. First is that of social biography. Although this is something of an old war horse in material culture studies now, it nonetheless works as an effective tool in relation to photographs because pho- tographs are objects specifically made to have social biographies. Their social efficacy is premised specifically on their shifting roles and meanings as they are projected into different spaces to do different things. Kopytoff's (1986) biographical model argued that objects cannot be understood through only one moment of their existence but are marked through successive moments of consumption across space and time.

Although taken up in relation to a wide range of cultural objects and institutions, such as museums, social biography provided a productive way of thinking about the lives of photographs. Pinney's *Camera Indica* (1997), on the social lives of Indian photographs, exemplifies this approach, concerning itself with the "concrete" circulations of photo- graphs (p. 10). Edwards and others also applied this model to museum collections to explore the institutionalization of anthropological photographs, for instance, the dynam- ics and material practices through which "touristic" photographs of "native types" could become "scientific" through acts of consumption, archiving, or the shifting apprehen- sion of photographs as they were displayed in different institutional contexts (Edwards 2001, 2002; Boast et al. 2001; Kratz 2001; Edwards and Hart 2004a; Geismar 2006). It was also a model that could accommodate, intellectually, the increasing demands on photographs to become something else again through indigenous demands for access to and rights over photographs within repatriation projects and highly charged reclama- tions of history (Fienup-Riordan 1998; Edwards 2001; Bell 2003; Peers and Brown 2003; Brown and Peers 2006; Isaac 2007, pp. 116–18; Geismar and Herle 2010).

Although of course photographs can have lives and "come alive" (Knappet 2002, p. 98) in many ways, the biography model, while effective, is, however, perhaps too linear to accommodate the analytical needs of the complex flows of multiple originals of photographs. For photographs have divergent, nonlinear, social biographies spread over divergent multiple material originals and multiple, dispersed, and atomized per- formances. Nonetheless, it offered a way in which the temporal dynamics of photo- graphs could be integrated with the potential of their materiality. The challenge in the material apprehension of photographs is for a model that can accommodate the double helix of the simultaneous existence of objects that are both singular and multiple.

A closely related model to that of social biography, but one more specifically pho- tographic in its conception, and thus more able to accommodate that demand for

multiplicity of lives over a number of dimensions, is that of visual economy. Developed by Poole in relation to the Peruvian Andes, this model presents an alternative to what Poole argues is the more static and leveling model of visual culture (Poole 1997). This latter approach, she argued, fails to account for asymmetries on which so much imaging practice is premised. Although emerging strongly from a Foucauldian sense of the scopic regime and discursive practices of knowledge, visual economy was nonetheless a strongly material argument, based in the circulation of images. Poole placed the meaning of photographs not in content alone but in the fluid relationships between a photograph's production, consumption, material forms, ownership, institutionalization, exchange, possession, and social accumulation, in which equal weight is given to content and use value.

If these two models have largely come to form the standard analytical framework for the photographic objects, a reformulation of the social and material work of photographs emerges in Hevia's more recent model of "photography complex." This model gives Poole's visual economy a more expansive dimension (Hevia 2009). Taking a Latourian model, drawn from actor network theory, this model maintains that the social saliency of objects and their efficacy is activated by networks of humans and nonhumans, people and things. It not only accounts for the flow of photographs as material objects, but encompasses, and gives a more dynamic role to, the technologies and structures that give photographs meaning. The photography complex constitutes a "novel form of agency" (Hevia 2009, p. 81) in which sets of photographic relations and the complex purposes and practices that entangle the photographic image have the capacity to mobilize new material realities. Given the nature of photographs and their relationships with concepts of the past, of memory and more particularly anticipated memory, based in the photographic trace, such a model of material efficacy and affect promises to be especially productive. The network model places photographs in a fluid set of productive relationships that "link or enumerate disparate entities without making assumptions about level or hierarchy" (Strathern 1996, p. 522). Strathern argues that networks are socially expanded hybrids, and indeed hybrids are condensed networks. This concept would appear to work well with photographs and the inherently hybrid range of values, relationships, desires, ideologies, and representational strategies that are mobilized and performed through the multiple material forms of the photograph.

Materiality: the physical and discursive condition of having material substance

However, Strathern also cautioned that networks might present endlessly proliferating hybrids intersecting with an inherently "fragile temporality" (1996, p. 523) in that networks are not stable entities. This position resonates with the recodable, repurposed, and remediated photograph, which functions ambiguously and sometimes precariously in shifting patterns of social use. Also pertinent in this connection is Gell's model of the "distributed object." The "distributed object," created through different microhistorical trajectories, yet discursively united as a single object, is another useful framework (Gell 1998, pp. 221–3) because it opens the space for a divergent, nonlinear, social biography of photographs spread over divergent multiple material originals

and multiple, dispersed, and atomized performances of photographic objects, which themselves initiate and act in social relations: "In the process [of viewing], photographs emerge as relational or *distributed objects* enmeshed within various networks of telling, seeing, and being, which extends beyond what a photograph's surface visually displays and incorporates what is embodied in their materiality" (Bell 2008, pp. 124–5, emphasis in original). The meaning of photographs, material forms, and ideas of appropriateness shift through the double helix of image biography and the biography of material refiguration and remediation.

Underlying all these positions, as they relate to photographs, is the central ethnographic question, why do photographs as "things" matter for people? Mattering claims important territory in the debate about materiality, and its importance is a register of the shift from asking semiotic questions about how images signify to cultural and phenomenological questions about how things mean (Miller 1998, 2005; Deger 2006). Miller has argued that thinking about "how things matter" as opposed to signify brings things into relations with practices and experience, rather than, as signifying implies, a distanced analytical category that intellectualizes responses to objects. The question "why do things matter?" is therefore a way of allowing space for the subjective and, as we shall see, it is a crucial one in the consideration of the huge social and cultural investment made in the possibilities of photographs. "Mattering" has, he argues, "a more diffused, almost sentimental, association that is more likely to lead us to the concerns of those being studied than those doing the studying" (Miller 1998, pp. 3, 11). This notion might be linked, as Pinney has done, with Lyotard's "figure," which "invokes a field of active intensity," a "zone where 'intensities are felt'" (Pinney 2005, p. 266). Here materiality itself becomes a form of "figural excess," which cannot be encompassed within linguistic and semiotic practices alone. Such approaches place photographs in subjective and emotional registers that cannot be reduced to the visual apprehension of an image. The stories told with and around photographs, the image held in the hand, features delineated through the touch of the finger, an object passed around, a digital image printed and put in a frame and carefully placed, dusted, and cared for, are key registers through which photographic meanings are negotiated.

However, in the pursuit of the analytical potential of the photograph's materiality it is important not to collapse into a dichotomous model that separates systems of abstract signs of semiotic approaches from material forms, because, of course, material properties are themselves signifying properties. As Keane (2005) has demonstrated, the material does not preclude the signifying energies of photographs, but rather challenges the radical separation of the sign from the material world to open the possibility of a better understanding of "the historicity *inherent* to signs *in their very materiality*" as signs exist within the "material world of consequences" (Keane 2005, p. 183 [emphasis in original], p. 186). In thinking about photographs materially, Keane's work, though not on photography as such, suggests nonetheless a fertile analytical ground in arguing that the semiotic signs must be understood not only as a mode of communicating abstract, linguistically framed meaning, but as signs that function "within a material world of consequences" in which materiality is not merely an element in the way that the sign is interpreted by its "reader" but that it "gives rise to and transforms modalities of action and subjectivity *regardless* of whether they are interpreted" (Keane 2005, p. 186, emphasis in original). Photographs behave precisely in this way.

Having outlined the theoretical and analytical landscape, I want now to address more specifically the ways in which material approaches to photographs have enriched the anthropological understanding of these ubiquitous objects. As I have suggested, these analytical positions constitute an overall unease with the dominant understandings of photographs in iconographical, semiotic, and linguistic models of photographic meaning. Although this unease has a strong interdisciplinary character, for instance in the work of Bal and of Mitchell who have argued for the multisensory and agentic nature of the visual image (Bal 2003; Mitchell 2005), the formative ethnographic tradition of anthropology has both grounded and demonstrated the methodological and theoretical potential of material approaches to photography, a position that has become increasingly pertinent in the context of the inexorable spread of global media (Ginsburg et al. 2002; Pinney and Peterson 2003).

Material practices

The potential range of material practices and material objects that comprises the category "photographs" is massive. Photographs exist as contact prints, enlargements, postcards, lantern slides, or transparencies, for example. They exist as professional formats, snapshots, artworks, or the products of bazaar and street photographers. They are glossy or matte, black and white, colored or hand-tinted. They are collaged, overpainted, cropped, framed, and reframed, placed in albums, hung on walls, kept in secret places, written on, exchanged, and sometimes destroyed or defaced in an act of self-conscious violence (Batchen 2004; Edwards and Hart 2004b). They are sung to, danced with, paraded, and placed on religious objects in assemblages of affect (see, for example, Peterson 1985; Edwards 1999; Brown and Peers 2006; Deger 2006; Van Dijck 2007; Vokes 2008; Empson 2011). They are joined now by a whole range of digital images (which are not in the strictest sense "photographs" but are popularly described as such). These aspects are beyond the scope of this review; however, digital images are enmeshed in a range of material practices and formations that both fulfill and exceed the social practices of analog photographs (Van Dijck 2007; Rose 2010). Furthermore, photographs, as objects defined in part by their reproducibility and potential repurposing, are objects with active biographies in a constant state of flux. They are reframed, replaced, rearranged; negatives become prints, prints become lantern slides or postcards, ID photographs become family treasures, private photographs become archives, analog objects become electronic digital code, private images become public property, and photographs of scientific production are reclaimed as cultural heritage (Bell 2003; Edwards 2003; Brown and Peers 2006; Geismar 2006; Geismar and Herle 2010; Strassler 2010).

A major anthropological contribution to thinking on photographs and photography more generally has been through its engagement with the social saliency of the photograph's material significance. Anthropology has produced ethnographically grounded accounts of photography as an everyday phenomenology of the photographic object, considered in conjunction with a careful attention to the photograph's ontology. This work has constituted an anthropological decentering of the normative assumption about the nature of photographs and has challenged and complicated the dominant categories of Western photographic analysis: realism, referent, trace, index, icon,

and the power of representation. For instance, in some popular practices in India the "reality" effect of a photograph is not located in the indexical trace of the image itself but in the way an imagined and dreamlike self is constructed through additive techniques of overpainting and collaging, practices that have strong parallels in West Africa (Pinney 1997; Wendl and Behrend 1998; Haney 2010, pp. 126–50). Such work points to the provincial nature of Eurocentric notions of photography (Pinney and Peterson 2003; Wright 2004) and demonstrates the inseparability of social practices, material practices, and imaging practices, as material forms are used to expand, enhance, and cohere the image content itself.

Index: In photographic theory "index" describes the relationship between a photograph and its subject, the former pointing to the latter

I explore briefly two interconnected elements of the material practices of photography, which have marked the anthropological literature in different ways. In both, the material qualities of photographs are laden with signifying properties and demonstrate the ways in which photographs are put to work in social relations. First is the idea of "placing." I use this term to mean the work of a photographic object in social space through which questions of materiality, adjacency, assemblage, and embodied relations frame the meaning of the image. Second, to consider the material conditions of photographs themselves, I consider the remediation and repurposing of photographic images: the material translation of a photograph from one kind of object to another, and from one purpose to another. My example is the ubiquitous ID card photograph because it exemplifies the complex double helix of a photograph's material biography. In the following section I then consider the embodied and sensory encounters with the photographic image implied by both these performances of photographs: placing and remediation.

Material culture studies have stressed the importance of the spatial dynamics of objects. The placing of photographs as objects in an assemblage of other objects and spaces is integral to the work asked of photographs and human relations with them. Placing is defined as a sense of appropriateness of particular material forms to particular sets of social expectation and desire within space and time. Such ideas of appropriateness and affordance in material forms saturate the ethnographies of photographic practice. As Drazin and Frohlich (2007) argue in their analysis of the practices of family photographs in British homes, photographs "demand of us that they be treated right"; that is, there is a sense of "morally correct" material practices around photographs (pp. 51, 54). This notion relates to Rose's concept of "affordances" and to Goffman's notion of "appropriateness" – the culturally determined accordance of content, genre, and material performance, in that the social work of photographs as material objects allows for them to be treated only in certain ways (Rose 2010).

Appropriateness is often articulated through material forms and additive material interventions in relation to the image itself, such as overpainting or collaging. But these material interventions are activated through the placing of photographs appropriately into wider assemblages. The process is well demonstrated in Empson's

(2011) study of the photomontages developed by Buriad nomads in Mongolia. These photographic constructions are carefully placed, both within the frame itself and within the broader assemblages of domestic space. Assemblages of images, often arranged to express kin links and social networks, are placed for display on the household chest, where "items of wealth and prestige are deliberately displayed on the chest's surface" and visitors are invited to admire and to touch (Empson 2011, p. 117). The placing exactly replicates that of the shamanistic ancestral figures of pre-Soviet days (p. 125). Through placing, the photograph becomes a statement of its social importance and efficacy because it carries too a sense of the placing of the image within social relations. Photographs are used to cohere both kin and other relations through practices of adjacency and exchange. Photographs to be "treated right" must be in the "right place" and with the "right people," in that inappropriateness of forms and treatment can perhaps have serious consequences. For conversely, in many instances a "misplacing" or "mistreatment" of the image risks the potential for witchcraft and inappropriate or undesired control; Behrend describes, for instance, the connection between witchcraft and the material destruction of photographs in Uganda (Behrend 2003).

Viewing photographs demands a certain form of behavior and etiquette in how images are both viewed and managed. For instance, Empson (2011) notes how "[d]ifferent images are . . . displayed at different seasonal places, allowing for change and adaption according to different needs" (p. 132). In another example, Vokes has explored ways in which albums are developed in the final months of the life of AIDS victims in Uganda (Vokes 2008). These albums carry sets of social relations and intersubjectivities. They are carefully crafted, self-conscious "biographical objects" through which stories can be told (Hoskins 1998) – statements of self and experience, intended as image-objects that will outlive their makers. These albums are affective objects because they are conceived of as, on the one hand, objects with a cathartic affect for the bereaved, and on the other, they "confer upon the deceased a particularly effective on-going 'presence' and 'agency' in the lives of the living" as an indistinguishable "life-form," articulated through the material object (Vokes 2008, p. 361). As is often so in the case of albums, to fulfill their social role, the albums must be in the right hands, both literally and metaphorically.

Questions of identity and the social agency of photographs bring me to the second example I consider. As I have suggested, photographs are called on to do their work in a multiplicity of ways, and these serial demands of repurposing carry an implicit requirement for remediation or re-placing. The material performance of images over space and time is amply demonstrated by one of the most widespread photographic forms but also one of the most widely appropriated and remediated: the humble and ubiquitous ID card photograph. ID cards photographs, as instrumental visual forms, are associated with the definition, registration, and control of the civil identity by the state, from everyday banal state management to the loathed and contested passbooks in apartheid South Africa. But as a highly normalized and accessible visual form, ID card photography has had a major quantitative and qualitative impact on photographic practices and practices of visual consumption globally, part of the social, economic, and commercial processes and networks through which images are obtained.

ID photographs are a form found extensively in photographic montages and albums, because they remain, for many people, the only access to photographs and photographic memorialization. For instance, a number of anthropologists have noted the way in which ID cards are cut up on the death of its holder to retrieve the photograph, often the only one in existence, as a memorializing object within the family and household. Unlike the replaceable and reproducible object of Western assumption, the photographic print becomes a precious object that carries a direct physical connection with the deceased. In such uses, the role of the ID card photography is realized not necessarily through remediation of the image itself into another format through its reproducibility, but through the removal of what is perceived as a unique photographic object into other social uses.

Whatever the precise processes through which new uses are achieved, ID card photographs famously fit Sekula's notion of "repressive" as opposed to "honorific" portraiture (Sekula 1992, p. 345). Although photographs have always encompassed a dual possibility between the poles of repressive and honorific, what is significant is the way in which the repurposing of photographs into newly desired functions is effected by material practices such as enlargement, overpainting, recoloring, framing, reframing, photocopying, juxtaposing, pasting into albums, collaging, or transformation into objects of political confrontation (Pinney 1997; Werner 2001; Noble 2009, pp. 68, 70). These material processes shape the signifying possibilities of the photograph and allow the image to be "transposed from one realm of significance to another" (Strassler 2010, p. 27), from the state management of its citizens to the world of affect and intimate social relations, and from public to private realms. As such ID photographs demonstrate the way in which photographs are revalorized and reimagined, and new identities and sets of connection forged, through material practices that mobilize content in different ways. These practices "demonstrate how the state's gaze is both extended and refigured as it seeps into popular 'ways of seeing" (Strassler 2010, p. 147), while at the same time changes in state regulations around ID cards, from black and white to color for instance, inflect the way in which those seepages work (Werner 2001; Zeitlyn 2010, p. 454).

Such processes are not, of course, confined to ID cards, but the radical shifts in meaning and the reinstrumentalizing that accompanies the repurposing and remediation of these photographs and the claims made of them highlight the process of a material, visual economy and social biography, the analysis of which has shaped so much anthropological work.

The sensory photograph

What is clear from these examples is that the understanding of photographs cannot be contained in the relation between the visual and its material support but rather through an expanded sensory realm of the social in which photographs are put to work. The shifts from meaning alone to mattering and from content to social process are integral to material approaches to photographs and have demanded an analytical approach that acknowledges the plurality of modes of experience of the photograph as tactile, sensory things that exist in time and space and are constituted by and through social relations.

Emerging from debates on materiality and those around the primacy of vision, especially in cross-cultural environments, there has been an increasing analytical interest in photography as a phenomenologically and sensorially integrated medium, embodied and experienced by both its makers and its users. It is a position that emerges from a confluence of work that, on the one hand, challenges the assumed hierarchy of the senses and the primacy of vision, positioned in a broader notion of sensory scholarship (Feld 1990; Stoller 1997; Howes 2003) and, on the other, phenomenological approaches to the work of affect in the apprehension of objects. The idea of photographs as agentic objects that elicit affect has its roots in Gell's analysis of the art object but is heavily inflected with ideas from phenomenological anthropology concerned with embodied constructions and negotiation of experience – a "being in the world" (Feld 1990; Csordas 1994; Jackson 1996; Ingold 2011). The development of these ideas has progressed within the emerging debate on materiality. What Keane has described as "bundled" signifying qualities are also affective qualities, hence efficacy of their signifying properties as the bundling of sensory and material affects in which an object is defined through the copresence of the visual with other qualities – such as texture, weight, or size – which invite tactility, gesture, and embodied apprehension (Keane 2005, p. 188).

These arguments have provided a fertile ground from which to consider how photographs are made to mean in relation to social actions across a range of sensory experience and in which different perceptual situations demand different sensual configurations, composed of sound, gesture, touch, language, song, and haptic relations. These arguments insist on a sense of the relationship between the body and the photographic images, how users position themselves in relation to photographic images, how they view, handle, wear, and move with photographic images and perform a sense of appropriateness through relationships with the photographic image (Harris 2004; Brown and Peers 2006). Pinney (2001), concerned to reinstitute the analytical significance and weight of performative embodiment within the everyday usage of images, and in "understanding photographs" in particular, has helped the theoretical formulation of this position. In an essay, itself a response to Gell's work, Pinney (2001) developed the term "corpothetics" as "the sensory embrace of images, the bodily engagement that most people . . . have with artworks." This position indicates not a lack in images but a rich and complex praxis through which people articulate their eyes and their bodies in relation to pictures (pp. 158, 160–1).

Similar ideas of the relation to the multisensory nature of images have been argued too in art history and visual culture studies. Mitchell (2005) has argued that there are no "visual media" as such, rather that "all media are, from the standpoint of sensory modality, 'mixed media'" (p. 257). Instead he presents images as "braided," in that "one sensory channel or semiotic function is woven together with another more or less seamlessly" (p. 262). Likewise Bal (2003) had pointed out the absurdity of an essentialized or pure form of "the visual": "The act of looking is profoundly 'impure'. . . . [T]his impure quality is also . . . applicable to other sense-based activities: listening, reading, tasting, smelling. This impurity makes such activities mutually permeable, so that listening and reading can also have visuality to them" (p. 9). Fundamental to these models is the acknowledgment that in the apprehension of the visual, one sensation is often integrally related to, and followed by, another to form continuous patterns of experience, representing a dense social embedding of an object.

> **Haptic:** while used primarily of touch, in visual theory it is used to imply a wider multisensory embodied perception

Consequently, there has been, as Taussig (1993) has argued, a rethinking of vision in relation to other sensory modalities. The relationship between orality and sound has been a particularly important strand in thinking about photographs and one that has been gathering with increasing force within anthropology. This is especially so in work of "visual repatriation" and the articulation of histories, as people use the material forms of photographs as foci for telling stories and claiming histories, singing, and chanting (Poignant 1996; Brown and Peers 2006; Edwards 2006). As anthropological studies, they have addressed the role of photographs in the processes of identity, history, and memory. What are the material and affective performances through which photographs might become a form of history or engagement with, and reclamation, of the past (see, for instance, Fienup-Riordan 1998; Bell 2003; Brown and Peers 2006; Geismar and Herle 2010)? These studies have revealed a range of cultural responses to the ontological insistence of photographs – that "it was there" – an "ectoplasm of 'what-had-been'" (Barthes 1984, p. 87). The apprehension of photographs in these contexts is premised on the content of the image (MacDonald 2003; Smith 2003; Wright 2004; Deger 2006; Edwards 2006; Bell 2008, 2010; Vokes 2008; Strassler 2010). This is not, however, necessarily simply a verbalized forensic description of the content, but more importantly a talking with and talking to photographs in which photographs become interlocutors. Photographs connect to life as experienced, to "images, feelings, sentiments, desires and meanings," but they also have the potential for "a process of enactment and rhetorical assertion" and as "nodes where various discourses temporarily intersect in particular ways" (Hoskins 1998, p. 6).

Many studies have focused, for instance, on the key relations between photographs, their place in the negotiation of relations between the past and the present, the living and the dead, the spirit world and the future (Wright 2004; Deger 2006; Smith and Vokes 2008), and the powerful connection between the photographic object, as a relic held in the hand and the physical connection to the subject. Halvaksz (2010), for example, has shown how for the Biangai people in Papua New Guinea, multiple social identities, the living and the dead, are folded into the very materiality of photographs, as photographs render the ancestors literally coeval with the living. What this example demonstrates is another aspect that has informed thinking about photographs, and their social efficacy: the photograph as a form of partible self. This notion draws on the work of anthropologists such as Strathern in which individuals are made up of different composite and divisible relations. Photographs are thus not merely surrogates for the absent, but powerful actants in social space "intertwined with a larger process of maintaining different forms of sociality and personhood" (Empson 2011, p. 109).

The detailed ethnographies of photographic use also give us a clear sense of the way in which photographs are absorbed into other forms and practices of narration. Photographs are seldom talked about without being touched, stroked, kissed, clasped, and integrated into a range of gestures. Furthermore, the flow of narration and the

handling of photographs, as they are passed around, is often determined by cultur-
ally specific hierarchies of authority, knowledge, and the right to speak, notably in
kin groups, age sets, or gender divisions (Niessen 1991; Poignant 1992; Bell 2003).
As such, photographs become important parts of the processes through which com-
munity coherence is articulated (Brown and Peers 2006). One example is the way in
which photographs work in a number of Australian aboriginal communities, them-
selves dispersed through attenuated kinship ties and urban migration (Poignant 1996;
Smith 2003, p. 20; Deger 2006). In such contexts, the performances of narrated pho-
tographs are demonstrated in how photographs become embodied within social rela-
tions as active constituents of social networks. Photographs move as tactile objects
around groups of people. It is again in these contexts that the work of Gell on the
agency of objects has focused on the ways in which objects, here photographs, elicit
both effect and affect, as things that, with echoes of Latour, are integrally constitutive
of and constituted through social processes. Its application to photographs intersects
with the ontology of the photographic image itself in a multisensory mediation in
experience in which sensory effects are social effects.

However, it is important to note here too that although the literature often
equates orality with the spoken voice and narration (for example, Langford 2001),
in understanding the use and impact of photographs' narrative environments, para-
linguistic sounds – sobbing, sighing, laughing – are of major communicative impor-
tance, just as the silences are filled with gesture and touch (Edwards 2006). The
crucial point of these ethnographies is that photographic meaning is made through
a confluence of sensory experience, in which the visual is only a part of the effi-
cacy of the image. This notion is powerfully demonstrated by an instance when a
decayed, much handled photograph, worn away by touch, handed to Chris Wright
in the Solomon Islands was still seen as being of someone and treasured as such,
long after the material decay of the photograph had rendered it illegible (Wright
2007).

Finally, these sensory responses to photographs are integrally related to ques-
tions of placing, discussed above, because the placing of photographs and bodily
interactions with them demand specific sets of relations (Hanganu 2004; Pinney
2004; Wright 2004, p. 81; Parrott 2009). The haptics of placing and adjacency are
significant in more than just the domestic space, however. They are equally perti-
nent as forms of political embodiment, such as demonstrated in the parading of
photographs or the public defilement of photographs in protest (Strassler 2010).
Such engagements with the laminated photographic object are part of a larger
photographic claim to citizenship and political power (for an extended discussion
of such issues, see Azoulay 2008). For instance, resonating with Pinney's concept
of "corpothetics," Harris has described the ways in which Tibetans slept with the
soles of their feet pointing at photographic portraits of Mao Tse Tung (often them-
selves heavily materially mediated by overpainting), constituting a major insult (Har-
ris 2004), whereas Strassler describes a haptically experienced landscape of images
that developed in Indonesia in the political protests of the 1990s. This included
the Outdoor Exhibition in which students produced a moving exhibition of held,
framed photographs of protest and violence, which was processed in the streets,
and the pictures were held up in moments of stillness within the procession (Stras-
sler 2010, pp. 246–7).

Closing thoughts

All these processes render photographs profoundly social objects of agency that cannot be understood outside the social conditions of the material existence of their social function – the work that they do. The ideas outlined here have been engaged with over a wide range of socio-photographic practices. Importantly, some of these practices are not, on the surface, primarily "photographic"; rather they demonstrate the way that photographs, their material forms, and their social purposes play through a range of practices and concepts such as elegance, social exchange, and of course, memorialization (Buckley 2000/2001, 2006; Drazin and Frohlich 2007). For instance, Buckley traces the complex relationship between photographs and their social uses, concepts of elegance and modernity, and what he describes as "the aesthetics of citizenship," which are performed through sets of relationships between the colonial and postcolonial imaging practices in The Gambia (Buckley 2006). He also suggests ways in which anthropological studies of photographic practices can illuminate not only the practices of photography itself, but that they can also furnish ways through which material and sensory approaches to photographs might illuminate other broader anthropological questions, for instance religious experience (Klima 2002), ideas of modern identity (Hirsch 2004; Buckley 2006), or claims to sovereignty, cultural property, and land (Bell 2003; Harris 2004; Brown and Peers 2006).

What all this work does is bring a theory of effects into the center of the understanding of photographs and displace the analytical dominance of looking at the image alone. This practice does not, of course, invalidate or elide the content of the image. Indeed, the content of the image must remain at the center because it is the basis through which photographs are understood. But what the material turn in visual anthropology has also made possible, to return to Keane's question with which I started, is the way in which those understandings are materially grounded in the experience of the world as users of photographic objects, not simply viewers of images. Arguably too, the ethnographic density now emerging in photographic studies in anthropology presents an opportunity to rethink the theoretical tools through which photographs and photography might be understood more broadly.

Original publication

'Objects of Affect: Photography Beyond the Image' in *The Annual Review of Anthropology* (2012).

Literature cited

Appadurai A. ed. 1986. *The Social Life of Things: Commodities in Cultural Perspective*. Cambridge: Cambridge Univ. Press

Azoulay A. 2008. *The Civil Contract of Photography*. New York: Zone

Bal M. 2003. Visual essentialism and the object of visual culture. *J. Vis. Cult.* 2(1):5–32

Banks M, Morphy H. 1997. *Rethinking Visual Anthropology*. New Haven: Yale Univ. Press

Barthes R. 1984 [1980]. *Camera Lucida*, transl. R Howard. London: Flamingo

Batchen G. 2004. *Forget Me Not: Photography and Remembrance*. New York: Princeton Archit. Press

Behrend H. 2003. Photo magic: photographs in practices of healing and harm in East Africa. *J. Relig. Afr.* 33 (Fasc. 2):129–45

Bell JA. 2003. Looking to see: reflections on visual repatriation in the Purari Delta, Gulf Province, Papua New Guinea. See Peers and Brown 2003, pp. 111–21

Bell JA. 2008. Promiscuous things: perspectives on cultural property through photographs in the Purari Delta of Papua New Guinea. *Int. J. Cult. Prop.* 15(2):123–39

Bell JA. 2010. Out of the mouth of crocodiles: eliciting histories in photographs and string-figures. *Hist. Anthropol.* 21(4):351–73

Belting H. 2011. *An Anthropology of Images: Picture, Medium, Body*, transl. T Dunlap. Chicago: Univ. Chicago Press

Boast R, Guha S, Herle A. 2001. *Collected Sights: Photographic Collections of the Museum of Archaeology and Anthropology, 1860s–1930s*. Cambridge: Mus. Archaeol. Anthropol.

Bourdieu P. 1965. *Un Art Moyen*. Paris: Éd. Minuit

Brown A, Peers L. 2006. *Pictures Bring Us Messages*. Toronto: Univ. Tor. Press

Buchli V. 2002. Introduction. In *The Material Culture Reader*, ed. V Buchli, pp. 1–22. Oxford: Berg

Buckley L. 2000/2001. Self and accessory in Gambian studio photography. *Vis. Anthropol. Rev.* 16(2):71–91

Buckley L. 2006. Studio photography and the aesthetics of citizenship in the Gambia, West Africa. In *Sensible Objects: Colonialism, Museums and Material Culture*, ed. E Edwards, C Gosden, R Phillips, pp. 61–86. Oxford: Berg

Csordas T. 1994. *Embodiment and Experience: The Existential Ground of Culture and Self*. Cambridge: Cambridge Univ. Press

Deger J. 2006. *Shimmering Screens: Making Media in an Aboriginal Community*. Minneapolis: Minn. Univ. Press

Drazin A, Frohlich D. 2007. Good intentions: remembering through framing photographs in English homes. *Ethnos* 72(1):51–76

Edwards E, ed. 1992. *Anthropology and Photography 1865–1920*. New Haven/London: Yale Univ. Press

Edwards E. 1999. Photographs as objects of memory. In *Material Memories*, ed. M Kwint, C Breward, pp. 221–36. Oxford: Berg

Edwards E. 2001. *Raw Histories: Photographs, Anthropology and Museums*. Oxford: Berg

Edwards E. 2002. Material beings: the objecthood of ethnographic photographs. *Vis. Stud.* 17(1):69–75

Edwards E. 2003. Talking visual histories. See Peers and Brown, pp. 83–99

Edwards E. 2006. Photographs and the sound of history. *Vis. Anthropol. Rev.* 21(1/2):27–46

Edwards E. 2011. Tracing photography. In *Made to be Seen*, ed. M Banks, J Ruby, pp. 159–89. Chicago: Chicago Univ. Press

Edwards E, Hart J. 2004a. Mixed box: the cultural biography of a box of "ethnographic" photographs. See Edwards and Hart 2004b, pp. 47–61

Edwards E, Hart J. 2004b. *Photographs, Objects, Histories: On the Materiality of the Image*. London: Routledge

Empson R. 2011. *Harnessing Fortune: Personhood, Memory and Place in Northeast Mongolia*. Oxford: Oxford Univ. Press

Feld S. 1990. *Sound and Sentiment: Birds, Weeping, Poetics, and Song in Kaluli Expression*. Philadelphia: Univ. Penn. Press

Fienup-Riordan A. 1998. Yup'ik elders in museums: fieldwork turned on its head. *Arct. Anthropol.* 35(2):49–58

Geismar H. 2006. Malakula: a photographic collection. *Comp. Stud. Soc. Hist.* 48:520–43

Geismar H. 2009. The photograph and the Malanggan: rethinking images on Malakula, Vanuatu. *Aust. J. Anthropol.* 20(1):48–73

Geismar H, Herle A, eds. 2010. *Moving Images: John Layard, Fieldwork and Photography in Malakula Since 1914*. Belair: Crawford House Press/Univ. Hawaii Press

Gell A. 1998. *Art and Agency: An Anthropological Theory*. Oxford: Clarendon

Ginsburg F, Abu-Lughod L, Larkin B, eds. 2002. *Media Worlds: Anthropology in New Terrain*. Berkeley: Univ. Calif. Press

Halvaksz J. 2010. The photographic assemblage: duration, history and photography in Papua New Guinea. *Hist. Anthropol.* 21(4):411–29

Haney E. 2010. *Photography and Africa*. London: Reaktion

Hanganu G. 2004. "Photo-cross": the political and devotional lives of a Romanian orthadox photograph. See Edwards and Hart 2004b, pp. 148–65

Harris C. 2004. The photograph reincarnate. See Edwards and Hart 2004b, pp. 132–47

Hevia J L. 2009. The photography complex: exposing Boxer-Era China 1900–1. In *Photographies East: The Camera and Its Histories in East and Southeast Asia*, ed. R Morris, pp. 79–99. Durham: Duke Univ. Press

Hirsch E. 2004. Techniques of vision: photography, disco and renderings of present perception in highland Papua. *J. R. Anthropol. Inst.* 10(1):19–39

Hoskins J. 1998. *Biographical Objects: How Things Tell the Stories of People's Lives*. New York/London: Routledge

Howes D. 2003. *Sensual Relations: Engaging the Senses in Culture and Social Theory*. Ann Arbor: Univ. Mich. Press

Ingold T. 2011. *Being Alive: Essays on Movement, Knowledge and Description*. London: Routledge

Isaac G. 2007. *Mediating Knowledges: Origins of a Zuni Tribal Museum*. Tucson: Univ. Ariz. Press

Jackson M, ed. 1996. *Things as They Are: New Directions in Phenomenological Anthropology*. Bloomington: Indiana Univ. Press

Keane W. 2005. Signs are not the grab of meaning: on the social analysis of material things. In *Materiality*, ed. D Miller, pp. 182–205. Durham: Duke Univ. Press

Klima A. 2002. *The Funeral Casino: Meditation, Massacre and Exchange with the Dead in Thailand*. Princeton: Princeton Univ. Press

Knappett C. 2002. Photographs, skeuomorphs and marionettes: some thoughts on mind, agency and object. *J. Mater. Cult.* 7(1):97–117

Kopytoff I. 1986. The cultural biography of things. See Appadurai 1986, pp. 64–94

Kratz C. 2001. *The Ones that Are Wanted: Communication and the Politics of Representation in a Photographic Exhibition*. Berkeley: Calif. Univ. Press

Langford M. 2001. *Suspended Conversations: The Afterlife of Memory in Photographic Albums*. Montreal/Kingston: McGill/Queens Univ. Press

Latour B. 2005. *Reassembling the Social: An Introduction to Actor Network Theory*. Oxford: Oxford Univ. Press

Lydon J. 2005. *Eye Contact: Photographing Indigenous Australians*. Durham: Duke Univ. Press

MacDonald G. 2003. Photos in Wiradjuri biscuit tins: negotiating relatedness and validating colonial histories. *Oceania* 73(4):225–42

Miller D, ed. 1998. *Materiality: Why Some Things Matter*. London: Univ. Coll. London Press

Mitchell WJT. 2005. There are no visual media. *J. Vis. Cult.* 4(2):257–66

Niessen S. 1991. More to it than meets the eye photo-elicitation amongst the Batak of Sumatra. *Vis. Anthropol.* 4:415–30

Noble A. 2009. Family photography and the global drama of human rights. In *Photography: Theoretical Snapshots*, ed. J Long, A Noble, E Welch, pp. 63–79. London: Routledge

Parrott F. 2009. *The Transformation of Memory Photography and the Domestic Interior: An Ethnographic Study of the Representational, Memorial and Ancestral Practices of South London Householders*. PhD thesis. Dep. Anthropol., Univ. Coll. London

Peers L, Brown A, eds. 2003. *Museums and Source Communities: A Routledge Reader*. London: Routledge

Peterson N. 1985. The popular image. In *Seeing the First Australians*, ed. I Donaldson, T Donaldson, pp. 164–80. Sydney: George Allen and Unwin

Pinney C. 1992. Parallel histories of anthropology and photography. In *Anthropology and Photography 1865–1920*, ed. E Edwards, pp. 74–95. New Haven/London: Yale Univ. Press

Pinney C. 1997. *Camera Indica: The Social Life of Indian Photographs*. London: Reaktion

Pinney C. 2001. Piercing the skin of the idol. In *Beyond Aesthetics*, ed. C Pinney, N Thomas, pp. 157–79. Oxford: Berg

Pinney C. 2004. *Photos of the Gods*. London: Reaktion

Pinney C. 2005. Things happen: or, from which moment does that object come? In *Materialty*, ed. D Miller, pp. 256–72. Durham: Duke Univ. Press

Pinney C. 2008. *The Coming of Photography to India*. London: Br. Libr.

Pinney C. 2011. *Photography and Anthropology*. London: Reaktion

Pinney C, Peterson N, eds. 2003. *Photography's Other Histories*. Durham: Duke Univ. Press

Poignant R. 1992. Wurdayak/Baman (life history) photo collection: report on the setting up of a life history photo collection at the Djomi Museum, Maningrida. *Aust. Aborig. Stud.* 2:71–7

Poignant R. 1996. *Encounter at Nagalarramba*. Canberra: Natl. Libr. Aust.

Poole D. 1997. *Vision, Race, and Modernity: A Visual Economy of the Andean Image World*. Princeton: Princeton Univ. Press

Rose G. 2010. *Doing Family Photography*. Farnham: Ashgate

Sekula A. 1992. The body and the archive. In *The Contest of Meaning: Critical Histories of Photography*, ed. R Bolton, pp. 342–89. Cambridge, MA: MIT Press

Smith BM. 2003. Images, selves and the visual record: photography and ethnographic complexity in Central Cape York Peninsula. *Soc. Anal.* 47(3):8–26

Smith BM, Vokes R. 2008. Haunting images: the affective power of photography. *Spec. Issue Vis. Anthropol. Rev.* 21(4):283–91

Stoller P. 1997. *Sensuous Scholarship*. Philadelphia: Univ. Penn. Press

Strassler K. 2010. *Refracted Visions: Popular Photography and National Modernity In Java*. Durham: Duke Univ. Press

Strathern M. 1996. Cutting the network. *J. R. Anthropol. Inst.* 2(3):517–35

Taussig M. 1993. *Mimesis and Alterity*. New York: Routledge

Van Dijck J. 2007. *Mediated Memories in the Digital Age*. Stanford: Stanford Univ. Press

Vokes R. 2008. On ancestral self-fashioning: photography in the times of AIDS. *Vis. Anthropol.* 21(4):345–63

Wendl T, Behrend H. 1998. *Snap Me One!: Studiofotografen in Afrika*. Münich/New York: Prestel

Werner J-F. 2001. Photography and individualization in contemporary Africa: an Ivoirian case-study. *Vis. Anthropol.* 14:3, 251–68

Wright C. 2004. Material and memory: photography in the Western Solomon Islands. *J. Mater. Cult.* 9(1):73–85

Wright C. 2007. Photo-objects. *Mater. World*. http://blogs.nyu.edu/projects/materialworld/2007/01/photoobjects.html

Zeitlyn D. 2010. Photographic props/the photographer as prop: the many faces of Jacques Tousselle. *Hist. Anthropol.* 21(4):453–77

Christian Metz

PHOTOGRAPHY AND FETISH[1]

T O BEGIN I WILL BRIEFLY RECALL some of the basic differences between film and photography. Although these differences may be well-known, they must be, as far as possible, precisely defined, since they have a determinant influence on the respective status of both forms of expression in relation to the fetish and fetishism.

First difference: the spatio-temporal size of the *lexis*, according to that term's definition as proposed by the Danish semiotician Louis Hjelmslev. The lexis is the socialized unit of reading, of reception: in sculpture, the statue; in music, the 'piece.' Obviously the photographic lexis, a silent rectangle of paper, is much smaller than the cinematic lexis. Even when the film is only two minutes long, these two minutes are *enlarged*, so to speak, by sounds, movements, and so forth, to say nothing of the average surface of the screen and of the very fact of projection. In addition, the photographic lexis has no fixed duration (= temporal size): it depends, rather, on the spectator, who is the master of the look, whereas the timing of the cinematic lexis is determined in advance by the filmmaker. Thus on the one side, 'a free rewriting time'; on the other, 'an imposed reading time,' as Peter Wollen has pointed out.[2] Thanks to these two features (smallness, possibility of a lingering look), photography is better fit, or more likely, to work as a fetish.

Another important difference pertains to the social use, or more exactly (as film and photography both have many uses) to their principal legitimated use. Film is considered as collective entertainment or as art, according to the work and to the social group. This is probably due to the fact that its production is less accessible to 'ordinary' people than that of photography. Equally, it is in most cases fictional, and our culture still has a strong tendency to confound art with fiction. Photography enjoys a high degree of social recognition in another domain: that of the presumed real, of life, mostly private and family life, birthplace of the Freudian fetish. This recognition is ambiguous. Up to a point, it does correspond to a real distribution of social practices: people do take photographs of their children, and when they want their feature film, they do go to the movies or watch TV. But on the other side, it happens that

photographs are considered by society as works of art, presented in exhibitions or in albums accompanied by learned commentary. And the family is frequently celebrated, or self-celebrated, in private, with super-8 films or other nonprofessional productions, which *are* still cinema. Nevertheless, the kinship between film and collectivity, photography and privacy, remains alive and strong as a social myth, half true like all myths; it influences each of us, and most of all the stamp, the look of photography and cinema themselves. It is easy to observe – and the researches of the sociologist Pierre Bourdieu,[3] among others, confirm it – that photography very often primarily means souvenir, keepsake. It has replaced the portrait, thanks to the historical transition from the period when long exposure times were needed for true portraits. While the social reception of film is mainly oriented toward a show-business-like or imaginary referent, the real referent is felt to be dominant in photography.

There is something strange in this discrepancy, as both modes of expression are fundamentally *indexical*, in Charles Sanders Pierce's terms. (A recent, remarkable book on photography by Philippe Dubois is devoted to the elaboration of this idea and its implications.)[4] Pierce called indexical the process of signification (*semiosis*) in which the signifier is bound to the referent not by a social convention (= 'symbol'), not necessarily by some similarity (= 'icon'), but by an actual contiguity or connection in the world: the lightning is the index of the storm. In this sense, film and photography are close to each other, both are *prints* of real objects, prints left on a special surface by a combination of light and chemical action. This indexicality, of course, leaves room for iconic aspects, as the chemical image often looks like the object (Pierce considered photography as an index *and* an icon). It leaves much room for symbolic aspects as well, such as the more or less codified patterns of treatment of the image (framing, lighting, and so forth) and of choice or organization of its contents. What is indexical is the mode of production itself, the principle of the *taking*. And at this point, after all, a film is only a series of photographs. But it is more precisely a series with supplementary components as well, so that the unfolding as such tends to become more important than the link of each image with its referent. This property is very often exploited by the narrative, the initially indexical power of the cinema turning frequently into a realist guarantee for the unreal. Photography, on the other hand, remains closer to the pure index, stubbornly pointing to the print of what *was*, but no longer *is*.

A third kind of difference concerns the physical nature of the respective signifiers. Lacan used to say that the only materialism he knew was the materialism of the signifier. Whether the only one or not, in all signifying practices the material definition is essential to their social and psychoanalytic inscription. In this respect – speaking in terms of set theory – film 'includes' photography: cinema results from an addition of perceptive features to those of photography. In the visual sphere, the important addition is, of course, movement and the plurality of images, of shots. The latter is distinct from the former: even if each image is still, switching from one to the next creates a *second movement*, an ideal one, made out of successive and different immobilities. Movement and plurality both imply *time*, as opposed to the timelessness of photography which is comparable to the timelessness of the unconscious and of memory. In the auditory sphere – totally absent in photography – cinema adds phonic sound (spoken words), nonphonic sound (sound effects, noises, and so forth), and musical sound. One of the properties of sounds is their expansion, their development in time (in space they only irradiate), whereas images construct themselves in space. Thus film disposes of

five more orders of perception (two visual and three auditory) than does photography, all of the five challenging the powers of silence and immobility which belong to and define all photography, immersing film in a stream of temporality where nothing can be *kept*, nothing stopped. The emergence of a fetish is thus made more difficult.

Cinema is the product of two distinct technological inventions: photography, and the mastering of stroboscopy, of the ϕ-effect. Each of these can be exploited separately: photography makes no use of stroboscopy, and animated cartoons are based on stroboscopy without photography.

The importance of immobility and silence to photographic *authority*, the nonfilmic nature of this authority, leads me to some remarks on the relationship of photography with death. Immobility and silence are not only two objective aspects of death, they are also its main symbols, they *figure* it. Photography's deeply rooted kinship with death has been noted by many different authors, including Dubois, who speaks of photography as a 'thanatography,' and, of course, Roland Barthes, whose *Camera Lucida*[5] bears witness to this relationship most poignantly. It is not only the book itself but also its position of enunciation which illustrates this kinship, since the work was written just after (and because of) the death of the mother, and just before the death of the writer.

Photography is linked with death in many *different* ways. The most immediate and explicit is the social practice of keeping photographs in memory of loved beings who are no longer alive. But there is another real death which each of us undergoes every day, as each day we draw nearer to our own death. Even when the person photographed is still living, that moment when she or he *was* has forever vanished. Strictly speaking, the person who *has been photographed* – not the total person, who is an effect of time – is dead: 'dead for having been seen,' as Dubois says in another context.[6] Photography is the mirror, more faithful than any actual mirror, in which we witness at every age, our own aging. The actual mirror accompanies us through time, thoughtfully and treacherously; it changes with us, so that we appear not to change.

Photography has a third character in common with death: the snapshot, like death, is an instantaneous abduction of the object out of the world into another world, into another kind of time – unlike cinema which replaces the object, after the act of appropriation, in an unfolding time similar to that of life. The photographic *take* is immediate and definitive, like death and like the constitution of the fetish in the unconscious, fixed by a glance in childhood, unchanged and always active later. Photography is a cut inside the referent, it cuts off a piece of it, a fragment, a pan object, for a long immobile travel of no return. Dubois remarks that with each photograph, a tiny piece of time brutally and forever escapes its ordinary fate, and thus is protected against its own loss. I will add that in life, and to some extent in film, one piece of time is indefinitely pushed backwards by the next: this is what we call 'forgetting.' The fetish, too, means both loss (symbolic castration) and protection against loss. Peter Wollen states this in an apt simile: photography preserves fragments of the past 'like flies in amber.'[7] Not by chance, the photographic act (or acting, who knows?) has been frequently compared with shooting, and the camera with a gun.

Against what I am saying, it could of course be objected that film as well is able to perpetuate the memory of dead persons, or of dead moments of their lives. Socially, the family film, the super-8, and so forth, to which I previously alluded, are often used for such a purpose. But this pseudosimilarity between film and photography leads me back, in a paradoxical way, to the selective kinship of photography (not film) with

death, and to a fourth aspect of this link. The two modes of perpetuation are very different in their effects, and nearly opposed. Film gives back to the dead a semblance of life, a fragile semblance but one immediately strengthened by the wishful thinking of the viewer. Photography, on the contrary, by virtue of the objective suggestions of its signifier (stillness, again) maintains the memory of the dead *as being dead*.

Tenderness toward loved beings who have left us forever is a deeply ambiguous, split feeling, which Freud has remarkably analyzed in his famous study on *Mourning and Melancholia*,[8] The work of mourning is at the same time an attempt (not successful in all cases: see the suicides, the breakdowns) to survive. The object-libido, attached to the loved person, wishes to accompany her or him in death, and sometimes does. Yet the narcissistic, conservation instinct (ego-libido) claims the right to live. The compromise which normally concludes this inner struggle consists in transforming the very nature of the feeling for the object, in learning progressively to love this object *as dead*, instead of continuing to desire a living presence and ignoring the verdict of reality, hence prolonging the intensity of suffering.

Sociologists and anthropologists arrive by other means at similar conceptions. The funeral rites which exist in all societies have a double, dialectically articulated signification: a remembering of the dead, but a remembering as well *that they are dead*, and that life continues for others. Photography, much better than film, fits into this complex psycho-social operation, since it suppresses from its own appearance the primary marks of 'livingness,' and nevertheless conserves the convincing print of the object: a past presence.

All this does not concern only the photographs of loved ones. There are obviously many other kinds of photographs: landscapes, artistic compositions, and so forth. But the kind on which I have insisted seems to me to be exemplary of the whole domain. In all photographs, we have this same act of cutting off a piece of space and time, of keeping it unchanged while the world around continues to change, of making a compromise between conservation and death. The frequent use of photography for private commemorations thus results in part (there are economic and social factors, too) from the intrinsic characteristics of photography itself. In contrast, film is less a succession of photographs than, to a large extent, a destruction of the photograph, or more exactly of the photograph's power and action.

At this point, the problem of the space off-frame in film and in photography has to be raised. The fetish is related to death through the terms of castration and fear, to the off-frame in terms of the look, glance, or gaze. In his well-known article on fetishism,[9] Freud considers that the child, when discovering for the first time the mother's body, is terrified by the very possibility that human beings can be 'deprived' of the penis, a possibility which implies (imaginarily) a permanent danger of castration. The child tries to maintain its prior conviction that all human beings have the penis, but in opposition to this, what has been seen continues to work strongly and to generate anxiety. The compromise, more or less spectacular according to the person, consists in making the seen retrospectively unseen by a disavowal of the perception, and in *stopping the look*, once and for all, on an object, the fetish — generally a piece of clothing or under-clothing — which was, with respect to the moment of the primal glance, near, just prior to, the place of the terrifying absence. From our perspective, what does this mean, if not that this place is positioned off-frame, that the look is framed close by the absence? Furthermore, we can state that the fetish is taken up in two chains of

meaning: metonymically, it alludes to the contiguous place of the lack, as I have just stated; and metaphorically, according to Freud's conception, it is an equivalent of the penis, as the primordial displacement of the look aimed at replacing an absence by a presence – an object, a small object, a part object. It is remarkable that the fetish – even in the common meaning of the word, the fetish in everyday life, a re-displaced derivative of the fetish proper, the object which brings luck, the mascot, the amulet, a fountain pen, cigarette, lipstick, a teddy bear, or pet – it is remarkable that the fetish always combines a double and contradictory function: on the side of metaphor, an inciting and encouraging one (it is a pocket phallus); and, on the side of metonymy, an apotropaic one, that is, the averting of danger (thus involuntarily attesting a belief in it), the warding off of bad luck or the ordinary, permanent anxiety which sleeps (or suddenly wakes up) inside each of us. In the clinical, nosographic, 'abnormal' forms of fetishism – or in the social institution of the striptease, which pertains to a collective nosography and which is, at the same time, a progressive process of framing/deframing – pieces of clothing or various other objects are absolutely necessary for the restoration of sexual power. Without them nothing can happen.

Let us return to the problem of off-frame space. The difference which separates film and photography in this respect has been partially but acutely analyzed by Pascal Bonitzer.[10] The filmic off-frame space is *étoffé*, let us say 'substantial,' whereas the photographic off-frame space is 'subtle.' In film there is a plurality of successive frames, of camera movements, and character movements, so that a person or an object which is off-frame in a given moment may appear inside the frame the moment after, then disappear again, and so on, according to the principle (I purposely exaggerate) of the *turnstile*. The off-frame is taken into the evolutions and scansions of the temporal flow: it is off-frame, but not off-film. Furthermore, the very existence of a sound track allows a character who has deserted the visual scene to continue to mark her or his presence in the auditory scene (if I can risk this quasi-oxymoron: 'auditory' and 'scene'). If the filmic off-frame is substantial, it is because we generally know, or are able to guess more or less precisely, what is going on in it. The character who is off-frame in a photograph, however, will never come into the frame, will never be heard – again a death, another form of death. The spectator has no empirical knowledge of the contents of the off-frame, but at the same time cannot help imagining some off-frame, hallucinating it, dreaming the shape of this emptiness. It is a projective off-frame (that of the cinema is more introjective), an immaterial, 'subtle' one, with no remaining print. 'Excluded,' to use Dubois's term, excluded once and for all. Yet nevertheless present, striking, properly fascinating (or hypnotic) – insisting on its status *as excluded* by the force of its absence *inside* the rectangle of paper, which reminds us of the feeling of lack in the Freudian theory of the fetish. For Barthes, the only part of a photograph which entails the feeling of an off-frame space is what he calls the *punctum*, the point of sudden and strong emotion, of small trauma; it can be a tiny detail. This *punctum* depends more on the reader than on the photograph itself, and the corresponding off-frame it calls up is also generally subjective; it is the 'metonymic expansion of the *punctum*.'[11]

Using these strikingly convergent analyses which I have freely summed up, I would say that the off-frame effect in photography results from a singular and definitive cutting off which figures castration and is figured by the 'click' of the shutter. It marks the place of an irreversible absence, a place from which the look has been averted forever. The photograph itself, the 'in-frame,' the abducted part-space, the place of presence

and fullness – although undermined and haunted by the feeling of its exterior, of its borderlines, which are the past, the left, the lost: the far away even if very close by, as in Walter Benjamin's conception of the 'aura'[12] – the photograph, inexhaustible reserve of strength and anxiety, shares, as we see, many properties of the fetish (as object), if not directly of fetishism (as activity). The familiar photographs that many people carry with them always obviously belong to the order of fetishes in the ordinary sense of the word.

Film is much more difficult to characterize as a fetish. It is too big, it lasts too long, and it addresses too many sensorial channels at the same time to offer a credible unconscious equivalent of a lacking part-object. It does *contain* many potential part-objects (the different shots, the sounds, and so forth), but each of them disappears quickly after a moment of presence, whereas a fetish has to be kept, mastered, held, like the photograph in the pocket. Film is, however, an extraordinary activator of fetishism. It endlessly mimes the primal displacement of the look between the seen absence and the presence nearby. Thanks to the principle of a *moving cutting off*, thanks to the changes of framing between shots (or within a shot: tracking, panning, characters moving into or out of the frame, and so forth), cinema literally *plays* with the terror and the pleasure of fetishism, with its combination of desire and fear. This combination is particularly visible, for instance, in the horror film, which is built upon progressive re-framings that lead us through desire and fear, nearer and nearer the terrifying place. More generally, the play of framings and the play with framings, in all sorts of films, work like a striptease of the space itself (and a striptease proper in erotic sequences, when they are constructed with some subtlety). The moving camera caresses the space, and the whole of cinematic fetishism consists in the constant and teasing displacement of the cutting line which separates the seen from the unseen. But this game has no end. Things are too unstable and there are too many of them on the screen. It is not simple – although still possible, of course, depending on the character of each spectator – to stop and isolate one of these objects, to make it able to work as a fetish. Most of all, a film cannot be *touched*, cannot be carried and handled: although the actual reels can, the projected film cannot.

I will deal more briefly with the last difference – and the problem of belief– disbelief – since I have already spoken of it. As pointed out by Octave Mannoni,[13] Freud considered fetishism the prototype of the cleavage of belief: 'I know very well, *but*. . . .' In this sense, film and photography are basically similar. The spectator does not confound the signifier with the referent, she or he knows what a *representation* is, but nevertheless has a strange feeling of reality (a denial of the signifier). This is a classical theme of film theory.

But the very nature of *what* we believe in is not the same in film and photography. If I consider the two extreme points of the scale – there are, of course, intermediate cases: still shots in films, large and filmlike photographs, for example – I would say that film is able to call up our belief for long and complex dispositions of actions and characters (in narrative cinema) or of images and sounds (in experimental cinema), to disseminate belief; whereas photography is able to fix it, to concentrate it, to spend it all at the same time on a single object. Its poverty constitutes its force – I speak of a poverty of means, not of significance. The photographic effect is not produced from diversity, from itinerancy or inner migrations, from multiple juxtapositions or

arrangements. It is the effect, rather, of a laser or lightning, a sudden and violent illumination on a limited and petrified surface: again the fetish and death. Where film lets us believe in more things, photography lets us believe more in one thing.

In conclusion, I should like to add some remarks on the use of psychoanalysis in the study of film, photography, theater, literature, and so on. First, there are presentations, like this one, which are less 'psychoanalytic' than it might seem. The notion of 'fetish,' and the word, were not invented by Freud; he took them from language, life, the history of cultures, anthropology. He proposed an *interpretation* of fetishism. This interpretation, in my opinion, is not fully satisfactory. It is obvious that it applies primarily to the early evolution of the young *boy*. (Incidentally, psychoanalysts often state that the recorded clinical cases of fetishism are for the most part male.) The fear of castration and its further consequence, its 'fate,' are necessarily different, at least partially, in children whose body is similar to the mother's. The Lacanian notion of the *phallus*, a symbolic organ distinct from the penis, the real organ, represents a step forward in theory; yet it is still the case that within the description of the human subject that psychoanalysis gives us, the male features are often dominant, mixed with (and as) general features. But apart from such distortions or silences, which are linked to a general history, other aspects of Freud's thinking, and various easily accessible observations which confirm it, remain fully valid. These include: the analysis of the fetishistic nature of male desire; in both sexes the 'willing suspension of disbelief' (to use the well-known Anglo-Saxon notion), a suspension which is determinant in all representative arts, in everyday life (mostly in order to solve problems by half-solutions), and in the handling of ordinary fetishes; the fetishistic pleasure of framing-deframing.

It is impossible to *use* a theory, to 'apply' it. That which is so called involves, in fact, two aspects more distinct than one might at first believe: the intrinsic degree of perfection of the theory itself, and its power of suggestion, of activation, of enlightenment *in another field* studied by other researchers. I feel that psychoanalysis has this power in the fields of the humanities and social sciences because it is an acute and profound discovery. It has helped *me* – the personal coefficient of each researcher always enters into the account, despite the ritual declarations of the impersonality of science – to explore one of the many possible paths through the complex problem of the relationship between cinema and photography. I have, in other words, used the theory of fetishism as a fetish.

Psychoanalysis, as Raymond Bellour has often underscored, is contemporary in our Western history with the technological arts (such as cinema) and with the reign of the patriarchal, nuclear, bourgeois family. Our period has invented neurosis (at least in its current form), *and* the remedy for it (it has often been so for all kinds of diseases). It is possible to consider psychoanalysis as the founding myth of our emotional modernity. In his famous study of the Oedipus myth, Lévi-Strauss has suggested that the Freudian interpretation of this myth (the central one in psychoanalysis, as everybody knows) could be nothing but the last variant of the myth itself.[14] This was not an attempt to blame: myths are always true, even if indirectly and by hidden ways, for the good reason that they are invented by the natives themselves, searching for a parable of their own fate.

After this long digression, I turn back to my topic and purpose, only to state that they could be summed up in one sentence: film is more capable of playing on fetishism, photography more capable of itself becoming a fetish.

Original publication

'Photography and Fetish', in *October*, 34 (1985).

Notes

1 A version of this essay was delivered at a conference on the theory of film and photography at the University of California, Santa Barbara, in May 1984.
2 Peter Wollen, 'Fire and Ice,' *Photographies*, 4 (1984), cf. Ch. 22 in this volume, pp. 197–200 [Ed.].
3 Pierre Bordieu *et al.*, *Un art moyen. Essai sur les usages sociaux de la photographie.* Paris, Editions de Minuit, 1965.
4 Philippe Dubois, *L'acte photographique*, Paris and Brussels, Nathan and Labor, 1983.
5 Roland Barthes, *Camera Lucida*, New York, Hill and Wang, 1981.
6 Dubois, p. 89.
7 Wollen, Ibid.
8 Sigmund Freud, 'Mourning and Melancholia,' *The Standard Edition of the Complete Psychological Works of Sigmund Freud*, trans. James Strachey, London, The Hogarth Press and the Institute of Psycho-Analysis, 1953–1974, vol. 14.
9 Freud, 'Fetishism,' *S.E.*, vol. 21.
10 Pascal Bonitzer, 'Le hors-champ subtil,' *Cahiers du cinéma*, no. 311 (May 1980).
11 Barthes, p. 45.
12 Walter Benjamin, 'A Short History of Photography,' trans. Phil Patton, *Classic Essays on Photography*, ed. Alan Trachtenberg, New Haven, Leete's Island Books, 1980.
13 Octave Mannoni, 'Je sais bien mais quand même . . .,' *Clefs pour l'imaginaire; ou, L'autre scène*, Paris, Seuil, 1969.
14 Claude Lévi-Strauss, *Anthropologie structurale*, Chapter 11, 'La structure des mythes,' Paris, Plon, 1958; translated as *Structural Anthropology*, New York, Basic Books, 1963.

Peter Wollen

FIRE AND ICE

T HE AESTHETIC DISCUSSION OF PHOTOGRAPHY is dominated by the concept of time. Photographs appear as devices for stopping time and preserving fragments of the past, like flies in amber. Nowhere, of course, is this trend more evident than when still photography is compared with film. The natural, familiar metaphor is that photography is like a point, film like a line. Zeno's paradox: the illusion of movement.

The lover of photography is fascinated both by the instant and by the past. The moment captured in the image is of near-zero duration and located in an ever-receding 'then'. At the same time, the spectator's 'now', the moment of looking at the image, has no fixed duration. It can be extended as long as fascination lasts and endlessly reiterated as long as curiosity returns. This contrasts sharply with film, where the sequence of images is presented to the spectator with a predetermined duration and, in general, is only available at a fixed programme time.

It is this difference in the time-base of the two forms that explains, for example, Roland Barthes' antipathy towards the cinema and absorption in the still photograph. Barthes' aesthetic is governed by a prejudice against linear time and especially against narrative, the privileged form of linear time as he saw it, which he regarded with typically high-modernist scorn and disdain. His major work on literature, S/Z, is a prolonged deceleration and freeze-framing, so to speak, of Balzac's (very) short story, marked throughout by a bias against the hermeneutic and proaeretic codes (the two constituent codes of narrative) which function in 'irreversible time'.

When Barthes wrote about film he wrote about film stills; when he wrote about theatre he preferred the idea of *tableaux vivants* to that of dramatic development. Photography appeared as a spatial rather than temporal art, vertical rather than horizontal (simultaneity of features rather than consecutiveness) and one which allowed the spectator time to veer away on a train of thought, circle back, traverse and criss-cross the image. Time, for Barthes, should be the prerogative of the reader/spectator: a free re-writing time rather than an imposed reading time.

I don't want, here and now, to launch into a defence of narrative; that can keep for another day. But I do want to suggest that the relationship of photography to time is more complex than is usually allowed. Especially, it is impossible to extract our concept of time completely from the grasp of narrative. This is all the more true when we discuss photography as a form of art rather than as a scientific or instructional instrument.

First, I am going to talk about 'aspect' rather than 'tense'. Linguists do not completely agree about the definition of 'aspect'. But we can say that while 'tense' locates an event in time in relation to the present moment of speech, 'aspect' represents its internal temporal structure. Thus, some verbs, like 'know' are 'stative' – they represent 'states', whereas others like 'run' represent dynamic situations that involve change over time – so we can say 'he was running', but not 'he was knowing'. 'Situations' can be subdivided into those that involve single, complete 'events' and those that involve 'processes', with continuous change or a series of changes, and so on. The verbs which represent 'events' and 'processes' will have different relations to 'aspectual' verb forms such as the 'imperfect', the 'perfect' (both past tense), the 'progressive', etc. (here I must acknowledge my dependence on and debt to Bernard Comrie's book on 'Aspect', the standard work on the subject). Aspect, on one level, is concerned with duration but this, in itself, is inadequate to explain its functioning. We need semantic categories which distinguish different types of situation, in relation to change (or potential for change) and perspective as well as duration. Comrie distinguishes between states, processes and events. Events themselves can be broken down between durative and punctual events. Alongside these categories aspect also involves the concepts of the iterative, the habitual and the characteristic. It is the interlocking of these underlying semantic categories which determines the various aspectual forms taken by verbs in different languages (*grosso modo*).

It is useful to approach photography in the light of these categories. Is the signified of a photographic image to be seen as a state, a process or an event? That is to say, is it stable, unchanging, or, if it is a changing, dynamic situation, is it seen from outside as conceptually complete, or from inside, as ongoing? (In terms of aspect, stative or perfective/imperfective non-stative?) The fact that images may themselves appear as punctual, virtually without duration, does not mean that the situations that they represent lack any quality of duration or other qualities related to time.

Some light is thrown on these questions by the verb-forms used in captions. (A word of warning: English, unlike French, distinguishes between perfective and imperfective forms, progressive and non-progressive, in the present tense as well as the past. The observations which follow are based on English-language captions.) News photographs tend to be captioned with the non-progressive present, in this case, a narrative present, since the reference is to past time. Art photographs are usually captioned with noun-phrases, lacking verb-forms altogether. So also are documentary photographs, though here we do find some use of the progressive present. This imperfective form is used more than usual, for example, in Susan Meiselas' book of photographs, *Nicaragua*. Finally, the imperfective is used throughout in the captions of Muybridge's series photographs, in participle form.

Evidently these choices of verb-form correspond to different intuitions about the subjects or signifieds of the various types of photograph. News photographs are perceived as signifying events. Art photographs and most documentary photographs signify states. Some documentary photographs and Muybridge's series in particular are seen as signifying processes. From what we know about minimal narratives, we might say that an ideal minimal story-form might consist of a documentary photograph, then a news photograph, then an art photograph (process, event, state).

In fact, the classic early film minimal narrative, Lumière's 'L' Arroseur Arrosé', does follow this pattern: a man is watering the garden (process), a child comes and stamps on the hose (event), the man is soaked and the garden empty (state). What this implies of course is that the semantic structure of still and moving images may be the same or, at least, similar, in which case it would not be movement but sequencing (editing, découpage) which made the main difference by determining duration differently.

Still photographs, then, cannot be seen as narratives in themselves, but as elements of narrative. Different types of still photograph correspond to different types of narrative element. If this conjecture is right, then a documentary photograph would imply the question: 'Is anything going to happen to end or to interrupt this?' A news photograph would imply: 'What was it like just before and what's the result going to be?' An art photograph would imply: 'How did it come to be like this or has it always been the same?' Thus different genres of photography imply different perspectives within durative situations and sequences of situations.

While I was thinking about photography and film, prior to writing, I began playing with the idea that film is like fire, photography is like ice. Film is all light and shadow, incessant motion, transience, flicker, a source of Bachelardian reverie like the flames in the grate. Photography is motionless and frozen, it has the cryogenic power to preserve objects through time without decay. Fire will melt ice, but then the melted ice will put out the fire (like in *Superman III*). Playful, indeed futile, metaphors, yet like all such games anchored in something real.

The time of photographs themselves is one of stasis. They endure. Hence there is a fit between the photographic image which signifies a state and its own signified, whereas we sense something paradoxical about the photograph which signifies an event, like a frozen tongue of fire. In a film, on the contrary, it is the still image (Warhol, Straub-Huillet) which seems paradoxical in the opposite sense: the moving picture of the motionless subject.

Hence the integral relationship between the still photograph and the pose. The subject freezes for the instantaneous exposure to produce a frozen image, state results in state. In *La Chambre claire*, Barthes keeps returning to the mental image of death which shadows the photographs that fascinate him. In fact these particular photographs all show posed subjects. When he treats unposed photographs (Wessing's photograph of Nicaragua, Klein's of May Day in Moscow) Barthes sees not death, even when they show death, but tableaux of history, 'historemes' (to coin a word on the model of his own 'biographemes'). Images, in fact, submitted to the Law.

I can't help wondering whether Barthes ever saw James Van Der Zee's *Harlem Book of the Dead*, with its photographs of the dead posed for the camera in funeral parlours: a triple registration of stasis – body, pose, image. The strange thing about these photographs is that, at first glance, there is an eerie similarity between mourners and corpses, each as formal and immobile as the other. Indeed, the interviewers whose questioning of Van Der Zee makes up the written text of the book, ask him why the eyes of the bodies aren't opened, since this would make them look more life-like, virtually indistinguishable from the mourners even to the smallest detail.

This view of death, of course, stresses death as a state rather than an event. Yet we know from news photographs that death can be photographed as an event: the Capa photograph of the Spanish Civil War soldier is the *locus classicus*, taken as he is felled. There is a sense, though, in which Barthes was right. This photograph has become a 'historeme', a 'pregnant moment' after Diderot or Greuze, or like the habitual narrative

present in Russian, where, according to Comrie, 'a recurrent sequence of events is nar-
rated as if it were a single sequence, i.e. one instance stands for the whole pattern'. In
my book of Capa photographs, it is captioned simply 'Spain, 1936'.

The fate of Capa's photograph focuses attention on another important aspect of
the way images function in time: their currency, their circulation and re-cycling. From
the moment they are published, images are contextualised and, frequently, if they become
famous, they go through a whole history of re-publication and re-contextualisation.
Far more is involved than the simple doubling of the encounter of photographer with
object and spectator with image. There is a very pertinent example of this in the case
of Capa's photograph. It is clearly the model for the pivotal image of death in Chris
Marker's film photo-roman *La Jetée* - the same toppling body with outstretched arm.

Marker's film is interesting for a lot of reasons. First of all, it is the examplar of a
fascinating combination of film and still: the film made entirely of stills. (In just one
image there is an eye-movement, the converse of a freeze frame in a moving picture.)
The effect is to demonstrate that movement is not a necessary feature of film; in fact,
the impression of movement can be created by the jump-cutting of still images. More-
over, *La Jetée* shows that still photographs, strung together in a chain, can carry a nar-
rative as efficiently as moving pictures, given a shared dependence on a sound-track.

It is not only a question of narrative, however, but also of fiction. The still photo-
graphs carry a fictional diegetic time, set in the future and in the present as past-of-
the-future, as well as an inbetween near-future from which vantage-point the story is
told. Clearly there is no intrinsic 'tense' of the still image, any 'past' in contrast with a
filmic 'present', as has often been averred. Still photography, like film (and like some
languages), lacks any structure of tense, though it can order and demarcate time.

Aspect, however, is still with us. In the 'past' of memories to which the hero returns
(through an experiment in time-travel) the images are all imperfective, moments
within ongoing states or processes seen as they occur. But the object of the time-
travel is to recover one fixated memory-image, which, it turns out at the climax of
the film, is that of the hero's own death. This image, the one based on Capa's 'Spain,
1936', is perfective; it is seen from the outside as a complete action, delimited in time
with a beginning and an end. Although *La Jetée* uses a whole sequence of photographs,
the single Capa image in itself carries the condensed implication of a whole action,
starting, happening and finishing at one virtual point in time: a 'punctual' situation, in
Comrie's terms. And, at this very point, the subject is split into an observer of himself,
in accordance with the aspectual change of perspective.

My own fascination with pictorial narrative is not a recalcitrant fascination, like
that of Barthes. Unlike him, I am not always longing for a way of bringing the flow to a
stop. It is more a fascination with the way in which the spectator is thrown in and out
of the narrative, fixed and unfixed. Traditionally, this is explained in terms of identifica-
tion, distanciation and other dramatic devices. Perhaps it is also connected with aspect,
a dimension of the semantics of time common to both still and moving pictures and
used in both to place the spectator, within or without a narrative.

Original publication

'Fire and Ice' in *Other than Itself* (1984).

PART FOUR

Art photography

Edward Weston, *Torso of Neil*, 1925. © Center for Creative Photography, The University of Arizona Foundation/DACS 2017.

Sherrie Levine, *Portrait of Neil, After Edward Weston, 3*, 1980. Courtesy of the artist.

Introduction

THE RELATIONSHIP BETWEEN PHOTOGRAPHY AND ART has been complex historically as artists both work with photographic media and use photographs as references or memory aids (see Wells 2015, chapter 6). The question of photography's status as art was particularly addressed in the second half of the twentieth century in two key respects; first, the argument that photography as a specific mode of vision implicating aesthetic judgements and technical skills should be given status within art museums alongside other two-dimensional art forms such as drawing, painting and print-making (see Chapter 13 of this volume). However, photography also became implicated in challenging the character and qualities associated with modern art, especially a pre-occupation with form and medium, for many critics, seemingly at the expense of subject-matter and social context.

Postmodernity referred to a set of developments in philosophy, architecture and the arts towards the end of the twentieth century, propelled primarily by new currencies in French thought. If we take the modern to date from the eighteenth century 'age of enlightenment' with its emphasis upon rationality, technological progress and the explanatory power of empirical sciences, then the postmodern (literally 'after the modern') challenged modern concepts and concerns.

The postmodern was characterised by a mixture of, on the one hand, political and cultural malaise and, on the other hand, an apparently knowing playfulness in the arts, from fine art to the commercial. In the humanities, postmodernism intersected with the poststructuralist critique of structuralism in linguistics and communications and, perhaps more loosely, with the postcolonial challenges to the hegemony of Western culture and philosophy. Thus, the postmodern was associated with, first, new semiotic models, as Madan Sarup noted:

> While structuralism sees truth as being 'behind' or 'within' a text, post-structuralism stresses the interaction of reader and text as a productivity. In other words, reading has lost its status as a passive consumption of a product to become performance. Post-structuralism is highly critical of the unity of the stable sign (the Saussurian view). The new movement implies a shift from the signified to the signifier: and so there is a perpetual detour on the way to a truth that has lost any status or finality. . . . Post-structuralism, in short, involves a critique of metaphysics, of the concepts of causality, of identity, of the subject, and of truth.
>
> (Sarup 1993: 3)

Questions of language were centrally addressed, with emphasis upon the play of references and of systems of difference within which meaning is endlessly deferred or flexible. For French linguistic philosopher, Jacques Derrida, the deconstruction of language systems involved investigating ways in which words, as units referencing particular concepts, carry, by implication, the erasure of alternative referential possibilities, and operate within a chain of signification whereby each ensuing word contributes to orienting the developing line of interpretation. Here, emphasis is upon the play of meaning, its lack of fixity. Transferred to the visual, it

would be argued that the picture, say, of a traditional rural landscape, derives its force not only from that which is represented but also from that to which it might be opposed, for instance, the industrial or the urban, or, indeed, a mountainous wilderness. Furthermore, aesthetic and technological codes operating across the picture plain would be seen as contributing within the fluidity of signification. Meaning here is seen more as a product of play within and between possibilities, than of formal, relatively rigid (visual) language structures.

Second, by extension, and following the writings of another key French philosopher, Jean Baudrillard, the postmodern dislocated any direct relation between the signifier and the real. Images were seen as central to consumer culture, but involved reference and discursive relations, rather than representation; focus was upon surface style, rather than form and function, opening space for parody, pastiche and irony which draw eclectically upon previous movements in art and popular culture. In effect, this challenged the notions of originality and genius previously associated with the arts and literature. It emphasised the 'emptiness' of the signifier, that is, the photograph in itself as a communicative artefact.

Third, postmodern philosophy challenged the legitimising myths and narratives of the modern era, including faith in technological progress, and proposed pluralistic models in place of what became seen as a monocular (Western-centric) world view. This induced historical and cultural investigations exemplified in particular in the critical writings of Michel Foucault in France and of Fredric Jameson in the USA. In relation to the arts, Foucault's excavation of circumstances, specific contexts and power relations in which knowledges are asserted or assumed, offers a model for analysing cultural histories and institutions. Likewise, Jameson, in considering the postmodern not as a decisive rupture with the modern, but rather as a logical consequence of the relation between industry and consumerism, contributes contemporary insights grounded in Marxist analysis.

To an extent, the postmodern seemed reactive, rather than proactive, in that, whilst critiquing previous artistic modes and cultural tenets, no new manifesto or set of principles was supported. Here, there is some resonance between feminist theory and the postmodern. Feminism, in the 1970s, challenged patriarchal values within liberalism and within Marxism, thereby clearly contributing to critique of totalising theory. However, as has been pointed out most assertively by French feminists including Julia Kristeva and Luce Irigaray, debates within postmodernism continued to be largely dominated by masculine voices and perspectives.

In photography, the central impact of the postmodern was to destabilise links between representation and reality. Thus, in genres such as photojournalism, documentary and, indeed, family photography, images were no longer to be taken at face value. Also, the unitary constitution of the viewer as subject was challenged in terms which started to take into account more fluid notions of identity and the influence of representation. Philosophic interrogations were particularly marked in European debates; theoretical and critical studies, including critique of aesthetic traditions, became common within the university and art college curriculum. As such, postmodernism was experienced primarily in terms of critical positions. Notwithstanding the contribution of a number of academics (for instance, in journals such as *October*), in North America 'postmodernism' appeared more as an aesthetic

movement through which formalist art practices and the set-up of the art institution was challenged. Thus, paradoxically, just as photography had become accepted as a modern art practice – within which emphasis was upon aesthetics and the fine print – so postmodern artists started to appropriate or pastiche the photographic or use photography to refer to popular culture, in order to question the themes of the art gallery and the status accorded to art objects. Hence, in the essay included here, Abigail Solomon-Godeau invites art photographers to reflect upon and recon-sider the tenets of their practice. In parallel, Rosalind Krauss invites photo historians to consider what is lost through the integration of photography histories within the discourses of art history. For art historians, especially in the modern era, aesthetic sensibilities were a primary focus; whereas photographers historically may have been more concerned with the (gallery or domestic) context and the mechanisms of viewing experience by audiences.

Briefly noting different manifestations of postmodern styles in architecture, dance and painting as a prelude to a more detailed discussion of photography, Grundberg, like Solomon-Godeau, emphasises strategic uses of the photographic within contemporary art. But, in direct contrast to Solomon-Godeau's conclud-ing critique of art photography, Grundberg suggests re-reading earlier twentieth-century imagery, noting, for instance, humour, irony and a sense of the apocalyptic as tactical effects pre-dating the postmodern. Although some such activity took place beyond the established gallery circuit – on billboards or installation in public spaces – paradoxically much of the questioning of elitism, taste and so on, contin-ued to use the art gallery as a site, attract agents, and, as cynics have remarked, operate profitably within the international art market – as can be seen in the con-temporary collections held by institutions such as MOMA, New York and the Tate Modern, London.

The fourth essay included here focuses on the everyday and argues against the notion of the postmodern as a critical category. Through wide-ranging critique of then contemporary theory, and taking examples from the high street store, Steve Edwards questions globalism, reminds us of the political purposefulness of the critical photographers of the 1920s and remarks ways in which political priorities are reflected in consumer imagery. Published in the British radical photography magazine, *Ten.8*, ten years into Margaret Thatcher's rule as British Prime Minis-ter, this (slightly amended) essay took the *Next catalogue* – then new to the high street chain of the same name – as an example of emphasis on 'dressing for suc-cess'. Debates in the 1980s thus challenged dominant modes of thought, and also brought new subject-matter into focus within photography criticism, in particular, media and consumer culture.

Lucy Soutter approaches the question of art through the trope of setting up a distinction between art photography and designer fashion in order to argue for the complexity of language, history and ideas that characterise art as a sphere of reflection, critical dialogues and risk-taking (on the part of artists). She empha-sises cultural context, noting, for example, that monochrome photographs critiqued within Western culture for romantisism or for modernist pre-occupation with form and artistry were viewed in eastern Europe as resistance to the dominant mode or

language of socialist realism. The point is that art, and the experience of viewing art, is culturally situated and in terms of themes engaged, meaning and interpretation, both responds to social change and hopes to influence it.

In his discussion with Hilde Van Gelder, Victor Burgin addresses the inter-relation of art and the political, reflecting on the political agency of art and artists, proposing that the critical role of art now is to question and offer alternatives to ways in which ideas and events are framed in everyday media. He suggests that the art affects audiences not only through themes opened up but also through installation, ways in which the experience of viewing is constructed and through psychological effects.

Increasingly debates about art, including photographic media, acknowledge the phenomenological import of the encounter with images and ideas, the physi-cality of the experience, and ways in which art installations operate differently to photographic documents viewed in other contexts, for instance, the media or his-torical archives. The context of debate has changed. Photographic media (still and moving image) are extensively explored and used by artists. Photography is now commonly acknowledged as an art form and included in art museum collections. The critical debates in the second half of the twentieth century wherein the role of art, the status of photography as art, art language and the social context of art if not exactly fully resolved, arguably have been superceded by concerns to understand the context, purpose and limitations of the import of art photography given image saturation and the seemingly incessant flow of visual media.

References and selected further reading

Bate, D. (2015) *Art Photography*. London: Tate.

Bolton, R. (ed.) (1990) *The Contest of Meaning*. Cambridge, MA: MIT Press. A collection of essays on photography published in the 1980s in USA journals.

Cotton, C. (2014) *The Photograph as Contemporary Art*. London: Thames and Hudson, revised ed., first published 2004.

Foster, H. (1996) *The Return of the Real*. Cambridge, MA: MIT Press. On critical theory and avant-garde art at the end of the twentieth century.

Jameson, F. (1992) *Signatures of the Visible*. London and New York: Routledge. Essays on theory and contemporary visual culture (argued through particular reference to cinema).

Sarup, M. (1993) (2nd ed.) *Post-Structuralism and Postmodernism*. Hertfordshire: Har-vester Wheatsheaf. Critical introductory discussion including chapters on Lacan, Der-rida, Foucault, Lyotard and Baudrillard (not about photography).

Wells, L. (ed.) (2015) *Photography: A Critical Introduction*. London: Routledge. Ch. 6.

Bibliography of essays in part four

Burgin, V. (2011) 'Conversation With Hilde van Gerder', in *Parallel Texts: Interviews and Interventions About Art*. London: Reaktion Books, pp. 207–226.

Edwards, S. (l989) 'Snapshooters of History: Passages on the Postmodern Argument', *Ten.8*, No. 32.

Grundberg, A. (1990) 'The Crisis of the Real: Photography and Postmodernism', in his book of same title. New York: Aperture. Reprinted in Daniel P. Younger (ed.) (1991) *Multiple Views*. Albuquerque: University of New Mexico Press; collection of essays courtesy the Logan Grants support for new writing on photography.

Krauss, R. (1982) 'Photography's Discursive Spaces', *Art Journal*, Vol. 42, Issue 4, The Crisis in the Discipline. (Winter, 1982), pp. 311–319. (Reprinted in Richard Bolton ed. 1989 *The Contest of Meaning*. Cambridge, MA: MIT Press, pp. 286–301).

Solomon-Godeau, A. (1984) 'Winning the Game When the Rules Have Been Changed: Art Photography and Postmodernism', *Screen*, Vol. 25, Issue 6, Nov/Dec, pp. 88–102.

Soutter, L. (2007) 'Why Art Photography?', *Source*, Issue 53, Winter, pp. 22–29.

Abigail Solomon-Godeau

PHOTOGRAPHY AFTER ART PHOTOGRAPHY

IN 1977, JOHN SZARKOWSKI organized a large photography exhibition at the Museum of Modern Art under the title "Mirrors and Windows," premised on the critical conceit that the two hundred-odd prints included could be apprehended either as records of some exterior reality (windows), or as interiorized visions revelatory of the photographer's own inner being (mirrors). Critical response to the exhibition was mixed. One persistent refrain, however, was that many of the pictures could easily be shifted from one category to the other and make just as much, or as little, sense.

In retrospect, what seems most curious about the organization of the exhibition – a significantly more ecumenical emporium than its recent predecessors at MoMA – was the inclusion of *artists*, such as Robert Rauschenberg, Ed Ruscha, and Andy Warhol. For like the proverbial foxes in the henhouse, the inclusion of these artists – and, more specifically, the issues raised by their respective uses of photography – posed an explicit challenge to the brand of modernism enshrined in MoMA's Department of Photography.

Common to the photographic usages of these three artists was an insistence on what Roland Barthes termed the *déjà-lu* (already-read, already-seen) aspect of cultural production, a notion alternatively theorized with respect to postmodernist art practice, as a shift from production to reproduction. In contrast to modernist art photography's claims in regard to the self-containment of the image and the palpable presence of the author, works such as those by Rauschenberg *et al.* emphasized in every way possible their dependency on already existing and highly conventionalized imagery drawn from the mass media. Thus, at the same time that modernist boundaries between "high" and "low" cultural forms were breached or obscured (an important component of pop art a decade earlier), the modernist stress on the purity of the aesthetic signifier was effectively jettisoned.

The culture of postmodernism has been theorized in various ways and approached from various perspectives. Whether premised on the shift from industrial capitalism and the national state to managed capital and the multinational corporation, or

identified with the new informational economies and the profound effects of mass communications and global consumerism, the occurrence of basic structural changes in society argues for a subsequent alteration in the terms of cultural production. Thus, while it is possible to currently identify an anti-modernist impulse which signals the declining authority of modernist culture, postmodernism has been thought to possess a critical agenda and distinct features of its own.

But however one wishes to theorize postmodernist art (and one cannot speak of a critical consensus), the importance of photography within it is undeniable. More interesting, the properties of photographic imagery that have made it a privileged medium in postmodern art are precisely those which for generations art photographers have been concerned to disavow.

Without in any way wishing to gloss over the very real differences between Rauschenberg, Ruscha, and Warhol, their respective uses of the medium had less to do with its formal qualities per se than with the ways that photography in its normative and ubiquitous uses actually functions. As photography has historically come to mediate, if not wholly represent, the empirical world for most of the inhabitants of industrialized societies (indeed, the production and consumption of images serves as one of the distinguishing characteristics of advanced societies), it has become a principal agent and conduit of culture and ideology.

Accordingly, when photography began to be incorporated in the art of the 1960s, its identity as a multiply reproducible mass medium was insistently emphasized, nowhere more so than in the work of Andy Warhol. Warhol's exclusive use of already existent mass imagery, his production of series and multiples, his replication of assembly-line procedures for the production of images, including the dubbing of his studio "The Factory," and his cultivation of a public persona that undercut romantic conceptions of the artist (Warhol presented himself as an impresario) constituted a significant break with modernist values.

The kind of art production exemplified by Andy Warhol displayed an important affinity to certain aspects of the work of Marcel Duchamp, most prominently with his readymades. Duchamp was concerned to demonstrate that the category of art was itself entirely contingent and arbitrary, a function of discourse and not of revelation. In contrast to any notion of the art object as inherently and autonomously endowed with significance, meaning, or beauty, Duchamp was proposing that the identity, meaning, and value of the work of art were actively and dynamically constructed – a radical refusal of modernist, idealist aesthetics. Following the logic of the readymade, artists such as Warhol, Rauschenberg, Ruscha, or Johns, in re-presenting photographic images from mass culture, moved on to the postmodernist concept of what might be called the "already-made."

Douglas Crimp has directed attention to another aspect of photographic use in postmodernism which he terms "hybridization" – another divergence from the formal categories of modernist aesthetics.[1] While the mixing of heterogeneous media, genres, objects, and materials violates the purity of the modernist art object, the incorporation of photography violates it in a particular way. As an indexical as well as an iconic image, the photograph draws the (represented) world into the field of the art work – thereby undermining its claims to a separate sphere of existence and an intrinsic aesthetic meaning.

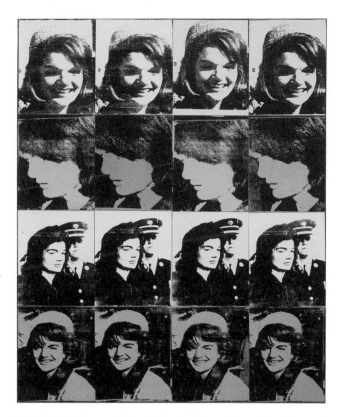

Figure 23.1 Andy Warhol, *Sixteen Jackies*, 1964. Acrylic and Enamel on Canvas, 80-3/8 × 64-3/8 inches. Collection Walker Art Center, Minneapolis; Art Center Acquisition Fund, 1968. © 2018 The Andy Warhol Foundation for the Visual Arts, Inc. / Licensed by DACS, London 2018.

For art photographers following in the footsteps of Alfred Stieglitz or Edward Weston, of Walker Evans or Harry Callahan, an intrinsic aesthetic yield – an auratic image – is not easily renounced. Indeed, photography's ascent to fine art status was virtually predicated on its claims to aura. Walter Benjamin, who theorized the concept, described it as composed of those qualities of singularity and uniqueness that produced the authoritative "presence" of the original work of art. Aura was the very quality, he argued, that must wither in the age of mechanical reproduction. Notwithstanding Benjamin's conviction of its demise, the continuous valorization of aura in the modern age masks an ideological construction (as does modernist theory), one of whose elements is the inevitable commodification of the art object itself.

While few contemporary photographers linger over aesthetic notions of Form and Beauty in the same way as the landscape photographer Robert Adams (in his recent *Beauty in Photography: Essays in Defense of Traditional Values*), neither are they prepared to go on record as recognizing such terms as historical constructions that today can only serve the purposes of a fetishistic, retrograde, and thoroughly commodified concept of art making. Insofar as contemporary art photography has become as much a creation of the marketplace as an engine of it, it comes as no surprise to encounter the ultimate

denial of photography as a mechanically reproducible technology in such phenomena as Emmet Gowin's production of "monoprints" – editions of a single print from a negative. Indeed, a recent press release from the Laurence Miller Gallery announces on the occasion of an exhibition entitled "The One and Only": "Contrary to popular belief that a photograph is but one of a potentially infinite number of prints capable of being printed from a single negative, this exhibition demonstrates that a long and exciting history of one-of-a-kind photographs exists. Two possible themes suggest themselves: unique by process and unique by conscious choice." Needless to say, it is the latter alternative that has, since at least the days of the Photo-Secession, served as an important strategy in realigning photographic discourse to conform to the demands of print connoisseurship.

The generic distinction I am attempting to draw between photographic use in postmodernism and art photography lies in the former's potential for institutional and/or representational critique, analysis, or address, and the latter's deep-seated inability to acknowledge any need even to think about such matters. The contradictory position in which contemporary art photography now finds itself with respect to both self-definition and the institutional trappings of its newly acquired status is nowhere better illustrated than in the head-scratchings and ramblings of museum curators confronted with the task of constructing some kind of logical framework for the inclusions (and exclusions) of photography in the museum. Although denizens of the art-photography establishment are well aware that something disjunct from traditional art photography is represented by postmodernist uses of the medium, the terms in which they are accustomed to thinking prevent them from discerning precisely the issues that are most at stake. And while occasionally, in a moment of media slippage, a photography writer is assigned to review a particularly well-publicized artist such as Cindy Sherman or Barbara Kruger, for the most part there is little discursive overlap between these two distinct domains. But to understand the conceptual impasse that contemporary art photography represents, it is important to trace the assumptions and claims that paralleled (and fueled) its ascent and then to examine the merit and usefulness of these notions as they exist in the present.

It has, for example, long been an uncontested claim in standard photographic history that the work of Paul Strand done around 1916 – and more particularly, its championship by Alfred Stieglitz in the last two issues of *Camera Work* – signaled the coming of age of art photography as an authentically modernist, hence fully self-conscious, art form. For while Stieglitz himself had for most of his career made unmanipulated "straight" prints, it was Strand's uncompromising formulation of the aesthetics of straight photography, his insistence that photographic excellence lay in the celebration of those very qualities intrinsic to the medium itself, that has traditionally been viewed as the moment of reorientation and renewal of American art photography.

Stieglitz's epiphanous designation of Strand as the aesthetic heir-apparent would seem a reasonable point of demarcation in the art history of American photography. For although the insistence that the camera possesses its own unique aesthetic has been asserted in various ways since the 1850s, the pictorialist phenomenon supplanted earlier concepts of photographic integrity or purity[2] and instead established a quite different aesthetic agenda. This agenda, however, had a pedigree fully as venerable as that of the protoformalist one: specifically, the presumption that photography, like all

the traditional visual arts, could lay claim to the province of the imaginary, the subjective, the inventive – in short, all that might be inscribed within the idea of the *creative*.

The specific strategies adapted by pictorialist photographers – be they the retrieval of artisanal printing processes, the appropriation of high-art subject matter (F. Holland Day crucified on the Cross, Gertrude Kasebier's Holy Families, etc.), or the use of gum bichromate and other substances, with extensive working of the negative or print and the concomitant stress on fine photography as the work of hand as well as of eye – are now generally supposed to constitute a historical example of the misplaced, but ultimately important energies of art photography at an earlier stage of evolution. Misplaced, because, current "markers" and print manipulators notwithstanding, contemporary photographic taste is predominantly formalist; important, because the activities and production of the Photo-Secession were a significant and effective lobby for the legitimation of photography as art. Thus, if, on the one hand, Edward Steichen's 1902 self-portrait, in which the photographer is represented as a painter and the pigment print itself disguised as a work of graphic art, is now reckoned to be distinctly unmodernist in its conception, on the other hand, the impulses that determined its making can be retrospectively recuperated for the progressive camp. Viewed from this position, photography's aspiration to the condition of painting by emulating either the

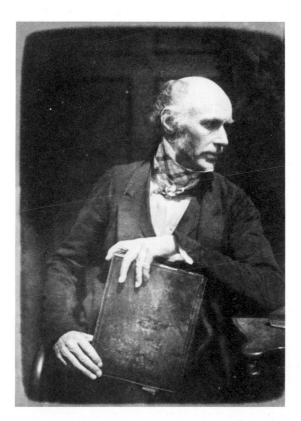

Figure 23.2 David Octavius Hill and Robert Adamson, *Reverend Mr. Smith*, ca. 1843. Salted-Paper Print, 19.5 × 14.6 cm. Gernsheim Collection, Harry Ransom Humanities Research Center, University of Texas at Austin.

subject or the look of painting was considered by the 1920s and the accompanying emergence of the post-Pictorialist generation – Sheeler, Strand, Weston, and others – to have been an error of means, if not ends.

What I wish to argue here is that the *ends* of mainstream art photography – its self-definition and accompanying belief system – have remained substantially unchanged throughout all the various permutations – stylistic, technological, and cultural – that it has undergone during its hundred-and-forty-year history. Of far greater importance than the particular manifestations and productions of art photography is the examination of the conditions that define and determine them. What needs to be stressed is that an almost exclusive concentration on the stylistic developments in art photography, no less than the accompanying preoccupation with its exemplary practitioners, tends to obscure the structural continuities between the "retrograde" pictorialism of the earlier part of the century and the triumphant modernism of its successors. Steichen's tenebrous platinum and gum print nude of 1904 entitled *In memoriam* might well seem on the stylistic evidence light years away from the almost hallucinatory clarity of Weston's work of the 1930s, but Steichen's "it is the artist that creates a work of art, not the medium" and Weston's "man is the actual medium of expression – not the tool he elects to use as a means" are for all intents and purposes virtually identical formulations.

Such are the continuing value and prestige of these notions in photographic criticism and history that they tend to be promiscuously imposed on just about any photographic *oeuvre* which presents itself as an appropriate subject for contemporary connoisseurship. Thomson and Riis, Atget and Weegee, Salzmann and Russell, Missions Héliographiques or 49th Parallel Survey – all tend finally to be grist for the aesthetic mill, irrespective of intention, purpose, application, or context.

Insofar as such concepts as originality, self-expression, and subjectivity have functioned, at least since romanticism, as the very warranty of art, the claims of art photography were *a priori* ordained to be couched in precisely such terms. "Nature viewed through a temperament" could be grafted onto the photographic enterprise as easily as to painting or literature and could, moreover, encompass both maker and machine. Thus was met the first necessary condition of art photography: that it be considered, at least by its partisans, as an expressive as well as a transcriptive medium.

Why then the need for a pictorialist style at all? And to the extent that exponents of art photography since the 1850s had established a substantial body of argument bolstering the claims to photographic subjectivity, interpretive ability, and expressive potential, why nearly half a century later was the battle refought specifically on painting's terms?

Certainly one contributing factor, a factor somewhat elided in the art history of photography, was the second wave of technological innovation that occurred in the 1880s. The fortunes of art photography, no less than those of scientific documentary, or entrepreneurial photography, have always been materially determined by developments in its technologies and most specifically by its progressive industrialization.[3] The decade of the 1880s witnessed not only the perfection of photogravure and other forms of photo-mechanical reproduction (making possible the photographically illustrated newspaper and magazine), but the introduction and widespread dissemination of the gelatino-bromide dry plates, perfected enlargers, hand cameras, rapid printing papers, orthochromatic film and plates, the international standardization of

photographic terminology, and, last but not least, the Kodak push-button camera. The resulting quantum leap in the sheer ubiquity of photography, its vastly increased accessibility (even to children, as was now advertised) and the accompanying diminution in the amount of expertise and know-how required to both take and process photographs, compelled the art photographer to separate in every way possible his or her work from that of the common run of commercial portraitist, Sunday amateur, or family chronicler. In this context, too, it should be pointed out that pictorialism was an international style: in France its most illustrious practitioners were Robert Demachy and Camille Puyo; in Germany Heinrich Kühn, Frank Eugene, Hugo Henneberg, and others were working along the same lines, and in the States, Stieglitz and the other members of the Secession effectively promoted pictorialism as the official style of art photography. And while influences ranging from symbolism, the arts and crafts movement, *l'art pour l'art*, and Jugenstil variously informed the practice of art photography in all these countries, the primary fact to be reckoned with is that art photography has always defined itself – indeed was compelled to define itself – in opposition to the normative uses and boundless ubiquity of all other photography.

It is suggestive, too, that the pictorialist and Photo-Secession period involved the first comprehensive look at early photography. Calotypes by David Octavius Hill and Robert Adamson and albumen prints by Julia Margaret Cameron were reproduced in *Camera Work*, Alvin Langdon Coburn printed positives from negatives by Hill and Adamson, Thomas Keith, and Lewis Carroll, and exhibitions of nineteenth-century photography were mounted in France, Germany, and Great Britain. These activities were to peak in 1939,[4] the centenary of the public announcement of the daguerreotype, and were to be matched (in fact, exceeded substantially) only in the decades following 1960.

One need not belabor the point to see certain correspondences between the art photography scene of the period of the Photo-Secession and that of the past fifteen years. If gum and oil prints are perhaps not in evidence, contemporary photography galleries and exhibitions are nonetheless replete with the products of 8×10 view cameras, palladium prints, platinum prints, dye transfer prints, etc. Such strategies are as much mandated by a thoroughly aestheticized notion of photography as they are by the demands of the art-photography market. To those who would counter such a categorization with remonstrations about the increasing shoddiness of commercially manufactured materials and the need for archival permanence, I would reassert that the photographer's aspirations to formal invention, individual expression, and signatural style are perpetually circumscribed by industrial decisions. Indeed, the very size and shape of the photographic image are the result of such decisions; the requirements of artists were only taken into account in camera design for a brief historical moment well before the industrialization of photography.

When the legacy of art photography passed from pictorialism to what Stieglitz described as the "brutally direct" photographic production of Strand and his great contemporaries, a crucial and necessary displacement of the art in art photography was required. No longer located in particular kinds of subject matter, in the blurred and gauzy effects of soft focus or manipulations of negative or print, in allegorical or symbolic meanings, the locus of art was now squarely placed within the sensibility – be it eye or mind – of the photographers themselves. Thus, from Heinrich Kühn's "the photographic instrument, the lifeless machine, is compelled by the superior will of the

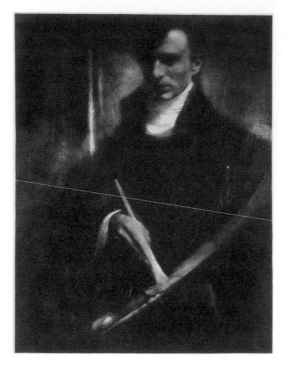

Figure 23.3 Edward J. Steichen, *Self-Portrait with Brush and Palette*, 1902. Gum Print (Single Printing Technique), 26.7 × 20 cm. © 1988, the Alfred Stieglitz Collection, the Art Institute of Chicago. Reprinted with the Permission of Joanna Steichen. © 2017. Digital Image Museum Associates/LACMA/Art Resource NY/Scala, Florence.

personality to play the role of the subordinate" through Paul Strand's formulation of photography as instrumental "to an even fuller and more intense self-realisation," to Walker Evans's litany of art photography's "immaterial qualities, from the realms of the subjective," among which he included "perception and penetration: authority and its cousin, assurance, originality of vision, or image innovation; exploration; invention" to, finally, Tod Papageorge's "as I have gotten older, however, and have continued to work, I have become more concerned with expressing who I am and what I understand," there exists a continuous strand that has remained unbroken from *Camera Work* to *Camera Arts*.

But if the strand has remained continuous, the quality of the art photography produced has not. Few observers of the contemporary art-photography scene would dispute, I think, the assertion that the work produced in the past fifteen years has neither the quality nor the authority of that of photographic modernism's heroic period, a period whose simultaneous apogee and rupture might be located in the work of Robert Frank. Additionally, it seems clear that the collapse of the so-called photography boom may have something to do with the general state of exhaustion, academicism, and repetition evident in so much art photography as much as with the deflation of an overextended market.[5]

The oracular pronouncements of Evans, Stieglitz, Strand, and Weston often have a portentous or even pompous ring, but the conviction that underlay them was validated

by the vitality and authority of the modernism they espoused. To the extent that a modernist aesthetic retained legitimacy, credibility, and most importantly, functioned as the vessel and agent of advanced art, it permitted the production of a corpus of great, now canonical, photography. The eclipse – or collapse, as the case may be – of modernism is coincident with art photography's final and triumphant vindication, its wholesale and unqualified acceptance into all the institutional precincts of fine art: museum, gallery, university, and art history. The conditions surrounding and determining art photography production were now, of course, substantially altered. No longer in an adversarial position, but in a state of parity with the traditional fine arts, two significant tendencies emerged by the early 1960s. One was the appearance of photography – typically appropriated from the mass media – in the work of artists. The second tendency was a pronounced academization of art photography both in a literal sense (photographers trained in art school and universities, the conferring of graduate degrees in photography) and in a stylistic sense: that is to say, the retrieval and reworking of photographic strategies now entirely formulaic, derived from the image bank of modernist photography, or even from modernist painting, thereby producing a kind of neo-pictorialist hybrid.

What was – and is – important about the two types of photographic practice was the distinct and explicit opposition built into these different uses. For the art photographer, the issues and intentions remained those traditionally associated with the aestheticizing use and forms of the medium: the primacy of formal organization and values, the autonomy of the photographic image, the subjectivization of vision, the fetishizing of print quality, and the unquestioned assumption of photographic authorship. In direct contrast, the *artists* who began to employ photography did so in the service of vastly different ends. More often than not, photography figured in their works in its most banal and normative incarnations. Thus, it was, on the one hand, conscripted as a readymade image from either advertising or the mass media in its various and sundry manifestations in the quotidian visual environment, or, alternatively, employed in its purely transcriptive and documentary capacities. In this latter usage, it did service to record site-specific works, objects, or events that had been orchestrated, constructed, or arranged to be constituted anew, preserved, and represented in the camera image.

It is from this wellspring that the most interesting and provocative new work in photography has tended to come. Although this relatively recent outpouring of art production utilizing photography encompasses divergent concerns, intentions, and formal strategies, the common denominator is its collective resistance to any type of formal analysis, psychological interpretation, or aesthetic reading. Consistent with the general tenor of postmodern practice, such work takes as its point of departure not the hermetic enclave of aesthetic self-reference (art about art, photography about photography) but, rather, the social and cultural world of which it is a part. Thus, if one of the major claims of modernist art theory was the insistence on the self-sufficiency and purity of the work of art, postmodern practice hinges on the assertion of contingency and the primacy of cultural codes. It follows that a significant proportion of postmodern art based on photographic usages is animated by a critical, or, if one prefers, deconstructive impulse. The intention of such work is less about provoking feeling than about provoking thought.

That the traditional art photography construct today functions as a theoretical no less than a creative cul-de-sac is revealed in a recent round-table discussion in the pages of *The Print Collector's Newsletter*. Every five years since 1973, six designated photography experts (the one practicing photographer being Aaron Siskind) have compared notes on the current state of the art. The interchange here takes place between gallery-owner Ronald Feldman and Peter Bunnell, McAlpin Professor of Photography and Modern Art at Princeton University:

RF: Well, Peter, do you find Cindy Sherman interesting?
PB: I find her interesting as an artist but uninteresting as a photographer.
RF: Interesting as an artist but not as a photographer?
PB: I don't see her raising significant questions with regard to this medium. I find her imagery fascinating, but as I interpret her work, I have no notion that I could engage her in a discourse about the nature of the medium through which she derives her expression. . . . I've had discussions with artists who have utilized our medium in very interesting ways as independent expression, but I have never perceived them as participants with the structure or the tradition I have referred to here. Of course, that changes or evolves. I think the tension between the structure that originates in an awareness of our own history and that of a number of artists who derive their vitality from the absence of that knowledge is right at the cutting edge. That's where the excitement is and that's where the pressure is coming from contemporary artists.[6]

Professor Bunnell is perhaps right to find Sherman interesting as an artist but not as a photographer. "Our medium" as he describes it, restricted to photography as defined, practiced, and understood within the framework of art photography, has little importance in Sherman's work. *Her* medium of photography – her use of it – is predicated rather on the uses and functions of photography in the mass media, be they in advertising, fashion, movies, pin-ups, or magazines. When Professor Bunnell employs the term "tradition" to indicate what Sherman and others of her ilk are not participating in, he is indicating his belief that the tradition that matters is the one carved out by art photographers (or those who have been assimilated into that tradition), and not the global production of imagery so profoundly instrumental in the production of meaning, ideology, and desire.

The photographic usages I am here designating as postmodernist are in no way to be understood as cohering into some kind of school, style, or overarching aesthetic. Quite the contrary: the kinds of production represented by artists as disparate as John Baldessari, Victor Burgin, Hilla and Bernd Becher, and Dan Graham, or more recently by younger artists such as Sarah Charlesworth, Barbara Kruger, Louise Lawler, Sherrie Levine, Richard Prince, Cindy Sherman, Laurie Simmons, or Jim Welling evidence a considerable range of concerns. What they share is an obdurate resistance to formal analysis or placement within the modernist paradigm. A formulation of common critical ground would encompass a shared propensity to contest notions of subjectivity, originality, and (most programmatically in the work of Levine and Prince) authorship. It is here, perhaps, that it is possible to locate the most obvious departure from the ethos of art photography and here, too, where the Duchampian legacy is most clearly demonstrated. Such work specifically addresses the conditions of commodification and

fetishization that condition and inform art production. The purview of such practices is the realm of discursivity, ideology and representation, cultural and historical specificity, meaning and context, language and significance.

That photography should thus figure as a crucial term in postmodernism seems both logical and (at least retrospectively) inevitable. Virtually every critical and theoretical issue with which postmodernist art may be said to engage in one sense or another can be located within photography. Issues having to do with authorship, subjectivity, and uniqueness are built into the very nature of the photographic process itself: issues devolving on the simulacrum, the stereotype, and the social and sexual positioning of the viewing subject are central to the production and functioning of advertising and other mass-media forms of photography. Postmodernist photographic activity may deal with any or all of these elements, and it is worth noting too that even work constructed by the hand (e.g., Troy Brauntuch, Jack Goldstein, Robert Longo) is frequently predicated on the photographic image.

Seriality and repetition, appropriation, intertextuality, simulation or pastiche – these are the primary devices employed by postmodernist artists. Utilized singly or in combination, what is of importance in the context of this essay is the way each device can be employed as a refusal or subversion of the putative autonomy of the work of art as conceived within modernist aesthetics. The appearance of such practices in the 1970s seemed to portend the possibility of a socially grounded, critical, and potentially radical art practice that focused on issues of representation as such. Collectively, use of such devices to prompt dialectical and critical modes of perception and analysis

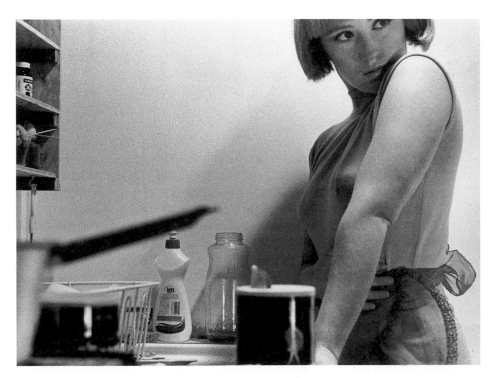

Figure 23.4 Cindy Sherman, *Untitled Film Still #3*, 1977. Gelatin silver print, 8 × 10 inches, 18 × 24 cm. black-and-white photograph courtesy of the artist and Metro Pictures, New York.

may be termed deconstructive. (This deconstructive impulse is of special importance for feminist theory and art practice in particular, in that the space of representation is increasingly theorized as a crucial site of feminist struggle.) Thus, if postmodernist practice has displaced notions of the self-sufficiency of the aesthetic signifier with a new concern for the referent, it must also be said that it is with the referent as a problem, not as a given.[7]

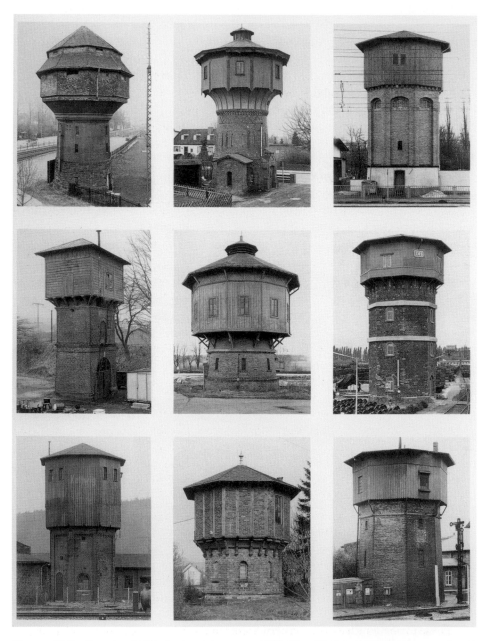

Figure 23.5 Bernd and Hilla Becher, *Watertowers*, 1980. Nine Black-and-White Photographs, 20 ¼ × 16 ¼ in. Each, 61 ½ × 49 ¼ Overall. Courtesy the Sonnabend Gallery.

Within the range of postmodernist art, it is those works that dismantle traditional notions of authorship or which most specifically address the institutional and discursive space of art that best demonstrate a deconstructive orientation. Roland Barthes's 1968 essay "The Death of the Author" remains the *Ur*-text to delineate the implications of the shift away from the author as both source and locus of meaning, asserting instead that meaning is never invented, much less locked in:

> "We know now that a text is not a line of words releasing a single 'theological' meaning (the 'message' of the Author-God) but a multidimensional space in which a variety of writings, none of them original, blend and clash. The text is a tissue of quotations drawn from the innumerable centers of culture. . . . Succeeding the Author, the scriptor no longer bears within him passions, humors, feelings, impressions, but rather this immense dictionary from which he draws a writing that can know no halt: life never does more than imitate the book, and the book itself is only a tissue of signs, an imitation that is lost, infinitely deferred."[8]

For Barthes, the refusal of authorship and originality was an innately revolutionary stance "since to refuse to fix meaning is, in the end, to refuse God and his hypostases – reason, science, law."[9] Similarly Barthes understood the dismantling of the notion of unique subjectivity as a salutary blow struck against an ossified and essentially retrograde bourgeois humanism. But whether postmodernist appropriation and other related strategies have indeed functioned in the liberating and revolutionary fashion that Barthes's text would indicate is open to question. While unmediated appropriation (exemplified by Levine and Prince) still retains its transgressive edge, pastiche operations are as much to be found in television commercials and rock videos as in Tribeca lofts. Moreover, if the workings of the art marketplace demonstrate anything at all, it is its capacity to assimilate, absorb, neutralize, and commodify virtually any practice at all. Finally, many artists find it difficult to avoid making those adjustments and accommodations that will permit their work to be more readily accepted by the market – a condition, after all, of simple survival.

In attempting to map out a topography of photographic practice as it presents itself now, I have constructed an opposition between an institutionalized art photography and postmodernist art practices that use photography. Such an opposition suggests itself because the working assumptions, and the goals and intentions of the respective approaches thereby reflect back on each other. A critical reading of modernist values does not devolve on the "failure" of modernism, any more than a discussion of postmodernist photographic practice implies a criterion of success. Rather, what is at stake in art photography or postmodernism concerns their respective agendas and how as art practices they are positioned – or how they choose to position themselves – in relation to their institutional spaces. By institutional spaces, I refer not only to the space of exhibition, but to all the discursive formations – canons, art and photography histories, criticism, the marketplace – that together constitute the social and material space of art.

These formations have been crucial agents in the relatively recent repositioning of photography as a modernist art form. Such a massive reconsideration mandates that the apparatuses of canon formation, connoisseurship, *Kunstwissenschaft*, and criticism be marshaled to impose the triple unities of artist, style, and *oeuvre* on the protean

field of photography. The principal problem of intentionality (which might appear to sabotage such an enterprise) has been neatly side-stepped by recourse to a modernist formulation of a photographic ontology. Once photography is theorized in terms of inherent properties (time, the frame, the detail, the thing itself, and the vantage point, in John Szarkowski's efficient distillation) instead of its actual uses, any picture and any photographer can in principle enter the canon. This enables the portal of the canon to take on the attributes of a revolving door, and messy questions of intention and context can be effectively banished.

Art photography and postmodernist photography do not, in any case, encompass all the field. The traditional uses and forms continue: documentary practices, reportage, and all the utilitarian and commercial functions photography has regularly fulfilled. Perhaps the most durable legacy of art photography has been its success in establishing that photography is a medium like any other with which an artist might work. But a too-circumscribed conception of how the medium should be used, as well as a blind and unquestioning adherence to the modernist values which historically elevated it, has produced the current impasse of art photography. Refuge from the generally lackluster, albeit plentiful contemporary production of art photography is now routinely taken by recourse to an assiduous mining of the past, the hagiographic re-presentation of the already canonized (the recent spate of texts and exhibitions on Alfred Stieglitz is one such example), and the relentless overproduction of third- and fourth-generation variants of a vitiated academic formalism.

In contradistinction, the most interesting of recent developments is the burgeoning, if not flourishing, of photographic practices that in a certain sense invent themselves for the project at hand. Here the issue is not photography *qua* photography, but its use toward a specific end. This instrumental approach to the medium often entails that photographs are combined with texts, adapted to book or multimedia format, or geared to pointedly critical ends.

By way of example, we might consider some recent work by Vincent Leo, who, in contrast to most other postmodernist artists now using photography, has a background as a practicing photographer. Upon first examination, these black-and-white photographs appear to belong to the ever-increasing stockpile of derivative variations on the work of the officially designated masters of American photography. More precisely, they look like pastiches of the photographs of Robert Frank. In fact – and here Leo's work separates itself resolutely from the realm of academic pasticheur – they *are* the photographs of Robert Frank. What Leo has done is to cut up the reproductions in Frank's seminal book *The Americans*, reposition and collage different photographs, and then rephotograph the results to yield . . . what?

On the most immediate level, the joke in Leo's photographs is that he is deliberately enacting what legions of contemporary art photographers unreflectively recapitulate. A photographer such as Tod Papageorge working in the manner or tradition of Garry Winogrand, Lee Friedlander, Robert Frank, or Walker Evans is by no means unusual in art photography. On the contrary, the pervasiveness of such "influence" in art photography is attended by remarkably little anxiety. However, as Harold Bloom has observed, a voluntary parody is more impressive than an involuntary one. Leo's direct conscription of his sources serves to undercut pointedly both the myth and mystique of photographic originality.

Although Leo uses the images from *The Americans* as the (literal) building blocks of his own work, his pictures are finally less about the style of Robert Frank or the

iconography of *The Americans* than about the discursive positioning of both within art photography. It is this emphasis that most decisively distinguishes the formalist belief that photography is ultimately about photography from Leo's critical demonstration of the way meaning as well as value are produced by photography's very textuality and the discourses around it. Photography, here, is conceived not as defined by its own making, but by what is made of it.

In a wholly different mode, Connie Hatch has produced, among other work, an ongoing photographic project entitled *The De-Sublimation of Romance*. If, as Laura Mulvey argues, woman is constructed as spectacle, as fetish, as object rather than subject of the gaze, Hatch's enterprise is to foreground precisely these operations – to take exactly those conventions of photographic representation (and, even more specifically, that mode of photographic practice most assaultive and appropriative) and turn them inside out.

The conventions that Hatch reappropriates and re-presents are first of all the kind of street photography exemplified by photographers such as Garry Winogrand, Lee Friedlander, and Tod Papageorge – a form of photographic production that is both dominated by men and predicated on the assumption that meaning is fortuitously found in the world and framed in the image. Hatch's rigorous understanding of the way photography works, with particular regard for subject/object relationships and the mastery conferred on the viewer, enables her to perform a critical intervention that goes beyond the revelation of the network of complicity between photographer, spectator, and spectacle. By taking as the very subject of her work the act of looking (or not looking), Hatch draws attention to the warp and woof of power relations as they are inscribed in the operations of the gaze itself: the photographer's, the spectator's, and the gazes represented in the pictures.

Martha Rosler's *The Bowery in Two Inadequate Descriptive Systems*, a work employing text and photographs, is yet another example of photographic work that conforms to no specific rubric, but demonstrates photography's potential for rigorous, critical, and conceptually sophisticated works. Pairing images of Bowery storefronts and doorways emptied of their bums with a lexicon of drunkenness, Rosler effects an incisive critique of traditional social documentary, an examination of the lacunae of representation, and an experiment in refusal as a politically informed art practice. Rosler's work "takes off" on two familiar currents in photography (the liberal humanist tradition of "concerned" documentary, and the formalist celebration of American vernacular culture), but is in no way a critical parody (as is Leo's) or a supplemental critique in any simple fashion. Rosler's laconic, frontal photographs evoke the shade of Walker Evans and certain of his progeny, but pointedly subvert the aesthetic premises that inform their photography. The aristocratic perception of exemplary form to be found in, say, sharecroppers' shanties, does not cross over to the streets of the Bowery.

The pieties of photographic concern are likewise dismantled by Rosler, who remarks in her later essay, "In, Around and Afterthoughts (on Documentary Photography)": "Imperialism breeds an imperialists sensibility in all phases of cultural life." The conspicuous absence of the subjects – the victims – in her photographs mentally conjures up their presence in all the representational sites where we have seen them before. And, as Rosler's project implicitly questions, to what end and to what purposes? It is more than moral rectitude that determines the refusal to image the victim as spectacle: it is rather an understanding of the structural complicities such representations propagate.

Leo, Hatch, and Rosler represent only three possible examples of photographic use that exists outside of photography as conventionally theorized and practiced. Such artists tend to be marginalized both within photography and within the mainstream art world. The promise of such work lies in its relative freedom from the institutional orthodoxies of both camps, although it is in its lack of conformity to these orthodoxies

Figure 23.6 Connie Hatch, from *The De-Sublimation of Romance*, 1978. 17 × 14 in. each. Courtesy of the artist.

Figure 23.7 Martha Rosler, from *The Bowery in two inadequate descriptive systems*, a photo/text work of 1974–75, reproduced in *Martha Rosler: Three Works* (Press of the Nova Scotia College of Art and Design, 1981).

that its marginalization inevitably follows. Moreover, the current political environment does not favor critical practices in any medium, and it seems reasonable to predict that the photographic practices that will remain most favored will be those that call the fewest things into question.

All things considered, it seems justified to conclude that photography after art photography is an expanded rather than a diminished field, in part a consequence of the success of art photography in legitimizing the camera. If at this point, however, art photography seems capable of yielding little of interest, the problems lie entirely within itself. Today art photography reaps the dubious reward of having accomplished all that was first set out in its mid-nineteenth-century agenda: general recognition as an art form, a place in the museum, a market (however erratic), a patrimonial lineage, an acknowledged canon. Yet hostage still to a modernist allegiance to the autonomy, self-referentiality, and transcendence of the work of art, art photography has systematically engineered its own irrelevance and triviality. It is, in a sense, all dressed up with nowhere to go.

Original publication

'Photography after Art Photography and Postmodernism', in *Photography at the Dock: Essays on Photographic History, Institutions and Practices* (1991).
[Originally published 1984]

Notes

1 Douglas Crimp, "The Photographic Activity of Postmodernism," *October 15* (Winter 1980), 91–101. See also Rosalind Krauss, "Sculpture in the Expanded Field," *The Anti-Aesthetic: Essays in Postmodern Culture*, ed. Hal Foster (Port Townsend, Wash.: Bay Press, 1983). From a critically negative and proformalist perspective, Michael Fried provided one of the earliest accounts of this new "violation" of the aesthetic signifier in his essay "Art and Objecthood," reprinted in Gregory Battcock, ed., *Minimal Art: A Critical Anthology* (New York: Dutton, 1968), 116–47.
2 The Société Française de Photographie, for example, from its inception in 1851 (initially called La Société Héliographique) forbade any retouching on photographic submissions to its exhibitions.

3 See in this regard Bernard Edelman's major study *Ownership of the Image: Elements for a Marxist Theory of Law* (London: Routledge and Kegan Paul, 1979).

4 In 1937 an important exhibition on the history of photography was mounted at the Museum of Modern Art which resulted in the publication of Beaumont Newhall's now standard text *The History of Photography*. For an extremely illuminating and suggestive account of the significance and context of the exhibition, see Christopher Phillip's "The Judgment Seat of Photography," *October 22* (Fall 1982), 27–63.

5 See Carol Squiers's discussion "Photography: Tradition and Decline," *Aperture 91* (Summer 1983), 72–76.

6 "Photographs and Professionals III," *The Print Collector's Newsletter* (July–August 1983), 86–89.

7 Jacqueline Rose, "Sexuality in the Field of Vision," in *Difference: On Representation and Sexuality*, ed. Kate Linker (New York: The New Mueseum of Contemporary Art, 1984). [Reprinted in Jacqueline Rose, *Sexuality in the Field of Vision* (London: Verso, 1986).]

8 Roland Barthes, "The Death of the Author," in *Image, Music, Text*, trans. Stephen Heath (New York: Hill and Wang, 1977), 146–47.

9 *Ibid.*, 147.

Rosalind Krauss

PHOTOGRAPHY'S DISCURSIVE SPACES
Landscape/view

Let us start with two images, identically titled *Tufa Domes, Pyramid Lake, Nevada*. The first (Figure 24.1) is a (recently) celebrated photograph made by Timothy O'Sullivan in 1868 that functions with special insistence within the art historical construction of nineteenth-century landscape photography. The second (Figure 24.2) is a lithographic copy of the first, produced for the publication of Clarence King's *Systematic Geology* in 1878.[1]

Twentieth-century sensibility welcomes the original O'Sullivan as a model of the mysterious, silent beauty to which landscape photography had access during the early decades of the medium. In the photograph, three bulky masses of rock are seen as if deployed on a kind of abstract, transparent chessboard, marking by their separate positions a retreating trajectory into depth. A fanatical descriptive clarity has bestowed on the bodies of these rocks a hallucinatory wealth of detail, so that each crevice, each granular trace of the original volcanic heat finds its record. Despite all this, the rocks seem unreal and the space dreamlike, the tufa domes appear as if suspended in a luminous ether, unbounded and directionless. The brilliance of this undifferentiated ground, in which water and sky connect in an almost seamless continuum, overpowers the material objects within it, so that if the rocks seem to float, to hover, they do so as shape merely. The luminous ground overmasters their bulk, making them instead, the functions of design. The mysterious beauty of the image is in this opulent flattening of its space.

By comparison, the lithograph is an object of insistent visual banality. Everything that is mysterious in the photograph has been explained with supplemental, chatty detail. Clouds have been massed in the sky. The far shore of the lake has been given a definitive shape. The surface of the lake has been characterized by little eddies and ripples. And most important for the demotion of this image from strange to commonplace, the reflections of the rocks in the water have been carefully recreated, so that gravity and direction are now restored to this space formerly awash with the vague luminosity of too rapidly exposed collodion.

Figure 24.1 Timothy O'Sullivan, *Tufa Domes, Pyramid Lake (Nevada)*, 1868. © Library of Congress, number 98503891.

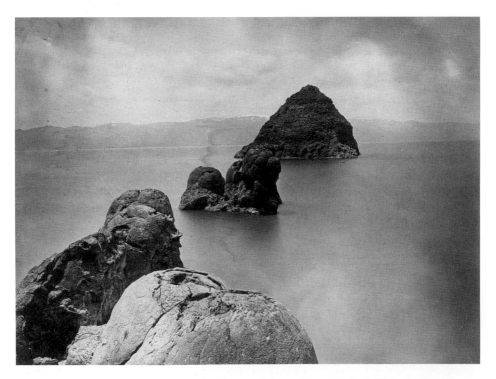

Figure 24.2 Photolithograph after O'Sullivan, *Tufa Domes, Pyramid Lake*, Published in King Survey report, 1875. © PF-(bygone1)/Alamy Stock Photo.

But it is clear, of course, that the difference between the two images – the photograph and its translation – is not a function of the inspiration of the photographer and the insipidity of the lithographer. They belong, instead, to two separate domains of culture, they assume different expectations in the user of the image, they convey two distinct kinds of knowledge; in a more recent vocabulary, one would say that they operate as representations within two separate discursive spaces, as members of two different discourses. The lithograph belongs to the discourse of geology and, thus, of empirical science. In order for it to function within this discourse, the ordinary elements of topographical description had to be restored to the image produced by O'Sullivan. The coordinates of a continuous homogeneous space, mapped not so much by perspective as by the cartographic grid, had to be reconstructed in terms of a coherent recession along an intelligibly horizontal plane retreating toward a definite horizon. The geological data of the tufa domes had to be grounded, coordinated, mapped. As shapes afloat on a continuous, vertical plane, they would have been useless.[2]

And the photograph? Within what discursive space does *it* operate?

Aesthetic discourse as it developed in the nineteenth century organized itself increasingly around what could be called the space of exhibition. Whether public museum, official salon, world's fair, or private showing, the space of exhibition was constituted in part by the continuous surface of wall, a wall increasingly unstructured for any purpose other than the display of art. The space of exhibition had other features besides the gallery wall. It was also the ground of criticism, which is to say,

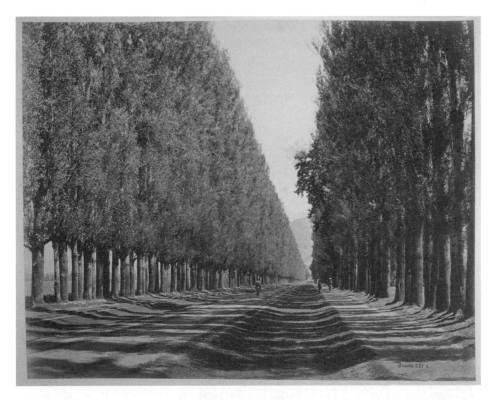

Figure 24.3 Samuel Bourne, *A Road Lined with Poplars, Kashmir,* 1863–70. Albumen-silver print from a glass negative, $8^{15}/_{16} \times 11''$, Collection, Paul F. Walter, New York. © British Library Board/Bridgeman Images.

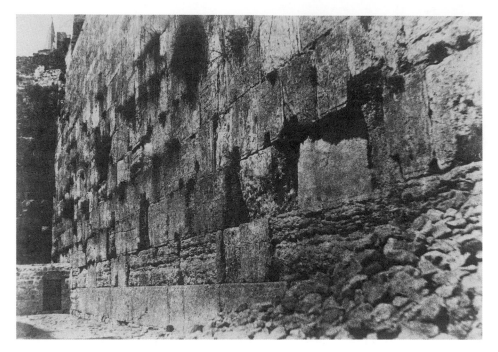

Figure 24.4 Auguste Salzmann, *Jerusalem, The Temple Wall, West Side,* 1853–54. Salt print from a paper negative, $9^3/_{16} \times {}^1/_8$", Collection, The Museum of Modern Art, New York, Purchase.

on the one hand, the ground of a written response to the works' appearance in that special context, and, on the other, the implicit ground of choice – of either inclusion or exclusion – with everything excluded from the space of exhibition becoming marginalized with regard to its status as Art.[3] Given its function as the physical vehicle of exhibition, the gallery wall became the signifier of inclusion and, thus, can be seen as constituting in itself a representation of what could be called *exhibitionality*, or that which was developing as the crucial medium of exchange between patrons and artists within the changing structure of art in the nineteenth century. And in the last half of the century painting – particularly landscape painting – responded with its own corresponding set of depictions. It began to internalize the space of exhibition – the wall – and to represent it.

The transformation of landscape after 1860 into a flattened and compressed experience of space spreading laterally across the surface was extremely rapid. It began with the insistent voiding of perspective, as landscape painting counteracted perspectival recession with a variety of devices, among them sharp value contrast, which had the effect of converting the orthogonal penetration of depth – effected, for example, by a lane of trees –into a diagonal ordering of the surface. No sooner had this compression occurred, constituting within the single easel painting a representation of the very space of exhibition, than other means of composing this representation were employed: serial landscapes, hung in succession, mimed the horizontal extension of the wall, as in Monet's Rouen Cathedral paintings; or landscapes, compressed and horizonless, expanded to become the absolute size of the wall. The synonymy of landscape and wall – the one a representation of the other – of Monet's late waterlilies is thus an

advanced moment in a series of operations in which aesthetic discourse resolves itself around a representation of the very space that grounds it institutionally.

Needless to say, this constitution of the work of art as a representation of its own space of exhibition is in fact what we know as the history of modernism. Thus, it is now fascinating to watch historians of photography assimilating their medium to the logic of that history. For if we ask, once again, within what discursive space does the original O'Sullivan — as I described it at the outset — function, we have to answer: that of the aesthetic discourse. And if we ask, then, what it is a representation *of*, the answer must be that within this space it is constituted as a representation of the plane of exhibition, the surface of the museum, the capacity of the gallery to constitute the objects it selects for inclusion as *art*.

But did O'Sullivan in his own day, the 1860s and 1870s, construct his work for the aesthetic discourse and the space of exhibition? Or did he create it for the scientific/topographical discourse which it more or less efficiently serves? Is the interpretation of O'Sullivan's work as a representation of aesthetic values — flatness, graphic design, ambiguity, and, behind these, certain intentions toward aesthetic significations: sublimity, transcendence — not a retrospective construction designed to secure it as art?[4] And is this projection not illegitimate, the composition of a false history?

This question has a special methodological thrust from the vantage of the present, as a newly organized and energized history of photography is at work constructing an account of the early years of the medium. Central to this account is that type of photography, most of it topographical in character, originally undertaken for the purposes of exploration, expedition, and survey. Matted, framed, labeled, these images now enter the space of historical reconstruction through the museum. Decorously isolated on the wall of exhibition, the objects can now be read according to a certain logic, a logic that insists on their representational character within the discursive space of art, in an attempt to "legitimate" them. The term is Peter Galassi's, and the issue of legitimacy was the focus of the Museum of Modern Art exhibition *Before Photography*, which he organized. In a sentence that has been repeated by every reviewer of his argument, Galassi sets up this question of photography's position with respect to the aesthetic discourse: "The object here is to show that photography was not a bastard left by science on the doorstep of art, but a legitimate child of the Western pictorial tradition."[5]

The legitimation that follows depends on something far more ambitious than proving that certain nineteenth-century photographers had pretensions to being artists, or theorizing that photographs were as good as, or even superior to, paintings, or showing that photographic societies organized exhibitions on the model of Establishment salons. Legitimations depend on going beyond the presentation of apparent membership in a given family; they demand, instead, the demonstration of the internal, genetic necessity of such membership. Galassi wants, therefore, to address internal, formal structures rather than external, circumstantial details. To this end he wishes to prove that the perspective so prominent in nineteenth-century outdoor photography — a perspective that tends to flatten, to fragment, to generate ambiguous overlap; a perspective to which Galassi gives the name "analytic," as opposed to the "synthetic" constructive perspective of the Renaissance — was fully developed by the late eighteenth century *within* the discipline of painting. The force of this proof, Galassi maintains, will be to rebut the notion that photography is essentially a "child of technical rather than

aesthetic traditions" and, thus, an outsider to the internal issues of aesthetic debate and to show, instead, that it is a product of that very same spirit of inquiry *within the arts* that welcomed and developed both "analytic" perspective and an empiricist vision. The radically foreshortened and elliptical sketches by Constable (and even Degas) can then be used as models for a subsequent photographic practice, which in Galassi's exhibition turns out overwhelmingly to be that of topography: Samuel Bourne, Felice Beato, August Salzmann, Charles Marville, and, of course, Timothy O'Sullivan.

And the photographs respond as they are bid. The Bourne of a road in Kashmir (Figure 24.3), in its steep split in values, empties perspective of its spatial significance and reinvests it with a two-dimensional order every bit as powerfully as a contemporary Monet. The Salzmann (Figure 24.4), in its fanatical recording of the texture of stone on a wall that fills the frame with a nearly uniform tonal continuum, assimilates its depiction of empirical detail to a representation of the pictorial infrastructure. And the O'Sullivans (Figures 24.1 and 24.5), with their rock formations engulfed by that passive, blank, collodion sky, flatten into the same hypnotically seen but two-dimensionally experienced order that characterized the *Tufa Domes* of Pyramid Lake. Viewing the evidence on the walls of the museum, we have no doubt that Art has not only been intended, but has also been represented: in the flattened, decoratively unifying drawing of "analytic" perspective.

But here is where the demonstration runs into difficulty. For Timothy O'Sullivan's photographs were not published in the nineteenth century and the only real public

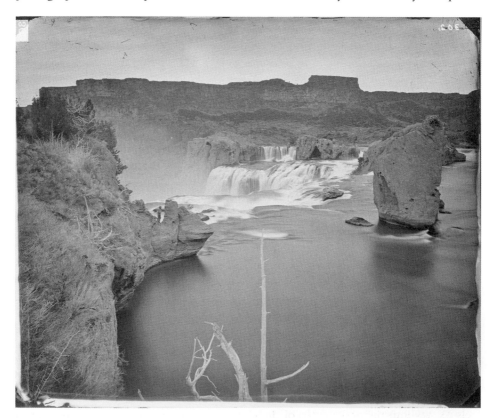

Figure 24.5 Timothy O'Sullivan, *Shoshone Falls (Idaho),* 1868. Public domain.

distribution they can be shown to have had was through the medium of stereography. Most of the famous O'Sullivans – the Canyon de Chelly ruins from the Wheeler Expedition, for example – exist as stereographic views, and it was to these that, in O'Sullivan's case, as in William Henry Jackson's, the wider public had access.[6] Thus, if we began with a comparison between two images – the photograph and the lithographic translation – we can continue with a comparison between two cameras: a 9 × 12 plate camera and a camera for stereoscopic views. And these two pieces of equipment mark distinct domains of experience.

Stereographic space is perspectival space raised to a higher power. Organized as a kind of tunnel vision, the experience of deep recession is insistent and inescapable. This experience is all the more heightened by the fact that the viewer's own ambient space is masked out by the optical instrument he must hold before his eyes. As he views the image in an ideal isolation, his own surrounds, with their walls and floors, are banished from sight. The apparatus of the stereoscope mechanically focuses all attention on the matter at hand and precludes the visual meandering experienced in the museum gallery as one's eyes wander from picture to picture and to surrounding space. Instead, the refocusing of attention can occur only within the spectator's channel of vision constructed by the optical machine.

The stereographic image appears multilayered, a steep gradient of different planes stretching away from the nearby space, into depth. The operation of viewing this space involves scanning the field of the image, moving from its lower left corner, say, to its upper right. That much is like looking at a painting. But the actual experience of this scan is something wholly different. As one moves, visually, through the stereoscopic tunnel from inspecting the nearest ground to attending to an object in the middle-distance, one has the sensation of refocusing one's eyes. And then again, into the farthest plane, another effort is made, and felt, to refocus.[7]

These micro-muscular efforts are the kinesthetic counterpart to the sheerly optical illusion of the stereograph. They are a kind of enactment, only on a very reduced scale, of what happens when a deep channel of space is opened before one. The actual readjustment of the eyes from plane to plane within the stereoscopic field is the representation by one part of the body of what another part of the body, the feet, would do in passing through real space. And it goes without saying that from this physio-optical traversal of the stereo field, another difference between it and pictorial space derives. This is a difference that concerns the dimension of time.

The contemporary accounts of what it was like to look at stereographs all dilate on the length of time spent examining the contents of the image. For Oliver Wendell Holmes, Sr., a passionate advocate of stereography, this perusal was the response appropriate to the "inexhaustible" wealth of detail provided by the image. As he picks his way over this detail in his writing on stereography – in describing, for example, his experience of an E. & H.T. Anthony view up Broadway – Holmes enacts for his readers the protracted engagement with the spectacle demanded by stereo viewing. By contrast, paintings do not require (and as they become more modernist, certainly do not support) this temporal dilation of attention, this minute-by-minute examining of every inch of the ground.

When Holmes characterizes this special modality of viewing, where "the mind feels its way into the very depths of the picture," he has recourse to extreme mental states – like hypnotism, "half-magnetic effects," and dream. "At least the shutting out

of surrounding objects, and the concentration of the whole attention which is a conse-
quence of this, produce a dream-like exaltation," he writes, "in which we seem to leave
the body behind us and sail away into one strange scene after another, like disembodied
spirits."[8]

The phenomenology of the stereoscope produces a situation that is not unlike
that of looking at cinema. Both involve the isolation of the viewer with an image from
which surrounding interference is masked out. In both, the image transports the
viewer optically, while his body remains immobile. In both, the pleasure derives from
the experience of the simulacrum: the appearance of reality from which any testing
of the real effect by actually, physically, moving through the scene is denied. And in
both, the real-effect of the simulacrum is heightened by a temporal dilation. What
has been called the *apparatus* of cinematic process had, then, a certain proto-history
in the institution of stereography, just as stereography's own proto-history is to be
found in the similarly darkened and isolating but spectacularly illusionistic space of the
diorama.[9] And in the case of the stereograph, as would later be the case for film, the
specific pleasures that seem to be released by that apparatus – the desires that it seems
to gratify – led to the instantly wild popularity of the instrument.

The diffusion of stereography as a truly mass medium was made possible by mech-
anized printing techniques. Beginning in the 1850s but continuing almost unabated
into the 1880s, the figures for stereo sales are dizzying. As early as 1857 the London
Stereoscopic Company had sold 500,000 stereoscopes and, in 1859, was able to claim
a catalogue listing more than 100,000 different stereo views.[10]

It is in this very term – *view* – by which the practice of stereoscopy identified
its object, that we can locate the particularity of that experience. First of all, *view*
speaks to the dramatic insistence of the perspectively organized depth that I have been
describing. This was often heightened, or acknowledged, by the makers of stereo views
by structuring the image around a vertical marker in fore- or middle-ground that
works to *center* the space, forming a representation within the visual field of the eyes'
convergence at a vanishing point. Many of Timothy O'Sullivan's images organize them-
selves around such a center – the staff of a bare tree-trunk, the sheer edge of a rock
formation – whose compositional sense derives from the special sensations of the *view*.
Given O'Sullivan's tendency to compose around the diagonal recession and centering
of the *view*, it is not surprising to find that in his one published account of his work as
a Western photographer he consistently speaks of what he makes as "views" and what
he does when making them as "viewing." Writing of the expedition to Pyramid Lake,
he describes the provisions, "among which may be mentioned the instruments and
chemicals necessary for our photographer to 'work up his view.'" Of the Humboldt
Sink, he says, "It was a pretty location to work in, and viewing there was as pleasant
work as could be desired."[11] *View* was the term consistently used in the photographic
journals, as it was overwhelmingly the appellation photographers gave to their entries
in photographic salons in the 1860s. Thus, even when consciously entering the space
of exhibition, they tended to choose *view* rather than *landscape* as their descriptive
category.

Further, *view* addresses a notion of authorship in which the natural phenomenon,
the point of interest, rises up to confront the viewer, seemingly without the mediation
of an individual recorder or artist, leaving "authorship" of the views to their publish-
ers, rather than to the operators (as they were called) who took the pictures. Thus,

authorship is characteristically made a function of publication, with copyright held by the various companies, e.g., ©Keystone Views, while the photographers remain anonymous. In this sense the phenomenological character of the view, its exaggerated depth and focus, opens onto a second feature, which is the isolating of the object of that view. Indeed, it is a "point of interest," a natural wonder, a singular phenomenon that comes to occupy this centering of attention. This experience of the *singular* is, as Barbara Stafford has shown in an examination of singularity as a special category associated with travel accounts beginning in the late eighteenth century, founded on the transfer of authorship from the subjectivity of the artist to the objective manifestations of nature.[12] For this reason, the institution of the view does not claim the imaginative projection of an author so much as the legal protection of property in the form of the copyright.

Finally, *view* registers this singularity, this focal point, as one moment in a complex representation of the world, a kind of complete topographical atlas. For the physical space within which the "views" were kept was invariably a cabinet in whose drawers were catalogued and stored a whole geographical system. The file cabinet is very different as an object from the wall or the easel. It holds out the possibility of storing and cross-referencing bits of information and of collating them through the particular grid of a system of knowledge. The elaborate cabinets of stereo views that were part of the furnishing of nineteenth-century middle-class homes as well as of the equipment of public libraries comprise a compound representation of geographic space. The spatiality of the view, its insistent penetration, functions, then, as the sensory model for a more abstract system whose subject is also space. View and land survey are interdetermined and interrelated.

What can be seen to emerge from this analysis, then, is a system of historically specific requirements that were satisfied by the view and in relation to which *view* formed a coherent discourse. That this discourse is disjunct from what aesthetic discourse intends by the term "landscape" is also, I hope, apparent. Just as the view's construction of space cannot be assimilated, phenomenologically, to the compressed and fragmented space of what *Before Photography* calls analytic perspective,[13] so the representation formed by the collectivity of these views cannot be likened to the representation organized by the space of exhibition. The one composes an image of geographic order; the other represents the space of an autonomous Art and its idealized, specialized History, which is constituted by aesthetic discourse. The complex collective representations of that quality called style – period style, personal style – are dependent upon the space of exhibition; one could say they are a function of it. Modern art history is in that sense a product of the most rigorously organized nineteenth-century space of exhibition: the museum.[14]

It is André Malraux who has explained to us how, in its turn, the museum, with its succession of (representations of) styles, collectively organizes the master representation of Art. Having updated themselves through the institution of the modern art book, Malraux's museums are now "without walls," the galleries' contents collectivized by means of photographic reproduction. But this serves only to intensify the picture:

> Thus it is that, thanks to the rather specious unity imposed by the photographic reproduction on a multiplicity of objects, ranging from the statue to the bas-relief, from bas-reliefs to seal-impressions, and from these to

the plaques of the nomads, a "Babylonian style" seems to emerge as a real entity, not a mere classification – as something resembling, rather the life-story of a great creator. Nothing conveys more vividly and compellingly the notion of a destiny shaping human ends than do the great styles, whose evolutions and transformations seem like long scars that Fate has left, in passing, on the face of the earth.[15]

Having decided that nineteenth-century photography belongs in a museum, having decided that the genres of aesthetic discourse are applicable to it, having decided that the art historical model will map nicely onto this material, recent scholars of photography have decided (ahead of time) quite a lot. For one thing, they have concluded that given images are *landscapes* (rather than *views*) and they are thus certain about the discourse these images belong to and what they are representations of. For another (but it is a conclusion that is reached simultaneously with the first), they have determined that other fundamental concepts of aesthetic discourse will be applicable to this visual archive. One of these is the concept *artist* with its correlative notion of sustained and intentional progress, to which we give the term *career*. The other is the possibility of coherence and meaning that will unfold through the collective body of work so produced, this constituting the unity of an *oeuvre*. But, it can be argued, these are terms that nineteenth-century topographic photography tends not only not to support, but also to open to question.

The concept *artist* implies more than the mere fact of authorship; it also suggests that one must go through certain steps to earn the right to claim the condition of being an author, the word *artist* somehow semantically being connected with the notion of vocation. Generally, "vocation" implies an apprenticeship, a juvenilia, a learning of the tradition of one's craft, the gaining of an individuated view of that tradition through a process that includes both success and failure. If this, or at least some part of it, is what is necessarily included in the term *artist*, can we then imagine someone being an artist for just one year? Would this not be a logical (some would say, grammatical) contradiction, like the example adduced by Stanley Cavell in relation to aesthetic judgments, where he repeats Wittgenstein's question: "Could someone have a feeling of ardent love or hope for the space of one second – *no matter what* preceded or followed this second?"[16]

But this is the case with August Salzmann, whose career as a photographer began in 1853 and was over in less than a year. Little else on the horizon of nineteenth-century photography appeared only to vanish quite so meteorically. But other major figures within this history enter this métier and then leave it in less than a decade. This is true of the careers of Roger Fenton, Gustave LeGray, and Henri LeSecq, all of them acknowledged "masters" of the art. Some of these desertions involved a return to the more traditional arts; others, like Fenton's, meant taking up a totally different field such as the law. What do the span and nature of these engagements with the medium mean for the concept of *career*? Can we study these "careers" with the same methodological presuppositions, the same assumptions of personal style and its continuity, that we bring to the careers of another sort of artist?[17]

And what of the other great aesthetic unity: *oeuvre*? Once again we encounter practices that seem difficult to bring into conformity with what the term comprises, with its assumptions that the oeuvre is the result of sustained intention and that it is

organically related to the effort of its maker: that it is coherent. One practice already mentioned was the imperious assumption of copyright, so that certain oeuvres, like Matthew Brady's and Francis Frith's, are largely a function of the work of their employees. Another practice, related to the nature of photographic commissions, left large bodies of the "oeuvre" unachieved. An example is the Heliographic Mission of 1851 in which LeSecq, LeGray, Baldus, Bayard, and Mestral (which is to say some of the greatest figures in early photographic history in France) did survey work for the Commission des Monuments Historiques. Their results, some 300 negatives in which were recorded medieval architecture about to submit to restoration, not only were never published or exhibited by the Commission, but were never even printed. This is analogous to a director shooting a film but never having the footage developed, hence never seeing the rushes. How would the result fit into the oeuvre of this director?[18]

There are other practices, other exhibits, in the archive that also test the applicability of the concept *oeuvre*. One of these is the body of work that is too meager for this notion; the other is the body that is too large. Can we imagine an oeuvre consisting of one work? The history of photography tries to do this with the single photographic effort ever produced by August Salzmann, a lone volume of archaeological photographs (of great formal beauty), some portion of which are known to have been taken by his assistant.[19] And, at the opposite extreme, can we imagine an oeuvre consisting of 10,000 works?

Eugène Atget's labors produced a vast body of work which he sold over the years of its production, roughly 1895–1927, to various historical collections, such as the Bibliothèque de la Ville de Paris, the Musée de la Ville de Paris (Musée Carnavalet), the Bibliothèque Nationale, the Monuments Historiques, as well as to commercial builders and artists. The assimilation of this work of documentation into a specifically aesthetic discourse began in 1925 with its notice and publication by the Surrealists and was followed, in 1929, by its placement within the photographic sensibility of the German New Vision.[20] Thus began the various partial viewings of the 10,000-piece archive; each view the result of a selection intended to make a given aesthetic or formal point.

The repetitive rhythm of accumulation that interested the *Neue Sachlichkeit* could be found and illustrated within this material, as could the collage sensibility of the Surrealists, who were particularly drawn to the Atget shopfronts, which they made famous. Other selections sustain other interpretations of the material. The frequent visual superimpositions of object and agent, as when Atget himself is captured as a reflection in the glazed entrance of the café he is photographing, permit a reading of the work as reflexive, picturing its own conditions of making. Other readings of the images are more architectonically formal. They see Atget managing to locate a point around which the complex spatial trajectories of the site will unfold with an especially clarifying symmetry. Most often images of parks and rural scenes are used for such analyses.

But each of these readings is partial, like tiny core samples that are extracted from a vast geological field, each displaying the presence of a different ore. Or like the blindmen's elephant. Ten thousand pieces are a lot to collate. Yet, if Atget's work is to be considered art, and he an artist, this collation must be made; we must acknowledge ourselves to be in the presence of an oeuvre. The Museum of Modern Art's four-part exhibition of Atget, assembled under the already loaded title *Atget and the Art of Photography*, moves briskly toward the solution of this problem, always assuming that the

model that will serve to ensure the unity for this archive is the concept of an *artist's oeuvre*. For what else could it be?

John Szarkowski, after recognizing that, from the point of view of formal invention, the work is extremely uneven, speculates on why this should be so:

> There are a number of ways to interpret this apparent incoherence. We could assume that it was Atget's goal to make glorious pictures that would delight and thrill us, and that in this ambition he failed as often as not. Or we could assume that he began photographing as a novice and gradually, through the pedagogical device of work, learned to use his peculiar, recalcitrant medium with economy and sureness, so that his work became better and better as he grew older. Or we could point out that he worked both for others and for himself and that the work he did for himself was better, because it served a more demanding master. Or we could say that it was Atget's goal to explain in visual terms an issue of great richness and complexity — the spirit of his own culture — and that in service to this goal he was willing to accept the results of his own best efforts, even when they did not rise above the role of simple records.
>
> I believe that all of these explanations are in some degree true, but the last is especially interesting to us, since it is so foreign to our understanding of artistic ambition. It is not easy for us to be comfortable with the idea that an artist might work as a servant to an idea larger than he. We have been educated to believe, or rather, to assume, that no value transcends the value of the creative individual. A logical corollary of this assumption is that no subject matter except the artist's own sensibility is quite worthy of his best attention.[21]

This inching forward from the normal categories of description of aesthetic production – formal success/formal failure; apprenticeship/maturity; public commission/personal statement – toward a position that he acknowledges as "foreign to our understanding of artistic ambition," namely, work "in the service of an issue larger than self-expression," evidently troubles Szarkowski. So that just before breaking off this train of thought he meditates on why Atget revisited sites (sometimes after several years) to choose different aspects of, say, a given building to photograph. Szarkowski's answer resolves itself in terms of formal success/formal failure and the categories of artistic maturation that are consistent with the notion of oeuvre. His own persistence in thinking about the work in relation to this aesthetic model surfaces in his decision to continue to treat it in terms of stylistic evolution: "The earlier pictures show the tree as complete and discrete, as an object against a ground; as centrally positioned within the frame; as frontally lighted, from behind the photographer's shoulder. The later pictures show the tree radically cut by the frame, asymmetrically positioned, and more obviously inflected by the quality of light that falls upon it."[22] This is what produces the "elegiac" mood of some of the late work.

But this whole matter of artistic intention and stylistic evolution must be integrated with the "idea larger than he" that Atget can be thought to have served. If the 10,000 images form *Atget's* picture of the larger idea, then that idea can inform us of Atget's aesthetic intentions, for there will be a reciprocal relation between the two, one inside, the other outside the artist.

To get hold, simultaneously, of this larger idea and of Atget's elusive intentions in making this vast archive ("It is difficult," Szarkowski writes, "to name an important artist of the modern period whose life and intention have been so perfectly withheld from us as those of Eugène Atget"), it was long believed to be necessary to decipher the code provided by Atget's negative numbers. Each of the 10,000 plates is numbered. Yet the numbers are not strictly successive; they do not organize the work chronologically; they sometimes double back on each other.[23]

For researchers into the problem of Atget's oeuvre, the numbers were seen as providing the all-important code to the artist's intentions and the work's meaning. Maria Morris Hambourg has finally and most definitively deciphered this code, to find in it the systematization of a catalogue of topographic subjects, divided into five major series and many smaller sub-series and groups.[24] The names given to the various series and groupings, names like Landscape-Documents, Picturesque Paris, Environs, Old-France, etc., establish as the master, larger idea for the work a collective picture of the spirit of French culture – not unlike, we could say, the undertaking of Balzac in the *Comédie Humaine*. In relation to this master subject, Atget's vision can then be organized around a set of intentions that are socio-aesthetic, so to speak; he becomes photography's great visual anthropologist. The unifying intention of the oeuvre can then be understood as a continuing search for the representation of the moment of interface between nature and culture, as in the juxtaposition of the vines growing beside a farmhouse window curtained in a lace representation of schematized leaves (Figure 24.6).

Figure 24.6 Eugène Atget, *Verrieres, coin pittoresque*, 1922. Printing-out paper, $9^{7}/_{16} \times 7^{1}/_{16}$", Collection, The Museum of Modern Art, New York, Abbot-Levy Collection, Partial Gift of Shirley C. Burden. © 2017. Digital image, The Museum of Modern Art, New York/Scala, Florence.

But this analysis, interesting and often brilliant as it is, is once again only partial. The desire to represent the paradigm nature/culture can be traced in only a small fraction of the images and then, like the trail of an elusive animal, it dies out, leaving the intentions as mute and mysterious as ever.

What is interesting in this case is that the Museum of Modern Art and Maria Morris Hambourg hold in their hands the solution to this mystery, a key that will not so much unlock the system of Atget's aesthetic intentions as dispel them. And this example seems all the more informative as it demonstrates the resistance of the museological and art historical disciplines to using that key.

The coding system Atget applied to his images derives from the card files of the libraries and topographic collections for which Atget worked. His subjects are often standardized, dictated by the established categories of survey and historical documentation. The reason many of Atget's street images uncannily resemble the photographs by Marville taken a half century earlier is that both are functions of the same documentary master-plan.[25] A catalogue is not so much an idea as it is a mathesis, a system of organization. It submits not so much to intellectual as to institutional analysis. And it seems very clear that Atget's work is the *function* of a catalogue that he had no hand in inventing and for which *authorship* is an irrelevant term.

The normal conditions of authorship that the Museum wishes to maintain tend to collapse under this observation, leading us to a rather startling reflection. The Museum

Figure 24.7 Eugène Atget, *Sceaux, coin pittoresque*, 1922. Printing-out paper, 9⁷⁄₁₆ × 7¹⁄₁₆"
Collection. © 2017. Digital image, The Museum of Modern Art, New York/Scala, Florence.

undertook to crack the code of Atget's negative numbers in order to discover an aesthetic anima. What they found, instead, was a card catalogue.

With this in mind we get a very different answer to various earlier questions, like the problem of why Atget photographed certain subjects piecemeal, the image of a façade separated by months or even years from the view of the same building's doorway or window mullions or wrought-iron work. The answer, it would seem, lies less in the conditions of aesthetic success or failure than in the requirements of the catalogue and its categorical spaces.

Subject is the fulcrum in all of this. Are the doorways and the ironwork balconies Atget's subjects, his choices, the manifest expression of him as active *subject,* thinking, willing, intending, creating? Or are they simply (although there is nothing simple in this) *subjects,* the functions of the catalogue, to which Atget himself is *subject?* What possible price of historical clarity are we willing to pay in order to maintain the former interpretation over the latter?

Everything that has been put forward about the need to abandon or at least to submit to a serious critique the aesthetically derived categories of authorship, oeuvre, and genre (as in *landscape*) obviously amounts to an attempt to maintain early photography as an archive and to call for the sort of archaeological examination of this archive that Michel Foucault both theorizes and provides a model for. Describing the analysis to which archaeology submits the archive in order to reveal the conditions of its discursive formations, Foucault writes that

> [They] must not be understood as a set of determinations imposed from the outside on the thought of individuals, or inhabiting it from the inside, in advance as it were; they constitute rather the set of conditions in accordance with which a practice is exercised, in accordance with which that practice gives rise to partially or totally new statements, and in accordance with which it can be modified. [The relations established by archaeology] are not so much limitations imposed on the initiative of subjects as the field in which that initiative is articulated (without however constituting its center), rules that it puts into operation (without it having invented or formulated them), relations that provide it with a support (without it being either their final result or their point of convergence). [Archaeology] is an attempt to reveal discursive practices in their complexity and density; to show that to speak is to do something – something other than to express what one thinks.[26]

Everywhere at present there is an attempt to dismantle the photographic archive – the set of practices, institutions, and relationships to which nineteenth-century photography originally belonged – and to reassemble it within the categories previously constituted by art and its history.[27] It is not hard to conceive of what the inducements for doing so are, but it is more difficult to understand the tolerance for the kind of incoherence it produces.

Original publication

'Photography's Discursive Spaces', in *Art Journal*, vol. 42: 4 (1982).

Notes

1 Clarence King, *Systematic Geology*, 1878, is Vol. 1 of *Professional Papers of the Engineer Department U.S. Army*, 7 vols. & atlas, Washington, DC, U.S. Government Printing Office, 1877–78.

2 The cartographic grid onto which this information is reconstructed has other purposes besides the collation of scientific information. As Alan Trachtenberg argues, the government-sponsored Western surveys were intended to gain access to the mineral resources needed for industrialization. It was an industrial as well as a scientific program that generated this photography, which "when viewed outside the context of the reports it accompanied seems to perpetuate the landscape tradition." And Trachtenberg continues: "The photographs represent an essential aspect of the enterprise, a form of record keeping; they contributed to the federal government's policy of supplying fundamental needs of industrialization, needs for reliable data concerning raw materials, and promoted a public willingness to support government policy of conquest, settlement, and exploitation." Alan Trachtenberg, *The Incorporation of America*, New York, Hill and Wang, 1982, p. 20.

3 In his important essay "L'espace de l'art," Jean-Claude Lebensztejn discusses the museum's function, since its relatively recent inception, in determining what will count as Art: "The museum has a double but complementary function: to exclude everything else, and through this exclusion to constitute what we mean by the word art. It does not overstate the case to say that the concept of art underwent a profound transformation when a space, fashioned for its very definition, was opened to contain it." In Lebensztejn, *Zigzag*, Paris, Flammarion, 1981, p. 41.

4 The treatment of Western survey photography as continuous with painterly depictions of nature is everywhere in the literature. Barbara Novak, Weston Naef, and Elisabeth Lindquist-Cock are three specialists who see this work as an extension of those landscape sensibilities operative in American nineteenth-century painting, with transcendentalist fervor constantly conditioning the way nature is seen. Thus, the by-now standard argument about the King/O'Sullivan collaboration is that this visual material amounts to a proof-by-photography of creationism and the presence of God. King, it is argued, resisted both Lyell's geological uniformitarianism and Darwin's evolutionism. A catastrophist, King read the geological records of the Utah and Nevada landscape as a series of acts of creation in which all species were given their permanent shape by a divine creator. The great upheavals and escarpments, the dramatic basalt formations were, it is argued, all produced by nature and photographed by O'Sullivan as proof of King's catastrophist doctrine. With this mission to perform, the Western photography of O'Sullivan becomes continuous with the landscape vision of Bierstadt or Church.

 Although there is some support for this argument, there is an equal amount of support for its opposite: King was a serious scientist, who, for example, made great efforts to publish as part of the findings of his survey Marsh's palaeontological finds, which he knew full well provided one of the important "missing links" needed to give empirical support to Darwin's theory. Furthermore, as we have seen, O'Sullivan's photographs in their lithographic form function as neutralized, scientific testimony in the context of King's report; the transcendentalists' God does not inhabit the visual field of *Systematic Geology*. See, Barbara Novak, *Nature and Culture*, New York, Oxford University Press, 1980; Weston Naef, *Era of Exploration*, New York, The Metropolitan Museum of Art, 1975; and Elisabeth Lindquist-Cock, *Influence of Photography on American Landscape Painting*, New York, Garland Press, 1977.

5 Peter Galassi, *Before Photography*, New York, The Museum of Modern Art, 1981, p. 12.

6 See the chapter "Landscape and the Published Photograph," in Naef, *Era of Exploration*. In 1871 the Government Printing Office published a catalogue of Jackson's work as, *Catalogue of Stereoscopic, 6 × 8 and 8 × 10 Photographs By Wm. H. Jackson.*

7 The eye is not actually refocusing, of course. Rather, given the nearness of the image to the eyes and the fixity of the head in relation to it, in order to scan the space of the image a viewer must readjust and recoordinate the two eyeballs from point to point as vision moves over the surface.

8 Oliver Wendell Holmes, "Sun-Painting and Sun-Sculpture," *Atlantic Monthly*, VIII (July 1861), pp. 14–15. The discussion of the view of Broadway occurs on page 17. Holmes's other two essays appeared as "The Stereoscope and the Stereograph," *Atlantic Monthly*, III (June 1859), pp. 738–48; and "Doings of the Sunbeam," *Atlantic Monthly*, XII (July 1863), pp. 1–15.

9 See, Jean-Louis Baudry, "The Apparatus," *Camera Obscura*, no. 1 (1976), pp. 104–26, originally published as "Le Dispositif," *Communications*, no. 23 (1975), pp. 56–72; and Baudry, "Cinéma: Effets idéologiques produits par l'appareil de base," *Cinéthique*, no. 7–8 (1979), pp. 1–8.

10 Edward W. Earle, ed., *Points of View: The Stereograph in America: A Cultural History*, Rochester, NY, The Visual Studies Workshop Press, 1979, p. 12. In 1856 Robert Hunt in the *Art Journal* reported, "The stereoscope is now seen in every drawing-room; philosophers talk learnedly upon it, ladies are delighted with its magic representation, and children play with it." Ibid., p. 28.

11 "Photographs From the High Rockies," *Harper's Magazine*, XXXIX (September 1869), pp. 465–75. In this article *Tufa Domes, Pyramid Lake* finds yet one more place of publication, in a crude translation of the photograph, this time as an illustration to the author's adventure narrative. Thus one more imaginative space is projected onto the blank, collodion screen. This time, in response to the account of the near capsize of the exploration party's boat, the engraver whips the waters into a darkened frenzy and the sky into banks of lowering storm clouds.

12 Thus Stafford writes, "The concept that true history is natural history emancipates the objects of nature from the government of man. For the idea of singularity it is significant . . . that geological phenomena—taken in their widest sense to include specimens from the mineral kingdom—constitute landscape forms in which natural history finds aesthetic expression. . . . The final stage in the historicizing of nature sees the products of history naturalized. In 1789, the German *savant* Samuel Witte—basing his conclusions on the writings of Desmarets, Duluc and Faujas de Saint-Fond—annexed the pyramids of Egypt for nature, declaring that they were basalt eruptions; he also identified the ruins of Persepolis, Baalbek, Palmyra, as well as the Temple of Jupiter at Agrigento and the Palace of the Incas in Peru, as lithic outcroppings." Barbara M. Stafford, "Toward Romantic Landscape Perception: Illustrated Travels and the Rise of 'Singularity' as an Aesthetic Category," *Art Quarterly*, n.s. I (1977), pp. 108–9. She concludes her study of "the cultivation of taste for the natural phenomenon as singularity," by insisting that "the lone natural object . . . need not be interpreted as human surrogates; on the contrary, [the 19th century Romantic landscape painter's] isolated, detached monoliths should be placed within the vitalist aesthetic tradition—emerging from the illustrated voyage—that valued the natural singular. One might refer to this tradition as that of a 'neue Sachlichkeit' in which the regard for the specifics of nature produces a repertory of animate particulars." pp. 117–18.

13 For another discussion of Galassi's argument with relation to the roots of "analytic perspective" in seventeenth-century optics and the *camera obscura,* see, Svetlana Alpers, *The*

Art of Describing: Dutch Art in the Seventeenth Century, Chicago, University of Chicago Press, 1983, Chapter 2.

14 Michel Foucault opens a discussion of the museum in "Fantasia of the Library," in *Language, Counter-Memory, Practice*, trans. D. F. Bouchard and S. Simon, Ithaca, Cornell University Press, 1977, pp. 87–109. See, also, Eugenio Donato, "The Museum's Furnace: Notes Toward a Contextual Reading of *Bouvard and Pécuchet*," *Textual Strategies: Perspectives in Post-Structuralist Criticism*, ed. Josué V. Harari, Ithaca, Cornell University Press, 1979; and Douglas Crimp, "On the Museum's Ruins," *October*, no. 13 (Summer 1980), pp. 41–57.

15 André Malraux, "Museum Without Walls," *The Voices of Silence*, Princeton, Princeton University Press, Bollingen Series XXIV, 1978, p. 46.

16 Stanley Cavell, *Must We Mean What We Say?* New York, Scribners, 1969, p. 91, n. 9.

17 Students of photography's history are not encouraged to question whether art historical models might (or might not) apply. The session on the history of photography at the 1982 College Art Association meeting (a session proudly introduced as the fruits of real scholarly research at last applied to this formerly unsystematically studied field) was a display of what can go wrong. In the paper "Charles Marville, Popular Illustrator: Origins of a Photographic Aesthetic," presented by Constance Kane Hungerford, the model of the necessary internal consistency of an oeuvre encouraged the idea that there had to be a stylistic connection between Marville's early practice as an engraver and his later work as a photographer. The characterizations of style this promoted with regard to Marville's photographic work (e.g., sharp contrasts of light and dark, hard, crisp contours) were not only hard to see, consistently, but when these did apply they did not distinguish him in any way from his fellows on the Mission Héliographique. For every "graphic" Marville, it is possible to find an equally graphic LeSecq.

18 An example of this is the nearly four miles of footage shot by Eisenstein in Mexico for his project *Que Viva Mexico*. Sent to California where it was developed, this footage was never seen by Eisenstein, who was forced to leave the U.S. immediately upon his return from Mexico. The footage was then cannibalized by two American editors to compose *Thunder over Mexico* and *Time in the Sun*. Neither of these is supposed to be part of Eisenstein's oeuvre. Only a "shooting chronology" assembled by Jay Leyda in the Museum of Modern Art now exists. Its status in relation to Eisenstein's oeuvre is obviously peculiar. But given Eisenstein's nearly ten years of filmmaking experience at the time of the shooting, given also the state of the art of cinema in terms of the body of material that existed by 1930 and the extent to which this had been theorized, it is probable that Eisenstein had a more complete sense, from the script and his working conception of the film, of what he had made as a "work" – even though he never saw it – than the photographers of the Mission Héliographique could have had of theirs. The history of Eisenstein's project is documented in full detail in Sergei Eisenstein and Upton Sinclair, *The Making and Unmaking of "Que Viva Mexico,"* ed. Harry M. Geduld and Ronald Gottesman, Bloomington, Indiana University Press, 1970.

19 See, Abigail Solomon-Godeau, "A Photographer in Jerusalem, 1855: Auguste Salzmann and His Times," *October*, no. 18 (Fall 1981), p. 95. This essay raises some of the issues about the problematic nature of Salzmann's work considered as *oeuvre* that are engaged above.

20 Man Ray arranged for publication of four photographs by Atget in *La Révolution Surréaliste*, three in the June 1926 issue, and one in the December 1926 issue. The exhibition *Film und Foto*, Stuttgart, 1929, included Atget, whose work was also reproduced in *Foto-Auge*, Stuttgart, Wedekind Verlag, 1929.

21 Maria Morris Hambourg and John Szarkowski, *The Work of Atget: Volume 1, Old France*, New York, The Museum of Modern Art, and Boston, New York Graphic Society, 1981, pp. 18–19.

22 Ibid., p. 21.

23 The first published discussion of this problem characterizes it as follows: "Atget's numbering system is puzzling. His pictures are not numbered in a simple serial system, but in a confusing manner. In many cases, low-numbered photographs are dated later than high-numbered photographs, and in many cases numbers are duplicated." See Barbara Michaels, "An Introduction to the Dating and Organization of Eugène Atget's Photographs," *The Art Bulletin*, LXI (September 1979), p. 461.

24 Maria Morris Hambourg, "Eugène Atget, 1857–1927: The Structure of the Work," unpublished Ph.D. dissertation, Columbia University, 1980.

25 See, *Charles Marville, Photographs of Paris 1852–1878*, New York, The French Institute/Alliance Française, 1981. This contains an essay, "Charles Marville's Old Paris," by Maria Morris Hambourg.

26 Michel Foucault, *The Archaeology of Knowledge*, trans. A. M. Sheridan Smith, New York, Harper and Row, 1976, pp. 208–9.

27 Thus far the work of Alan Sekula has been the one consistent analysis of the history of photography to attack this effort. See, Alan Sekula, "The Traffic in Photographs," *Art Journal*, XLI (Spring 1981), pp. 15–25; and "The Instrumental Image: Steichen at War," *Artforum*, XIII (December 1975). A discussion of the rearrangement of the archive in relation to the need to protect the values of modernism is mounted by Douglas Crimp's "The Museum's Old/The Library's New Subject," *Parachute*, (Spring 1981).

Andy Grundberg[1]

THE CRISIS OF THE REAL
Photography and postmodernism

Disneyland is presented as imaginary in order to make us believe that the
rest is real, when in fact all of Los Angeles and the America surrounding it
are no longer real, but of the order of the hyperreal and of simulation. It is
no longer a question of a false representation of reality (ideology), but of
concealing the fact that the real is no longer real

(Jean Baudrillard)[2]

TODAY WE FACE A CONDITION in the arts that for many is both
confusing and irritating – a condition that goes by the name of postmodernism.
But what do we mean when we call a work of art postmodernist? And what does post-
modernism mean for photography? How does it relate to, and challenge, the tradition
of photographic practice as Beaumont Newhall has so conscientiously described it?[3]
Why are the ideas and practices of postmodernist art so unsettling to our traditional
ways of thinking? These are questions that need to be examined if we are to understand
the nature of today's photography, and its relation to the larger art world.

What *is* postmodernism? Is it a method, like the practice of using images that already
exist? Is it an attitude, like irony? Is it an ideology, like Marxism? Or is it a plot hatched
by a cabal of New York artists, dealers, and critics, designed to overturn the art-world
establishment and to shower money and fame on those involved? These are all defini-
tions that have been proposed, and, like the blind men's descriptions of the elephant,
they all may contain a small share of truth. But as I hope to make clear, postmodernist
art did not arise in a vacuum, and it is more than merely a demonstration of certain
theoretical concerns dear to twentieth-century intellectuals. I would argue, in short,
that postmodernism, in its art and its theory, is a reflection of the conditions of our
time.

One complication in arriving at any neat definition of postmodernism is that it
means different things in different artistic media. The term first gained wide currency
in the field of architecture,[4] as a way of describing a turn away from the hermetically

sealed glass boxes and walled concrete bunkers of modern architecture. In coming up with the term postmodern, architects had a very specific and clearly defined target in mind: the 'less is more' reductivism of Mies van der Rohe and his disciples. At first, postmodernism in architecture meant eclecticism: the use of stylistic flourishes and decorative ornament with a kind of carefree, slapdash, and ultimately value-free abandon.

Postmodernist architecture, however, combines old and new styles with an almost hedonistic intensity. Freed of the rigors of Miesian design, architects felt at liberty to reintroduce precisely those elements of architectural syntax that Mies had purged from the vocabulary: historical allusion, metaphor, jokey illusionism, spatial ambiguity. What the English architectural critic Charles Jencks says of Michael Graves's Portland building is true of postmodern architecture as a whole:

> It is evidently an architecture of inclusion which takes the multiplicity
> of differing demands seriously: ornament, colour, representational sculp-
> ture, urban morphology – and more purely architectural demands such as
> structure, space and light.[5]

If architecture's postmodernism is involved with redecorating the stripped-down elements of architectural modernism, thereby restoring some of the emotional complexity and spiritual capacity that the best buildings seem to have, the postmodernism of dance is something else. Modern dance as we have come to know it consists of a tradition extending from Loie Fuller, in Paris in the 1890s, through Martha Graham, in New York in the 1930s. As anyone who has seen Graham's dances can attest, emotional, subjective expressionism is a hallmark of modern dance, albeit within a technically polished framework. Postmodernist dance, which dates from the experimental work performed at the Judson Church in New York City in the early 1960s, was and is an attempt to throw off the heroicism and expressionism of modernist dance by making dance more vernacular.[6] Inspired by the pioneering accomplishments of Merce Cunningham, the dancers of the Judson Dance Theater – who included Trisha Brown, Lucinda Childs, Steve Paxton, and Yvonne Rainer – based their movements on everyday gestures such as walking and turning, and often enlisted the audience or used untrained walk-ons as dancers. Postmodern dance eliminated narrative, reduced decoration, and purged allusion – in other words, it was, and is, not far removed from what we call modern in architecture.

More recently this esthetic of postmodernist dance has been replaced in vanguard circles in New York by an as-yet-unnamed style that seeks to reinject elements of biography, narrative, and political issues into the structure of the dance, using allusion and decoration and difficult dance steps in the process. It is, in its own way, exactly what postmodern architecture is, inasmuch as it attempts to revitalize the art form through inclusion rather than exclusion. Clearly, then, the term postmodernism is used to mean something very different in dance than it does in architecture. The same condition exists in music, and in literature – each defines its postmodernism in relation to its own peculiar modernism.

To edge closer to the situation in photography, consider postmodernism as it is constituted in today's art world – which is to say, within the tradition and practice of painting and sculpture. For a while, in the 1970s, it was possible to think of

postmodernism as equivalent to pluralism, a catchword that was the art-world equivalent of Tom Wolfe's phrase 'The Me Decade.' According to the pluralists, the tradition of modernism, from Paul Cézanne to Kenneth Noland, had plumb tuckered out – had, through its own assumptions, run itself into the ground. Painting was finished, and all that was left to do was either minimalism (which no one much liked to look at) or conceptualism (which no one could look at, its goal being to avoid producing still more art 'objects'). Decoration and representation were out, eye appeal was suspect, emotional appeal thought sloppy if not gauche.

Facing this exhaustion, the artists of the 1970s went off in a hundred directions at once, at least according to the pluralist model. Some started making frankly decorative pattern paintings. Some made sculpture from the earth, or from abandoned buildings. Some started using photography and video, mixing media and adding to the pluralist stew. One consequence of the opening of the modernist gates was that photography, that seemingly perennial second-class citizen, became a naturalized member of the gallery and museum circuit. But the main thrust was that modernism's reductivism – or, to be fair about it, *what was seen as modernism's reductivism* – was countered with a flood of new practices, some of them clearly antithetical to modernism.

But was this pluralism, which is no longer much in evidence, truly an attack on the underlying assumptions of modernism, as modernism was perceived in the mid to late 1970s? Or was it, as the critic Douglas Crimp has written, one of the 'morbid symptoms of modernism's demise'?[7] According to those of Mr. Crimp's critical persuasion (which is to say, of the persuasion of *October* magazine), postmodernism in the art world means something more than simply what comes after modernism. It means, for them, an attack on modernism, an undercutting of its basic assumptions about the role of art in the culture and about the role of the artist in relation to his or her art. This undercutting function has come to be known as 'deconstruction,' a term for which the French philosopher Jacques Derrida is responsible.[8] Behind it lies a theory about the way we perceive the world that is both rooted in, and a reaction to, structuralism.

Structuralism is a theory of language and knowledge, and it is largely based on the Swiss linguist Ferdinand de Saussure's *Course in General Linguistics* (1916). It is allied with, if not inseparable from, the theory of semiotics, or signs, pioneered by the American philosopher Charles S. Pierce at about the same time. What structuralist linguistic theory and semiotic sign theory have in common is the belief that things in the world – literary texts, images, what have you – do not wear their meanings on their sleeves. They must be deciphered, or decoded, in order to be understood. In other words, things have a 'deeper structure' than common sense permits us to comprehend, and structuralism purports to provide a method that allows us to penetrate that deeper structure.

Basically, its method is to divide everything in two. It takes the sign – a word, say, in language, or an image, or even a pair of women's shoes – and separates it into the 'signifier' and the 'signified.' The signifier is like a pointer, and the signified is what gets pointed to. (In Morse code, the dots and dashes are the signifiers, and the letters of the alphabet the signifieds.) Now this seems pretty reasonable, if not exactly simple. But structuralism also holds that the signifier is wholly arbitrary, a convention of social practice rather than a universal law. Therefore structuralism in practice ignores the 'meaning,' or the signified part of the sign, and concentrates on the relations of the signifiers within any given work. In a sense, it holds that the obvious meaning is

irrelevant; instead, it finds its territory within the structure of things – hence the name structuralism.

Some of the consequences of this approach are detailed in Terry Eagleton's book *Literary Theory: An Introduction*:

> First, it does not matter to structuralism that [a] story is hardly an example of great literature. The method is quite indifferent to the cultural value of its object. . . . Second, structuralism is a calculated affront to common sense. . . . It does not take the text at face value, but 'displaces' it into a quite different kind of object. Third, if the particular contents of the text are replaceable, there is a sense in which one can say that the 'content' of the narrative is its structure.[9]

We might think about structuralism in the same way that we think about a sociology, in the sense that they are pseudo-sciences. Both attempt to find a rationalist, scientific basis for understanding human activities – social behavior in sociology's case, writing and speech in structuralism's. They are symptoms of a certain historical desire to make the realm of human activity a bit more neat, a bit more calculable.

Structuralism fits into another historical process as well, which is the gradual replacement of our faith in the obvious with an equally compelling faith in what is not obvious – in what can be uncovered or discovered through analysis. We might date this shift to Copernicus, who had the audacity to claim that the earth revolves around the sun even though it is obvious to all of us that the sun revolves around the earth, and does so once a day. To quote Eagleton:

> Copernicus was followed by Marx, who claimed that the true significance of social processes went on 'behind the backs' of individual agents, and after Marx Freud argued that the real meanings of our words and actions were quite imperceptible to the conscious mind. Structuralism is the modern inheritor of this belief that reality, and our experience of it, are discontinuous with each other.[10]

Poststructuralism, with Derrida, goes a step further. According to the poststructuralists, our perceptions only tell us about what our perceptions are, not about the true conditions of the world. Authors and other sign makers do not control their meanings through their intentions; instead, their meanings are undercut, or 'deconstructed,' by the texts themselves. Nor is there any way to arrive at the 'ultimate' meaning of anything. Meaning is always withheld, and to believe the opposite is tantamount to mythology. As Eagleton says, summarizing Derrida:

> Nothing is ever fully present in signs: it is an illusion for me to believe that I can ever be fully present to you in what I say or write, because to use signs at all entails that my meaning is always somehow dispersed, divided and never quite at one with itself. Not only my meaning, indeed, but *me*: since language is something I am made out of, rather than merely a convenient tool I use, the whole idea that I am a stable unified entity must also be a fiction. . . . It is not that I can have a pure, unblemished meaning, intention or

experience which then gets distorted and refracted by the flawed medium of language: because language is the very air I breathe, I can never have a pure, unblemished meaning or experience at all.[11]

This inability to have 'a pure, unblemished meaning or experience at all,' is, I would submit, exactly the premise of the art we call postmodernist. And, I would add, it is the theme which characterizes most contemporary photography, explicitly or implicitly. Calling it a 'theme' is perhaps too bland: it is the crisis which photography and all other forms of art face in the late twentieth century.

But once we know postmodernism's theoretical underpinnings, how are we to recognize it in art? Under what guise does it appear in pictures? If we return to how postmodernism was first conceived in the art world of the 1970s – namely, under the banner of pluralism – we can say quite blithely that postmodernist art is art that looks like anything *except* modernist art. In fact, we could even concede that postmodernist art could incorporate the modernist 'look' as part of its diversity. But this pinpoints exactly why no one was ever satisfied with pluralism as a concept: it may well describe the absence of a single prevailing style, but it does not describe the *presence* of anything. A critical concept that embraces everything imaginable is not of much use.

The critical theory descended from structuralism has a much better chance of defining what postmodernist visual art should look like, but even with that there is some latitude. Most postmodernist critics of this ideological bent insist that postmodernist art be oppositional. This opposition can be conceived in two ways: as counter to the modernist tradition, and/or as counter to the ruling 'mythologies' of Western culture, which, the theory goes, led to the creation of the modernist tradition in the first place. These same critics believe that postmodernist art therefore must debunk or 'deconstruct' the 'myths' of the autonomous individual ('the myth of the author') and of the individual subject ('the myth of originality'). But when we get to the level of *how* these aims are best accomplished – that is, what style of art might achieve these ends – we encounter critical disagreement and ambiguity.

One concept of postmodernist style is that it should consist of a mixture of media, thereby dispelling modernism's fetishistic concentration on the medium as message – painting about painting, photography about photography, and so on. For example, one could make theatrical paintings, or filmic photographs, or combine pictures with the written word. A corollary to this suggests that the use of so-called alternative media – anything other than painting on canvas and sculpture in metal – is a hallmark of the postmodern. This is a view that actually lifts photography up from its traditional second-class status, and privileges it as the medium of the moment.

And there is yet another view that holds that the medium doesn't matter at all, that what matters is the way in which art operates within and against the culture. As Rosalind Krauss has written, 'Within the situation of postmodernism, practice is not defined in relation to a given medium – [e.g.,] sculpture – but rather in relation to the logical operations on a set of cultural terms, for which any medium – photography, books, lines on walls, mirrors, or sculpture itself – might be used.'[12] Still, there is no denying that, beginning in the 1970s, photography came to assume a position of importance within the realm of postmodernist art, as Krauss herself observed.[13]

Stylistically, if we might entertain the notion of style of postmodernist art, certain practices have been advanced as essentially postmodernist. Foremost among these is

the concept of pastiche, of assembling one's art from a variety of sources. This is not done in the spirit of honoring one's artistic heritage, but neither is it done as parody. As Fredric Jameson explains in an essay called 'Postmodernism and Consumer Society':

> Pastiche is, like parody, the imitation of a peculiar or unique style, the wearing of a stylistic mask, speech in a dead language; but it is a neutral practice of such mimicry, without parody's ulterior motive, without the satirical motive, without laughter, without that still latent feeling that there exists something *normal* compared to which what is being imitated is rather comic. Pastiche is blank parody, parody that has lost its sense of humor[14]

Pastiche can take many forms; it doesn't necessarily mean, for example, that one must collage one's sources together, although Robert Rauschenberg has been cited as a kind of Ur-postmodernist for his combined paintings of the 1950s and photocollages of the early 1960s.[15] Pastiche can also be understood as a peculiar form of mimicry in which a simultaneous process of masking and unmasking occurs.

We can see this process at work in any number of artworks of the 1980s. One example is a 1982 painting by Walter Robinson titled *Revenge*. The first thing to be said about *Revenge* is that it looks like something out of a romance magazine, not something in the tradition of Picasso or Rothko. It takes as its subject a rather debased, stereotypical view of the negligee-clad *femme fatale*, and paints her in a rather debased, illustrative manner. We might say that it adopts the tawdry, male-dominated discourse of female sexuality as found at the lower depths of the mass media. It wears that discourse as a mask, but it wears this mask not to poke fun at it, nor to flatter it by imitation, nor to point us in the direction of something more genuine that lies behind it. It wears this mask in order to unmask it, to point to its internal inconsistencies, its inadequacies, its failures, its stereotypical unreality.

Other examples can be found in the paintings of Thomas Lawson, such as his 1981 canvas *Battered to Death*. Now nothing in this work — which depicts a blandly quizzical child's face in almost photo-realist style — prepares us in the least for the title *Battered to Death*. Which is very much to the point: the artist has used as his source for the portrait a newspaper photograph, which bore the unhappy headline that is the painting's title. The painting wears the mask of banality, but that mask is broken by the title, shifted onto a whole other level of meaning, just as it was when it appeared in the newspaper. So this painting perhaps tells us something about the ways in which newspapers alter or manipulate 'objectivity,' but it also speaks to the separation between style and meaning, image and text, object and intention in today's visual universe. In the act of donning a mask it unmasks — or, in Derrida's terminology, it deconstructs.

There is, it goes without saying, a certain self-consciousness in paintings like these, but it is not a self-consciousness that promotes an identification with the artist in any traditional sense, as in Velasquez's *Las Meninas*. Rather, as Mark Tansey's painting *Homage to Susan Sontag* (1982) makes explicit, it is a self-consciousness that promotes an awareness of photographic representation, of the camera's role in creating and disseminating the 'commodities' of visual culture.

This self-conscious awareness of being in a camera-based and camera-bound culture is an essential feature of the contemporary photography that has come to be called

Figure 25.1 Thomas Lawson, *Battered to Death*, 1981 [original in colour]. Courtesy of Thomas Lawson.

postmodernist. In Cindy Sherman's well-known series *Untitled Film Stills*, for example, the 8-by-10-inch glossy is used as the model from which the artist manufactures a series of masks for herself. In the process, Sherman unmasks the conventions not only of *film noir* but also of woman-as-depicted-object. The stilted submissiveness of her subject refers to stereotypes in the depiction of women and, in a larger way, questions the whole idea of personal identity, male or female. Since she uses herself as her subject in all her, photographs, we might want to call these self-portraits, but in essence they deny the self.

A number of observers have pointed out that Sherman's imagery borrows heavily from the almost subliminal image universe of film, television, fashion photography, and advertising. One can see, for instance, certain correspondences between her photographs and actual film publicity stills of the 1950s. But her pictures are not so much specific borrowings from the past as they are distillations of cultural types. The masks Sherman creates are neither mere parodies of cultural roles nor are they layers like the skins of an onion, which, peeled back, might reveal some inner essence. Hers are perfectly poststructuralist portraits, for they admit to the ultimate unknowable-ness of the 'I.' They challenge the essential assumption of a discrete, identifiable, recognizable author.

Another kind of masking goes on in Eileen Cowin's tableaux images taken since 1980, which she once called *Family Docudramas*. Modeled loosely on soap-opera

Figure 25.2 Cindy Sherman, *Untitled Film Still #13*, 1978. Gelatin silver print (MP# CS—13). Courtesy of the artist and Metro Pictures, New York.

Figure 25.3 Cindy Sherman, *Untitled Film Still #56*, 1980. Gelatin silver print, (MP# CS—56). Courtesy of the artist and Metro Pictures, New York.

vignettes, film stills, or the sort of scenes one finds in a European *photo-roman*, these rather elegant color photographs depict arranged family situations in which a sense of discord and anxiety prevails. Like Sherman, Cowin uses herself as the foil of the piece, and she goes further, including her own family and, at times, her identical twin sister. In the pictures that show us both twins at once, we read the two women as one: as participant and as observer, as reality and fantasy, as anxious ego and critical superego. Cowin's work unmasks many of the conventions of familial self-depiction, but even more important, they unmask conventional notions of interpersonal behavior, opening onto a chilling awareness of the disparity between how we think we behave and how we are seen by others to behave.

Laurie Simmons's photographs are as carefully staged – as fabricated, as directorial – as those of Cindy Sherman and Eileen Cowin, but she usually makes use of miniaturized representations of human beings in equally miniaturized environments. In her early doll-house images, female figures grapple somewhat uncertainly with the accouterments of everyday middle-class life – cleaning bathrooms, confronting dirty kitchen tables, bending over large lipstick containers. Simmons clearly uses the doll figures as stand-ins – for her parents, for herself, for cultural models as she remembers them from the sixties, when she was a child growing up in the suburbs. She is simultaneously interested in examining the conventions of behavior she acquired in her childhood and in exposing the conventions of representations that were the means by which these behavior patterns were transmitted. As is true also of the work of Ellen Brooks, the doll house functions as a reminder of lost innocence.

Figure 25.4 Eileen Cowin, *Untitled*, 1984. © Eileen Cowin.

The works of Sherman, Cowin, and Simmons create surrogates, emphasizing the masked or masking quality of postmodernist photographic practice. Other photographers, however, make work that concentrates our attention on the process of unmasking. One of these is Richard Prince, the leading practitioner of the art of 'rephotography.' Prince photographs pictures that he finds in magazines, cropping them as he sees fit, with the aim of unmasking the syntax of the advertising photography language. His art also implies the exhaustion of the image universe: it suggests that a photographer can find more than enough images already existing in the world without the bother of making new ones. Pressed on this point, Prince will admit that he has no desire to create images from the raw material of the physical world; he is perfectly content – happy, actually – to glean his material from photographic reproductions.

Prince is also a writer of considerable talent. In his book, *Why I Go to the Movies Alone*, we learn something of his attitudes toward the world – attitudes that are shared by many artists of the postmodernist persuasion. The characters he creates are called 'he' or 'they,' but we might just as well see them as stand-ins for the artist, as his own verbal masks:

> Magazines, movies, TV, and records. It wasn't everybody's condition but to him it sometimes seemed like it was, and if it really wasn't, that was alright, but it was going to be hard for him to connect with someone who passed themselves off as an example or a version of a life put together from reasonable matter. . . . His own desires had very little to do with what came from himself because what he put out (at least in part) had already been out. His way to make it new was *make it again*, and making it again was enough for him and certainly, personally speaking, *almost* him.

And a second passage:

> They were always impressed by the photographs of Jackson Pollock, but didn't particularly think much about his paintings, since painting was something they associated with a way to put things together that seemed to them pretty much taken care of.
>
> They hung the photographs of Pollock right next to these new 'personality' posters they just bought. These posters had just come out. They were black and white blow-ups . . . at least thirty by forty inches. And picking one out felt like doing something any new artist should do.
>
> The photographs of Pollock were what they thought Pollock was about. And this kind of take wasn't as much a position as an attitude, a feeling that an abstract expressionist, a TV star, a Hollywood celebrity, a president of a country, a baseball great, could easily mix and associated together . . . and what measurements or speculations that used to separate their value could now be done away with. . . .
>
> I mean it seemed to them that Pollock's photographs looked pretty good next to Steve McQueen's, next to JFK's, next to Vince Edwards', next to Jimmy Piersal's and so on [. . .][16]

Prince's activity is one version of a postmodernist practice that has come to be called appropriation. In intelligent hands like those of Prince, appropriation is certainly

postmodernist, but is not the *sine qua non* of postmodernism. In certain quarters appropriation has gained considerable notoriety, thanks largely to works like Sherrie Levine's 1979 *Untitled (After Edward Weston)*, for which the artist simply made a copy print from a reproduction of a famous 1926 Edward Weston image (*Torso of Neil*) and claimed it as her own. It seems important to stress that appropriation as a tactic is not designed *per se* to tweak the noses of the Weston heirs, to *épater la bourgeoisie*, or to test the limits of the First Amendment. It is, rather, a direct, if somewhat crude, assertion of the finiteness of the visual universe. And it should be said that Levine's *tabula rasa* appropriations frequently depend on (one) their captions, and (two) a theoretical explanation that one must find elsewhere.

Those artists using others' images believe, like Prince, that it is dishonest to pretend that untapped visual resources are still out there in the woods, waiting to be found by artists who can then claim to be original. For them, imagery is now overdetermined – that is, the world already has been glutted with pictures taken in the woods. Even if this weren't the case, however, no one ever comes upon the woods culture free. In fact, these artists believe, we enter the woods as prisoners of our preconceived image of the woods, and what we bring back on film merely confirms our preconceptions.

Another artist to emphasize the unmasking aspects of postmodernist practice is Louise Lawler. While perhaps less well-known and publicized than Sherrie Levine, Lawler examines with great resourcefulness the structures and contexts in which images are seen. In Lawler's work, unlike Levine's, it is possible to read at least some of its message from the medium itself. Her art-making activities fall into several groups: photographs of arrangements of pictures made by others, photographs of arrangements of pictures arranged by the artist herself, and installations of arrangements of pictures.

Why the emphasis on arrangement? Because for Lawler – and for all postmodernist artists, for that matter – the meaning of images is always a matter of their context, especially their relations with other images. In looking at her work one often gets the feeling of trying to decode a rebus: the choice, sequence, and position of the pictures she shows us imply a rudimentary grammar or syntax. Using pictures by others – Jenny Holzer, Peter Nadin, Sherrie Levine's notorious torso of Neil – she urges us to consider the reverberations between them.

In James Welling's pictures yet another strategy is at work, a strategy that might be called appropriation by inference. Instead of representing someone else's image they present the archetype of a certain kind of image. Unlike Prince and Lawler, he molds raw material to create his pictures, but the raw material he uses is likely to be as mundane as crumpled aluminum foil, Jello, or flakes of dough spilled on a velvet drape. These pictures look like pictures we have seen – abstractionist photographs from the Equivalent school of modernism, for instance, with their aspirations to embody some essence of human emotion. In Welling's work, however, the promise of emotional expressionism is always unfulfilled.

Welling's pictures present a state of contradiction. In expressive terms they seem to be 'about' something specific, yet they are 'about' everything and nothing. In the artist's eyes they embody tensions between seeing and blindness; they offer the viewer the promise of insight but at the same time reveal nothing except the inconsequence of the materials with which they were made. They are in one sense landscapes, in another abstractions; in still another sense, they are dramatizations of the postmodern condition of representation.

Figure 25.5 James Welling, *Untitled*, 1981. Courtesy of James Welling and the Marian Goodman Gallery.

The kind of postmodernist art I have been discussing is on the whole not responsive to the canon of art photography. It takes up photography because photography is an explicitly reproducible medium, because it is the common coin of cultural image interchange, and because it avoids the aura of authorship that poststructuralist thought calls into question – or at least avoids that aura to a greater extent than do painting and sculpture. Photography is, for these artists, the medium of choice; it is not necessarily their aim to be photographers, or, for most of them, to be allied with the traditions of art photography. Indeed, some of them remain quite happily ignorant of the photographic tradition. They come, by and large, from another tradition, one rooted theoretically in American art criticism since World War II and one rooted practically in conceptual art, which influenced many of them when they were in art school. But at least as large an influence on these artists is the experience of present-day life itself, as perceived through popular culture – TV, films, advertising, corporate logoism, PR, *People* magazine – in short, the entire industry of mass-media image making.

I hope I have made clear so far that postmodernism means something different to architects and dancers and painters, and that it also has different meanings and applications depending on which architect or dancer or painter one is listening to. And I hope that I have explained some of the critical issues of postmodernism as they have made themselves manifest in the art world, and shown how these issues are embodied in photographs that are called postmodernist. But there remains, for photographers,

still another question: 'What about Heinecken?' That is to say, didn't photography long ago become involved with pastiche, appropriation, questions of mass-media representation, and so on? Wasn't Robert Heinecken rephotographing magazine imagery, in works like *Are You Rea?* (Figure 25.6), as early as 1966, when Richard Prince was still in knickers?

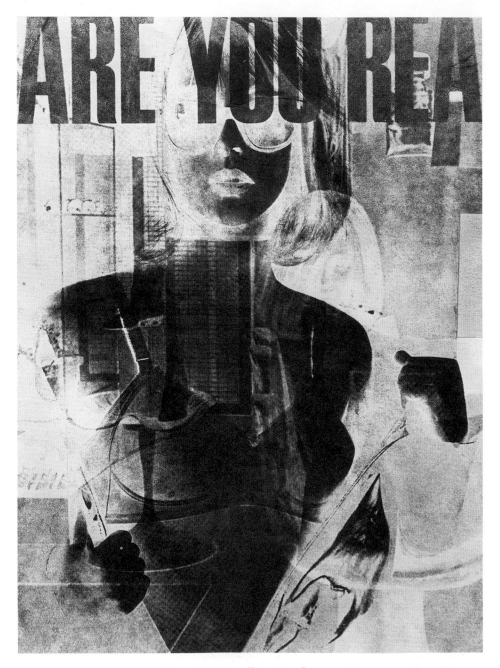

Figure 25.6 Robert Heinecken, *Are You Rea #1*, 1966. © 1966, Robert Heinecken. Courtesy Pace/MacGill Gallery, New York.

To clarify the relationship between today's art world-derived postmodernist photography and what some feel are its undersung photographic antecedents, we need to consider what I would call photography's inherent strain of postmodernism. To do this we have to define photography's modernism.

Modernism in photography is a twentieth-century esthetic which subscribes to the concept of the 'photographic' and bases its critical judgments about what constitutes a good photograph accordingly. Under modernism, as it developed over the course of this century, photography was held to be unique, with capabilities of description and a capacity for verisimilitude beyond those of painting, sculpture, printmaking, or any other medium. Modernism in the visual arts valued (I use the past tense here partly as a matter of convenience, to separate modernism from postmodernism, and partly to suggest modernism's current vestigial status) the notion that painting should be about painting, sculpture about sculpture, photography about photography. If photography were merely a description of what the pyramids along the Nile looked like, or of the dissipated visage of Charles Baudelaire, then it could hardly be said to be a form of art. Modernism required that photography cultivate the photographic – indeed, that it invent the photographic – so that its legitimacy would not be questioned.

In a nutshell, two strands – Alfred Stieglitz's American Purism and László Moholy-Nagy's European experimental formalism – conspired to cultivate the photographic, and together they wove the shape of modernism in American photography. Moholy, it should be remembered, practically invented photographic education in America, having founded the Institute of Design in Chicago in the 1930s. As the heritage of Stieglitzian Purism and Moholy's revolutionary formalism developed and coalesced over the course of this century, it came to represent photography's claim to be a modern art. Ironically, however, just at the moment when this claim was coming to be more fully recognized by the art world – and I refer to the building of a photographic marketplace in the 1970s – the ground shifted underneath the medium's feet.

Suddenly, it seemed, artists without any allegiance to this tradition were using photographs and, even worse, gaining a great deal more attention than traditional photographers. People who hardly seemed to be serious about photography as a medium – Rauschenberg, Ed Ruscha, Lucas Samaras, William Wegman, David Haxton, Robert Cumming, Bernd and Hilla Becher, David Hockney, etc., etc. – were incorporating it into their work or using it plain. 'Photographic-ness' was no longer an issue, once formalism's domain in the art world collapsed. The stage was set for what would come next; what came next we now call postmodernism.[17] Yet one can see the seeds of a postmodernist attitude within what we think of as American modernist photography, beginning, I would argue, with Walker Evans. However much we admire Evans as a documentarian, as the photographer of *Let Us Now Praise Famous Men*, as a 'straight' photographer of considerable formal intelligence and resourcefulness, one cannot help but notice in studying his work of the 1930s how frequently billboards, posters, road signs, and even other photographs are found in his pictures.

It is possible to believe, as some have contended, that these images within Evans's images are merely self-referential – that they are there to double us back and bring us into awareness of the act of photographing and the two-dimensional, cropped-from-a-larger-context condition of the photograph as a picture. But they are also there as signs. They are, of course, signs in the literal sense, but they are also signs of the growing dominion of acculturated imagery. In other words, Evans shows us that even in

the dirt-poor South, images of Hollywood glamor and consumer pleasures – images designed to create desire – were omnipresent. The Nehi sign Evans pictured was, in its time, as much a universal sign as the Golden Arches of hamburgerland are today.

Evans's attention to signs, and to photography as a sign-making or semiotic medium, goes beyond the literal. As we can see in the images he included in *American Photographs*, and in their sequencing, Evans was attempting to create a *text* with his photographs. He in fact created an evocative nexus of signs, a symbology of things American. Read the way one reads a novel, with each page building on those that came before, this symbology describes American experience as no other photographs had done before. And the experience Evans's opus describes is one in which imagery plays a role that can only be described as political. The America of *American Photographs* is governed by the dominion of signs.

A similar attempt to create a symbolic statement of American life can be seen in Robert Frank's book *The Americans*. Frank used the automobile and the road as metonymic metaphors of the American cultural condition, which he envisioned every bit as pessimistically as today's postmodernists. While not quite as obsessive about commonplace or popular-culture images as Evans, he did conceive of imagery as a text – as a sign system capable of signification. In a sense, he gave Evans's take on life in these United States a critical mass of pessimism and persuasiveness.

The inheritors of Frank's and Evans's legacy adopted both their faith in the photograph as a social sign and what has been interpreted to be their skeptical view of American culture. Lee Friedlander's work, for example, despite having earned a reputation as formalist in some quarters, largely consists of a critique of our conditioned ways of seeing. In his picture *Mount Rushmore, South Dakota*, we find an amazingly compact commentary on the role of images in the late twentieth century (Figure 25.7). Natural site has become acculturated sight. Man has carved the mountain in his own image. The tourists look at it through the intervention of lenses, like the photographer himself. The scene appears only as a reflection, mirroring or doubling the condition of photographic appearances, and it is framed, cropped by the windows, just like a photograph.

Although Friedlander took this picture in 1969, well before anyone thought to connect photography and postmodernism, it is more than a modernist explication of photographic self-referentiality: I believe it also functions critically in a postmodernist sense. It could almost be used as an illustration for Jean Baudrillard's apocalyptic statement, 'For the heavenly fire no longer strikes depraved cities, it is rather the lens which cuts through ordinary reality like a laser, putting it to death.'[18] The photograph suggests that our image of reality is made up of images. It makes explicit the dominion of mediation.

We might also look again at the work of younger photographers we are accustomed to thinking of as strictly modernist. Consider John Pfahl's 1977 image *Moonrise over Pie Pan*, from the series *Altered Landscapes*. Pfahl uses his irrepressible humor to mask a more serious intention, which is to call attention to our absence of innocence with regard to the landscape. By intervening in the land with his partly conceptual, partly madcap bag of tricks, and by referencing us not to the scene itself but to another photograph, Ansel Adams's *Moonrise over Hernandez*, Pfahl supplies evidence of the postmodern condition. It seems impossible to claim in this day and age that one can have a direct, unmediated experience of the world. All we see is seen through the kaleidoscope of all that we have seen before.

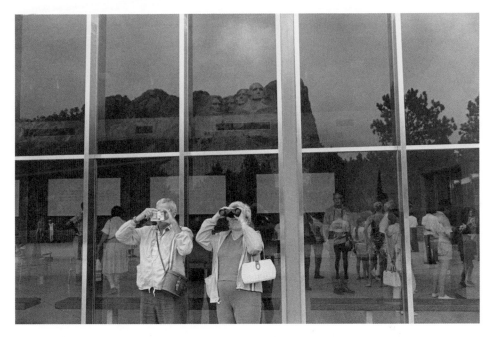

Figure 25.7 Lee Friedlander, *Mount Rushmore, South Dakota*, 1969. Courtesy of the artist and the Fraenkel Gallery, San Francisco.

So, in response to the Heinecken question, there is abundant evidence that the photographic tradition incorporates the sensibility of postmodernism within its late or high modernist practice. This overlap seem to appear not only in photography but in the painting and sculpture tradition as well, where, for example, one can see Rauschenberg's work of the 1950s and 1960s as proto-postmodern, or even aspects of Pop Art, such as Andy Warhol's silkscreen paintings based on photographs.[19] Not only did Rauschenberg, Johns, Warhol, Lichtenstein, and others break with Abstract Expressionism, they also brought into play the photographic image as raw material, and the idea of pastiche as artistic practice.

It seems unreasonable to claim, then, that postmodernism in the visual arts necessarily represents a clean break with modernism – that, as Douglas Crimp has written, 'Post-Modernism can only be understood as a specific breach with Modernism, with those institutions which are the preconditions for and which shape the discourse of Modernism.'[20] Indeed, there is even an argument that postmodernism is inextricably linked with modernism – an argument advanced most radically by the French philosopher Jean François Lyotard in the book *The Postmodern Condition: A Report on Knowledge*:

What, then, is the Postmodern? . . . It is undoubtedly a part of the modern. All that has been received, if only yesterday . . . must be suspected. What space does Cézanne challenge? The Impressionists. What object do Picasso and Braque attack? Cézanne's. What presupposition does Duchamp break with in 1912? That which says one must make a painting. . . . *A work can become modern only if it is first postmodern.* Postmodernism thus understood is not modernism at its end but in the nascent state, and this state is constant.[21]

It is clear, in short, that postmodernism as I have explained it — not the postmod-
ernism of pluralism, but the postmodernism that seeks to problematize the relations
of art and culture — is itself problematic. It swims in the same seas as the art market-
place, yet claims to have an oppositional stance toward that marketplace. It attempts
to critique our culture from inside that culture, believing that no 'outside' position is
possible. It rejects the notion of the avant garde as one of the myths of modernism,
yet in practice it functions as an avant garde. And its linkage to linguistic and literary
theory means that its critical rationale tends to value intellect more than visual analysis.
But for all that, it has captured the imagination of a young generation of artists. And
the intensity of the reactions to postmodernist art suggests that it is more than simply
the latest fashion in this year's art world.

Many people, photographers among them, view postmodernism with some hostil-
ity, tinged in most cases with considerable defensiveness. I suspect that the problem for
most of us with the idea of postmodernism is the premise that it represents a rupture
with the past, with the traditions of art that most of us grew up with and love. But it
is only through considerable intellectual contortions that one can postulate so clean a
break. One has to fence in modernism so tightly, be so restrictive about its practice,
that the effort hardly seems worthwhile. So perhaps, *contra* Crimp, we can find a way to
conceive of postmodernism in a way that acknowledges its evolution from modernism
but retains its criticality.

One of the ways we might do this is by shifting the ground on which we define
postmodernism from questions of style and intention to the question of how one con-
ceives the world. Postmodernist art accepts the world as an endless hall of mirrors, as
a place where all we *are* is images, as in Cindy Sherman's world, and where all we *know*
are images, as in Richard Prince's universe. There is no place in the postmodern world
for a belief in the authenticity of experience, in the sanctity of the individual artist's
vision, in genius or originality. What postmodernist art finally tells us is that things have
been used up, that we are at the end of the line, that we are all prisoners of what we
see. Clearly these are disconcerting and radical ideas, and it takes no great imagination
to see that photography, as a nearly indiscriminate producer of images, is in large part
responsible for them.

Original publication

The Crisis of the Real (1990).

Notes

1 This essay is the title piece of the author's anthology, *Crisis of the Real* (New York: Aper-
 ture, 1990). It also appears in a substantially revised version in *Photography and Art: Inter-
 actions Since 1946* (New York: Abbeville Press, 1987).

2 Jean Baudrillard, *Simulations*, trans. Paul Foss, Paul Patton, and Philip Beitchman (New
 York: Foreign Agents Series/Semiotext(e), 1983), 25.

3 In his classic text, *The History of Photography From 1839 to the Present*, Newhall uses the
 technological development of the medium as a model for describing its esthetic tradi-
 tion. In other words, by his account the artistic practice of photography progresses in an

ascending curve from its primitive beginnings to an apotheosis in the High Modernism of the 1930s. As a result, in his 1983 revision of the history (Museum of Modern Art, New York) Newhall is unable to account coherently for photography's path since. Anything after Weston and Cartier-Bresson is, in his eyes, *prima facie* 'post.'

4 I have been unable to ascertain a 'first use' of the term *Post modern*, which is also encountered as *Postmodern* or *Post-modern*, but it almost certainly dates from the late 1960s. In architecture, it is most often associated with Robert Venturi, the advocate of vernacular forms. In 'On the Museum's Ruins' (*October* 13), Douglas Crimp cites the usage of 'postmodernism' by the art critic Leo Steinberg in 1968, in Steinberg's analysis of the paintings of Robert Rauschenberg. But the term's popularity in the art world came much later; as late as 1982 John Russell of *The New York Times* could call postmodernism 'the big new flower on diction's dungheap' (August 22, 1982, Section 2, p. 1).

5 Charles Jencks, *The Language of Post-Modern Architecture* (New York: Rizzoli International Publishers, 1981), 5.

6 See Sally Banes, *Terpsichore in Sneakers: Post-Modern Dance* (New York: Houghton-Mifflin, 1980), 1–19.

7 Douglas Crimp, 'The Museum's Old, the Library's New Subject,' *Parachute* 22 (Spring 1981): 37.

8 See Derrida's seminal work, *Writing and Difference* (Chicago: University of Chicago Press, 1978), a collection of eleven essays written between 1959 and 1966.

9 Terry Eagleton, *Literary Theory: An Introduction* (Minneapolis: University of Minnesota Press, 1983), 96.

10 Ibid., 108.

11 Ibid., 129–30.

12 Rosalind Krauss, 'Sculpture in the Expanded Field,' *October* 8 (Spring 1979): 42.

13 'If we are to ask what the art of the '70s has to do with all of this, we could summarize it very briefly by pointing to the pervasiveness of the photograph as a means of representation. It is not only there in the obvious case of photo-realism, but in all those forms which depend on documentation – earth-works . . ., body art, story art – and of course in video. But it is not just the heightened presence of the photography itself that is significant. Rather it is the photograph combined with the explicit terms of the index.' Rosalind Krauss, 'Notes on the Index: Part 1,' *October* 3 (Spring 1977): 78.

14 Fredric Jameson, 'Postmodernism and Consumer Society,' in *The Anti-Aesthetic: Essays on Postmodern Culture*, ed. Hal Foster (Port Townsend: Bay Press, 1983), 114.

15 See, for example, Douglas Crimp's essay 'Appropriating Appropriation,' in the catalog *Image Scavengers* (Philadelphia: Institute of Contemporary Art, 1982), 33.

16 Richard Prince, *Why I Go to the Movies Alone* (New York: Tantam Press, 1983), 63 and 69–70.

17 A more elaborated and political view of art photography's waning dominion can be found in Abigail Solomon-Godeau's 'Winning the Game When the Rules Have Been Changed: Art Photography and Postmodernism,' *New Mexico Studies in the Fine Arts,* reprinted in *Exposure* 23:1 (Spring 1985): 5–15, cf. Ch. 17 in this volume, pp. 152–63. [Ed.].

18 Baudrillard, *Simulations*, 51.

19 For further evidence of photographic imagery's impact on Pop and concurrent movements see the catalog to the show 'Blam,' organized by the Whitney Museum, which surveyed the art of the sixties.

20 Douglas Crimp, 'The Photographic Activity of Postmodernism,' *October* 15 (Winter 1980): 91.

21 Jean François Lyotard, *The Postmodern Condition: A Report on Knowledge*, trans. Geoff Bennington and Brian Massumi (Minneapolis: University of Minnesota Press, 1984), 79. The emphasis is mine.

Steve Edwards

SNAPSHOOTERS OF HISTORY
Passages on the postmodern argument

The postmodern world from within

IN THE SHOP BELOW MY FLAT stand two medium sized trees. Between them is a sign which reads:

'We are approved stockists & installation specialists for the Rain Forest range of artificial foliage. The lifelike appearance of this range includes the natural stem trees together with sophisticated photographic techniques for printing the image of the original leaf on fabric. Overcome the problems of maintenance, changing, temperatures & lighting which are experienced with live plants'.

Nature is photographically transformed into its opposite. This artificial rain foliage is part of the dense and nihilistic forest of signs that make up the postmodern condition. For in our age the mass media saturates all experience. We live in, and through, this network of signs. Information swirls around us in a vast process of exchange, no longer coming to rest on an object. This media(ted) exchange creates the objects of our knowledges, calls up our desires and frees us from our illusions of coherence. It is clear, according to Lyotard and others, that information is the principle force of production. They claim our world is that of the simulacrum – the exact copy of that which has never existed.

The postmodern media form a huge sphere. or perhaps a double helix: for if our knowledges are produced by this circulation of mass media signs (and from where else could they originate?) then it is clear that the knowledge generating machine is itself always already media(ted). We live not in some world prior to representation that is then expressed, reflected or articulated at some other level. There is nothing anymore but surface. Representation is all there is and can ever be. There, simply, can be no outside to this endless round of meaningless meaning. What we experience as reality is, in reality, the reality effect. The age of a life beyond the image has gone forever. Now, all we can know are media projections; the beams of flickering images, and the whirr of tape heads. As Lyotard has argued, 'Data banks are the Encyclopedia of tomorrow. They are

"nature" for postmodern man'.[1] Abandoning our nostalgia for the fixed and the stable we should grasp the possibilities offered by the fluid subject and cast off the barriers to our desires. Following Baudrillard,[2] television can be seen as the direct prefiguration of what this subject might be, creating and recreating itself in the flow of signs like flicking stations. But while T.V. with its multiple channels may provide a useful model for thinking through this transformation, photography waits in the wings.

If we take, for instance, that manual of the postmodern – *The Next Directory* – we can see how photography constructs for us, in full simulated colour, worlds without origin or end. Here the popular apes high culture, draped in quality, authenticity and class. As we flip the pages multiple identities whizz past our eyes. Distance and depth collapse into the intricate and exquisite surface of the image. What is there now to prevent us switching back and forth between these marvellous identities? She: now sipping tea on the lawn of the country seat, bathed in golden light, 'well-dressed, well-bred', in that 'endless summer'. Now the belle of the southern states, young and raw, perhaps with an illicit negro love. Now the cultured woman, on her travels through Europe in search of adventure. He: from big city gentleman, to rugged biker, to the fictions of Havana. These are the worlds that the photograph has to offer. Back and forth, one on one day, another the next. Extending in all directions, like the great nineteenth-century department stores, growing section by section, and producing ordering knowledges in the process. We dwell inside the directory, within a set of photographs whose boundaries frame us. Our only choice is between its choices, we have no choice but to consume . . . or so the argument goes.

Snaps for the album

It's impossible to enter the field of cultural debate in the 1980s without encountering the 'Postmodern': however, this does not grant the argument immunity from criticism.[3] The all-encompassing world of the *Directory*, for example, is in some difficulty, with Next's profits down by £12 million, its standing on the stock market at a low and its founder and guru removed from the Board of Directors. Postmodernism needs to be scrutinised rather than assumed precisely because in practice and theory its positions are produced, distributed and consumed on industrial proportions. So that by the time this essay appears another half dozen important works will already be on the shelves. This is to say that the themes of postmodernism have attained the status of 'radical' common sense. While some of this work has been productive, particularly in relation to gender and race, exposing many reactionary assumptions as cultural productions, increasingly it has come to silence other arguments. Or, in the parlance of the moment, it attributes to them the prefix *post*. Postmodernism's radical credentials go unquestioned. But as Dews has argued: 'while there has often been *a de facto* alliance between the intellectual left and recent French theory, with post-structuralism providing tools of analysis which have been widely applied, there has sometimes been little attempt to think through the ultimate compatability of progressive political commitments with the dissolution of the subject, or a totalising suspicion of the concept of truth'.[4]

We need, then, to attempt to freeze this flow in order to examine, frame by frame, the assumptions of postmodernism. To ask why modernism has been abandoned with such undignified haste.

Photographs without objects

In an often cited text, 'The originality of the Avant-Garde: A Postmodern Repetition',[5] Rosalind Krauss argues that to perceive a landscape as picturesque is (obviously) to see it as a picture. As such the picturesque is always prefigured, always already, an image. But this notion of the copy, she believes, is a home truth rigorously repressed by modernism which always seeks to construe itself as a practice which grasps the original moment. The truly radical question would be what constitutes a discourse of reproduction without an original? Answer – Sherrie Levine.

For if Levine re-presents facsimiles of Eliot Porter's landscapes, are we not then in the presence of images of images of images . . . Levine's public exhibition of her copies of other photographers' work, for the theorists of postmodernism, is a move which opens up to question the sanctity of the author as origin. For who is the author of Levine's work?

Levine and her compatriots – Vikky Alexander, Sylvia Kolbowski, Barbara Kruger, Richard Prince, Cindy Sherman and one could add, the Burgin school in Britain – are seen to question the assumed idea that photographs depict some pro-filmic event. Their's is a practice which is fundamentally cynical to the claims that there is a world prior to the shutter, or a meaning authorised by the artistic subject. This group of artist-photographers concentrate on media images, working on their categories, tropes, epistemes. According to the postmodern argument the mass media produce our knowledges and desires. Any political project which would wish to re-route those definitions must, then, compete on this terrain.

Of this group Sherman's work is probably the best known in Britain. In a range of 'Film Stills' she has anatomised the media ideologies of 'feminity'. She pictures herself in the roles presented for woman; as virgin/whore, starlet/housewife, and so on. Each of these pictures is staged with great detail and attention to the codes, so that taken together they display a set of ideological spaces and invite us to ask, 'Which is the real Cindy Sherman?'

In the recent exhibition of portraits by Mapplethorpe at the National Portrait Gallery, a soft and diffuse picture of Sherman operated as a kind of banana skin under the institution's master-plan to cast Mapplethorpe as Cecil Beaton for the 1980s. For given Sherman's own practice, why should we be prepared to accept this image of her (and by extension any of the other pictures) as either privileged or loaded with authorial integrity?

We needn't disagree with the postmodernist description of Sherman. Her attention to the sense of ambiguity between the identity of woman and the signs which locate her is undoubtedly productive: it depicts just how limited and limiting these possibilities are. We encounter a difficulty when a critic like Douglas Crimp wishes to claim that Sherman isn't acting a role but is, in fact, a role or a series of roles.[6] And this reveals the fiction of all selves. But if all subjects are fictions then by definition there can be nothing special about Sherman's work. At best it is just less deluded. The real problem, however, arises when the particulars of Sherman's practice are extended to form a generalised model of culture (while simultaneously, the cultural form of the age always boils down to three or four photographers). Ultimately it's their own method which produces this closure. Because, for the shock troops of the postmodern transformation, there is no outside to representation. If our ideas and knowledges are

products of texts then everything is framed by representation, and there is no limit to this framing. Any attempt to find some prior space of meaning can only be a naive illusion. All is just an image. A discourse of representations without origins: or rather, representations that are now theorised as origins. For we are within the realm of the reality effect. The photographer doesn't capture an image of the world on celluloid, only an image of that which is already an image. Yve Lomax suggests:

> If the photograph ceases to refer to the real world; if the photograph no longer points to that which we assumed is beyond the frame which photography snaps; if the outside of the frame ceases to be the photograph's reference point, in what terms can we constitute to speak of representation?[7]

Saussure's shock troops

The category postmodernism should not simply be assumed to be a descriptive label, but needs to be perceived as the product of a certain theory of representation. In the tradition of Saussurian linguistics meaning can only be produced internal to the formal system (or, in post-structuralism, in its breakdown). The Swiss linguist Ferdinand De Saussure argued that traditional theories of language assumed some necessary connection between a word and object; in this sense they were adamic, with god assigning names. What Saussure did was to point out that language is arbitrary, having no necessary connection to that which it is assumed to refer. This gives rise to a problem: if words (or more specifically signs) are products of convention, then how can language be understood? Saussure's solution was to argue that language is a formal, self-regulating, system in which difference constitutes sense. We understand the word *cat* because it's not *bat* or *can*. This formal and autonomous system necessitated, at the level of abstraction at least, the privileging of *langue* (system) over *parole* (actual language use).

Saussure continued to believe that the sign was linked to the signified (the intended meaning) like two sides of a sheet of paper. Built into this theory, however, is an inherent instability. For if meaning is produced by the movement from sign to sign (difference) rather than from sign to object (reference), then there is no way to prevent some smart theorist (enter Jacques Derrida) from severing the link between signifier and signified and asserting pure difference. Language, or any other system of signs, then becomes not only arbitrary but autonomous.

Representation, in this argument, then ceases to refer to anything but itself. As Terry Eagleton has argued the Saussurian sign is best understood on the models of the commodity which represses the marks of its production in order to present itself as pure and unmediated exchange.[8]

Once this model has been set up representation can be perceived as an infinitely flexible, infinitely unstable system in which meanings slip and slide. With no external world to anchor meaning signification can never be exhausted; there are always more possible readings and none of these can be privileged over others. Any attempt to introduce a prior reality to stabilise this flow of signification is not only vain but a terroristic attempt to smuggle in a 'transcendental signified'. [. . .] Don Slater writes in this vein: 'Behind the photograph there is no real object, only another image (even if

this "image" happens to be in the form of a commodity, or art unemployment figure, or a Falklands war).We consume photographs of photographs of photographs [. . .]'[9]

We need to grasp, however, that this is a particular theory of language, not a self-evidently correct argument. Nor is it even necessarily the best theory, but simply one which, for a number of historical reasons, has come to be seen as the model.The commitment to repressing the referential dimensions of representation could only result in severing the links between language and the world to the extent that a 'megalomania of the signifier' develops. All other social activities become explained by reference to this linguistic model.[10] Thus, post-Saussurian linguistics which weaken any notion of cause condemn us to dwell in a world of eternal now.This conventionalism can be seen as the fundamental reason why postmodernist critique has been confined to the ideological. Any attempt at a systematic critique of postmodernism requires the elaboration of a different theory of representation. I do not intend, in this short piece, to deal with that key question beyond indicating that a sophisticated theory of this kind already exists in the work of the Bakhtin School.[11] This group of Soviet semioticians working in the 1920s treated representation not as a fixed and immutable practice but, by refusing to elevate *langue* over *parole*, insisted that meaning was bound to definite historical contexts. In this theory language works, not as some kind of indeterminate play, but as a dynamic set of social representations. Meaning in Bakhtin's argument cannot be infinite because it is bound to historical blocks and conflictual social forces; it cannot spiral or plummet beyond their protocols. For Bakhtin representation may be problematic (it's certainly never self-evident) but the problematic is not the same as chaos.

A flat world rediscovered

According to Baudrillard and other doyens of postmodernism, representation doesn't distort or reflect, re-present or articulate some prior reality: it's all there is.This move signals a fundamental transformation in the way society is thought about. While we have traditionally considered representations in relation to some other prior realm which could be seen to hold the key to their secrets, postmodernism operates with a flat earth theory: a conception which Fredric Jameson has called 'the disappearance of the depth model'.[12] Within theories based upon deep structure, discourses have been explained by reference to some other theory which is perceived not as a discourse but as truth itself. In this way discourses could be looked through, as if they were transparent: documentary photography stands as the obvious example. But it is precisely these meta-narratives, the theories which claim universal validity and hence the ability to render the truth of representation, which for postmodernists have to be abandoned. Now we are told there is only surface.The meta-narrative has become the very paradigm of metaphysics which attempts to deny the problematic status of representation by smuggling in some prior unmediated instance (the transcendental signifier).

Thus the depth-model has come to be seen as a kind of terrorism that seeks to halt the inevitable play of difference by claiming some fictitious universal knowledge. Lyotard argues, 'I will use the term *modern* to designate any science that legitimates itself with reference to a metadiscourse of this kind, making an explicit appeal to grand narrative: such as the dialectics of Spirit, the hermeneutics of meaning, the emancipation of the rational or the working subject, or the creation of wealth'.[13]

For the postmodernist the key theorisations of the modern world are either no longer valid, or else were always fictions (according to whom you read). For example, Lyotard argues that it is impossible for any one person to now master the proliferation of machine languages; therefore humanist or speculative knowledge is forced to abandon its legitimation duties.[14] Any claim to be able to interpret representations by reference to some deeper level of meaning is seen as an illusion. While Marxism and psychoanalysis are the obvious targets of this polemic, photography also stands accused. If the surface is all there is, if what you see is what you get, then any claim of a photographic dialogue with the world is an illusion. If meaning is constructed within the frame, photography turns out to be far more deluded than art. Philosophy is dethroned by the young pretender literature. It might be noted, however, that whilst this kind of post-structuralist/postmodernist argument presents itself as the latest or even the last word in philosophical chic, these debates are little more than a re-run of phenomenological or analytic language philosophy, where they were presented with a greater sense of modesty.

The postmodern assault on the idea of the meta-narrative includes an attack on totality – the idea that all can be grasped through some great single theory of society. Postmodernists argue that the notion of this totalising discourse represses social differences: it produces a terrible homogeneity, a singularity in whose name dissent and difference are persecuted. We are told that the radical way out of this problem is to embrace pluralism and respect difference. This is a cultural politics that would have its audience identify with the oppressed and the 'marginalised'. It invites us to join them in a manner which solicits liberal guilt. Part of the postmodern argument, then, cancels Brecht's theory of alienation (or disidentification) which sought to provide a critical distance between audience and narrative. With the collapse of that distance, the notion of a totalising theory which might critically reposition those forms of oppression and marginality is itself rendered as a form of totalitarian power. As Lyotard wrote in 1979, 'In any case, there is no question here of proposing a "pure" alternative to the system: we all know, as the 1970s come to a close, that an attempt at an alternative of that kind would end up resembling the system it was meant to replace'.[15] This is another sign of the swing to the right by the Parisian intelligentsia.

All we have left is a pragmatics of representation, a kind of listing of differences to be imaged. This one is Tagg's: 'men and women, black and white, working class and middle class, manual and mental workers, able bodied and disabled, young and old, and so on . . .'[16]

It is important to stress just how productive this conception of difference has been. As a theoretical category, difference has enabled us to blast apart so many received, homogenous notions, and to call into question the idea of a singular audience or unified work. It has allowed us to operate with a set of social registers too often ignored by a conception of class as a necessary unity. But ultimately, it must be said, difference remains a theoretical term embedded in liberalism. The politics it produces are the politics of pluralism.

The central tenet of this flat field is that none of these differences is any more fundamental than any other. Each is equally productive of meaning, while any attempt to elevate some over others is repressive. While on the one hand, it's apparent that these differences can occur in limitless combinations, recreating the individual subject, the real difficulty with the argument lies in the opposite direction – in the abandonment

of agency. If the subject is simply a product of discourse, then conscious action disappears into the discursive. The crisis of certain theories of the subject is seen as the death of the subject. Instead we concentrate on unpacking representation in an (idealist) belief that the subject can thus be reformed.

Without depth the play of representation can be endless. The need for tactical thinking disappears into the freeplay of difference. Unity is perceived as homogeneity, internationalism as universalism. Postmodernism rubs shoulders with a rediscovered notion of the market. While Baudrillard announces the end of the social, Margaret Thatcher pronounces there is no society. This abandonment of social transformation has inclined postmodernists to search for dissipation and difference, for ways of surviving under capitalism. They have developed a politics which has annexed the ideas of feminism and at the same time abandoned the concept of liberation: this seems to me one of the most dangerous effects of the postmodern rhetoric. To disagree that the world isn't flat has come to be seen by many cultural workers as a sign of masculine terrorism. Nothing could be more terroristic.

A commitment to social transformation, however, necessitates tactical thinking, and this means we have to locate some agency capable of carrying through this project. Whilst the kinds of difference of which postmodernists speak might be a fine democratic ideal, the problem remains how to face a highly organized, disciplined and motivated state with a hippy notion of spontaneous difference. Marxists, on the other hand, have traditionally argued that the working class, because of its potential cohesion and possible structural power, constitutes the indispensable agency of socialism. Postmodernism seems incapable of grasping how this class can be simultaneously fractured and yet totalised by its conditions of existence. How to think this problem through remains the base-line for any left photographic practice.

While philosophical ideas cannot be proved, they can be tried out in practice. But this necessitates long durations if research programmes are not to be abandoned at the first hurdle. As such, we need to consider theories in relation to various possible contingencies. This might be stated as a theory of plausibility. Postmodernism can grip the intelligentsia in periods of Thatcherite offensive, for instance, but can't think the conditions under which it would be implausible. The return of a counter-offensive remains, forever, its structured absence. In this sense postmodernists are 'blind' to the historical determinants of their own discourse. The outcome of this failure to historicise their own practice means, of necessity, they misrecognise their dilemmas, their *imaginaire* as the (post) modern condition. They misread their inability to produce a discourse which fastens onto the real as the impossibility of realism. They misconstrue their inability to hold onto history as society's loss of history. By a peculiar route we come back to the traditional intellectuals' universalisation of their crisis as the crisis of all knowledge.[17]

The Baudrillard effect

Probably nothing stands in the postmodernist phantasmagoria quite like the Centre Georges Pompidou (Beaubourg). Important to this mytheme is Baudrillard's essay 'The Beaubourg Effect'.[18] For Baudrillard, the Beaubourg Centre is a condensation of key postmodern themes: a monumental cultural and social implosion which causes a

vacuum of meaning. It is a kind of mediafied black hole which draws in society, only to turn it inside out, creating an arch simulacrum: a copy of meanings and experiences that have no originals. He describes it thus: 'A monument to mass simulation effects, the Centre functions like an incinerator, absorbing and devouring all cultural energy, rather like the black monolith of *2001* – a mad convection current for the materialisation, absorption, and destruction of all the contents within it'.[19]

This vacuum-making machine functions like a nuclear power centre, where the real threat is not from pollution or explosion but from 'the maximum security system that radiates from it'.

The Centre, operating as a kind of cultural fission, draws in resistance only to crush it under the weight of its overbearing and repressive structures. In this way, it becomes the very model of political deterrence. It is a machine of power or total mechanism of control to which there can be no outside, no alternative space from which to read, no other uses. And yet, in Mike Baldwin's television broadcast for the Open University[20] which is closely based on this analysis, as he describes this strategic response to the radical movements of 1968, this monument to discussion, there ascending the escalator is the socialist historian of photography André Rouillé.[21]

Thus we have one of the key contradictions of postmodernist theory and practice. For if a Baudrillard here, or a Foucault there, tells us that power is total and always present, if the subject is constituted by the relations of power, and the wish for a pure space on its outside is a dream, then from what space do they write? How does Baudrillard get outside to look in? This a real problem of knowledge that has bedevilled the cultural left at least since Althusser. Unless a theoretical system has built contradiction into it as the possible site of resistance, the author's own space of opposition becomes a mystery.

The solution to this dilemma, as far as postmodernism is concerned, is through a slip of the word-processor. It always turns out that there is some contradiction in the apparatus of power which causes it to implode. In this case:

> Happily, this whole simulacrum of cultural values is undermined from the very outset by the architectural shell . . . This thing openly declares (that) our only culture is basically that of hydrocarbons – that of refining molecules, and of their recombination into synthetic products. This Beaubourg-Museum wants to hide, but Beaubourg-Carcass proclaims it. And here, truly, is the source of the shell's beauty and the disaster of the interior spaces. The very ideology of 'cultural production' is, in any case, antithetical to culture, just as visibility and multi-purpose spaces are: for culture is a precinct of secrecy, seduction, initiation, and symbolic exchange, highly ritualised and restrained. It can't be helped. Too bad for populism. Tough on Beaubourg.[22]

This is the postmodern theorists' small print. This is the point at which their research programme comes into contradiction with the way people live social relations. Rather than abandon the method as untenable, they fudge, and introduce an *ad hoc* escape clause to exempt themselves from the 'logic' of their own constructs. Having totalised power so that it constitutes the objects of knowledge, not only within discourse but as real objects, postmodernism has become unable to explain resistance. How well Marx's

notion of contradictory material interests fares in the face of this anarcho-Nietzchean 'will-to-power' that at present characterises postmodernist politics.

Modernism's other, enlightenment's opposite

To speak of postmodernism means that we have some idea of that which has been superseded – modernism. However, the problem is that there have been a multiplicity of modernisms. Which one is selected depends on medium and a set of ideological resonances: Joyce or Kafka, Schoenberg or Stravinsky, Moholy-Nagy or Rodchenko, Modetti or Weston. . . .

The track that postmodernists usually take through the minefield of visual modernism is heavily indebted to the art critic Clement Greenberg. Greenberg's particular research programme gained a pre-eminence in the post-war art schools. Stressing that which separated painting from the other arts he came increasingly to emphasize the medium's formal characteristics, primarily its flatness. His was also a historicist method in which end is already inscribed in origin. Whilst the narrative may begin with Manet it is always destined to come to rest in the studio of Jackson Pollock. Like all forms of historicism, Greenberg's reading of art history is incredibly selective; it is instructive as much for what it excludes as includes. In fact Greenberg's story of art depends on the particular axis Paris/New York.

If we take an alternative pathway through the culture of modernism then a very different picture emerges. The pathway I have in mind is Berlin/Prague/St Petersburg/Moscow. We see a dialectic of surface and representation, in which a complex process of fracturing broke with an art of resemblance in order to depict those experiences and contradictions which could not be pictured as homogenous surface. This was an art of juxtaposition which sought to make passive consumption difficult. For instance, Heartfield's montages of confrontation and opposition, which sought to get below the surface of Nazi representation, always insisted they were arguments put up for discussion rather than smuggled in under the guise of empirical truth. Or Rodchenko's attempt to construct a 'visual' practice which problematized the idea of value-free imaging in line with the transformation of the USSR. This is not to valorise the work of the pioneers of left modernism but to point out that their project entailed a sophisticated attempt to scrutinise representation while at the same time trying to grip the real.

Postmodern theorists have, essentially, accepted Greenberg's account of modernism (and in photography its close relative promulgated by Szarkowsky from MOMA in New York). This cardboard modernism then becomes an easy target. It is a relatively simple matter to dispatch its ideology of the subjective genius as no more than a bourgeois illusion; its theory of expression as a fiction of mastery over language, which actually resists and masters its user: its overt masculinism and Eurocentrism. Having vanquished an illusory foe, the credentials of postmodern can be established. The difficulty comes, however, when we shift axis and ask if Heartfield, Rodchenko, Hoch or Modetti ignore race and gender? Or if the authors of some of the fiercest anti-author polemics ever to have been written (Heartfield and Grosz) held a naive belief in the mastery of the subject?

It ought to be clear by now that the postmodernist assault on modernism is part of a much wider assault on the theories of modernity. There is more at stake here than

art. As Jürgen Habermas has written, 'The idea of modernity is intimately tied to the development of European art, but what I call "the project of modernity" comes only into focus when we dispense with the usual concentration on art'.[23]

This project was formulated in the eighteenth century by the philosophers of the Enlightenment as a narrative of the rational growth of the human subject. It contained as its central kernel the belief in human emancipation. In the first instance this meant liberation from superstition (religion) and ignorance through the application of science and a rationalist ethics. These philosophers believed that higher levels of truth could be attained by working through the inner logics of the various rational disciplines. These knowledges could then be deployed to order the world. It is, or ought to be, clear that this heritage is not unproblematic. The narrative of continual growth of knowledge and wealth clearly does not stand up well in the face of twentieth-century history; the particular conception of rationality is instrumental, oppressive and has definite gender implications. The overall cast of this thought is historicist, with all the closures and absences that this entails. But it is also clear that an attempt to abandon the Enlightenment is immensely problematic. As Terry Eagleton has argued, 'Those who now fight for justice and emancipation in their pluralistic, post-Enlightenment ways forget too quickly that it was the Enlightenment which bred and nurtured those very values for our time: that what they do is, ineluctably, at once enabled and impeded by it'.[24]

The modern critics of the Enlightenment often seem to believe that to recite the tragedies of the twentieth century is enough to be rid of it. What the Trotskyist writer Victor Serge called the midnight of the century, that conjuncture that gave us Nazism and Stalinism, Auschwitz, the labour camps and Hiroshima, is seen to prove decisively that human liberation is a naive dream. And worse, a dream with a dark side, in which the very belief in social change contains a will to power that has as its necessary corollary repression. But this a fatalism/determinism of a staggeringly banal kind. Lyotard in *The Postmodern Condition* assumes as a first category that Hitler and Stalin were inevitable, nothing could be done to prevent their narratives of mastery and power. Yet even a cursory knowledge of the history of the period would indicate its numerous 'might have beens'. The important question remains whether the Enlightenment project is over, or if its present problems stem from its necessary incompleteness.

As an alternative to this meta-narrative of emancipation, postmodernism postulates a kind of dropping out and doing your own thing. Transformation now impossible, any alternative just more of the same, postmodernism advocates a culture of hippy resistance: working on ideologies and representations, exposing their rhetorics, demonstrating that all knowledge is representation and all representation contains its own will to power. Instead of an attempt to go beyond capitalism we should work for a pluralism that accepts our differences . . .

While these strategies of endless resistance might from time to time produce the odd rupture, discontinuity or instability, at bottom this is simply a good pragmatics to replace a bad one. Having long ago abandoned the possibility of human liberation as metaphysics, having collapsed socialism into Stalinism, the theorists of postmodernism now see anti-capitalist struggle as part of the regulation of the system. But as Eagleton argues, if socialism has been defeated by capitalism, it shouldn't have much trouble with the odd unorthodox experiment, scientific, literary or whatever.[25] If power is endless and always already present then resistance is at best a thankless task. One might as well stay at home.

This does not bode well for photography. If the postmodern excision of Enlightenment/modernism is accepted, then photography, which is linked to the instrumental practices of optics and chemistry, and which is implicated in vision as a founding moment of the unified subject, would have nothing to do but deconstruct its own impulses. This is a para-photography so thoroughgoing in its idealism that it forgets just how industrial the photographic field is. From its very beginnings photography has been circled by the debates of an industrial society, while its matrix of meanings have been produced in and through the multiple registers of an industrial mode of production. Severed from these founding conditions, photography implodes. To activate the differences for the photographic is, then, as problematic as it is social democratic.

Benjamin's spector exorcised

The implications of postmodernism for photography are immense, most obviously if, *pace* Saussure, meaning is constructed internal to the frame: then photography becomes exactly like any other form of art. Having excised reference the photograph is reduced to a painting with light. Photogenic Drawing makes a spectacular comeback. So that any dialogue with the pro-filmic event is characterised as an ideological fiction.

Armed with this critique whole sectors of the cultural left have turned to a practice as problematic as documentary but smug in its knowingness and content in its self-assured anti-illusionism. Increasingly, we have come to identify a certain kind of studio work with left photography itself. A radical orthodoxy which, for a theoretical position which worships at the altar of openness and indeterminacy, has everything worked out in advance, a series of rigorous formulas to be replicated. This practice reaches its high point with the Burgin school which works through a set of conventions, a hierarchy of subjects, established procedures, codified knowledges, institutional sites, and canonical texts. For an approach which makes so much of difference it produces a sameness, a practical homogeneity unrivalled by anything but the nineteenth century academy. It has created a house style of enigmatic, tangential text combined with studio images typically modelled on, or incorporating, the painted image of a woman. Are we seriously to believe that the female subject is produced by magazine advertisements? Or consider Burgin's own anti-photographic photography. A practice in which ever more sophisticated readings of feminist readings of Lacan's reading of Freud produce a work dazzled by its own (thoroughly hermetic) brilliance. A project which set out to challenge the art school idea of 'private language' comes about as close to that philosophical absurdity as anyone is likely to get. The difficulty of producing a representational practice which can deal with the density of history is reduced to a fetishistic picturing of its surface images. These are endlessly and parasitically recycled, so that history figures as a mere repository of advertisements, magazine photographs and general media ideologies.

For Benjamin and the productionist aesthetic more generally, photography had a key role to play in breaking down the metaphysical ideologies of art. In closing the distance between the privileged object and its audience through mass circulation, they believed, art's bogus religiosity could be blown apart. Their's was a materialist practice based upon active intervention through the accessible technologies of image and publication.[26] Many of these ideas, and the attendant practice of Heartfield, Rodchenko,

or Arbeiter Fotographen have become inscribed in the cultural consciousness. It is, as such, interesting to note that while Burgin *et al.* pay at least a formal homage to Benjamin they simultaneously reinstate the art object into the privileged space of eternity. As Eagleton notes, postmodern parody isn't simply neutral but a sick joke on the revolutionary avant-garde whose major impulse was to dismantle art and its institutional base.[27] Postmodernist anti-avant-gardism can very easily be seen as a manoeuvre to construct for itself the space of the avant-garde. In this form at least, with modernism inverted, postmodernism reverts to pre-modernism and reinstates the aura. Henry Peach Robinson's 'Little Red Riding Hood' turns out to be the epitome of revolutionary good sense.

Into the depths

> There was the Englishman who worked in the London office of a multinational corporation based in the United States. He drove home one evening in his Japanese car. His wife, who worked for a firm which imported German kitchen equipment was already at home. Her small Italian car was often quicker through the traffic. After a meal which included New Zealand lamb, Californian carrots, Mexican honey, French cheese and Spanish wine, they settled down to watch a programme on their television set which had been made in Finland. The programme was a retrospective celebration of the war to recapture the Falkland Islands. As they watched they felt warmly patriotic, and very proud to be British.[28]

In a recent essay in the magazine *Flash Art*, Deitch and Guttman argue that the recent stock market crash constitutes a perfect example of 'economic postmodernism'.[29] The securities market, they insist, once had a direct relationship to the general economy, but this relationship has now broken down, reacting more to its own internal process than to any demand from the manufacturing sector. This is an occurrence entrenched by the postmodern instantaneous international communications network. The stock market functions as spectacle: incapable of representation it draws attention to itself.

A straw target perhaps: art critics who might be expected to know no better. But the example serves, at least, as a useful textual trope. For one of the key problems of postmodernism is, given its separation of society into discreet and autonomous units, the rejection of deep-structure. This move has the effect of rendering postmodern arguments untestable. Contradictions between different practices cannot be assessed. John Tagg has recently stated this clearly, arguing that it is not possible to combine a Marxist theory of levels with a conception of language as arbitrary and differential.[30] This is indeed the case. If representation is the only reality and its criteria of assessment are internal coherence and effectivity then any attempt to reference the social relations of production is already 'offside'. Postmodernism produces for itself a hermetic space. Sealed off from these social relations often labelled (ignorantly) as the economic, it can continue to replicate its untroubled culturalism. In this manoeuvre history is in effect randomised, reduced to a kind of junk store that can be picked through for whatever knick-knacks might interest the cultural producer. Locking together incompatible styles or contradictory arguments, the past is plundered. In the

'anything goes' world of the postmodern the one thing that does go is the coherence of arguments. The road from Sir Karl Popper's Cold War text *The Poverty of Historicism* to the postmodern ideology is a fairly straight one. While Popper's targets were the work of Hegel and Marx, postmodernism claims to reject all totalising theories (despite this claim being one itself), so that history is randomised. Deprived of some general theory, the historical process can only appear as the chance combination of accidents and/or discourse, and is thus placed beyond the control of human agents. A micro-politics of despair is the outcome.

If, however, we suspend our contemporary knowingness regarding the necessary autonomy of culture, then a very different picture emerges. Whilst postmodernism is structurally linked to the various kinds of post-industrial society theories which, in the last 20 years, have come to posit knowledge, information, science and so on as the principle forces of production, industrial capitalism spreads across the globe undaunted.

The economist Nigel Harris has in two recent books[31] tracked this growth, arguing that the fundamental contradictions of the capitalist mode of production now encompass the entire planet. So that the process of capital accumulation and its attendant contradictions now invade all lands. There is no longer any hiding place from the ravenous appetite of the accumulators. Harris argues that this process of world economic integration, the formation of one market in which sectors of capital compete, whether they are private corporations or state capitals, is leading to the end of the Third World. He means by this not the disappearance of countries, or their poor, but of an ideology: an ideology of subordination which came to posit nation rather than class as the key category of struggle. This era, Harris insists, is drawing to a close as capitalist production spreads way beyond its heartlands of Western Europe and North America.

These books need to be read to sample their extraordinary erudition and no attempt will be made here to examine the dense statistical information that litter the texts. It is enough to note the emergence of The Newly Industrialized Countries onto the world market: the four Pacific Tigers – South Korea, Taiwan, Singapore and Hong Kong; the three Latin American Giants – Brazil, Mexico and Argentina: and in addition India, South Africa, Iran, Poland and Japan. These countries have decisively broken the grip of the older capitalist nations. It is predicted that Europe and the US will generate less than half the world's manufacturing output by 1990.[32]

This is the terrain of post-industrialism and postmodernism: a Eurocentric reflex. This is the farewell to the working class and to modernism. It's broadening out across the globe so that the conditions of modern life are now experienced from Korea to Brazil, while the contradictions of capitalism reverberate from the Phillipines to Burma, to South Africa. The theorists of the postmodern are, I would argue, unconscious of the way their own discourse is produced as part of this transformation. For there is clearly no reason (other than that old metropolitan response) why the important articulations of our world should not emanate from Taiwan rather than from New York or Paris. The ground of the postmodern debate is this spread of commodity culture out of its heartlands, and with it the transformation of life, cultural, social and economic in the new and old centres of capital accumulation.

It must be noted that in this process the structural power of the working class is not necessarily weakened in the old heartlands. In fact, it can be argued that whilst fewer industrial workers have power concentrated in their hands, ever larger layers of white-collar workers find themselves proletarianized. Reduced production and reduced producers are not the same thing,

While the new technologies are once again hailed as the end of the capitalist world, similar arguments echo in the cultural sphere where the new information and entertainment technologies are represented as the end of civilization as we know it. This is little more than a fanciful and despairing technological determinism; it is put into perspective if we consider the analogous outcry over the end of art and the industrialization of social life produced by photography in the 1840s. This crude determinism brings with it the notion that people are unable to resist the values purveyed by the media. This is a very real arrogance, for it rules out the possibility of those millions who have no access to media production ever being able to determine their own lives. And by return of post, medianics are set up as the social vanguard.

Having abolished historical time, it's probably no wonder that this programme is so short term. It may well be that people for much of the time live through ideas, images, spectacles drawn from media (though even this weak formulation undervalues popular knowledges). But what is missing from this argument is any sense of counterveiling tendencies, contradictory interests which pull in other directions, and which at moments of crisis can blast apart these spectacles. This is what materialism means – a dynamic or set of contradictions which carry on often unseen and unheard; which operate independently of commodified consciousness, but which nevertheless, sooner or later, emerge into visibility. Intersecting with material interests they wrench consciousness in a different direction. At such moments oppositional politics and representations come into their own. Struggling over the signs of our times, pulling them this way and that in a fierce dialogue between conflictual social forces. Photography contributes to this process of meaning formation, focussing images and desires. But it must be understood that there are definite limits to this dialogue, and those limits are the material interest which contest our world. Deep-structure continues to be the sense of our time. Picturing it remains our problem.

Original publication

'Snapshooters of History: passages on the postmodem argument' in *Ten 8*, no. 32 (1989).

Notes

1 J.F. Lyotard, *The Postmodern Condition: A Report on Knowledge, 1979*, Translated by G. Bennington and B. Massumi, Manchester University Press 1986, p. 51.

2 J. Baudrillard, *The Ecstasy of Communication, Postmodern Culture*, Edited by Hal Foster, Pluto 1985, p. 128.

3 It must be noted that there is an ambiguity throughout this text that could have been rendered (tediously) by enclosing the term postmodernism in inverted commas. While it is clear that postmodernism exists as a discourse within the intelligentsia and this gives it a certain status as a set of objects in the world, I remain fundamentally sceptical about its claims to constitute an ontology – a theory of being in the world. To collapse these two categories can only lead to more confusion, and it's possible that in places I have been guilty of just that. This only serves to indicate that we need to approach the postmodern debate with a good deal more acuity than has often been the case. Further, I have assumed some identity between postmodernism and poststructuralist theory.

4 P. Dews, *Logics of Disintegration, Post-Structuralist Thought and the Claims of Critical Theory*, Verso 1987, p. xv.

5 R. Krauss, 'The Originality of the Avant-Garde: A Postmodern Repetition', *October 18*, Fall 1981.

6 D. Crimp, 'The Photographic Activity of Postmodernism', *October 15*, Winter 1980.

7 Y. Lomax, 'When Roses Are No Longer Given Meaning in Terms of Human Future', *Camerawork*, No. 26, 1983, p. 10.

8 T. Eagleton, 'Wittgenstein's Friends', in *Against the Grain, Selected Essays*, Verso 1986, p. 119.

9 D. Slater, 'The Object of Photography', *Camerawork*, No. 26, 1983, p. 4.

10 See P. Anderson, *In The Tracks of Historical Materialism*, Verso 1983, pp. 41–4. It is worth noting that Levi-Strauss's two principle extensions of structural linguistics to explain 'the exchange of women' as the basis of kinship structure and the exchange of goods in the economy were the two moves specifically ruled out by Saussure.

11 The key works of this group include, V.N. Volosinov, *Marxism and the Philosophy of Language and Freudianism, a Marxist Critique*; P.M. Medvedev, *The Formal Method in Literary Scholarship*; M.M. Bakhtin, *Rabelais and His World, Problems in Dostoevsky's Poetics* and *The Dialogic Imagination*.

12 F. Jameson, 'Postmodernism, or the Cultural Logic of Late Capitalism', *New Left Review*, No. 146, July–August 1984. This influential essay contains many subtle readings of individual works and conjunctures. Whether this commits us to an ontology of postmodernism is, however, another question.

13 Lyotard, op. cit., introduction, p. xiiii.

14 Ibid. p. 41.

15 Ibid. p. 66.

16 J. Tagg, 'Practicing Theories, an Interview With John Tagg', *Afterimage*, January 1988, p. 6.

17 For an elaboration of this argument see P. Anderson, op. cit.: A. Callinicos, *Is There a Future for Marxism?* Macmillan 1982, Chapter 1: 'Postmodernism, Post-Structuralism, Post-Marxism?', *Theory, Culture & Society*, Vol. 2, No. 3, 1985: and A. Rifkin, 'Humming and Hegemony', *Block Winter*, 1986/87.

18 J. Baudrillard, *The Bealbourg Effect: Implosion and Deterrence*, Translated by R. Krauss and Michelson, Spring, October 20, p. 82.

19 Ibid. p. 3.

20 M. Baldwin, *Beaubourg*, Open University, A315. *Modern Art and Modernism*, BBC TV 31.

21 André Rouillé is editor of the journal *La Recherche Photographique,* and amongst other works is the author of *L'Empire de la Photographie*, 1839–1870, Editions Le Sycamore, Paris 1982; *Le Corps et Son Image, Photographies Du Dix-Neuvieme Siecle*, Contrejour 1986: and, with Jean-Claude Lemagny, co-editor of *A History of Photography*, Translated by Janet Lloyd, Cambridge University Press, 1987.

22 Baudrillard, 'The Beaubourg Effect . . .', op. cit., p. 5.

23 J. Habermas, 'Modernity – An Incomplete Project', in Foster op. cit., p. 5.

24 T. Eagleton, 'The Politics of Subjectivity', *Identity,* ICA Documents 6, p. 47.

25 T. Eagleton, 'Capitalism, Modernism and Postmodernism', *Against the Grain . . .* op. cit., pp. 134–5.

26 See W. Benjamin, 'The Work of Art in the Age of Mechanical Reproduction', *Illuminations*, Fontana 1970.

27 T. Eagleton, 'Capitalism, Modernism and Postmodernism', op. cit., p. 131.

28 R. Williams, *Towards 2000*, Penguin 1985, p. 177.

29 J. Deitch and M. Guttman, 'Art and Corporations', *Flash Art*, No. 139, March–April 1988.

30 J. Tagg, *The Burden of Representation, Essays on Photographies and Histories*, Macmillan 1988, p. 23.

31 N. Harris, *Of Bread and Guns, The World Economy in Crisis*, Penguin 1983; *The End of the Third World, Newly Industrializing Countries and the End of an Ideology*, Penguin 1986, as well as numerous essays in the journal *International Socialism*.

32 N. Harris, *The End of the Third World*, ibid., p. 102.

Chapter 27

Lucy Soutter

WHY ART PHOTOGRAPHY?

WHAT IS THE DIFFERENCE between an art photograph and a designer handbag? I pose this rhetorical question to my photography students from time to time. It's a crude provocation, but invariably leads to a productive discussion. The room polarises sharply. Knee-jerk, common-sense-based responses gradually unfold into more complex positions. The students fall into roughly four different camps on the relationship of photography to commercial culture. With the fervency of mid-20th century modernists, some argue for the aesthetic, expressive and craft value of photography; they see the mass-produced handbag as a different category of object. Others occupy a cynical, even Baudrillardian position. They feel that contemporary art and fashion are both capitalist conspiracies, covering up a central bankruptcy in our culture. A third group embodies a critical realist stance. They argue that photography's function is to tell important social truths. These truths, they feel, are too easily obscured in an art context, with the art photograph reduced to the superficial commodity status of the handbag. There tends to be a small (well-dressed) group who believe that the commercial fashion industry makes an important contribution to individuals' identity formation via personal style. These students defend the handbag and may even prefer it to the photograph, unless the photograph is also concerned with design and visual self-expression.

The handbag question, as we could call it, helps students to articulate their own relationship to photography as art. For some of them, this may be the moment that they begin to identify themselves as art photographers or artists using photography (and to wrestle with the semantic confusion of these interlocking terms). For others it is a defining moment of rejection, in which they choose to distance themselves from the use of photography within the institutional settings of art. From an educational standpoint, one of the reasons I pose the question is to make my own position clear, so as not to merely sweep the students along in my own personal net of taste and ideology. Yes, I am a believer in art photography – but it's not a matter of blind faith.

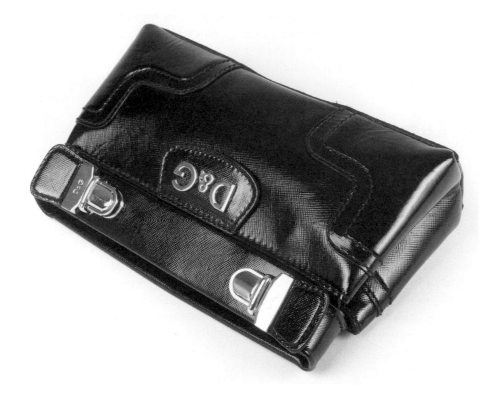

Figure 27.1 D&G black handbag. © Chris Leachman/Alamy Stock Photo.

If art photography has value in our culture beyond its market price, what might that value be? Do we believe that there is 'work' to be done by photographs within an art context? Is such work expressive, critical or something else? And how do photographs go about doing such work? This essay is a brief status report on the relationship between the terms art and photography. It explores some of the different positions that currently have a stake in the matter. Issues raised by the handbag question – market forces, aesthetics and desire – will all play into my account. Along the way I will also discuss the ongoing tension between modern and postmodern positions, both still prevalent, though often taken for granted or repressed.

To its detractors, art photography is elitist, pretentious, irrelevant, self-indulgent and even misleading – a kind of distortion of photography's proper function as a vernacular democratic medium. These accusations sometimes cross over and attach themselves, ad hominem, to the photographer, critic or art historian who takes up the art photography torch. The opponents of photography as an art form come from a number of different constituencies. Although the more intellectual detractors would distance themselves from the philistine view that photography is too easy and direct to be used for artistic purposes, the more subtle arguments against art photography still rest on a commitment to photography's relationship to reality. At stake are fundamental questions about what photography is, what it ought to be doing, and how it ought to be disseminated and received.

Since the mid-19th century, and the earliest attempts to articulate an aesthetics for photography as an art form, the field has been a specialist area, with its own vocabulary

and ideas, drawing on various disciplines including academic painting, avant-garde theory and optics. The specialized nature of art photography is at odds with the ubiquity of the medium as a whole. One of the criticisms of an art historical approach to photography is that it displaces and distorts photographs made for non-art reasons – the vast majority of photographs in existence. Drawing on social history, cultural studies and visual studies, both Christopher Phillips and Geoffrey Batchen have described the violence done to the meaning of anonymous and/or vernacular images when they are shoe-horned into elite museum collections such as that of The Museum of Modern Art, and formalist histories such as Beaumont Newhall's. Such images, they argue convincingly, benefit from being studied from a more heterogeneous, inter-disciplinary point of view. Yet for photographs made with an art orientation, an art historical approach can provide layers of context and meaning.

Contemporary art photography has a number of tangled strands that are difficult to tease apart, and often overlap in the work of a single photographer. One of the most influential has been formalist, and engaged with the modernist history of photography. MoMA curator John Szarkowski had a significant role to play in shaping this tradition, tracing a lineage from Paul Strand and Walker Evans to Lee Friedlander and William Eggleston. While all of these photographers recorded elements of everyday experience, the work has been valued primarily for its formal innovation (different ways of arranging the elements of the picture) and singular, idiosyncratic vision. Alec Soth could be seen as carrying this torch. Another strand of art photography goes back to surrealism, and images that are staged, manipulated or loaded with metaphorical import. Joel-Peter Witkin falls into this category, as do Loretta Lux and Anna Gaskell. A third strand of work aspires to transcend the specialist context of photography and be taken seriously within a broader contemporary art arena (and a higher-priced contemporary art market). With its academic critical framework, work by artists such as Andreas Gursky, Thomas Struth or Thomas Demand makes more exalted claims to historical and political relevance. As I will discuss in further detail, this work is dominated by a large-format deadpan aesthetic. The different kinds of art photography are categorized partly by the way they look, and also by the constantly shifting ways they are framed by language and institutions.

Fine art photography – that is work with a more formalist, modernist orientation – tends to circulate in specialist photography galleries and fairs. Yet the reception of photographic work is just as important as its appearance or subject matter in determining how it will be contextualized. A successful photographer who accrues critical attention and market value may graduate from an art photography context to the institutions that exchange and promote photography within contemporary art. There is certainly overlap between the worlds, but it would be rare, for example, to see a Gursky for sale at Photo-London, or conversely to see a Loretta Lux at the Frieze Fair.

Whether art photographers or contemporary artists using photography, both sets of practitioners are committed to photography as a serious field of enquiry, full of visual and intellectual satisfactions (in this piece I leave aside artists who only occasionally pick up a camera or use an appropriated photograph). They are united in regarding photography as a medium that is tied to the world, but flexible in its relationship to appearances, and independent in its production of meaning.

Some of the most passionate defences of art photography are made by and on behalf of practitioners. Bob Hirsch's 1999 history of photography, entitled *Seizing the*

Figure 27.2 Christopher James, *Book of Alternative Photographic Processes* [Original in colour]. From James, *The Book of Alternative Photographic Processes*, 1E. © 2002 Delmar Learning, a part of Cengage, Inc. Reproduced by permission. www.cengage.com/permissions.

Light, tells the story from a maker's point of view. Artist and curator Hirsch is interested in describing images, but he is not merely re-telling Beaumont Newhall's formalist, genius-centred version of events. Photography itself becomes a protagonist, with its aesthetic value, craft value, visual and intellectual pleasures made available to a reader who is invited implicitly to add to and participate in this history. Hirsch is deeply sceptical of postmodern theories, in part because he reads them as iconophobic and anti-photographic. Yet he is not anti-intellectual; he places photography against a backdrop of 19th and 20th century intellectual history, pointing out that photography has been repeatedly allied with positivist and realist agendas, at the expense of the metaphysical idealism and expressionism found in the contemporary work that he champions.

The sense of being inducted into the traditions of an art is even stronger in Christopher James' *The Book of Alternative Photographic Processes*, soon to be reprinted in expanded form. This is an inspirational how-to book, detailing dozens of processes, with sections of technical, art historical and biographical information about photographers provided in the interests of informing and empowering the aspiring photographer. The kinds of photographic handwork demonstrated in James' book might be seen as regressive, a head-in-the-sand refusal to engage with contemporary visual culture. Alternatively, the celebration of photographic craft could be read as a resistance to the

spectacularization of contemporary art, and as a holding fast to photography's amateur (i.e. done for love) roots. James hearkens back to the strand of photographic modernism that celebrated photography's relationship to light, and its ability to defamiliarize and create new realities, rather than slavishly imitate 'reality'.

For those engaged in the doing, art photography is a subject area with rich internal dialogues and a continuing engagement with traditions. Hirsch and James as writers and teachers on the practitioner side do not judge the motivations that might lead to the making of particular kinds of image. Photographs may highlight fleeting moments, reveal hidden realities, challenge assumptions, transgress norms (all classic modernist drives) but for them, a creative engagement with materials and form is itself an acceptable motivation, as is a traditional urge to self-expression. They do not see themselves as elitists competing with, co-opting or excluding non-art photographs, but as establishing an inclusive domain of practice. They do not defend galleries, collectors or institutions, neither do they praise them; the economic critique of art is held to one side.

Critic and curator David Hickey occupies a related position. Writing about a range of historical and contemporary art in *The Invisible Dragon*, Hickey argues that academic language excludes audiences, and that critics have insinuated themselves into the triangle of artist, artwork and viewer. He likes to place himself on the side of the 'beholder,' aiming his writing at the curious but not necessarily trained reader / viewer. He argues that the viewer has been badly treated by contemporary critics, and that the age-old desire for visual pleasure should not be dismissed as conservative or as collapsing straight into the logic of the market. There is also space within Hickey's scheme for art to be subversive; he describes the rhetorical triumph of Robert Mapplethorpe's exquisitely beautiful photographs of gay sex acts, images whose persuasive power was amply demonstrated by the conservative backlash that they generated.

Hirsch, James and Hickey provide arguments that support photography from a standpoint of art-for-art's-sake. The artists and art historians who developed theories of postmodernism in the visual arts had a totally different logic for valuing photography as art. These writers, including Craig Owens, Rosalind Krauss and Abigail Solomon-Godeau, were not interested in photography as a medium carrying its own traditions as an art form – quite the contrary. Rejecting traditional fine art photography aesthetics, they embraced photography as an anti-aesthetic form, paradoxically making it the centre of a new model of art. As these writers understood it, the crucial task of art in the moment was to reflect back on the way that images make meaning. As Victor Burgin put it in his 1977 article, 'Looking at Photographs': 'The photograph is a place of work, a structured and structuring space within which the reader deploys, and is deployed by, what codes he or she is familiar with in order to make sense.'

Photography, following its self-conscious uses by conceptual artists in the 1960s and 70s, was seen as a perfect medium for enacting postmodern critiques of representation. Race, gender, sexuality, consumerism and various other cultural constructs came under scrutiny as part of this project. Work made with these ideas in mind can be powerful, not least for students who aspire to be image makers. I regularly witness the 'Barbara Kruger effect,' in which individuals discover the artist's work for the first time, embrace it enthusiastically, and go on to develop a more active, combative relationship to official and commercial culture.

Postmodern theories brought a new level of seriousness and academicism to the study of photography. There was also a potential playfulness brought to work in the

postmodern embrace of eclectic styles and genres, and in the transgressive shock of appropriation. For the first time large, colourful and visually dramatic (and expensively framed) photography was for sale in art galleries. The prices for photography rose exponentially. At the same time there was a puritanism to postmodernism, a purging of the modernist values of originality and authenticity, accompanied by a rejection of preciousness, craft and markers of personal expression. Academic photography programmes can still be categorized by the degree to which they embrace this postmodern model of photography-as-art, or continue to tolerate modernist values and aspirations. Photography students on their individual journeys of discovery are often baffled as they hit the invisible postmodern barrier. Some are disappointed when they discover that the subjective, expressive urges that brought them to photography in the first place are considered highly problematic within contemporary photographic practice.

Not all photography as art made since the 1980s has been anti-photographic or anti-subjective. At the same time as Richard Prince and Sherrie Levine made use of appropriation, other practitioners, less resistant to the label 'photographer' were making work that explored issues around representation while still engaging with and even developing photographic aesthetics. Artists like Carrie Mae Weems and Joy Gregory actively mobilised the aesthetic of cyanotypes and platinum prints. Addressing issues of cultural identity and history, they took advantage of the lyrical potential of alternative processes to heighten their critique of the representational status quo. Nan Goldin and Andres Serrano, among others, forged a new aesthetics for large-scale colour photography, using large grain and large areas of shiny darkness within the colour photograph in unforeseen ways, underpinning confessional or shock-based content that transgressed cultural norms. Jeff Wall pioneered a new form within photography-as-art – the lightbox – to heighten the visual appeal of his large staged tableaux. This commercial aesthetic could not be more different from the subtle pleasures of the traditional modernist silver print, yet the work imagines a new field of operation for photography. On the postmodern side, Wall is interested in all the ways that meaning can be constructed and communicated within photographs; he is also very much invested in the making of pictures. His conceptual framework for staging the photographs in relation to painting, social history and critical theory gives him permission to raise the production values of the work while still projecting a sense of seriousness and engagement.

The model of art photography I have set up is very Western, and operates on a New York-London-Düsseldorf axis. Photographic aesthetics read differently depending on their cultural context. In Eastern Europe under communism, for example, a melancholic mode of black and white photography was coded as a form of resistance against an official aesthetic of socialist realism. Czech photographers like Jan Svoboda and Peter Zupnik worked this way, drawing on both conceptual art and surrealism. Contemporary Czech photographers like Marketa Othova might draw on these precedents, and the style of her work would become difficult to read for viewers unfamiliar with a Czech context. In Japan, Iran or any number of other specific cultural contexts, photographic aesthetics have a life of their own. A mode of art photography that seems culturally exhausted in one place or at one moment may provide a unique way of communicating in another.

The anti-subjective tendency of postmodern photography continues in the prevalent mode of photography as art in Europe and America. This large-scale, sharp-focus

colour work is both immediately accessible – what you see is what you get – and intensely academic, in that its layers of meaning cannot be accessed without insider knowledge about both the specific project and contemporary photography as a field of inquiry. This work trades on a central confusion; its deadpan sharp-all-over aesthetic appears to overlap significantly with documentary photography. And indeed, much of this contemporary photographic art shares with documentary an urge to describe the visual world. While traditional documentary photography seeks to educate, agitate, activate its audiences, much of this art-based work is conceived as a spur to contemplation. Although subject matter is usually apparent in the images, the meaning of the work is frequently ambiguous. While modernist works were proudly autonomous, this work is contingent on the language that circulates loosely around it: artist's statements, press releases, reviews and catalogue essays.

The work of Bernd and Hilla Becher is often cited as foundational for contemporary document-based photographic art, and the connection is fruitful. The Becher's work has a dual identity in which it has the appearance of a rational inquiry, a masterful study of industrial structures. Yet at the same time, the logic for approaching the project in this particular way is not manifest, and the efforts gone through to achieve many of the images are superhuman (ask yourself: where is the camera located to achieve these evenly lit vistas of god-like objectivity?). The gridded results are visually satisfying because they have the visual presence and anti-subjective geometry of minimalist sculpture. Their appeal is in their resistance to subjectivity, rather than in any true embrace of objectivity. Although one might imagine contexts in which historians would study these documents for knowledge of a lost industrial age, for the majority of viewers the works are supremely anti-functional.

Jean-François Chevrier has written productively on the rise of the document in contemporary photographic art. In the 2006 exhibition catalogue *Click Double Click*, he describes the 'assiduous regulation of context' necessary in order for photographic documents to transcend the specifics of their making and generate a wealth of interpretations for diverse audiences. He argues that it is in this 'transcultural permanence' that effective work exceeds the limitations of its original context to gain lasting value as art.

Photographs with documentary content but limited documentary function seems pointless – decadent even – to those who are committed to traditional photojournalism. But to judge such work against the standards of social documentary is to miss the point. Simon Norfolk and Luc Delahaye both draw on their experience as photojournalists to produce large-scale images of the aftermath of war. The photographs have some documentary status, as everything depicted is actual (if somewhat rearranged). Yet the images are severed from a documentary function by their painterly aesthetic and their framing within an art context. The gallery images tell us little about the mechanics or ethics of contemporary war, but a good deal about the representation and assimilation of the image of war. Rather than a polemic, they offer an aestheticized space to pause and consider.

Some art historians and critics argue that it is in working out what is at stake, in negotiating the terms and terrain of the art debate, that art does its cultural work. Art may not bring about revolution, but there may still be some worth in the notion of avant-garde activity. In his 1996 book *Modern Art in the Common Culture*, Thomas Crow admits that the radical ambitions of the artistic avant-garde are never fully realized: 'Culture under conditions of developed capitalism displays both moments of negation

and an ultimately overwhelming tendency toward accommodation.' For Crow, art's ongoing value lies in the way it struggles to maintain an independent identity for itself, even as it is constantly swallowed up by the market. For art is not addressed to the market, but to audiences, who are diverse and constantly changing. On the one hand, the discourse about art is ever-more abstract and specialized, on the other, contemporary art and photography exhibitions attract ever-larger new audiences.

This paradox lies at the heart of the work of writers such as Nicholas Bourriaud, whose *Relational Aesthetics* (1996) is designed to revitalize and redefine art in relation to social situations rather than static objects or images. Photography has a role to play too in such works. An artist like Phil Collins creates complex social situations within an art context, following on from performance works of the 1970s and institutional critiques of the 1990s to use photography as a means of documentation and dissemination. South African artist Robin Rhode uses photography to record people on the street in interaction with objects both real and drawn. His serial stagings have some of the narrative appeal of Duane Michals, but with a more pointed social and political edge. Such works use photography as part of a broader practice that aspires to be global, vernacular, tied to life and attuned to reception as much as to itself. In the brief moments that it seems to work, this model offers a new dynamism to photography as art, though of course photography is never really the point. Relational aesthetics focuses on the situation and social exchange rather than the medium. And indeed a photographic document of a relational piece can be all too easily decontextualized, losing its ability to reflect back on human culture or behaviour, and becoming just another picture.

In his 1985 book, *Patterns of Intention*, art historian Michael Baxendall provides an extremely eloquent rebuttal to the over-simplified economic analysis of art. I quote at length because the web of interconnecting motivations that he describes for the making of paintings has direct relevance for the discussion of photographs as art:

> In the economists' market what the producer is compensated by is money: money goes one way, goods or services the other. But in the relation between paintings and cultures the currency is much more diverse than just money: it includes such things as approval, intellectual nurture and, later, reassurance, provocation and irritation of stimulating kinds, the articulation of ideas, vernacular visual skills, friendship and – very important indeed – a history of one's activity and a heredity, as well as sometimes money acting both as a token of some of these and a means to continuing performance. And the good exchanged for these is not so much pictures as profitable and pleasurable experience of pictures. The painter may choose to take more of one sort of compensation than of another – more of a certain sense of himself within the history of painting, for instance, than of approval or money. The consumer may choose this rather than that sort of satisfaction. Whatever choice painter or consumer makes will reflect on the market as a whole. It is a pattern of barter, barter primarily of mental goods.

Of course it is not only art that participates in this kind of significant, pleasurable system of mental barter. Some people spend their time thinking about poetry, ceramics, computer games, haircuts. To some extent, all of these cultural forms – along with handbags – can carry symbolic as well as exchange value, can relate both to everyday

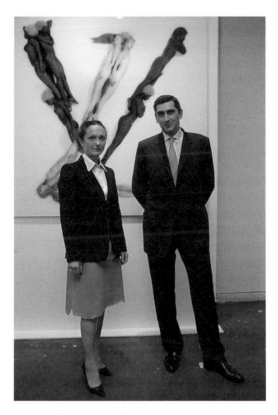

Figure 27.3 Vanessa Beecroft and the European president of Louis Vuitton, Jean Marc Gallot, standing in front of a photograph from the Alphabet Series VBlV which shows the Louis Vuitton logo arranged in female models. [Original in colour] Courtesy of DPA.

life and to abstract ideas, and can employ appropriation, intertextuality, and a mixing of high and low forms of culture. But do they do it as well as art photography? To conclude this discussion, I will return briefly to the handbag question, and to the relative merits of the handbag and art photograph within contemporary culture.

Over the past few years, a legal battle has unfolded in France, in which Moët Hennessy Louis Vuitton, the world's largest luxury goods maker, has fought for the right to open their flagship store on the Champs-Élysées on Sundays. Under French law, this privilege is reserved for businesses that offer their customers some sort of cultural experience. Handbags alone were not enough to win the case. In the summer of 2007, the handbag maker ensured a favourable ruling on Sunday trading by launching a small contemporary art space within the shop. The inaugural exhibition at Espace Louis Vuitton, of video and photographic work by artist Vanessa Beecroft, saw contemporary art and commerce at their most symbiotic.

As with many contemporary artists, Beecroft works across several different forms. In the Vuitton work, the videos and photographs were documents of a performance she had staged at the original opening of the shop in 2005. In *Alphabet Concept VBLV* (2005) black and white female models, dressed only in makeup and pastel coloured wigs are arranged on the floor, their bodies forming the crossed L and V of the Louis Vuitton

logo. The photograph is as visually seductive as a top-budget advertisement. Unlike 1970s performance art, in which the documentation was a shabby afterthought, Beecroft's work places equal emphasis on event and image. Shot from above, and brightly lit, the final form of the photograph was clearly integral to the conception of the work.

On one level the piece operates as branding; idealized female bodies promote the Louis Vuitton label (and the Vanessa Beecroft label, vis the title *VBLV*). For viewers trained in contemporary art, particularly postmodern critiques of representation, the work kicks up a number of disturbing questions about gender, race and consumerism. Part mannequin, part clown, part doll, these figures draw attention to the way the culture industry turns women into mere ciphers. As a commission, exhibited in a commercial space, the work is surely more affirmative than it is critical of fashion or advertising. Yet the photograph is not straight advertising, it is art. In the gap between these two contexts a small space opens up for reflection. By being called art, by being framed institutionally as art, and by relating to previous works of art, this photograph claims greater cultural significance than a handbag. It may not be good art, and not every viewer will like it. But it participates in a rich and well-established field of endeavour.

Among other things, art photographs are elite commodities, status symbols. Yet each one also represents a set of risks taken. In order for one image to be significant, expressive, critical, provocative, etc., there must be others that fail to be so. Whether one views the Beecroft photograph as a success or failure is a matter of training, politics and taste. In my view, this particular image is repellent – like a drink with too much sweetener in it – but also fascinating in its deranged complicity with Louis Vuitton branding (do LV customers really aspire to such an image?). I view it as effective in that it functions as a kind of art parasite. It feeds on the commercial host, while retaining its own slightly perverse agenda.

The different constituencies within art photography are constantly at odds with each other. Modernists are appalled by what they perceive to be the cold blankness of the deadpan documentarians (Christopher James calls them 'the boring postcard people'). Postmodernists revile the makers of expressive or process-based photography as romantic and clichéd. Contemporary artists using photography want to escape from the confines of the art photography ghetto. Art photographers resent artist-photographers for being paid more money for their work (especially since it has usually been printed by somebody else). Yet for all the differences among their makers, the photographs have far more in common with each other than they do with other forms of cultural production. The manifold forms of art photography share a language, history and body of ideas far richer than handbags can ever hope to achieve.

Original publication

'Why Art Photography?' in *Source*, Winter (2007).

Victor Burgin

CONVERSATION WITH HILDE VAN GELDER

HILDE VAN GELDER: *You figure prominently among a pioneering group of artists that, as of the late 1960s, rejected American modernist aesthetic ideals. What you seem to have disliked most in modernist discourse was the belief its adherents seemed to express in 'the ineffable purity of the visual language'*[1] *— a conviction that you trace back to a Platonic tradition of thought in which images have the capacity to reveal mystic truths enshrined in things 'in a flash, without the need for words and arguments'.*[2] *I wonder if you can say today, some 30 years later, how exactly you feel that words in your work have come to counteract such illusions of pure visibility of the image?*

I do not believe, or rather *no longer* believe, that my work can 'counteract' such illusions. Although I realize that your question refers to my photo-text work, I can perhaps more directly answer it by reference to my written work. At the time of *Thinking Photography*[3] I thought that a more broadly informed photographic criticism would eventually dispel the unexamined assumptions that then dominated writing and talking about photography. The notion of the 'purely visual' was prominent amongst these, as was the naive realist idea that photography is a transparent 'window on the world'. The former belief dominated 'fine art' photography at that time, while the latter provided the ideological underpinning of 'social documentary'. When I first started to teach film and photography students, after having first taught in an art school, the 'art' and 'documentary' approaches were mutually antagonistic — ironical, given the fact that their founding assumptions are different formulations of the same Platonic idea. The film and photography department where I went to teach in 1973 was at the time one of only two schools in Britain openly dedicated to a documentary project and hostile to 'fine art' photography. The BA theory course I was asked to construct there, of which *Thinking Photography* is a trace, did for a while succeed in putting critical discussion — the 'reflective stance' you refer to — in

place of the acting out of inherited ideologies. But that period is now, as a friend of mine put it, a 'parenthesis in history'. There has since been a massive return of 'previous' frames of mind that had never in fact gone away, even among some of those who participated in the initial project – as if the mere fact of having acknowledged the validity of the arguments advanced in the 1970s and 80s now provides exemption from acting in response to them. In retrospect I can see – which should not surprise me, given my theoretical inclinations – that reason rarely prevails where there are professional and emotional benefits to be derived from irrationality. We are again confronted, as so often, with the psychological structure of disavowal: 'I know very well, but nevertheless . . .'.

The label 'critical', or stronger even, 'political' art, has often been attached to, particularly, your earlier practice. It seems, however, that, with regard to your work, this notion needs some clarification. It seems doubtful that you would agree with your art being identified as 'critical realist', a term Benjamin H. D. Buchloh coined in 1995 in order to describe Allan Sekula's photography.[4]

I have heard references to the time when my work 'used to be political'. My work has never ceased to be political, what has changed is my understanding of the form of politics specific to *art*, rather than, for example, investigative journalism or agit-prop. Benjamin Buchloh's expression seems to me a symptom of the disavowal I just cited, not least because the issue of *representation* has simply dropped out of the picture. Beyond the attempt to rebrand what used to be called 'social documentary' it is difficult to see what work the expression 'critical realist' is intended to do. Either of the two terms Buchloh associates requires careful specification. To simply conjoin them as if their meanings were self-evident is inevitably to fall into complicity with the *doxa* – in terms of which to be critical is to *criticize*. Here the 'critic' assigns the 'artist' a position analogous to the one he himself assumes – that of a literally *exceptional* person who surveys, discriminates and judges. Where such a position is assigned we do well to ask if there are not blind spots in the critical view. In the early to mid-1970s, when my work had an unambiguously obvious political content, there was very little such work in the art world. Forty years later 'political art' is the new orthodoxy, but it is 'political' only in the way the media understands the term. For example, the enthusiasm for 'documentary' in the art world of the past quarter-century has provided a spectrum of gallery-sited narratives – from intimately anecdotal 'human interest' stories to exposés of the devastation of the human and natural environment by rapacious global capitalism. But there is nothing in the content or analysis of these stories that is not already familiar from the mass media, and I have seen only insignificant departures from conventional media forms. Such 'artworks' solicit the same range of interests and the same reading competences that the media assumes in its audiences. Complementing 'documentary' work in the art world are other kinds of work offering spectacle, decoration or scandal. Here again we have not left the discursive space of the media, we have simply turned the page or changed channels. Brecht defined 'criticism' as that which is concerned

with what is *critical* in society. My own sense of what is now fundamentally critical to the Western societies in which I live and work is the progressive colonization of the terrain of languages, beliefs and values by mainstream media contents and forms – imposing an industrial uniformity upon what may be imagined and said, and engendering compliant synchronized subjects of a 'democratic' political process in which the vote changes nothing. The art world is no exception to this process. Artists making 'documentaries' usually encounter their subject-matter not at first hand but from the media. The audience for the subsequent artworks will instantly recognize the issues addressed, and easily understand them in terms already established by the media. What is 'documented' in such works therefore is not their ostensible contents but rather the mutating world view of the media, and they remain irrelevant *as art* if they succeed in doing no more than recycle facts, forms and opinions already familiar from these prior sources. I would emphasize that I am talking about documentary *in the art world*. As I write, the Iranian filmmaker Jafar Panahi is in prison – primarily, it seems, because he was making a documentary about the mass protests that followed last year's dubious elections in Iran. The political value of documentary is conjunctural, context is as important as content. The political value of art primarily bears on neither content nor context but upon *language*. I see no point to 'art' that calls upon the same general knowledge and interpretative capabilities I deploy when I read a newspaper.

What about the other word in Buchloh's expression, 'realism'? Arguably, your work Zoo *(1978–9), consisting of eight photo diptychs that quite explicitly address the Cold War situation in Berlin, can be seen as a turning / closing point in your view of realism. I say 'arguably' because in 1987, in an essay entitled 'Geometry and Abjection', you launch a plea for a 'realist' artistic project. However, you now define this project in terms of 'psychical realism', an expression you take from Sigmund Freud.*[5] *The term already takes a central position in your essay 'Diderot, Barthes, Vertigo' (1986), where you argue that 'psychical reality', 'unconscious fantasy structures', constantly exercises 'its effects upon perceptions and actions of the subject', such that the world can never be known 'as, simply what it is'.*[6] *To what extent do you still rhyme this notion of psychical realism with your earlier emphasis on art's function as cultural critique? In other words, can you articulate the kind of socio-cultural reflection you wish to put forward through your work ever since the concept of psychical realism has become one of its principal motors?*

The British philosopher Gilbert Ryle long ago commented on the habitual distinction in which 'reality' is seen as something separate from our 'inner' lives. In terms of this distinction we simultaneously inhabit two parallel worlds – one private and psychological, the other public and material. In this view the expression 'psychical reality' would be an oxymoron. Ryle noted, however, that in this version of our experience of the world there is no way of accounting for the *transactions* that take place between public and private histories, as by definition such transactions belong to neither of the 'two' worlds. There is therefore no account of how individual subjects become inserted into general political processes – except in terms of such, now mainly redundant, categories as 'class consciousness'. What Ryle

did not note, but might well have done, is that the distinction between private and public is hierarchical – as when 'subjective fantasy' is subsumed to 'objective reality'. With the idea of 'psychical reality' Freud in effect 'deconstructs' this hierarchy. Anticipating Derrida's critique of the 'logic of the supplement' Freud shows how the 'supplemental' category, that which is considered as superfluous and undesirable, is at the very heart of the category that is upheld as primary and essential. I see no contradiction between a commitment to art as cultural critique and a taking into account of psychical reality. The British cultural and political theorist Stuart Hall said that his attempts to understand the mass appeal of Thatcherism had led him to conclude that the logic of the appeal was not that of a philosophical argument but rather the logic of a dream. To take a more recent example, Michael Moore's film *Sicko* – a damning account of the US health care system and the pharmaceutical and insurance industries that benefit from it – was released in 2007 to enormous acclaim, quickly becoming the third largest-grossing documentary film of the past 30 years. Barack Obama was elected US president the following year, and since then has encountered overwhelming opposition to his proposed health care reforms from the very people who have most to gain from them. As the American expression succinctly puts it, 'Go figure'. If nothing else, this recent history might have prompted a little self-reflection on the part of 'political artists' who see their work as 'consciousness raising'. Not only is there something inevitably patronizing in the attitude of artists setting out to raise other consciousnesses to the level of their own, but also the exercise is generally futile – either the mass of the people 'know very well, but nevertheless . . .' or their consciousnesses are the unique and unassailable product of the populist-tabloid Fox News Channel.

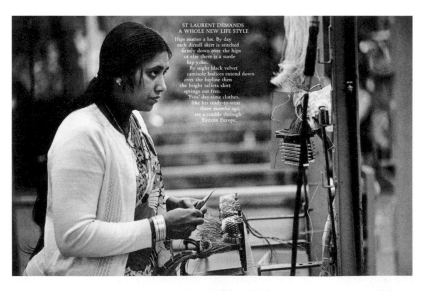

Figure 28.1 'St Laurent demands a whole new lifestyle', from *UK76*, 1976, one of eleven parts, 100 × 150 cm. [Original in colour].

In your work in the 1970s you often drew directly on codes and conventions of the media, espe-
cially advertising, to make ironic comment on various kinds of exploitation and inequality, such as
in UK *76 (Figure 28.1), where in one of the panels you insert an excerpt from a fashion magazine*
into a photograph of a female Asian factory worker. You now say you conceive differently of 'the
place of the political in art'.[7] *In this regard you cite Jacques Rancière, who says that 'aesthetics*
has its own meta-politics',[8] *as a privileged ally in your own attempts to understand how art relates*
to politics and ideology.[9] *You conclude by insisting that 'the political meaning of attempts . . .*
to give aesthetic form to a phenomenological truth or a psychical reality . . . may lie precisely in
the ways in which they fail to conform . . . to established regimes of intelligibility'.[10] *Could you*
elaborate on this?

Art, at least in our Western populist liberal democracies, has no direct
political agency. When I joined the protest march against the Iraq War in
London, when I joined demonstrations against the National Front in Paris,
I acted as a citizen, not as an artist. When I refused to cooperate with
'obligatory' but intellectually ridiculous government research assessment
exercises, when I refused to join a 'compulsory' training day for academic
staff run by a private management-training consultancy, I acted as a uni-
versity teacher, not an artist. The work of 'political artists' usually harms
no one, and I would defend their right to make it; what I cannot support
is their complacent and self-serving assumption that it 'somehow' has a
political effect in the real world. In a university art department, I would
prefer as my colleague the artist who makes watercolours of sunsets but
stands up to the administration, to the colleague who makes radical polit-
ical noises in the gallery but colludes in imposing senseless and educa-
tionally disastrous government policies on the department. The political
agency of artists is not 'on the ground' in everyday life – at this level they
must be content to act as citizens and/or, in my example, teachers (I have
always considered teaching to be my most important political activity) –
their agency is in the sphere of representations. Since the work to which
you refer, and up to the present day, I have measured the political and
critical dimensions of my work by their relation to the mainstream mass
media – as the media is most responsible for the production of a subject
for the political process, most instrumental in delivering votes to politi-
cians. You are nevertheless right to note that my position in relation to the
media has shifted. My initial position combined Lévi-Strauss' notion of
bricolage with Barthes' idea of 'semioclasm'. For example, the panel we have
already mentioned from *UK76* juxtaposes fragments from two disparate
and 'antagonistic' discursive formations – social documentary photography
and fashion journalism – in order to bring out a social contradiction. The
problem I see with this now is that it leaves the fragments intact, and what
one is able to construct – to 'say' – depends entirely on what it is possible
to do with the fragments. No great surprise therefore that what I was able
to say with this particular panel of *UK76* was already well known, and that
the only 'value-added' element to the source materials was my own irony
(albeit there was also a cultural-political significance *at that time* – it was
relatively short-lived – in putting such content on the wall of a gallery). As

I have already said, I see the critical task of art today as that of offering an alternative to the media. I am opposed to any form of conformity to the contents and codes of the *doxa* – what Rancière calls 'consensual categories and descriptions' – even when these are deployed with a 'left' agenda, as I believe that in this particular case 'one cannot dismantle the master's house with the master's tools'. At the present conjuncture it seems to me that society is most present in an artwork – as a critical project – when the artwork is most absent from society.

If we can turn then to your more recent work: Hôtel D *(2009) is a site-specific piece consisting of a digital-projection loop inside a box installed in a principle room of the ancient former pilgrims' hospital Hôtel-Dieu Saint-Jacques in Toulouse, once known as the 'salle des portraits des bienfaiteurs'.*[11] *Could one understand this 'sequence of images' as a 'sequence-image', a term you have defined earlier in your writings;*[12] *and more recently in conversation with Alexander Streitberger, where you call it 'both the elemental unit from which chains of signifiers are formed and the hinge between movement and stasis, the motionless point of turning between unconscious fantasy and the real'?*[13]

The short answer to that question is 'no', as the 'sequence-image' is a purely theoretical entity. I coined the expression to allow me to talk about an image that is neither still nor moving or, to put it the other way, both still and moving. The fact that such an image is by definition impossible signals its location in psychical space on the side of the unconscious, where what logic calls the 'law of excluded middle' does not apply (as when a woman in a dream is both the dreamer's mother *and* sister). I coined the neologism reluctantly but there was no other way of speaking about what for me is an important aspect of the 'psychical reality' I try to represent. The material images projected in the Hôtel-Dieu, and the material sound of the *voix-off* in the adjoining chapel, were combined in an attempt to represent the strictly unrepresentable. Each new work renews this attempt, making its singular contribution to the generality at which I aim. I think by analogy of an old movie version of H. G. Wells's *The Invisible Man* where a number of devices are used to signify the invisible man's form – for example, in one scene, some trash whirls into the air on a windy street and sticks to him; in another scene, disembodied footprints advance across a snow-covered field. We would not say that either the trash or the tracks are the invisible man, but they are the more or less contingent conditions of his 'appearance' in the visible world. *Hôtel D*, in common with all of my works in recent years, is an attempt to represent some unrepresentable 'thing' – in this case deriving from my being *there,* in the *Hôtel-Dieu* in Toulouse, and being aware of the lives and deaths of those who were there before me, aware of the past function of the building, and at the same time aware of the forms of the architecture, of the time it takes to cross the room – *everything*, in fact, at the same time, including the connotations and fantasies that accompanied my perceptual experience and knowledge of the place.

Hôtel D *offers itself as a key case study in order to understand your interest in 'perceptual reality', as you name it in your 'note' accompanying the piece. The research component of this interest*

brings in the 'historical identity' of the place as a space of labour for the 'filles de service' — female hospital orderlies. The sequence of images and the spoken text testify to a paradox encountered in your own initial observation of the reality of this room. Among the five large-size portraits of illustrious historical benefactors of this establishment you found an equally monumental picture of a woman identified only as 'fille de service'. The image of this woman, named at the bottom of the portrait itself as Marguerite Bonnelasvals (d. 1785), is exhibited together with the other portraits, which are all of people of a higher social rank. Facing Marguerite Bonnelasvals, as you point out, hangs a tableau of Princess Marie-Thérèse de Bourbon, daughter of Louis XVI and Marie-Antoinette. This striking finding, a result of your scrupulous perception and observation of the place, is a key theme in Hôtel D. *Can you perhaps clarify how, from a strictly methodological point-of-view, you decided to focus your work on this quite incredible coincidence?*

In the perceptual and associative complex that is my experience of a place there is often a privileged point around which everything else turns. It might be a detail, an anecdote or something else. The juxtaposition of the two portraits in the Hôtel-Dieu became this point of anchorage for everything that made up my awareness of the place. One of the things that interests me is the way 'the political' may be manifest as a mutable aspect of our everyday reality, on the same perceptual basis as the changing light, an aching knee or a regret. The coincidence of the portraits is a trace of the political in the overlooked and, therefore, part of what I look for in the everyday. There is no need for the political artist, too often a disaster tourist, to 'sail the seven seas' looking for injustices to denounce. Inequality and exploitation saturate the ground on which we stand, they are in the grain

Figure 28.2 Still from the projection work *Hôtel D*, 2009, loop, 14 min, 29 sec. [Original in colour].

Figure 28.3 Still from the projection work *Hôtel D,* 2009, loop, 14 min, 29 sec. [Original in colour].

of everyday life. This granular-perceptual manifestation of the political is
part of what I try to represent in my works.

I have come to understand Hôtel D *as a work that brings together all the major themes
and preoccupations of your oeuvre. With the concept of psychical realism entering your work,
your interest in the representation of women entered the foreground. Many of your pieces, as of
the early 1980s, take account of the impact of male desire on female perception and vice versa,
and the issue of sexuality and sexual difference in general. You have emphasized the influence
that 1970s feminism exercised on your artistic trajectory, for example in the attention in your
work to 'the construction of gendered identities through identifications with images'.[14] Now,
in* Hôtel D, *the long-lasting key importance you have accorded to this very subject appears to
engage in a dialogue with an interest you have had, in an even earlier phase of your work, with
regard to the representation of labour. Many contemporary artists have taken on the problematic
consequences of currently globalized labour conditions by directly representing people at work.
Whereas the atmosphere of* UK76 *seems to have something in common with such an approach,
you have later come to take the representation of labour in your work in a different direction.*

I do not understand how 'directly representing people at work' can be said
to 'take on' the issue of the globalization of the labour force – at most it can
only redundantly *illustrate* it. Amongst other things, the issue is fundamen-
tally one of organizing collective action across cultural, linguistic and legal
international borders. How can adding more pictures to the mountain of
images of the labouring classes have any relevance to such questions, let

Figure 28.4 Installation, *Hôtel D*, 2009. Hôtel-Dieu Saint-Jacques, Toulouse – Chapelle (soundtrack) and Salle des Pellerins (image track). [Original in colour].

alone any purchase on them? And what about the act of picture-taking itself? As your reference to *UK76* invokes the historical perspective, I would like to quote what I said in an interview from the late 1970s when I was asked how I felt about the power relation between myself and the Asian woman worker whose image appears in this work:

> I'd been commissioned to take photographs by the Coventry work-shop, they were working with various other local workers' organisa-tions and they wanted someone to take some pictures in some of the factories around Coventry. It was in that capacity that I took that particular picture: it was not shot as a work of art but as something for their publications and their files . . . No one was photographed who didn't want to be. Some obviously didn't feel comfortable with the camera on them, so I didn't take photographs of them, but oth-ers obviously enjoyed being the centre of attention. I was a source of entertainment for them for the afternoon. Having said all that, the fact remains that I was free to walk out of that place and they weren't – a fundamental distinction. The work I was doing was intended to sup-port them, the same goes for the art piece that some of the images were subsequently used in, but the fact remains that my interven-tion there, if not actually exploitative, was politically irrelevant; that's

Figure 28.5 Installation, *Hôtel D*, 2009. Hotel-Dieu Saint-Jacques, Toulouse – Chapelle (soundtrack) and Salle des Pellerins (image track). [Original in colour].

how I feel about it now, and that's how I feel about the work of other 'artists' who take their cameras into such situations.[15]

Under what circumstances is it acceptable for a middle-class photographer to point a camera at a wage-slave? A campaigning journalist illustrating a news story that might mobilize public opinion and embarrass corporations and politicians into changing their behaviour is certainly justified, but I find something profoundly distasteful in the spectacle of workers having a last increment of value extracted from them by 'political artists' parading their moral narcissism in pursuit of their careers.

In your photo-textual work Office at Night *(1986) the 'psychical' component has already entered the very depiction of labour. The work prominently focuses on male-female power relationships in the workplace. It's extremely dense, sexually and power(less)-loaded atmosphere differentiates it from Jeff Wall's more neutral photographic depictions of labour, not least with regard to the so-called 'iconography of cleaning up', an issue I would like to come to in a minute.[16] In Hôtel D, the representation of labour is only indirectly present, as this was already the case in your* Performative / Narrative *(1971), a photo-textual piece that shows an empty office of a male employer (as the accompanying text indicates). In Hôtel D it is not so much in the sequence of images itself but instead in the 'voix-off' – the voice heard in the adjoining chapel – that the humble work of cleaning up is more explicitly addressed.[17] The voix-off operates 'in parallel' to the images, as Philippe Dubois has argued with regard to other of your works*

with a similar approach.[18] The sequence of images shows the perfectly neat tiled floors, walls and ceiling of the 'salle des portraits des bienfaiteurs', and a perfectly clean hotel room — although subtle details, such as a playing tv, luggage, gloves on a desk and a bottle of pills besides the bed, reveal it is in use. Yet for a major part of the eight-and-a-half-minute-long parallel audio sequence a woman's voice slowly describes the repetitive activities of making a bed and cleaning a hotel room. I wonder if this (by definition) 'non-iconographic' soundtrack can be understood as performing a double function in your work. I feel that its descriptive character can be seen as programmatic with regard to your decision, articulated one year after Office at Night, *in 'Geometry and Abjection' (1987), that a 'political' art theory should simply 'describe' rather than exhort or admonish, or offer 'solutions'.[19]*

Perhaps I should first describe the work, as it is unlikely that anyone reading our exchange will have seen it. *Hôtel D* comprises four components: the two actual spaces in the Hôtel-Dieu, an image-track and a soundtrack. The image sequence assembled from the photographs I made in the Salle des Pèlerins is projected in a continuous loop in a 'viewing box' constructed inside the Salle itself. The room represented in the box is therefore a *mise-en-abyme* of the room that contains the box. The 'work of art' here is in good part a work of the visitor in a coming and going between the experience of the actual rooms and their representations. There is an analogous coming and going between the real and projected images in the Salle des Pèlerins (as you have noted, formerly the '*salle des portraits des bienfaiteurs*') and the voice heard in the adjoining space of the Chapel. Rather than 'voice-over', the equivalent French expression '*voix-off*' is more appropriate here as the text is heard not over the images but at a distance from them. *Hôtel D* is the product of a reflection upon the 'perceptual reality' of the Salle des Pèlerins — as I experienced it and as it is refracted through the photographs I made there — and upon the historical identity of the room as a place of care for the sick and dying, a place of work for the '*filles de service*'. Another axis of my work — prompted by the historical function of the Hôtel-Dieu as a place of rest for the pilgrim — is formed in a coming and going between associations to the meaning of the term '*hôtel*' in this particular building in Toulouse, and to the more usual meaning of the term in everyday use today. Images of a hotel room in a modern city (in actual fact, in Chicago) therefore come to join my images of the Salle des Pèlerins. Similarly, in the *voix-off*, references to the repetitive routine task of bed making occur in both a hospital and a hotel setting. *Hôtel D* is not 'about' such things in the way that either a documentary or a fiction film might be about them. It is a work best considered not as one might view a film, but rather as one might approach a painting.

You have in fact said that the spectator should try to view the complex perceptual installation called Hôtel D *as a painting in which you see 'everything and nothing at the same time'.[20] Could this statement perhaps help to grasp what you have elsewhere identified as the 'uncinematic feel' of your video practice?[21] Also, in order to better understand this fascinating concept of the dispersed painting or tableau, to be discovered layer by layer in a mode of 'reprise', as you call it,[22] would it be helpful to recur to an analogy with the notion Allan Sekula coins for several*

of his works, namely that they are 'disassembled movies'?[23] *Could we say with regard to* Hôtel D *that it is to be considered as a 'disassembled tableau'?*

> In the 1970s I used to speak of my large-scale photo-text works as the remnants of hypothetical films – for example, I described *US77* as 'a sort of "static film" where the individual scenes have collapsed inwards upon themselves so that the narrative connections have become lost'.[24] However, I also at that time spoke of the viewing conditions of such works as being the 'negative of cinema' – for example, in the cinema the spectator is in darkness whereas the gallery is light; the cinematic spectator is still while the images move, whereas the visitor to the gallery moves in front of static images; or again, the sequence and duration of images in the cinema is predetermined, whereas visitors to the gallery determine their own view-ing times and sequences. Or again, there is little opportunity for reflection during the course of a film [. . .] whereas my work in the gallery solicits active reflection on the part of the viewer/reader. To take such differences into account is to pay attention to the *specificity* of the practice – that which distinguishes it from other neighbouring practices. For example, one of my constant technical concerns is with the elaboration of forms of language adapted to the situation of reading or listening in the gallery [. . .]
>
> Now, although the words and images that make up my work are neces-sarily deployed in time, my accommodations to the indeterminacy in their viewing and reading in effect breaks up and spatializes the temporal flow – so your expression 'disassembled tableau' may fit my work quite well.

I would like to end with some questions on a more institutional topic. You have recently spoken of art departments that share 'a history of research initiatives'.[25] *By this, you seem to imply that the new 'art-as-research' initiatives popping up in these departments are in fact not so new at all. To what extent can you agree with the assertion one often hears that it is Conceptual Art that provided the fundamental impetus to the research-based developments that have now become* bon ton *not only inside of many art departments but increasingly also in the broader artistic discourse? Are there, according to you, other historical elements that are perhaps more easily overlooked but that should also be taken into account in order to understand the new research-related dynamics the art world experiences nowadays? Also, as you have repeatedly expressed your concern with regard to the 'universal hegemony of global capitalism, and its preferred form of political expression, neo-liberalism', do you think that the insertion of 'market values and rela-tions' into what you call the 'previously "alternative" spaces of the university and the art institu-tions' can also partly be held responsible for the developments in academia that are now more prolifically described as artistic research?*[26] *To what degree can we say that the academicization of the arts brings with it a new logic of financial gain for institutions that traditionally used to cherish a nonprofit logic, parallel to and in competition with the already-existing one of the galleries?*

> In the sentence you quote from my article I am referring to those artis-tic initiatives, mainly in the 1960s, that were self-consciously associated with *scientific* research – for example, the projects undertaken by the group 'Experiments in Art and Technology' (EAT) in the US. Outside of

these initiatives the word 'research' was rarely used in art schools at that time – one was more likely to hear talk of 'creativity'. It was only when I began to teach in a British art department in 2001 – after thirteen years in the Humanities at the University of California – that I encountered such expressions as 'research-led practice', 'practice-led research', 'practice-as-research', 'research-artist' and so on. In the interim, the terminological shift from 'creativity' to 'research' had been brought about by political and economic necessity rather than intellectual self-searching. [. . .] In the 1970s the previously autonomous 'colleges of art' were incorporated into newly formed multi-disciplinary 'polytechnics' that from 1992, under Margaret Thatcher, were rebranded as 'universities'. In order to receive government funding, art departments then had to meet the same kinds of criteria that were applied to the assessment of other university departments – with quantity and quality of research foremost amongst these. It was then that, somewhat in the manner of Molière's Monsieur Jourdain, the former art schools found they had been doing 'research' all their lives. What you call the 'academicization' of the arts would have been anathema to the old art schools, where the reigning ethos was rigorously anti-intellectual – I think of the painter Barnett Newman's remark that philosophical aesthetics, to him, was what ornithology must be to a bird. The drive of successive British governments for standardization and centralized control of the universities not only imposed fundamentally alien and incompatible academic practices on the old art schools but, more perniciously, also undermined the very meaning and culture of research in the universities – so that in the same historical moment when the art schools were entering the university research environment, this environment itself was radically changing. When I first started teaching in the UK the art colleges and universities were under the 'Ministry for Education and Science'; they are now administered by the 'Department for Business, Innovation and Skills'. I am speaking of the British example, but there are comparable tendencies throughout Europe, such as the 'Bologna Process' initiative to establish a 'European Area of Higher Education' – an intellectual equivalent of the common market which appears to have much the same economic-instrumental values and goals. In Britain, a government-appointed body has recently set out a 'Research Excellence Framework' for the assessment and funding of research that makes short-term 'outcome' in terms of demonstrable 'impact' on society the primary funding criterion: in the various sciences, 'impact' will mean measurable technological and economic benefits; in the arts and humanities it can only mean measurably visible publicity and entertainment value – assessment of this will inevitably defer to the media. In fact, for some long time now the art world and art departments have provided media-ready art much as supermarkets provide oven-ready chickens. The mainstream media has become increasingly populist over the last quarter-century or more, a process that was at first commented on, to again take the British example, in frequent references to the 'dumbing down' of the 'quality' press – now a *fait accompli* that no one mentions any longer. This consequence of the political demagogy of the Thatcher–Blair

years was accompanied by a new demagogic spirit in art – incarnated most visibly by Charles Saatchi and his protégés – and a corresponding mutation in the audience for art. The art world congratulates itself on the fact that art today has a larger audience than at any time in its history – but this is simply an epiphenomenon of the increasing mediatization of art. As the saying goes, 'we get the art we deserve', and it is increasingly apparent that we will get the universities we deserve too. The meanings and aims of both art and academic research are being harmonized with those of ordinary democratic non-elitist common sense. I met a routine manifestation of this the other day when I went into my local organic food store to buy sweet potatoes. I had bought some there the previous week, and they had been labelled with Spain as their country of origin. I picked up a couple of them and took them to the counter, but I noticed that the label was gone. I asked the woman behind the counter if these sweet potatoes were also from Spain. 'They're from Israel', she said. 'Then I don't want them', I replied. 'Oh', she said, 'the farmers are not the government. They just want to make money, like the rest of us'. She said this in a tone and with an expression that made it clear she believed she had made an argument to which there was no possible reply – and in fact it left me speechless. She spoke exactly as she might have if she had said: 'They just want peace, liberty and happiness, like the rest of us'. How could I argue? To 'make money' is our fundamental desire and inalienable right, it guarantees our common humanity, it's what joins each atomic individual to 'the rest of us' – what hope is there for either art or the university if this mind-set prevails?

Original publication

'Conversation with Hilde Van Gelder' in *Parallel Texts: Interviews and Interventions about Art* (2011).

Notes

1 V. Burgin, "Photographic Practice and Art Theory" (1975), in V. Burgin (ed.), *Thinking Photography* (London: MacMillan, 1982), 81.
2 Id., "Photography, Phantasy, Function" (1980), Ibid., 214.
3 Ibid., 214.
4 V. Burgin, "Modernism in the Work of Art" (1976), in A. Streitberger (ed.), *Photographie moderne / Modernité photographique* (Brussels: SIC, 2008),120.
5 V. Burgin, *The End of Art Theory: Criticism and Postmodernity* (London and Basingstoke: Macmillan Press; New Jersey: Humanities Press International, 1986), viii.
6 B. H. D. Buchloh, "Allan Sekula: Photography between Discourse and Document", *Fish Story. Allan Sekula* (Rotterdam: Witte de With, 1995), 196.
7 V. Burgin, *In / Different Spaces: Place and Memory in Visual Culture* (Berkeley and Los Angeles: University of California Press, 1987), 56. See also A. Streitberger, "Questions to Victor Burgin", A. Streitberger (ed.), *Situational Aesthetics. Selected Writings by Victor Burgin* (Leuven: University Press Leuven, 2009), 109-110.

8 Id., "Diderot, Barthes, Vertigo", A. Streitberger, J. Donald and C. Kaplan (eds.), *Formations of Fantasy* (London and New York: Methuen, 1986), 105.

9 V. Burgin, *Components of a Practice* (Milan: Skira, 2008), 80.

10 J. Rancière, *The Politics of Aesthetics*, trans. G. Rockhill (London, New York: Continuum, 2004), 60.

11 Id., "Evolution", Ibid., 43.

12 Id., "Ideology", Ibid., 85.

13 V. Burgin, "*Une note sur Hôtel D*", 2009, unpublished essay.

14 Id., *The Remembered Film* (London: Reaktion Books, 2004), 27.

15 A. Streitberger, "Questions to Victor Burgin," *Situational Aesthetics*, 268.

16 V. Burgin, *Components of a Practice*, 50.

17 Interview with Tony Godfrey recorded in 1979, published in *Block* 7, 1982; reprinted in V. Burgin, *Between* (London: Blackwell/ICA, 1986), 39.

18 H. Van Gelder, "A Matter of Cleaning up: Treating History in the Work of Allan Sekula and Jeff Wall", *History of Photography*, 31: 1 (Spring 2007), 76.

19 V. Burgin, "*Une note sur Hôtel D*".

20 Ph. Dubois, "L'événement et la structure. Le montage de temps hétérogènes dans l'oeuvre de Victor Burgin", in N. Boulouch, V. Mavridorakis and D. Perreau, *Victor Burgin. Objets temporels* (Rennes: Presses universitaires de Rennes, 2007), 77.

21 V. Burgin, *In/Different Spaces*, 56.

22 Id., "*Une note sur Hôtel D*".

23 Id., *Components of a Practice*, 90.

24 Ibid., 91.

25 B.H.D. Buchloh and A. Sekula, "Conversation between Allan Sekula and B.H.D. Buchloh" in S. Breitwieser (ed.) *Allan Sekula. Performance under Working Conditions*. (Vienna: Generali Foundation, 2003), 25.

26 V. Burgin, *Between*, 40; V. Burgin, "Thoughts on "Research" Degrees in Visual Arts Departments", in J. Elkins (ed.) *Artists with PhDs. On the New Doctoral Degree in Studio Art* (Washington, DC: New Academia Publishing, 2009), 72.

PART FIVE

Documentary

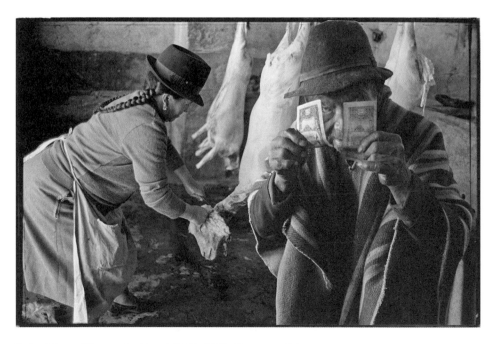

Pedro Meyer, *Where is the Money?* 1985–2000. Courtesy of the artist.

Introduction

PEDRO MEYER'S IMAGE, 'Where is the Money?', is a digital composite of two photographs, both taken at the same time and place in Ecuador. The background image of the woman with the dead sheep was turned round in order to synthesise the direction of light within the picture and make space for the man with the money (Meyer 2000). So is this a documentary image? Meyer argues that it is, in that it draws information together to make a point, just as journalists draw upon notes and interviews in order to weave a story, and documentary film-makers utilise narrative conventions and editing processes. Debates about documentary and photojournalism regularly return to questions of authenticity. Yet arguably, in considering the status of photographs as documents, the fundamental issues are ethical, relating primarily not to questions of naturalistic accuracy, but to seriousness of purpose, detail and depth of research, and to integrity of story-telling.

The term 'documentary' was coined by Scottish film-maker, John Grierson, in 1926, to designate work based upon the 'creative interpretation of reality'. However, documentary-style street photography dates from the mid-1860s (for instance, Thomas Annan in Glasgow, John Thomson in London, Jacob Riis in New York). Experiments in half-tone printing of photographs, thereby allowing their mass circulation in 'illustrated' magazines, also date from the late nineteenth century. Sylvia Harvey suggests that, historically, documentary – as opposed to news – was not popular in Britain. Generally, it was photographers from the middle and upper classes who sought images of the poor for purposes which included curiosity, philanthropy and sociology, but also policing and social control (Harvey 1986: 28). Likewise John Tagg has argued:

> Though an honorific culture continued, in which it was a privilege to be looked at and pictured, its representations were institutionally and economically separated from instrumental archives in which the production of normative typologies was joined to the tasks of surveillance, record, and control. To be pictured here was not an honor, but a mark of subjugation: the stigma of another place; the burden of a class of fetishized Others; scrutinized, pathologized, and trained, forced to show but not to speak, cut off from the powers and pleasures of producing and possessing meaning, fashioned and consumed in . . . a cycle of derision and desire.
>
> (Tagg 1988: 11–12)

Arguably, the documentary movements of the 1930s in Britain and the USA (e.g. Humphrey Spender, Mass Observation and Walker Evans, Dorothea Lange of the Farm Security Administration (FSA)) were characterised by paternalism which, despite the veneer of liberalism, is equally stigmatic. Yet the 1930s also witnessed radical film and photography workshops (fostered by the communist parties in Britain and North America) which portrayed events and social circumstances from working-class experience. In other words, in assessing particular projects we need to take into account underlying purposes and attitudes.

It is difficult now to imagine a world without images of different, often distant, places. But, as Giselle Freund has remarked:

> Before the first press pictures, the ordinary man [sic] could visualize only those events that took place near him, on his street, or in his village. . . . The faces of public personalities became familiar and things that happened all over the globe were his to share. As the reader's outlook expanded, the world began to shrink.
>
> (Freund 1980: 103)

Photographic documents, whether botanical illustrations, architectural pictures, portraits or landscapes allowed our predecessors to see something about people or places that they had not directly experienced. This is absolutely commonplace nowadays, but imagine the excitement of viewing the first ever photographs depicting distant places or people unknown to them! Yet, as Susan Sontag has commented, photographs give us an *unearned* sense of familiarity with and knowledge about the world (Sontag 1979). In fact, images may tell us very little about the cultural circumstances and complexities of life as lived elsewhere.

Photographs reflect particular points of view and sets of attitudes. In photojournalism, subject-matter and photographic coding intersect with broader sets of codes and conventions associated with news publications (see Hall 1973). They are subject to the social and political practices of news production and circulation. The idea of documentary attracted much critical debate in the 1970s and 1980s. This stemmed in part from concern with the politics of representation, and, as Sarah Kember (see Chapter 33) reminds us, in part from more abstract philosophical debates through which the Cartesian distinction between subject and object, viewer and viewed, was challenged. These strands of debate came together to undermine the twin bases of documentary, namely, the idea of documentary 'truth' and the notion of the neutrality of the observer. The photographer as observer had been seen as the framer and taker of the image, with creativity in photography reliant on recognising 'telling' moments. French photographer, Cartier-Bresson, famously emphasised the 'decisive moment' when aesthetic composition and subject matter come together. But Bill Jay has remarked on the willingness of photographers to abandon 'good behavior' for the sake of a picture, remarking that 'this image of the photographer/aggressor is inescapable in the fictional characters of photographers in short stories and novels' (Jay 1984: 8). Indeed, as Susan Sontag observed, the terminology of photography is analogous to that of the military: 'load', 'aim', 'shoot' (Sontag 1979: 14). In the 1970s, images were interrogated in terms of the context of making, the intentions and power of the photographer, and how meaning shifts as photographs become variously recontextualised. Questions were raised as to who got to photograph whom, in what circumstances, in what ways, why and for what purposes?

One consequence of such concerns was a burgeoning number of books and exhibitions exploring the lives of the working people in order to expose and question taken-for-granted social histories. Such projects inter-linked with work by feminists

and radical labour historians and, slightly later, those involved in postcolonial stud-ies. Here, archive photographs, including family albums, were seen as sources of information or taken as evidence of ways of life; as well as becoming interrogated as particular types of documents whose origins lay in specific class relations. Pho-tography projects were set up to encourage people to explore and document their own locality and social relations; such projects often inter-connected with local oral history projects. In this context, photography workshops were intended not only to assert alternative stories/histories (in terms of class, locality, gender, ethnicity) but also to empower people as makers of images.

The first three essays included here interrogate ways in which photographs are used as evidence, and question documentary attitudes and practices. John Tagg draws attention to uses of images as documents within government disciplinary systems. In the 1980s, increasing attention was paid to Michel Foucault's research on ways in which the organisation of ideas or systems or things (for instance, build-ings, such as prisons; the writing of history; knowledge hierarchies) reflects author-ity and power relations. Archives of photographs thus can be seen as systems begging analysis. Tagg's essay argues that photography as such has no identity but is formed through the play of various discourses. It was first published in the British journal *Ten.8* in 1984, then an emerging focus for critical discussions of photography and of the 'politics of representation'. Arguing that documentary pho-tography contributes to how we understand social values and identities in our own culture and that of others, Darren Newbury explores ways in which working-class life in Britain towards the end of the twentieth century was depicted, like Tagg, arguing that photographs demonstrate a range of differing perspectives on social circumstances that contribute and compete within the broad realm of visual cultural representation.

Likewise, but from an American perspective, in an essay first published in 1981, Martha Rosler discusses the power relations which characterise documen-tary, arguing that photographs of the poor and the dispossessed are framed by a liberal rhetoric and morality which stands in place of political activism; furthermore, that photos – aestheticised and marketable – have become a part of the genre of documentary, rather than a part of a politics. Political concerns about America's role in Vietnam, along with the civil rights movement and the women's movement, had contributed a radical edge to debates about representation and participation in decision-making processes; this in turn influenced critical debates about the photograph and the attitudes, role and responsibilities of the photographer. Lisa Henderson directly addresses questions of accountability. Her study was con-ceived in the tradition of the 'anthropology of visual communication': the situation and responsibilities of the photographer were analysed in terms of social interac-tion, and of attitudes expressed by photographers (interviewed during her research when she was an MA student). It is suggested that the exploitative relation between subject and photographer is consequent not only on class relations but also on the structures and contexts of image publishing.

Given digital media and the sheer mass of images that we encounter as a con-stituent element of daily experience, from billboards to Instagrams, from broadcast

media to Facebook, arguably there has been a loss of trust in photographs and a shift in ways in which we respond to them, consciously and unconsciously. Although images have always been manipulated through framing, depth of field lending emphasis to particular elements, tonal contrast, cropping and so on, digital manipulation facilitates speedy alteration. What then is the status of photographs as evidential documents now. Addressing the loss of the real, Sarah Kember critiques positivism and scientific rationality as key theoretical positions underpinning emphasis on the photograph as 'truth' and asks what is at stake in investment in photographic realism. (This essay was first published in the mid-1990s when debates about the nature of the digital and its impact upon photographic practices were central.) Van Gelder and Baetens shift the terms of this debate by enquiring into 'critical realism', a term that references the work of the playwright, Bertholt Brecht, whose aim was to induce people to reflect not on what they see, but on the circumstances and power relations underlying surface appearances (also see Roberts 1998; Sekula 2000).

Lynn Berger reflects on amateur photography, taking the assumption that they are somehow more authentic than pictures made by professionals as a starting point for considering the import of vernacular imagery. Through her investigation of anonymous photos, exhibited or brought together in albums, she suggests that snapshot style lends credulity, by contrast with an increasing scepticism towards professional news and commercial institutions. Nonetheless, culturally situated processes of interpretation outweigh questions of veracity – it is not what is seen but what is learnt from what has been depicted that matters. Finally, Edmundo Desnoes considers images of Central America. The essay was first published in 1985 in a collection concerned with meaning, semiotic systems and the materiality of signs. In that context it stood as an example of the value of semiotics in decoding the photographic image, taking into account first-world presumptions and third-world perspectives. In this context, a discussion of the status of photographs as evidential documents, it is included to indicate ways in which pictures reinforce currencies of ideas, regularly repeated, albeit articulated slightly differently in various spheres of practice from travel photography to art practices, from advertising and fashion to photojournalism and documentary. Now, we might also consider how the changing political relationship between Cuba and America influences our response to Desnoes article written over thirty years ago and, of course, whether and how this might influence readings of the images.

References and selected further reading

Freund, G. (1980) *Photography and Society*. London: Gordon Fraser. Originally published in French, 1974. Part 2 includes a critical history of press photography.

Hall, S. (1973) 'The Determinations of News Photographs', in Stanley Cohen and Jock Young (eds.) *The Manufacture of News*. London: Constable. Detailed discussion of decoding, meaning and contexts.

Harvey, S. (1986) 'Who Wants to Know What and Why? – Some Problems for Documentary in the 80s', *Ten.8* No. 23, pp. 26–31.

Jay, B. (1984) 'The Photographer as Aggressor', in David Featherstone (ed.) *Observations*. Carmel: Friends of Photography.

Meyer, P. (2000) 'Redefining Documentary Practice', in *Zonezero*. www.zonezero.com/ editorial, 4 February 2001.

Roberts, J. (1998) *The Art of Interruption*. Manchester: Manchester University Press. On twentieth-century theory, photography, art, realism and the everyday within which the realist dimension of the photograph is reclaimed despite the recent critique of positivism.

Sekula, A. (2000) *Photography Against the Grain*. London: MACK. Originally published, 1984. Halifax, Nova Scotia: The Press of Nova Scotia College of Art and Design. Collection of his essays variously discussing realism, photography, the collection and the circulation of images.

Sontag, S. (1979) *On Photography*. Harmondsworth: Penguin.

Tagg, J. (1988) 'The Proof of the Picture', *Afterimage*, 15:6, pp. 11–13.

Bibliography of essays in part five

Berger, L. (2009) 'The Authentic Amateur and the Democracy of Collecting Photographs', *Photography and Culture*, 2:1, March, pp. 31–50.

Desnoes, E. (1995) 'Cuba Made Me So', in Marshall Blonsky (ed.) *On Signs*. Oxford: Basil Blackwell.

Henderson, L. (1988) 'Access and Consent in Public Photography', in Larry Gross, John Stuart Katz and Jay Ruby (eds.) *Image Ethics*. New York and Oxford: Oxford University Press.

Hilde Van Gelder and Jan Baetens (2010) 'A Note on Critical Realism Today', in Hilde Van Gelder and J. Baetens (eds.) *Critical Realism in Contemporary Art*. Leuvan, Belgium: Leuvan University Press.

Kember, S. (1996) 'The Shadow of the Object': Photography and Realism', *Textual Practice*, 10:1, London: Routledge, pp. 145–163. Reprinted as Chapter 1 of her book, *Virtual Anxiety, Photography, New Technologies and Subjectivity*. Manchester University Press, 1998.

Newbury, D. (1999) 'Photography and the Visualisation of Working Class Lives in Britain', *Visual Anthropology Review*, 15:1, Spring–Summer, pp. 21–44.

Rosler, M. (1989) 'In, Around, and Afterthoughts (on Documentary Photography)', in Richard Bolton (ed.) *The Contest of Meaning*. Cambridge, MA: MIT Press. First published, 1981, in Martha Rosler, *3 works*. Halifax: The Press of the Nova Scotia College of Art and Design.

Tagg, J. (1988) 'Evidence, Truth and Order: Photographic Records and the Growth of the State', Chapter 2 of his *The Burden of Representation*. London: Macmillan. First published, 1984, as 'The Burden of Representation: Photography and the Growth of the State', *Ten:8*.

John Tagg

EVIDENCE, TRUTH AND ORDER
Photographic records and the growth of the state

IN THE LAST QUARTER of the nineteenth century, the photographic industries of France, Britain and America, in common with other sectors of the capitalist economy, underwent a second technical revolution which laid the basis for a major transition towards a structure dominated by large-scale corporate monopolies. The development of faster dry plates and flexible film and the mass production of simple and convenient photographic equipment opened up new consumer markets and accelerated the growth of an advanced industrial organisation. At the same time, the invention of means of cheap and unlimited photomechanical reproduction transformed the status and economy of image-making methods as dramatically as had the invention of the paper negative by Fox Talbot half a century earlier. In the context of generally changing patterns of production and consumption, photography was poised for a new phase of expansion into advertising, journalism and the domestic market. It was also open to a whole range of scientific and technical applications and supplied a ready instrumentation to a number of reformed or emerging medical, legal and municipal apparatuses in which photographs functioned as a means of record and a source of evidence. Understanding the role of photography in the documentary practices of these institutions means retracing the history of a far from self-evident set of beliefs and assertions about the nature and status of the photograph, and of signification generally, which were articulated into a wider range of techniques and procedures for extracting and evaluating 'truth' in discourse. Such techniques were themselves evolved and embodied in institutional practices central to the governmental strategy of capitalist states whose consolidation demanded the establishment of a new 'regime of truth' and a new 'regime of sense'. What gave photography its power to evoke a truth was not only the privilege attached to mechanical means in industrial societies, but also its mobilisation within the emerging apparatuses of a new and more penetrating form of the state.

At the very time of photography's technical development, the functions of the state were expanding and diversifying in forms that were both more visible and more rigorous. The historical roots of this process, however, go back fifty years across a

period which coincides exactly with the development and dispersal of photographic technology, especially in Britain and France. Here, the reconstruction of social order in the period following the economic crises and revolutionary upheavals of the late 1840s depended, in different ways, on a bolstering of state power which in turn rested on a condensation of social forces. At the expense of an exclusive political rule which they could not sustain, the economically dominant industrial and financial middle classes of both countries entered into a system of political alliances with older, contending class fractions which stabilised the social conflicts that had threatened to destroy the conditions in which capitalist production could expand and diversify. These increasingly integrated, though continually modified, governing blocs dominated national political life and thus the expanding machinery of the centralised state. This great bureaucratic and military machine may have appeared to stand to one side, but it secured capitalism's conditions of existence, not only by intervention but precisely by displacing the antagonisms of contending class fractions and appearing to float above sectional concerns and represent the general or national interest.

At the local level, however, and especially within the expanding industrialised urban areas, the dominance of industrial capital and its allied mercantile and intellectual strata was more explicit and less subject to compromise. Here, too, an increasingly secure middle-class cultural domination was cashed at the level of more diffuse practices and institutions which were nonetheless crucial to the reproduction and reconstruction of social relations. This more general hegemony was, by stages, secured and made effective through a constellation of regulatory and disciplinary apparatuses, staffed by newly professionalised functionaries, and subjected to a centralised municipal control. The pressing problem, locally and generally, was how to train and mobilise a diversified workforce while instilling docility and practices of social obedience within the dangerously large urban concentrations which advanced industrialisation necessitated. The problem was solved by more and more extensive interventions in the daily life of the working class within and without the workplace, through a growing complex of medical, educational, sanitary and engineering departments which subsumed older institutions and began to take over the work of private and philanthropic agencies. Force was not, of course, absent. Local police forces and the administrative arms of the Poor Law were of central importance to the emerging local state, but even these could not operate by coercion alone. They depended on a more general organisation of consent, on disciplinary techniques and a moral supervision which, at a highly localised and domestic level, secured the complex social relations of domination and subordination on which the reproduction of capital depended. In a tightening knot, the local state pulled together the instrumentalities of repression and surveillance, the scientific claims of social engineering, and the humanistic rhetoric of social reform.

By the closing decades of the century, bourgeois hegemony in the economic, political and cultural spheres seemed beyond all challenge. In the midst of economic depression, the break up of liberalism and the revival of independent working-class movements, the apparatuses of the extended state provided the means of containing and negotiating change within the limits of democratic constitutionalism, even while the state itself took on an increasingly monolithic and intrusive form, liable to panic and periodic relapse into directly repressive measures. But such relapses cannot belie the important fact that a crucial shift had taken place. In the course of a profound economic and social transformation, the exercise of power in advanced capitalist societies

had been radically restructured. The explicit, dramatic and total power of the absolute monarch had given place to what Michel Foucault has called a diffuse and pervasive 'microphysics of power', operating unremarked in the smallest duties and gestures of everyday life. The seat of this capillary power was a new 'technology': that constellation of institutions – including the hospital, the asylum, the school, the prison, the police force – whose disciplinary methods and techniques of regulated examination produced, trained and positioned a hierarchy of docile social subjects in the form required by the capitalist division of labour for the orderly conduct of social and economic life. At the same time, the power transmitted in the unremitting surveillance of these new, disciplinary institutions generated a new kind of knowledge of the very subjects they produced; a knowledge which, in turn, engendered new effects of power and which was preserved in a proliferating system of documentation – of which photographic records were only a part.

The conditions were in play for a striking *rendezvous* – the consequences of which we are still living – between a novel form of the state and a new and developing technology of knowledge. A key to this technology from the 1870s on was photography, and it is into the workings of the expanded state complex that we must pursue it, if we are to understand the power that began to accrue to photography in the last quarter of the nineteenth century. It is in the emergence, too, of new institutions of knowledge that we must seek the mechanism which could enable photography to function, in certain contexts, as a kind of proof, even while an ideological contradiction was negotiated so that a burgeoning photographic industry could be divided between the domain of artistic property, whose privilege, resting on copyright protection, was a function of its lack of power, and the scientifico-technical domain, whose power was a function of its renunciation of privilege. What we begin to see is the emergence of a modern photographic economy in which the so-called medium of photography has no meaning outside its historical specifications. What alone unites the diversity of sites in which photography operates is the social formation itself: the specific historical spaces for representation and practice which it constitutes. Photography as such has no identity. Its status as a technology varies with the power relations which invest it. Its nature as a practice depends on the institutions and agents which define it and set it to work. Its function as a mode of cultural production is tied to definite conditions of existence, and its products are meaningful and legible only within the particular currencies they have. Its history has no unity. It is a flickering across a field of institutional spaces. It is this field we must study, not photography as such.

Like the state, the camera is never neutral. The representations it produces are highly coded, and the power it wields is never its own. As a means of record, it arrives on the scene vested with a particular authority to arrest, picture and transform daily life; a power to see and record; a power of surveillance that effects a complete reversal of the political axis of representation which has confused so many labourist historians. This is not the power of the camera but the power of the apparatuses of the local state which deploy it and guarantee the authority of the images it constructs to stand as evidence or register a truth. If, in the last decades of the nineteenth century, the squalid slum displaces the country seat and the 'abnormal' physiognomies of patient and prisoner displace the pedigreed features of the aristocracy, then their presence in representation is no longer a mark of celebration but a burden of subjection. A vast and repetitive archive of images is accumulated in which the smallest deviations may be

noted, classified and filed. The format varies hardly at all. There are bodies and spaces. The bodies – workers, vagrants, criminals, patients, the insane, the poor, the colonised races – are taken one by one: isolated in a shallow, contained space; turned full face and subjected to an unreturnable gaze; illuminated, focused, measured, numbered and named; forced to yield to the minute scrutiny of gestures and features. Each device is the trace of a wordless power, replicated in countless images, whenever the photographer prepares an exposure, in a police cell, prison, mission house, hospital, asylum, or school. The spaces, too – uncharted territories, frontier lands, urban ghettos, working-class slums, scenes of crime – are confronted with the same frontality and measured against an ideal space: a clear space, a healthy space, a space of unobstructed lines of sight, open to vision and supervision; a desirable space in which bodies will be changed into disease-free, orderly, docile and disciplined subjects; a space, in Foucault's sense, of a new strategy of power-knowledge. For this is what is at stake in missionary explorations, in urban clearance, sanitary reform and health supervision, in constant regularised policing – and in the photography which furnished them from the start with so central a technique.

These are the strands of a ravelled history tying photography to the state. They have to do not with the 'externals' of photography, as modernists would have us believe, but with the very conditions which furnish the materials, codes and strategies of photographic images, the terms of their legibility, and the range and limits of their effectiveness. Histories are not backdrops to set off the performance of images. They are scored into the paltry paper signs, in what they do and do not do, in what they encompass and exclude, in the ways they open on to or resist a repertoire of uses in which they can be meaningful and productive. Photographs are never 'evidence' of history; they are themselves the historical. [. . .]

From this point of view, exhibitions such as *The British Worker*, must appear not only incoherent but entirely misleading in their purpose, eliding as they do the complex differences between the images they assemble – between their contrasting purposes and uses, between the diverse institutions within which they were made and set to work, between their different currencies which must be plotted and mapped.[1] The notion of evidence on which *The British Worker* rests can never be taken as given. It has itself a history. And the ways in which photography has been historically implicated in the technology of power-knowledge of which the procedures of evidence are part, must themselves be the objects of study.

Original publication

'Evidence, Truth and Order: Photographic Records and the Growth of the State' reprinted in *The Burden of Representation: Essays on Histories and Photographies* (1988).

Note

1 The British Worker: Photographs of Working Life 1839–1939 (London: Arts Council of Great Britain, 1981). The catalogue accompanying the exhibition includes an introduction, catalogue notes and biographies of 48 identified photographers by Colin Osman, and an essay on 'Working Life in Britain 1839–1939' by David Englander.

Darren Newbury[1]

PHOTOGRAPHY AND THE VISUALIZATION OF WORKING-CLASS LIVES IN BRITAIN

Looking at working-class lives

WORKING-CLASS LIVES have been of continual interest to middle and upper class audiences since at least the nineteenth century. Photographic representations of working-class life have an equally long history, doing justice to which would take considerably more space than is available to me in this paper. It is important however to recognize that the images I intend to discuss can be situated in a historical context. Indeed, it is part of my argument that photographic representations can only really be understood in relation to other representations, both those that serve as historical points of reference and those that occupy the same contemporary cultural space. Photographic representations both draw from and contribute to a social and cultural imagery that is part of a broader public dialogue about society. Documentary photography becomes part of the way in which societies inform themselves about their own identities and values and those of other cultures and societies.

The practical focus of this paper is photographic representations of working-class life in Britain, primarily from the mid-1970s to the early 1990s, though some reference will be made to earlier work. Aside from its intrinsic interest, this focus is valuable for the opportunity it provides to explore a number of theoretical issues. Although there are significant variations across the different examples I will discuss, there are also a range of common concerns. First, social and cultural reference is fundamental to an understanding of the works discussed here. The photographers are quite consciously concerned with representing historically and culturally specific ways of life. For most of the examples, this places the images firmly within a national context and an explicit politics of representation. Some of the work discussed here shares a common aim with what Clifford refers to as "salvage ethnography" (cited in Stanley 1998: 16), to save both visually, and literally in some cases (through a belief that images will change the minds of politicians), communities that are about to disappear. Konttinen's *Byker* for example, can be seen as one of a number of photographic studies of

the impact of urban renewal in Britain in the wake of the 1954 Housing Act (Jobling 1993). Ironically, the threat to communities and traditional ways of life is no longer industrialization but its dissipation in a post-industrial era:

> Any documentary project is, in the end, about memory. The creative drive of independent photography during the second half of this century has been sparked by a painful sense of the disappearance of communities. There has been a race to record them and their ways of life before and in the process of a destruction that can only be described as wilful.
>
> (Side 1995: 6)

Second, there are a number of methodological commitments made by the photographers that draw upon anthropological paradigms. Most straightforwardly, much of the work depends on the kind of long-term engagement that is typical of ethnographic fieldwork. The validity claims of documentary are often supported by a discussion of the makers' sustained engagement and understanding of the subject. For example, Sirkka-Liisa Konttinen's documentary photographic study of the North East community at Byker (Konttinen 1988) is based on several years of living and photographing in the area.[2] There are of course some interesting counter examples. Despite the influence of anthropology,[3] Humphrey Spender's photographic documentation of Bolton as part of the Mass Observation project in Britain in the 1930s was based on as little as five or six visits to the town, each lasting not much more than a week at the most.[4] Spender himself has commented at length on his position as a stranger on such photographic expeditions, and the recurrent social awkwardness of his photographic encounters. Furthermore, a number of the more recent photographers discussed are recording

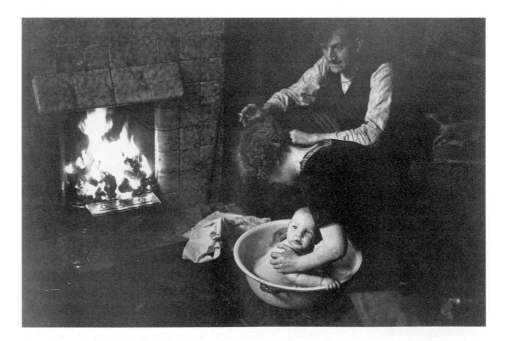

Figure 30.1 Humphrey Spender, *Baby Getting a Bath*, 1937. Courtesy of the artist's estate.

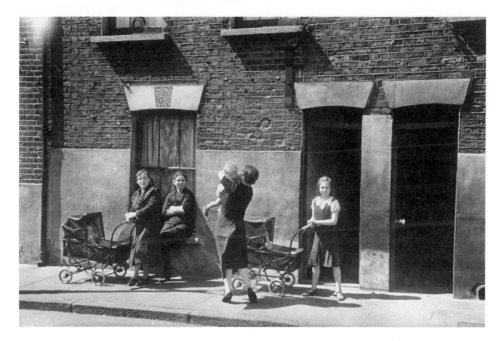

Figure 30.2 Humphrey Spender, *London, Stepney*, 1934. Taken for probation services and magistrate Sir William Clarke-Hall. Courtesy of the artist's estate.

their own communities and lives. This reflects, more or less consciously depending on the particular example, a questioning of the legitimacy of the conventional approach to documentary fieldwork in which there is a clear demarcation between those being looked at and those doing the looking; though most of the examples discussed here retain a strong commitment to realism, to the notion that it is possible to represent other people's lives and that there is some value in doing so. In some respects, then, the work can be considered as insider accounts or forms of indigenous ethnography.

Humphrey Spender

These two images are from Spender's Mass Observation work in Bolton and are reproduced in Spender and Mulford 1982 under the category "Work". The categorization in the 1982 publication follows to some extent the categorization used in the 1975 publication, though it is much less journalistic both in the section titles and in the visual style; "It was a lovely funeral" becomes "Funeral", "The Local" becomes "Drinking". Perhaps unsurprisingly, the most recent major publication of Spender's images (Frizzell 1997) recontextualises the images again; in this case structuring them chronologically, and by implication placing Spender's development as an artist centrally.

The latter image is the only domestic interior in the Mass Observation work and was the result of a request from someone working for Mass Observation rather than being initiated by the photographer. Spender had previously photographed successfully in the home of a family in Stepney, to provide evidence of living conditions for

a probation officer. He describes his approach then as one of spending many days with the family in order to make his presence as unobtrusive as possible (Spender and Mulford 1982: 16). However, Tom Harrisson's preference for a methodology of covert observation precluded Spender producing many such images in the work for Mass Observation.

The period is of particular interest for two reasons. First, it represents a period of political and social change and a restructuring of class relations in Britain. In the early seventies working-class institutions such as the trade unions represented a powerful political force, and, for working-class men at least, images of manual labour often had a powerful and celebratory appeal. This would not be the case for long.[5] In the 1990s images of working-class life have been predominantly seen as negative and often associated with the past. Successive British Prime Ministers (Conservative and Labor) have declared the end of class conflict, cementing its current unfashionability as a critical category in the discussion of contemporary life. What is interesting when one looks across the documentary photographic work of the period is a shift from an explicitly politicized representation of class that characterized some of the work in the early 1970s, for example work associated with the early *Camerawork*, towards a more cultural rendering of working-class life. The vision embodied in the work of Paul Trevor, Nicholas Battye and Chris Steele-Perkins in *Survival Programmes* arguably has more of the desperate tone of nineteenth century social explorers to it, than any sense of class transformation, ending as it does in an apocalyptic series of images of street conflict across the United Kingdom. Nevertheless, it attempts to offer in visual form an analysis of working-class poverty as the product of capitalist economic relations: "Documentary photographers have traditionally been concerned with 'the human condition'. But to document a condition is not to explain it. The condition is a symptom, not a cause; more precisely, it is the outcome of a process. Therefore, in the way we present the material in this book we are as much concerned to indicate processes as to record conditions" (Exit 1982: 7).[6] Later work, for example Tom Wood's documentary account of bus travel in Liverpool, records in increasingly close detail the texture of working-class life (Wood 1998). There has also been a notable shift during this period away from working-class life as a subject for documentary practice. The notion of a consumer society became central to public debate in Britain during the 1980s, which has meant that what is seen as culturally salient subject matter for the documentary photographer has tended to move, with some notable exceptions, towards those who have the resources to participate most actively. Associated with the change in the focus of concern for documentary is the break in the link between photographic documentary and social democratic politics established in the postwar period, and evident most clearly on the pages of *Picture Post*, within which the display of poverty was viewed as a step towards building a consensus for social and welfare reform (cf. Hall 1972).

The period is interesting in terms of the development of a relatively autonomous photographic culture that both sustained and justified a documentary practice. This was a result of two main factors, the decision in the early 1970s of the Arts Council of Great Britain to begin supporting photography as an art form, and the establishment of a relatively secure base for photography in higher education. Up until that point documentary photography was either synonymous with photojournalism, Humphrey Spender, for example, does not distinguish between photojournalism and documentary,[7] or was sustained as a semi-amateur activity, for example Margaret Monck's

work in the East End of London, Shirley Baker's work in Salford or Jimmy Forsyth's documentation of the area around Scotswood Road in Newcastle (Forsyth 1986). The work of Euan Duff is of some significance in this respect as he was a photographer who sought to work in a sustained documentary mode as opposed to the shorter term commitment involved in photojournalism, where he began his career. Duff published a book length study of life in 1960s Britain (Duff 1971), pointedly titled *How we are,* and also collaborated with sociologist Dennis Marsden on a study of unemployment (Marsden 1975).[8] Although, Duff continued to photograph during the period in which he worked in photographic higher education, very little of this work has been published or exhibited.

The commitment over this period to publishing documentary photographs in book form, often supported financially by the British Arts Council, has contributed to the dissemination of this work and its value as a public resource of social and cultural memory. It is interesting that the institutional success of photography has also led to a greater emphasis on the individual practitioners. One of the problems, as Becker (1986) would recognize, of discussing these photographers within a sociological or anthropological context is that it is more often to the institutions of the photographic art world that they look for validation, than the academy of social science.

While I am writing from a British context it is also important to realize that many of the images discussed have also been circulated internationally. As a British understanding of what the 1930s depression in the United States looked like has been informed by the photographic work of the Farm Security Administration, so an international view of British working-class life in the 1980s has, for those without any other experience to rely upon, been interpreted through the images of Nick Waplington, Chris Killip and others.[9]

In order to focus my discussion of photographic work in this period, I want to consider two particular moments. First, the emergence of a collaborative and sustained approach to documentary practice in the 1970s. In particular I want to consider the body of work that was developed around the Amber/Side group in Newcastle. Second, I want to consider how and why the visual concerns and the approach of photographers to the documentation of working-class life appeared to shift away from this position during the 1980s.

A collaborative documentary practice in the North East of England

In 1968 a group of documentary filmmakers and photographers at the Central London Polytechnic came together to form the Amber Associates. The formation of a collective was motivated by the desire to carry on working collaboratively, and importantly to work outside of the mainstream film industry, once they finished studying. A central aim of the group was to develop a film and photographic practice amongst working-class communities in the North East of England.[10] For a number of the group the move to Newcastle-upon-Tyne, an industrial city in the North East, was a return home, for others the appeal was perhaps more symbolic. Sirkka-Liisa Konttinen, a member of the group originally from Finland, makes the following observation: "The choice of a northern working-class city was for most of our members a way of returning to their

own roots – for the others the North East held a warm attraction, which led to a lasting commitment to the region" (Konttinen 1989: 5).

Central to the photographic work of Amber was the Side Gallery opened in Newcastle in 1977. The gallery came out of the Amber group's frustration with the lack of venues in which to exhibit the kind of work that they were producing, and as a way of bringing photography to the region which they otherwise would not have the opportunity to see.[11] Chris Killip, although not formally part of the Amber collective, also became involved in the running of the gallery. Killip came into contact with the group during his time in the North East working on a fellowship funded by the Northern Arts and the Northern Gas Board, and developed a close working relationship with the group during this period. Killip had already published a documentary study of the Isle of Man, and been funded by the Arts Council of Great Britain to work on a project documenting British cities. The approach to the gallery, as articulated by Killip and Murray Martin (a founder member of Amber), was informed by a commitment to the communities of the region both as a subject and audience of visual work. The gallery also sought to place the regionally based documentary work in the context of a history of socially engaged photographic practice. This was signalled by the choice of the work of American social reform photographer Lewis Hine for the first exhibition, accompanied by a publication based on the layout of the popular national newspaper, the *Daily Mirror*.[12] The vision was of a gallery that was both populist and interventionist, with a program that was of direct relevance to the area, at the same time as fostering international connections. As early as 1974 ("The River Project"), and before Killip's involvement, the Amber group had begun commissioning artists, writers and photographers to work on documentary projects. Once the gallery was established, the raising of funding to commission photographers to document aspects of the region, and the development of a photographic archive, became an important part of the work.[13] Unlike some community based photographic practices that were being developed at the time, such as those discussed by De Cuyper (1997), the work at "Side was not primarily about putting cameras in the hands of ordinary community members, though it did promote the work of local photographers. The practice was one of professional image-makers developing work in dialogue with communities. At the time, and since, this has opened the work to criticism in the context of a politics of representation that questioned the voyeurism of documentary photography in general.

The aims of the group of photographers and filmmakers that constituted Amber/ Side can be understood as involving both a methodological commitment to develop visual work out of a sustained local engagement – "Our initial ambition as filmmaker and photographers to work collectively and produce documents of working-class life in the region, involving long-term relationships with local communities, has remained constant" (Side 1995) – and a political commitment to the representation of the everyday and ordinary in the lives of working-class communities.

Methodologically, the work depended on a long-term involvement with the people and communities represented. Tish Murtha, one of the photographers commissioned by Side Gallery, made a series of images of unemployed youth in the west end of Newcastle – "her angry photographs of young people on early youth employment schemes involve some members of her own family" (Side 1995).[14] Konttinen had lived in Byker for two years before she began photographing there, and continued to live there until the street she lived in was demolished as part of the urban renewal

process that she was documenting. The documentary film *Seacoal* produced by Amber Associates was the outcome of two years spent with the seacoaling community at Lynemouth, also photographed by Killip. This does not mean of course that access to those communities was unproblematic, or that the work produced was appreciated or even welcomed by members of those communities. Killip's access to the seacoaling community where he photographed in the early 1980s was the result of serendipity rather than any recognition of value in what he was doing by those who he wanted to photograph. As Killip recounts the story, he had tried several times to photograph on the beaches but had always been chased away by the men there. Understandably, Killip's presence was perceived as unwelcome surveillance and the fact that many of the men were claiming social security benefits meant that the circulation of photographic images was a genuine threat. It was only when one of the men recognized him from a previous meeting at a fair, and agreed to take responsibility for him on the beach that he was able to photograph in safety.[15]

The commitment involved in the work extended beyond the use of images as an adjunct to political campaigns, say for better housing, such as those of photographers involved in projects in Merseyside (Bootle *Art in Action*) and London (*Camerawork*). Within individual photographic studies, as well as reading across the work as a whole, one is offered a vision of the integrity of working-class communities and ways of life; the images are not simply about people as victims of poverty: "The irony of Chris Killip's seacoal photographs being used nationally, to illustrate poverty in the UK, shows metropolitan culture's inability to read some of this work. They are images of capitalism in the raw, of a kind of freedom at the edges of our civilization, but they are not about poverty" (Side 1995: 5). As a consequence of this kind of commitment there is in much of the work produced by this loose association of photographers an interest in an aesthetics of social and cultural life. This is expressed in different ways, for example the work of Chris Killip (1988) represents a significant attempt to produce a kind of monumental imagery of Northern working-class life. Sirkka-Liisa Konttinen on the other hand explores a quieter aesthetic, exemplified in her study of a dancing school in North Shields, an aesthetic respite from everyday existence, published as *Step by Step* (Konttinen 1989). As in the earlier *Byker* there is a concern to document cultural aspects of the environment in which people lived.

Konttinen's *Byker* is a complex piece of work combining both images and text, and followed by a film produced by Konttinen in the same year as the book was first published. The 115 images that make up the main part of the book are accompanied by three kinds of text: an introduction that reflects on the photographer's entry into and relationship with the community; a postscript that reflects on the impact of the redevelopment; and interspersed with the photographs are quotations taken from conversations that Konttinen had heard and recorded during the many years that she lived in the area.[16]

The two images that mark the entry into, and exit from, the main sequence are tightly framed photographs of the Byker rooftops, the former showing the old rows of terraces, and the latter the rooftops of the new developed Byker. The viewer is invited to reflect on the patterns of life that the book reveals existed in the old Byker, and by implication to speculate on the new patterns that are being established in the wake of redevelopment. The photographs are a mixture of formal portraits as well as more informal documentary images taken in the streets, homes and community spaces in the

area. Several of the images record interiors, drawing attention to the ways in which the occupants had humanized and personalized their rooms with photographs and other artefacts. A number of these images also make reference to imaginative worlds beyond the harsh realities of daily existence. Many of the images represent spaces of leisure: men racing pigeons, young people playing pool, the bookmakers, the bingo hall. There are very few images of men working, though a number show women working (cleaning the step, the wash-house, the hairdressers). The book seems to alternate between suggesting a way of life which is receding – the sequencing is punctuated by wider street images, which, as one moves through the book, show their gradual demolition – and bringing the viewer up close to the day to day life of the people who live in Byker, whose existence should not be ignored, and which is presented with a strong sense of its integrity. This is not to say that the image of working-class life presented is a uniform one, as Jobling notes the photographs can be read in a number of ways: "In attempting to decode these images, we become aware of the heterogeneity of working-class culture and of the plurality of life-styles embraced by it. Konttinen's photographs teem not only with the signifiers of the popular tastes of the time and place, the clashing patterns of ornate carpets and wallpaper for instance, but are also revealing barometers of social class and status" (Jobling 1993: 257). However, the sense of the integrity and validity of a way of life is clearly important to Konttinen's view of the work and its audiences; she quotes scathingly a Newcastle city planning officer, who describes the value of redevelopment as a means of breaking up communities of which he does not approve. Importantly, though Konttinen was not just presenting her view of the way of life of the people of Byker for future town planners and others who had no understanding of the area, but also for the people of Byker themselves: "people did believe

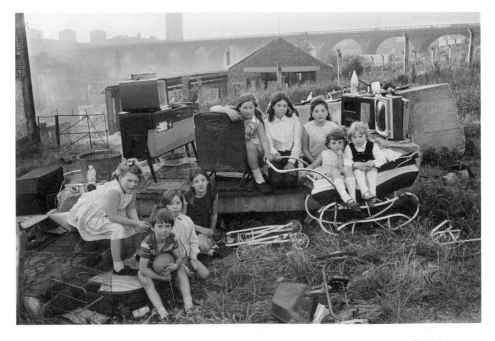

Figure 30.3 Sirkka-Liisa Konttinen, *Kids with junk near Byker Bridge*, 1971. © Sirkka-Liisa Konttinen, Courtesy L. Parker Stephenson Photographs, NYC and Amber.

what I was doing and that I was doing it, not as a service to the community as such but as a way of trying to understand how the community works and eventually trying to return that statement to them, which I promised to do in the form of a book" (Martin 1983: 1160). Photographs from the project are now on permanent exhibition in Byker.

The photographic work of Chris Killip, as opposed to his involvement in the Side Gallery, is interesting for the way in which it moves away from the kinds of methodological commitments of the Amber/Side group and towards a greater emphasis on developing an aesthetics of working-class life in the North of England. Killip was not formally a part of the Amber collective, and in terms of his practice placed a greater emphasis on his own personal and artistic vision. Nevertheless, the work demands to be taken seriously as it provides some of the most powerful and widely disseminated visual records of working-class life in this period. Although he worked on sustained documentary projects, Killip also brought to the work a particular kind of visual sensibility, which demands further interrogation. Killip was born and grew up on the Isle of Man and after working in London for a while returned to the Isle of Man to begin his first major documentary project. Between 1968 and 1972 he produced the photographic work there which was eventually published in book form. It is in the connections between the Isle of Man work and his later documentation in England that one finds a key to Killip's visual imagination. Killip's photographic work in the Northern coastal communities of Askam and Skinningrove, although at one level the documentation of particular lives, can also be understood as an attempt to place those represented

Figure 30.4 Sirkka-Liisa Konttinen, *Living Room of Harry and Bella Burness, Raby Street*, 1975. © Sirkka-Liisa Konttinen, Courtesy L. Parker Stephenson Photographs, NYC and Amber.

within a personal vision. In the communities of the North East Killip saw immigrant workers brought in to work in steel through industrialization, but with backgrounds in fishing and agriculture which they were able to sustain. Arguably they provided a link to a pre-industrial past, and also a link with his own background in the peasant culture of the Isle of Man – "my work in England is mixed up with those changes". Killip understood his work as a way of trying to "open a dialogue with that history".[17]

For Killip industrialization is perceived as a negative force cutting people off from the past – "for me there is very little . . . difference between a coal mine, a steel mine and the Pirelli factory, they're all pretty awful . . . the rough end of industrial production" – whereas ironically for many of the documentary photographers in the North, and in fact in the working-class political struggles of the 1980s, it was the very communities and patterns of life created by industrialization that were under threat and in need of political support and cultural articulation.

Exit photography group

Exit consisted of three photographers, Chris Steele-Perkins, Chris Battye and Paul Trevor. In the publication that came out of the work made during the mid to late seventies, which included transcribed interviews as well as photographs (Exit 1982), individual photographs were not attributed: "our responsibility throughout has been for the work as a whole" (p. 7). Trevor recalls that they looked at the model of shooting scripts used by the US Farm Security Administration when planning the work, though in actual fact the photographers worked more or less individually. The images reproduced here are by Paul Trevor.

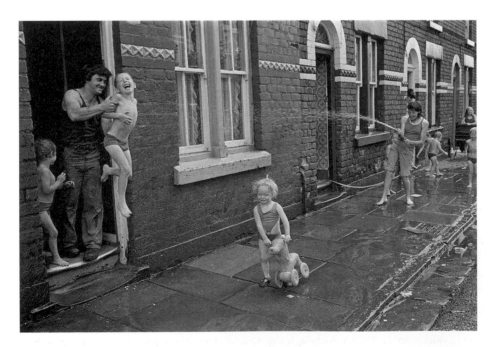

Figure 30.5 Paul Trevor, *Sunday afternoon, Mozart Street, Toxteth, Liverpool*, 1975. Paul Trevor © 2017.

Figure 30.6 Paul Trevor, *Looting, Notting Hill, London*, 1977. Paul Trevor © 2017.

One aim of the book was to make connections between the conditions in which working-class people live and wider political and economic processes. The political analysis is conveyed by the building of a visual narrative that has its climax in the images of street conflict that dominate the final section.

From workers to consumers?

In comparison with the work that originated in the 1970s, the work that began to be produced in the 1980s and early 1990s represents a significant shift, both visually and methodologically, in the representation of working-class lives. Representations of communal spaces such as the street, the pub and the workplace which had dominated many visual studies of working-class life up to that point, and still resonate in the popular symbolism of working-class life, ceased to provide the main focus for photographic documentation. Instead, there is a greater emphasis on sites of cultural consumption and the home, including in some cases the detailed recording of the everyday lives of individual families. The shift from black and white to colour is also significant. Paul Graham, who set about producing a systematic record of the interior spaces of social security offices across Britain at a time of rising unemployment (Graham 1986), recounts the responses to the use of colour: "People were shocked to see work like this made in color; 'serious' photographers used black and white and that was that. Color was seen as trivial, and it's hard now to imagine the flack it received, people thought I was taking a serious subject and trivializing it, as if color film removed any social context" (Wilson et al. 1996). Although the switch from black and white to color might at one level be considered relatively trivial, or the subject of technical determinants, I

want to argue that it was also indicative of a shift in concerns, from an explicitly politi-
cal to a cultural representation of working-class life. Rather than presenting the devel-
opment as a stylistic innovation led by particular practitioners, I would like to suggest
the emergence of the color school in British social documentary photography can be
traced back to the work in the 1970s that began to systematically record working-class
culture, and partly from the inside. Although there are clear differences in terms of
political commitment to those represented, there is a continuity of visual and cultural
concerns between the living room interiors in Konttinen's *Byker* and the collaboration
between sociologist Nicholas Barker and photographer Martin Parr (1992) to record
people in the domestic interiors they had fashioned.

The move into color arguably signalled a closer interest in the texture and aes-
thetic qualities of the living spaces of the subjects of the photographic work. Graham's
particular take on, what in photographic terms might be considered a traditional sub-
ject in the history of documentary photography, (largely male) unemployment was
very much about the environment in which this was experienced – "lemon green
walls, orange Formica benches and flickering fluorescent lights" (Graham 1986).

Similarly, it is interesting that interior decoration seems to be a consistent theme
in the reception of the work of Nick Waplington and Richard Billingham. In both cases
reviewers find the images simultaneously fascinating and repulsive, echoing responses
to visual alterity common in cross-cultural encounters: "These suffocating interiors
are not the accidental result of indifference or accumulation but, far more disturbingly,
have been created on purpose, with some care even" (Williams 1996: 31); "the interi-
ors bear all the grubby claustrophobic signs of bad British housekeeping. But Wapling-
ton isn't appalled by the overflowing ashtrays, cheap furniture, kitsch-lined shelves, and
low ceilings; indeed, it his complete lack of irony or distance from the subjects that
makes these pictures so incredibly beautiful in their frightening way" (Spring 1992:
100). What is it that the reviewer finds frightening here? That they may be seduced by
what they know by culture and education to be bad taste?

There are a number of reasons for such a shift in focus. First, as I have suggested
the emergence of the notion of consumption rather than work as the locus of cul-
tural identity became more prominent. Second, in relation to this, color photographic
imagery in advertising and elsewhere was altering the visual culture, inevitably visual
practitioners were responding to this context. Paul Trevor of the Exit group worked
in parallel on a photographic project about television ("A Love Story") which he saw
as the "flipside" to the world presented in *Survival Programmes*.[18] In methodological
terms photographic practice was also influenced by debates that questioned both the
possibility and legitimacy of representing others. The corresponding lack of faith in
narratives of political change suggested a more relativistic and increasingly circum-
scribed practice. I think it is also arguable that for the first time a significant number of
photographers were emerging who themselves came from working-class backgrounds,
and therefore had a different relation to working-class spaces than those who had gone
before, though of course this was true of some of the earlier work discussed already.

The title of Nick Waplington's first publication – *Living Room* – which has subse-
quently been taken as the title for the body of work as a whole, draws attention to the
significance of the representation of domestic space. A simple count of the photographs
confirms the dominance of interior spaces. In the fifty-eight photographs that make up
Living Room, thirty-seven are of interior spaces, another twelve depict the immediate

exterior of the houses, with the rest being made up of various photographs which sug-
gests some sense of community space, the school, the doctors, the news agent. This can
be seen as a reversal of the balance in Konttinen's *Byker*, where the interior is a second-
ary theme in relation to more public communal spaces. What Waplington offers in the
series of images is a sense of communal, shared space centered on the domestic interior.
Although in many ways this is a contemporary vision, and the specificity of the work to
time and place is important to the photographer, there is in Waplington's quotation of
earlier photographic images of working-class life (cf. *Picture Post*), a romantic reference
to a disappearing sense of community.[19] I'm thinking here particularly of the scenes in
which the street is being used as an extension of the domestic space as a place for chil-
dren to play, and adults to talk – these make up a very small, but I suggest, significant
number of images. One might compare also the opening image in *Survival Programmes*, as
a further example of this type of image used to evoke an entire view of working-class life.
Waplington makes this explicit in his introduction to the second book: "This is a large,
close-knit community; everyone takes care of everyone else and nothing is too much
trouble. At one time, there were a lot of communities like this one, but modern living no
longer allows it. Nowadays, most people seem to love being in their own personal worlds.
Thankfully that is not so everywhere". The images, then, are positioned as representing
a last bastion of communal values. It is interesting that in the context of a society that is
increasingly placing an emphasis on mobility and the ownership of the means of trans-
port, Waplington presents images of cars as things that do not work, or, in what I find one
of the most intriguing images in the series, they suggest a sense of foreboding.

A number of other photographers share this concern to record in detail domestic
spaces, including Anthony Haughey in his study – "Home" – of Catholic families in
Ireland and Richard Billingham in his study of his parents (1996).[20] All but three of
the images in *Ray's a Laugh* are taken inside Billingham's parents' flat. The three that
are taken outside – close-up images of birds – are intended no doubt to offer a kind of
visual poetic counterpoint to the interiors and the condition of the main character Ray.
Billingham offers a different view of domestic space, one that draws attention continu-
ally to the boundary between inside and out. Unlike Waplington this is not a communal
space that has a web of links to local sites, but instead is one of confinement. Several
images in the book draw our attention to the edge of the domestic space, but instead
of offering a view of outside deliberately frustrate it. As Billingham says of his father:
"If he went outside he became ill. He had a friend from a neighboring tower block –
himself an alcoholic – who came around to make strong home-brew for him. This was
much cheaper than normal beer and meant that Ray didn't have to venture outside to
the off-licence" (Billingham 1996).

One of the most striking things about the work of Waplington and Billingham is
the representation of working-class masculinity within a domestic space. Images of
working-class men have predominantly been either directly or indirectly about physi-
cal work,[21] the aesthetic possibilities inherent in black and white photography have
often been harnessed to good effect in giving expression to this view of working-class
life. It is significant that in a period in which traditional manual employment has been
in rapid decline in Britain, these two bodies of work come to prominence representing
working-class men almost without reference to work.

At first glance the photographic approach adopted by these photographers seems to
be one of extreme naturalism. Despite the intimacy of the scenes which the photographs

record, the subjects rarely appear conscious of the photographer's presence. Yet, this in itself is a kind of clue to the circumstances that surrounded the production of this work. The photographer's presence is not that of a stranger, but instead it is clear that Waplington is as at home within this environment as his subjects are at home with him. As is true of ethnographic practice generally, so with photography, the resulting image is, in part at least, dependent on the particular quality of the interaction between photographer and subject. One image shows a girl crying approaching the camera, would she approach the camera in this way if the photographer was a stranger within this context? Indeed, access to many of the scenes in the work of both photographers is highly dependent on the particular relationship between photographer and subject.

Susan Sontag's characterization of the photographer as a tourist in other people's realities (Sontag 1979) does not apply in the context of the work of Waplington, Billingham or Haughey. Billingham chose to photograph the fraught domestic life of his parents, Haughey returned to where his uncle lived in Ireland to photograph family life, motivated in part by a desire to explore his own relationship to Catholicism,[22] and Waplington's subjects could be considered as an adopted extended family with whom he clearly has a close relationship.[23] The long-term engagement on which the photographic work is based brings the work close to a form of ethnography. Harper refers to Waplington's work as a "visual ethnography of daily life" (Harper 1998: 37), however there are two distinct issues. First, the biographical link with the subjects, and second, the structuring of an approach around visual rather than textual recording. Waplington's work was the result of a methodology structured by the rhythm of his photographic practice, and in that sense is a distinct kind of ethnographic approach:

> What basically used to happen was when I first started making the pictures, I used to shoot during the day. I'd go down to the college, the technician would give me the films from the day before and I'd go and contact sheet them in the evening, then I'd go down to the Newcastle Arms have a few beers and then go home, and then in the morning I'd go back there and I'd take the contact sheets from the day before, and they'd look through them, and they actually became very good at looking at contact sheets, then the next day I'd maybe make some prints, and I used to give them prints, so by the time it came to put the book together in 1990 they were well aware of the pictures, they'd seen them at a couple of exhibitions, they had prints of all of them.

The relationship between photographer and subject raises important questions.[24] Perhaps most importantly, can this work be considered as a form of cultural self-representation? If the work does not exactly fulfil what Don Slater argues is the promise of photography, to enable people to tell their own stories (Slater 1995), then it does come close to it in an interesting way.

A brief comparison with photographic documentary from Britain in the 1930s is revealing. The seeming ease with which these photographers are able to make photographs at such close range contrasts strongly with the social awkwardness, such as that recounted by Humphrey Spender, which has accompanied many other photographic studies of working-class life. The use of photographs to document working-class life in the North of England in the 1930s was predicated on a social and hence spatial

separation between the photographer and the photographed. As Stanley points out in his study of the methods of Mass Observation:[25] "the only way to be sure that 'natives' were not acting up was to catch them about their ordinary life without their knowledge. Consequently, in the M-O records, there are almost no photographs of interiors" (Stanley 1981: 128). This social divide has visual and aesthetic consequences.

Gillian Rose, also discussing photographs of working-class life in the 1930s, though in this case from East London, directs attention to images of the street, often taken showing the houses in linear perspective, imposing a sense of visual order (Rose 1997: 283). Similarly, Rose draws attention to the way in which women can be seen standing in doorways in formal poses for the camera physically and symbolically barring entry to the home: "Documentary photography's perspective produced a viewing position that distanced the photographer (and, through him or her, their audience) from the photographed people and places" (Rose 1997: 284). As I have argued above, Waplington's use of a similar visual construction in a small number of the Living Room series photographs, both situate the work in the broader context of representations of working-class life, but also signal a break from this work.

The elision Rose makes here between the photographer and the viewer, is no doubt correct for the context about which she is writing. However, the work under discussion here evidences a more complex relationship between photographer and viewer. In these bodies of work it would be a mistake to assume that the viewer and photographer have similar relationships to the space represented. Indeed, part of the interest of the work is precisely this difference. The photographers make visually available spaces with which they have an intimate relationship, but which the viewer does not. These bodies of work are insider accounts, and not simply the result of a long-term study, made available for wider consumption.

Waplington's comment that, "For me the pictures are just a record of the great times we have together", could be made by many people talking about the purpose of keeping a family album, and this is the frame of reference which is used by the families represented: "In 1991 Living Room was published. Suddenly Janet, family and friends were in print, and we all looked at the book and laughed, and reminisced about the moments it contained. Then it was put away like any family album and saved for moments of quiet reflection". This is reinforced visually by two images in the second of the two Living Room series books, one of which shows the earlier book being viewed by a family member, and the other showing the wedding photograph used on the cover adorning the living room wall. Billingham on the other hand describes his image-making as an attempt to make sense of what was a difficult context: "I was just trying to make order out of chaos", indicating an inner psychological motivation for the work. Nevertheless, despite these caveats, it is clear that the images have been taken up and circulated in public contexts. Despite any claims to the contrary on the part of the photographers this makes them part of a public discourse on contemporary working-class life in Britain. Several commentators, including Irvine Welsh in an essay in *Weddings, Parties, Anything*, make reference to the photographs as images of poverty in post-industrial economies.

Despite the fact that *Living Room* is presented with virtually no contextualization, the work can still be considered political in its intent, though the intervention is at a broader cultural level. Although he may be open to the charge of Romanticism, Waplington was attempting to articulate a positive version of life in Margaret Thatcher's Britain for those who had been most denigrated by recent politics. The work was

deliberately and consciously against both Thatcherite values and the kind of visual representations that viewed working-class people living in a kind of low-end consumer nightmare surrounded by cheap goods and rubbish (cf. Parr 1986). The images are then both a documentary recording but also part of a visual polemic or dialogue about contemporary society. One of the mistakes of anthropological photography is the belief that the meanings of images can be restricted to the former, thereby ignoring their cultural and political import.

Towards a theory of photographic visualization

I want to conclude by drawing out a number of issues that I think are important to a theory of visualization, that is to the understanding of the making of photographic images of cultures and societies, whether by anthropologists or others. A theory of visualization, I suggest, will need to consider two principal elements: the methodological, and the aesthetic.

Methodologically the making of photographs of others can be understood as a particular kind of ethnographic engagement. It therefore requires to be understood in its own terms not merely as an adjunct to participant observation. The way in which the photographer relates to the photographed is of some considerable significance. Spender's effort to become an unobserved observer through a process of building trust and familiarity while photographing a family in Stepney in 1934, is considerably different in practical and ethical terms from the kind of covert photography he engaged in for Mass Observation, and which at times brought him into conflict with his subjects (Spender and Mulford 1982: 127). Neither is it simply a matter of being open with the camera. In relation to his images of the Jarrow Hunger Marches, some of which were published in *The Left Review*, Spender recounts the resentment of the marchers who saw an exploitative element and a lack of commitment in his joining the march ten miles outside of London.[26] Similarly, there are important ethical and moral considerations that pertain to the construction of visual accounts of culture. These might parallel those involved in the construction of ethnographic texts, but they are not the same. Visual accounts for example cannot be anonymized in the way that texts can. It is interesting that Spender's documentation of the northern industrial city of Bolton, went under the generalizing title of "Worktown". However, it is only separation in time and place of the making of the work and its publication that makes this strategy genuinely effective. The publication of photographic work closer in time and place to its origination enters the photographs into a more local politics of representation, as Spender discovered in his photographing of Tyneside for *Picture Post* when the published images were challenged as misleading by local politicians. The initial reception of Waplington's *Living Room* work in Nottingham is an example of how the representation working-class life in inner cities continues to be strongly contested. The work, which documented a particular housing estate in the city, became known at the same time as the local council were involved in trying to improve the image of the estate, in particular the reputation that had built up through the local press of the estate as an area notorious for crime and drug use. The council saw Waplington's work as reinforcing this view of the estate and commissioned a photographer to take more "positive" images in order to stage a counter exhibition.[27] Waplington is also acutely conscious

of the fact that the publication of his photographs has made the subjects vulnerable to invasions of privacy by journalists and others who have seen the work.

One also has to be aware that photographs have a particular cultural value as artefacts, independent of their place within a particular documentary study, in a way that is not equally true of ethnographic texts. Konttinen's work at Byker, for example, began with her setting up a photographic studio and taking portraits for free, "which was a further attempt to establish a relationship with the people there. The giving away of photographs was always there from the beginning as a way of saying thank you for taking people's time. . . . The photographs were appreciated and they ended up on the mantelpieces" (Martin 1983: 1160). Chris Killip offers a particularly striking example. After the drowning of a young man who had been in a boat at Skinningrove where Killip was photographing, the photographer was asked by the person's mother if he had any photographs of him. Killip replied that he did not – "I went home that night and nearly hit myself over the head with a hammer, I'd answered her in the wrong way, in the sense that did I have any pictures I was thinking of my pictures, do I have my pictures of Simon, meaning the pictures that I think are good . . . I had a lot of pictures of Simon". From his negatives Killip was able to create an album of sixty images which he gave to the mother. On two later occasions Killip also made up albums of people who died.[28] Photographic images, then, are not simply the outcome of the relationship between photographer and photographed, but also an aspect of that relationship, as objects of collaborative reflection and exchange.

In contrast to issues of methodology and the ownership and display of images, anthropologists have given relatively little attention to the visual-aesthetic aspect. The question of visual style is one that is often perceived as problematic for visual anthropology. Although photography has had a significant, if marginal, presence in anthropology, and to a lesser extent sociology; with a few notable exceptions, the work of professional image-makers has been much less discussed. One reason for this is the predominance of naturalistic modes of photographic interpretation. The photographic image is treated as unproblematic, and theoretically, if not always technically, transparent. For example, the camera is used simply as a visual notebook to record social phenomena such as gesture, dress and the organization of social space. Indeed, for the anthropologist or sociologist as photographer, professional training as an image-maker may be perceived to get in the way of rather than assist the research process, as is indicated in the title of a book by Hagaman, *How I Learned not to be a Photojournalist* (Hagaman 1996). Michael Young's discussion of Malinowski's photographic practice equates a serious ethnographic photography with a straight-on middle distance viewpoint. Having dismissed the character of Malinowski's interaction with his subjects as the reason for his photographic style, Young argues that

> The only plausible explanation is that his marked preference for the middle distance was methodologically driven, albeit of an inarticulately nature. The implication is that Malinowski invariably felt obliged to capture a background, a setting, a situation, a social context. He sought to inscribe visual clues to what he was later to define in a theoretical contribution to linguistics as "context of situation".
>
> (Young 1998: 18)

Malinowski is reproached for the consideration of formal qualities in the images, which are seen as a distraction from the true concerns of the ethnographer: "[the] photograph of juxtaposed logs and sticks of varying bulk and texture is further testimony to Malinowski's occasional surrender to an aesthetic impulse. It conveys little ethnographic information, though the inscription on the reverse dutifully appeals to realism" (Young 1998: 147). This is not a criticism of Young's analysis of Malinowski's images, but simply to wonder if in all cases the question of the visual can be dealt with so simply.

Documentary photographers are often seen to be giving greater weight to the visual at the expense of the subject. Becker argues that the conventional approach to photographic criticism is to distinguish between photographs that are informational and those that are expressive. In other words to mark the boundary between scientific and artistic photographic practices. This can be construed as an institutional problem, social scientific research demands valid representations, whereas the art world demands stylistic innovation.[29] I concur with Becker when he argues that this distinction is unhelpful to an understanding of documentary photographs, which derive at least part of their significance from their social reference; and that in any case the distinction is a false one – "every photograph has some of both, and that has consequences for the way we look at, experience, think about, and judge photographs of all kinds" (Becker 1986). However, Becker's point that the stylistic devices available to the photographer offer the means to emphasize some facts and de-emphasize others, is only the most obvious issue in relation to the visual and aesthetic.[30]

What I want to suggest here is the notion that visual representations have historical and cultural depth.[31] Killip's photograph of the Jarrow youth taken in 1976, for example, invokes through the reference to this symbolic location a whole history of working-class struggle.[32] As I hope I have demonstrated, photographs of working-class life are not transparent windows on the world, but instead are competing versions, defining themselves and being defined in relation to other visual accounts. A selection of the photographic work produced since the formation of Amber/Side was exhibited in a series of eight exhibitions that toured regional venues in 1995 and 1996, as a means to explore the significance of images of the communities' recent past in a period of redefinition. The aim of the work was described as "reflect[ing] on a past which in many cases has disappeared, yet is still uppermost in our minds when we come to define particular communities around the region. . . . The work does not lay claim to delivering some kind of definitive history of the region. Yet Side's consistent policy of documenting everyday life, the unremarkable, the non-newsworthy, does reveal a different interpretation of the history of the period to, say, that which has been generated by public relations and news organizations" (Side 1995: 2). What needs to be considered is the currency of visual representations in an increasingly professionalized image dominated society.

The historical depth of visual imagery is clearly not lost on Killip, who, when invited to return to Jarrow to photograph in 1996, deliberately worked in color in order to avoid the slippage into pastness that would arguably surround images produced in black and white. Over time the photographs and the ways of life they visualize become resources of social and cultural memory and imagination; the indexical becomes iconic.[33] The reality of the North East in the photography of Chris Killip becomes a "place of memory" (Augé 1995), perhaps an "historical fantasy",[34] at least for viewers who have no other knowledge of, or connection with, the region.

In his paper "In Search of a Social Aesthetic" MacDougall draws attention to the importance of the aesthetic dimension of everyday life. A social aesthetic, he argues, consists of a complex of interrelated elements, in the example he gives of the life of a particular school in Northern India, "such things as the design of buildings and grounds, the use of clothing and color, the rules of dormitory life, the organization of students' time, particular styles of speech and gesture, and all the rituals of everyday life" (Mac-Dougall 1999). For my purposes here, while I want to retain something of the notion of a social aesthetic as MacDougall describes it — it is, I believe, central to the concerns of the photographic practices I have been discussing here — I also want to draw attention to the further visual aesthetic layer that inevitably mediates any attempt to represent the texture of social and cultural life in a medium such as photography. Visual anthropology should consider both aspects: the visual and aesthetic dimension in everyday life; and the ways in which everyday life has been visualized through photography.[35]

What I want to argue is that those concerned with the visual representation of cultures must make two kinds of commitment. First, a methodological commitment to understand the cultures in which they work. This is a commitment from which no anthropologist is likely to dissent. Second, they must also seek to understand the complexity of the visual domain into which their work is entered. The complex mediascape of competing images of cultures and societies cannot be ignored. Although it would be an extreme position to argue that cultures exist only through their visualization, it is certainly true that the majority rely on visual images for their knowledge of other cultures, and that therefore those images have real effects in the world. The reproducibility and circulation of images of other people has profound moral and ethical implications, with which visual anthropologists have necessarily to engage.

Acknowledgments

My thanks to: Bolton Museum and Art Gallery for permission to reproduce two of Humphrey Spender's photographs from the Mass Observation collection; the Hulton Getty Picture Collection for permission to reproduce one Spender photograph from the Picture Post Collection; the photographers, Paul Graham, Sirkka-Liisa Konttinen, Humphrey Spender, Paul Trevor and Nick Waplington for permission to reproduce images from their work and for kindly providing prints and slides from which to do so; Murray Martin for taking time to read a draft of the paper and discussing with me the history of Side Gallery; Rob Perks and the staff of the National Sound Archive at the British Library for their assistance in making use of the Oral History of British Photography collection; Humphrey Spender for granting permission to listen to his interview in the OHBP collection; Marie Jefsioutine for assisting me in scanning the images for publication; and finally to J. David Sapir and the reviewers at *VAR* for their assistance in preparing this article.

Note on illustrations

The images reproduced here inevitably represent only a small fraction of the work that is discussed, and for that reason I would suggest that interested readers look to the

published books cited in the paper. However, two omissions warrant brief comment. Both Richard Billingham and Chris Killip declined permission to reproduce any of their photographs to accompany this article. Billingham felt that he did not want to be associated with the other photographers referenced in the article, and wanted to down play the representational and documentary aspects of the work. In my view this is a naïve perspective on how the work can be understood, and the historical contexts and practices upon which it depends for its effectiveness. It is also perhaps, slightly disingenuous particularly given that his book was edited by Julian Germain, a photographer whose own work has been about the post-industrial North, and Michael Collins, formerly a picture editor with a national newspaper magazine. Killip's reasons I think are similar, though he declined to articulate them. Although he worked closely with Amber/Side for a period during the late seventies and early eighties, he has since deliberately distanced himself from the Amber/Side group and their approach to photography, preferring to cultivate a more individualistic perception of his own artistic purpose.

Original publication

'Photography and the Visualisation of Working Class Lives in Britain' in *Visual Anthropology Review*, volume 15, issue l (1999).

Notes

1 Darren Newbury is currently research co-ordinator for visual communication at Birmingham Institute of Art and Design, University of Central England. He completed his PhD on the theory and practice of photographic education in 1995, and has published in the areas of photographic education, research education and training and visual research.

2 "Sirkka-Liisa Konttinen lived in the old Byker area of Newcastle for six years and photographed it for twelve", (back cover, Konttinen 1988).

3 Tom Harrisson who set up the Mass Observation project of which Spender became a part was an anthropologist, and Mass Observation had as an advisor Bronislaw Malinowski. Malinowski also contributed an essay to the M-O publication *First Year's Work*. Spender recalls attending a course given by Raymond Firth in preparation for another of Harrisson's planned projects, though this project was never actually carried out.

4 Humphrey Spender interviewed by Grace Robertson, 1992, Oral History of British Photography Collection, National Sound Archive, British Library. There is a lack of clarity on exactly how long Spender spent photographing in Bolton for Mass Observation, elsewhere himself giving varying accounts (see Taylor 1994).

5 For a discussion of the nostalgic reinvestment in this type of image in the 1990s see Taylor and Jamieson (1997).

6 According to Paul Trevor it was the political nature of the work that led many national venues to decline the opportunity to show the Exit photographic work, though arguably it was as much if not more to do with the changing concerns of photographic galleries since the original production of the work. As Val Williams suggests in her interview with Trevor, and as has been pointed out by one of the reviewers of this paper, the work was probably seen as representing a period in British photography that had been left behind (Paul Trevor interviewed by Val Williams, 1991, Oral History of British Photography Collection). The Side Gallery in Newcastle was one of the few galleries willing to show the work and now holds the material as one of the collections in the Amber/Side archive.

7 This question was put to Spender directly in an interview by Grace Robertson. However, although Spender did not make this distinction he did make a different kind of distinction in respect of some of his photographic work. Spender talks about his three unpaid jobs — coverage of the Jarrow marches, the photographs in Stepney for the probation officer Clemence Paine, and the work for Mass Observation — as linked to his left-wing political stance. The fact that they are unpaid is what marks them out, ironically, as Spender was well aware, it was his private income and class position that allowed him to do work unpaid. It is not unfair to say that he saw this as an indication of his commitment, though he is also aware of its role in appeasing his conscience. Humphrey Spender interviewed by Grace Robertson, 1992, Oral History of British Photography Collection.

8 The photographs were dropped from the revised edition published in 1982 by Croom Helm.

9 For a discussion of the American view of British social documentary from the 1980s see Kismaric (1990). (The exhibition brought together the work of Chris Killip, Graham Smith, John Davies, Martin Parr and Paul Graham.)

10 The group is still based and working actively in Newcastle, with a number of its original members remaining, including photographer Sirkka-Liisa Konttinen. A current collaborative project looks at the impact of the demise of the mining industry on communities in the Durham Coalfield area.

11 "During the early seventies the photographers within Amber felt an acute need to create a gallery (Side) in order to exhibit their own work, and to be able to see and show the best of international work. This was at a time when there were no galleries in Newcastle showing photography" (personal communication, Murray Martin, March 2000).

12 Ron McCormick was the initial choice of the group to run the gallery, and he played an important part in raising funding. However, partly perhaps because he did not share the same ideological and political commitments to the use of photography as Amber/ Side, he only lasted six months. McCormick was followed by Murray Martin (one of the founder members of Amber Associates) for a period of two years and then by Killip for about the same length of time. The philosophy of the group was to have a practitioner-led exhibition space, hence the relatively short periods that individuals ran the gallery, and decisions were made collectively by the gallery team. This account is based on the Killip interview held at the National Sound Archive (Chris Killip interviewed by Mark Haworth-Booth, 1997, Oral History of British Photography Collection) and personal communication with Murray Martin, March 2000. Killip offers a more individualistic account of the work of the gallery, and in particular his role, whereas Martin argues that the gallery, like all the practical work at Amber, was never the responsibility of any one individual but instead was a collective enterprise. According to Martin, it was he, rather than Killip, who did most of the commissioning during this early period, though with Killip playing a strongly influential advisory role.

13 The current archive database lists 191 separate holdings with a varying number of prints in each. The majority of the holdings, though certainly not all, are bodies of work concerning the region. Personal communication, Richard Grassick, Side Gallery, November 1999.

14 Side (1995) wrongly attributes these images as being taken in Scotswood. Personal communication with the photographer, March 2000.

15 Chris Killip interviewed by Mark Haworth-Booth, 1997, Oral History of British Photography Collection.

16 The latter texts emphasize the North East accent and vernacular, which I think reads very differently now than it would have done when the book was first produced.

17 Chris Killip interviewed by Mark Haworth-Booth, 1997, Oral History of British Photography Collection. The work of Graham Smith another photographer who worked with Amber/Side, and with whom Killip collaborated on the 'Another Country' exhibition in

1985, is also worth considering here, and should be part of any extended study of this period.

18 Paul Trevor interviewed by Val Williams, 1991, Oral History of British Photography Collection.

19 Although Waplington noted that there was no deliberate intention to make visual reference in the way I suggest, he did make the following comment on the street image with the child in the bath: "I almost didn't use that because I thought it was too traditional in its structure" (Nick Waplington interviewed by the author 2/6/98).

20 My comments here refer to the construction of the book which it has been suggested to me was as much the work of Michael Collins and Julian Germain (Billingham's college tutor) as it was the work of Billingham himself.

21 Paul Graham's book *Beyond Caring* (Graham 1986) which records the scenes inside numerous social security waiting rooms perhaps signals the endpoint of this type of photography in the context of contemporary Britain.

22 Anthony Haughey interviewed by Val Williams, 1994, Oral History of British Photography Collection.

23 Waplington first began to photograph the two families soon after he came to Nottingham, where he already had family connections, to study photography at Trent Polytechnic: "What actually happened was that I was photographing my grandfather and Dawn, one of the ladies in the *Living Room* book, used to collect his pension for me, and I was photographing my grandfather in his house, and she came round. So she walked into the situation where I was photographing, I didn't walk into her house with a camera. She came with her kids and I was photographing him and they wanted their pictures taken, and she just said why don't you come round and take pictures at our house, take some pictures of the kids for me. I knew her husband anyway, and I'd been going round to their house to watch football on Sunday afternoons, I just hadn't taken my camera. So I tried it one Sunday, I took my camera with me and I took a particular picture which ended up in the *Living Room* book, which at that particular stage was by far and away the most interesting and the best picture I'd ever taken" (Nick Waplington interviewed by the author 2/6/98). Although the *Living Room* work was begun while Waplington was at college, it now represents a body of work developed over more than ten years.

24 This could be referred to as "consent through habituation. Not only do the subjects know they are being photographed, they get to see how they are being photographed" (Nick Stanley 1998, personal communication).

25 Photography made a small but significant contribution to the methods of the Mass Observation movement in Britain (see Stanley 1981).

26 Humphrey Spender interviewed by Grace Robertson, 1992, Oral History of British Photography Collection. Jarrow, a former shipbuilding and coalmining town on Tyneside, lent its name to the hunger marches that took place during the economic depression of the 1930s when the unemployed from across Britain walked to London to demand the right to work.

27 Nick Waplington interviewed by the author 2/6/98.

28 Chris Killip interviewed by Mark Haworth-Booth, 1997, Oral History of British Photography Collection.

29 Tagg (1988) discusses the institutional separation of these two dominant "photographies".

30 There is in Becker's argument an implicit structuralist theory of photography underlying his view that angle of view, focus, etc. can be combined by the photographer to create or emphasize meaning.

31 This notion is developed from Foster in his paper on the borrowings from anthropology in recent art practice (Foster 1995, 1996).

32 See note 25.

33 One might consider as analogous developments, the emergence in recent years of an increasing number of working-class heritage sites, for example around mining communities, which both visualize and perform the "nearly past" (Stanley 1998).

34 This interpretation of Killip's *In Flagrante* was suggested to me in an interview with photographer Nick Waplington. Waplington made the following comments: "*In Flagrante* is a very strong book, but I just think that he was too tied up in Paul Strand and the historical references to Paul Strand, and I feel that because of that he made very quantifiable decisions to cut out things within the frame of the images that actually pin those images down to the time in which the pictures were taken, therefore he was producing a sort of historical fantasy book, and therefore even though some of those pictures are extremely strong and extremely powerful, as a work as a whole I think it's a very poor interpretation of the eighties" (Nick Waplington interviewed by the author 2/6/98).

35 An extended development of MacDougall's views on social aesthetics appear on pp. 3–20 of the original publication of this article.

References

Augé, M. 1995 *Non-Places: An Introduction to an Anthropology of Supermodernity*. London: Verso.

Becker, H. 1986 Aesthetics and Truth. In *Doing Things Together*. Evanston: Northwestern University Press, pp. 293–301 [Available at www.sscf.ucsb.edu/~hbecker/truth.html]

Billingham, R. 1996 *Ray's a Laugh*. Zürich: Scalo Press.

De Cuyper, S. 1997 On the Future of Photographic Representation in Anthropology: Lessons From the Practice of Community Photography in Britain. *Visual Anthropology Review* 13(2): 2–18.

Duff, E. 1971 *How We Are*. London: Allen Lane.

Edwards, E. 1997 Beyond the Boundary: A Consideration of the Expressive in Photography and Anthropology. In *Rethinking Visual Anthropology*. Banks, M. and Morphy, H. (eds.). New Haven: Yale University Press.

Exit Photography Group 1982 *Survival Programmes in Britain's Inner Cities*. Milton Keynes: Open University Press.

Forsyth, J. 1986 *Scotswood Road*. Newcastle: Bloodaxe Books.

Foster, H. 1995 The Artist as Ethnographer? In *The Traffic in Culture: Refiguring Art and Anthropology*. Marcus, G.E. and Myers, F.R. (eds.). Berkeley: University of California Press.

———— 1996 *The Return of the Real: The Avant-Garde at the End of the Century*. London: MIT Press.

Frizzell, D. 1997 *Humphrey Spender's Humanist Landscapes: Photo-Documents, 1932–1942*. New Haven: Yale Center for British Art.

Graham, P. 1986 *Beyond Caring*. London: Grey Editions.

Hagaman, D. 1996 *How I Learned Not to Be a Photojournalist*. Lexington: University Press of Kentucky.

Hall, S. 1972 *The Social Eye of Picture Post*. Working Papers in Cultural Studies 2. Birmingham: Centre for Contemporary Cultural Studies.

Harper, D. 1998 An Argument for Visual Sociology. In *Image-based Research: A Sourcebook for Qualitative Researchers*. Prosser, J. (ed.). London: Falmer Press.

Jobling, P. 1993 Sirkka-Liisa Konttinen: The Meaning of Urban Culture in Byker. *History of Photography* 17(3): 253–62.

Killip, C. 1988 *In Flagrante*. London: Secker & Warburg.

Kismaric, S. 1990 *British Photography From the Thatcher Years*. New York: Museum of Modern Art.

Konttinen, S. 1988 *Byker*. Newcastle: Bloodaxe Books in association with AmberSide.
———— 1989 *Step by Step*. Newcastle: Bloodaxe Books and AmberSide.
MacDougall, D. 1999 In Search of a Social Aesthetic. In *Sights —Visual Anthropology Forum* [Available at http://cc.joensuu.fi/sights/david.htm. Accessed 2nd June 1999].
Marsden, D. 1975 *Workless: An Exploration of the Social Contract Between Society and the Worker*. London: Penguin.
Martin, M. 1983 Interview With Sirkka-Liisa Konttinen. *Creative Camera* 227: 1154–63.
Parr, M. 1986 *The Last Resort: Photographs of New Brighton*. Wallasey: Promenade Press.
Parr, M. and Barker, N. 1992 *Signs of the Times: A Portrait of the Nation's Tastes*. Manchester: Cornerhouse Publications.
Rose, G. 1997 Engendering the Slum: Photography in East London in the 1930s. *Gender, Place and Culture* 4(3): 277–300.
Side Gallery 1995 *Unremembered Lives: North East Communities and the Documentary Photographer*. Newcastle: Side Gallery.
Slater, D. 1995 Domestic Photography and Digital Culture. In *The Photograph in Digital Culture*. Lister, M. (ed.). London: Routledge.
Sontag, S. 1979 *On Photography*. London: Penguin.
Spender, H. 1975 *Britain in the Thirties. London: The Lion and Unicorn Press in Association With the Mass Observation Archive* (Introduction and commentary by Tom Harrisson).
Spender, H. and Mulford, J. 1982 *Worktown People: Photographs From Northern England 1937–38*. Bristol: Falling Wall Press.
Spring, J. 1992 Nick Waplington. *Artforum* 30(January): 100–1.
Stanley, N. 1981 *"The Extra Dimension": A Study and Assessment of the Methods Employed By Mass-Observation in Its First Period, 1937–40*. PhD thesis, Birmingham Polytechnic.
———— 1998 *Being Ourselves for You: The Global Display of Cultures*. London: Middlesex University Press.
Tagg, J. 1988 *The Burden of Representation: Essays on Photographies and Histories*. London: Macmillan.
Taylor, I. and Jamieson, R. 1997 "Proper Little Mesters": Nostalgia and Protest Masculinity in De-industrialised Sheffield. In *Imagining Cities: Scripts, Signs, Memory*. Westwood, S. and Williams, J. (eds.). London: Routledge.
Taylor, J. 1994 *A Dream of England: Landscape, Photography and the Tourist's Imagination*. Manchester University Press.
Waplington, N. 1991 *Living Room*. Manchester: Cornerhouse Publications (in association with Aperture).
———— 1996 *Weddings, Parties, Anything*. New York: Aperture Foundation.
Williams, G. 1996 Richard Billingham. *Art Monthly* 199(September): 31–2.
Wilson, A., Wearing, G. and Squiers, C. 1996 *Paul Graham*. London: Phaidon Press.
Wood, T. 1998 *All Zones Off Peak*. Stockport: Dewi Lewis Publishing.
Young, M. 1998 *Malinowski's Kiriwina: Fieldwork Photography 1915–1918*. Chicago: University of Chicago Press.

Martha Rosler[1]

IN, AROUND, AND AFTERTHOUGHTS (ON DOCUMENTARY PHOTOGRAPHY)

I

T HE BOWERY, in New York, is an archetypal skid row. It has been much pho-
tographed, in works veering between outraged moral sensitivity and sheer slum-
ming spectacle. Why is the Bowery so magnetic to documentarians? It is no longer
possible to evoke the camouflaging impulses to "help" drunks and down-and-outers or
"expose" their dangerous existence.

How can we deal with documentary photography itself as a photographic prac-
tice? What remains of it? We must begin with it as a historical phenomenon, a practice
with a past. Documentary photography[2] has come to represent the social conscience
of liberal sensibility presented in visual imagery (though its roots are somewhat more
diverse and include the "artless" control motives of police record keeping and sur-
veillance). Photo documentary as a public genre had its moment in the ideological
climate of developing State liberalism and the attendant reform movements of the
early-twentieth-century Progressive Era in the United States and withered along with
the New Deal consensus sometime after the Second World War. Documentary, with
its original muckraking associations, preceded the myth of journalistic objectivity and
was partly strangled by it. We can reconstruct a past for documentary within which
photographs of the Bowery might have been part of the aggressive insistence on the
tangible reality of generalized poverty and despair – of enforced social marginality
and finally outright social uselessness. An insistence, further, that the ordered world of
business-as-usual take account of that reality behind those images newly seen, a reality
newly elevated into consideration simply by *being photographed* and thus exemplified
and made concrete.

In *The Making of an American*, Jacob Riis wrote:

We used to go in the small hours of the morning to the worst tene-
ments . . . and the sights I saw there gripped my heart until I felt that I

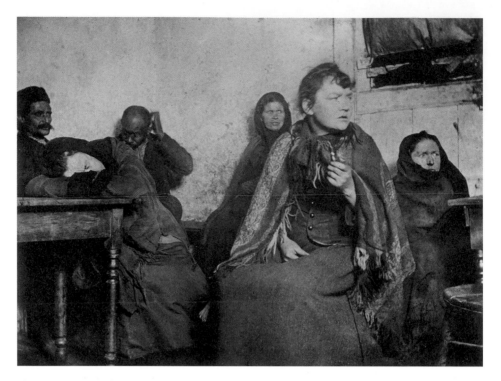

Figure 31.1 Jacob Riis, *Hell on Earth,* 1903. Riis commented: "One night, when I went through one of the worst dives I ever knew, my camera caught and held this scene . . . When I look upon that unhappy girl's face, I think that the Grace of God can reach that 'last woman' in her sins; but what about the man who made profit upon the slum that gave her up to the street?" From "The Peril and Preservation of the Home," in Jacob Riis, photographer and Citizen, ed. Alexander Alland Sr. (Millerton, NY, Aperture, 1974). Courtesy of Preus Museum.

must tell of them, or burst, or turn anarchist, or something. . . . I wrote, but it seemed to make no impression. One morning, scanning my newspaper at the breakfast table, I put it down with an outcry that startled my wife, sitting opposite. There it was, the thing I had been looking for all those years. A four-line dispatch from somewhere in Germany, if I remember right, had it all. A way had been discovered, it ran, to take pictures by flashlight. The darkest corner might be photographed that way.[3]

In contrast to the pure sensationalism of much of the journalistic attention to working-class, immigrant, and slum life, the meliorism of Riis, Lewis Hine, and others involved in social work propagandizing argued, through the presentation of images combined with other forms of discourse, for the rectification of wrongs. It did not perceive those wrongs as fundamental to the social system that tolerated them — the assumption that they were tolerated rather than *bred* marks a basic fallacy of social work. Reformers like Riis and Margaret Sanger[4] strongly appealed to the worry that the ravages of poverty — crime, immorality, prostitution, disease, radicalism — would threaten the health and security of polite society as well as to sympathy for the poor, and their appeals were

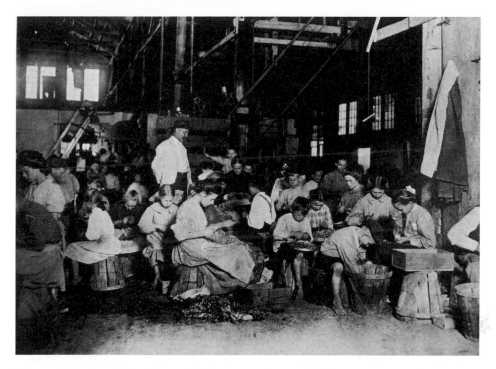

Figure 31.2 Lewis Hine, *Cannery Workers Preparing Beans*, c. 1910. From Maerica and Lewis Hine: Photographs 1904–1940 (Millerton, NY: Aperture, 1977). © Alamy.

often meant to awaken the self-interest of the privileged. The notion of charity fiercely argued for far outweighs any call for self-help. Charity is an argument for the preservation of wealth, and reformist documentary (like the appeal for free and compulsory education) represented an argument within a class about the need to give a little in order to mollify the dangerous classes below, an argument embedded in a matrix of Christian ethics.

Documentary photography has been much more comfortable in the company of moralism than wedded to a rhetoric or program of revolutionary politics. Even the bulk of work of the U.S. version of the (Workers') Film and Photo League[5] of the Depression era shared in the muted rhetoric of the popular front. Yet the force of documentary surely derives in part from the fact that the images might be more decisively unsettling than the arguments enveloping them. Arguments for reform – threatening to the social order as they might seem to the unconvinced – must have come as a relief from the potential arguments embedded in the images: With the manifold possibilities for radical demands that photos of poverty and degradation suggest, any coherent argument for reform is ultimately both polite and negotiable. Odious, perhaps, but manageable; it is, after all, social *discourse*. As such, these arguments were surrounded and institutionalized into the very structures of government; the newly created institutions, however, began to prove their inadequacy – even to their own limited purpose – almost as soon as they were erected.

II

Let us consider the Bowery again, the site of victim photography in which the victims, insofar as they are now victims of the camera – that is, of the photographer – are often docile, whether through mental confusion or because they are just lying there, unconscious. (But if you should show up before they are sufficiently distracted by drink, you are likely to be met with hostility, for the men on the Bowery are not particularly interested in immortality and stardom, and they've had plenty of experience with the Nikon set.) Especially now, the meaning of all such work, past and present, has changed: The liberal New Deal State has been dismantled piece by piece. The War on Poverty has been called off. Utopia has been abandoned, and liberalism itself has been deserted. Its vision of moral idealism spurring general social concern has been replaced with a mean-minded Spencerian sociobiology that suggests, among other things, that the poor may be poor through lack of merit (read Harvard's Richard Herrnstein as well as, of course, between Milton Friedman's lines).[6] There is as yet no organized national Left, only a Right. There is not even drunkenness, only "substance abuse" – a problem of bureaucratic management. The exposé, the compassion and outrage, of documentary fueled by the dedication to reform has shaded over into combinations of exoticism, tourism, voyeurism, psychologism, and metaphysics, trophy hunting – and careerism.

Yet documentary still exists, still functions socially in one way or another. Liberalism may have been routed, but its cultural expressions still survive. This mainstream documentary has achieved legitimacy and has a decidedly ritualistic character. It begins in glossy magazines and books, occasionally in newspapers, and becomes more expensive as it moves into art galleries and museums. The liberal documentary assuages any stirrings of conscience in its viewers the way scratching relieves an itch and simultaneously reassures them about their relative wealth and social position; especially the latter, now that even the veneer of social concern has dropped away from the upwardly mobile and comfortable social sectors. Yet this reminder carries the germ of an inescapable anxiety about the future. It is both flattery and warning (as it always has been). Documentary is a little like horror movies, putting a face on fear and transforming threat into fantasy, into imagery. One can handle imagery by leaving it behind. (*It is them, not us.*) One may even, as a private person, support causes.

Documentary, as we know it, carries (old) information about a group of powerless people to another group addressed as socially powerful. In the set piece of liberal television documentary, Edward R. Murrow's *Harvest of Shame*, broadcast the day after Thanksgiving in 1960, Murrow closes with an appeal to the viewers (then a more restricted part of the population than at present) to *write their congressmen* to help the migrant farm workers, whose pathetic, helpless, dispirited victimhood had been amply demonstrated for an hour – not least by the documentary's aggressively probing style of interview, its "higher purpose" notwithstanding – because *these people* can do nothing for themselves. But which political battles have been fought and won by someone for someone else? Luckily, César Chávez was not watching television but rather, throughout that era, was patiently organizing farm workers to fight for themselves. This difference is reflected in the documentaries made by and for the Farm Workers' Organizing Committee (later the United Farm Workers of America, AFL-CIO), such

works as *Sí, Se Puede* (Yes, We Can) and *Decision at Delano*; not radical works, perhaps, but militant works.

In the liberal documentary, poverty and oppression are almost invariably equated with misfortunes caused by natural disasters: Causality is vague, blame is not assigned, fate cannot be overcome. Liberal documentary blames neither the victims nor their willful oppressors – unless they happen to be under the influence of our own global enemy, World Communism. Like photos of children in pleas for donations to international charity organizations, liberal documentary implores us to look in the face of deprivation and to weep (and maybe to send money, if it is to some faraway place where the innocence of childhood poverty does not set off in us the train of thought that begins with denial and ends with "welfare cheat").

Even in the fading of liberal sentiments one recognizes that it is impolite or dangerous to stare in person, as Diane Arbus knew when she arranged her satisfyingly immobilized imagery as a surrogate for *the real thing*, the real freak show. With the appropriate object to view, one no longer feels obligated to suffer empathy. As sixties' radical chic has given way to eighties' pugnacious self-interest, one displays one's toughness in enduring a visual assault without a flinch, in jeering, or in cheering. Beyond the spectacle of families in poverty (where starveling infants and despairing adults give the lie to any imagined hint of freedom and become merely the currently tedious poor), the way seems open for a subtle imputation of pathetic-heroic choice to victims-turned-freaks, of the seizing of fate in straitened circumstances. The boringly sociological becomes the excitingly mythological/psychological. On this territory a more or less overt sexualization of the photographic image is accomplished, pointing, perhaps, to the wellspring of identification that may be the source of this particular fascination.[7]

III

It is easy to understand why what has ceased to be news becomes testimonial to the bearer of the news. Documentary testifies, finally, to the bravery or (dare we name it?) the manipulativeness and savvy of the photographer, who entered a situation of physical danger, social restrictedness, human decay, or combinations of these and saved us the trouble. Or who, like the astronauts, entertained us by showing us the places we never hope to go. War photography, slum photography, "subculture" or cult photography, photography of the foreign poor, photography of "deviance," photography from the past – W. Eugene Smith, David Douglas Duncan, Larry Burrows, Diane Arbus, Larry Clark, Danny Lyon, Bruce Davidson, Dorothea Lange, Russell Lee, Walker Evans, Robert Capa, Don McCullin . . . these are merely the most currently luminous of documentarian stars.

W. Eugene Smith and his wife, Aileen Mioko Smith, spent the early 1970s on a photo-and-text exposé of the human devastation in Minamata, a small Japanese fishing and farming town, caused by the heedless prosperity of the Chisso chemical firm, which dumped its mercury-laden effluent into their waters. They included an account of the ultimately successful but violence-ridden attempt of victims to gain redress. When the major court fight was won, the Smiths published a text and many photos in the American magazine *Camera 35*.[8] Smith had sent in a cover photo with a carefully

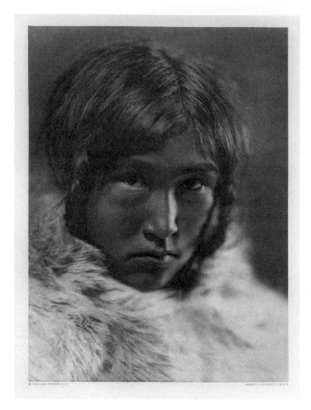

Figure 31.3 Robert Flaherty, *Eskimo Woman*, c. 1914. Women identified as "Allegoo (Shining Water), Sikoslingmuit Eskimo Woman, Southern Baffin Lands," but she may be a woman named Kanaju Aeojiealia. Published in March 1915 in a Toronto newspaper with the caption, "Our little lady of the snows . . . makes a most engaging picture." From Robert Flaherty, Photographer/ Filmmaker: the Inuit 1910–1922 (Vancouver Art Gallery, 1980). Public domain.

done layout. The editor, Jim Hughes, knowing what sells and what doesn't, ran *a picture of Smith* on the cover and named him "Our Man of the Year" ("*Camera 35*'s first and probably only" one). Inside, Hughes wrote: "The nice thing about Gene Smith is that you know he will keep chasing the truth and trying to nail it down for us in words and pictures; and you know that even if the truth doesn't get better, Gene will. Imagine it!"[9] The Smiths' unequivocal text argues for strong-minded activism. The magazine's framing articles *handle* that directness; they convert the Smiths into Smith; and they congratulate him warmly, smothering his message with appreciation.

Help preserve the "cultural heritage" of the mudmen in New Guinea, urges the travel editor of the Vancouver *Province*. Why should you care? he asks; and he answers, to safeguard the value received for your tourist dollar (Canadians also love Disneyland and Disney World). He is asking for donations to a cultural center. The "mudmen" formerly made large, grimacing pull-on masks to frighten their opponents in war and now wear them in adventure ads for Canadian Club ("We thought we were in a peaceful village until . . ."). The mudmen also appear in the "small room" of Irving Penn's *Worlds in a Small Room*,[10] an effete mimicry of anthropological documentary, not to

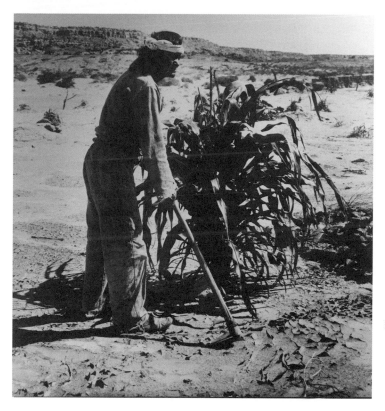

Figure 31.4 Adam Clark Vromen, *Hopi towns: The Man with a Hoe*, 1902. From Photographer of the Southwest, Adam Clark Vroman, 1856–1916, ed. Ruth Mahood (New York: Bonanza Books, n.d.). © 2017. Manuel Cohen/Scala, Florence.

mention in photos with the Queen. Edward S. Curtis was also interested in preserving someone's cultural heritage and, like other itinerant photographers operating among native North American peoples, he carried a stock of more or less authentic, more or less appropriate (often less, on both counts) clothing and accoutrements with which to deck out his sitters.[11] Here, as with Robert Flaherty a bit later,[12] the heritage was considered sufficiently preserved when captured within the edges of the photographic record and in the ethnographic costume shops being established in museums of "natural" history. In Curtis's case, the photographic record was often retouched, gold-toned, and bound in gold-decorated volumes selling for astonishing sums and financed by J. P. Morgan. We needn't quibble over the status of such historical romances, for the degree of truth in them may (again) be more or less equivalent to that in any well-made ethnographic or travel photo or film. An early – 1940s, perhaps – Kodak movie book[13] tells North American travelers, such as the Rodman C. Pells of San Francisco, pictured in the act of photographing a Tahitian, how to film natives so that they seem unconscious of the camera. Making such photos heightened patriotic sentiments in the States but precluded any understanding of contemporary native peoples as *experiencing subjects* in impoverished or at least modern circumstances; it even assisted the collective projection of Caucasian guilt and its rationalizations onto the "Indians" for having sunk so

and having *betrayed their own heritage*. To be fair, some respect was surely also gained for these people who had formerly been allowed few images other than those of abject defeat; no imagination, no transcendence, no history, no morals, no social institutions, only vice. Yet, on balance, the sentimental pictorialism of Curtis seems repulsively contorted, like the cariogenic creations of Julia Margaret Cameron or the saccharine poems of Longfellow. Personally, I prefer the cooler, more "anthropological" work of Adam Clark Vroman.[14] We can, nevertheless, freely exempt all the photographers, all the filmmakers, as well as all the ethnographers, ancillas to imperialism, from charges of willful complicity with the dispossession of the American native peoples. We can even thank them, as many of the present-day descendants of the photographed people do, for considering their ancestors worthy of photographic attention and thus creating a historical record (the only visual one). We can thank them further for not picturing the destitution of the native peoples, for it is difficult to imagine what good it would have done. If this reminds you of Riis and Hine, who first pictured the North American immigrant and native-born poor, the connection is appropriate as far as it goes but diverges just where it is revealed that Curtis's romanticism furthered the required sentimental mythification of the Indian peoples, by then physically absent from most of the towns and cities of white America. Tradition (traditional racism), which decreed that the Indian was the genius of the continent, had nothing of the kind to say about

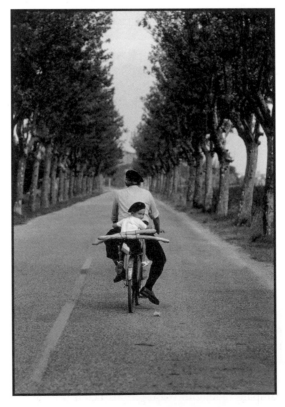

Figure 31.5 Elliott Erwitt, on an assignment for the French office of tourism in the 1950s (Agency: Doyle Dane Bernbach). © Elliott Erwitt/Magnum Photos.

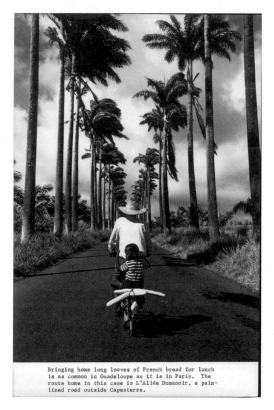

Bringing home long loaves of French bread for lunch is as common in Guadeloupe as it is in Paris. The route home in this case is L'Allée Dumanoir, a palm-lined road outside Capesterre.

Figure 31.6 Unknown, *Riding Home with a French loaf*, 1981. In the *Sunday New York Times* travel section for November 22, 1981, captioned, "Riding home with a French loaf at Capesterre on Basse-terre." Basse-Terre is part of Guadeloupe in the French West Indies. Frank J. Prial's accompanying article, "A Francophile's Guadeloupe," avers that despite U.S. tourism, "thank heaven, everything has remained resolutely French, or at least French-Caribbean." ZUMA Press, Inc./Alamy Stock Photo.

the immigrant poor, who were fodder for the industrial Moloch and a hotbed of infection and corruption.

Or consider a photo book on the teeming masses of India – how different is looking through it from going to an Indian restaurant or wearing an Indian shirt or sari? We consume the world through images, through shopping, through eating. . . .

> Your world is waiting and Visa is there.
>> 120 countries
>> 2.6 million shops, hotels, restaurants, and airlines
>> 70,000 banking offices
>> For traveling, shopping and cash advances . . .
>> Visa is the most widely recognized name in the world.
>> We're keeping up with you.

This current ad campaign includes photographs taken here and there in the world, some "authentic," some staged. One photo shows a man and a boy in dark berets on a bicycle on a tree-lined road, with long baguettes of bread tied across the rear of the

bike: rural France. But wait — I've seen this photo before, years ago. It turns out that it was done by Elliott Erwitt for the Doyle Dane Bernbach ad agency on a job for the French office of tourism in the fifties. Erwitt received fifteen hundred dollars for the photo, which he staged using his driver and the man's nephew: "The man pedaled back and forth nearly 30 times till Erwitt achieved the ideal composition. . . . Even in such a carefully produced image, Erwitt's gift for documentary photography is evident," startlingly avers Erla Zwingle[15] in the column "Inside Advertising" in the December 1979 issue of *American Photographer* — which also has articles, among others, on Bill Owens's at best ambivalent photos of mid-American suburbs, leisure activities, and work ("sympathetic and honest, revealing the contentment of the American middle class," according to Amy M. Schiffman); on a show of photos from the Magnum news-photo agency held in a Tokyo department store ("soon after the opening [Magnum president Burk] Uzzle flew off to hunt down refugees in Thailand while Glinn remained in Japan, garnering much yen from assignments for the likes of IBM, Seagram, and Goldman Sachs," says E. F.); on Geoff Winningham's photos of Texas high school football ("Inevitably one can compare him with the legendary Robert Frank, but the difference . . . is that . . . Winningham clearly loves the craziness [more on craziness later] he dwells upon," writes Schiffman); on Larry Clark's photos of Tulsa speed freaks ("A beautiful, secret world, much of it sordid" and "although there is plenty of sex, death, violence, anxiety, boredom . . . there is no polemic apparent . . . so it doesn't really matter whether or not we can trust these photos as documents; to see them as photographs, no more and no less, is enough," remarks Owen Edwards). There is a Washington column by James Cassell complaining that "the administration frowns upon inspired photojournalism" and a page on Gamma photographer David Burnett, who arrived in Santiago de Chile a few days after the brutal putsch in 1973. On a government tour of the infamous stadium where people were detained and shot, he and other photographers "noticed a fresh batch of prisoners." Burnett says, "The Chileans had heard many stories about people being shot or disappearing [in a war does one learn of death from hearing stories?] and they were terribly frightened. The haunting gaze of one man in particular, whose figure was framed by two armed soldiers . . . caught my eye. The picture has always stayed with me." We see a contact sheet and that image enlarged. The article, by Yvette E. Benedek, continues: "Like most agency photographers, Burnett must shoot both color and black and white to satisfy many publications in different countries, so he often works with three Nikons and a Leica. His coverage of the coup . . . won the Overseas Press Club's Robert Capa Award . . . 'for exceptional courage and enterprise.'"

What happened to the man (actually men) in the photo? The question is inappropriate when the subject is photographs. And photographers. The subject of the article is the photographer. The name of the magazine is *American Photographer*. In 1978 there was a small news story on a historical curiosity: the real-live person who was photographed by Dorothea Lange in 1936 in what became *the world's most reproduced photograph*. Florence Thompson, seventy-five in 1978, a Cherokee living in a trailer in Modesto, California, was quoted by the Associated Press as saying, "That's my picture hanging all over the world, and I can't get a penny out of it." She said that she is proud to be its subject but asked, "What good's it doing me?" She has tried unsuccessfully to get the photo suppressed. About it, Roy Stryker, genius of the photo section of the Farm Security Administration, for which Lange was working, said in 1972: "When Dorothea took that picture, that was the ultimate. She never surpassed it. To me, it was

the picture of Farm Security. . . . So many times I've asked myself what is she think-ing? She has all of the suffering of mankind in her but all of the perseverance too. . . . You can see anything you want to in her. She is immortal."[16] In 1979, a United Press International story about Mrs. Thompson said she gets $331.60 a month from Social Security and $44.40 for medical expenses. She is of interest solely because she is an incongruity, a photograph that has aged; of interest solely because she is a postscript to an acknowledged work of art. Mr. Burnett's Chilean photograph will probably not reach such prominence (I've never seen it before, myself), and we will not discover what happened to the people in it, not even forty-two years later.[17]

A good, principled photographer I know, who works for an occupational health and safety group and cares about how his images are understood, was annoyed by the articles about Florence Thompson. He thought they were cheap, that the photo *Migrant Mother,* with its obvious symbolic dimension, stands over and apart from her, is *not-her*, has an independent life history. (Are photographic images, then, like civiliza-tion, made on the backs of the exploited?) I mentioned to him that in the book *In This Proud Land*,[18] Lange's field notes are quoted as saying, "She thought that my pictures might help her, and so she helped me." My friend the labor photographer responded that the photo's publication caused local officials to fix up the migrant camp, so that although Mrs. Thompson didn't benefit directly, others like her did. I think she had a different idea of their bargain.

I think I recognize in his response the well-entrenched paradigm in which a docu-mentary image has two moments: (1) the "immediate," instrumental one, in which an image is caught or created out of the stream of the present and held up as testimony, as evidence in the most legalistic of senses, arguing for or against a social practice and its ideological-theoretical supports, and (2) the conventional "aesthetic-historical" moment, less definable in its boundaries, in which the viewer's argumentativeness cedes to the organismic pleasure afforded by the aesthetic "rightness" or well-formedness (not necessarily formal) of the image. The second moment is ahistorical in its refusal of *specific* historical meaning yet "history minded" in its very awareness of the pastness of the time in which the image was made. This covert *appreciation* of images is dangerous insofar as it accepts *not* a dialectical relation between political and formal meaning, not their interpenetration, but a hazier, more reified relation, one in which topicality drops away as epochs fade, and the aesthetic aspect is, if anything, enhanced by the loss of specific reference (although there remains, perhaps, a cushioning backdrop of vague social sentiments limiting the "mysteriousness" of the image). I would argue against the possibility of a nonideological aesthetic; any response to an image is inevitably rooted in social knowledge – specifically, in social understanding of cultural products. (And from her published remarks one must suppose that when Lange took her pictures she was after just such an understanding of them, although by now the cultural appropria-tion of the work has long since removed it from this perspective.)

A problem with trying to make such a notion workable within actual photo-graphic practice is that it seems to ignore the mutability of ideas of aesthetic rightness. That is, it seems to ignore the fact that historical interests, not transcendental verities, govern whether any particular form is seen as adequately revealing its meaning – and that you cannot second-guess history. This mutability accounts for the incorporation into legitimate photo history of the work of Jacob Riis alongside that of the incom-parably more careful Lewis Hine, of Weegee (Arthur Fellig) alongside Danny Lyon. It

seems clear that those who, like Lange and the labor photographer, identify a power-fully conveyed meaning with a primary sensuousness are pushing against the gigantic ideological weight of classical beauty, which presses on us the understanding that in the search for transcendental form, the world is merely the stepping-off point into aesthetic eternity.

The present cultural reflex of wrenching all art works out of their contexts makes it difficult to come to terms with this issue, especially without seeming to devalue such people as Lange and the labor photographer, and their work. I think I understand, from the inside, photographers' involvement with *the work itself*, with its supposed autonomy, which really signifies its belongingness to their own body of work and to the world of photographs.[19] But I also become impatient with this perhaps-enforced protectiveness, which draws even the best intentioned of us nearer and nearer to exploitiveness.

The Sunday *New York Times Magazine*, bellwether of fashionable ideological conceits, in 1980 excoriated the American documentary milestone *Let Us Now Praise Famous Men* (written by James Agee and photographed by Walker Evans in July and August of 1936, in Hale County, Alabama, on assignment from *Fortune* magazine, rejected by the maga-zine and only published in book form in 1941).[20] The critique[21] is the same as that suggested in germ by the Florence Thompson news item. We should savor the irony of arguing before the ascendant class fractions represented by the readership of the Sunday *New York Times* for the protection of the sensibilities of those marginalized share-croppers and children of sharecroppers of forty years ago. The irony is greatly height-ened by the fact that (as with the Thompson story) the "protection" takes the form of a new documentary, a "rephotographic project," a reconsignment of the marginal and pathetic to marginality and pathos, accompanied by a stripping away of the false names given them by Agee and Evans – Gudger, Woods, Ricketts – to reveal their real names and "life stories." This new work manages to institute a new genre of victimhood – the victimization by *someone else's* camera of helpless persons, who then hold still long enough for the indignation of the new writer to capture them, in words and images both, in their current state of decrepitude. The new photos appear alongside the old, which provide a historical dimension, representing the moment in past time in which these people were first dragged into history. As readers of the Sunday *Times*, what do we discover? That the poor are ashamed of having been exposed as poor, that the pho-tos have been the source of festering shame. That the poor remain poorer than we are, for although *they* see their own rise in fortunes, their escape from desperate poverty, we *Times* readers understand that our relative distance has not been abridged; we are still doing much better than they. Is it then difficult to imagine these vicarious protec-tors of the privacy of the "Gudgers" and "Ricketts" and "Woods" turning comfortably to the photographic work of Diane Arbus?[22]

The credibility of the image as the explicit trace of the comprehensible in the liv-ing world has been whittled away for both "left" and "right" reasons. An analysis that reveals social institutions as serving one class by legitimating and enforcing its domina-tion while hiding behind the false mantle of even-handed universality necessitates an attack on the monolithic cultural myth of objectivity (transparency, unmediatedness), which implicates not only photography but all journalistic and reportorial objectivity used by mainstream media to claim ownership of all truth. But the Right, in con-tradistinction, has found the attack on credibility or "truth value" useful to its own

ends. Seeing people as fundamentally unequal and regarding elites as natural occur-
rences, composed of those best fitted to understand truth and to experience plea-
sure and beauty in "elevated" rather than "debased" objects (and regarding it as social
suicide to monkey with this natural order), the Right wishes to seize a segment of
photographic practice, securing the primacy of authorship, and to isolate it within the
gallery–museum–art-market nexus, effectively differentiating elite understanding and
its objects from common understanding. The result (which stands on the bedrock of
financial gain) has been a general movement of legitimated photography discourse to
the Right – a trajectory that involves the aestheticization (consequently, formalization)
of meaning and the denial of content, the denial of the existence of the political dimen-
sion. Thus, instead of the dialectical understanding of the relation between images and
the living world that I referred to earlier – in particular, of the relation between images
and ideology – the relation has simply been severed in thought.

The line that documentary has taken under the tutelage of John Szarkowski at
New York's Museum of Modern Art – a powerful man in a powerful position – is exem-
plified by the career of Garry Winogrand, who aggressively rejects any responsibility
(or shall we say culpability?) for his images and denies any relation between them and
shared or public human meaning. Just as Walker Evans is the appropriate person within
the history of street photography to compare with Lee Friedlander, the appropriate
comparison for Winogrand is Robert Frank (who is compared with almost everyone),
whose purloined images of American life in the 1950s suggest, however, all the pas-
sionate judgments that Winogrand disclaims.[23] Images can yield any narrative, Wino-
grand says, and all meaning in photography applies only to what resides within the
"four walls" of the framing edges. What can, in Frank's work, be identified as a person-
ally mediated presentation has become, in Szarkowski's three "new documentarians,"
Winogrand, Arbus, and Friedlander, a privatized will o' the wisp:

> Most of those who were called documentary photographers a generation
> ago . . . made their pictures in the service of a social cause. . . . to show what
> was wrong with the world, and to persuade their fellows to take action and
> make it right. . . . [A] new generation of photographers has directed the
> documentary approach toward more personal ends. Their aim has not been
> to reform life, but to know it. Their work betrays a sympathy – almost an
> affection – for the imperfections and the frailties of society. They like the
> real world, in spite of its terrors, as the source of all wonder and fascina-
> tion and value – no less precious for being irrational. . . . What they hold in
> common is the belief that the commonplace is really worth looking at, and
> the courage to look at it with a minimum of theorizing.[24]

Szarkowski wrote that introduction to the *New Documents* show in 1967, in an
America already several years into the "terrors" and disruptions of the Vietnam War.
He makes a poor argument for the value of disengagement from a "social cause" and in
favor of a connoisseurship of the tawdry. How, for example, do we define the boundar-
ies and extent of "the world" from looking at these photographers' images, and how we
can be said to "know it"? The global claim he makes for their work serves to point out
the limits of its actual scope. At what elevated vantage point must we stand to regard
society as having "frailties" and "imperfections"? High enough to see it as a circus

before our eyes, a commodity to be "experienced" the way a recent vodka ad entices us to "experience the nineteenth century" by having a drink. In comparison with nightmarish photos from Vietnam and the United States' Dominican adventure, the work of Friedlander, Winogrand, and Arbus might be taken as evidencing a "sympathy" for the "real world." Arbus had not yet killed herself, though even that act proved to be recuperable by Szarkowki's ideological position. In fact, the forebears of Szarkowski are not those "who made their pictures in the service of a social cause" but bohemian photographers like Brassaï and the early Kertész and Cartier-Bresson. But rather than the sympathy and almost-affection that Szarkowski claimed to find in the work, I see impotent rage masquerading as varyingly invested snoop sociology – fascination and affection are far from identical. A dozen years later, aloofness has given way to a more generalized nihilism.

In the San Francisco Sunday paper for November 11, 1979, one finds Jerry Nachman, news director of the local headline-and-ad station, saying:

> In the sixties and seventies all-news radio had its place in people's lives: What was happening in Vietnam? Did the world blow up last night? Who's demonstrating where? . . . Now we're on the cusp of the eighties and things are different. To meet these changes KCBS must deliver what's critical in life in a way that's packaged even perversely. . . . There's a certain craziness that goes on in the world and we want people to understand that we can chronicle it for them.

Nachman also remarks, "Our broadcasters tell people what they saw out there in the wilderness today." The wilderness is the world, and it inspires in us, according to this view, both anxiety and perverse fascination, two varieties of response to a spectacle.

IV

Imperialism breeds an imperialist sensibility in all phases of cultural life. A safari of images. Drunken bums[25] retain a look of threat to the person. (Not, perhaps, as well as foreign prisoners . . .)[26] They are a drastic instance of a male society, the lumberjacks or prospectors of the cities, the men who (seem to) choose not to stay within the polite bourgeois world of (does "of" mean "made up of" or "run by" or "shaped by" or "fit for"?) *women and children.* They are each and every one an unmistakably identifiable instance of a physically coded social reality. The cynicism they may provoke in observers is far different from the cynicism evoked by images of the glitter world, which may end in a politically directed anger. *Directed toward change.* Bums are an "end game" in a "personal tragedy" sort of chance. They may be a surreptitious metaphor for the "lower class" but they are not to be confused with a social understanding of the "working class." Bums are, perhaps, to be finally judged as *vile,* people who deserve a kick for their miserable *choice.* The buried text of photographs of drunks is not a treatise on political economy, on the manipulation of the unemployment rate to control inflation and keep profits up and labor's demands down, on the contradictory pressures on the institution of the family under capitalism, on the appeal of consciousness-eradicating drugs for people who have little reason to believe in themselves.

V

The Bowery in two inadequate descriptive systems is a work of refusal. It is not defiant anti-humanism. It is meant as an act of criticism; the text you are reading now runs on the parallel track of another descriptive system. There are no stolen images in this book; what could you learn from them that you didn't already know? If impoverishment is a subject here, it is more centrally the impoverishment of representational strategies tottering about alone than that of a mode of surviving. The photographs are powerless to *deal with* the reality that is yet totally comprehended-in-advance by ideology, and they are as diversionary as the word formations – which at least are closer to being located within the culture of drunkenness rather than being framed on it from without.

There is a poetics of drunkenness here, a poetry-out-of-prison. Adjectives and nouns built into metaphoric systems – food imagery, nautical imagery, the imagery of industrial processes, of militarism, derisive comparisons with animal life, foreignisms, archaisms, and references to still other universes of discourse – applied to a particular state of being, a subculture of sorts, and to the people in it.

The words begin outside the world of skid row and slide into it, as people are thought to slide into alcoholism and skid to the bottom of the row. The text ends twice, comprising two series. First the adjectives, beginning with playful metaphor to describe the early, widely acceptable stages of intoxication and moving toward the baldness of stupor and death. A second series begins, of nouns belonging firmly to the Bowery and not shared with the world outside. Occasionally the texts address the photographs directly; more often, if there is a connection, it is the simultaneous darkening of mood as the two systems run along concurrently.

The photos represent a walk down the Bowery seen as arena and living space, as a commercial district in which, after business hours, the derelict residents inhabit the small portal spaces between shop and street. The shops range from decrepitude to splendor, from the shabbiest of ancient restaurant-supply houses or even mere storage spaces to astonishing crystal grottoes whose rapt cherubim entwined in incandescent fixtures and whose translucent swans in fountains of fiber-optic tubes relentlessly dripping oil blobs into dishes radiate into the street. Above the street, the now-infrequent flophouses and their successors the occasional, unseen living lofts, vary from mean raw space to constructed tropical paradises, indoor boweries whose residents must still step over the sleeping bums in the doorway and so are not usually the type who think of having kids. None of this matters to the street, none of it changes the quality of the pavement, the shelter or lack of it offered by the doorways, many of which are spanned by inhospitable but visually discreet rows of iron teeth – meant to discourage sleep but generally serving only as peas under the mattress of a rolled-up jacket. While the new professional-managerial urban gentry devour discarded manufactories and vomit up architectural suburbiana in their place, the Bowery is (so far) still what it has been for a hundred years and more. Bottles, and occasionally shoes, never flowers, are strewn on the Bowery, despite a name that still describes its country past.

The photos here are radical metonymy, with a setting implying the condition itself. I will not yield the material setting, though certainly it explains nothing. The photographs confront the shops squarely, and they supply familiar urban reports. *They are not reality newly viewed.* They are not reports from a frontier, messages from a voyage of discovery or self-discovery. There is nothing new attempted in a photographic style

that was constructed in the 1930s when the message itself was newly understood, differently embedded. I am quoting words and images both.

VI

Sure, images that are meant to make an argument about social relations can "work." But the documentary that has so far been granted cultural legitimacy has no such argument to make. Its arguments have been twisted into generalizations about the condition of "man," which is by definition not susceptible to change through struggle. And the higher the price that photography can command as a commodity in dealerships, the higher the status accorded to it in museums and galleries, the greater will be the gap between that kind of documentary and another kind, a documentary incorporated into an explicit analysis of society and at least the beginning of a program for changing it. The liberal documentary, in which members of the ascendant classes are implored to have pity on and to rescue members of the oppressed, now belongs to the past. The documentary of the present, a shiver-provoking appreciation of alien vitality or a fragmented vision of psychological alienation in city and town, coexists with the germ of another documentary – a financially unloved but growing body of documentary works committed to the exposure of specific abuses caused by people's jobs, by the financier's growing hegemony over the cities, by racism, sexism, and class oppression; works about militancy or about self-organization, or works meant to support them. Perhaps a radical documentary can be brought into existence. But the common acceptance of the idea that documentary precedes, supplants, transcends, or cures full, substantive social activism is an indicator that we do not yet have a real documentary.

Original publication

'In, Around, and Afterthoughts (On Documentary Photography)' in *Decoys and Disruptions: Selected Writings, 1975–2001* (2004).
[Originally published 1981]

Notes

1 This essay was originally published in *Martha Rosler: 3 Works* (Halifax: Press of the Nova Scotia College of Art and Design, 1981). It was republished in Richard Bolton, ed., *The Contest of Meaning: Critical Histories of Photography* (Cambridge, MA: MIT Press, 1990), and in Liz Wells, ed., *Photography: A Critical Reader* (London: Routledge, 2000). It has been translated into several languages, including as "I, omkring og ettertanker (om dokumenterende fotografi)," *UKS-Forum for Samtidskunst* (Oslo) 1–2 (1979); and as "Drinnen, drumherum und nachträgliche Gedanken (zur Dokumentarfotografie)," in Sabine Breitwieser and Catherine de Zegher, eds., *Martha Rosler, Positionen in der Lebenswelt* (Vienna and Cologne: Generali Foundation and Walther König, 1999).
 Permission to reproduce Irving Penn's photograph *Asaro Mudmen, New Guinea, 1970* was refused by Condé Nast Publications, Inc., in a one-sentence rejection stating: "Unfortunately, the material requested by you is unavailable for republication." By phone their representative suggested that it was Penn who had refused the request.

Permission to reproduce a photograph of Ida Ruth Tingle Tidmore, one of Walker Evans's Hale County subjects, taken in 1980 by Susan Woodley Raines and reproduced in conjunction with Howell Raines's article "Let Us Now Revisit Famous Folk" in the Sunday *New York Times Magazine* of May 25, 1980, was refused by Ms. Raines because Ms. Tidmore was suing Mr. Raines over the content of the article (see note 20). The photo requested was captioned "Ida Ruth Tingle Tidmore and her husband, Alvin, outside their mobile home, which is adjacent to Alvin's collection of junked automobiles." A small corner inset showed one of Evans's photos from *Let Us Now Praise Famous Men* and was captioned "Young Ida Ruth struck this pensive pose for Walker Evans' camera." However, the inset photo is identified in *Walker Evans: Photographs for the Farm Security Administration 1935–1938* (New York: Da Capo Press, 1973, photo number 298) as being of Ida Ruth's younger sister Laura Minnie Lee Tengle (*sic*) (LC-USZ62-17931).

2 In England, where documentary practice (in both film and photography) has had a strong public presence (and where documentary was named, by John Grierson), with well-articulated theoretical ties to social-democratic politics, it is customary to distinguish social documentary from documentary per se (photos of ballerinas, an English student remarked contemptuously). The more general term denotes photographic practice having a variety of aesthetic claims but without involvement in exposé. (What is covered over by this blanket definition, such as the inherently racial type of travelogue, with its underpinnings of essentialist rather than materialist theories of cultural development, will have to remain under wraps for now.) Of course, such distinctions exist in documentary practice everywhere, but in the United States, where positions on the political spectrum are usually not named and where photographers and other artists have only rarely and sporadically declared their alignment within social practice, the blurring amounts to a tactic. A sort of popular front wartime Americanism blended into Cold War withdrawal, and it became socially mandatory for artists to disaffiliate themselves from Society (meaning social negativity) in favor of Art; in the postwar era, one finds documentarians locating themselves, actively or passively, as privatists (Dorothea Lange), aestheticians (Walker Evans, Helen Levitt), scientists (Berenice Abbott), surrealists (Henri Cartier-Bresson), social historians (just about everyone, but especially photojournalists like Alfred Eisenstaedt), and just plain "lovers of life" (Arthur Rothstein). The designation "concerned photography" latterly appears, signifying the weakest possible idea of (or substitute for) social engagement, namely, compassion, of whom perhaps the war photographers David Douglas Duncan, Donald McCullin, and W. Eugene Smith have been offered as the signal examples. If this were a historical essay, I would have to begin with ideas of truth and their relation to the developments of photography, would have to spell out the origins of photographic instrumentalism, would have to tease apart the strands of "naturalistic," muckraking, news, socialist, communist, and "objective" photographic practice, would have to distinguish social documentary from less defined ideas of documentary unqualified.

3 Jacob A. Riis, *The Making of an American* (1901; reprinted, New York: Harper Torchbooks, 1966), p. 267.

4 In quoting Jacob Riis, I am not intending to elevate him above other documentarians— particularly not above Lewis Hine, whose straightforward involvement with the struggles for decent working hours, pay, and protections, as well as for decent housing, schooling, and social dignity, for the people whom he photographed and the social service agencies intending to represent them, and whose dedication to photography as the medium with which he could best serve those interests, was incomparably greater that Riis's, to whom photography, and probably those whom he photographed, were at best an adjunct to, and a moment in, a journalistic career.

Margaret Sanger, a nurse in turn-of-the-century New York, became a crusader for women's control over reproduction. She founded the American Birth Control League in

the 1920s (and much later became the first president of the International Planned Parenthood Federation) and similar leagues in China and Japan. Like many women reformers, she was arrested and prosecuted for her efforts, which ranged from disseminating birth control literature to maintaining a clinic in the Lower East Side. Many other people, including Jane Addams, founder of Hull House in Chicago, and Lillian Wald, founder of New York's Visiting Nurse Association, might be cited as dedicated reformers in this tradition of middle-class championship of the oppressed, with varying relations to the several strategies of self-help, charity, and the publication of wrongs to awaken a healing empathic response.

5 The buried tradition of "socialist photography," a defined – though no doubt restricted – practice in some parts of Europe and North America in the late nineteenth and early twentieth centuries, is being excavated by Terry Dennett (of Photography Workshop) in England. His research so far suggests that the showing of lantern slides depicting living and working conditions and militant actions were a regular part of the working-class political organizing, and references to "socialist photography" or photographers appeared in the leftist press in that period. Furthermore, the world's first news-photo agency, World's Graphic Press, seems to have had a leftish orientation. In the collection *Photography / Politics: One* (London: Photography Workshop, 1979), a start was made toward a worldwide history of the photo leagues. In relation to Left photography, one must mention the illustrated magazines, the most popular of which was the German *Arbeiter-Illustrierte Zeitung,* or *AIZ* (Worker-Illustrated Newspaper, 1924–38).

6 For a discussion of the work of Richard Herrnstein, chairman of the psychology department at Harvard University, see Karl W. Deutsch and Thomas B. Edsall, "The Meritocracy Scare," *Society* (September–October 1972), and Richard Herrnstein, Karl W. Deutsch, and Thomas B. Edsall, "I.Q.: Measurement of Race and Class" (in which Herrnstein debates Deutsch and Edsall on some of their objections to his work), *Society* (May–June 1973); both are reprinted in Bertram Silverman and Murray Yanowitz, eds., *The Worker in "Post-Industrial" Capitalism: Liberal and Radical Responses* (New York: Free Press, 1974). See also Richard Herrnstein's original article, "I.Q.," in *Atlantic Monthly*, September 1971, 43–64; and Arthur Jensen, "How Much Can We Boost IQ and Scholastic Achievement?" *Harvard Educational Review*, reprint series no. 2 (1969): 126–34. See, e.g., Samuel Bowles and Herbert Gintis, "IQ in the U.S. Class Structure," *Social Policy* (November–December 1972 and January–February 1973), also reprinted in Silverman and Yanowitz, *The Worker*, for a critique of the theorizing behind intelligence testing. There have been many critiques of I.Q. – a very readable one is Jeffrey Blum's *Pseudoscience and Mental Ability* (New York: Monthly Review Press, 1977) – and of sociobiology, exposing their ideological foundations and poor scientific grounding – critiques that haven't inhibited either enterprise.

Milton Friedman, best known of the extremely conservative "Chicago school" (University of Chicago) anti-Keynesian, "monetarist" economists, has strongly influenced the policies of the Conservative Thatcher government in England and the rightist Begin government in Israel and has advised many reactionary politicians around the world (and "los Chicago boys" laid the foundations for the brutally spartan policies of the Pinochet military regime toward all but the richest Chileans). Implicit in the pivotal conception of economic "freedom" (competition) is that the best will surely rise and the worst will sink to their proper level. That is the only standard of justice. In remarks made while accepting an award from the Heritage Foundation, Friedman, referring to the success of his public (i.e., government- and corporate-sponsored) television series *Free to Choose*, commented that conservatives had managed to alter the climate of opinion such that the series could succeed and proclaimed the next task to be the promulgation of "our point of view" in philosophy, music, poetry, drama, and so on. He has also recommended the dismantling of the National Endowments for the Arts and the Humanities (government

funding agencies). We can expect the currency of such policies and their ideological corollaries to grow as they increasingly inform the policies and practices of rightist U.S. governments.

7 A remarkable instance of one form that such fascination may take, in this case one that presented itself as militantly chaste (and whose relation to identification I won't take on now), is provided by the lifelong obsession of an English Victorian barrister, Arthur J. Munby, which was the *observation* of female manual laborers and servants. (The souvenir *cartes de visite* of young female mine workers, at the pit head and in studio poses, suggest that some version of Munby's interest was widely shared by members of his class.) Simply seeing them dressed for work rather than watching them work generally sufficed for him, though he often "interviewed" them. Munby was no reformer or ally of feminists, but in opposing protective legislation he considered himself a champion of working-class women, particularly the "robust" ones whose company he much preferred to that of the genteel women of his class, sufferers from the cult of enforced feebleness. After a secret liaison of nineteen years with a maid-of-all-work (a low servant rank), Hannah Cullwick, Munby married her but kept the marriage secret, and although he dressed her as a lady for their journeys, they lived separately and she remained a servant – often waiting on him. He also insisted she keep a diary. Munby's great interest in the new field of photography was frustrated by the fact that as in painting most aspirants had no interest in images of labor; he bought whatever images of working women he could find and arranged for others, often escorting women in work dress to the photo studio and sometimes using Hannah as a stand-in. He would dress her in various work costumes for photo sessions, and his diary describes how, pretending no relationship, he savored the sight of the photographer bodily arranging her poses and the degradation it imposed on her. In 1867 he took her to be photographed by O. J. Rejlander, the famous painter-turned-photographer of (simulated) "genre" scenes.

The huge Munby collection at Cambridge, consisting of six hundred surviving photos as well as his sketches and private papers running to millions of words, provided the material for Derek Hudson's *A. J. Munby, Man of Two Worlds: The Life and Diaries of Arthur J. Munby, 1828–1910* (London: J. Murray, 1972), and Michael Hiley's lavishly illustrated *Victorian Working Women: Portraits From Life* (London: Gordon Fraser, 1979). (I am profoundly grateful to Stephen Heath not only for calling Munby and his preoccupations to my attention but also for generously sharing his own research with me.)

Not in relation to photographic imagery but to the sexualization of class itself that lies behind Munby's scopophilic obsession, we note that in Victorian England, where only working-class women were supposed to have retained any interest in sexuality, gentlemen might cruise working-class neighborhoods to accost and rape young women.

8 April 1974. (I thank Allan Sekula for calling this issue to my attention.) The Smiths subsequently published a book whose title page reads *Minamata, Words and Photographs By Eugene Smith and Aileen M. Smith* (New York: Holt, Rinehart and Winston, 1975). I am not arguing for or against Smith's art-history-quoting, bravura photographic style. Nevertheless, and in spite of the ideological uses to which Smith's (and in this case the Smiths') work has been put in the photo world, the Smiths' work at Minamata was important in rallying support for the struggle throughout Japan.

9 *Camera 35* (April 1974): 3.

10 Irving Penn, *Worlds in a Small Room, By Irving Penn as an Ambulant Studio Photographer* (New York: Grossman, 1974).

11 The work of Edward S. Curtis, incorporating photographs from his monumental work *The North American Indian,* is now widely available in recent editions, including Ralph Andrews, *Curtis' Western Indians* (Sparks: Bonanza Books, 1962), and the far more elevated editions of the 1970s: the very-large-format *Portraits From North American Indian*

Life (New York: Outerbridge & Lazard, 1972; small-format paperback edition, New York: A & W Publishers, 1975); an exhibition catalogue for the Philadelphia Museum, *The North American Indians* (Millerton: Aperture, 1972); and *In a Sacred Manner We Live* (Barre: Barr Publishing, 1972; New York: Weathervane, 1972). One can speculate that it was the interest of the "counterculture" in tribalism in the late 1960s and early 1970s coupled with Native American militancy of the same period that ultimately called forth these classy new editions; posters of some of Curtis's (and others') portraits served as emblems of resistance for radicals, office workers, college students, and dope smokers.

Curtis, who lived in Seattle, photographed Native Americans for several years before J. Pierpont Morgan—to whom Curtis had been sent by Teddy Roosevelt—agreed to back his enterprise. (Curtis's "first contact with men of letters and millionaires," in his phrase, had come about accidentally: on a mountaineering expedition Curtis aided a stranded party of rich and important men, including the chiefs of the U.S. Biological Survey and the Forestry Department and the editor of *Forest and Stream* magazine, and the encounter led to a series of involvements in governmental and private projects of exploration and the shaping of attitudes about the West.) The Morgan Foundation advanced him fifteen thousand dollars per year for the next five years and then published (between 1907 and 1930) Curtis's resulting texts and photographs in a limited edition of 500 twenty-volume sets, selling for three thousand dollars (now worth over eighty thousand dollars and rising). The title page read:

> The North American Indian, Being a Series of Volumes Picturing and Describing the Indians of the United States and Alaska, written, illustrated and published by Edward S. Curtis, edited by Frederick Webb Hodge [of the United States Bureau of American Ethnology], foreword by Theodore Roosevelt, field research under the patronage of J. Pierpont Morgan, in twenty volumes.

Fabulously wealthy society people, including Andrew Carnegie, Solomon R. Guggenheim, Alexander Graham Bell, Mrs. Frederick W. Vanderbilt, and the kings of England and Belgium, were among the sets' early subscribers. But according to Curtis, over half the cost of a million and a half dollars was borne by Morgan and his estate.

Curtis dedicated himself completely to his task, and in addition to his photography and notes (and the writing of popular books, two of which became best-sellers), he recorded thousands of songs on wax rolls, many of which, along with oral histories, were transcribed and published in his *magnum opus*. Curtis's fictionalized film about the Kwakiutl of Vancouver Island, British Columbia, originally titled *In the Land of the Head Hunters* (1914), has recently been released under the title *In the Land of the War Canoes*.

On the subject of costuming, see, for example, Joanna Cohan Scherer, "You Can't Believe Your Eyes: Inaccuracies in Photographs of North American Indians," *Studies in the Anthropology of Visual Communication* 2:2 (Fall 1975), reprinted in *Exposure* (Journal of the Society for Photographic Education) 16:4 (Winter 1978).

Curtis's brother, Asahel Curtis, was a commercial photographer and city booster in Seattle and an enthusiast of development. A book of the distinctly nonpictorialist photographs of life and especially commerce in the Puget Sound area has been assembled and published by David Sucher as *An Asahel Curtis Sampler* (Seattle: Puget Sound Access, 1973). The one brother was integrated into the system of big capital and national government, the other into that of small business and regionalism.

12 Robert Flaherty is well known for his fictionalized ethnographic films, especially the first, *Nanook of the North* (made in 1919–20, released in 1922). A catalogue of his photographs (formerly ignored) of the Inuit, with several essays and many reproductions, has recently been published by the Vancouver Art Gallery: Joanne Birnie Danzker, ed., *Robert*

Flaherty, Photographer-Filmmaker: The Inuit 1910–1922 (Vancouver: Vancouver Art Gallery, 1980).

13 Eastman Kodak Company, *How to Make Good Movies* (Rochester: Kodak, n.d.).

14 Cameron's work can be found in Graham Ovenden, ed., *Victorian Album: Julia Margaret Cameron and Her Circle* (New York: Da Capo Press, 1975), and elsewhere. For Vroman's work, see Ruth Mahood, ed., *Photographer of the Southwest: Adam Clark Vroman, 1856–1916* (Los Angeles: Ward Ritchie Press, 1961; reprinted, Sparks: Bonanza Books, n.d.); or William Webb and Robert A. Weinstein, eds., *Dwellers at the Source: Southwestern Indian Photographs of Adam Clark Vroman, 1895–1904* (New York: Grossman, n.d.). It might be noted that Vroman was occasionally quite capable (as were Hine and Smith) of thrusting his work into the mold of the "traditional" Western sentimental iconographic coding of piety, humbleness, simplicity, and the dignity of labor: a photo of a mother and child is titled *Hopi Madonna;* one of a man working is called *Man with a Hoe.*

15 Zwingle's story seems to derive almost verbatim from the book *Private Experience, Elliott Erwitt: Personal Insights of a Professional Photographer*, with text by Sean Callahan and the editors of Alskog, Inc. (Los Angeles: Alskog/Petersen, 1974). The strange assertion about Erwitt's gift for documentary follows an interestingly candid quotation from ad agency president Bill Bernbach (as does most of the anecdote): "Elliott was able to grasp the idea quickly and *turn it into a documentary photograph.* This was tremendously important to us because the whole success of the campaign rested on the *believability* of the photographs. We were telling people that there was a France outside of Paris, and Elliott *made it look authentic*" (p. 60, emphasis added). In repeating the book's remark that Erwitt had achieved "the ideal composition" – called in the book "the precise composition" – the focus point marked with a stone, Zwingle has ignored the fact that the two photos – the one shown in *Private Experience* and the one used by Visa – are not quite identical (and the one in the ad is flopped). Questions one might well ask include what does "documentary" mean? (This question, for example, lay at the heart of an often-cited political furor precipitated when photographer Arthur Rothstein placed a locally obtained cow skull in various spots in drought-stricken South Dakota to obtain "the best" documentary photograph. When FDR was traveling through the area months later, the anti-New Deal editor of the *N. D. Fargo & Forum* featured one of the resulting photos [as sent out by the Associated Press, with its own caption] as "an obvious fake," implying that trickery lay at the heart of the New Deal.) And how precise is a "precise" or "ideal" composition? As to the relationship between documentary and truth: The bulk of Zwingle's article is about another photo used by Visa, this one of two (Bolivian) Indian women that the photographer (not Erwitt) describes as having been taken during a one-day sojourn in Bolivia, without the women's knowledge, and in which "some graffiti, . . . *a gun and the initials ELN, were retouched out to emphasize the picture's clean, graphic style*" (p. 94, emphasis added). The same photographer shot a Polynesia ad for Visa in San Francisco's Golden Gate Park using "a Filipino model from San Jose" who "looks more colorful in the picture than she did in real life. She was freezing" (pp. 94–5). The question of documentary in the wholly fabricated universe of advertising is a question that can have no answer.

16 Roy Emerson Stryker and Nancy Wood, *In This Proud Land: America, 1935–1943, as Seen in the FSA Photographs* (Greenwich: New York Graphic Society, 1973; New York: Galahad Books, 1973), p. 19.

17 Sometime at the end of the twentieth century, it seems, this man, a survivor of the terror, was identified and located.

18 Stryker and Wood, *In This Proud Land*, p. 19.

19 I am not speculating about the "meaning" of photography to Lange but rather speaking quite generally here.

20 Agee and Evans went to Hale County to do an article or a series on a white sharecropper
family for Henry Luce's *Fortune* magazine; because Evans was employed by the Histori-
cal Section of the Farm Security Administration, it was agreed that his negatives would
belong to it. When Agee and Evans completed their work (dealing with three families),
Fortune declined to publish it; it finally achieved publication in book form in 1941. Its
many editions have included, with the text, anywhere from sixteen to sixty-two of the
many photographs that Evans made. A new, larger, and more expensive paperback edi-
tion has recently been published; during Agee's lifetime the book sold about six hundred
copies.

It hardly needs to be said that in the game of waiting out the moment of critique of
some cultural work it is the capitalist system itself (and its financial investors) that is the
victor, for in cultural matters the pickings of the historical garbage heap are worth far
more than the critical moves of the present. By being chosen and commodified, by being
affirmed, even the most directly critical works in turn may be taken to affirm the system
they had formerly indicted, which in its most liberal epochs parades them through the
streets as proof of its open-mindedness. In this case, of course, the work did not even see
publication until its moment had ended.

21 Howell Raines, "Let Us Now Praise Famous Folk," *New York Times Magazine*, May 25,
1980, pp. 31–46. (I thank Jim Pomeroy for calling this article to my attention and giv-
ing me a copy of this issue.) Raines is the chief of the *Times's* Atlanta bureau. The article
seems to take for granted the uselessness of Agee's and Evans's efforts and in effect convicts
them of the ultimately tactless sin of prying. To appreciate the shaping effects of one's
anticipated audience, compare the simple "human interest" treatment of Allie Mae Fields
("Woods") Burroughs ("Gudger") Moore in Scott Osborne, "A Walker Evans Heroine
Remembers," *American Photographer* (September 1979): 70–3, which stands between
the two negative treatments: the *Times's* and the sensationalist newswire stories about
Florence Thompson, including ones with such headlines as "Migrant Mother' doubtful,
she doesn't think today's women match her" (*Toronto Star,* November 12, 1979). Mrs.
Moore (she married a man named Moore after Floyd Burroughs's death), too, lived in a
trailer, on Social Security (the article says $131 a month—surely it is $331.60, as Mrs.
Thompson received), plus Medicare. But unlike Thompson and Mrs. Moore's relatives as
described by Raines, she "is not bitter." Osborne ends his article thus: "Allie Mae Bur-
roughs Moore has endured. . . . She has survived Evans [she died, however, before the
article appeared], whose perception produced a portrait of Allie Mae Burroughs Moore
that now hangs on permanent display in the Museum of Modern Art. Now the eyes that
had revealed so much in that picture stare fixedly at the violet rim along the horizon.
'No, I wouldn't change my life none,' she says." According to Raines, *that picture* is the
most sought-after of all Evans's Alabama photos, and one printed by Evans would sell for
about four thousand dollars. Predictably, in Osborne's story, Mrs. Moore, contemplating
the photo, accepts its justice, while Raines has Mrs. Moore's daughter, after her mother's
death, bitterly saying how much her mother had hated it and how much unlike her it
looked.

22 In the same vein, but in miniature, and without the ramified outrage but with the
same joke on the photographed persons – that they allowed themselves to be twice
burned – *Modern Photography* (July 1980) ran a small item on its "What's What" pages
entitled "Arbus Twins Revisited." A New Jersey photographer found the twins, New Jer-
sey residents, and convinced the now-reluctant young women to pose for him, thirteen
years after Arbus's photo of 1967. There is presently a mild craze for "rephotographing"
sites and people previously seen in widely published photos; photographers have, I sup-
pose, discovered as a profession that time indeed flows rather than just vanishing. *Mod
Photo* probably had to take unusual steps to show us Arbus's photo. It is very difficult to

obtain permission to reproduce her work — articles must, for example, ordinarily be *read* before permission is granted — her estate is very tightly controlled by her family (and perhaps Szarkowski) and Harry Lunn, a photo dealer with a notorious policy of "enforced scarcity" with respect to the work of "his" photographers (including Arbus and Evans). *Mod Photo*'s staff photographed the cover of the Arbus monograph (published by Aperture in 1972), thus quoting a book cover, complete with the words "diane arbus," rather than the original Arbus print. Putting dotted lines around the book-cover image, they set it athwart rather than *in* a black border, while they did put such a border around the twins' photo of 1979. The story itself seems to "rescue" Arbus at the expense of the twins, who supposedly without direction, "assumed poses . . . remarkably like those in the earlier picture." (I thank Fred Lonidier for sending me a copy of this item.)

23 Although both Frank's and Winogrand's work is "anarchic" in tendency, their anarchism diverges considerably; whereas Frank's work seems to suggest a Left anarchism, Winogrand is certainly a Right anarchist. Frank's mid-1950s photo book *The Americans* (initially published in Paris in 1958, by Robert Delpire, but republished by Grove Press in New York in 1959 with an introduction by Jack Kerouac) seems to imply that one might travel through America and simply *see* its social-psychological meaning, which is apparent everywhere to those alive to looking; Winogrand's work suggests only the apparent inaccessibility of meaning, for the viewer cannot help seeing himself, point of view shifts from person to person within and outside the image, and even the *thought* of social understanding, as opposed to the leering face of the spectacle, is dissipated.

24 John Szarkowski, introduction (wall text) to the *New Documents* exhibition, Museum of Modern Art, New York, February 28–May 7, 1967. In other words, the photographer is either *faux naïf* or natural man, with the power to point but not to name.

25 Among the many works that have offered images of drunks and bums and down-and-outers, I will cite only Michael Zettler's *The Bowery* (New York: Drake Publishers, 1975), which I first saw only after I completed *The Bowery in two inadequate descriptive systems* but which, with its photographs and blocks of text — supposed quotations from the pictured bums and from observers — can nevertheless be seen as its perfect foil.

26 Such as the photographs of Chilean detainees taken by David Burnett, to which I referred earlier. See also note 16.

Lisa Henderson

ACCESS AND CONSENT IN PUBLIC PHOTOGRAPHY

FRAMED AS AN ASPECT of photographic practice, the issue of consent in public photography occurs at the juncture of at least two sets of contingencies; the first includes features of social interaction between photographers and their subjects, and the second, organizational constraints on doing photographic work – for example, those imposed by the division of labor in newspaper production. In the discussion of consent that follows I concentrate on the first, social interaction in photographic encounters, drawing from research on the strategies both amateur and professional photographers use to take pictures of people unknown to them in public places.[1]

The study was based on a conception of photographing as patterned social interaction among photographers, subjects, and off-camera participants in particular settings, and of photographs as products of this interaction whose meaning depends in part on its assessment. Moreover, while all photographic behavior is conventional to some degree, in public encounters between photographers and subjects unknown to each other, picture-taking is adapted to the broader setting, in contrast to situations or events organized around photographic imperatives, among them studio portrait sessions and press conferences. This adaptive perspective implies the need to contextualize a description of photographic strategies in public places; such a description must account for those contextual features that constrain photographers' choices among possible strategic alternatives.

By 'strategy' I mean the behavioral move or set of moves a photographer makes in order to get the picture he or she wants. 'Strategy' needn't imply premeditation or even consciousness of these analytically distinct moves at the moment they and the picture are made, though some photographers' descriptions of their activities do suggest degrees of premeditation, particularly where they or their pictures are threatened. Suffice to say that premeditation is a frequent though not required criterion of 'strategy' as I use the term here.

As well, 'context' is not defined by the setting alone but refers to a more general set of constraints upon what photographers do, including features of the subject

and of the shifting relations between photographer, subject and setting. Context also embraces a photographers' notions of both the nature of photography and of his or her professional or avocational role, to the extent these notions may foster, inhibit, or justify particular interactional approaches. Finally, it includes formal and informal conceptions of privacy photographers hold.

Consent

In photographic interactions, what do subjects consent to? To have their pictures taken or to have them used in some way? While photographic encounters imply both issues, consent strategies are framed in terms of what photographers do to sustain access (and in some cases co-operation) long enough to get the pictures they want, in other words, consent to take. In this attempt, some explanation of how the image will be used is occasionally though not necessarily offered as part of a photographer's strategic repertoire. While photographers recognize that a subject's uncertainty about the use of a picture is often the source of interactional tension, they are for the most part sufficiently confident about the harmlessness of their photographing (to subjects) or its importance (to themselves, or to 'public information') and sufficiently interested in carrying on doing it that consent is not so much to be reckoned with among subjects as dispensed with. The rule of thumb is to offer up only as detailed an explanation of one's conduct as might be required to sustain access, in some cases for moments, in others for months. There is an effective distinction between consent to take and consent to use, and the second issue, consent to use, is typically not part of the strategy during the encounter.

If consent to take pictures is therefore a matter of access, how do photographers get access and how do they keep it? At the most general level, they do so by maintaining what Erving Goffman has called 'normal appearances.'

In *Relations in Public* (1971), Goffman outlines eight 'territories of the self' to which we stake claims in our social lives. These territories include: personal space; stalls, fixed and portable, such as theater seats and beach mats; use space, respected because of apparent instrumental need; turns, that is, the order in which goods of some kind are received; sheath of skin and clothing; possessional territory ('personal effects'); information preserve, 'that set of facts about himself to which an individual expects to control access while in the presence of others'; and conversation preserve, controlling when and by whom the individual can be summoned into talk.[2] Here I am concerned with a subset of 'information preserve,' in particular those facts about an individual that can be directly perceived, his body sheath and his current behavior. As Goffman points out, the cultural issue is the individual's right not to be stared at or examined, and between strangers in public places, a glance, a look, or a penetration of the eyes may constitute a violation of this territory, or, in more familiar terms, an invasion of privacy.

As practitioners (and sometimes perpetrators) of a technical form of looking, photographers are aware of the threats to privacy they sometimes pose when they work in public places. In some cases, a camera may reduce the threat of the stare by identifying its proprietor as a photographer, with a mission to look and a right to be there in the first place – for example, as a tourist or a representative of the media.[3] In others, enough people may be photographing to render the act unremarkable. In still other cases, the camera is the very source of suspicion. In any event, and in the

interests of a particular type of photograph, photographers attempt to maintain 'normal appearances.'

In Goffman's terms, 'normal appearances mean that it is safe and sound to continue with the activity at hand with only peripheral attention given to checking up on the stability of the environment.'[4] Importantly, such appearances may be real or contrived, reflecting either a stable situation or a predator's successful attempt to conceal from his prey his threatening intentions. Only rarely, however, does such an extreme model represent the circumstance between photographers and their subjects. Typically, the photographer is aware of the minor threat he may pose or the curiosity he may arouse, and will address himself in advance to the task of learning what is unexceptional for the setting, then engage in photography in whatever form or with whatever approach will fit. Maintaining normal appearances is a behavioral fact attended to by people in their everyday lives quite apart from activities as specific as photographing; to varying degrees we monitor ourselves and others all the time with or without a camera present. But where the ante is raised by photography is in the camera's capacity not to only observe but record a person's behavior (to whatever manipulated degree, be it slight or extreme, intended or naive). Recording devices effectively undermine the everyday assumption that 'there is only a hearsay link between what happens inside the frame and allegations made about this outside the frame.'[5]

The maintenance of normal appearances needn't imply the photographer's concealment of himself or his camera, though in some cases this is an option and a preference. Rather, it means he will be present but of no concern. Thus a photographer's verbal or non-verbal declaration of his presence and his intention to photograph also fit within the normal appearances rubric to the extent that he is recognized as doing what is conventional for photographers to do. We therefore have a stylistic continuum in the maintenance of normal appearances that extends between concealment and declaration, with a popular midpoint of non-concealment, where photographers neither hide nor deliberately inform potential subjects of their imminent subjectivity; they are simply there.

Access and practice in public places: settings, subjects, and strategies

The utility of the concept of normal appearances lies in its descriptive breadth and its sensitivity to context. 'Normal appearances' does not denote a specific set of moves or behaviors, but a quality of the environment sustained by a variety of behaviors depending on the type of setting and the type of interaction. What follows then is a description of those features of settings and subjects that make a difference to how photographers take pictures in public places.

Settings

Setting features relevant to photographic strategies include (1) familiarity; (2) whether the setting constitutes the 'front' or 'back' region of a larger area or establishment;

(3) the frequency of photographic activity within the setting; and (4) the general spirit or purpose of the primary events taking place.

By 'familiarity' is meant the photographer's familiarity with a specific setting, a setting category, or both (e.g. Washington Square Park in particular or parks in general). The greater a photographer's familiarity the easier it is to maintain normal appearances. He or she is better acquainted with what subjects consider ordinary and thus better able to adjust his or her conduct. However, familiarity also goes beyond the specific instance and the category to include sub-cultural knowledge about the setting and its participants that can't be known from the setting alone. Thus some photographers work amid groups in which they are or used to be members, tailoring their interactive style in light of what they know to be threatening or appealing to current participants.

The distinction between 'front' and 'back' regions derives from a theatrical metaphor Goffman uses to assign role, function, and stage places to social actors in day-to-day life. 'Performers appear in the front regions and back regions; the audience appears only in the front region, and the outsiders are excluded from both regions.'[6]

For photographic strategies, the front/back distinction implies the variety of access routes photographers take into settings which, while public to a degree, demand special status from their members. Some examples are film production units on location in public and semi-public places and repair sites in subway tunnels. Both locales are back regions in settings made up of front and back, where photographers have attempted short-term status changes from audience to performer. Again, the goal is to maintain normal appearances, and in back regions this is managed in part by acquiring or pretending to appropriate status or by affiliation with a legitimate performer. For example, a photojournalist working on a feature story about the Philadelphia subway system was accompanied by a police officer, allowing her protection and entree to areas usually reserved for technicians and other officials. In another instance, a photographer's equipment choice reflects his interest in being identified as a denizen of the back stage:

> [On the sets] I used a 35mm, because it was one that I'd always used and I felt the most comfortable with it. It also was the one that the still photographer who was hired as part of the production crew used, so I seemed to be just part of the production crew in a way, or at least I felt more comfortable.

In front regions, special status is not required for access once admission to the 'audience' is secure, though special claims for the photographer's role are sometimes made to mediate between other features of the situation and picture-taking.

Photographers describe an ease in photographing among other photographers whose cameras are aimed at the same principal subjects. The group's activity absorbs or neutralizes the behavior of any one member; observation and photography are expected components of the situation. Settings that include a number of photographers can therefore be thought of on a continuum of access between those in which photographing is clearly an invasion requiring maximum negotiation and those designed and conducted to accommodate photographers – for example, press conferences. However, such a neutralizing effect varies depending on the nature and function of the setting or

event, be it festive or serious. In either case, the meaning of the camera in the setting changes, and with it the role identification of the photographer to other participants. At a festive event the photographer may be a reporter or specially equipped and appreciative spectator. In many instances she is an otherwise undifferentiated member of the crowd, depending on her participation in a variety of activities within the setting. At a political demonstration on the other hand, a new role for photographers is introduced, that of surveillance agent. For example:

> . . . photographing at the cruise-missile conversion project, people always ask me what I'm doing. . . . One time at a demonstration there was a man who was convinced without having spoken to me that I was a detective, and that I was doing some sort of surveillance or something. He was very snarky. He said something like 'Did you get that one? iDd you get the shot that time? Do they pay you by the shot or by the hour? Who pays for your film?' and those kinds of questions . . . he was convinced that I was working for some group that was trying to infiltrate or survey that group, and I just didn't say anything.

This sense of surveillance persists where photography poses the threat of personal identification or where people are generally concerned about security if not their personal identity. Conduct ordinarily considered unremarkable is contextually redefined. Threats to security are thus among the features that define a setting for a photographer. Where the possibility of posing such a threat is known, a photographer with normal appearances at heart can try to balance the situation through a variety of verbal or nonverbal means, generally declaring her intentions and not making any moves she feels would substantiate her subject's fear. In situations where the threat can't be anticipated, where she fails to anticipate it, or where it's ignored, a photographer may discover herself embroiled in that rare instance of non-compliance and be forced to restore the equilibrium or leave. If the picture is worth it, she may persist, depending on her sense of the likely consequences. A scolding is tolerable, being shot at isn't, though the forms of non-compliance are routinely more subtle than such consequences suggest.

Subjects

No group of people is categorically off-limits or of no interest to photographers. Still, a shifting set of characteristics among subjects invite photographers to take pictures in some instances, intimidate them in others, and modify their practice in most. The most salient among these characteristics are age, race, sex, apparent social class, situational mobility, engagement in instrumental activities, solitude or group membership, and role relation to the setting (e.g. as visitor, employee, passerby, performer, or victim).

A frequently photographed subject group (especially for amateurs) is made up of front-stage participants in a variety of formal and informal outdoor performances. Street musicians, parade marchers, craftspeople demonstrating their work, dancers, acrobats, and drill team members are familiar examples. Taking pictures of performers, photographers are usually among other spectators, making their presence and

attention unexceptional and in many cases a welcome and flattering sign of apprecia-tion. But even without a stationary audience – for example, in the case of the street musician who plays for money from passers-by – a person's engagement in focused activity often relieves a photographer of special negotiation. Characterized both by dis-play and engagement, such performances occupy the high end of an access continuum which diminishes as a subject's activity becomes less focused or more personal. This isn't to say that people who fall at the other end aren't photographed, but rather that different consequences are anticipated or different strategies employed, for example, using a telephoto lens. However, such an approach also depends on whether the subject is alone or with a group.

The photographers I interviewed describe photographing people in public places as a form of 'singling out' that sometimes requires an explanation or justification, espe-cially when it is clear to an individual that he or she is being isolated by the lens and where it's not apparent that he or she has special status in the setting (for example, as performer). But this too varies depending on the nature of the location. At well-populated festivities, few restrictions are felt to exist even when singling out individu-als. If the territory is uncrowded and the activity more private, care is required to avoid alarming subjects.

The situation is tempered further if the person is mobile, either walking, running, or riding a bicycle. Under these circumstances photographers anticipate that people are less likely to notice them, less likely to be sure they were the ones being photo-graphed, and less likely to interrupt their course in any event.

Demographically, normal appearances (and thus access) are sustained most smoothly when photographers work among people whose status or characteristics they share, particularly in settings that are racially, economically, or generationally seg-regated. (Photographing children is an exception. Children are thought to be less self-conscious about their appearance and less likely to anticipate the 'possible horrors' of photographs as they might appear in publication.) Though occupants of segregated areas can move amongst each other in integrated locations, a strong sense of toler-ance or intolerance upon entry into segregated territory is apparent to the newcomer whose race or economic status is different from the established community's. This is particularly true when he or she arrives as a mechanically equipped observer, prepared to leave with recorded images that probably don't reflect the community's sense of itself and which, most likely, its members will never see. Moreover, such features of a setting not only modify how photographers approach its residents, they often prevent photographers (particularly amateurs) from even considering that setting in the first place, depending on what and how much they know or believe about the place through experience or hearsay.

Strategies

The emphasis given to long-term projects by the photographers I interviewed sets up an initial point of access I call the entry point. Where entry to a setting is controlled (for example, by invitation, membership, or price of admission), a photographer has to get in before access to individuals becomes an issue.

In some cases entry is made through a sympathetic contact who provides a photographer with both passage and a personal introduction to individual subgroups. Entry is also made through official permission from an organizer or organizing body, allowing a photographer initial access and legitimate status thereafter. Finally, a photographer may be recruited to photograph particular aspects of an event and then extend his activity beyond his assignment.

Getting in is often a matter of fitting in where access to a setting is not restricted but where the population is well-defined. Appearing to belong, in terms of such immediately visible characteristics as age, sex, and dress can be enough to enter.

In situations that require entry moves, making them relieves photographers of a lot of subsequent negotiation. Once a photographer's position is established, individuals assume he's entitled to be there and he probably won't have to explain himself from subject to subject. This is not to say that having gained entry, photographers disregard the type and form of activity among their subjects – they don't, and here we shift from getting access to keeping it.

Fitting in is used to stay in a situation as well as to enter it, requiring a photographer's attention to how she looks and how she acts. This is particularly true among groups marked by conformity in appearance and conduct, be they businessmen at lunch meetings or teenagers at parties.

Particularly in small spaces a photographer's work is almost never concealed, but rather moves between non-concealment and declaration while remaining unobtrusive. His presence is known and acknowledged, though he rarely asks subjects to do anything for the camera. If and how people pose reflects their own preference, though is usually a conventional response to a photographer's declared intention to photograph (e.g. grouping for portraits or smiling).

Some photographers act like regular participants, working their way into subgroups within the setting as they might without a camera, treating it merely as an accessory. The following comment comes from an art photographer working on a project about upper-class teenagers in bars.

> I bought a Leica winder for my camera which advances the film, but it doesn't have the attachment for a flash bracket to fit onto the bottom, so if you use a flash, you have to hold it in your left hand, and hold the camera with the winder attachment in your right hand. I immediately realized the futility of a system like that for what I'm doing, because I want to be able to photograph with one hand, since I socialize with them all the time, my way of getting closer. So I have to hold a beer. Or a cigarette. My way to get close to them is I go up and say hey, can I have a cigarette? Okay. I smoke the cigarette and take their picture.

In still other instances, photographers render their activity as un-alarming as possible by remaining within a conventional role, in turn exploiting the authority that role is typically accorded. Several non-photojournalists, professionals and amateurs among them, describe a photojournalist's deliberateness as a good way to appear to belong when you don't engage as a regular participant in the ongoing activity. Journalists are said to look almost blasé about their work. They photograph constantly, then break, never appearing undecided about what their next picture will be. When they're not

working, they put their camera bags down and relax rather than glancing furtively from one person to the next. When something interesting occurs, they recognize it and take the picture, lending a purposive air to their activity rather than wandering aimlessly. To dramatize work or the idea of 'serious business' by taking on a journalistic style is useful only where a journalist's presence is unremarkable in the first place. Still, photographers cultivate those features of a journalistic approach that work in their favor without necessarily hoping to be identified as photojournalists.

Finally, photographers who wish to return to a setting over a period of time are careful to stop photographing from visit to visit when it becomes apparent they are no longer welcome. They notice individuals breaking away from small groups as they approach, or waning enthusiasm among people once eager to have their picture taken. To continue despite these signs can cost photographers co-operation or even admission next time around, therefore they rarely persist.

In open settings, where no specific entry move is in order and where access need be sustained momentarily, a different set of strategies comes into play. Here photographers stress the need to be fast and ready to shoot. This means either knowing your equipment well enough to reflexively control focus and exposure, or using a preset camera. It also means swift framing, sometimes at the expense of preferred composition, and agile though not necessarily speedy movement among people. The goal is to attract as little notice as possible, and fast maneuvering through a slow-moving crowd can provoke unwanted attention. Where the stakes are high and the risks great, photographers keep moving, exposing just a frame or two in any one spot. In this way they're able to minimize the duration of each encounter and thus the duration of their focused attention on potentially hostile subjects. However, most photographers also want to avoid appearing sneaky or suspicious. They carry cameras where they can be seen or use wide lenses that often require them to be close to their subjects. They effectively engage in what Goffman has called the 'overdetermination of normalcy,'[7] declaring their intentions to a degree that won't be interpreted as covert or suspect.

In open situations, photographers rarely offer subjects prior explanation of their activity unless they want them to adjust what they're doing in some way, unless they anticipate difficulty, or unless they need information, such as the subject's name for a newspaper caption. In these cases, photographers simply ask people if they mind having their picture taken, or they offer a brief explanation of why someone was selected in the first place. But even here, guided by the premises of photographic naturalism, photographers usually wait until after they've exposed the negative to explain themselves or ask permission, not necessarily telling their subjects that pictures have already been taken. The technique is to 'get in a few frames' before disturbing the event by asking questions. However, if things are happening quickly or an emergency is under way, photographers shoot first and ask questions later. Appearances are already not normal and expectations rearranged about what is ordinary conduct. The event is news and doesn't require delicate negotiation.

In the absence of constraints such as newspaper identification, photographers explain their activity only when subjects ask, though they may seek consent informally, in some cases a swift 'take your picture?' followed by an equally swift positioning of the camera and release of the shutter. More often, photographers let subjects see the camera at some point then wait for a sign of their approval. This may be a nod or smile; or it is simply inferred from the absence of overt disapproval.

Finally, those photographers who conceal their activity are usually after a particular kind of picture, though are sometimes concerned for their safety. Only in extreme circumstances do they try to hide their activity altogether, using very small cameras or very long lenses, or shooting from the hip. Rather, they simply avoid making it clear who is being photographed. Those members of a group who care to notice may realize an active photographer is present, without knowing that they are his subjects at any given moment. A common approach here is to point the lens away from the subject, pretending to photograph something or someone else until people no longer attend to the camera directed toward them. At the moment, the photographer can shift aim and expose.

Resistance

When photographers encounter resistance (any move on the subject's part that makes a photographer think she has to do more than just take the picture) they consider whether the photograph is worth it before persevering with unwilling or threatening subjects. If it is, they can take it and leave or stay and face the consequences. On the other hand, they may attempt to neutralize resistance so that no consequences remain to be faced. In the latter two circumstances photographers undertake 'remedial work'[8] in order to allay any fear, anger, or annoyance their subjects might experience. Simple requests for permission to photograph (tacit and explicit, verbal and non-verbal) are the common form of remedial work, and with the exception of the news photographer who shoots first and asks later, are usually made before the picture is taken. However, more labor-intensive forms are sometimes necessary. Again, the issue is access; photographers must judge whether co-operation is required and, if it is, what kind of account is needed to continue.

The most efficient communicative mode for remedial work is talk, and the kinds of remedial talk photographers engage in include explanation, elaboration, justification, flattery, and trivialization, each or all brought to bear depending on the photographer's sense of why the subject resisted in the first place. If a subject seems wary, the photographer may trivialize his activity, claiming, for example, to be taking pictures 'only' for himself, not for the newspaper or vice squad. If the subject seems to be shy, the photographer can try flattery. Indeed, many photographers report the tiresome frequency with which subjects respond to their declared intentions or to their requests by saying, 'Nah, it'll break your lens.' This is clearly a conventional response that may refer to a variety of types of self-consciousness quite apart from whether a subject thinks himself attractive. It is also a polite way of evading the picture, that is, without having to refuse the photographer directly. In either case, it requires the persistent assurance by the photographer that in fact the subject looks terrific and should consent to the exposure.

The flattery in this example may also constitute an elaborating move where it follows a permission request and thus becomes the second in a series of two or more remedial tasks, or an element in the process of remedial exchange. What is elaborated is the photographer's appeal for access, and in this sense every such move a photographer makes elaborates those made earlier. However, more specific elaborative talk extends on initial explanation by offering further detail concerning the photographer's motivation and purpose. For example, a newspaper photographer I interviewed approached

riders on the Philadelphia subway by introducing herself as a *Daily Planet* staffer work-ing on a subway story and explaining what it was about the subject that had caught her eye. At that point, she followed any resistance with an embellished description of the attractive feature, be it how the children's red plastic trains looked great against their navy coats, or how the gentleman holding his baby looked pleasantly calm amid the chaos of rush-hour. In turn, she followed these elaborations with another permission request and the photograph was rarely denied.

What is being elaborated upon in these examples is the initial explanation. Pho-tographers explain themselves in order to assure subjects that their motives are honest, benign, or exciting (witness the prospect of having one's picture published in a high-circulation daily). In the subway examples, the elaborated explanations serve in part to tone down the minor threat of singling out. They account for why a subject was chosen in the first place and help him overcome any mild suspicion he might experience about his selection. This can also be accomplished by describing the subject as a member of a class of subjects ('I'm photographing shoppers') or by displacing accountability for the choice ('My boss told me to,' 'It's a school project'). Such institutional affiliations (work, school) are also called upon to justify a photographer's actions under scrutiny.

An important issue relevant to all types of remedial talk is the potential for pho-tographers to fabricate their explanations. Some photographers make up stories as a way of getting around lengthy truths they feel would be meaningless to subjects, in exchange for terse and effective deceptions. They believe that as long as no harm will come to their subjects as a result of the photograph, it's okay to tell them whatever they seem to want to hear based on who they appear to be and how their apprehensions are expressed. From these photographers I got the sense that *they* considered their work and their photographs to be innocent and their subjects' suspicions unreason-able. Again, the emphasis is on getting the picture. However, even the most concerted efforts at remedial work are sometimes unsuccessful, and here photographers usually don't persist. Though photographers on the run often shoot despite a mild frown or left-to-right nod of the head, those who fail to get permission after an elaborated attempt rarely take the picture.

Conclusion: photography and privacy

What emerges from an account of photographic practice in public places is a con-tradiction between taking pictures and 'informed consent,' if by this phrase we mean consent without coercion given the consequences of taking and publishing a picture to the extent these consequences can be anticipated. In other words, there emerges a contradiction between consent to take and consent to use. In maintaining normal appearances, photographers downplay the intrusion or threat a camera represents, a practice clearly at odds with the discussion that would ensue were any subset of the potential outcomes of publication to be understood by photographer and subject. While photographers recognize this incompatibility, their practice is guided by the notion that 'you can decide not to publish, but you can never publish what you didn't take.' The practical emphasis is on getting the picture, and the ethical emphasis, where there is one, is on whether or not to publish it.

Not one of the photographers I interviewed, amateur or professional, reported ever using model releases for public photography. As a legal issue, the invasion for

privacy by photographic means is based on the non-consensual publication of a photograph for purposes of advertising or trade.[9] Generally, in the U.S. news photography and artistic exhibition are protected by the First Amendment. Among amateur public photographers, the legal right to privacy isn't an issue because their photographs aren't sold. Among professionals, it is rarely an issue because their photographs are used for technically 'editorial' purposes (in the case of news, documentary, and artistic publication).[10] Moreover, those photographers who have thought about consent consider model releases strictly in terms of their own protection and vulnerability to legal action. They are a way of 'covering yourself,' not a means of ensuring that the rights and concerns of subjects are respected.

Cast as a more broadly defined social issue, however, personal privacy is of concern to photographers, related to a subject's activity and his capacity to resist being photographed if he so chooses, or in other words, to his power. These two dimensions intersect whenever someone's activity renders him powerless to resist – for example, the victim laying prone at the scene of a car accident. For subjects in intimate, embarrassing, or grievous circumstances, some photographers consider it improper or cruel to intrude upon the situation at the moment or to create a record of private behavior that subjects would probably find undesirable or that might violate cultural norms. Even if there is nothing apparently grievous or embarrassing about the situation, it may deny participants the chance to present themselves to the camera in their 'best light,' according to prevailing standards of representation.

However, it is part of a professional photographer's socialization to overcome a reluctance to photograph in the face of grief or threat (conditions routinely encountered by photojournalists). Among fellow professionals, it is a sign of competence and reliability to be able to get pictures regardless of the circumstances, an ability seasoned photographers are assumed to possess and novices are rewarded for acquiring.

What the practical contingencies of public photography therefore suggest is the essentially exploitative relationship that prevails between photographers and subjects. Moreover, as long as professional photography continues as it is currently organized in the news, documentary, and artistic mainstreams, the likelihood of changing that relationship is small.[11] This is not to say that photographers are an unusually predatory group, for anyone whose work requires the participation of others who stand to gain little or nothing in exchange are similarly implicated, be they photographers, film-makers, or social-science fieldworkers. Despite some recent challenges (see note 10), existing privacy law is not designed to protect the public except against invasive abuses as they are commercially defined. Importantly, however, it is not only the 'abusive' photographers, the *paparazzi*, who exploit their subjects. It is instead a quality of the relationship that persists as long as photographers and their employers, not subjects, control the production of photographs. Some people, with more money and more power, are better able to intervene in this relationship, better able to inhibit access, maintain privacy, and take to task those photographers and publishers whom, for whatever reasons, they feel have trespassed. But this doesn't help the less-monied, less powerful person whose objections to being photographed are dismissed by the photographer working on assignment, or the person who might not object until some unanticipated consequence occurs after the picture is published.

Original publication

'Access and Consent in Public Photography' in *Image Ethics: The Moral Rights of Subjects in Photographs, Film, and Television* (1988).

Notes

1 This exploratory research combined field observation and in-depth, semi-structured interviews with fifteen photographers, representing the traditions of photojournalism and art photography. Henderson, Lisa. 1983. *Photographing in Public Places: Photography as Social Interaction*. Unpublished Master's Thesis, Annenberg School of Communications, University of Pennsylvania.

2 Goffman, Erving. 1971. *Relations in Public*. New York: Harper Colophon, pp. 40–1.

3 Becker, Howard. 1974. 'Photography and Sociology,' *Studies in the Anthropology of Visual Communication* 1(1), 3–26.

4 Goffman, 1971, op. cit., p. 239.

5 Goffman, 1971, op. cit., p. 286.

6 Goffman, Erving. 1959. *The Presentation of Self in Everyday Life*. New York: Anchor Doubleday, p. 145.

7 Goffman, 1971, op. cit., p. 256.

8 Goffman, 1971, op. cit., pp. 108–9.

9 *Galella vs. Onassis* is an important exception, where a photographer was held liable not for publication but for his aggressive conduct while photographing. For a good discussion of *paparazzi* photography in general and Galella in particular, see Sekula, Allan. 1984. 'Paparazzo Notes,' in *Photography Against the Grain: Essays and Photo Works 1973–1983*. Halifax: The Press of the Nova Scotia College of Art and Design.

10 However, in 1982 news photography was threatened by the New York State Court of Appeals ruling in partial favor of the plaintiff in *Arrington vs. New York Times Company et al.* Three years earlier, Clarence Arrington, a financial analyst in New York City, has sued the *New York Times*, Contact Press Images photo agency, CPI director Robert Pledge, and CPI freelancer Gianfranco Gorgoni for the non-consensual publication of a photograph of him in the *New York Times Magazine*. Unbeknownst to Arrington before hearing from a friend one Sunday morning, he'd been photographed by Gorgoni for the over illustration of an article 'Making It in the Black Middle Class,' an article he felt offensively misrepresented the attitudes of many middle-class blacks. Arrington's suit was dismissed in the State Supreme Court, though his complaint against CPI and its employees and directors was upheld on appeal. According to the appeals court ruling, the *New York Times* involvement with the photograph was for purposes of news and therefore not actionable, while the agency's involvement was for purposes of trade and therefore liable under state privacy law. Though the suit was finally settled out of court some two years later, the interim threat to freelance agencies and their photographers was widely felt. Either photographers would have to get signed model releases from all identifiable individuals in any photograph that would eventually be sold, or indemnify clients against claims of privacy invasion, both measures that would have radically altered, or destroyed, the freelance industry and publications dependent upon it.

11 Some photographers, notably members of oppositional groups, have tried to find ways of doing things more collaboratively. See, for example, JEB (Joan E. Biren), 1983. 'Lesbian Photography – Seeing Through Our Own Eyes,' *Studies in Visual Communication* 9(2), Spring, 81–96.

Sarah Kember

'THE SHADOW OF THE OBJECT'[1]
Photography and realism

> The question at hand is the danger posed to *truth* by computer-manipulated photographic imagery. How do we approach this question in a period in which the veracity of even the *straight*, unmanipulated photograph has been under attack for a couple of decades?
>
> (Rosler 1991: 52)

MARTHA ROSLER EXPOSES THE PARADOX which is at the heart of debates about the current status of photographic realism. Computer manipulated and simulated imagery appears to threaten the truth status of photography even though that has already been undermined by decades of semiotic analysis. How can this be? How can we panic about the loss of the real when we know (tacitly or otherwise) that the real is always already lost in the act of representation? Any representation, even a photographic one only constructs an image-idea of the real; it does not capture it, even though it might seem to do so. A photograph of the pyramids is an image-idea of the pyramids, it is not *the* pyramids. Semiotics is at large outside of the academy. It informs a variety of cultural practices including advertising and photography itself, and it may well have slipped along a chain of signifiers from Marlboro to Mazda into a collective cultural awareness. But it is not necessary to be a semiotician in order to know that photographs, much as we might choose to believe in them, are not 'true'.

This is a particularly thorny issue for photojournalists who have an ethical and professional stake in the truth status of the photograph and resort in some cases to semantic and logical gymnastics in order to defend it. Before the threat posed by new imaging technologies to photographic realism had become apparent, Harold Evans stated that: 'The camera cannot lie; but it can be an accessory to untruth' (Evans 1978, Introduction). In his more recent book addressing 'the coming revolution in photography', Fred Ritchin argues that photography is indeed an 'interpretation' of Nature, but one which remains 'relatively unmediating' and therefore 'trustworthy' (Ritchin 1990: 2). Ritchin

disavows his knowledge of photography as a language, a form of representation, in order to assert that computer imaging practices pose a fundamental threat to the truth of the image and indeed that they signal 'the end of photography as we have known it' (Ritchin 1991).

Following on from these issues, this essay sets out to do two things: first, to explore the paradox of photography's apparently fading but always mythical realism, and to suggest that the panic over the loss of the real is actually a displacement or projection of a panic over the potential loss of our dominant and as yet unsuccessfully challenged *investments* in the photographic real. These investments are social and psychological. They exist in the terms of power and knowledge and in the terms of desire and subjectivity. What I will argue is that the current panic over the status of the image, or object of photography, is technologically deterministic and masks a more fundamental fear about the status of the self or the subject of photography, and about the way in which the subject uses photography to understand the world and intervene in it.

The second aim of the essay is to examine the subject's social and psychological investment in photography in some detail and to suggest ways in which the reappraisal of photography brought about by technological change has made possible a different investment in the medium and a transformation in the terms of knowledge, power and subjectivity.

Digital iconoclasm – the pyramids, the Queen and Tom Cruise

Icons are doubly valued: for their realism, and for their reverence toward a sacred object. Traditionally, they are representations of Christ, angels and saints. Contemporary secular icons may include members of the Royal Family, politicians and film stars, and more often than not they are photographic. Photographic icons appear to be representationally faithful to the object, and photography is a cheap and efficient means of promoting secular-sacred objects for mass consumption.

Digital images would seem to be inherently iconoclastic – unrealistic and irreverent. Three instances of digital iconoclasm which I want to look at include: *National Geographic*'s manipulation of the pyramids at Giza, Benetton's blackening of the Queen's face and *Newsweek*'s unconventional portrait of Tom Cruise and Dustin Hoffman.

The Italian clothes company Benetton blackened the Queen as part of an advertising campaign which addressed issues of race. Prior to the publication of the image *The Guardian* reported that 'Her Majesty's nose and lips have been broadened in the computer-aided photograph, which will appear with the words "What if?"'. The newspaper also mentions the other photos due to appear in the Benetton catalogue *Colours*: 'the Pope as Chinese, Arnold Schwarzenegger as black and Michael Jackson and Spike Lee as white' (Saturday, 27 March 1993). The lack of amusement reported from Buckingham Palace was not overtly about the image itself, but about its use to promote products (presumably other than the usual Royal Family paraphernalia).

Ritchin discusses the issue of *Newsweek* which ran a feature on the film *Rain Man* and included an image of Dustin Hoffman and Tom Cruise apparently shoulder to shoulder in their camaraderie over their joint box-office success. Only their story and

sentiment seems fake when it emerges that the image was composited from two separate photographs:

> The actors were not together when the image was made (one turned out to have been in Hawaii and the other in New York). The caption, which simply read 'Happy ending. The two "main men" of "Rain Man" beam with pardonable pride', does not explain that this image was not the photograph it seemed to be.
>
> (Ritchin 1990: 9)

The actors' complicity in this fake, but not unusual, sort of image renders it iconoclastic for Ritchin, who also finds his belief in the facticity of the photograph and the immutability of the observable world 'extraordinarily shaken':

> Certainly subjects have been told to smile, photographs have been staged, and other such manipulations have occurred, but now the viewer must question the photograph at the basic physical level of fact. In this instance, I felt not only misled but extraordinarily shaken, as if while intently observing the world it had somehow still managed to significantly change without my noticing.
>
> (Ritchin 1990: 9)

The case of the moving pyramids is already well documented.[2] In February 1982, *National Geographic* published a 'photograph' of two of the pyramids at Giza on its front cover. The image had been digitally altered in order to obtain the required vertical format from the original horizontal format photograph. The alteration involved moving the two pyramids closer together. As Fred Ritchin points out, this move 'has been talked about a great deal in photojournalistic circles' (1990: 14) and the editor's reference to it as 'merely the establishment of a new point of view by the retroactive repositioning of the photographer a few feet to the side' (1990: 17), though totally credible, did nothing to lessen the talk. Despite the time-honoured and generally acknowledged tradition of manipulating or staging press and documentary photographs, this act of digital manipulation appears to have overstepped the ethical mark. Ritchin doesn't exactly specify why, but goes on to discuss the fate of the photographer's valued ability to capture the 'decisive moment' of a scene or event:

> The 'decisive moment', the popular Henri Cartier-Bresson approach to photography in which a scene is stopped and depicted at a certain point of high visual drama, is now possible to achieve at any time. One's photographs, years later, may be retroactively 'rephotographed' by repositioning the photographer or the subject of the photograph, or by adding elements that were never there before but now are made to exist concurrently in a newly elastic sense of space and time.
>
> (1990: 17)

Along with the decisive moment then, there seems to be a threat to the integrity of the original photograph, to the subject and object of the photograph, and to time

and space itself. For Martha Rosler 'the pyramids are the very image of immutability — the immutability of objects' (1991: 52). She is referring to natural objects, the object of Nature, and she goes on to ask what moving the pyramids 'as a whim, casually' (p. 53) tells us about ourselves:

> Are we betraying history? Are we asserting the easy dominion of our civilization over all times and all places, as *signs* that we casually absorb as a form of loot?
>
> (1991: 55)

If this is the case, then the looting of time and space, of places and objects, is what has become more apparent with the advent of new imaging technologies, and some photojournalists at least, don't like it. They want their external world to stay where they imagined it was, to be there for them (to represent). However, photography was considered to be the means of representing this reassuring world in which everything appeared to stay in its time, space and place.

The technical procedure for digitally manipulating photographs is also well documented[3] and is not of primary concern here, except in as far as a brief sketch serves to reinforce the sense of an object world made newly mutable. The process of manipulation then, involves scanning a photograph, translating it into digital information (or number codes) and feeding into a computer. On the computer screen the photograph is broken down into pixels, or picture elements — very small squares that can be changed individually or collectively. Colour and brightness can be changed instantly, and areas of the photograph can be either deleted or cloned. The borders of the image can be either cropped or extended and other images or text can be seamlessly incorporated. Whereas retouching a photograph by conventional means is time-consuming and detectable, these changes are immediate and effectively undetectable.

Techniques of scanning, sampling and 'electrobricollage' (Mitchell 1992: 7) differ fundamentally from the techniques of traditional realist photography where the impact of light onto film at one specific moment in time and space 'faithfully' records a scene or event for posterity. For Andy Cameron the new techniques and technologies of image-making transform photography from a modernist to a postmodernist practice (1991: 6). Mitchell also locates this transformation in the development of technology itself:

> The tools of traditional photography were well suited to Strand's and Weston's high-modernist intentions — their quest for a kind of objective truth assured by a quasi-scientific procedure and closed, finished perfection.
>
> (Mitchell 1992: 8)

But the most striking facility of new imaging technologies is their ability to generate a realistic image out of nothing — to simulate it from scratch using only numerical codes as the object or referent. Tim Druckrey gives the example of a press 'photograph' of a fighter plane crashing in Finland. Although there was a plane and it did crash, there was never a photograph as such. The image was simulated, assembled by a computer on the basis of eyewitness descriptions (Druckrey 1991: 17). The techniques which enable

'photographs' to be simulated also form the basis of other modes of image simulation including virtual reality. Here, the object world is not regarded as being simply mutable but totally malleable. It no longer exists as something exterior, but marks the realization of the subject's desire and imagination.

From a technologically deterministic viewpoint this malleability signals a revolution in image-making and the final demise of photography. If a completely simulated computer image, or even a digitally manipulated photograph can masquerade effectively as a straight photograph, then surely the authority and integrity of photography are always going to be in question? This is certainly so if you accept the prior existence of straight photography and an unmediated real, and if you only consider change wrought by technology itself. But photography is clearly much more than a particular technology of image-making. It is also a social and cultural practice embedded in history and human agency. Like any other form of technology it has neither determined nor been wholly determined by wider cultural forces, but it has had its part to play in the history of how societies and individuals represent and understand themselves and others. I agree with Kevin Robins that 'the question of technology . . . is not at all a technological question', and that new imaging technologies are informed by the values of western culture and 'by a logic of rationality and control'. This wider framework undermines technologically deterministic and apocalyptic claims and presents us with 'the continuities and transformations of particular dynamics in western culture' (Robins 1991: 55). Also, as Robins further points out, underneath the logic of rationality and control that informs the development of technology there are 'powerful expressions of fantasy and desire' which reveal the presence of the subject behind the rhetoric of objectivity (p. 57).

According to Mitchell, the alarm occasioned by digital imaging is the result of a breakdown of the boundaries between objectivity and subjectivity, causality and intentionality:

> The smug apartheid that we have maintained between the objective, scientific discourses of photography and the subjective, artistic discourses of the synthesized image seemed in danger of breaking down.
>
> (Mitchell 1992: 16)

He states that 'the distinction between the causal process of the camera and the intentional process of the artist can no longer be drawn so confidently and categorically' (p. 30). What the loss of such a distinction signifies is not only an instability in the terms of photographic representation, but an instability in the epistemological foundations of photography – its structures of knowledge and thought. What is more, epistemological uncertainty undermines the stability of the subject.

I can't think therefore I don't know who I am

> We have faith in the photograph not only because it works on a physically descriptive level, but in a broader sense because it confirms our sense of omnipresence as well as the validity of the material world.
>
> (Ritchin 1990: 132)

Realist photography is traditionally informed by a scientific system of thought fashioned in Enlightenment philosophy and by Cartesian dualism and perspectivalism. Cartesian thought splits and privileges the mind over the body, the rational over the irrational, culture over nature, the subject over the object and so on along an infinite chain which continues to structure Western epistemology. Feminist work on philosophy, epistemology and the history of science has established that these dualisms are value-laden and specifically gendered.[4] The female body of nature emerges as a symbolic construct in Bacon's writings[5] and serves as the object of scientific inquiry (and of the rational, masculine scientific mind). Nature, in Bacon's account, is at times quite an elusive object, and he employs a rhetoric of domination and control in order to demonstrate the process by which scientific knowledge is to be obtained. Nature must if necessary be 'forced to reveal her secrets' – and even 'raped'.[6] Bacon's use of language exposes the fault lines of power and desire which underlie and ultimately threaten his apparently value-free, neutral method of scientific inquiry.

Inductivism is a means of acquiring knowledge through detailed observation and experimentation in the natural world. It is opposed to deductivism – a method of trying out preconceived ideas, of testing a hypothesis, of imposing a theory rather than exposing a fact. Inductivism was Francis Bacon's preferred method because it was a supposedly truer method of gaining knowledge about the natural or object world. But it is clearly not commensurate with the use of force. Inductivism is premised on a passive, willing, submissive sort of Nature, but it is clear that Bacon's concept of it was fundamentally split. The presence of such a split in his theory is perhaps not surprising since Nature, for Bacon, had symbolically acquired a female body, and the female body in Christian discourse was either pure or impure.

Ludmilla Jordanova has identified the eroticism of images and metaphors of unveiling in early modern science and particularly medicine (1989: 89). Nature, personified in the body of a woman, is figuratively unveiled or undressed before science (p. 87). Female corpses are stripped of their skin in anatomical drawings and paintings (p. 104). Dead or inert Nature is unveiled. Wild or untamed Nature is subjected to a greater force of power and desire because it takes more effort to master and threatens to deny mastery altogether. Nature, for science, was always an unstable object, encompassing elements of elusiveness and availability which somehow could not be held together in one image, but became split off in an attempt to divide and rule.

Bacon's inductivism was one of a number of seventeenth-century scientific developments which marked a major epistemological shift away from the holistic world view of the Middle Ages. Elsewhere, I have referred to this as a shift from an analogical to an anatomical world view, and one which encompasses the 'discoveries' of Copernicus and Vesalius.[7] What these explorers in outer and inner space discovered is that the geometry of what Burgin calls 'classical space' (Burgin 1990) could not be upheld. Microcosm and macrocosm do not accurately map each other or the universe, and as Leonardo da Vinci found out 'the veins of the centenarian were in fact not a bit like the rivers of Tuscany' (Kember 1991: 58). The geometry of classical space is the geometry of concentric spheres where earth and man are the stable focus point of a closed and complementary system. The geometry of classical space is displaced by that of modern space, and this takes the form not of concentric spheres but of the 'cone of vision' (Burgin 1990). Imagine a circle within a circle, then imagine occupying the inner circle and looking outwards. The cone of vision represents the way you see when you take up your

previously figurative position at the centre of the universe. You see space extend infinitely from the fixed point of your eye. For Burgin, the Euclidean geometry of the cone of vision maps out 'the space of the humanist subject in its mercantile entrepreneurial incarnation' (Burgin 1990: 108). This space is not infinite, however – it only appears to be. Modern space reaches an end point; it implodes and is reformed in postmodern space 'traversed by electronics' (ibid.).

The authority of photographic realism is founded on the principle of Euclidean geometry (the cone of vision) and on the application of scientific methods to forms of social life. When light is refracted through the lens of a camera the cone of vision is inverted – just as it is through the lens of the human eye. This is how we obtain focused images.

Victor Burgin points to the connection between Euclidean geometry and the concept of perspective in the history of art (Burgin 1990: 106) and in an article on the politics of focus, Lindsay Smith states that 'in histories of documentary photography, "focus" has been instrumental in confirming a belief in the sovereignty of geometrical perspective' (Smith 1992: 238). The focused image is geometrically and therefore optically 'true'. It is an 'authoritative mapping of the visual' (ibid.). Smith points out how 'a deconstruction of the "truth" of documentary . . . has grown out of a recognition of the historical, material, ideological and psychic complexities implicit in Barthes' now familiar coinage, "the evidential force of the photograph"' (ibid.). But she remains critical of recent photography theories which fail to recognize the instability in the optical truth status of photography since its inception in the nineteenth century. She is also critical of how these theories remain unaware of the gender politics of focus in early photographic practice. They seem to her to tacitly accept that in the nineteenth century the ungendered, universal humanist subject was unproblematically centred in the field of photographic vision. She is referring in part to the work of Allan Sekula and John Tagg who have used Foucault's concepts of surveillance and control to problematize and politicize the scientific status of nineteenth-century medical and legal photographs, and social documentary photographs of the 1930s.

It seems to me that the crucial term which displaces and then effectively replaces the authority of geometrical perspective in Foucauldian accounts of nineteenth-century photography is not as much panopticism as positivism. The panopticon is an architectural model which comes to structure and universalize the operations of the camera. But positivism is the philosophy behind panopticism, and one which structures and universalizes the operations of the human eye and the human subject in its quest for knowledge. Positivism (after Comte) holds that the (inductivist) methods of the natural sciences may be transferable to the social or human sciences. Like the sciences it derives from, positivism assumes the unproblematic existence of an observable external reality and a neutral, detached and unified observing subject. The sovereignty of this universal humanist subject is centred and affirmed in positivism through the retention of Cartesian hierarchical dualism.

Positivism is regarded as photography's originary and formative way of thinking. It appears to transcend historical and disciplinary boundaries and constitute the stable foundation of realist and documentary practices. I have suggested that the gendered and unconscious relation between the photographer and photographed can be seen to destabilize both epistemology and subjectivity, not least through the constitution of the photographed object as a fetish (Kember 1995). Similarly, Lindsay Smith outlines

the existence of 'difference in vision' in the nineteenth century and demonstrates how a gendered politics of focus and a variation in practice enacts 'a critique of the ahistorical, "disembodied" subject perpetuated by "Cartesian Perspectivalism"' (1992: 244). She compares the work of Julia Margaret Cameron with that of Lewis Carroll and finds that whereas Cameron contests the authority of focus and 'the ideology of perceptual mastery' (p. 248), Carroll retains the authority of focus and thereby 'mobilises processes of fetishism' (p. 256) as a defence against the object which threatens him with the loss of his own power and authority (a loss symbolized by the threat of castration).

Smith is careful to acknowledge that Foucauldian debates on nineteenth-century photography apply only to specific institutional practices such as medicine and law, but is right to insist that they are nevertheless woefully ungendered and fail to give an account of contesting practices or dynamics. (Sekula does problematize the authority of optical realism however.) This, I would add, is largely a facet of the uncomplicated importation of Foucault's early monolithic and also ungendered account of power and the docile body.[8] What this use of Foucault fails to do for photography theory is to give an adequate picture of the instability in the terms of photographic realism and its positivist and humanist base that was always already there.

Foucault exposes the ideology of positivism and humanism and provides an invaluable critique of the Enlightenment with his formulation of knowledge as power. But this formulation is frequently represented in photography theory as an almost unshakable formula of perceptual mastery and control. However, the gendered and unconscious relation between observer and observed, knower and known constitutes an inherent weakness in the formula, a weakness manifested through sexual difference and through fear and desire.

Psychoanalysis provides a means of inquiring into the unconscious aspects of subjectivity and for Adam Phillips, a psychoanalytic theory 'is a story about where the wild things are' (1993: 18). It is undoubtedly problematic as 'a fiction which functions in truth' (Walkerdine 1990) and as one wrought with the hierarchical binaries and gender discriminations. But I would maintain that it is nevertheless the most illuminating story about the wild things like fear and desire which by comparison are inadequately accounted for elsewhere. And I support the call of Haraway and others not only to persist in our consideration of psychoanalysis as a story, but to dare to imagine new and better ones.[9]

Fetishism is a resonant concept within psychoanalysis and one which originates in Freud's story of castration and the Oedipal complex. Fetishism is a scopic mechanism of defence based on the male child's identification of the mother's body as castrated. He defends himself against the threat of castration by creating a fetish object. The fetish object serves as an unstable defence – as both a compensation for and a reminder of the terrifying space of absence. Fetishism may be tied to the Oedipal and to the concept of the female body as lack but it can be reconceptualized through alternative psychoanalytic stories and it is useful as a means of discussing other objects, cultural objects, which are used as a way of defending the subject against a perceived threat, or of compensating the subject for a felt or imagined loss.

A photograph can be, and has been regarded as one such object.[10] Photography, as Susan Sontag now famously stated, 'is mainly a social rite, a defense against anxiety, and a tool of power' (1979: 8). Family photographs 'restate symbolically, the imperilled continuity and vanishing extendedness of family life' and tourist photographs 'help

people to take possession of space in which they are insecure' (p. 9). They are not only forms of power-knowledge but also reactions to fear (Phillips 1993: 18). They supply the 'token presence' (Sontag 1979: 9) of that which is lost or absent, and 'give people an imaginary possession of a past that is unreal' (ibid.). They are able to do this by means of their status as small, tangible, collectable objects.

Yet photographs are fragile not only as material objects 'easily torn or mislaid' (Sontag 1979: 4), but as compensatory or fetish objects:

> Photographs are a way of imprisoning reality, understood as recalcitrant, inaccessible; of making it stand still. . . . But. . . . To possess the world in the form of images is, precisely, to reexperience the unreality and remoteness of the real.
>
> (1979: 164)

So the photograph as an object which contains the subject's conscious and unconscious investments in the external world both embodies and shatters the realist enterprise and its positivist and humanist baggage. At its most grandiose, says Sontag, the photographic enterprise gives us 'the sense that we can hold the whole world in our heads' (p. 3), but this same enterprise generates objects that remind us that the whole world only ever exists in our heads.

What happens in the transition from analogue to digital photography is that this reminder is underlined, the constructedness of the real becomes far more visible. One response to this increased awareness is a re-fetishization of the photographic image-object as evidence.

In this context, it is clear that despite his acknowledgement that 'photography's relationship with reality is as tenuous as that of any other medium' (Ritchin 1990: 1), Ritchin finds it fundamentally reassuring in its facility of 'confirming human perception in the quasi-language of sight' (p. 2). He also makes it very clear that once this apparent confirmation is removed, the subject can be left with a considerable amount of anxiety. While travelling on the New York City subway, Ritchin imagines that the advertising photographs inside the train are 'unreal' and that 'everything depicted in them had never been'. The result is quite striking:

> As I stared more, at images of people in business suits, on picnics, in a taxi, I became frightened. I looked at the people sitting across from me in the subway car underneath the advertisements for reassurance, but they too began to seem unreal. . . . I became very anxious, nervous, not wanting to depend upon my sight, questioning it. It was as if I were in a waking dream with no escape, feeling dislocated, unable to turn elsewhere, even to close my eyes, because I knew when I opened them there would be nowhere to look and be reassured.
>
> (Ritchin 1990: 3)

Ritchin finds that he is trapped in his own head, unable to rely on what he sees to confirm his or another's existence in the external world. His anxiety about what is real is experienced as a feeling of 'dislocation', and it is experienced psychologically and emotionally.

It is then apparent to him that an image which depicts something that has never been (that has no connection with the external world) is a projection, a facet of desire

and of the subject's interior world rather than of the exterior world of objects. And what is worse: 'the viewer cannot tell what is being depicted and what projected' (1990: 5). Ritchin encounters both fear and desire in the experience of new imaging technologies, and in the perceived loss of photography's epistemological and psychological certainties.

In response to his experience, he seems to go in two different directions. On the one hand he is willing to accept the projective status of the image in general, and to envision a reappraisal of the photograph as an image-statement which the photographer is made newly responsible for. On the other, he seeks to reinstate the photograph as depiction. As a photojournalist he is concerned to maintain the integrity of photographic practice, and such a concern tends to lead to a re-fetishization of the photograph as evidence. But there is also a concern in Ritchin's work – one which is related but somehow separate – to maintain the integrity of a certain experience which is unique or essential to photography. This can be described as 'a sense of being there' (Ritchin 1990: 116) – or as affectivity.

The aesthetic moment – photography as a transformational object

Ritchin is not alone in his presentation of Vietnam war photography as having a special status in the history of photojournalism. Photographs of Vietnam were images 'that contradicted official thinking and challenged the legitimacy of the American-sponsored war'. They preceded a time when 'greater corporate control was exerted on publications' (Ritchin 1990: 42). He is referring to a set of images which are still widely known and reproduced:

> A little girl running from napalm, a Buddhist monk self-immolating, a member of the Viet Cong being summarily executed, a grieving widow crying over an anonymous body bag.
>
> (p. 42)

Susan Sontag compares this impact of photographic images of the war with television coverage and suggests that photographs are more memorable than moving images 'because they are a neat slice of time, not a flow' (Sontag 1979: 17) and can be kept and pondered over. She says that photographs like that of the South Vietnamese girl sprayed by napalm 'running down a highway toward the camera, her arms open, screaming with pain – probably did more to increase public revulsion against the war than a hundred hours of televised barbarities' (p. 18).

Photography's status as a portable object is a means to both avowal and disavowal, memory and forgetfulness. According to Sontag, what sticks in the memory does not filter into sustained political and ethical consciousness because photographs offer only uncontextualized, fragmented bits of information:

> The camera makes reality atomic, manageable, and opaque. It is a view of the world which denies interconnectedness, continuity, but which confers on each moment the character of a mystery. Any photograph has multiple

meanings; indeed, to see something in the form of a photograph is to encounter a potential object of fascination.

(Sontag 1979: 23)

These war photographs then, deliver a short, sharp but undirected shock. They resonate in the subject's memory but perhaps more at an unconscious than at a conscious level. What they capture becomes mysterious and they become objects of fascination. It may be said that the photographic image is not merely memorable but that it mimics memory:

> It is easier for us, most of the time, to recall an event or a person by summoning up a single image, in our mind's eye we can concentrate on a single image more easily than a sequence of images. And the single image can be rich in meaning because it is a trigger image of all the emotions aroused by the subject.
>
> (Evans 1978: 5)

This affective capacity of the photograph may be accidental or sought after. In *Camera Lucida* Barthes describes his own exploration and experience of what he calls the power of 'affect' (p. 21) which functions as the essence or 'aesthetic moment' (Bollas 1994) of photography. In order to arrive at this essence or to experience the aesthetic moment Barthes finds that he must reject all means of classifying the image (for example aesthetically as 'Realism/Pictorialism' (Barthes 1980: 4)) and all theoretical disciplines, including semiology which he was so central in establishing. Barthes declares his 'ultimate dissatisfaction' with critical language (p. 8) and so resolves to 'make myself the measure of photographic "knowledge"' (p. 9). 'What', he asks, 'does my body know of Photography?' (ibid.).

Barthes experiences the power of affect in his being – more in his body than his mind, and more in emotion than in thought. The affect is ultimately non-verbal: 'what I can name cannot really prick me' (p. 51). The power of affect in photography seems to derive – perversely – from the 'Real' that critical languages can reason away but cannot finally expunge from the subject's experience of photography. That is, we can *know* the impossibility of the real in representation (as Barthes clearly does) but we can nevertheless *feel* its presence. And here I agree with one of Ritchin's final points that:

> The photograph, held up as the more efficient inheritor of the replicating function, has survived the advent of Freud and semiology; its reputation for fidelity remains largely intact in the popular imagination.
>
> (Ritchin 1990: 143)

But perhaps it is intact at a level other than that of knowledge and understanding. The action of knowledge is, for Barthes, a secondary action but a photograph 'in effect, is never distinguished from its referent (from what it represents), or at least it is not *immediately* or *generally* distinguished from its referent' (Barthes 1980: 5). Barthes chooses the term 'punctum' to describe the immediacy of a photograph's effect on him. The punctum is that element of the photograph that does not belong to language or culture, and it is more accidental than sought after: 'It is this element which rises

from the scene, shoots out of it like an arrow, and pierces me' (p. 26). As the punctum can be a detail or 'partial object' it shares some qualities of the fetish, but it becomes apparent in the context of the affect Barthes seeks from a photograph of his mother, that he is seeking something more like avowal than disavowal, more like memory than forgetting. In this case, the photograph is functioning as something other than a fetish object for Barthes.

Barthes wrote *Camera Lucida* shortly after his mother's death, and shortly before his own. Ostensibly, he seeks a photograph of his mother which will enable him to disavow her death, and in a sense, bring her back for a moment:

> There I was, alone in the apartment where she had died, looking at these pictures of my mother, one by one, under the lamp, gradually moving back in time with her, looking for the truth of the face I had loved. And I found it.
>
> (p. 67)

What he found was a photograph of his mother aged five, taken in 1898. She was standing in a conservatory or 'Winter Garden' with her brother and 'holding one finger in the other hand, as children often do, in an awkward gesture' (p. 69). Here Barthes 'at last rediscovered my mother' (ibid.) in one true or 'just image' (p. 70).

Even if this photograph does function in some way as a fetish object, it also functions more profoundly as what Christopher Bollas terms a 'transformational object'. A transformational object is one through which the adult subject remembers 'not cognitively but existentially' an early object experience (Bollas 1994: 17). The object here is the infant's primary love object – the mother. What stimulates this memory is an 'intense affective experience' or an 'aesthetic moment', and what is being remembered is 'a relationship which was identified with cumulative transformational experiences of the self' (ibid.).

So the mother is the original transformational object, and it is the infant's transformational experience of her that is sought through the adult's search for subsequent objects which may, according to Bollas, take the form of the analyst or of the aesthetic experience of 'a painting, a poem, an aria or symphony, or a natural landscape' (p. 16) – or presumably a photograph.

The concepts of the transformational object and of the aesthetic moment shed a new light (not an Enlightenment light) on our not altogether rational insistence on the separateness and integrity of an object world. Not only do 'our individual and collective sanities' depend on it, as Bollas suggests, but there are occasions when we actively seek the moment when we feel with 'absolute certainty' that we have been 'cradled by, and dwelled with, the spirit of the object' (Bollas 1994: 30). Such moments are 'fundamentally wordless' and they are 'notable for the density of the subject's feeling and the fundamentally non-representational knowledge of being embraced by the aesthetic object' (p. 31). Despite Barthes' attempts to put his experience of the Winter Garden Photograph into words, as it were retrospectively, the experience itself is wordless and so unique to him that he sees no point in reproducing the photograph in his book.

Because aesthetic moments are non-verbal, or rather pre-verbal, they constitute part of what Bollas terms 'the unthought known'. That is, they are part of the essential or 'true self' which is known but has not yet been thought – brought into consciousness

and into representation. The transformation which the subject seeks through a trans-
formational object or an aesthetic moment, is of the unthought known into thought.
And this transformation occurs when the shadow of the object falls on the subject, or
when the mother's presence is felt.

For Barthes the maternal replaces (is exchangeable with) the real, or the referent.
Nature, the object and the female body are (still) aligned, but the relation he seeks with
them is originary and undifferentiated. It is not caught up in the dualistic terms of
knowledge and representation. It is symbiotic, not split and hierarchical – an encoun-
ter with origin that facilitates a certain evolution, a transformation of the self and of
the unthought known into thought.

Barthes' search for the place where he has been is related to his concern with 'that-
has-been' – a quality which he considers to be essential to photography. He reproduces
a photograph of an old house in Grenada where he would like to live (pp. 38, 39). He
describes this 'longing to inhabit' as 'fantasmatic, deriving from a kind of second sight
which seems to bear me forward to a utopian time, or to carry me back to somewhere
in myself' (p. 40). Landscapes like this give him a certain sense 'of having been there or
of going there' which he relates to Freud's 'heimlich' (ibid.) and the uncanny.

The Winter Garden Photograph presents him with the mother-as-child, and it is
the experience of his dying mother as being like a child which seems to transform and
bring into thought Barthes' sense of his own death. Shortly before he found the Win-
ter Garden Photograph, Barthes nursed his weak and dying mother. He tells how 'she
had become my little girl, uniting for me with that essential child she was in her first
photograph' (p. 72). This experience of her as his 'feminine child' provided him with a
'way of resolving Death' (ibid.). Childless himself, he had engendered his mother, and
'once she was dead I no longer had any reason to attune myself to the progress of the
superior Life Force (the race, the species). . . . From now on I could do no more than
await my total, undialectical death'. This, he says, 'is what I read in the Winter Garden
Photograph' (p. 72).

I am suggesting then, that for Barthes (in *Camera Lucida*) the photograph has a dual
function. It is (at once) a fetish object and a transformational object (the two may be
closer together than they appear in Oedipal terms). The photograph is also the means
by which the shadow of the object understood as the real (and/as the mother) falls on
the subject. The moment in which the shadow of the object falls on the subject may be
understood as the aesthetic moment of photography, and the affect of this moment is
of a transformation of the unthought known into thought.

It may be said that this transformative experience of the self based on an uncanny
encounter with the real has been at the heart of our persistent (but irrational) faith
in photography. It is a faith which precisely cuts across our more rational investments
in, and our knowledge about, the truth status of photography – because it is placed
in a real located ultimately in our own interior worlds rather than in an exterior one.

I have argued that digital images pose a threat to our investments in photographic
realism. These investments are in a sense of mastery and control over the object world
which is secured (unsafely) by positivism, and conversely in a transformative experi-
ence of the self which occurs in a non-hierarchical relationship to the object world.
Because positivism obscures the presence of the subject in photography, its guarantees
and reassurances are ultimately illusory and were always already lost. Positivism is, it
would seem, a faulty way of thinking which maintains that the real is representable

rather than experiential – located in the exterior world rather than the interior world of the subject. Our investment in photography as a transformational object is an investment in our experience of the real, and it implies a different, non-positivist, way of thinking. This other way of thinking which is latent in our experience of photography as a transformational object is, of necessity, coming nearer to being thought through our experience of digital images, and our awareness of their constructedness.

Digital images may be regarded as partial rather than universal forms of knowledge, and as image statements rather than truths. Ritchin recognized that they may become newly authored and situated in language and culture (Ritchin 1990: 88, 99) and that they 'represent both openings to new knowledge and an invitation to its constriction' (p. 144). In her reappraisal of the epistemological foundations of science and technology, Donna Haraway argues that only partial knowledge guarantees objectivity (Haraway 1991: 192). Similarly, when he acknowledges the possibility of a radical reappraisal of image-making, Ritchin maintains that images should be a means for 'exploring territories that exist independently of us' (1990: 146) and wonders whether we will 'use photography to respect and value the complexity of the other, whether another person, place, people, idea, or the other that exists in ourselves?' (ibid.).

An epistemological shift in the terms of image-making involves a transformation in the relationship between the subject and object of the image, or between the self and other. The object is no longer understood as being wholly separate from the subject, but retains an equivalent status and integrity. This subject-object relation is inherent in our experience of photography as a transformational object and it may be continuous, I would argue, with a reappraisal of photography in the light of digital imaging.

Original publication

'The Shadow of the Object: photography and realism' in *Textual Practice*, 10/1 (1996).

Notes

1 C. Bollas, *The Shadow of the Object: Psychoanalysis of the Unthought Known* (London: Free Association Books, 1994).
2 See, for example, F. Ritchin, *In Our Own Image: The Coming Revolution in Photography* (New York: Aperture, 1990), and M. Rosler, 'Image simulations, computer manipulations, some considerations', *Ten. 8 Digital Dialogues. Photography in the age of Cyberspace*, vol. 2, no. 2, 1991.
3 See W. J. Mitchell, *The Reconfigured Eye: Visual Truth in the Post-Photographic Era* (Cambridge, MA: MIT Press, 1992).
4 See particularly S. Harding, *The Science Question in Feminism* (Ithaca: Cornell University Press, 1986), and D. Haraway, *Simians, Cyborgs and Women* (London: Free Association Books, 1991).
5 See M. Jacobus, E. Fox Keller and S. Shuttleworth (eds), *Body / Politics: Women and the Discourses of Science* (London: Routledge, 1990).
6 See C. Merchant, *The Death of Nature* (New York: Harper & Row, 1990).
7 S. Kember, 'Medical diagnostic imaging: The geometry of chaos', *New Formations*, no. 15, 1991.
8 M. Foucault, *Discipline and Punish* (London: Allen Lane, 1977).

9 See D. Haraway interview in C. Penley and A. Ross (eds), *Technoculture* (Minneapolis: University of Minnesota Press, 1991), p. 9, and A. Braidotti, *Nomadic Subjects. Embodiment and Sexual Difference in Contemporary Feminist Theory* (New York: Columbia University Press, 1994).

10 C. Metz, 'Photography and fetish', *October*, 34, cf. Ch. 16 in this volume, pp. 138–45 [Ed.].

Bibliography

Barthes, R. (1980) *Camera Lucida*, Flamingo, London.

Bollas, C. (1994) *The Shadow of the Object: Psychoanalysis of the Unthought Known*, Free Association Books, London.

Burgin, V. (1990) 'Geometry and abjection', J. Fletcher and A. Benjamin (eds), *Abjection, Melancholia and Love: The Work of Julia Kristeva*, Routledge, London.

Cameron, A. (1991) 'Digital dialogues: An introduction', *Ten. 8 Digital Dialogues. Photography in the Age of Cyberspace*, vol. 2, no. 2.

Chaudhary, V. (1993) 'Benetton "black queen" raises palace hackles', *Guardian*, Saturday, 27 March.

Druckrey, T. (1991) 'Deadly representations', *Ten. 8 Digital Dialogues*.

Evans, H. (1978) *Pictures on a Page: Photojournalism, Graphics and Picture Editing*, Heinemann, London.

Haraway, D. (1991) *Simians, Cyborgs and Women*, Free Association Books, London.

Jordanova, L. (1989) *Sexual Visions: Images of Gender in Science and Medicine Between the Eighteenth and Twentieth Centuries*, Harvester Wheatsheaf, Brighton.

Kember, S. (1991) 'Medical diagnostic imaging: The geometry of chaos', *New Formations*, no. 15.

Kember, S. (1995) 'Medicine's new vision?', M. Lister (ed), *The Photographic Image in Digital Culture*, Routledge, London.

Mitchell, W. J. (1992) *The Reconfigured Eye: Visual Truth in the Post-Photographic Era*, MIT Press, Cambridge, MA.

Phillips, A. (1993) *On Kissing, Tickling and Being Bored: Psychoanalytic Essays on the Unexamined Life*, Faber & Faber, London.

Ritchin, F. (1990) *In Our Own Image: The Coming Revolution in Photography*, Aperture, New York.

Ritchin, F. (1991) 'The end of photography as we have known it', P. Wombell (ed), *Photo Video: Photography in the Age of the Computer*, Rivers Oram Press, London.

Robins, K. (1991) 'Into the image: Visual technologies and vision cultures', P. Wombell (ed), *Photo Video: Photography in the Age of the Computer*, Paul & Co., New York.

Rosler, M. (1991) 'Image simulations, computer manipulations, some considerations', *Ten. 8 Digital Dialogues*.

Smith, L. (1992) 'The politics of focus: Feminism and photography theory', I. Armstrong (ed), *New Feminist Discourses*, Routledge, London.

Sontag, S. (1979) *On Photography*, Penguin.

Walkerdine, V. (1990) *Schoolgirl Fictions*, Verso, London.

Chapter 34

Hilde Van Gelder and Jan Baetens

INTRODUCTION
A note on critical realism today

TWENTIETH-CENTURY ART, both in its modernist and postmodernist or – if one prefers – in its avant-garde or post-avant-garde paradigms, is at odds with realism, at least with the term. Realism seems incompatible with the basic features of what creative work and thinking in art is supposed to achieve: a distance toward reality itself, which art is not supposed to reproduce but to contest, to transform, and to supersede. Realism appears to go against the grain of a contemporary refusal of the canonical ways of presenting and representing (perspective in painting, narrative in literature, melody in music, and so on). Art should be a constant challenge to explore the boundaries of the not yet known and realism does not seem to serve this project. Realism, therefore, is often relegated to the museum of – in the eyes of current thinking – pre-modern styles and devices, safely locked in the toolbox of 19th-Century art history.

Yet modern societies are always divided. It should therefore not come as a surprise that 20th-Century art has been marked by a strong current or undercurrent of realism. Some avant-garde and modernist authors have deliberately claimed their commitment to reality, whereas certain postmodernist authors and artists have been trying to catch the 'signs of the times'. Moreover it is not exaggerated to argue that, probably under the double pressure of formalist exhaustion on the one hand (since the late 1960s, roughly speaking) and the explosion of virtual disembodiment of culture on the other hand (more or less since the last decade), realism is making a solid comeback, both in the art world and in society at large.

It is however mistaken to infer from the persistence of a word –'realism'– that it is one and the same thing or practice that bridges the gap between traditional and modern art (provided of course one accepts the dichotomy between tradition and modernity, but that is another story). The very notion of realism has indeed been radically redefined, in verbal as well as in visual frameworks or environments. One might say, although this is an oversimplification, that the concept of realism has undergone a series of dramatic changes.

First of all, technically or formally speaking, realism is no longer restricted to the implicit connotation of 'photographic realism': the 19th-Century model of detail realism as the production of a mechanical replica, no longer holds, either in literature, or in the visual arts. On the contrary, for those eager to maintain a realist stance in art today, realism is never simply reproductive (mimesis), but productive: it is the invention of new ways of representing the real, which always takes the risk of appearing utterly unrealistic, until these new styles become hegemonic, then stereotyped, and finally . . . unrealistic once again. Second, the notion of realism has shifted from the art-object to the attitude of the reader or the spectator, for whom a work appears to be realistic if it reflects their ways of seeing and thinking reality, instead of directly reflecting reality itself. Third, realism itself is no longer a period label; it has itself been historicized, so that we have, instead of one realism, a full-fledged history of variegated and competing meanings, interpretations and assessments of the concept of realism. It is of course in this perspective that one has to examine the notion of 'critical realism'.

One of those who coined the concept was Georg Lukács, in his perhaps quixotic attempts to save realism from the attacks of the avant-garde. For Lukács, art *is*, i.e. *ought to be* realistic, many modernisms falling prey to shallow and hollow formalisms which often reflect reactionary politics. This is an argument that has become rather widespread in post-World War II attacks on interwar modernism as well as from the artistic anti-model of socialist realism. For Lukács, art cannot – nor should it – be separated from a class perspective and therefore socialist realism may not be wrong in se.

But there were other uses of the term 'critical realism' and therefore other meanings. One of the major challenges of the concept is of course the difficulty – some might say the impossibility – of combining the adjective 'critical' and the noun 'realism'. For 'critical' is, in art theory, so strongly determined by the influence of the Frankfurt School and its 'critical philosophy', that it is not easy to reconcile the basic stance of transparency supposed by most types of realism with the Frankfurters' modernism and the violent anti-realism it implies. Theodor Adorno's art theory, for instance, is impregnated with the idea of negativity and anti-representation, not to speak of the conflict between the mostly democratic tendencies of realism and the Frankfurters' elitism, which discards all realism as vulgar populism. Critical realism, which is today often closer to the pole of the 'critical' than to the pole of 'realism', continues to be linked to avant-garde, formalism, and iconoclasm, and the two traditions rarely meet. Engaged literature and art have been using rather formulaic devices for many years. In their most radical form, they simply do not care about forms, for art being seen as just one more type of political action is not something that should be assessed on aesthetic or formal grounds. Seen from this perspective the meaning, of a form is measured by its political impact, i.e. its capacity to generate social change. On the contrary innovative literature or art tends to be discarded and debunked as fetishistic, anti-social and even anti-democratic.

It has been the merit of some 'enlightened' contemporary artists to bridge the gap between both worlds and to maintain the stance of commitment in art forms that do not accept the necessity of using and reusing too well-known forms in order to achieve a well inclined and broad audience, while being applauded at the same time for reasons which might be called politically correct. Allan Sekula's work is one of the most salient of such projects. His work features a number of characteristics whose combination makes it unique: Sekula's iconography rediscovers and reinvents the theme of labor, which had become completely outdated and artistically impossible after socialist

realism. His photos, on the edge between art and documentary, and thus creating a kind of proto-documentary, reflect on the possibilities for the visual arts today to deliver an 'act of criticism', as his fellow-American artist Martha Rosler has named it. The oeuvre of Allan Sekula, internationally known as one of the most prominent artists engaged in this debate, allows us to discuss the ways art can be critical about contemporary social questions without succumbing to a plain or overtly partial political statement. What comes to the fore as crucial in order for artistic images to avoid the trap of the slogan or propaganda, is the way they succeed in employing their metaphorical potential.

Critical realism, as we understand it, is a practice, a research method rather than an artistic style. It is a way of seeking to understand the social reality by critically 'making notes' of it. The visual comments artists such as Allan Sekula communicate to their public, are inscriptions and traces of the reality surrounding us, dialectically generated through the paradoxes of that reality and as such reflecting its contradictions. They bring questions to the foreground, without offering readymade answers, well aware as they are that clear answers are not to be found anyway. Yet, as scratches of reality, Sekula's photographs and films leave their traces in our minds. They encourage, yes, even force reflection, and through that, slow changes can probably become a reality, certainly at the level of the individual.

Photography – for many different reasons but especially because of its causal relationship to reality (its indexicality) – today appears as the best instrument to realize those ambitions, as many of the contributors to this book have asserted. Even after the so-called digital revolution, the photo is a material, tangible form of communication between the image and the reality it visually displays. The photo digs its critical potential out of this privileged relationship to reality; it really has something to say about it because it arises out of it. In this the strength and potential of photography is situated today. Photography, when conceived in this way, testifies to an attitude, an artistic way of approaching reality, whereby the artwork is not only the result of a committed process of investigation but also an actual, personally experienced record of it. In this search for the deliverance of visual information about the reality surrounding us, photography does appear to be a medium. Medium here is no longer to be understood in modernist, autonomist terms of self-definition but rather in terms of a method that researches reality rather than aspiring to reinvent an updated realist style. What the method does, is not trying to find its own very essence, but rather its boundaries and limits as a technique that aspires to do as best as possible what it can do: analytically and critically reflect on the reality it aspires to fathom.

Thanks to Sekula's work, realism has become once again critical (which it had been in the very beginning of the concept: in the 18th Century, realism meant social critique and satire), without resigning the experimental aspects of the creative process. The very method of the work enables it to link its realist content with all the questions that proved so crucial for 20th-Century avant-garde: the dialogue with an active audience, the limits of a medium, the social impact of art, the very distinction – and even more the very refusal of the distinction – between art and life.

Original publication

'A Note on Critical Realism Today' in *Critical Realism in Contemporary Art* (2010).

Lynn Berger

THE AUTHENTIC AMATEUR AND THE DEMOCRACY OF COLLECTING PHOTOGRAPHS

Perhaps because of his very artlessness, and his very numbers, this name-less picturetaker may in the end be the truest and most valuable recorder of our times. He never edits; he never editorializes; he just snaps away . . . all the while innocently freezing forever the plain people of his time in all their lumpishness, their humanity, and their universality.

(Graves 1977)

While everything would lead one to expect that this activity, which has no traditions and makes no demands, would be delivered over to the anarchy of individual improvisation, it appears that there is nothing more regulated and conventional than photographic practice and amateur photographs.

(Bourdieu 1990 [1965])

A Parisian photo-booth

THE YOUNG MAN IS THIN AND WIDE-EYED. He wears an old-fash-ioned helmet and drives an old-fashioned moped through the historic city center of Paris. He is mysterious and, like most mysterious men, does not speak much. Late at night he appears in public spaces – train stations, say, or shopping malls – scavenging around that late-nineteenth-century invention called a photo-booth. With the aid of a ruler, tweezers, and utter patience he rescues, from the garbage and the cracks, those photos that the sitters did not want to keep. He straightens them if creased, restores them when torn, and pays them tribute by gluing them in old-fashioned photo albums that he carries around in an old-fashioned bag on his old-fashioned moped.

If one day this young man should lose one of his albums, this happens of course only for it to be found by a thin, wide-eyed, mysterious young woman, who then embarks on a quest to find him. If one day they should finally meet, this happens only for them

to live happily ever after, cruising Paris together on his old-fashioned moped – for this is a movie, not life.

But even if this mysterious savior of thrown-away photographs is a figment of Jean-Pierre Jeunet's imagination, realized in his 2001 hit film *Le Fabuleux Destin d'Amélie Poulain*, that does not mean such people don't really exist. In fact, there are many res-cuers of photographs out there, searching for pictures near photo-booths or on the street; in drugstore labs or attics; at flea markets and in estate sales. Alternatively, they might get them off other people's memory sticks or photoblogs – this is, after all, the twenty-first century. Those rescuers might glue their found photographs in old-fashioned photo albums, or they might print them in coffee-table-worthy books with titles like *Photo Trouvée* or *Anonymous*.[1] They might exhibit them at renowned photogra-phy festivals like the one in Arles, France; or in first-class art institutes like the Getty Center in Los Angeles or the National Gallery in Washington. Or, they might publish them on news sites or accumulate them in digital archives, accessible to anyone with a computer and an Internet connection.

The photo-finders will refer to themselves as artists or curators, editors or collectors – often, as an unclassifiable mixture. Depending on their self-described sta-tus, the archives of found, anonymous photographs they produce will be labeled works of art, exhibitions, projects, or studies – or something in between.

Departing from an understanding of the amateur photographer as an "innocent naïf," and of his snapshot as "authentic," the brothers and sisters of *Amélie*'s myste-rious collector "revise the distinction between author and audience," as the cultural critic Walter Benjamin wrote, in a different context, seventy-five years ago. Turning "consumers . . . into producers – that is, readers or spectators into collaborators,"[2] their archives become political statements that embody the workings of democratic societies, and that downplay the professional in favor of the supposedly "disinterested" amateur. The twentieth century has greeted photojournalism and art photography with postcolonial critique and a postmodern "crisis of representation"; digitization and the camera-equipped cell phone define the beginning of the twenty-first. The stage is thus set for a new kind of witness to enter the scene: the amateur photographer. Closer inspection reveals, however, that he is not really all that new – nor, for that matter, all that "authentic."

Found photography

One of the real-life alter egos of *Amélie*'s scavenger of photo-booths is the London artist Dick Jewell, who, in 1977, published *Found Photos* – a collection of discarded pictures he had gathered from around photo-booths in English cities. In 2002, Los Angeles-based curator Babette Hines produced *Photobooth*, another book of photo-booth pic-tures, this time found in people's attics rather than on the street. The focus of German artist Gerhard Richter, who started his *Atlas* project after he moved from East to West Germany in 1961, was less narrow: his grids of "second-hand" photographs include found amateur snapshots as well as magazine clippings and postcards (currently, this ongoing project contains approximately 4,000 images, grouped together on more than 600 panels).[3] One early panel, for example, shows twenty-eight photographs from family albums that all picture leisure activities. In one image, a group of women is

sitting in the grass, smiling at the photographer; in another, a group of young men and women play acrobats at the beach.

While Richter's *Atlas* serves among other things as a study and inspiration for his paintings, he has a colleague for whom collecting found photographs is both means and end: the artist Joachim Schmid, also German, whose project *Bilder von der Straße* started in 1985 and continues today. Schmid's practice is rather straightforward: he finds pictures on the street, repairs them the best he can if they are torn or ripped, and archives them chronologically, based on the date they were found. Galleries and museums interested in displaying Schmid's archive are asked to submit a list with random numbers, upon which they receive the corresponding photographs. The result in an exhibition might be that the flash-lit picture of a little girl wearing a birthday hat is hung next to the torn, and then carefully put back together, picture of a sunbathing girl; which in turn sits next to the tossed out photo-booth image of a balding, white man with an empty gaze. Thus placing the found photo at the heart of his artistic practice, Schmid at once emphasizes the anonymity of his found photographs and the role that chance and randomness play in his work. As such he challenges a more traditional view of the artist as an identifiable, authoritative, and deliberate *auteur* – a view that, if anything, would exclude precisely such concepts as randomness, chance, and anonymity.

The pictures in *Bilder* range from creased photo-booth pictures to snapshots of women who pose next to their car, to photographs with the gaping, square holes that are left when a person's head is cut out of a picture – like the smile of a child with a tooth missing. Comparable, but more politically charged, is *Album* (1996) by the Irish artist Patrick McCoy, which contains damaged and discarded photographs found on the streets of Belfast. Although McCoy has repaired the pictures, the marks of breaks and scratches are still visible; in some cases, the people in the photographs are almost entirely washed away by damage from water or fire, giving the album a sense of loss and violence that is absent from the work of Schmid or Jewell.

Since 2001, Dutch art director Erik Kessels has been publishing *In Almost Every Picture*, a series of handsome little books with anonymous photographs found at flea markets, showing for example the same middle-aged woman in different holiday-like settings; photographs taken by a taxi driver of one particular passenger; or two identically clad twin sisters posing in various times and places, growing up through the Second World War, until one of them finally disappears from the frames. *In Almost Every Picture* was also exhibited at the 2007 photography festival *Les Recontres d'Arles*, where an entire program section had been devoted to "vernacular photography" – that broad term that is used to describe the kind of common, everyday photography practiced by amateurs, or by professionals outside the realms of art and journalism, such as portrait and commercial photographers.

The terrorist attacks on Manhattan's World Trade Center and the Pentagon in Washington, DC, on September 11, 2001 gave rise to two photographic projects that were, in a way, quite similar to those of "found photography" artists such as Jewell, Schmid, and McCoy: *Here Is New York: A Democracy of Photographs* and *The 9/11 Photo Project*.[4] In both cases, days after the attacks, a downtown gallery storefront became the publicly accessible archive of 9/11-related photographs, submitted by New Yorkers both professional and amateur.

Here Is New York ended up featuring about 4,000 photographs on the theme of 9/11, printed on 11 × 17 in. (28 × 43 cm) sheets of paper, and attached, casually,

with binder clips to metal wires. Photographs of the twin towers clouded in smoke. Photographs of people gazing upward, and of hands covering mouths in disbelief. Photographs of the ruined site; of firemen; of Bill Clinton visiting Ground Zero; of flags; of "Missing" notes, of shrines. Last year, a selection of approximately 1,400 such photographs was on view at the New York Historical Society — the anonymous pictures covered the walls of the society's two large galleries and danced, like washing-line laundry touched gently by the wind, on the metal wires above the visitors' heads.[5]

As *Here Is New York* demonstrated, there are *photos trouvés* with sources less innocent than flea markets and Parisian photo-booths. After 9/11, there was the hunt for Osama Bin Laden in Afghanistan, which segued into the war in Iraq. With that war came an archive of "found" amateur photographs that reached iconic proportions in an instant — for who today does not have engraved, in some mental place or other, the image of a hooded Iraqi prisoner, standing on a box and attached to electrical wires, having been told that he would be electrocuted if he fell off?[6] The CD-ROM with pictures that emerged from the military prison at Abu Ghraib gained worldwide attention and caused nearly as much outrage in the West as it did in the Middle East.

The photographs' iconicity on the one hand, and their visual "style" on the other, stood in striking contrast — for the tortures perpetrated by American soldiers at Abu Ghraib were photographed in a highly casual, even sophomoric way. Indeed, the manner in which those soldiers were smiling and pointing, posing thumbs-up next to their naked or hooded victims, was almost indiscernible from frat party pictures on any given Facebook account.[7]

If anything, the Abu Ghraib archive's amateurish, snapshot-like quality probably gave it a credibility in a way that no photographic evidence provided by professional photojournalists could ever have — especially given the testy relationship between the Pentagon and the national press at that time. For it was not uncommon in those days for military officers to complain that there was "no coverage of the good news from Iraq. . . . The focus is on violence. . . . Reporters cannot or will not get out and about in Iraq and tell the whole story. Editors and reporters are biased" (Shanker 2008:A13). When the official media are seen as susceptible to fraud, and professional journalists as biased, the fact that a nonprofessional insider is the bearer of bad news can only strengthen the impact of his message.

It was again the amateur status of soldiers-with-digicams that led editor Devin Friedman of *GQ* magazine to produce a less politically sensitive album of their personal snapshots: *This Is Our War*, a hefty, full-color album of pictures solicited from American soldiers serving in Iraq — who, it turns out, consider their digital point-and-shoot cameras or cell phones to be equipment as standard as their helmets and their guns.[8]

This is Our War, published in 2006, contains hazy, camouflage-colored desert shots of soldiers next to army vehicles and airplanes, talking strategy, chatting, or taking a break. Many a picture was taken through the window or the rearview mirror of an armed vehicle, on the road or in the desert. There are group portraits, of one unit after another, each of them showing confident, broad-shouldered, uniformed men — squinting, always squinting. Guns, many guns — but also guitars, pets, and destroyed sites. Saddam statues and soldiers sleeping, or lazing in their barracks, pass in view.

Desert-like and desolated landscapes appear, too, in the photographs of the *Border Film Project*, an undertaking in which anti-immigrant "minutemen" and illegal immigrants on both sides of the US–Mexico border were given disposable cameras and

prestamped envelopes and were asked to photograph their experiences. The cameras were sent back anonymously, and the nearly two thousand pictures – stored in an online archive, exhibited in various galleries, and printed in a compact hardcover for sale in museum bookstores as well as in all branches of the hipster clothing chain American Apparel – are meant, according to the project's website, to "show the human face of immigration, and . . . challenge us to question our stereotypes and to see through new and personal lenses." A challenge, apparently, that professional documentation of this same phenomenon does not provide.

And so on, and so forth; if you know where to look, artists, journalists, and collectors who work with (relatively) anonymous amateur photography are everywhere to be found. On the one hand, the practice seems aided by the digitization of photography, which has facilitated the taking, transmission, and public storage of great numbers of photographs.

Yet at the same time, the emphasis on amateur photographs signifies a widespread skepticism toward professional photographers and news organizations, as well as to what digital photo manipulation software at such professional hands can do. In 1990, on the eve of digital photography's breakthrough, the critic and editor Fred Ritchin, for example, saw "a revolution in image-making underway that is beginning to remove the accepted certainties of the photograph" (Ritchin 1990: 4). In Ritchin's doomsday view, the application of the computer's manipulating abilities to photography meant that people's trust in journalism was in for a steady decline.

To be sure, the public's trust has not – thus far – deteriorated as much as Ritchin feared.[9] Unbelievable and horrifying as the behavior they depicted was, hardly anyone questioned the veracity of the Abu Ghraib photographs *as such*, to name but one example. Indeed, at a time when Photoshop and other picture manipulation software programs are desktop shortcuts on nearly every household computer, and well-nigh everyone is familiar with the forgery that even "respectable" media can engage in – like, for example, *National Geographic* in 1982, when it electronically moved the pyramids of Giza closer together for them to fit on the cover, or *Time* in 1992, when it darkened the skin of O.J. Simpson in the mugshot they put on their cover – the default mode of the general public still is to accept most photographs as "true" – even those with subject matter that defies both the senses and standard conceptions of humanity and civilization.[10]

Apparently digitization, while important, is not a sufficient, and perhaps not even a necessary condition for today's "cult of the amateur."[11] In fact the roots of working with found and anonymous photographs date back at least fifty years, and art-historical precedents can be found as far back as the nineteenth century.

Amateurs and professionals

Let's call *Amelie*'s collector of orphaned passport pictures an artist, and his artistic method the finding, and recycling, of images that already exist. Then his is a method that says something about the artist's (in)ability to produce original images – and in fact, his method isn't all that original either. For the trick has been done before: Marcel Duchamp's readymade sculptures, or Andy Warhol's Brillo boxes spring to mind. And while it is true that the practice of working with found photography *as* found

photography did not really come into its own until four decades ago, and did not go viral until the 1990s,[12] amateur photographs have featured in artistic practice pretty much since the 1878 invention of dry gelatin plates, and the 1888 introduction of the user-friendly and relatively cheap "You Press the Button, We Do the Rest" Kodak cameras that propelled the growth of amateur photography.[13]

To be sure, the democratization of photography brought about by technological innovations and Kodak advertising was not met with enthusiasm exclusively. Alfred Stieglitz, founder of the Photo Secession and a champion of artistic photography, wrote in *Scribner's* in 1899 that "The placing in the hands of the general public a means of making pictures with but little labor and requiring less knowledge, has of necessity been followed by the production of millions of photographs."[14] As a result of this "fatal facility," photography had "fallen into disrepute," as "the popular verdict finds all photographers . . . 'fiends.'"[15] Also, as privacy laws did not yet exist, enthusiastic amateur photographers could snap anyone's picture and sell prints in shops or on the streets — right at a time when there was a craze for photo postcards, portraits, and *cartes de visite*: small, pocket-size photographs with a portrait that people sold or traded, much like baseball cards today.

For it was "above all . . . the photographic portrait that captured the enthusiasm of the general public and, from the earliest daguerreotypes to the present, the portrait has remained the most popular of photographic genres," as Miles Orvell wrote in *American Photography* (Orvell 2003: 19). Indeed, in Paris in the nineteenth century, "there began to be as many portraits displayed in the shop windows along the . . . boulevards as there were people in the milling crowd" (Chevrier 1986: 9–15) — and in New York, the amateur photographers who were snapping and selling such portraits at will eventually made people feel so exposed and vulnerable that a number of lawsuits and court appeals finally initiated legislation about the right to, and protection of, privacy (Mensel 1991: 21). Still, some amateurs actually managed to make good money by selling their photographs of celebrities, politicians, or people from the working classes (Mensel 1991); a situation not unlike that of today, when amateurs submit their photographs to online "microstock" agencies, which sell them to publications at rates much lower than those of stock agencies working with professional photographers, but with still enough profit to make it worthwhile for the contributing amateurs (Zalchman 2007).

With all this going on, it should not be surprising that the artistic avant-gardes of the turn of the century took an interest in the rapidly growing medium as well. Cubist painters such as Picasso and Braque had done pioneering work by incorporating newspaper illustrations and picture postcards into their collages; a practice that later fed into the development of photomontage by artists of the Berlin Dada circle. Meanwhile, Surrealist artists in France and elsewhere sought those random juxtapositions and recontextualizations that could turn even completely banal and prosaic snapshots into triggers for the mind to lapse into that so beloved space between wakefulness and dream: surreality. Surrealist journals such as *La Révolution Surréaliste* and *Minotaure*, for example, featured ordinary snapshots that the artists found at flea markets during their wanderings and strolls through the old city center of Paris (Phillips 1989: 65–108).

So, the stage was set, and subsequent artists working with found photography would strip the amateur snapshot ever more, laying it ever more bare. Surrealism lifted the snapshot out of the photomontage, but still presented it in a theory-heavy, artistic

context. By contrast, the found photography archives that emerged in the second half of the twentieth century focused more and more on the amateur photograph *as such*, celebrating precisely its nonartistry and its banality.

Rather than incorporating their found photographs in, or aligning them with, professional or art photography, artists such as Schmid, Kessels, and Hines propose them as *alternatives to* such professional work; and, in most cases, as better alternatives at that.

In a foreword to Dick Jewell's *Found Photographs*, for example, Martin Schouten wrote that, given that no professional photographer is involved in the making of a photo-booth portrait, "only the photo-booth is truly objective. Only in the photobooth do you not get things to do with intention, foreknowledge or the making of a striking image" (Jewell 1977). (Curiously, Schouten seemed oblivious to the fact that the absence of a professional photographer does not automatically imply the absence of intentions and the desire to make "a striking image" on the part of the sitter.) And curator John Weber wrote about Joachim Schmid that "At its heart, Schmid's work expresses a quiet but persistent skepticism about the central role assigned to art photography and what we might call 'high journalism' as documents of human photographic culture" (Schmid 2007: 11).

Interestingly enough, the institutions that for a long time functioned as harbors of precisely this kind of art photography and high journalism – the academy, the museum, and news organizations – are opening their doors to amateur photography with an enthusiasm matching that of artists who open their oeuvres to it. With amazing ease and speed, the amateur photograph marches into the canon and into the highest regions of the visual culture establishment.

Canonization

Found photography archives began emerging in the late 1960s and 1970s – a time when, in the academic world, there was a "revival of history from below," and historians started zooming in on "everyday life and everyday consciousness," rather than telling top-down political histories.[16]

From the late 1980s onward, historians of photography such as Geoffrey Batchen, Joel Smith, and others suggested that photographic history move away from art-historical models, and focus on vernacular photography instead.[17]

And in recent years, as terms like "visual culture" and "media society" have become commonplace, scholars who previously worked with textual documents only are turning their gaze onto the visual as well. Indeed, last summer the *Journal of American History* devoted an entire issue to photography, with many of the essays either studying amateur photographs or urging historians to do so.[18]

The Museum of Modern Art in New York was the first art museum to establish a department of photography, in 1937. Many critics have faulted MoMA for equating the history of photography with the history of art; for imposing on the medium a modernist, formalist canon; and for ignoring other photographies (such as amateur photography, say);[19] but it was actually also the first art museum to exhibit amateur photographs.

In 1944, the Department of Photography organized "The American Snapshot: An Exhibition of the Folk Art of the Camera." This exhibition, containing some 350 snapshots taken in the United States from 1888 to 1944, with subject matter ranging from

"home and family pictures" to "pets and animals" and "travel and scenic photographs," was initiated by the Eastman Kodak company, which paid the production costs of the exhibition as well.[20] But even if the show – which went on a traveling tour across the country for almost two years, received coverage in major publications such as *Look* and *The Christian Science Monitor*, and attracted, in its first weeks in New York, an average of 10,000 visitors a week – was a great advertising stunt for the company, the museum functioned as more than just a host; art-historical and ideological considerations tied in as well.

"The basic strength of America stems from the solidity of each family group," Willard D. Morgan, then MoMA's director of photography, wrote in his exhibition proposal. "I am certain that the familiar snapshot deserves tremendous credit for preserving the memories and relationships even though a family may be scattered to all parts of the world." And, he continued:

> There is sometimes a tendency on the part of more experienced people to belittle the snapshot as a photograph. These pictures would never have a chance to pass by the dogmatic salon judge. I feel that the dead walls of judgment . . . should be changed when it comes to evaluating the spontaneous free spirit which is so often expressed in the personal snapshot.
>
> (Morgan 1944)

Although the United States was still entangled in the Second World War, foreign politics went virtually unmentioned in the communication surrounding the exhibit; yet such references to families "scattered" around the world, "free spirit," and the democratic, accessible nature of snapshot photography ("There are no limits or restrictions to who can make a picture," Morgan also wrote in his proposal, "practically anyone can use the snapshot camera of today"), were politics' back door entrance.

If "The American Snapshot" set an example, it was one that other art museums would not follow until the late 1990s. The San Francisco Museum of Modern Art, in 1998, showcased "Snapshots – The Photography of Everyday Life," a series of nostalgia-evoking photographs made by anonymous amateurs. It was around this same time that art collectors and dealers discovered the amateur photograph as well, as prices for professional art photography went through the ceiling, and vernacular photographs seemed like an original and affordable alternative.[21] This led to further collaborations between collectors and museum institutions in the ensuing decade; the Metropolitan Museum of Art organized an exhibition of snapshots from Thomas Walther's collection in 2000; the Boston University Art Gallery took its turn in 2004 with "In the Vernacular: Everyday Photographs from the Rodger Kingston Collection," and this was also the year that the LA Getty Center organized "Close to Home: An American Album"; and last year, the National Gallery in Washington worked with collector Robert Jackson to mount "The Art of the American Snapshot." Overall, such exhibitions would celebrate both the vernacular and everyday nature of snapshots, as well as their unexpected, accidental creativity and aesthetic and artistic value: "Although usually taken by an untrained eye, and often violating rules of good design and composition, family snapshots can succeed brilliantly because they are the product of pure instinct and because they represent endlessly fascinating combinations and variations of everyday life," the press release to Close to Home read.

Elsewhere, collectors put out anthologies of their own; the Austrian photographer-turned-collector Christian Skrein published *Snapshots–The Eye of the Century* in 2004, and a smaller collection with *Funny Snapshots* a little later. Also in 2004, art collector R. F. Johnson published *Anonymous: Enigmatic Images from Unknown Photographers*, and the French historian of photography Michel Frizot printed his collection of found photos in *Photo Trouvée*, in 2006. The publications all contain idiosyncratic, sepia-toned pictures, sometimes accidentally double-exposed, oddly cropped or beautiful in their banality, allowing for Surrealist experiences as well as quiet meditation on memory, or fantasies about the lives behind those photographs.

Citizen journalism

Around the same time that museums and universities began taking a heightened interest in amateur photography, digital technology and the Internet allowed for the emergence of related archives, stemming this time from a journalistic or democratic impulse rather than an artistic one; *This Is Our War* and the *Border Film Project* are but two of many examples. If, after all, the 1970s were marked by an interest in "history from below," then the current era, with user-generated content and Web 2.0 technology, is the age of "bottom-up" access to knowledge and cultural artefacts. Dreams of a digital, all-encompassing "universal library" occupy the mind of many an Internet geek and scholar (Grafton 2007: 50–4), while the digitization of photography is often considered such a liberating and democratizing force that in February of last year, the Swiss Musée de l'Elysée organized "We Are All Photographers Now" – an "event, experiment and exhibition" about "the rapid mutation of amateur photography in the digital age."[22] Inviting amateurs, professionals, curators, and editors to participate (i.e., to submit their photographs), "We Are All Photographers Now" revolved around the question of whether "the digital revolution [has] tilted the field of battle irrevocably in the amateur's favor."

The show at Elysée exemplified how the "new archivists in town" find their pictures not in the cracks of cobblestone streets or the garbage cans alongside photobooths, but on the memory sticks, personal websites, and cell phones of today's digitally equipped amateur.[23]

As citizen journalism, "comprised of blogs and news sites that rely on small armies of amateur reporters and eyewitnesses with cell phone cameras to deliver news online," comes of age, professional news organizations feature an increasing amount of amateur photographs on their printed and online pages (Mintz 2007). In February and March of 2007, news agencies Associated Press and Getty Images began partnerships with citizen journalism websites NowPublic.com and Scoopt.com, respectively; and meanwhile, weather channels use photographed sunsets and snowstorms that people from across the country have submitted.

To be sure, the phenomenon is not quite as novel as the current hype suggests. For example, the beating up of Rodney King by L.A.P.D. officers in 1991 made the news by way of a videotape shot by an amateur bystander; earlier, footage of John F. Kennedy's assassination had come largely from amateur bystanders as well.

In fact, already as far back as 1923, the Soviet Union established the "Worker- and Farmer Correspondent Movement"; a network of citizens who contributed – on

a voluntary basis and from all over the Union – to a journal that addressed itself to workers and farmers in a clear, nonliterary way. It also enrolled approximately 100,000 amateur "photo-correspondents" to take care of the visual propaganda, under the motto "Every photo-amateur a photo-correspondent!" (Guski 1978: 94–104; Sartoti 1978: 105–12). In a similar vein, Professor Evan Cornog of the Columbia University Graduate School of Journalism recounts that in the 1990s, one of Hong Kong's largest circulating newspapers, the *Apple Daily*, equipped pizza deliverers in the city with cameras, reasoning that it would be easier to teach such amateurs how to take photographs, than to teach professional photographers how to drive around the city fast enough for capturing all important news events.

Democracy

The democratization that "We Are All Photographers Now," and other supporters of citizen journalism so celebrate, lies in the increased access to picture-making and publishing technology. But when it comes to amateur archives, "democracy" comes in other guises as well.

The relationship between professional journalism and democracy goes way back – democratic societies are after all governed by the choices and decisions of their citizens; and it is through information provided by the press that such choices can be informed ones. Photojournalism, therefore, is generally understood to "underwrite liberal-democratic public culture," as John Lucaites wrote in the *Rhetoric Review* in 2001: "The practice of photojournalism operates as a political aesthetic . . . that provides crucial social, emotional, and mnemonic resources for animating the collective identity and action necessary to a liberal-democratic politics" (Lucaites 2001: 38).

Here Is New York was called "a democracy of photographs" because anyone, amateur or professional, could submit their work; the photographs had no captions or credit lines, and were therefore equally anonymous and equally worthy. This harked back to the idea of photography as a democratic medium – "a photograph has only one language and is destined potentially for all," Susan Sontag wrote in 2003 (Sontag 2003: 20); also, as the sociologist Pierre Bourdieu observed in 1965, "One might say of photography what Hegel said of philosophy: 'No other art or science is subjected to this last degree of scorn, to the supposition that we are masters of it without ado'" (Bourdieu 1990 [1965]: 5).

Moreover, even if some of the individual photographs in *Here Is New York* might not, in themselves, be visually all that compelling or interesting, it was the combination of *so many* of them[24] that really made the project; a whole that was more than its parts, just as a democratic society is more than the mere sum of its citizens.[25]

Similarly referring to a whole that is more than its parts, curator John Weber wrote of Joachim Schmid that his work "rests on small components and gestures that accumulate emotional intensity and visual scale only when combined. As Schmid observes, 'Five pictures from the street are rather uninteresting, but fifty are interesting and five hundred are extremely interesting. The quantity adds to the quality" (Schmid 2007: 18).

On the occasion of 2006's midterm elections, the nonprofit organization Design for Democracy launched the *Polling Place Photo Project* – asking Americans to photograph the place where they voted. The aim, through the mere accumulation of thousands upon

thousands of photographs, was to create "an archive of photographs that captures the richness and complexity of voting in America"[26] – a complexity and richness peculiar to a democratic society, that the efforts of a single professional photographer apparently never could have captured (with the 2008 presidential campaign in full swing, the *New York Times'* website has in fact adopted the *Polling Place Photo Project*).

On yet another note, the historian Miles Orvell accounted for the appeal of the (then) new medium to Americans in the nineteenth century by saying that "The camera has been the prime instrument for self-representation, capable of fashioning an image for public consumption *in a democratic republic* where personal identity and national identity were always to be invented and reinvented" (Orvell 2003: 13). And meanwhile, the photographic portrait was considered, "by its very nature and affordability, the emblem of a democracy" (ibid.: 21).

The politics of portraiture

Had the young photo-booth collector in Jeunet's film lived a hundred years earlier, people might have read his chiseled face as indicative of a poetic personality, and his wide eyes as mirrors to his soul. Toward the end of the nineteenth century, physiognomy – that pseudoscience according to which the assessment of a person's outer appearance provides insight into his character, closely related to the shape-of-head reading propagated by phrenology – was widely accepted both in Western Europe and the United States.[27] Accordingly, photography – especially the photographic portrait – was deemed a direct representation of the inner self, and portraits were "read" for what they could reveal about the sitter's individuality (Ebner 2003: 48–60).

Such an understanding of portraiture seems straightforward; who does not, today, carry a picture of his loved one in his wallet or purse, or has the background of her computer desktop feature the digital photograph of a – often newborn – relative? However, the idea of representing the self in a single frame lost credibility in the twentieth century, when "Western culture's fear of representation as an invitation to deceit" (Krauss 1985: 20) hit photography as well.

Both in professional and amateur photography, series of portraits began to replace the single image (Ebner 2003: 48–60). Among the better-known examples is the German photographer August Sander, who, in the late 1920s, embarked upon his – never completed – project, *People of the Twentieth Century*. It was intended to become a photographic index of the German population, according to social "type" – the farmer, the skilled tradesman, etc. – for which Sander meant to represent each type through a series of portraits. In his Farmers series, currently on view in the Museum of Modern Art's photography galleries, ten or so men were all portrayed outside, the wrinkles of their hands and faces visible in the fullest detail. The women, on the other hand, Sander chose to photograph indoors, sitting on chairs and with the background revealing the furniture and decoration "typical" of their houses.

Thus, the multiplicity of perspectives that had marked Cubist collage became mirrored by the multiple, often disorienting points of view in avant-garde photomontages as well as by the serialized photographic portrait. For example, the Bauhaus teacher Josef Albers's 1928 portrait of the Structuralist painter El Lissitzky consisted of no less than eleven different pictures of his sitter, shot from various angles and distances,

pieced together in one frame.[28] Presumably, this amalgam was a better representation of El Lissitzky than any of the images on their own – again, the whole was more than its parts: as for democracy, so too for the individual self.

Yet serialization did not solve all the problems that surrounded representation. During the 1970s and 1980s, postmodern theory and postcolonial critique ensured that everyone who even considered representing "the Other" would think twice, if not three times, about it. The supposed objectivity of the photographic image – long taken for granted because of photography's scientific and technological nature[29] – was questioned alongside the documentary tradition that, so the postcolonialists argued, had always served the Western, colonial, and male gaze.[30] Or, as the critic David Levi-Strauss put it: "When one, anyone, tries to represent someone else, to 'take their picture' or 'tell their story,' they run headlong into a minefield of real political problems . . . [The] question is: what right have I to represent you?" (Levi Strauss 2003: 8).

"The objective nature of photography confers on it a quality of credibility absent from all other picture-making," wrote the famous critic André Bazin in 1960. "We are forced to accept as real the existence of the object reproduced, actually re-presented, set before us . . ." (Bazin 1960: 4–9). Yet that credibility became less obvious once it was taken into account that photographers still choose their subject and their point of view, and make decisions about what is included or excluded from the frame. While objective in some ways, photography is extremely subjective too, in so many others.

Indeed, the postmodern critics who made up the generation that followed Bazin brought with them a more scrutinizing regard of photography and the power relations invested in it. To speak of an "authentic" photograph became all but impossible when, in the 1980s, photography became central subject matter for writers such as Rosalind Krauss, Allan Sekula, Sally Stein, Abigail Solomon-Godeau, Douglas Crimp, Victor Burgin, Christopher Phillips, and John Tagg. The latter for example argued that: "Like the state, the camera is never neutral. The representations it produces are highly coded, and the power it wields is never its own . . . but the power of the apparatuses of the local state which deploy it and guarantee the authority of the images it constructs to stand as evidence or register a truth" (Tagg 1988: 63–4). Whereas the job description of the photojournalist or the documentary photographer had long been that of a witness to world events and an objective outsider to conflicts, the whole notion of objectivity seemed to become vacuous in those postmodern, academic circles of either utter subjectivity or sheer state control.[31]

If Robert Capa, famous for his iconic imagery of the Spanish Civil War, was the embodiment of the modern war photographer, then his postmodern counterpart may well be the Chilean-American photographer Alfredo Jaar, who in 1994 went to Rwanda in order to document the genocide and who, upon returning, decided not to exhibit any of the photographs he had taken. "Refusing the flux of images and overabundance of visual stimuli that have ceased to signify" (Bacque 2001: 271), Jaar exhibited his images in filing cabinets and boxes, with the lid of each box describing the photograph inside –that remained unseen.[32]

The radical questioning of photography's agenda, authenticity, and veracity remained, for many years, confined to the academic circles of cultural and literary criticism. But the arrival on the scene of digital photography and, on its heels, of Photoshop, which – theoretically at least – put an end to the indexical quality that film-based photography still enjoyed, appears to have made the issue real for the public at large, as well.

Representation, in short, was still in crisis: and artists and journalists alike continued to seek for ways to respond.

The authentic amateur

The man has hollow features and empty eyes. He appears to be somewhere in his mid-fifties, and he reappears in many a picture the mysterious young Parisian has collected. In every photo, he has the same, odd gaze, directed not at the camera but at a point slightly above it. Strangely enough, the young archivist has found the portraits of this man at nearly every photo-booth in the city's many districts. To Amélie, the young woman with the rich imagination who finds one of the albums, the sitter becomes at least as great a mystery as the young collector; for why would someone go all over town, taking pictures of himself in every booth he comes across, only to discard the result almost immediately?

It's a good question, and in Jeunet's film, the result is an amusing "whodunit, and why?" storyline. But questions not asked are often the more interesting ones. For why on earth would a young man in the prime of his life spend his days going all over town, only to collect other people's photographs?

If we ask this of the moped-driving photo-booth collector in *Amélie*, we might as well ask it of all those artists, editors, curators, collectors, and journalists who are collecting and archiving the tsunami of amateur photographs surrounding us today.

Remember the foreword to Dick Jewell's *Found Photos*. "Only the photo-booth is truly objective," it read: "only in the photo-booth do you not get things to do with intention, foreknowledge or the making of a striking image." We should know better, by now. Not even the photo-booth is truly objective, despite the fact that "you go in and out of free will and there is only a machine to observe."

Observation by "only a machine" doesn't count – it takes eyes and interpretation to make observation meaningful. The fantasies Amélie dreams up about the hollow-faced man with the off-key gaze are entertaining for any viewer of the movie – and much more interesting in fact than the actual truth, when she finally discovers it (the overly exposed man is the mechanic who maintains Parisian photo-booths). Indeed, it was what the pictures did in Amélie's head that made them of interest to the film.

"Authenticity" is not a feature of the material itself, not something inherent in the photograph, whether it is an amateur snapshot or a skillfully composed documentary shot. Everyone, amateur and professional alike, comes to the taking and making of pictures informed by social or political intentions, cultural norms and values, and visual examples. They say beauty is in the eye of the beholder; authenticity resides in the exact same place.

Original publication

'The Authentic Amateur and the Democracy of Collecting Photographs' in *Photography and Culture*, 2:1 (2009).

Notes

1 *Photo Trouvée* by Michel Frizot (2006) and *Anonymous: Enigmatic Images From Unknown Photographers*, by R. F. Johnson (2004).

2 See Benjamin (1934). To be sure, Walter Benjamin's address focused much more on the political role of artists, and was delivered in a specific context, namely that of encroaching fascism and a search for the way in which art might contribute directly to the class struggle and help achieve socialism. Nevertheless, the remarks he made about ways in which the "author as producer" should always work not only on the product but also on the means of production, outlive their historic and political contexts and sound surprisingly timely today.

3 For an in-depth analysis of Gerhard Richter's *Atlas*, see, for example, Buchloh (1999).

4 "The practice of 'found photography' [is] broadly speaking, the appropriation of pre-existing photographic material to create new work" (Bull 2001). See also "Raiders of the Lost Archives" at http://vads.ahds.ac.uk.

5 www.hereisnewyork.org; and www.sep11photo.org. *Here Is New York* has become a traveling exhibition; *The September 11 Photo Project* has become a permanent part of the collection of the New York Public Library.

6 For an elaborate discussion of the Abu Ghraib photographs, see the writings of Errol Morris at, for example, www.errolmorris.com. Morris's documentary, *Standard Operating Procedure* (2008), addresses the photographs as well.

7 "Perhaps the powerful and direct public outrage brought about by the pictures can be accounted for, not only by the fact that they showed terrible, completely unheard-of tortures falling outside our norms of acceptable, decent and human behavior; but also by the fact that the production and circulation of the Abu Ghraib photos is very similar to our own acceptable, civilized, daily and humane media-practices," Richard Grusin observed recently (Grusin 2007).

8 In *Business and Finance Magazine*, for example, Max Kelly wrote that "Thousands of clips of warfare in the Middle East shot by young Americans in uniform in Iraq . . . are being swapped around in the neighborhoods of their hometowns—arguably more accurate depictions of their experience than footage recorded by reporters, who are usually one step behind the troops in a war zone" (Kelly 2007).

9 In 1996, for example, Liz Wells wrote: "In terms of photography many people anticipated a loss of confidence in the medium because of the ease with which images could be seamlessly altered and presented as accurate records. That this does not appear to have happened is testimony to the complex ways in which we use and interpret photographs" (Wells 1996: 23).

10 Of course, manipulation of photographs had been around long before Photoshop entered the scene, or *National Geographic* and *Time* blundered their ways into publicity; for example, when Joseph Stalin still reigned over the Soviet Union, people would routinely "disappear" from photographs if they had fallen out of grace with him and the party. But with digitization, as Martha Sandweiss wrote last summer, in a *Journal of American History* issue devoted entirely to photography, the "presumption about the physical existence of the scene preserved in the photographic view falls away . . . [Photoshop allows us] to invent digital images of scenes that never existed, except on a computer screen." This provides a challenge to any viewer of photographs, for even though "photographic manipulation is not new; photographers have long altered backgrounds, removed facial blemishes, combined two negatives to create a single print," Sandweiss argues that what is new, is "the absence of any physical trail of evidence that lets the researcher see what was done" (Sandweiss 2007).

11 In *The Cult of the Amateur: How Today's Internet is Killing Our Culture*, Andrew Keen (2007) fulminates against the demise of professionalism in favor of amateurishness, on weblogs, online music sites, and other fields of cultural production.

12 In the introduction to a recently published monograph on Joachim Schmid, curator John Weber wrote that the "period from the mid-1970s to the early 1980s . . . saw an international upsurge of interest in snapshots, photo archives, photojournalism, art

photography, and the broader role of photography in culture" (see Schmid 2007). Subsequently, according to Stephen Bull (1997), "the tendency to appropriate, then recontextualize other people's photographs, for exhibition or publishing, has become a major feature of 1990s practice."

13 That George Eastman's Kodak Company revolutionized photography by simplifying the technique and making it much more affordable, is generally agreed upon. In "George Eastman and the Origins of Mass Amateur Photography," Reese Jenkins wrote that "The change in practice of photography from the dominance of the professional to that of the amateur [in the 1890s] revolutionized both the photographic industry and the social role of photography . . . a series of interrelated changes in technology and marketing . . . culminated in a changed conception of who was to practice photography" (Jenkins 1975). Indeed, while technology was part of the story, marketing was at least as important; in *Kodak and the Lens of Nostalgia*, for example, Nancy Martha West describes how in the late nineteenth and early twentieth centuries, Kodak "created a new kind of desire for photography" and "transformed American consumers' perception of how they could organize, present, and even remember their lives through snapshots" (West 2000).

14 Quoted in Nickel (1998).

15 Ibid.

16 "A rereading and re-viewing of family pictures came with the radical history movements of the 1970s, which brought different ways of understanding history, more sensitive to the type of information carried by everyday documents, including family snaps" (Holland 2003). Moreover, Liz Wells described how, in the 1970s, photojournalism and documentary photography became scrutinized and interrogated "in terms of the context of making, the intentions and power of the photographer, and how meaning shifts as photographs become variously recontextualized." One consequence of this debate was "a burgeoning number of books and exhibitions exploring the lives of working people in order to expose and question taken-for-granted social histories. . . . Here, archive photographs, including family albums, were seen as sources of information or taken as evidence of ways of life; as well as becoming interrogated as particular types of documents whose origins lay in specific class relations" (Wells 2003a).

17 See Batchen (2001). This new approach has proven a real challenge to the old, more formalistic one, as Douglas Nickel explained in his survey article "History of Photography: The State of Research":

> The blanket importation of traditional art-historical concepts (artist, style, oeuvre, masterpiece) to photographic materials of all stripes engendered forceful reaction in the form of a metacritique, as commentators as diverse as Rosalind Krauss, Allan Sekula, Sally Stein, Abigail Solomon-Godeau, Douglas Crimp, Victor Burgin, Christopher Phillips, and John Tagg lined up against photography's indiscriminate appropriation as art . . . these writers brought to their task an orientation steeped in the 1960s politics of confrontation, and they joined with contemporary artists in prompting photography to assume a central position in the larger project of postmodern criticism.
>
> (Nickel 2001)

18 See, for example, Lesy (2007).

19 See, for example, Phillips (1982); Warner Marien (1986); and Nickel (2001).

20 In a letter to W. B. Potter of Eastman Kodak Company on January 7, 1944, Director of Photography at MoMA, Willard D. Morgan wrote: "I am pleased to note that everything has gone through with full approval including the agreement on Kodak's part to print a catalog for free distribution and also to pay the sum of $3,000.00 to cover the expenses incurred by The Museum of Modern Art in the preparation of this exhibit. Naturally, I am very much interested in making this show the best possible" (Morgan 1944).

21 See, for example, Kinsella, E. (1998).
22 See http://allphotographers.wordpress.com/
23 When the philosopher Michel Foucault published *The Archaeology of Knowledge* (1969), Gilles Deleuze welcomed him as "the new archivist in town."
24 "In keeping with its democratic and truly populist nature, which the organizers feel is not only appropriate to the events of 9.11.01 but intrinsic to their understanding, all of the pictures are hung identically, unframed and without names, stressing the fact that the significance of the exhibition lies in its content, in its breadth and its multiplicity—not in the source or significance of any image or group of images" (brochure of the exhibition, www.hereisnewyork.org).
25 For example, John Lucaites writes that "The articulation of liberal-democracy in American public culture operates in a . . . tension between individual sovereignty and collective agency. The individual is the locus of value, but the collective is the locus of power" (Lucaites 2001: 38–9).
26 See http://pollingplacephotoproject.org/
27 In "Reading Faces: Physiognomy Then and Now," Brian Street writes that:

> In the last century 'ethnology' permeated far more areas of social, public and artistic life than does anthropology today . . . The belief that the variety of human types could be interpreted in terms of their physical differentiation took a number of forms and a major strand was the theory of 'physiognomy'—that the structure of the face was a guide to inner characteristics of the person [. . .]
> (Street 1990: 11–12)

28 Josef Albers, *El Lissitzky at the Bauhaus* (1928–1930). Museum of Modern Art.
29 In *The Real Thing: Imitation and Authenticity in American Culture*, Miles Orvell explained it thus: "To the twentieth century, the fact that the camera was a machine became its most exalted characteristic, guaranteeing the authenticity of its products and forming the basis of its appeal, among artists and intellectuals, as a model for the synthesis of science and art" (Orvell 1989: 198).
30 See, for example, Gierstberg (2003: 130–43). Also, in *The Photography Reader*, Liz Wells writes that in the 1970s, "The twin bases of documentary, namely, the idea of documentary 'truth' and the notion of the neutrality of the observer," were put to question. While long before, the photographer as observer had been seen as "the framer and taker of the image," with creativity in photography residing in the recognition of "telling' moments," in the 1970s "Images were interrogated in terms of the context of making, the intentions and power of the photographer, and how meaning shifts as photographs become variously recontextualized. Questions were raised as to who got to photograph whom, in what circumstances, in what ways, why and for what purpose?" (Wells 2003a: 252–5).
31 See, for example, *Art Press* in 2003, in which Dominique Bacque gave voice to a view shared among many a postmodern photography critic:

> More than any other event, it was war that crystallized the mythology of the photographer as historical witness, working at the heart of the battle, sometimes risking his own life in order to render the 'authenticity' . . . of bodies in combat, of bombs and massacres, of famines and mass graves. . . . Today we have lost the possibility of such a truth. Not only that: the testifying subjectivity itself has become suspect and the status of the document is in crisis . . . the document can no longer raise itself to the level of testimony.
> (Bacque 2001)

To be sure, attempts to "rescue" objectivity from the hands of postmodernists have been made as well – see, for example, Datson and Peter (2007).

32 www.alfredojaar.net. Jaar took over 3,000 photographs of the genocide in Rwanda, and
 so far, only five of them have been publicly displayed. His installation of archival boxes
 with descriptions on the top was exhibited in the Museum of Contemporary Photogra-
 phy in Chicago, in 1995.

References

Adler, R. C. V. and Huneycutt, B. 2007. *Border Film Project: Migrant and Minutemen Photos From US–Mexican Border*. New York: Harry N. Abrams Inc.

Bacque, D. 2001. The Age of Suspicion. *Art Press* 271.

Batchen, G. 2001. *Each Wild Idea: Writing, Photography, History*. Cambridge, MA: MIT Press.

Baudrillard, J. 1995. *The Gulf War Did Not Take Place*. Bloomington: Indiana University Press.

Bazin, A. 1960. The Ontology of the Photographic Image. *Film Quarterly* 13(6): 4–9.

Benjamin, W. 1934. *The Author as Producer: Address at the Institute for the Study of Fascism, Paris*.

Bennamu-Uvet, J. 2004. The Photographer's Flaw Show. *Art Press* 306.

Bourdieu, P. 1990 [1965]. *Photography: A Middle-Brow Art*. Cambridge: Polity Press.

Buchloh, B. H. D. 1999. Gerhard Richter's *Atlas:* The Anomic Archive. *October* 88: 117–45.

Bull, S. 1997. Other People's Photographs. *Creative Camera* 344: 38–41.

Bull, S. 2001. *Raiders of the Lost Archives*. http://vads.ahds.ac.uk.

Chevrier, J.-F. 1986. The Image of the Other. In J. Lingwoord (ed.), *Staging the Self: Self-Portrait Photography 1840s–1980s*. London: National Portrait Gallery, pp. 9–15.

Dewitz, B. von. 1989. So wird bei Uns den Krief geführt. In *Amateurfotografie im Ersten Werlt-kriech*. Munich: Tudur Verlagsgesellschaft.

Ebner, F. 2003. Ein Motiv/Der Mensch. In Robert Eskilden (ed.), *Ein Bilderbuch: Die Fotograf-ische Sammlung im Museum Folkwang, Essen*. Göttingen: Steidl, pp. 48–60.

Friedman, D. 2006. *This Is Our War*. New York: Condé Nast Publications, Inc./Artisan.

Frizot, M. and Cédric. 2006. *Photo Trouvée*. Paris: Phaidon.

Gierstberg, F. 2003. Van Realisme naar Reality? Documentaire Fotografie in het Tijdperk van "Post-Media". In *Reflect # 4: Documentaire Nu!* Rotterdam: Nai Publishers, pp. 130–43.

Grafton, A. 2007. Future Reading: Digitization and its Discontents. *New Yorker*. New York, Advance Magazine Publishers Inc. LXXXIII: 50–4.

Graves, K. and Payne, M. 1977. *American Snapshots*. Oakland: The Scrimshaw Press.

Grusin, R. 2007. Bewijsmateriaal, Pornografie, of Alledaagse Mediapraktijk? Over de foto's van Abu Ghraib. *Open—De Opkomst van Informele Media* 13: 46–61.

Guski, A. 1978. Zur Enwicklung der Sowjetischen Arbeiter- und Bauernkorrespondentenbe-wegung 1917–1932. In E. Knödler-Bunte (ed.), *Kultur und Kulturrevolution in der Sowje-tunion*. Berlin-West: Kronberg/T.S., pp. 94–104.

Holland, P. 2003. "Sweet It Is to Scan . . ." Personal Photographs and Popular Photography. In L. Wells (ed.), *Photography: A Critical Introduction*. London and New York: Routledge, pp. 115–58.

Jenkins, R. V. 1975. Technology and the Market: George Eastman and the Origins of Mass Ama-teur Photography. *Technology and Culture* 16(1): 1–19.

Jewell, D. 1977. *Found Photos*. London: Dick Jewell.

Johnson, R. F. 2004. *Anonymous: Enigmatic Images From Unknown Photographers*. London: Thames & Hudson.

Keen, A. 2007. *The Cult of the Amateur: How Today's Internet Is Killing Our Culture*. New York: Doubleday/Currency.

Kelly, M. 2007. Mobile Citizen Journalism. *Business and Finance Magazine*.

Kinsella, E. 1998. Collecting: Photography Accidental Art—Snapshots, Just Like Dad's, Earn the Imprimatur of Museums and Galleries. *The Wall Street Journal*, October 2.

Krauss, R. 1985. *L'Amour Fou: Photography and Surrealism*. New York: Abbeville Press.

Lesy, M. 2007. Visual Literacy. *Journal of American History* 94: 143–53.

Levi Strauss, D. 2003. *Between the Eyes: Essays on Photography and Politics*. New York: Aperture Foundation.

Lucaites, J. L. H. and Robert. 2001. Visual Rhetoric, Photojournalism, and Democratic Public Culture. *Rhetoric Review* 20(1–2): 37–42.

Mensel, R. E. 1991. "Kodakers Lying in Wait": Amateur Photography and the Right to Privacy in New York, 1885–1915. *American Quarterly* 43(1): 21.

Mintz, J. 2007. *Associated Press Launches Citizen Journalism Partnership With NowPublic.Com*. AP Press Release.

Morgan, W. D. 1944. *The American Snapshot: An Exhibition of the Folk Art of the Camera, March 1 to April 30, 1944*. New York: The Museum of Modern Art.

Nickel, D. 1998. *Snapshots: The Photography of Everyday Life, 1888 to the Present*. San Francisco: San Francisco Museum of Modern Art.

Nickel, D. 2001. History of Photography: The State of Research. *The Art Bulletin* 83(3): 548–58.

Orvell, M. 1989. *The Real Thing: Imitation and Authenticity in American Culture, 1880–1940*. Chapel Hill and London: The University of North Carolina Press.

Orvell, M. 2003. *American Photography*. Oxford and New York: Oxford University Press.

Phillips, C. 1982. The Judgment Seat of Photography. *October* 22: 27–63.

Phillips, C. 1989. Resurrecting Vision: The New Photography in Europe Between the Wars. In *The New Vision: Photography Between the World Wars*. New York: The Metropolitan Museum of Art, pp. 65–108.

Ritchin, F. 1990. *In Our Own Image: The Coming Revolution in Photography. How Computer Technology Is Changing Our View of the World*. New York: Aperture Foundation, Inc.

Sandweiss, M. 2007. The Photograph as Evidence in the Digital Age. *Journal of American History* 94: 193–202.

Sartoti, R. 1978. Die Sowjetische Fotokorrespondentenbewegung. In E. Knödler-Bunte (ed.), *Kultur und Kulturrevolution in der Sowjetunion*. Berlin-West: Kronberg/T.S., pp. 105–12.

Schmid, J. 2007. *Photoworks 1982–2007*. Brighton and Göttingen: Photoworks, Steidl.

Shanker, T. 2008. For Pentagon and New Media, Relations Improve With a Shift in War Coverage. *New York Times*, January 7: A13.

Skrein, C. 2004. *Snapshots—The Eye of the Century*. Ostfildern-Ruit: Hatje Cantz Verlag.

Sontag, S. 1977. *On Photography*. New York: Farrar, Strauss and Giroux.

Sontag, S. 2003. *Regarding the Pain of Others*. New York: Farrar, Strauss and Giroux.

Spence, J. and Holland, P. 1991. *Family Snaps: The Meanings of Domestic Photography*. London: Virago Press.

Sternberger, P. S. 2001. *Between Amateur and Aesthete: The Legitimization of Photography as Art in America, 1880–1900*. Albuquerque: University of New Mexico Press.

Street, B. 1990. Reading Faces: Physiognomy Then and Now. *Anthropology Today* 6(6): 11–12.

Tagg, John. 1988. *The Burden of Representation: Essays on Photographies and Histories*. Minneapolis: University of Minnesota Press.

Warner Marien, M. 1986. What Shall We Tell the Children? Photography and Its Text (Books). *Afterimage* 13(9): 4–7.

Wells, L. (ed.). 1996. *Photography: A Critical Introduction*. London and New York: Routledge.

Wells, L. (ed.). 2003a. *The Photography Reader*. London and New York: Routledge.

Wells, L. (ed.). 2003b. *Photography: A Critical Introduction*. London and New York: Routledge.

West, N. M. 2000. *Kodak and the Lens of Nostalgia*. Charlottesville and London: University Press of Virginia.

Zalchman, D. 2007. Stock Waves: Citizen Photo Journalists Are Changing the Rules. *Wired*. Wired.com.

Edmundo Desnoes

CUBA MADE ME SO

1

ALMOST TWENTY YEARS AGO, I was rash enough to write something on how they see us in the North and how we see ourselves in the South. This dialogue came out with a descriptive, if clumsily worded, title: 'The Photographic Image of Underdevelopment.' I have just reread it, and it creaks with the sound and fury of the sixties. How much of it has survived and how much is dead?

Photography is no longer the Cinderella of the fairy-tale of criticism. Within the visual arts, it now has its body of ideas, its beauty parlour, and even an incipient grammar. A respectable discourse that allows it to look and be looked at in galleries and museums.

Excuse the irony. It is the irritating question of where and how one breathes the atmosphere of culture. We Latin Americans complain when doors are closed to us and nobody wants to listen to us, and if some doors are then opened and we are observed attentively, we suspect that we are being manipulated and turned into court buffoons. The world is impure – and we should be glad not to be angels – but if life is being used, knowing *how* to use is creation. Photography is in fashion – and we are glad.

'Photography,' I wrote then, 'has fooled the world. There's no more convincing fraud. Its images are nothing but the expression of the invisible man working behind the camera. They are not reality, they form part of the language of culture.'

Today it would be going too far to insist that 'reality and photography *are not* the same thing.' Roland Barthes and Susan Sontag have done for photography what those of us on the outskirts of Western culture could only have dreamed of offering you: they have defined and minutely examined its cultural operations and ambiguous spiritual impact.

Photography is not reality, but it does have a special relationship with reality. It is another of art's plausible lies, as Picasso thought. But it would not be a bad idea to give this lie a special place.

I am interested in the space (a word I would not have used ten or fifteen years ago) of photography and the way it functions. If in those days a sad ignorance prevailed, today too much critical competence can succeed by its subtleties in breaking down the obvious image and causing it to evaporate. Physical reality is the specific raw material of photography. The environment, the people, the objects are physically present – found, surprised, placed or arranged – they are outside, before the camera, not in memory.

Let us take a look.

'As she stared she found herself wondering why it was that a diseased face, which basically means nothing, should be so much more horrible to look at than a face whose tissues are healthy but whose expression reveals an interior corruption. Port would say that in a non-materialistic age, it would not be thus. And probably he would be right.' The heroine of Paul Bowles' novel *The Sheltering Sky* is contemplating the face of a North African beggar.

That diseased face, or that face of healthy tissues, is photography's point of departure.

The novelist could have recorded or invented the scene, but the photographer could only have been there, stolen the reality, and snatched a face from the beggar.

The existence of the photographic camera allows man's intervention to be reduced to a minimum, but at the same time it forces him to impose his presence at the moment of creation, to establish a living relationship with the subject, and to initiate a hand-to-hand struggle. He disappears behind the keyhole but he cannot separate himself from the door. His absence is his presence.

The inexhaustible material world and the camera – the black artefact of the profession – create a new space for photography, a space of its own, a breach that henceforth will always belong to the photographer.

There is no more down-to-earth art than photography – beside it, the cinema is dreamland, a composite of time and space, a daydream in the darkness. Next to this red fringe come dance, theatre, painting, literature and music. Photography is always the same temperature as the planet.

And everything comes out in the interpreter of photographs: in the reaction of the spectators of photographic violence; in the perceptual penetration of the image and its effect in the field of consciousness. Let us go back to our specific theme and continue with what I wrote in 1966:

> Photography is just as closely tied to economic and political interests as to dreams and art. The photographic image of underdevelopment, for example, impinges constantly on our experience and is a decisive ingredient in our vision of the Third World. We live in that world and we are not sure to what extent we are conditioned by the gaze of the other one. Our thoughts are often based on press, propaganda, fashion, and art photographs that claim to express our surroundings. Photography is a much more influential and penetrating cultural ingredient than the great majority of people are capable of realizing. The visual code – and here one can only agree with Barthes – depends on language. And language in its turn on social action, without separating us from certain fundamental Marxist formulations.
>
> (Desnoes 1966)

Photography is an index of values. Both in production and consumption. Photographs are matter in cultural movement. In order to live, they include their time and space. The analysis or contemplation of photographs as objects in themselves, independent of their context, outside the system of social circulation, is an illusion, a methodological trap. There is no great difference, and we should not, or rather we cannot, separate looking from seeing, perception from the perceived. What our eyes propose and what we see. Photographs are detonators. They explode in us. We are the gaze as well as the gazed-at. The observer and the observed.

2

What we observe today in the Third World has changed little since the middle of the sixties – that is, if we go by the tourist business. Travel folders still insist on a photographic utopia of endless, deserted, unpolluted beaches. We may travel accompanied by our partner, or meet her/him at the hotel – the photograph is not clear on this point – but the sea, rippled by the breeze, and the soft white sand are both obvious and real, as is the protective shade of the palm trees that have sprung up at the proper distance so that we can stretch our hammock and relax. It remains only to buy the airline ticket and make our hotel reservations. Hardly any changes are to be seen in these photographs over the last ten years. They form part of a conservative and effective advertising method. Our Caribbean goes on being a tropical paradise.

If some inhabitant of paradise appears, he/she is being photographed to show that the natives are obliging and of an innocent and exotic beauty. If we are unable to travel, a photograph then helps us to travel as consumers. The products of our world are pure, free of chemical contamination; sweaty black hands separate the two halves of a wholesome green coconut and from its heart emerges the white bottle of CocoRibe liqueur. Naturally, the sharp machete cannot fail to be seen in the foreground.

In recent years, alongside the well-behaved savage and the traditional planter, alongside the profitable local product, a worldly native middle class has emerged. The last advertising campaign for Puerto Rican rums offers us a gallery of elegant professionals from the national bourgeoisie, with drinks in their hands and on the table, made with island rum. Architects or horse trainers. This new and accordingly young bourgeoisie is the one appointed to know and relish the major products of its native land. It is a campaign that also indicates the growing importance and strength of the national white elite of dark-skinned America.

Certain advertising appeals have disappeared. The sixties were marked by radical political tremors and wars of national liberation in Asia, Africa and Latin America. Advertising then helped to neutralize political anxiety. At first it made use of the social prestige, the impact of revolutionary ideas; the revolution was a fabric, and men wore Tergal shirts and pants, with Mexican hats and decorative guns; only the most resistant gear survived lawful violence; the women's revolution was Popoff, the underwear that set off the sensual lines of the body. Photographs demonstrate the commercial effectiveness of advertising pseudo-reality.

'Advertising based on situations of political confrontation,' Umberto Eco pointed out as early as 1971, 'is declining. A recent statistic shows a shrinking of the political theme, an obvious sign that the public at large is entering a phase of proletarian

tranquillity and middle-of-the-road indifference.' The observation can be extended to the whole capitalist world; by the mid-seventies it develops into a sharp turn to the right. However much it uses its voice, advertising is still an echo – and there is every reason to suspect that since 1968, fear has elicited pacifying advertising campaigns.

For the moment, it is preferable to bathe with Vita-bath of the forest, amid delicate ferns and beneath refreshing waterfalls as seen in an Italian advertisement: to return to the condition of the noble savage, guided by the nostalgic text reinforced by the photograph, in order for men to 'feel like Tarzan' and women to come back into their own.

The social revolution might have gone on being a necessity, but it was no longer in fashion; fear clothed itself with loathing. In the twilight of the seventies, fashion was playing with Arab oil. The West was contemplating the world of the petrodollar with fear and fascination. Models posed like odalisques on soft cushions, and even a towel could be converted, at least in the pages of *Vogue*, into a chaste and perilous veil. And from there to the social tranquillity, preserver of poverty, of India and its worn-out mystery. They went back to posing in front of an elephant (though Richard Avedon had already placed Dovima between two elephants in 1955) or a camel for variation.

Today, revolution in the United States is no longer related to sex, as during the sixties, but to food. Food is the sex obsession of the eighties. *New York* magazine, in its 1 August 1983 cover, refers to the new conservative orgasm: food – 'You've had sushi, falafel, dim sum, bacon cheeseburgers and tandoori chicken. Now it's time for the Mexican Revolution.' At the table, eating next to the gringo, sits a taciturn survivor of the troops of Pancho Villa. The food is as hot as the revolution: and as they eat under the burning title, the revolution in Central America is just a distant echo, one of the possible connotations of the image. Taming the barbarian, the heathen, has been a lucrative game. Some southern countries will be swallowed up by the attractive skin of the consumer society; others will find their own way. But the most deplorable, perhaps inevitable, aspect is the interiorization in underdeveloped countries of the metropolitan vision, and the squandering of photographic opportunities to affirm our identity and create or reflect adequate values. Creating values, and disputing them if they are empty – these are the two sides of cultural activity.

Fashion photographs are an even more critical field, since clothes do indeed make the man. Our manner of dressing – the fashion photographs in our publications – indeed transmit popular values and cultural identity. On our continent, the photographs of clothed (and even unclothed) models imitate like parrots when they exaggerate colours, or like monkeys when they copy the styles of Paris or the dynamic capitalism of New York. Latin American magazines, from the Rio Grande to Patagonia, operating in the fertile soil of a middle-class subservience to the industrial centres of capitalism, are a warning to the countries of Africa and Asia that are still capable of learning from the mistakes of others. These two continents still have a strong identity in their wearing apparel, adapted to the cultural and climatic realities of each region.

Photography, by its special relation to reality, plays a decisive role in this implacable dream. A dream fabricated and conditioned by base interests, but with a credible face thanks to this blessed or cursed photography. The advertising world, fashion as we know it today, would collapse without it. Painting and the written word lack the realistic charms of a photograph.

As a young man in Cuba I saw the world, history, in photographic imagery. History took place where photographs were taken, shot. I remember how stupidly thrilled I

was, at the age of twenty-four, when I saw the island in *Harper's Bazaar*. 'Flying Down to Cuba;' who is up and who is down in a round earth? I felt the pulpless fashion model was validating the island by coming down to sight-see and be seen in a magazine that infused meaning into every sight she appeared before.

Even the discourse of travel was convincing, sequential: the Angel announced our existence as she landed at the Havana airport; the proof was there: the airstrip, the fuselage of the plane, her expensive suitcase. A 'Cadillac from Havana's Amber Motors' arrived to pick her up. The Hotel Nacional, the Plaza de la Catedral, the sugarcane fields, the cock fights. It was true, because I recognized the background; she was beautiful because she was powerful (her name never appeared in the captions, only the price of the garments). I was being culturally colonized by the Annunciation.

If the image had the strength of physical existence – regardless of how impossible the model was as a prop for the camera statement – the text of the photograph essay reveals the weaving of arbitrary relations. The Cuban background for the fashions is justified because, for example, they are 'in colours that happen to be native to the Cuban scene.' 'Daiquirí white fleece. The whipped, golden white that foams on the rim of your Bacardí daiquirí,' and 'under it, rich pungent brown – Tobacco brown.' Words reveal the gimmickry of a meaning the photographs hide in their contrived physicality.

'Native to the scene,' a double-spread tryptich of photographs, enhances the packaged model as she deigns to chat with smiling, ragged toothless campesinos. The model, like the ladies of the Spanish court, uses wasted creatures to heighten her beauty.

The model wears white gloves to avoid the dangerous parasites that lodge under your fingernails in the tropics as she talks to a child, as she looks down to a child while a creased old man admires her androgynous presence. Or she stands before an ox-cart as she shows off her calm, cool clothes and blesses poverty; she spreads her arms, palms out, as a saint or a magician.

Cuba – then an economic colony of the United States – made me see the ideal, the rag flower doll; Cuba – as a country involved in building a socialist society – made me appreciate the fruit, the wound hidden behind the froth of a daiquirí. I decode within a cultural context. I can't help it, Cuba made me so.

3

Only a few attempt, in press photographs and reports, to reveal the true face of the world, the scar hidden under the froth. Various traps are customarily laid.

The true scar of Africa, one of the deepest wounds of the world, is the work of white men in the name of European civilization; there is nevertheless an insistence on black barbarism, on the dark-skinned savage as an irresponsible murderer. The skill displayed in the photographs of the innocent whites of Kolwezi, that froth of the world, those inert, blond, white-skinned bodies rotting amid the demolished equipment of the mining camp, is proof of the effectiveness of the press, of its power of empathy, in the insolent capitalist world. Next to the full-colour photograph of the livid corpses, there had to be, of course, a black-and-white reproduction of the true wounded of the continent, forced to prostrate themselves on the ground before soldiers of the French Inquisition. These two pages of *Newsweek*, published on 5 June 1978, are an admirable treatise on the photographic wisdom of the historical murderers.

And to make you shriek with laughter there is the grotesque coronation of Bokassa, in full imperial colour, with his uniform, arrogantly bracing himself on his Napoleonic throne. The naïve savage repeats history as a farce. The reporting takes advantage of the context to reinforce prejudices and profound myths of Western Culture.

In October 1978, *Life* came out with an article on the Shah of Iran and his royal family. On the last page, a general, having just arrived from Teheran, receives instructions from the monarch. Everything is in order, to the point of reverence. Then an explosion: but the American press reports that the armed forces are keeping the situation, a popular uprising, under control. The army always manages to disperse the demonstrators. Baktiar stands fast and lets himself be photographed next to a picture of Mossadegh. The carrot and the stick. Tanks patrol the calm streets. The Ayatollah Khomeini is neither seen nor spoken of. He does not exist.

This is the way they write history. Readers are always informed by what the press wants to see and to say with photographs. And even as it misinforms, it does not lose credibility. Yesterday's news stories and photographs are forgotten. It is an absence. It is the final trap. The lies of yesterday are always the truth of today.

Faced with photographic pseudo-reality, one can only rely on one's memory and an inconsolable intelligence.

Rebellion in the Third World has passed to urban centres without abandoning the rural areas; from Beirut and Teheran to Soweto and San Salvador the masses are taking to the streets, burning the symbols of consumerist colonization, and defying the military repression. It is a new revolutionary reality, a new photographic countenance.

Nicaragua, because of the feudal cruelty of Somoza, counted for a moment on the sympathy of the world. The pictures of the young people of Masaya, León, Jinotega and Matagalpa filled us with astonishment. The bandit's kerchief has become the uniform of urban revolution in Central America. The pistol is added to the rifle, and carnival masks protect the identity of the new urban guerrilla. Susan Meiselas' photographs, taken inside the liberated towns and not from behind or in the footsteps of the National Guard, seize us with their sensual texture and pierce us by their political sympathy. The tension is overwhelming. The position of the photographer and the angle of press photographs are what is most difficult to neutralize: though not impossible.

These photographs followed two paths: they fell on the cushion of established publications, and they circulated in a series of projections designed to collect funds to continue the struggle against Somoza. A lone photographer, no matter what his or her photographs may say, is powerless unless he functions within a definite context, unless the pressure of other bodies exists behind his images. If five years ago the photographs of revolution in Nicaragua were used to support the Sandinistas, today the photographs of revolution in El Salvador are used against the rebels. Yet it is the same Central American revolution.

The least deceitful publications acknowledge a political party, a stated bias; they can be mistaken and often are, but we know beforehand what their viewpoint is.

When we read the newspaper *Granma*, we hold in our hands the official organ of the Cuban Communist Party; we understand why a picture of a brigade of sugarcane cutters that have downed a million juicy stalks takes up more space than one of Carter, Giscard, Callaghan and Schmidt holding a summit meeting on the island of Guadalupe in 1979. It is a value judgement, and these everyday images correspond to a well-defined, consciously motivated social plan.

The decade of the seventies opened with an irreproachable figure in the Moneda Palace. Salvador Allende holds the office of President of Chile under all the provisions of the law. His noble portrait appears repeatedly on the pages of the world press, while the millions of faces and bodies that make up Chile leap in the streets, without weapons, to show that they are not starving. The tragedy is summed up in two indelible moments: the burning of the Moneda Palace and the dignified President in his white helmet, gripping a rifle given to him by Fidel, and with this image he defends his words: 'I am not made of the stuff of martyrs, I am a simple social fighter, but I want it clearly understood that I am fulfilling the mandate of the people, and to get me out of the Moneda Palace they'll have to take me out dead.'

So much for press photographs.

4

There is a kind of photography that has a refined presence in the history of images stolen from reality. It is the art photograph as a lie. It transcends fluid reality and creates a closed unity. When it achieves an aesthetic synthesis, it immediately attains static unity. Cartier-Bresson's photographs taken in Indonesia, for example, have this paralysing effect. One is compelled to believe in the perfection of the original reality; the image is a harmonious entity in itself. 'Do not change a single thing!', one feels inclined to exclaim, like a stupid tourist in any 'exotic and primitive' country. The closed architecture of the image is beauty that tends, as the Greeks thought, to be its own justification. Art frequently creates a comfortable world that detaches itself and becomes independent from action. The photographs of Edward Weston, for example, are closer to the world of painting than to the active realism that characterizes impure photography. Weston's sensual texture or Cartier-Bresson's implacable composition are apt to close over themselves, attaining the perfection of a certain sensual and harmonious bliss. We see textures, volumes, equilibrium – and reality, open and ragged, is lost and transcended. Images as self-sufficient, perceptually and culturally, as Velásquez's *Las Meninas*, irreproachable in their own space.

There is another manner of escaping: the effects obtained through excessive interference when the photograph is taken and especially when it is processed in the darkroom. Effects that break the obvious, recognized connection with physical reality.

On emerging from the embrace of reality, photographs do not remain floating in a no-man's land: they cross the frontier and surrender to the world of painting. They are perceived and analysed within a sensibility refined by painting: texture, composition, equilibrium and spatial tension, eternal harmony. If painting is already this archetypal world of absolute and eternal truth, photography governs the field of the contingent, the temporal, the broken, and the scattered, the interrupted.

This, roughly speaking, is the way to read the kind of photography that has matured in our time. An unsettled composition, an uprooted space, an intercepted light. The other way of producing images, of seeking closed and organized images, belongs to painting. From a Weston nude to a crumbling wall by Enrique Bostelmann. It is photography but we read it as painting.

This is not an absurd excommunication, it is a distinction. Let us for the moment assign to the established canons of painting the photograph that longs for fluid reality.

A photographic genre in no way to be despised, it would merit a separate analysis of its own – both for the pleasure and the astonishment it sometimes affords us. Modern man's avidity is constant because it is insatiable: no one, especially today, voluntarily resigns himself to limiting his intake. Not to speak of the Latin American, who, with his broad context and cultural pressures, has a universal curiosity well expressed by Pablo Neruda: 'I am omnivorous of feelings, beings, books, events and battles. I would eat the whole earth. I would drink the whole sea.'

This vast and recognizable link with reality has special importance for the critical photography of the emerging South. Our America (Latin, not Anglo-America), particularly now that its economic, political and cultural development allows it to speak out vigorously on an equal footing, requires the weight of the planet. Now that we can travel all over the world like exotic Indians and obliging blacks, we must develop photography as a critical attitude revealing and directing a world that can offer a possible alternative, another reality, to the Euro- and USA-centric vision and cultural conceptions. Not only do we live other economic and social problems, but we live them differently.

We are recognized for artistic imagination, elemental strength and creative exuberance. I have given a certain weight to theoretical and ideological discourse in this essay because it is less important to affirm our presence than to define our outlook. Our criticism and thought have consumed our creative energies from Simón Bolívar to Fidel Castro, in the struggle for political independence. 'There is no literature that expresses anything' – I extend José Martí's words to culture as a whole – 'so long as there is no essence in it to be expressed. There will be no Hispanic American literature so long as there is no Hispanic America.'

If we judge the photography of our continent – the most advanced and aware in the southern world – by some of its more striking recent examples, we can recognize that, on the one hand, it largely satisfies the requirements of a critical and orienting vision and, on the other, gives evidence of a sensibility open to all currents.

These photographs have freed themselves from certain deep and recurrent myths that have been imposed on us and which we sometimes internalize: archetypes that have accompanied us since the Conquest. In press and advertising photographs, for example, the view of the noble savage or the atrocious cannibal is obvious. Either we are innocent and docile, living in surprising harmony with our surroundings, or this natural beauty turns into the ferocious grimace of the irrational savage, who manifests his discontent by overturning cars and setting fire to shops and proconsular offices, incapable of understanding the civilizing influence of Europe and the United States. Either we are noble examples of utopia, or we are soulless inferior beings, incapable of joining the modern world: docile parrots or dangerous jaguars.

Three friendly female natives offer themselves smiling to the colonizer in a girlie magazine, *Hustler*. The metaphor could not be more eloquent. The women open themselves, surrender willingly to the new God. A double oppression, as natives and as women. Could this posed photograph fail to explain why many women's organizations in the United States support revolution in Latin America?

In the field of artistic photography, the myths live on by the eternal return: the immensity of nature, the vastness of rivers, plains and mountains; the delicate beauty of the hummingbird or the endless voracity of the boa constrictor; the utopian beauty of civilizations destroyed by the Conquest; ruins with ruined people, who are nevertheless deserving in their beautiful handmade rags.

When some of these subjects appear, their idealist and exotic burden may be neutralized by their position in a specific historical and social context. Or they may be converted into symbols, like the photograph of the destroyed, roofless colonial church by the Mexican Renato von Hanffstengel; the typical hut is also destroyed by fire in the pathetic desolation of the touristic development of Brazil, depicted by Adriana de Queirós.

The urbanized Indian affirms his stubbornness before a wall that shrieks Coca-Cola; as a mother with her baby on her back, sitting on the sidewalk with her miserable subsistence merchandise, this Indian suffers under the circumspect and classical gaze of the white stone sculpture adorning so many parks and residences of the New World; and he even appears with class-conscious satisfaction when he sits in the colonizer's chair in front of the photographer Pedro Meyer. Blacks and mestizos are men and women in the photographs of the Panamanian Sandra Eleta; to be men and women is not an easy thing for the Latin Americans who sustain the continent. Photographing men and women, as men and women, is here a positive and vital feat.

It is not an easy vision. It involves a knowledge that is erotic and at the same time rational. The eros of knowledge must join with the logos of our America. Without knowledge, intuitive or conscious, of the structure of the world around us, we are lost.

Alejo Carpentier, in touching on the present problems of Latin American fiction, opened his eyes to the continent:

> Someone has written a novel about the jungle after peering at it for a couple of days. As for myself, I believe that certain American realities, for not having been exploited in literature, not having been named, require a prolonged, vast, patient process of observation. And that perhaps our cities, for not having yet entered into literature, are more difficult to handle than the jungles or mountains.

Carpentier is speaking of the novel, but he conjures up our photography as well. Naming things can be confusing and tiring for the reader of novels. Photography, with its immense visual ambiguity, its ability to cover so much in the little time it takes to absorb it, is different.

> Our cities *have no style*. And yet we are now beginning to discover that they have what we might call a *third style*: the style of things that have no style. . . . What happens is that the *third style*, just as it defies everything that was hitherto been taken for *good style* and *bad style* — synonyms for *good taste* and *bad taste* — is usually ignored by those who contemplate it every day, until a clever writer or photographer proceeds to reveal it. . . . It is difficult to *reveal* something that offers no preliminary information in books, an archive of emotions, contacts, epistolary exclamations, personal images and approaches; it is difficult to see, define, weigh something like what Havana was, scorned for centuries by its own inhabitants, the object of allegations expressing tedium, the wish to escape, the inability to understand.

This necessity, although it can manifest itself as pure scenography, answers to a real need to name our things and situate them in a real context.

The coexistence of people of the same nationality belonging to different races, Indians, blacks, and whites, of different cultural levels, often living simultaneously in *different periods*, if you consider their degree of cultural development. . . . The political and military context of Latin America has inexhaustible implications. Though it should be taken into account, one must be careful not to fall into a facile and declamatory literature of *denunciation*. . . . Valid connections should be established between the man of America and chthonic contexts, without resorting to the exploitation – in any case, discredited – of the bright colors of the shawl, the charm of the sarape, the embroidered blouse, or the flower worn over the ear. *Distance* is another important context, as is the *scale of proportions*. The dimensions of what surrounds the American man. . . . The disproportion is cruel insofar as it conflicts with the module, Pythagorean eurhythmy, the beauty of number, the golden section.

All this has to do with photography.

The Latin American photographer has the possibility, and the means, for naming the things of our world, for demonstrating that there is another kind of beauty, that faces of the First World are not the only ones. These Indian, black, plundered white and mestizo faces are the first element defining the demographic content of our photography. Cultural, economic and social conflicts are also obvious in many photographs. An eagerness to name our reality is present in the dark splendour of most of these images, as well as the need to reject the exploitation of exotic colours so as not to fall into a facile and declamatory photography of denunciation.

The military and religious contexts also appear in our photography, without resorting to the visual pamphlet. As heirs of Spanish colonization, we are still countries of soldiers and priests. But although the priests are privileged, many Latin Americans are genuine believers, poor devotees of syncretisms of Afro-Spanish origin. 'Religious suffering is, on the one hand, the expression of real suffering, and on the other a protest against it': Marx's acute observation now applies more to us than to the North. The two faces of religion, oppression and escape, are nevertheless a powerful refuge in this uncertain and fluid decade.

The same cannot be said when we find the military in certain photographs: it is always the naked form of power, deciding national destinies and repressing genuine aspirations, those aspirations that have continued to propel us since the emancipation struggles of the last century. This active, revolutionary face seldom appears. The rebellion of the continent appears in a photograph of Allende in the hands of the Chilean people and in the frustrated scrawl of the word 'revolution' on a rough wall.

The revolution in power is the presence of Cuba. Yet historic images appear in many Cuban photographs: militiamen of Playa Girón, armed peasants, popular demonstrations, grimy machete wielders more staunch than smiling. Cuban photographs have the force of nostalgia, they are historical pictures, imbued with the spirit of the sixties. The image of the sixties is the most powerful and recognized one of Cuba. It is a real vision, but already stereotyped. The decade of the seventies is visually almost unknown. Enough of scratching the surface, naming the absent appearances: the jeans of the high-school student in the Campo, the white helmets of the members of the

micro-brigades, the epaulettes and uniform caps of the military. Adventure has given way to order. Images have to be analysed for a programmed response. Critical photography of everyday life is inseparable from cultural dialogue.

The style of Cuban photographs can be recognized by a certain frontal candour. The photographer seems to be arrested frontally before a powerful reality where the struggle is as obvious as an open smile, where social homogeneity produces a photography of pure denotation, with no remote connotations. These are testimonies that open like fruits in the smile of Nicolás Guillén or the worker with the machete standing with his trophies in his hands on a vast field of cut sugarcane. Mayito and Marucha artfully transcend this ingenuous frontality.

I would say it is no accident that the least regional photographs, those most obviously related to international photography – both in theme and in the way of treating the theme – are made in Mexico and Brazil, the countries with the highest level of economic development, and where modern neocapitalist society is already the lifestyle of a substantial minority. They are authentic photographs of a real colonization.

Theft, as Picasso used to say, is only justified when it is followed by a murder. In many photographs we easily discover the chicken thief. Chickens from another roost: desolate urban landscapes, ostracized transvestites, fragments of figures, surrealistic montages, hygienic textures and so on.

Perhaps the only excusable case might be that of Francisco X. Camplis, with his photograph of a Chicano nude. Faced with the erotic buffetings of Anglo-American beauties, he gives us the female beauty of his own race. It is an ambiguous photograph, as ambiguous as the difficult position of the Chicano artist in the United States. The photographer himself acknowledges it:

> I am keenly aware of the influence, subliminally or otherwise, upon my work by the plethora of American designed imagery. . . . We continue to hold a fascination for things European, for *gente güera*, for *la gabacha* or *gringa* and so forth. In effect, we help to perpetuate the myth that beauty solely resides in creatures blonde and blue-eyed.

Latin American photographers in the United States suffer – with greater violence – the same contradictions when they speak or look at themselves in the mirror. The face and features are Chicano, but the whole body responds to the aesthetic standards of the North. Their graphic style could have been used to specify another physical type: strong face, short legs, broad hips. The photograph is a sweet trap. On a macho continent, marked by rigid and watertight sexual definitions.

Centred around the positive social pole are the photographs of Paolo Gasparini, a critical artist committed to one of the most difficult tasks of Latin American photography: to clean away the golden, filthy cobwebs that hinder moral clarity. His work has dwelt for the past twenty years on the revealing contexts of our southern world: the vast American geography marked by the exploitation of its natural resources and by immense garbage dumps of consumerism. The geography that Gasparini has shown us includes not only the tenacity of its men but also its cemeteries of crosses and oil rigs. The money that reposes on the neoclassical columns of the banks and the garbage that the many mestizos of the continent transport in order to live.

His pictures today preach about diamonds and children. One series is devoted to the exploitation of diamonds in Venezuela. They are images of the hellish circle of plunder. Earth and men plundered by livid, invisible hands that create a vicious circle, which in San Salvador de Paúl wastes away 'a small mirror in which the history of lost humankind is concentrated.' These are his own words:

> Children looking without much astonishment at wealth consuming itself, wealth that generates poverty right there in the very place where the offense, the crime against nature, was committed. The diamond becomes poverty despite the mirth of the prostitute, in the greed and futility of the middleman.

Children, for Gasparini, have taken on the role of witnesses; Latin American children, who will inherit what we, the adults, are already revealing and imprinting on their minds.

When he gets to this point, Gasparini breaks out in curses. His voice is the most despairing of all. 'Each image can be read in many ways,' he remarks in connection with his Venezuelan diamonds.

> In a Finnish museum, these photographs might simulate exotic appetites, in a European or American magazine they would form part of one more 'coverage,' in socialist Cuba they might illustrate an article in *Prensa Latina* on the inconsistencies of democracy, in the house of a friend they would appear as 'the body of Maria Luisa inviting you to go to bed,' to the squinting eyes of some museum curator the out-of-focus hand of the same Maria Luisa would be disturbing, and for me it will go on being a vivid experience, an apprenticeship in memory that draws me back to the garden of childhood.

Gasparini's perplexity emerges from the monstrous distance between creation and distribution: between creation and the form of consumption. This distance, which erodes or destroys the work and the original intention, is more pronounced and exaggerated with photography.

Its images are scattered, they do not have the inner cohesion of the cinema film nor the precise location of a projection room. The ambiguity of the image, including the documentary reportage, requires definition, demands a context. Inexorably we fall into the trap: be it the magazine with its columns of print or the museum wall with its antiseptic time and space. In a magazine, the photograph usually argues as it informs, and in the museum it casts off its historical and social moorings.

Museums and galleries are a new element; they increase the distance but satisfy a repressed vanity of the creator of photographs: to be recognized as wholly an artist in society. Yet photography triumphs when 'the press photograph merges with world news, the family portrait with everyday life, and the photo in a magazine or book with countless cups of coffee.' This is the greatest and most ambiguous triumph of photography.

But the photographer who has very precise intentions feels himself at a loss. 'Is photography capable of giving a good version of reality? At least an adequate version of

our intentions? I don't think so, nor am I even sure of what photographs really say,' the despairing Gasparini concludes.

5

There throbs in all of us a certain overevaluation of photography, art and the mass media. Despair, the need to entrust everything to the effectiveness of creative beauty, the hope of concentrating everything in the content of a message, is an illness, a form of alienation. It is not art, photography included, that will liberate us but a revolution in our way of working and living. Photographs and art are indexes of value. They are elements for cultural dialogue. They refer to our existence but they are not our existence.

Let us not reject the aesthetic, humanizing function. The young Marx based his work on the prospect of placing man in the centre of his world: 'The eye has been transformed into a human eye, just as man has become a social, human aim, an aim flowing from man for man.'

It is not, however, an isolated element.

The richness of our contemporary visual world must be seen as a danger. It is an overwhelming and oppressive world. A world that manifests itself fundamentally through the image is only a few steps from totalitarian manipulation. Images, the visual power of present-day capitalism, like the ritual constructions of ancient Egypt, are refined ways of inhibiting and crushing man. I have lived more than twenty years with these anxieties. I am convinced of the effectiveness of shared, collective work, and of the decisive importance of dialogue among people. I have learned much more by conversing, in animated exchanges and collective discussions, than in eyeing and reading the barrage of information that imposes on us a docile passivity. That is the lure of pseudo-reality.

The photographs in magazines and books, or blown-up on posters and billboards, have the limited power of a watchword, of visual phraseology. We do not commit ourselves by giving our word, we do not assume a real and considered position within the group. The image only incites us, it does not commit us. It customarily manipulates us. For better or for worse. The visual image has a limited value within a social and cultural system.

The Greek habit of dialogue continues to be a liberating principle; and when this dialogue becomes universal among men and bases itself on work, on coherent action – only then will the image be able to play a humanizing role.

The prestige of the visual image is out of all proportion. Photographs are ideas, memories, feelings, thought – and thought devotes itself only to death, to what is mechanical in life, to regularities or distortions. Life is first action, then words, and a photograph in death. It is an instantaneous truth that has already ceased to exist.

Photography has taught us not to twist ourselves around a discourse that should always be an open dialogue. It is what we have been, and not necessarily what we will be. We are ignorant of the future.

There are one, two, three paths . . .

Original publication

'Cuba Made me So' in *On Signs* (1985).

PART SIX

Photomedia

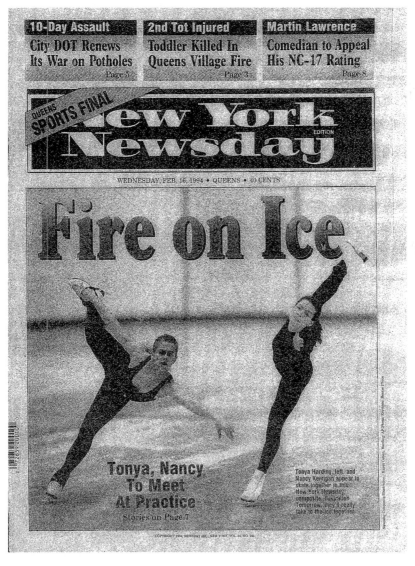

The 1994 image may be the first published 'future' news photograph [New York Newsday, 'Fire on Ice: Tonya, Nancy to meet at Practice'] — *Newsday*. [Original in colour].

Introduction

FOR SOME CRITICS, DEVELOPMENTS in digital imaging in the 1980s and 1990s heralded the 'death' of photography and new modes of vision. It was suggested that digital imaging would replace previous image-making forms, primarily through rupturing any necessary link between image and reality. As William J. Mitchell argued:

> Photographs appeared to be reliably manufactured commodities, readily distinguishable from other types of images. They were comfortably regarded as causally generated truthful reports about things in the real world. . . . The visual discourses of recorded fact and imaginative construction were conveniently segregated. But the emergence of digital imaging has irrevocably subverted these certainties, forcing us to adopt a far more wary and more vigilant interpretive stance. . . . An interlude of false innocence has passed. Today, as we enter the post-photographic era, we must face once again the ineradicable fragility of our ontological distinctions between the imaginary and the real, and the tragic elusiveness of the Cartesian dream. We have indeed learnt to fix shadows, but not to secure their meanings or to stabilize their truth values; they still flicker on the walls of Plato's cave.
>
> (Mitchell 1992: 225)

A number of theorists have argued that this approach either rests upon a false assumption about the nature of chemical photography and its essential relation to reality, or overstates the significance of this technological shift. Various debates have been pursued, including: reference to the contribution of semiotics in demonstrating the coded nature of the image; and emphasis upon continuities of aesthetic traditions despite changing means of creating images. In addition, dominant histories of photography have been challenged through drawing attention to the long history of alternative practices (for instance, cameraless artisanal modes of image-making such as cyanotypes and rayograms). Others have stressed the importance of uses of photographs, of social investments and expectations and of the representational power of the image, rather than the manner of its generation. For instance, taking the infamous 1982 example of the narrowing of space between the pyramids in order that an image might fit the cover of *National Geographic*, Martha Rosler asked 'if we move (the pyramids) photographically, are we betraying history? Are we asserting the easy domination of our civilization over all times and all places, as *signs* that we casually absorb in the form of loot?' (Rosler 1991: 55).

What, then, was at stake in the early twenty-first century in thinking about photo-digital? Here, the ontological status of the image came up for discussion in two key respects. First, the loss of a clear origin. There is no longer a precise creative moment when the image is photographed, literally 'written with light'. This not only affects the value of the fine print as an art market commodity, but also has legal ramifications in terms of authorship, ownership and copyright. Second, the

loss of the real. There is no longer a necessary link between the people, places and events pictured and the image, which may be digitally constructed or manipulated. If a photograph is to be taken as some form of witness or testament then emphasis has shifted onto the circumstances of its making, the intentions of the photographer and the context of publication. But, it has long been noted that, as documents of personal or social history, photographs offer selective testament, tending to record highlights of personal and public events, births, weddings, carnival, school or student graduation, and so on, rather than the everyday banal. Also, that selection, framing, editing and cropping are integral to picture-making. What was of interest was not so much the manner of the making of the image (chemically or digitally) as the continuing desire to claim photographic accuracy. Discussions in the mid-1990s as to whether photojournalistic images should carry some sort of certificate of authenticity strangely echoed nineteenth-century claims for veracity whereby illustrations were published with a caption asserting that they were based on actual photographs. With digital imaging, it is not the method of the making so much as the authority of the message which is primarily in question. To reflect upon the loss of the 'shadow' or 'trace' immanent to lens-based, chemical photographs is to ignore the relative insignificance of this element within the image economy.

As Martin Lister has commented, debates about the impact of the digital have been conducted at two very different levels: on the one hand, as noted above, there has been concern about impact on the practical and embodied procedures of photography, one in which the photographer traditionally acted as observer. On the other hand, the digital was greeted as heralding an epochal shift in our relation to and understanding of the world as a social and economic space. In this respect, much reference has been made to Benjamin's 'Artworks' essay and its engagement with what may be seen as an earlier but equally significant paradigmatic shift in the circulation of cultural artefacts (Lister 2013: 3–4). At both levels, rather than somehow simply superseding previous modes of production and practices, technological developments engage dialectically with previous forms, and do so within multifarious historical and cultural contexts. Ways of seeing articulate complexities of physiological responses, cultural associations and conventions, memories and desires. New visualities may articulate discourses differently; in dialectical terms this represents an engagement with that which obtained previously, one which does not necessarily imply wholesale displacement or erasure.

The first chapter in this section formed the inaugural editorial introduction for the then new academic journal, *photographies*. Emerging from extensive discussions between the journal editors, it identifies issues and difficulties in conceptualising the field of photographic practices in the era of the digital in order to indicate the widely dispersed parameters of the journal. In so doing it stands as a record of key debates, of what seemed most puzzling about the cultural import of technological innovations in the early years of the twenty-first century.

Historically, photography has incorporated various innovations, and obsolescences. The next three essays particularly explore this, the first more in relation to gallery practices, the second through reference to digital initiatives and the third in terms of continuities through change. Geoffrey Batchen is best known for his

archaeology of photography wherein he questions singular, progressive accounts of the history of photography and also the idea of an 'original' (authorial) print (Batchen 1997). In this essay, he suggests conceptual similarities between the digital and older photographic processes, arguing that the electronic image, derived through code, can be compared with the work of the early Victorian photographer, Anna Atkins, who made systematic use of the photogram.

Following on the contention by philosopher, Vilém Flusser (1920–91) that most photography is redundant due to over-familiarity, Daniel Palmer considers digital photography, image saturation and the excess of imagery. Inter-relating histories of photo technologies with changing uses of photographs, he proposes that we are now witnessing a central collaboration between photographers and databases. Taking William J. Mitchell's heralding of the 'post-photographic' as a starting point, Lev Manovich argues that such assertions are based upon partial and selective histories of photographic practices, especially stress on the relation of photographs to actuality. This is illustrated through noting aesthetic continuities in everyday visual communication, for instance, the hyper-realism common within computer graphics.

Overall, each essay makes the fundamental point that the economy of the photographic is not determined by the technological. Rather, it encompasses a multiplicity of concepts and variously articulates images and concerns associated with time and space, with nature and culture, with subject – object relations, with aesthetics, with representation, memory and identity. By contrast, Fred Ritchin proposes a seismic shift consequent upon digitality facilitating multiple links so that no image can be conceptualised as a single and singular referent. As he remarks, 'the digital age has entered us' (Ritchin 2009: 9). For him this means we inhabit a post-photographic era within which the still photo is merely one element within multi-media sites and strategies. In 1995, responding to ways in which debates were developing, Martin Lister argued that the newness of the digital had been over-emphasised through setting up a false opposition with lens-based media and proposed a dialectical approach to analysing the impact of the digital within which historical and cultural continuities, along with the contexts within which images operate, are kept in focus. This position is further elaborated in this introduction to the second – and extensively revised – edition of what was the first British major collections of essays on photo-digital.

Matthew Biro's essay pursues the question of continuities through technological change by comparing the art photography of Andreas Gursky and that of Bernd and Hilla Becher. Likewise, contrasting photo-montage with digital image manipulation, Stephen Skopik addresses questions of aesthetics and realism in gallery photography in the digital era, concluding, as do many of the writers in this section, that questions of representation, culture and meaning remain central regardless of technological change.

Although technical developments and innovative uses of imagery may seem ever more revolutionary, arguably it is the aesthetic and the social that remain of paramount import when thinking critically about photographic practices now.

References and selected further reading

Batchen, G. (1997) *Burning With Desire, the Conception of Photography*. Cambridge, MA: MIT Press.

Cameron, A. (ed.) (1991) 'Digital Dialogues: An Introduction', *Ten.8* Vol. 2/2, Autumn. Special issue of the British-based journal; essays by various authors.

Coleman, A.D. (1998) *The Digital Evolution*. Munich: Nazraeli Press. Reviews, talks, and interviews, 1967–1998.

Cubitt, S. (1998) *Digital Aesthetics*. London: Sage.

Druckery, T. (ed.) (1996) *Electronic Culture*. New York: Aperture. See especially Section Two, on 'Representation: Photography and After'.

Kember, S. and Zylinska, J. (2012) *Life After New Media*. Cambridge, MA: MIT Press.

Mitchell, W.J. (1992) *The Reconfigured Eye: Visual Truth in the Post-Photographic Era*. Cambridge, MA: MIT Press. Emphasises rupture between the photographic and the digital.

———— (2004) *What Do Pictures Want?* Chicago: University of Chicago Press.

Rosler, M. (1991) 'Image Simulations, Computer Manipulations: Some Considerations', in Cameron (1991), see above.

Wombell, P. (ed.) (1991) *Photovideo: Photography in the Age of the Computer*. London: Rivers Oram Press. Catalogue for exhibition of same title, Photographer's Gallery, London.

Bibliography of essays in part six

Batchen, G. (1998) 'Photogenics', in *History of Photography* Vol. 22/No. 1, Spring. London: Taylor & Francis.

Bate, D., Kember, S., Lister, M. and Wells, L. (2008) 'Editorial Statement', *Photographies* Vol. 1:1, pp. 1–8.

Biro, M. (2012) 'From Analogue to Digital Photography: Bernd and Hilla Becher and Andreas Gursky', *History of Photography* Vol. 36:3, pp. 353–66.

Lister, M. (2013) 'Introduction', in *The Photographic Image in Digital Culture*, 2nd ed. London: Routledge.

Manovich, L. (1995) 'The Paradoxes of Digital Photography', in Hubertus v. Amelunxen *et al.* (eds) (1996) *Photography After Photography*, G + B Arts or at: http://jupiter.ucsd.edu/%7Emanovich/essays.html, accessed 25 June 2000.

Palmer, D. (2012) 'Redundancy in Photography', *Philosophy of Photography* Vol. 3.

Ritchin, F. (2009) extracts from 'Of Pixels and Paradox', in *After Photography*. New York: W. W. Norton & Co.

Skopik, S. (2003) 'Digital Photography: Truth, Meaning, Aesthetics', *History of Photography* Vol. 27:3, pp. 264–271.

David Bate, Sarah Kember, Martin Lister and Liz Wells

EDITORIAL STATEMENT

Photographies *seeks to construct a new agenda for theorizing photography as a heterogeneous medium that is changing in an ever more dynamic relation to all aspects of contemporary culture.*

THIS NEW JOURNAL AIMS to open up a forum for thinking about photography within a trans/disciplinary context, open to different methods, models, disciplines and tactics. The editors want to construct a critical space that can address the sites of production, consumption and the multifarious industries of distribution and dissemination that make photographic images so central in much of our culture. We believe that the discussion of photography needs to be developed, expanded and interrogated, along with, where necessary, rethinking the critical methods we employ.

The title *Photographies* is intended to recognize both this openness in approach and the inevitable questions about how we constitute "photography" as an object of study in the twenty-first century. Of course, it has long been useful to think of *Photographies,* rather than a monolithic photography; a view which must lead us to conclude that the singular noun "photography" is more a convenient way of gathering up diverse practices than a secure marker for an irreducible medium. As John Tagg famously put it "Photography as such has no identity" and can have no single history (63). And yet the medium specificity that photography as discourse as "a flickering across a field of institutional spaces" (Tagg 63) warned us to be wary of, or indeed the distinctive and compelling photographic conjunction of index and icon as semiotics conceives it, or even the founding notion of the photograph as a physical trace, do not give way easily. In a recent book *Photography Theory*, in which forty eminent historians and philosophers discuss the nature of photography, each of these ideas, and many more, finds its champions (Elkins). Yet the same book seems to suggest that while photography has been around for nearly two centuries, we are no closer to understanding what a photograph is. This particular publication was framed in terms of an "art seminar", so

the focus was on theory in relation to photography within a particular type of context. Photographic practices are diverse, yet even when the parameters are narrowed the epistemological framing is still cause for dissent. Remarkably, we appear to be in this bewildered and intractable state some twenty years after the "death of photography" was announced at the hands of the digital revolution; a moment in which, as one commentator put it, a short one hundred and fifty year period, an age of false innocence as far as photography is concerned, came to a close (Mitchell 225). Indeed, photography was far from innocent during this period; a period in which it became ever more diverse and ubiquitous, underwent continuous technological reinvention, extension and hybridization, and during which much that has come to pass in the digital age was prefigured or glimpsed.

It might be thought that one of the contexts for this journal's project is technology; that the main issue confronting photographers today is the endless onslaught of technological change. No sooner has one thing been updated than another "needs upgrading". However strong this may seem in terms of our everyday experience, it begs reflection. As we observed above, the technologies of "photography" have always been changing. Whether our recent and current experience of change is itself new, is historically novel, is something we cannot be sure about without further research. We cannot even be sure, as some will argue strongly, that there is a difference between the ceaseless technological change in photography's history and "our change" and "our technologies" because they are qualitatively different from those experienced in the past. Further, technological change is not of one kind. We have been experiencing at least three kinds (and each may have precedents of sorts). First, the kind of apparatus used to pursue a practice is replaced with another, in this instance the computer for the camera. In this kind of change images that appear to be, and are used and valued as "photographic", continue to be made but with new means. Second, there is the widespread and profound change in geo-politics in the now global media ecology, within which photographies (of older and newer kinds) now exist. Institutions from news media to the art museum, scientific research to surveillance (military and economic) operate on a scale and with an instantaneity previously unimagined. Third, personal imagery circulates in parallel within virtual space and actual space, flowing, as it were, in between two "worlds" of existence and experience.

However, another context in which this project takes place is the state of the intellectual field with which we approach such questions: the context of the disciplines and the critical discourses with which we study photography. This is a context which cannot entirely escape the force field of technology either. During the 1990s, much critical thought about photographies was preoccupied by the import of the emergent digital image technologies. Debates passed through speculations on the "death of photography", the nature of the "post-photographic" and a "photography after photography" as a liberation from the (always contested) referential nature of photography, of the afterlife of photography as an ideological realist rhetoric, and as the antecedent of the panoptic and spectacular machinic assemblages of contemporary visual culture.

The view, implicit or explicit, that a radical displacement, even the death of photography by digital means, was at hand, was clearly wrong (as have been most previous pronouncements across the twentieth century of the demise of this or that medium). However, while photographies have proliferated, photography's critical apparatus may not have fared so well. Since the 1980s at least, the theory of photography evolved,

it developed its own themes for analysis and often borrowed (and developed) new models of analysis from other disciplines: film studies, literary theory, sociology, media studies, anthropology, philosophy, psychoanalysis, cultural theory and art criticism. Cultural studies, visual studies, visual theory, visual culture, contemporary aesthetics and art theory all contain important perspectives on photography. Yet we might recall that *Ten-8*, the key British journal dedicated to the critical study of contemporary photography and which productively borrowed from many of these disciplines and frameworks, folded on the very eve of the period that it announced in one of its last issues "Digital Dialogues: Photography in the Age of Cyberspace" (2.2, January 1992). It was then in the subsequent period that we experienced an overriding preoccupation with the threat of digital imaging to photographic "truth" and realism, its evidential value and its veracity. Given that photography's realism and its relation to personal and social uses have been constant themes throughout the history of photographic theory and criticism, this resurgence of interest in those abiding questions might not surprise us. It was certainly a situation that was compounded by the utopian and dystopian registers with which technological change is typically accompanied, and much time was spent framing and putting into perspective the questions which digital and network technologies raised (and continue to raise) for photography.

Arguably, this consumed so much energy throughout the 1990s that we took our eyes off the ball and have not looked closely at the actual changes taking place. As a result, we hardly have a map of recent and current changes (some of which are raised in this issue). While photography has thrived and developed in new ways, much of the critical apparatus surrounding it lost its impetus in respect of interrogating and understanding those developments. The study of photography can, indeed must, proceed with its inherited and diverse conceptual frameworks and histories, including those late twentieth-century developments we refer to above. When such resources are used to investigate, analyse and interpret the kinds of photography with which they were coeval, they are useful tools. This journal will respect them and publish work which uses them to effect. Yet, arguably, critical work on contemporary photographies is also constrained by the legacy of these theoretical debates of the late twentieth century. These frameworks and histories are not always appropriate to the photographic processes, objects and contexts that are now emerging (as some of the contributors to this issue observe – Rubinstein and Sluis; Lager Vestberg). Neither have they been much in dialogue with the new theoretical paradigms evolving around the study of new media forms even though, in practice, much photography is deeply involved with such forms. Conversely, there are unwritten histories of photography, or notes in the margins of the histories we do have, which might tell us much of value about how to think of contemporary developments (as others of our contributors show – Baylis in "Remediations"; Lieberman in "Traumatic Images").

At the same time many of the disciplines from which photography theory has borrowed and to which it has contributed have themselves moved to take very seriously indeed the new technological context for the production, distribution and consumption of cultural forms. If continuing proliferation, accelerated reinvention and transformation, of both dramatic and subtle kinds, are key phrases for describing contemporary photography, the range of disciplinary and conceptual frameworks available to us now needs to be joined by others. It is no accident that some important kinds of attention and highly pertinent insights into photography have come from outside

the more orthodox discourses on photography: from scholars of "new media", some of whom contribute to the conceptual framing of specific essays in this first issue of *Photographies*. These include Lev Manovich's conceptualization of the "database" (218–37), Jay Bolter and Richard Grusin's concept of "remediation" and Paul Frosh's suggestive phrase "the code without a message" (74).

One thing seems certain: there is now more photography, possibly of more kinds, than ever before. We are dealing with a truly expanded field where deep continuities run alongside unforeseen and radical transformations. With an appreciative nod to Bruno Latour's introduction to *We Have Never Been Modern*, in which he analyses the complex of objects and discourses contained within a single daily newspaper (1–5), we can try here to make present this complex field, however impressionistically.

The United Kingdom's *Guardian* newspaper of 22 June 2007 is replete with powerful photographs (few of which fit neatly into a photo-journalistic genre) and celebrates being awarded the "Newspaper of the Year" in the 14th Annual Picture Editors Awards. On page 29 it carries a feature entitled "Jessops Photo Chain Bailed Out by HSBC". "Hit by falling camera prices . . . " this photographic retailer has seen its shares crash from 150p to 15p in a three-month period. The *Independent* newspaper of 29 September 2007 reports that the British government's Secretary for Culture (noted for denouncing some recent editorial improprieties in British television) faces a call to resign after agreeing to have his image digitally inserted into a group photograph for which he had arrived late. On 24 October *Guardian Online* carried a video report of the shooting of a Japanese photo-journalist while working amidst the demonstrations against military rule in Burma.

Surfing the web, we find that mobile phone cameras are responsible for transgressing what is right and appropriate to photograph in public space. An email petition circulates, collecting signatures against the alleged intention of the British government to ban street photography. The Spring/Summer 2007 issue of the United Kingdom's Arts and Humanities Data Service newsletter carries a debate in which one author asks: what do Google Images provide? "A hotch-potch of hackneyed sunsets, drunken student parties and gawping sportsmen" and provocatively calls for the *banning of all digital cameras* on the practical grounds of ubiquity, low quality and the amount of time now consumed in uploading and adjusting images. More specifically he argues that obsession with providing access to images for an extended audience distracts from more sophisticated uses of the Internet as a communicative tool, remarking that, for instance, in museum collections content is little without context. We are exhorted to focus on "ideas in the mind" rather than objects in the world. By contrast, his respondent argues that everyone should be given a digital camera so that we can experience the world as it has been historically from Lascaux's cave art onwards, as "a world of pictures".

Elsewhere, the web is awash with talk of the rise of "the 'citizen journalist", while we all become photographically surveilled subjects on an extraordinary scale. An article in the journal *Social Text* (23.2, Summer 2005) demonstrates how the post-9/11 exponential ramping up of investment in biometric facial recognition software (machines to look at photographs) has its deep roots, and its deep contradictions, in nineteenth-century appropriations of photography for criminological and surveillance purposes *à la* Bertillon and others. The accumulation of dysfunctional and "disorderly piles" of photographs in police archives is now being matched by the self-defeating miles of

video footage and traffic congestion snaps. *In the face of human fallibility and fatigue the automation of picture making is now followed by the need to automate "looking at" pictures* ("Biometrics and Post-9/11 Technostalgia").

A draft manuscript is submitted to this journal describing an emergent trade in the (illicit) fallout – physical prints – of digitalized photographic archives. An online advert reaches our computer screens alerting us to the new "digital frames" which will restore, via an online feed, our photographic "prints" to the mantelpiece. At a conference in Finland run by the International Photography Research Network, Nokia's Director of Image Development claims that the mobile phone has put more cameras into people's hands than in the whole previous history of photography; the Kodak revolution is relived and transcended by the Nokia revolution.

On the website of TED (Technology, Entertainment, Design), an annual conference which claims to bring together the "most fascinating thinkers and doers" in those three fields, streaming video shows a Microsoft researcher demonstrating the Photo-Synth software technology currently in development. In response to the selection of a single photograph, the "meta data" attached to images posted online allows thousands of images depicting the same subject to be sucked out of their niches in online galleries, archives and social networking sites, to display a huge tiled mosaic of related images. The demonstration reveals how the smallest portions of an image can be rendered in extraordinary detail – although, in one sense these are not images in any conventional sense but intelligent digital simulations harnessing pattern recognition technology. Further, by analysing the multiple photographs taken of the same subject the 3D position of the photographed object is calculated and rendered in space (www.ted.com/index.php/talks/view/id/129).

An article from the *New York Times* reprinted in *The Observer* (Sunday 14 October 2007) introduces the field of digital forensics, which analyses various forms of digital media – images, audio, video – in order to establish whether they have been subject to forms of manipulation. It appears that when South Korean scientists published a paper incorporating the photographic evidence of cloned stem cells, those stem cells "were effectively Photoshop-cloned, and not laboratory cloned". In another report, the *New York Times* discussed scientific photographs of natural phenomena produced as art works by Felice Frankel. Frankel acknowledges manipulating her images and claims that she does so not to obscure but rather to highlight their veracity. For example, when she photographed bacteria growing on agar, the agar cracked. So she digitally removed the crack "because I wanted the reader to pay attention to the bacteria pattern". Photography has become a medium for capturing pattern, phenomena and process and reveals (again) that the boundary between the terrains of nature and culture was never secure.

Photographic values soared as, on 7 February 2007, Andreas Gursky sold a single but vast photographic print at Sotheby's for £1.8 million.

In Britain, following "Cruel and Tender" (2003), Tate Modern's first exhibition of photography some one hundred and fifty years after its "invention", blockbuster exhibitions of photography have become a more regular part of art gallery fare. Tate Britain held "How we Were" in June 2007, and in October 2007 the Hayward Gallery hosted "The Painting of Modern Life", an exhibition exploring painting's traffic with photographs. Re-viewing photo-realist works by Warhol, Richter and Hockney we are reminded that it is only very recently, in the early 1980s, that it became possible to

print photography, in colour, to the scale that we now take for granted. Confusions abound: in September 2007 police seized a Nan Goldin picture of two naked girls from the Baltic Centre for Contemporary Art in Gateshead, UK, only to return it a month later having determined that it did not breach child pornography legislation. Yet Nan Goldin is the 2007 Hasselblad Award winner.

A feature in the September 2007 issue of the *Independent Magazine* reveals the fashion photography produced by the documentary photographers of Magnum over some sixty years. In local libraries and cafés amateur photographers display their creations – the picturesque, the domestic . . . alternating with the work of amateur artists, painters and printmakers, and in October 2007, in a supplement on Photography published by the *Guardian*, the newspaper's editor claimed that this is "the age of the amateur". In the United Kingdom alone, some forty new postgraduate courses in photography have been launched in the last ten years. Many have built wet darkrooms, the craft discipline they house being seen crucial to the pedagogy of photographic education. Conversely, other courses are made economically possible by the "born digital" image; photography's new means. These have no analogue foundations and they celebrate it. Yet photography education continues to draw upon theoretical models and discourses from the 1970s/1980s when, of course, there had been sets of tensions over structuralist and "post-structuralist" models of analysis that tended to be driven from linguistics/semiotics, and also a return of interest in the 1920s/1930s writings of Frankfurt Institute theorists newly translated for the benefit of Anglo-American scholars. Meanwhile, hermeneutic modes of enquiry continued to characterize Germanic academia and, more generally, debates were enlivened through the introduction of feminist and postcolonial interventions. Models from this era remain influential, despite more recent paradigmatic shifts. Indeed, arguably, critical scholarly work on photography is constrained by the legacy of these theoretical debates of the late twentieth century. There are those who continue to seek the elusive "photographic" and its essence in the index, the punctum, subjectivity and the experience and technology of modernity. On the other hand, there are those who want to address only the present and future, formulating the impact of the digital as "post-photographic" and transcending photography as previously constituted. Yet, if throughout its history photography has constantly been reinvented, and there are photographies rather than photography, surely we should expect the new to become complexly interwoven with the old as new conceptions, uses and practices emerge.

Photographies will construct a new agenda for theorizing the photographic, one which is alert to photography's changing contexts and meanings, and to the unprecedented scale and diversity of sites of image production, reproduction and consumption now. It will seek diversity of focus through fostering a wide range of themes, methodologies and contexts of exploration.

All such issues – and examples – have implications for how we might characterize photography in terms of the political and how we might consider photographies now. So how might we theorize photographies in ways that take us beyond those discourses that burgeoned so productively in the late 1970s and early 1980s? What, then, is the condition of photography now and how might we approach it in terms of theory? Are there new photographies to take account of? Do they "Flickr differently across institutional spaces?" To the extent that photographies are the product of discursive investments, what are they and what interests and which institutions do they serve?

How and why do older photographies continue to exist, and how might they be trans-
formed or revalued? What part does technology play in contemporary changes within
photography (or, indeed, in any cultural change)? Why have the most recent phases of
photography's reinvention returned us yet again to the vexed question of its nature?
What is at stake when some argue that new imaging technologies throw such questions
into new and urgent relief, promising new kinds of answers, while others take the view
that they are a marginal diversion?

Photographies will on occasion include translations of key papers published elsewhere
in order to make such material available in English. It will also seek to sponsor or
contribute to symposia, workshops and other events designed to encourage innovative
thinking in order to identify potential issues and contributors. In relation to this, from
time to time it will act as a forum for publication of conference papers – for example,
a selection of contributions to the conference on Global Photographs: Histories, Theo-
ries, Practice at the Institute of Art, Technology and Design, Dublin in June 2007, will
be published in 2009. It also aims to foster overarching debates, critical re-evaluations
and reflection on contemporary initiatives and developments. In respect of this, we
shall be running a regular "Alerts" column, not for news items but for raising issues
which are challenging politically, socially or epistemologically. It is hoped that this will
provoke longer reflective papers or debates in subsequent issues of the journal.

Given the range of concerns and debates that might be addressed, shaping the first
issue has been challenging. One focus is on digitality in terms of modes and speed of
communication and of continuing questions of the import and impact of imagery. As
the digital image proliferates online and increasingly becomes delivered via networks,
numerous practices emerge surrounding the image's transmission, encoding, ordering
and reception. Informing these practices is a growing cultural shift towards a concep-
tion of the Internet as a platform for sharing and collaboration. In "Mapping the Net-
worked Image" Daniel Rubinstein and Katrina Sluis re-examine the field of snapshot
photography as this practice shifts from prints to a transmission-oriented, screen-
based experience, raising questions about the ways in which digital photography is
framed institutionally and theoretically. It is argued that new alignments emerge as
everyday domestic imagery interacts with established and experimental photographic
(and filmic) forms. This perhaps gives the lie to the assertion, noted above, that there
is too much low-quality imagery in circulation and the rhetorical demand that digital
cameras be banned. On the contrary, the point is that the Internet as a repository
of imagery changes how we engage with pictures forging connections in terms of
meaning and allegiances. This links to some of the concerns raised by Gail Baylis in
"Remediations" wherein she assesses predictions about the effects of digital technolo-
gies through revisiting the animated debates that greeted the emergence of photogra-
phy as a popular medium no longer the preserve of the "gentleman amateur". Through
a case study of the work of Victorian photographer Hugh Annesley she reminds us of
shortcomings in pursuing technologically determinist arguments for an understanding
of changes in visual culture and argues for the importance of locating photographic
practices within specific cultural and historical contexts.

Through a reading of Stephen Poliakoff's television drama *Shooting the Past,* cen-
tred on a photographic collection, Nina Lager Vestberg proposes a new perspec-
tive on the physical archive, increasingly under threat of replacement by the digital
database. "Archival Value: On Photography, Materiality and Indexicality" argues for a

reconception of indexicality that privileges the photograph as object, as opposed to the photographic image. She particularly argues that the contemporary repackaging of erstwhile ephemeral and disposable photographic prints in the context of both the art museum and auction house obscures other histories.

Jessica Lieberman re-engages theoretical debates about photography's indexicality. "Traumatic Images" explores an analogy between the meaning structure of psychic trauma and photographic images, arguing that, like traumatic experience, photographs are displaced from the "reality" they reference and therefore, ultimately, are not records of an event. It is argued that, rather than looking at a photograph as the depiction of an irredeemable past or the promise of a redeemable future, we can look at it as analogous to a trauma, where what matters is not the inaccessible original event but the history of interpretations. This is particularly pertinent to Gunthert's discussion of the circulation of the infamous Abu Ghraib photographs. André Gunthert traces the circulation of these images as key testimony to the mode of conduct of the war in Iraq, arguing that their emergence responded to incipient shifts in public attitudes to the war as well as reinforcing such shifts.

"Blessed be the Photograph", a photo + text essay, explores the choreography of tourism, particularly the visitor arrangements at Nordkapp (at the northernmost point of Norway). We aim to include an image + text contribution in each issue. Please contact us if you have suitable material to submit. Finally, we hope to establish a section alerting us to new events, issues and developments which might provoke future reflections and debates. This will act as a notice board and as a sounding board for comments and ideas which, we hope, may provoke reflection and responses, in the form of papers submitted to future issues of the journal.

So, there are more and more photographies! It follows that there is a need to foster debate and reflective dialogue on practices, contexts and ideological implications of contemporary developments. In relation to this, a future issue will include discussions of photography theory now and issues in photography education which we hope will generate ongoing discussions.

Original publication

'Editorial Statement' in *Photographies* (2008).

Works cited

Bolter, Jay David, and Richard Grusin. *Remediation: Understanding New Media*. Cambridge, MA and London: MIT Press, 1999.

Elkins, James. *Photography Theory*. New York and London: Routledge, 2007.

Frosh, Paul. *The Image Factory: Consumer Culture, Photography and the Visual Content Industry*. Oxford and New York: Berg, 2003.

Latour, Bruno. *We Have Never Been Modern*. Cambridge, MA: Harvard University Press, 1993.

Manovich, Lev. *The Language of New Media*. Cambridge, MA and London: MIT Press, 2001.

Mitchell, William. *The Reconfigured Eye: Visual Truth in the Post-Photographic Era*. Cambridge, MA and London: MIT Press, 1992.

Tagg, John. *The Burden of Representation*. London: Macmillan, 1988.

Geoffrey Batchen

PHOTOGENICS

T HIS ESSAY WAS PROMPTED BY an exhibition of the past decade's photography acquisitions at the Art Museum of the University of New Mexico in Albuquerque.[1] Not that the work in the exhibition was particularly exceptional. As one might expect in a museum already well-known for its photography holdings, it featured a broad range of different photographic approaches, functions and techniques (from an anonymous 1865 portrait of an amputated leg made for an Army Medical Corps to an illustrated fan by contemporary Japanese photo-artist Yasumasa Morimura), and exemplary prints by some *well-known* names (Watkins, Seeley, Salomon, Lange, Friedlander). An impressive collection, especially for a university museum. But what caught the attention was not the work itself but the way in which it was presented. Hung on the usual tastefully coloured walls, the display was organized in a roughly chronological fashion; that is, as a kind of history, a history of photography. Nothing exceptional here either, except for the way the exhibition chose to begin and end its chronology. For the exhibition's curators began their historical exposition with one of photography's earliest products, an 1850 cyanotype contact print by Anna Atkins, and ended with another much larger cyanotype work made in 1977 by American artist Barbara Kasten. The exhibition thereby seemed to be presenting photography's history, as one of the wall texts explicitly told us, as a 'full circle'.

To repeat, this otherwise unassuming exhibition chose to represent photography's history as a movement that is now turning back on itself, almost consuming itself, repeating certain motifs and self-understandings in a kind of cannibalistic homage to itself. It is as if the exhibition wanted to tell us that photography's history has reached a point not of no return but of nothing but returns. This sense of photographic history as a narrative constituted by 'forward motion through endless return' was made all the more poignant by a recent phenomenon that the exhibition excluded from its story; specifically, the displacement of traditional photographs by computer-generated digital images.[2] Continuing in the spirit of the UNM Art Museum curators, my essay therefore seeks to place the digital phenomenon back into this exhibition's intriguing historical circuitry.

On 2 April 1996, Corbis Corporation, owned by American billionaire Bill Gates, announced that it had signed a long-term agreement with the Ansel Adams Publishing Rights Trust for the exclusive electronic rights to works by Adams. This followed an earlier announcement from Corbis regarding its acquisition of the Bettmann Archive, one of the world's largest image libraries.[3] In this one purchase Gates gained reproduction rights to over 16 million photographic images. But this is only the beginning. Thousands of new images are being added to the Corbis Collection every week, drawn from a multitude of individual commercial photographers as well as institutions such as NASA, the National Institutes of Health, the Library of Congress, the National Gallery of Art in London, the Seattle Art Museum, the Philadelphia Museum of Art and the Hermitage in St Petersburg.[4] Selected images are scanned into the Corbis computer banks, promoted via web site, CD-ROMs and catalogues, and then leased, in the form of digital files; to those who are willing to pay for specified electronic 'use-rights'. According to its 1996 catalogue, Corbis is now able to offer its customers over 700,000 of these digital images to choose from.[5]

Even the *New York Times* felt the need to refer to Marxist critic Walter Benjamin when trying to describe the potential consequences of this new industry (for Corbis is but one company in a rapidly expanding trade in electronic images).[6] Benjamin's 1936 essay on the effects of mechanical reproduction tells a rather complicated tale of sacrifice and resurrection.[7] According to this tale, authentic social relations are depleted by their technically induced commodification, in the process creating the conditions for the phoenix-like return of these relations in a post-capitalist economy. His central point was that the shift from production to reproduction, one of the 'basic conditions' of capitalism, would also be the source of this system's downfall. Technological manifestations of this shift, such as photography, therefore embodied the potential for both oppression and liberation. This explains Benjamin's strange ambivalence about technical reproducibility. Interestingly, it is an ambivalence that has been repeated in many of the commentaries on its electronic version. These commentaries often combine Utopian predictions of unfettered, democratized access to the world's visual archives with a fear of the potential trivialization or meaning and history produced by this same access.

There is also a certain nervousness about the prospect of one man, none other than the world's wealthiest capitalist, gaining so much power over the very process, reproduction, that Benjamin saw as crucial to capitalism's demise. This nervousness is understandable when one puts Gates's sudden interest in images into a bigger picture. The Internet is on the verge of becoming an essential part of daily life, providing a vast, competitive electronic market-place in which virtually anything can be bought and sold. Microsoft, another Gates company, is currently struggling with smaller corporate entities such as Netscape to achieve dominance over the means of access to this market. For example, Microsoft is spending millions to develop search and navigation software that will make it possible for any interested subscriber, from schoolchild to industry executive, to locate, download and automatically pay for the images owned by Corbis. The consequence of all this is that Gates may soon control not only the vehicle but also a major portion of the visual content being conveyed over the information superhighway. To really cash in, all he needs to devise now is the right sort of electronic toll-gate. Here we have the ultimate goal of this whole exercise, and Gates obviously plans to make considerable profits on his investments. But will this new enterprise also

accelerate the alienation of his subscribers from their own culture, thereby hastening what Benjamin saw as that culture's inevitable implosion and transformation? Only time will tell.

While we wait, there are a number of more immediate concerns to ponder. One of these is censorship. In November 1995, America Online declared that 'breast' was an indecent word and cut off access to any users' groups who identified themselves with it. The decision was later reversed in the face of complaints from enraged subscribers interested in information on breast cancer. In December 1995, Compuserve temporarily denied four million users of the Internet access to more than 200 discussion groups and picture databases after a federal prosecutor in Munich said the material contained in them violated German pornography laws. On 8 February 1996, American legislators, keen to capture the moral high ground in the lead-up to an election, introduced laws designed to outlaw electronic traffic considered 'indecent'.[8] The Microsoft Network, like the other companies currently offering access to the Internet, already warns its subscribers against exchanging what it deems 'offensive' speech.

It remains to be seen whether Corbis chooses to exercise a similar level of control over its ever-expanding image empire. At this stage the company claims to have no formal policy on the matter, using the undefined criterion of what a spokesman called 'good taste' as a way of assessing images offered to them (resulting, for example, in their rejection of an offer of images of 'babes'). Presumably the company will eventually have to monitor the range of pictures made available to its school-age market. But to what degree will this censorship be extended to its adult customers? As I say, no policy has yet been announced. However, on one level, a selection process of some kind or other is already taking place – only about 5 per cent of the company's holdings have been converted to digital form. Perhaps certain pictures will simply never see the (electronic) light of day.

By dominating the market in electronic reproductions, Gates has also acquired a measure of control over what many might have naively thought to be a public resource – history. Remember that image of Truman holding up the premature issue of the *Chicago Daily Tribune* declaring his defeat by Dewey? It is in the Corbis catalogue. Remember Malcolm X pointing out over his crowd of listeners, the airship *Hindenberg* exploding in the New Jersey sky, that naked Vietnamese child running towards us after being burned by napalm, Churchill flashing his V-for-victory sign, Dorothea Lange's *Migrant Mother*, Patty Hearst posing with her gun in front of the Symbionese Liberation Army banner, LBJ being sworn into office aboard Air Force One beside a blood-spattered Jacky? Corbis offers to lease us electronic versions of them all; it offers to sell us, in other words, the ability to reproduce our memories of our own culture, and therefore of ourselves.

The company's objective, according to its chief executive officer, is to 'capture the entire human experience throughout history'.[9] Notice that experience and image are assumed to be one and the same thing, as are image and reproduction. The 1996 Corbis Catalogue reiterates its CEO's ideal by dividing the company's offerings into an exhibition of digestible themes: Historical Views, World Art, Entertainment, Contemporary Life, Science and Industry, Animals, Nature, Travel and Culture. In the world according to Corbis, human experience is defined by the needs and demands of commercial publishing. More than anything else, the Corbis Catalogue is full of generic images of the kind desired by busy picture editors: human faces from across the globe, plants

and animals of every stripe, cityscapes from Agra to New York, human activity in all its varieties. Want an image of a bi-racial couple? Want a shot of rosary beads and a Bible? Want the view from across the handlebars of a speeding mountain bike? Want to see a welder working on a high-rise building? Corbis can supply any of these and many more like it, all in a glossy, saturated colour, perfect for magazine reproduction and company brochures. Human experience comes suspended in the sickly sweet amniotic fluid of commercial photography. And a world normally animated by abrasive differences is blithely reduced to a single, homogeneous *National Geographic* way of seeing.

All this talk of capturing things brings us to another question – what exactly is Corbis buying and selling? What *is* a digital image? It is notable that in the case of the work of Ansel Adams, they have not bothered to acquire any actual prints (although Gates could obviously afford them). They do not even own the copyright to any of the photographs by Adams (this has been retained by the Adams Publishing Trust). All that Corbis owns are the electronic reproduction rights to certain of Adams's images. The assumption is that, in the near future, *electronic* reproduction is the only kind that is going to matter. The other assumption in play here is that *reproduction* is already the only aspect of an image worth owning. The world's richest man has declared in no uncertain terms that the original print, always a contradiction in terms for photography in any case, is of absolutely no interest. He does not want to accumulate photographs; he just wants to be able to sell endless reproductions of them. He seeks to control not photography but the total flow of photo-data.

And that is just what he's going to do. *Moonrise, Hernandez, New Mexico*, a photograph taken by Adams in November 1941, has been transformed through the wizardry of the computer into a series of digits that take up somewhere between 20 and 50 megabytes of an optical disc (depending on the quality of the reproduction you want).[10] After you pay the required fee, Corbis removes its electronic watermark and gives you the temporary use of a certain system of coded numbers. These numbers, when transposed through a computer program and printer, will reproduce an image that resembles the photograph taken by Adams. If we go back to Benjamin's commentary for a moment, we might conclude that capital has here finally reached the limits of its own logic. It has erased the aura of authenticity from its system of values, and replaced it once and for all with the glitter of reproducibility.

In effect, what a customer is leasing from Corbis is the performance rights to a digitized Adams score.[11] But this otherwise useful musical analogy is also a little misleading. For what Corbis actually seems to want to bring to photography is the logic of a certain kind of science. After all, the Corbis Catalogue is insistent that, 'we bring you all the beauty of the original work in a convenient digital format'. In positing a faithful one-to-one correspondence between original and copy, code and image, Corbis claims to go beyond mere performance, inviting us instead to associate digitization with the precise replication practices of something like genetic engineering.

What are the consequences of such an association? For a start, Corbis's photogenics runs against the grain of photography as understood and practised by Adams. When one orders, for example, *Moonrise, Hernandez, New Mexico* from Corbis one gets a quite particular reproduction. No matter how many times a customer might order this title from Corbis, one is guaranteed exactly the same image, an image precisely cloned from the genetic code that is the new identity of this picture. However, I myself have seen several versions by Adams based on the negative.[12] Indeed, Mary Street Alinder's 1996

biography of Adams details the complex history of this picture, which she suggests is 'for many . . . the greatest photograph ever made'.[13] Alinder suggests that *Moonrise* is an early product of his Zone System of photography, a differentiation of visible light devised by Adams to allow the practitioner to previsualize the entire gamut of values that will appear in the final print. Thus the image comes before the photograph (which is merely its reproduction) and the film is already inscribed with a picture before it is ever exposed to light. This particular exposure was taken by Adams under difficult circumstances on the side of a road in failing light; a recalcitrant negative was the result. Adams made his first print from it in late November 1941, now in the collection of the Museum of Modern Art. In 1948 he attempted to intensify the foreground of the negative, and made further prints in December of that year. By 1980, when he stopped printing from it, Adams had made at least 1300 original prints from that negative, dodging and burning selected areas of the print in an evolving interpretation of its tonal possibilities.

The complication of photography's physical identity (and we are not talking here about the added complexities of contextual or historical determinations of a photograph's meaning) has always been that there is no fixed point of origin; neither the negative nor any one print can be said to represent in its entirety the entity that is called *Moonrise, Hernandez, New Mexico*. And if there is no 'original work', then there can be no 'faithful copy' either. To borrow a phrase from Ferdinand de Saussure's description of language, in photography there are 'only differences *without positive terms*'.[14] As a consequence, photography is produced within and as an economy that Jacques Derrida calls *différance*; any particular photographic image is 'never present in and of itself' but 'is inscribed in a chain or in a system within which it refers to the other, to other [images], by means of the systematic play of differences'.[15] The irony haunting Corbis's electronic reproduction business is that cloning obeys this same [il]logic. In biology, a clone is a copy of another organism produced by implanting an unfertilized egg with a 'differentiated' sample of that organism's DNA.[16] The clone is genetically identical to its donor (its DNA code is a replication of the donor's) and yet the clone is not the same being – it is younger (a lamb is produced from the mammary cell of an adult sheep) – even while, at the same time, its genetic material carries the history of that donor alongside and within its own. *Moonrise* has an equally complicated identity, produced by differentiation and further dividing itself from itself in each and every one of its clones (which are always the same but different, even if this difference is not immediately discernible to the eye).

Bill Gates does not see this proliferation of reproductions as a problem. In his book *The Road Ahead*, he argues that 'exposure to the reproductions is likely to increase rather than diminish reverence for the real art and encourage more people to get out to museums and galleries'.[17] This is the hope of museums and historians alike, many of whom now offer web sites as an enticement to potential visitors or as an archival resource for scholars. But what is interesting about the new archiving is that everyone who has access to the data can curate their own museum or devise their own history. Gates, for example, has commissioned a series of large electronic screens to be installed in his new 30-million dollar house in Seattle and these will be linked to the Corbis database. 'If you're a guest, you'll be able to call up on screens throughout the house almost any image you like – presidential portraits, reproductions of High Renaissance paintings, pictures of sunsets, airplanes, skiers in the Andes, a rare French

stamp, the Beatles in 1965'.[18] The eclecticism of his proposed choices — choices so kitsch they're sublime — suggests a further element of digital imaging.[19] Classification, once the closely policed art form of the librarian, is now as potentially idiosyncratic as the famous entry from 'a certain Chinese encyclopedia' that so amused both Borges and Foucault.[20] Participants who follow the Gates lead can surf an image archive as arbitrarily as people already surf art museums, happily jumping from Rembrandt to ancient Egyptian sculpture to Japanese armour, or from sunsets to stamps to Nobel Prize winners, as the whim takes them.[21] With electronic reproduction, no one has to care about history as a linear sequence any more. History instead becomes a matter of individual invention, a conjuring of talismans of the not-now as a way of confirming our own fragile presence in time and space. History, in other words, takes on something of the poignantly personal character of the photographic (at least as this is described by Roland Barthes in *Camera Lucida*).[22]

Imagine this future. You will venture, electronically of course, into the global supermarket and find offered for sale, side by side on your screen, digital files for an Adams photograph, an improved heart valve and a disease-resistant zucchini. Impossible? Actually, that future is already here. In 1994 Calgene, a California-based biotechnology company, put a tasty genetically engineered tomato on the market, a programmed vegetable that *Newsweek* magazine playfully called 'DNA on a plate'. The human body is already on that same plate. The Human Genome project, for example, presumes that *homo sapiens* too is no more than so much manifest data. At least four firms are currently racing to produce a genetically modified pig whose DNA, having been rendered identical to that of humans, will allow rejection-free organ transplants to take place. In 1995 the US Department of Health and Human Services received a patent (No. 5 397 696) for a virus-resistant cell line found in the blood of Hagahai tribes people in New Guinea.[23] The list could go on. The point is that Corbis and other companies like it are intent on taking photography into a well-established economy, an economy all about the distillation and exchange of the world's most valuable commodity — data. And within the logic of that (electronic) economy, the identity of an image is no longer distinguishable from that of any other piece of data, be it animal, vegetable or 'experiential' in origin. Indeed, given the rhizomatic structure of the electronic universe, the point of origin is no longer of consequence. All that matters (in every sense of this word) is the possibility of data's instant dissemination and exact reproduction.

Here we have one of the major consequences of advent of the age of electronic reproduction. The old familiar distinctions between reality and its representation, original and reproduction, nature and culture — we are talking about the very infrastructure of our modern world-view — seem to have collapsed in on each other. More specifically, the substance of an image, the matter of its identity, is no longer to do with paper or particles of silver or pictorial appearance or place of origin; it instead comprises a pliable sequence of digital codes and electrical impulses. It is their configuration that will decide an image's look and significance, even the possibility of its continued existence. It is their reproduction and consumption, flow and exchange, maintenance and disruption, that already constitute our culture (that now constitute even our own flesh and blood).

This meditation on the current state of photography's identity brings me back to my essay's beginning, just as the UNM Art Museum's exhibition layout had suggested it would. For it might well be argued that much of what I have just identified with

the digital phenomenon can already be found in the work of the medium's earliest practitioners. In the work of Anna Atkins (1799–1871), for example. The cyanotype that opened UNM's exhibition, *Hymenophyllum Wilsoni*, comes from a systematic series of 389 such images that Atkins produced between October 1843, when she issued the first part of her pioneering photographically illustrated book (titled *Photographs of British Algae: Cyanotype Impressions*), and 1853, when it was completed. Thus the inspiration for this image was the science of botany, a discipline in which Atkins's father was an established expert, and to whom her book is dedicated. [. . .]

The visual design of Atkins's book followed the lead of an established botanical genre in which actual specimens of seaweed were mounted in bulky, annotated albums or botanical specimens were transformed into engravings, silhouettes or 'cut flower mosaics'.[24] Using William Harvey's unillustrated *Manual of British Algae* of 1841 as her guide, Atkins tells us in her introduction to Part 1 of *British Algae* that she was attempting a 'systematic arrangement', trying to photographically represent 'the Tribes and Species in their proper order'. In Atkins's own schema then, the photogram titled *Hymenophyllum Wilsoni* is but one typical example of a genus; it was made to be representative of a group of images thought to have common structural properties. It should be remembered that each image was printed about 15 times for the different editions of the book, usually re-using the same botanical specimen for each print. So each page always contains the same basic information but also always with slight variations in the arrangement of that information between each edition, as befits a hand-made contact print. In short, like Gates, Atkins presents her images as data, as precisely repeated, invariably differentiated information derived from a common master code and disseminated in image form. Accordingly, to refer to the original print of *Hymenophyllum Wilsoni* would be a nonsense; for Atkins, photography is a processing of data that produces nothing but reproductions.

There is some confusion as to how this reproduction was actually achieved. In *Sun Gardens*, Larry Schaaf suggests that 'the evidence is that she printed most of her specimens "nude", not mounted on any surface. This can be detected from the fact that identical specimens were sometimes printed in different positions, including as a perfect mirror image'.[25] A little later, in a caption for one of these mirrored pairs, he claims that their existence 'prove[s] that Atkins printed many of the plates by placing the unmounted dried-algae original directly on the cyanotype paper'.[26] But if the two images are mirror-versions of each other, surely this verifies that she cannot have simply placed them directly on the prepared paper? To get an exact mirror copy, surely she must have sandwiched them between two sheets of glass or mica, as Schaaf elsewhere suggests, and then flipped the sheets over as she went from one print to the next?[27] The existence of a mirror version of certain images implies a desire for an exact, even if reversed, copy of a particular specimen. But it also suggests a fledgling effort towards a system of mass production, a gesture towards the possibility of that endless reproduction of images now being engineered by Corbis. [. . .]

The particular example in the UNM exhibition repeats the major visual attributes of all the others Atkins made (a repetition that itself works to give the project some 'scientific' credence). She has carefully centred the image on her page, leaving the plant form to float in an appropriately blue sea of cyan. This symmetry gives the image both a pleasing aesthetic order but also the reasoned geometry of a scientific illustration. A desirably scientific character is further enhanced by the addition of an appropriate

Latin name in a photographic facsimile of Atkins's own handwriting, along the lower edge of each print.

What more could be said about these images? What further possible relation could they be said to have to the logic of electronic reproduction? Atkins herself described these images as 'impressions of the plants themselves'. She thus conjures up that direct indexical relationship between an object and its representation which is presumed to be photography's special privilege. As Allan Sekula puts it, photographs are 'physical traces of their objects'.[28] This raises the whole question of the relationship between photograph and object, and necessitates some investigation of 'tracing' in general. Talbot tells us in 1839 about how he showed a contact print of a piece of lace to some friends and asked them whether it was a good representation. The friends replied, he tells us with some pride, 'that they were not to be so easily deceived, for that it was evidently no picture, but the piece of lace itself'.[29] The philosophical dimensions of the blurring of this distinction must surely have occurred to Atkins as she or her servants laboriously made each of her own botanical contact prints.

To make a contact print or photogram, objects such as specimens of seaweed are placed directly on a material made sensitive to the difference between the presence and absence of light. Here object and image, reality and representation, come face to face, literally touching each other. Indeed the production of a photogram requires real and representation to begin as a single merged entity, as inseparable as a mirror and its image, as one and its other. These objects have to be removed before their photographic trace (the articulation of a differential exposure to light) can be seen. By this means, photography allows botanical specimens to be present as images even when they are absent as objects. This continuous play between presence and absence provides, as Talbot put it, 'evidence of a novel kind'.[30] For the photogram's persuasive power depends on precisely a lingering spectre of the total entity, a continual re-presentation of this coming together of image and object on the photographic paper. This is the prior moment, that something other than itself, to which the photogram must always defer in order to be itself.

The photogram (which Rosalind Krauss has argued 'only forces, or makes explicit, what is the case of all photography') therefore could be said to mark what is set aside from itself.[31] It is a marker of the space between the object and its image, but also the temporal movement (the spacing) of this object's placement and setting aside – the very condition of the image's production. So we are actually talking about a surprisingly complicated manoeuvre here, a manoeuvre that simultaneously circumscribes and divides the identity summoned by the photogram. Sekula is obviously right to describe the essence of photography as 'trace', for the word itself simultaneously designates both a mark and the act of marking, both a path and its traversal, both the original inscription and its copy, both that which is and that which is left behind, both a plan and its decipherment. To call photography a form of trace is therefore to recognize activity that, as Derrida puts it, 'produces what it forbids, making possible the very thing that it makes impossible'.[32]

To reiterate, the photogram could be said to incorporate a kind of spacing that Derrida has described as 'the impossibility for an identity to be closed in on itself, on the inside of its proper interiority, or on its coincidence with itself'.[33] The contact print, then, like the digital image, represents a visible convolution of the binary relationship of absence/presence, nature/culture, real/representation, inside/outside, time/

space, that seemingly constitutes the very possibility of photographing of any kind. So with Atkins's prints we witness not just the beginnings of photography, but also that same collapse of oppositional terms (original/reproduction) that I have already identified with electronic reproduction. Moreover, this investigation of the photogram once again reveals not a simple correspondence of object and photograph, code and image, but what Derrida calls 'an infinite chain, ineluctably multiplying the supplementary mediations that produce the sense of the very thing they defer: the image of the thing itself, of immediate presence, of originary perception'.[34]

I have tried to show that the model adopted by UNM's exhibition, its presentation of photographic history as a 'full circle' comprising a paradoxical play of continuities and differences, absences and presences, differences and deferrals, is repeated wherever one looks – in the work of Anna Atkins and in the logic of electronic reproduction, at the beginnings of photography and at its ends. In that context, I hope I have also been able to present a way of thinking about photography that persuasively accords with the medium's own undeniable conceptual and historical complexity.

Original publication

'Photogenics' in *History of Photography*, 22/1 (1998).

Notes

1 The exhibition, curated by Kathleen Howe with the assistance of Floramae Cates and Carol McCusker, was titled *'With the Help of Our Friends: Photography Acquisitions, 1985– 1995'* (28 August 1996 to 8 December 1996). This paper is an expanded version of a talk I gave in conjunction with the exhibition on 8 October 1996, under the title 'Photography as Trace'. It also incorporates aspects of a talk, 'The Matter of Photography', I gave at the College Art Association Annual Conference in New York on 13 February 1997, and elements of two earlier publications 'Manifest Data: The Image in the Age of Electronic Reproduction', *Afterimage*, 24:3 (November/December 1996), 5–6, and 'Evidence of a Novel Kind: Photography as Trace', *San Francisco Camerawork*, 23:1 (Spring/Summer 1996), 4–7. Thanks to Carla Yanni, Thomas Barrow, Larry Schaaf, Sheldon Brown, and Vicky Kirby for their editional suggestions.

2 See the bibliography in this issue of *History of Photography*, and my 'Ectoplasm: The Photograph in the age of Electronic Reproduction', in Carol Squiers, ed., *The Critical Image: Essays on Contemporary Photography* (Seattle: Bay Press, second edn., 1997).

3 Steve Lohr, 'Huge Photo Archive Bought by Software Billionaire Gates', *New York Times* (11 October 1995), C1, C5.

4 For example, Corbis announced on 4 December 1996 that it had expanded its New York stock agency business with the purchase of the LGI Photo Agency. LGI specializes in images for the entertainment business and editorial marketplace. It should be noted that, for most of the institutions mentioned, Corbis has actually negotiated non-exclusive rights, with each institution continuing to have some say over where and how their pictures are reproduced.

5 Corbis, *Corbis Catalogue: Selections From the Corbis Digital Archive, Volume One* (Seattle: Corbis Corporation, 1996).

6 See Edward Rothstein, 'How Bill Gates Is Imitating Art', *New York Times* (15 October 1995), E3. For more on Corbis and its operations, see Corey S. Powell, 'The Museum of Modern Art', *World Art*, 1:2 (1994), 10–13; Richard Rapaport, 'In His Image', *Wired*, 4:11

(November 1996), 172–5, 276–83; Warren St John, 'Bill Gates Just Points and Clicks, Zapping New York's Photo Libraries', *New York Observer*, 10:48 (16 December 1996), 1, 19; and my 'Manifest Data: The Image in the Age of Electronic Reproduction', *Afterimage*, 24:3 (November/December 1996), 5–6.

7 See Walter Benjamin, 'The Work of Art in the Age of Mechanical Production' (1936), in *Illuminations* (London: Fontana/Collins, 1970), 219–53.

8 On 27 June 1997, the US Supreme Court declared unconstitutional a Federal law that had made it a crime to send 'indecent' material over the Internet. This ruling associated the Internet with books and newspapers in terms of its entitlement to freedom of speech (rather than with the more limited rights accorded broadcast and cable television). For general discussions of this decision and other legal debates about indecency on the Internet see, Linda Greenhouse, 'Statute on Internet Indecency Draws High Court's Review', *New York Times* (7 December 1996), A1, A8; Linda Greenhouse, 'What Level of Protection for Internet Speech?', *New York Times* (24 March 1997), C5; and Linda Greenhouse, 'Decency Act Fails: Effort to Shield Minors Is Said to Infringe the First Amendment', *New York Times* (27 June 1997), A1, A16.

9 This aspiration was voiced by Corbis's CEO Doug Rowen, in Kate Hafner, 'Picture This', *Newsweek* (24 June 1996), 88–90.

10 In 1991 an amateur astronomer, Dennis di Cicco, calculated the exact time and date when this photograph was taken: 4:49:20 p.m. Mountain Standard Time on 1 November 1941. Interestingly, this calculation was achieved by first transforming the photograph into astronomical data (derived from the pictured moon's altitude and angle from true north). See Mike Haederle, "Moonrise" Mystery', *Los Angeles Times* (31 October 1991), E1, E4, Thanks to Tom Barrow for this reference.

11 For an introduction to the complexities of American copyright law, see Robert A. Gorman, *Copyright Law* (Washington: Federal Judicial Center, 1991). As Gorman points out, 'Copyright is a form of "intangible" property. The subject of copyright – the words of a poem or the notes of a song – can exist in the mind of the poet or composer, or can be conveyed orally, without being embodied in any tangible medium. Even when thus embodied, it is possible for persons to recite a poem, sing a song, perform a play, or view a painting without having physical possession of the original physical embodiment of the creative work' (p. 6). For this reason a computer program is covered by copyright law as a form of 'literary work'.

12 The Christie's auction catalogue of 17 April 1997, for example, reproduces two visibly different versions of this image, one printed between 1958 and 1961 and one printed in 1978 (Lots 278 and 282).

13 Mary Street Alinder, *Ansel Adams: A Biography* (New York: Henry Holt, 1996), 185.

14 Ferdinand de Saussure, *Course in General Linguistics*, trans. Wade Baskin (New York: McGraw-Hill, 1966), 120.

15 Jacques Derrida, 'Différance' (1968), in *Margins of Philosophy*, trans. Alan Bass (Chicago: University of Chicago Press, 1982), 63.

16 Scottish scientist Ian Wilmut announced that he had cloned the first mammal from a single adult cell on 22 February 1997. For commentaries on this event, see Gina Kolota, 'With Cloning of a Sheep, the Ethical Ground Shifts', *New York Times* (24 February 1997), A1, C17; Lawrence M. Fisher, 'Cloned Animals Offer Companies a Faster Path to New Drugs', *New York Times* (24 February 1997), C17; Michael Specter, with Gina Kolata, 'After Decades and Many Missteps, Cloning Success', *New York Times* (3 March 1997), A1, A8–A10; J. Madeleine Nash, 'The Age of Cloning', *Time* (10 March 1997), 62–5; Sharon Begley, 'Little Lamb, Who Made Thee?', *Newsweek* (10 March 1997), 52–9.

17 Bill Gates, *The Road Ahead* (London: Penguin, 1996), 258.

18 Ibid, 257.

19 Lyotard claims that 'modern aesthetics is an aesthetic of the sublime, though a nostalgic one'. See Jean-François Lyotard, 'Answering the Question: What Is Postmodernism?' (1982), in *The Postmodern Condition: A Report on Knowledge* (Minneapolis: University of Minnesota Press, 1984), 71–82, and 'Presenting the Unrepresentable: The Sublime', *Artforum* (April 1982), 64–9. Commenting on these articles. Sydney-based critics Rex Butler and David Messer have offered the following speculation: 'I wonder if a "true" Sublime art – if it existed – could seem anything other than kitsch to us, because it must always attempt to "present the unrepresentable", that which cannot be represented, and fail. Whether, in fact, the *art itself* would not always be this fallen Sublime, or kitsch? That there could be a Sublime but never a sublime art, except *in the very form of kitsch?*' See Rex Butler and David Messer, 'Notes Towards a Supreme Fiction: An Interview With Meaghan Morris', *Frogger* 15 (May 1985), 11.

20 Foucault opens his Preface to *The Order of Things* by recalling his encounter with a passage written by the novelist Borges. The passage quotes from a 'certain Chinese encylopedia' in which it is written that 'animals are divided into: (a) belonging to the Emperor, (b) embalmed, (c) tame, (d) sucking pigs, (e) sirens, (f) fabulous, (g) stray dogs, (h) included in the present classification, (i) frenzied, (j) innumerable, (k) drawn with a very fine camelhair brush, (l) *etcetera*, (m) having just broken the water pitcher, (n) that from a long way off look like flies'. Foucault speaks of the 'wonderment of this taxonomy', taking it to demonstrate 'the exotic charm of another system of thought'. But it also makes him think more keenly about the presumed logic of his own. See Michel Foucault, *The Order of Things: An Archaeology of the Human Sciences* (New York: Vintage Books, 1973), xv–xx.

21 As Gates has suggested, 'We make it so easy to call up images, whether art or people or beaches or sunsets or Nobel Prize winners'. See Trip Gabriel, 'Filling in the Potholes in the "Road Ahead"', *New York Times* (28 November 1996), B6.

22 See Roland Barthes, *Camera Lucida: Reflections on Photography*, trans. Richard Howard (New York: Hill & Wang, 1981). Barthes describes his relationship to photography in terms of an intensely personal experience he calls *punctum*; 'it is what I add to the photograph and *what is nonetheless already there*' (p. 55).

23 See Laura Shapiro, 'A Tomato With a Body that Just Won't Quit', *Newsweek* (6 June 1994), 80–2; Lawrence M. Fisher, 'Down on the Farm, a Donor: Genetically Altered Pigs Bred for Organ Transplants', *New York Times* (5 January 1996), C1, C6; Teresa Riordan, 'A Recent Patent on a Papua New Guinea Tribe's Cell Line Prompts Outrage and Charges of "Biopiracy"', *New York Times* (27 November 1995), C2. The genetically engineered foods that are now, or soon will be, available to consumers include abalone, apples, asparagus, carrots, catfish, chestnuts, corn, grapes, lettuce, potatoes, prawns, rice, salmon, walnuts and wheat. As the *New York Times* reports, 'for now the only way Americans can avoid genetically engineered food is to choose certified organic food'. See Marian Burros, 'Trying to Get Labels on Genetically Altered Food', *New York Times* (21 May 1997), B8.

24 In 1823 Atkins had herself produced 256 drawings of shells which were then transformed into engravings to illustrate her father's translation of Lamarck's *Genera of Shells*. The 'cut flower mosaic' technique of illustration was invented by a Mrs. Delany in the eighteenth century. See plate 50 in Mrs. Neville Jackson, *Silhouette: Notes and Dictionary* (New York: Charles Scribner's Sons, 1938).

25 Larry Schaaf, *Sun Gardens: Victorian Photograms By Anna Atkins* (New York: Aperture, 1985), 31.

26 Ibid, 33. The reference is to Figure 13A–C, showing the same specimen of *Dictyota dichotoma* in three different arrangements.

27 In email correspondence with the author, exchanged in October 1996, Schaaf made the following comment on this possibility: 'Mica was available in larger sheets than we are

used to now but it was still scarce and relatively expensive. She might have used waxed paper (as in the labels) but I have no direct evidence of this. But the number of specimens that are arranged in subtly different ways – i.e. rotated slightly, would indicate that they were printed nude. If one was working with even a very large sheet of mica, one would be likely to orient it more consistently'.

28 Allan Sekula, 'Photography Between Labour and Capital', in Benjamin H. D. Buchloh and Robert Wilkie (eds.), *Mining Photographs and Other Pictures 1948–1968: A Selection from the Negative Archives of Shedden Studio, Glace Bay, Cape Breton* (Halifax: Press of the Nova Scotia College of Art and Design and The University College of Cape Breton Press, 1983), 218.

29 William Henry Fox Talbot, 'Some Account of the Art of Photogenic Drawing' (1839), in Beaumont Newhall (ed.), *Photography: Essays an Images* (New York: Museum of Modem Art, 1980), 24.

30 William Henry Fox Talbot, *The Pencil of Nature, 1844–46*; facsimile edition (New York: Da Capo, 1968), plate 3.

31 Rosalind Krauss, 'Notes on the Index: Part I' (1977), in *The Originality of the Avant-Garde and Other Modernist Myths* (Cambridge, MA; MIT Press, 1985), 203.

32 Jacques Derrida, *Of Grammatology*, trans. Gayatri Spivak (Baltimore: Johns Hopkins University Press, 1976), 143.

33 Jacques Derrida, *Positions*, trans. Alan Bass (Chicago: University Chicago Press, 1991), 94.

34 Derrida, *Of Grammatology*, 157.

Daniel Palmer

REDUNDANCY IN PHOTOGRAPHY

As inhabitants of the photographic universe we have become accustomed to photographs: They have grown familiar to us. We no longer take any notice of most photographs, concealed as they are by habit; in the same way, we ignore everything familiar in our environment and only notice what has changed. Change is informative, the familiar redundant. What we are surrounded by above all are redundant photographs.

(Flusser 2000: 65)

THE HISTORY OF PHOTOGRAPHY is also a history of *automation*. And at various moments – such as when George Eastman pre-loaded the Kodak camera with film – the activity of photography has been fundamentally altered by changes to the camera apparatus. Indeed, certain kinds of cameras – such as those designed to identify car number plates – now need no human operator at all. In the realm of consumer photography, automation has been sold on the basis that it enables photographers to concentrate on responding immediately to the world around them rather than to the technology. The camera-as-prosthetic automatically focuses and adjusts exposure, so – as a typical Minolta advertisement from the 1970s put it – you can 'translate the vision in your mind to your film'. Recently, however, camera makers have sought to give a different kind of control to their consumers, to revitalize and individualize their picture making. These are not the parameters we are familiar with from the history of photography – of focus, shutter speed, aperture, lens and film. The cutting edge of camera design lies in software that enables more *experimental forms of image capture*. Currently this seems to entail an extension of the moment of capture itself. Thus, the radically un-camera like Lytro lightfield camera enables a user to focus the image *after* the exposure. Meanwhile, the new Olympus OM-D camera, despite its traditional appearance, 'aims to change the way in which you experience photography'. Olympus claim in their promotional rhetoric that:

> Its Electronic View Finder (EVF) enables photographers to check the Art
> Filter effect, colour temperatures and exposure levels in real-time. When
> shooting, you can instantly 'create' a truly unique world and preserve it in
> exceptional quality. The 'world' will be transformed from something you
> see to something in which you 'take part'. The OM-D is a groundbreaking
> new digital interchangeable lens camera perfect for people who want to
> 'take part', 'create' and 'share'.

Of course not all of this rhetoric is new or unique. But photography, it would appear,
needs updating – at least in the eyes of camera company marketing departments. As
their use of scare quotes in the around the words 'world', 'take part', 'create' and 'share'
underline, this way of framing the act of photography appears to reflect a certain
anxiety on the part of the camera maker about the status of conventional photog-
raphy. Indeed, the advertisement's rather phenomenological acknowledgement that
photographers *take part in* and *create* the world – rather than *merely take photographs* –
implicitly critiques traditional behaviours of the photographer. It is almost as though
the Olympus marketing department have taken seriously Susan Sontag's well-known
complaint that the camera promotes a 'detached' and 'passive' way of seeing the world
(Sontag 1978).

Of course these newly 'experiential' ways of framing the act of photography are
perfectly understandable from a marketing point of view. Camera makers are engaged
in an ongoing effort to commodify photographic activity as a leisure pursuit worthy
of a dedicated consumer device. Low-fi Lomo-style analogue approaches that embrace
accidents and imperfections – like the popularity of iPhone apps such as Hipstamatic –
are part of a related development that harks back to the Polaroid era. But another way
to understand the current rush to experiential photography is that it points to a crisis
in, and consequent reframing of, the conception of photography that is sustained by
the 'I was there' 'possession-based' ideology of what we might call 'photographic indi-
vidualism' – which no doubt continues to underpin most single photographic acts. Of
course, Olympus' exhortation to 'create your own world' appeals directly to the pho-
tographer's ego, but one can speculate differently: are these new cameras not, at least
in part, a response to our age of online photo sharing, in which images produced by
geographically dispersed individuals, largely redundant *on their own*, are aggregated and
organized by metadata into something useful *en masse*?

Flickr and Microsoft's stitching software, Photosynth, is the oft-cited example
of this new photographic universe. Photosynth is proprietary software that analyses
digital images in order to generate a three-dimensional model and a point cloud of
the represented space, and then reassembles the images into a near-seamless compos-
ite. In what has been dubbed an 'algorithmic turn', viewers are then free to explore
the assembled photographic space from any direction, including depth (Uricchio
2011: 28). According to its website photosynth.net:

> You can share or relive a vacation destination or explore a distant museum
> or landmark. With nothing more than a digital camera and some inspira-
> tion, you can use Photosynth to transform regular digital photos into a
> three-dimensional, 360-degree experience. Anybody who sees your synth

is put right in your shoes, sharing in your experience, with detail, clarity
and scope impossible to achieve in conventional photos or videos.

Inspired by research in photographic tourism, 'creating a synth', as Microsoft's promo-
tional rhetoric states, 'allows you to share the places and things you love by using the
cinematic quality of a movie, the control of a video game, and the mind-blowing detail
of the real world'. Thus articulated as a libidinal fantasy of ever-increasing verisimili-
tude, the user of such software is able to shape and control an image space that is both
open-ended and potentially tailor-made to the individual. In the process, not only is
the status of the individual photograph reconfigured, the activity of picture making is
reinvented as a *participatory experience* even as the photography is assumed to remain a
transparent broker of the real world.

Photographic excess

At this point I want to backtrack briefly to a different era of photographic history. For
it is worthwhile to consider how the current participatory turn in photography is fun-
damentally antithetical to the modern period of photography, despite the continuation
of certain marketing rhetoric. Take Ansel Adams, who was arguably the most influen-
tial photographer of the twentieth century – not for his redemptive landscape images,
which are admittedly well loved, but for his insistence on the photographer's abso-
lute control of the photographic processes. For at least three decades his instructional
books – such as *The Print* and *The Negative* – were standard texts among amateurs and
professionals alike. Adams' argument was that the 'creative photographer' must master
the craft of photographic technology and the darkroom in particular in order to be
free to express themselves through the finished print. His attempt to establish artisan
credentials for photography relied on a commitment to 'pre-visualization' ('real time'
'art filters' would have been anathema to Adams) – a stance that embodies the broader
modernist privilege given to *subjective vision*. While the logic of subjective vision does
not determine the pictorial outcomes, and a variety of results were possible, the mod-
ern photographer essentially treated the camera as a transparent medium to master,
in order to represent one's encounter with the world. Thus Robert Adams (no relation
to Ansel), most celebrated for his 'New Topographic' work, writing in his 1981 book
Beauty In Photography, expressed his conviction in the following way:

> Without the photographer in the photograph the view is no more com-
> pelling than the product of some anonymous record camera, a machine
> perhaps capable of happy accident but not of response to form.
>
> (Adams 1981: 15)

Needless to say, in contemporary art discourse, this arch-modernist idea of photog-
raphy as a 'response to form' is out of favour, and together with the 'fine art print' has
been the subject of broad attack by 'postmodern' critics as irredeemably conserva-
tive and even inherently patriarchal. By contrast, the idea of the 'anonymous record
camera' and the 'happy accident' have both been embraced in the post-conceptual art
world.

The idea of photography as a personal, pre-visualized 'response to form' had already been undermined from within the field of 'art photography' itself by those who embraced chance and the happy accident – even including street photographers such as Garry Winogrand. Winogrand, famously, amassed an unworkably large number of negatives in his effort 'to see what the world looks like photographed'. When he died in 1984 he left 2500 rolls undeveloped, as well 6500 rolls of developed film he had not seen or edited. One is reminded of the complaint, repeated regularly since the 1970s and typified in the writings of Jean Baudrillard (1983), that the world is over-saturated with images and the result is that no single photograph can 'stake a claim to originality or affect' (Wiley 2011: 88). Such claims of image saturation are invariably at once iconophobic and iconophilic, since they typically rely on a question of judgement around what is a 'good image'. What seems more important to note in the case of Winogrand is that he treated the photograph as *information*, as more or less interesting. He was completely unsentimental about 'previsualization' or the 'decisive moment' or other Romantic photographic approaches. His approach, not coincidentally, paralleled the rise of conceptual artists adopting the camera as an art-making tool for precisely the reason that Robert Adams disparages: that is, as an anonymous record camera. (Chevrier 2003: 123) The artist Ed Ruscha famously stated in a 1965 interview about his work that 'photography is dead as a fine art; its only place is in the commercial world, for technical or information purposes' (Coplans 1965: 24). Ruscha's 'collection of "facts" was followed by other 'serial' approaches in which artists took to the camera only in order to make their own *agency* within the photographic process *redundant*. In the case of Douglas Huebler, this conceptual approach amounts to a something like a philosophy of photography. The operations that Huebler set up for his 'variable pieces' from the late 1960s involved him taking on the role of *photographer-functionary* – most notably in *Variable Piece #70, (In Process) Global*, 1971 – his life-long project to 'photographically document . . . the existence of everyone alive'. As he wrote of his working method in a 1969 statement: 'I use the camera as a "dumb" copying device that only serves to document whatever phenomena appears before it through the conditions set by a system' (Miller 2006: 222). One might detect a certain utopianism in Huebler's systematic deciphering of the world, but more importantly his role – performative and mimetic – appears to dutifully reenact the logic of the camera itself.

Flusser, redundancy and digital photography

As John Miller has perceptively intuited, Huebler is here outlining a position that is given more full expression in Vilem Flusser's 1983 book *Towards a Philosophy of Photography* (Flusser 2000; Miller 2006). Flusser posits the photograph as a 'technical image' and the camera as a programmable apparatus, one that, paradoxically, programs the photographers (functionaries) who use it. The terms redundant and redundancy are important ones in Flusser's writing, influenced as he was by Shannon's communication theory, and the history of communication technology as a process of increasing *abstraction* and *automation*. For Flusser, 'redundant' photographs are those that carry no *new information* and are therefore superfluous. Flusser speaks of 'the challenge for the photographer: to oppose the flood of redundancy with informative images' (Flusser 2000: 65), that is, those that provide the photographic universe with new information.

Flusser allocates 'snapshots' to the realm of redundant images, and his critique of so-called 'creative photography' is based on the idea that most of what people are doing when they photograph is to reproduce clichés set in place by the apparatus (Flusser 2000: 26). However, Flusser's critique is more complex than often recognized, counterbalanced as it is by his praise for what he calls 'experimental photography': 'to create a space for human intention in a world dominated by apparatuses' (Flusser 2000: 75). Elsewhere Flusser speaks of 'envisioners' who actively work against the automation of the apparatus – and at times he would appear to be a straightforward defender of subjective vision. Thus, on the one hand, he pessimistically states that 'the photographer can only desire what the apparatus can do . . . [and] the intention of the photographer is a function of the apparatus' (Flusser 2011a: 20), while, on the other hand, he celebrates 'envisioners' as those with 'the capacity to step from the particle universe [of abstraction] back into the concrete' (Flusser 2011a: 34).

In 'The Gesture of Photographing', published the year of his death in 1991, but only recently translated into English, Flusser presents an even more sanguine perspective of the photographer's potential. Here, between periods of reflection and moments of action, photography is part of a phenomenological 'project of situating oneself in the world' (Flusser 2011b: 280). Flusser goes so far as to call this 'a movement of freedom', 'a series of decisions that occur not in spite of, but because of the determining forces that are in play' (Flusser 2011b: 289). Flusser also celebrates the 'reflection' on the part of the photographer, the editing process that 'rejects all the other possible pictures, except this one, to the realm of lost virtualities' (Flusser 2011b: 291). However, as we have seen, today's photographer may in fact retain such 'lost virtualities' (of focus, for instance) – and one might legitimately ask how the editing of photographs in software such as Lightroom complicates Flusser's equation, given that endless virtual versions of an image are enabled by the lossless editing of raw files. Rather than situating oneself in the world in the act of photographing, a photographer may now approach the world as fluid raw material to be manipulated later. In some sense, the photographic moment has been extended indefinitely.

Flusser's basic position was given a manifesto-like rendering in 1985 by the German artist and photography critic Andreas Müller-Pohle. In his essay 'Information strategies', written at the cusp of the emergence of digital photography, Müller-Pohle predicted that soon 'it will be possible to generate and regenerate literally every conceivable – or inconceivable – picture through a computer terminal' (Müller-Pohle 1985). This realization coincided with Müller-Pohle's critique of conventional photography, which he found 'exhausted' as a strategy. He wrote of its 'impressionistic gestures' that 'can only be consistent in so far as they are concentrated into "a personal way of seeing" (stylization) and dubbed this process 'photographism'. Müller-Pohle's own response as an artist was to turn his attention to the apparatus itself, and to digital code in particular. Flusser's arguments, pitting the photographer against the apparatus, also reverberate in Julian Stallabrass's 1996 essay '60 billion sunsets'. Stallabrass is concerned with what he calls 'the demise of the amateur attitude to reality' – by which he means the meaningful use of cameras that were understood by their users (Stallabrass 1996: 36). Stallabrass argues that the increasing automation of cameras paradoxically disables the amateur photographer by removing their erstwhile control under a haze of electronic sophistry. As he says, 'the camera becomes a mystical object which uses its possessor' (Stallabrass 1996: 36). Moreover, in the digital world, Stallabrass predicts, narcissistic

simulations are likely to prevail: 'the represented object loses it rights: there is no bar to unleashed subjectivity' (Stallabrass 1996: 36). One is reminded again of the marketing for the Olympus OM-D, which implores users to 'create your own world'.

Conclusion: the networking of photography

What Flusser, Müller-Pohle and Stallabrass – not to mention Adams and Huebler – could not have anticipated is how the online networking of photography might alter the dynamic between photographer and machine; that is, how the apparatus of photography is reorientated in the participatory world of Web 2.0. The camera is no longer detached from the network. Thus the Dutch site Woophy (WOrld Of PHotographY) encourages amateurs anywhere – in Borges-like fashion – to fulfil its modest ambition 'to ultimately cover every inch of our world map with images that represent the world's beauty'. With computer software increasingly capable of reading the images that reside in online databases, both via metadata and image pattern recognition, the status of individual image-making is indeed in the process of being irrevocably socialized. Meanwhile, at the same time, viewers of online images are increasingly 'free to explore an extensive and dynamic image space unconstrained by . . . an authorised or "correct" viewing position' (Uricchio 2011: 25). Increasingly in other words, the editing process that Flusser reserved for human operators is outsourced and opened up to three different agents: other producers, software and the final viewer. All three of these networked dimensions – collaborative mass authorship, machine-readable imagery and new modes of viewer engagement – have major implications for how we think about the idea of photography and its fundamentally human-centred terms such as 'witnessing'. This shift from individual views to aggregations has potentially important consequences for how we understand image-making as an act of resistance, or 'interference'. My purpose here in this highly compressed discussion is not to evoke nostalgia for master photographers and their frequently grandiose claims, nor to elicit concern about image saturation. I am simply interested in whether photography historians, theorists and curators can and need to start thinking about photographic authorship in different ways. For the question must be asked: is the individual photographer redundant in the age of participation? I began this article with reference to the release of recent digital cameras that seek to extend the creative act via delayed decision making – respectively, post-capture focus, and 'real time' engagement with the world via the electronic viewfinder. We can now interpret these developments as introducing participatory experiences of a particular kind, ones that are romantically attached to the individual who is immersed in the network and yet still struggling to visualize a sense of their own position outside it. That is, participatory photography is a paradoxical appeal to resist the performative logic of the networked apparatus, and its transfer of agency, already underway, from the camera operator to the new functionaries, both human and nonhuman, of the database.

Original publication

'Redundancy in Photography' in *Philosophy of Photography*, vol 3:1 (2012).

References

Adams, Robert (1981), *Beauty in Photography*, Millerton: Aperture.

Baudrillard, Jean (1983), *Simulations*, trans. Paul Foss, Paul Patton and Philip Beitchman, New York: Semiotext(e).

Chevrier, Jean-François (2003), 'The Adventures of the Picture Form in the History of Photography', in Douglas Fogle (ed.), *The Last Picture Show: Artists Using Photography 1960–1982*, Minneapolis: Walker Art Centre, pp. 113–28.

Coplans, John (1965), 'Concerning *Various Small Fires*: Edward Ruscha Discusses His Perplexing Publications', *Artforum*, 3:5, pp. 24–5.

Flusser, Vilém (2000), *Towards a Philosophy of Photography*, trans. Anthony Matthews, London: Reaktion Books.

——— (2011a), *Into the Universe of Technical Images*, trans. Nancy Ann Roth, Minneapolis: University of Minnesota Press.

——— (2011b), 'The Gesture of Photographing' (trans. Nancy Roth), *Journal of Visual Culture*, 10:3, pp. 279–93.

Miller, John (2006), 'Double or Nothing: On the Art of Douglas Huebler', *Artforum*, 44:8, pp. 220–7.

Müller-Pohle, Andreas (1985), 'Information Strategies' (trans. Jean Säfken), *European Photography 21*, 6:1, pp. 5–14, http://equivalence.com/labor/lab_mp_wri_inf_e.shtml. Accessed 2 June 2010.

Sontag, Susan (1978), *On Photography*, Middlesex: Penguin Books.

Stallabrass, Julian (1996), 'Sixty Billion Sunsets', in Julian Stallabrass (ed.), *Gargantua: Manufactured Mass Culture*, London: Verso, pp. 13–39.

Uricchio, William (2011), 'The Algorithmic Turn: Photosynth, Augmented Reality and the Changing Implications of the Image', *Visual Studies*, 26:1, pp. 25–35.

Wiley, Chris (2011), 'Depth of Focus', *Frieze*, 143:88.

Lev Manovich

THE PARADOXES OF DIGITAL PHOTOGRAPHY

Digital revolution?

COMPUTERIZED DESIGN SYSTEMS that flawlessly combine real photographed objects and objects synthesized by the computer. Satellites that can photograph the license plate of your car and read the time on your watch. 'Smart' weapons that recognize and follow their targets in effortless pursuit – the kind of new, post-modern, post-industrial dance to which we were all exposed during the televised Gulf War. New medical imaging technologies that map every organ and function of the body. Online electronic libraries that enable any designer to acquire not only millions of photographs digitally stored but also dozens of styles which can be automatically applied by a computer to any image.

All of these and many other recently emerged technologies of image-making, image manipulation, and vision depend on digital computers. All of them, as a whole, allow photographs to perform new, unprecedented, and still poorly understood functions. All of them radically change what a photograph is.

Indeed, digital photographs function in an entirely different way from traditional – lens and film-based – photographs. For instance, images are obtained and displayed by sequential scanning; they exist as mathematical data which can be displayed in a variety of modes – sacrificing color, spatial, or temporal resolution. Image processing techniques make us realize that any photograph contains more information than can be seen with the human eye. Techniques of 3-D computer graphics make possible the synthesis of photorealistic images – yet, this realism is always partial, since these techniques do not permit the synthesis of any arbitrary scene.[1]

Digital photographs function in an entirely different way from traditional photographs. Or do they? Shall we accept that digital imaging represents a radical rupture with photography? Is an image, mediated by computer and electronic technology, radically different from an image obtained through a photographic lens and embodied in film? If we describe film-based images using such categories as depth of field, zoom, a

shot or montage, what categories should be used to describe digital images? Shall the phenomenon of digital imaging force us to rethink such fundamental concepts as realism or representation?

In this essay I will refrain from taking an extreme position of either fully accepting or fully denying the idea of a digital imaging revolution. Rather, I will present the logic of the digital image as paradoxical; radically breaking with older modes of visual representation while at the same time reinforcing these modes. I will demonstrate this paradoxical logic by examining two questions: alleged physical differences between digital and film-based representation of photographs and the notion of realism in computer-generated synthetic photography.

The logic of the digital photograph is one of historical continuity and discontinuity. The digital image tears apart the net of semiotic codes, modes of display, and patterns of spectatorship in modern visual culture – and, at the same time, weaves this net even stronger. The digital image annihilates photography while solidifying, glorifying, and immortalizing the photographic. In short, this logic is that of photography after photography.

Digital photography does not exist

It is easiest to see how digital (r)evolution solidifies (rather than destroys) certain aspects of modern visual culture – the culture synonymous with the photographic image – by considering not photography itself but a related film-based medium – cinema. New digital technologies promise to radically reconfigure the basic material components (lens, camera, lighting, film) and the basic techniques (the separation of production and post-production, special effects, the use of human actors and non-human props) of the cinematic apparatus as it has existed for decades. The film camera is increasingly supplemented by the virtual camera of computer graphics which is used to simulate sets and even actors (as in *Terminator 2* and *Jurassic Park*). Traditional film editing and optical printing are being replaced by digital editing and image processing which blur the lines between production and post-production, between shooting and editing.

At the same time, while the basic technology of filmmaking is about to disappear, being replaced by new digital technologies, cinematic codes find new roles in the digital visual culture. New forms of entertainment based on digital media and even the basic interface between a human and a computer are being increasingly modeled on the metaphors of movie making and movie viewing. With Quicktime technology, built into every Macintosh sold today, the user makes and edits digital 'movies' using software packages whose very names (such as Director and Premiere) make a direct reference to cinema. Computer games are also increasingly constructed on the metaphor of a movie, featuring realistic sets and characters, complex camera angles, dissolves, and other codes of traditional filmmaking. Many new CD-ROM games go even further, incorporating actual movie-like scenes with live actors directed by well-known Hollywood directors. Finally, SIGGRAPH, the largest international conference on computer graphics technology, offers a course entitled 'Film Craft in User Interface Design' based on the premise that 'The rich store of knowledge created in 90 years of filmmaking and animation can contribute to the design of user interfaces of multimedia, graphics applications, and even character displays.'[2]

Thus, film may soon disappear — but not cinema. On the contrary, with the disappearance of film due to digital technology, cinema acquires a truly fetishistic status. Classical cinema has turned into the priceless data bank, the stock which is guaranteed never to lose its value as classic films become the content of each new round of electronic and digital distribution media — first video cassette, then laser disk, and, now, CD-ROM (major movie companies are planning to release dozens of classic Hollywood films on CD-ROM by the end of 1994). Even more fetishized is 'film look' itself — the soft, grainy, and somewhat blurry appearance of a photographic image which is so different from the harsh and flat image of a video camera or the too clean, too perfect image of computer graphics. The traditional photographic image once represented the inhuman, devilish objectivity of technological vision. Today, however, it looks so human, so familiar, so domesticated — in contrast to the alienating, still unfamiliar appearance of a computer display with its 1,280 by 1,024 resolution, 32 bits per pixel, 16 million colors, and so on. Regardless of what it signifies, any photographic image also connotes memory and nostalgia, nostalgia for modernity and the twentieth century, the era of the pre-digital, pre-post-modern. Regardless of what it represents, any photographic image today first of all represents photography.

So while digital imaging promises to completely replace the techniques of film-making, it at the same time finds new roles and brings new value to the cinematic apparatus, the classic films, and the photographic look. This is the first paradox of digital imaging.

But surely, what digital imaging preserves and propagates are only the cultural codes of film or photography. Underneath, isn't there a fundamental physical difference between film-based image and a digitally encoded image?

The most systematic answer to this question can be found in William Mitchell's recent book *The Reconfigured Eye: Visual Truth in the Post-Photographic Era*.[3] Mitchell's entire analysis of the digital imaging revolution revolves around his claim that the difference between a digital image and a photograph 'is grounded in fundamental physical characteristics that have logical and cultural consequences.'[4] In other words, the physical difference between photographic and digital technology leads to the difference in the logical status of film-based and digital images and also to the difference in their cultural perception.

How fundamental is this difference? If we limit ourselves by focusing solely, as Mitchell does, on the abstract principles of digital imaging, then the difference between a digital and a photographic image appears enormous. But if we consider concrete digital technologies and their uses, the difference disappears. Digital photography simply does not exist.

The first alleged difference concerns the relationship between the original and the copy in analog and in digital cultures. Mitchell writes: 'The continuous spatial and tonal variation of analog pictures is not exactly replicable, so such images cannot be transmitted or copied without degradation . . . But discrete states can be replicated precisely, so a digital image that is a thousand generations away from the original is indistinguishable in quality from any one of its progenitors.'[5] Therefore, in digital visual culture, 'an image file can be copied endlessly, and the copy is distinguishable from the original by its date since there is no loss of quality.'[6] This is all true — in principle. However, in reality, there is actually much more degradation and loss of information between copies of digital images than between copies of traditional photographs.

A single digital image consists of millions of pixels. All of this data requires considerable storage space in a computer; it also takes a long time (in contrast to a text file) to transmit over a network. Because of this, the current software and hardware used to acquire, store, manipulate, and transmit digital images uniformly rely on lossy compression – the technique of making image files smaller by deleting some information.[7] The technique involves a compromise between image quality and file size – the smaller the size of a compressed file, the more visible are the visual artifacts introduced in deleting information. Depending on the level of compression, these artifacts range from barely noticeable to quite pronounced. At any rate, each time a compressed file is saved, more information is lost, leading to more degradation.

One may argue that this situation is temporary and once cheaper computer storage and faster networks become commonplace, lossy compression will disappear. However, at the moment, the trend is quite the reverse with lossy compression becoming more and more the norm for representing visual information. If a single digital image already contains a lot of data, then this amount increases dramatically if we want to produce and distribute moving images in a digital form (one second of video, for instance, consists of 30 still images). Digital television with its hundreds of channels and video on-demand services, the distribution of full-length films on CD-ROM or over the Internet, fully digital post-production of feature films – all of these developments will be made possible by newer compression techniques.[8] So rather than being an aberration, a flaw in the otherwise pure and perfect world of the digital, where even a single bit of information is never lost, lossy compression is increasingly becoming the very foundation of digital visual culture. This is another paradox of digital imaging – while in theory digital technology entails the flawless replication of data, its actual use in contemporary society is characterized by the loss of data, degradation, and noise; the noise which is even stronger than that of traditional photography.

The second commonly cited difference between traditional and digital photography concerns the amount of information contained in an image. Mitchell sums it up as follows: 'There is an indefinite amount of information in a continuous-tone photograph, so enlargement usually reveals more detail but yields a fuzzier and grainier picture . . . A digital image, on the other hand, has precisely limited spatial and tonal resolution and contains a fixed amount of information.'[9] Here again Mitchell is right in principle: a digital image consists of a finite number of pixels, each having a distinct color or a tonal value, and this number determines the amount of detail an image can represent. Yet in reality this difference does not matter anymore. Current scanners, even consumer brands, can scan an image or an object with very high resolution: 1,200 or 2,400 pixels per inch is standard today. True, a digital image is still comprised of a finite number of pixels, but at such resolution it can record much finer detail than was ever possible with traditional photography. This nullifies the whole distinction between an 'indefinite amount of information in a continuous-tone photograph' and a fixed amount of detail in a digital image. The more relevant question is how much information in an image can be useful to the viewer. Current technology has already reached the point where a digital image can easily contain much more information than anybody would ever want. This is yet another paradox of digital imaging.

But even the pixel-based representation, which appears to be the very essence of digital imaging, can no longer be taken for granted. Recent computer graphics software have bypassed the limitations of the traditional pixel grid which limits the amount of

information in an image because it has a fixed resolution. Live Picture, an image edit-ing program for the Macintosh, converts a pixel-based image into a set of equations. This allows the user to work with an image of virtually unlimited size. Another paint program, Matador, makes possible painting on a tiny image which may consist of just a few pixels as though it were a high-resolution image (it achieves this by breaking each pixel into a number of smaller sub-pixels). In both programs, the pixel is no longer a 'final frontier'; as far as the user is concerned, it simply does not exist.

Mitchell's third distinction concerns the inherent mutability of a digital image. While he admits that there has always been a tradition of impure, re-worked pho-tography (he refers to 'Henry Peach Robinson's and Oscar G. Reijlander's nineteenth-century "combination prints," John Heartfield's photomontages'[10] as well as numerous political photo fakes of the twentieth century), Mitchell identifies straight, unmanipu-lated photography as the essential, 'normal' photographic practice: 'There is no doubt that extensive reworking of photographic images to produce seamless transformations and combinations is technically difficult, time-consuming, and outside the mainstream of photographic practice. When we look at photographs we presume, unless we have some clear indications to the contrary, that they have not been reworked.'[11] This equa-tion of 'normal' photography with straight photography allows Mitchell to claim that a digital image is radically different because it is inherently mutable: 'The essential char-acteristic of digital information is that it can be manipulated easily and very rapidly by computer. It is simply a matter of substituting new digits for old . . . Computational tools for transforming, combining, altering, and analyzing images are as essential to the digital artist as brushes and pigments to a painter.'[12]

From this allegedly purely technological difference between a photograph and a digital image, Mitchell deduces differences in how the two are culturally perceived. Because of the difficulty involved in manipulating them, photographs 'were comfort-ably regarded as causally generated truthful reports about things in the real world.'[13] Digital images, being inherently (and so easily) mutable, call into question 'our onto-logical distinctions between the imaginary and the real'[14] or between photographs and drawings. Furthermore, in a digital image, the essential relationship between signifier and signified is one of uncertainty.[15]

Does this hold? While Mitchell aims to deduce culture from technology, it appears that he is actually doing the reverse. In fact, he simply identifies the pictorial tradition of realism with the essence of photographic technology and the tradition of mon-tage and collage with the essence of digital imaging. Thus, the photographic work of Robert Weston and Ansel Adams, nineteenth- and twentieth-century realist painting, and the painting of the Italian Renaissance become the essence of photography; while Robinson's and Reijlander's photo composites, constructivist montage, contemporary advertising imagery (based on constructivist design), and Dutch seventeenth-century painting (with its montage-like emphasis on details over the coherent whole) become the essence of digital imaging. In other words, what Mitchell takes to be the essence of photographic and digital imaging technology are two traditions of visual culture. Both existed before photography, and both span different visual technologies and mediums. Just as its counterpart, the realistic tradition extends beyond photography *per se* and at the same time accounts for just one of many photographic practices.

If this is so, Mitchell's notion of 'normal' unmanipulated photography is problem-atic. Indeed, unmanipulated 'straight' photography can hardly be claimed to dominate

the modern uses of photography. Consider, for instance, the following photographic practices. One is Soviet photography of the Stalinist era. All published photographs were not only staged but also retouched so heavily that they can hardly be called photographs at all. These images were not montages, as they maintained the unity of space and time, and yet, having lost any trace of photographic grain due to retouching, they existed somewhere between photography and painting. More precisely, we can say that Stalinist visual culture eliminated the very difference between a photograph and a painting by producing photographs which looked like paintings and paintings (I refer to Socialist Realism) which looked like photographs. If this example can be written off as an aberration of totalitarianism, consider another photographic practice closer to home: the use of photographic images in twentieth century advertising and publicity design. This practice does not make any attempt to claim that a photographic image is a witness testifying about the unique event which took place in a distinct moment of time (which is how, according to Mitchell, we normally read photography). Instead, a photograph becomes just one graphic element among many: few photographs coexist on a single page; photographs are mixed with type; photographs are separated from each by white space, backgrounds are erased leaving only the figures, and so on. The end result being that here, as well, the difference between a painting and a photograph does not hold. A photograph as used in advertising design does not point to a concrete event or a particular object. It does not say, for example, 'this hat was in this room on May 12.' Rather, it simply presents 'a hat' or 'a beach' or 'a television set' without any reference to time and location.

Such examples question Mitchell's idea that digital imaging destroys the innocence of straight photography by making all photographs inherently mutable. Straight photography has always represented just one tradition of photography; it always coexisted with equally popular traditions where a photographic image was openly manipulated and was read as such. Equally, there never existed a single dominant way of reading photography; depending on the context the viewer could (and continue to) read photographs as representations of concrete events, or as illustrations which do not claim to correspond to events which have occurred. Digital technology does not subvert 'normal' photography because 'normal' photography never existed.

Real, all too real: socialist realism of *Jurassic Park*

I have considered some of the alleged physical differences between traditional and digital photography. But what is a digital photograph? My discussion has focused on the distinction between a film-based representation of an image versus its representation in a computer as a grid of pixels having a fixed resolution and taking up a certain amount of computer storage space. In short, I highlighted the issue of analog versus digital representation of an image while disregarding the procedure through which this image is produced in the first place. However, if this procedure is considered, another meaning of digital photography emerges. Rather than using the lens to focus the image of actual reality on film and then digitizing the film image (or directly using an array of electronic sensors) we can try to construct three-dimensional reality inside a computer and then take a picture of this reality using a virtual camera also inside a computer. In other words, 3-D computer graphics can also be thought of as digital – or synthetic – photography.

I will conclude by considering the current state of the art of 3-D computer graphics. Here we will encounter the final paradox of digital photography. Common opinion holds that synthetic photographs generated by computer graphics are not yet (or perhaps will never be) as precise in rendering visual reality as images obtained through a photographic lens. However, I will suggest that such synthetic photographs are already more realistic than traditional photographs. In fact, they are too real.

The achievement of realism is the main goal of research in the 3-D computer graphics field. The field defines realism as the ability to simulate any object in such a way that its computer image is indistinguishable from its photograph. It is this ability to simulate photographic images of real or imagined objects which makes possible the use of 3-D computer graphics in military and medical simulators, in television commercials, in computer games, and, of course, in such movies as *Terminator 2* or *Jurassic Park*.

These last two movies, which contain the most spectacular 3-D computer graphics scenes to date, dramatically demonstrate that total synthetic realism seems to be in sight. Yet, they also exemplify the triviality of what at first may appear to be an outstanding technical achievement – the ability to fake visual reality. For what is faked is, of course, not reality but photographic reality, reality as seen by the camera lens. In other words, what computer graphics has (almost) achieved is not realism, but only photorealism – the ability to fake not our perceptual and bodily experience of reality but only its photographic image.[16] This image exists outside of our consciousness, on a screen – a window of limited size which presents a still imprint of a small part of outer reality, filtered through the lens with its limited depth of field, filtered through film's grain and its limited tonal range. It is only this film-based image which computer graphics technology has learned to simulate. And the reason we think that computer graphics has succeeded in faking reality is that we, over the course of the last hundred and fifty years, have come to accept the image of photography and film as reality.

What is faked is only a film-based image. Once we came to accept the photographic image as reality, the way to its future simulation was open. What remained were small details: the development of digital computers (1940s) followed by a perspective-generating algorithm (early 1960s), and then working out how to make a simulated object solid with shadow, reflection, and texture (1970s), and finally simulating the artifacts of the lens such as motion blur and depth of field (1980s). So, while the distance from the first computer graphics images circa 1960 to the synthetic dinosaurs of *Jurassic Park* in the 1990s is tremendous, we should not be too impressed. For, conceptually, photorealistic computer graphics had already appeared with Félix Nadar's photographs in the 1840s and certainly with the first films of the Lumières in the 1890s. It is they who invented 3-D computer graphics.

So the goal of computer graphics is not realism but only photorealism. Has this photorealism been achieved? At the time of this writing (May 1994) dinosaurs of *Jurassic Park* represent the ultimate triumph of computer simulation, yet this triumph took more than two years of work by dozens of designers, animators, and programmers of Industrial Light and Magic (ILM), probably the premier company specializing in the production of computer animation for feature films in the world today. Because a few seconds of computer animation often requires months and months of work, only the huge budget of a Hollywood blockbuster could pay for such extensive and highly detailed computer-generated scenes as seen in *Jurassic Park*. Most of the 3-D computer animation produced today has a much lower degree of photorealism and this

photorealism is uneven, higher for some kinds of objects and lower for others.[17] And even for ILM photorealistic simulation of human beings, the ultimate goal of computer animation, still remains impossible.

Typical images produced with 3-D computer graphics still appear unnaturally clean, sharp, and geometric looking. Their limitations especially stand out when juxtaposed with a normal photograph. Thus one of the landmark achievements of *Jurassic Park* was the seamless integration of film footage of real scenes with computer simulated objects. To achieve this integration, computer-generated images had to be degraded; their perfection had to be diluted to match the imperfection of film's graininess.

First, the animators needed to figure out the resolution at which to render computer graphics elements. If the resolution were too high, the computer image would have more detail than the film image and its artificiality would become apparent. Just as Medieval masters guarded their painting secrets now leading computer graphics companies carefully guard the resolution of images they simulate.

Once computer-generated images are combined with film images additional tricks are used to diminish their perfection. With the help of special algorithms, the straight edges of computer-generated objects are softened. Barely visible noise is added to the overall image to blend computer and film elements. Sometimes, as in the final battle between the two protagonists in *Terminator 2*, the scene is staged in a particular location (a smoky factory in this example) which justifies addition of smoke or fog to further blend the film and synthetic elements together.

So, while we normally think that synthetic photographs produced through computer graphics are inferior in comparison to real photographs, in fact, they are too perfect. But beyond that we can also say that paradoxically they are also too real.

The synthetic image is free of the limitations of both human and camera vision. It can have unlimited resolution and an unlimited level of detail. It is free of the depth-of-field effect, this inevitable consequence of the lens, so everything is in focus. It is also free of grain – the layer of noise created by film stock and by human perception. Its colors are more saturated and its sharp lines follow the economy of geometry. From the point of view of human vision it is hyperreal. And yet, it is completely realistic. It is simply a result of a different, more perfect than human, vision.

Whose vision is it? It is the vision of a cyborg or a computer; a vision of Robocop and of an automatic missile. It is a realistic representation of human vision in the future when it will be augmented by computer graphics and cleansed from noise. It is the vision of a digital grid. Synthetic computer-generated image is not an inferior representation of our reality, but a realistic representation of a different reality.

By the same logic, we should not consider clean, skinless, too flexible, and in the same time too jerky, human figures in 3-D computer animation as unrealistic, as imperfect approximation to the real thing – our bodies. They are a perfectly realistic representation of a cyborg body yet to come, of a world reduced to geometry, where efficient representation via a geometric model becomes the basis of reality. The synthetic image simply represents the future. In other words, if a traditional photograph always points to the past event, a synthetic photograph points to the future event.

We are now in a position to characterize the aesthetics of *Jurassic Park*. This aesthetic is one of Soviet Socialist Realism. Socialist Realism wanted to show the future in the present by projecting the perfect world of future socialist society on a visual reality familiar to the viewer – streets, faces, and cities of the 1930s. In other words, it had to retain enough of the then everyday reality while showing how that reality would look

in the future when everyone's body will be healthy and muscular, every street modern, every face transformed by the spirituality of communist ideology.

Exactly the same happens in *Jurassic Park*. It tries to show the future of sight itself – the perfect cyborg vision free of noise and capable of grasping infinite details – vision exemplified by the original computer graphics images before they were blended with film images. But just as Socialist Realist paintings blended the perfect future with the imperfect reality of the 1930s and never depicted this future directly (there is not a single Socialist Realist work of art set in the future), *Jurassic Park* blends the future super-vision of computer graphics with the familiar vision of film image. In *Jurassic Park*, the computer image bends down before the film image, its perfection is undermined by every possible means and is also masked by the film's content.

This is then, the final paradox of digital photography. Its images are not inferior to the visual realism of traditional photography. They are perfectly real – all too real.

Original publication

'The Paradoxes of Digital Photography' in *Photography After Photography* (1995).

Notes

1 Lev Manovich, 'Assembling Reality: Myths of Computer Graphics,' *Afterimage* 20/2 (September 1992), pp. 12–14.
2 SIGGRAPH 93. ADVANCE PROGRAM (ACM: New York, 1993), 28.
3 William Mitchell, *The Reconfigured Eye: Visual Truth in the Post-Photographic Era* (Cambridge, MA: MIT Press, 1992).
4 Ibid., 4.
5 Ibid., 6.
6 Ibid., 49.
7 Currently the most widespread technique for compressing digital photographs is JPEG. For instance, every Macintosh comes with JPEG compression software.
8 For almost a century, our standard of visual fidelity was determined by the film image. A video or television image was always viewed as an imperfect, low-quality substitute for the 'real thing' – a film-based image. Today, however, a new even lower quality image is becoming increasingly popular – an image of computer multimedia. Its quality is exemplified by a typical, as of this writing, Quicktime movie: 320 by 240 pixels, 10–15 frames a second. Is the 35 mm film image going to remain the unchallenged standard with computer technology eventually duplicating its quality? Or will a low-quality computer image be gradually accepted by the public as the new standard of visual truth?
9 Mitchell, *The Reconfigured Eye*, 6.
10 Ibid., 7.
11 Ibid.
12 Ibid.
13 Ibid., 225.
14 Ibid.
15 Ibid., 17.
16 The research in virtual reality aims to go beyond the screen image in order to simulate both the perceptual and bodily experience of reality.
17 See Manovich, 'Assembling Reality.'

Fred Ritchin

EXTRACTS FROM *OF PIXELS AND PARADOX*

Figure 41.1 Zbigniew Libera, "Nepal" from series *Positives*, 2003. Zbigniew Libera, Nepal, from the Positives series, 2003. Courtesy of Raster Gallery, Warsaw.

> Already, one would say that human cloning is on its way to becoming, for a part of the contemporary public, an operation as simple as having one's portrait taken by a photographer in the previous century.
>
> —Paul Virilio, *The Information Bomb* (1998)

AFTER A LECTURE I GAVE IN THE 1990S on some of the ways in which photographs were being manipulated with a computer, a woman in the audience

stood and responded: That's exactly what we're doing in genetics. Except while you're working with the images, we're working with the DNA.

While those in media have been modifying the eye or skin color in photographs, changing textures or modifying body types, geneticists have been experimenting with strategies to change the actual physical person. Whether aware of it or not, those manipulating photographs are preparing the way for fundamental personal and societal changes.

The more than two decades of frequent alteration of photographs in the press have made genetic manipulation more palpable, immanent, and perhaps even inevitable. If one can repeatedly show brown eyes turning blue, lips and breasts enlarging, and any and all putative "flaws" disappearing, the process seems less scary or remote. If we, like our jeans and our cars, can transition from a solid physicality into the allure of image, then we too become more likely candidates for manipulation.

Our celebrities are already easy prey. As one who was, during the past decade, offered Mel Gibson's body to replace my own by an editor of a major magazine, I can attest to the insinuating seduction of becoming image, even someone else's. After first having refused any image alteration at all of my body I was asked, "What are your ground rules?" "For what?" I asked. "For manipulating your image." I had not thought about any ground rules, but I felt I should be generous: "You can change my tie, or make my hair shorter," I replied. It was then that I was offered Gibson's body and rejected it. I had a queasy feeling that by doing so I might have forestalled the publication of another writer's article on image ethics, for which this composite was apparently needed.

But a photographer was sent to make my portrait. However, he told me that the photo would be manipulated later. I asked him if he knew how the editors would modify his photograph. He did not. Watching his assistant set up lights, the lens pointed at me, I felt that however I would choose to present myself would be meaningless; the photograph would later be changed by someone who had never even met me. And for the first time I saw a photographer as no more than a paid researcher looking for images for someone else to re-present. The new post-photographic process had diminished both the professional photographer and his subject — we were, like so much else these days, part of a larger system controlled elsewhere.

Now it can be possible as well for an art director or editor on another continent to virtually look through a viewfinder to consult on the framing, or to review the images as they are uploaded even while the assignment is in progress. In the days of film one would have had to be physically on site to be able to micromanage the photographer; the photographer's autonomy was somewhat more impervious.

If I had to pick a date when the digital era came to photography, it would be 1982. It was then that *National Geographic's* staff modified a horizontal photograph of the pyramids of Giza and made it vertical, suitable for the magazine's February cover. They electronically moved a section of the photograph depicting one of the pyramids to a position partially behind another pyramid, rather than next to it. It was a banal change — after all, the original photograph was an already romanticized version of the scene that excluded the garbage, tourist buses, and souvenir hawkers — but it opened the digital door. Robert E. Gilka, then *Geographic's* director of photography, said the introduction of such technique was "like limited nuclear warfare, There ain't none." Interviewed two years after the cover's publication, the magazine's editor-in-chief, Wilbur E. Garrett, was more sanguine, referring to the image modification as merely the retroactive repositioning of the photographer a few feet to one side so as to get another point of view.

Figure 41.2 The digital era in photography can be said to have begun with this manipulated 1982 cover [National Geographic, vol 161, no. 2, Feb 1982]. Due to legal issues surrounding the image, we are unable to print here.

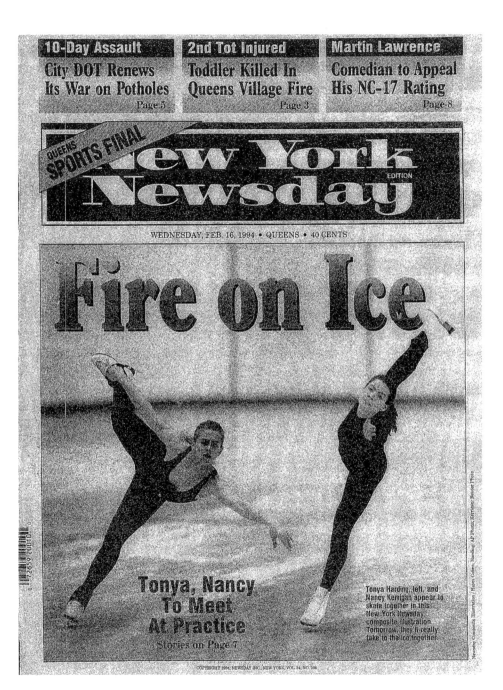

Figure 41.3 The 1994 image may be the first published "future" news photograph [New York Newsday, "Fire on Ice: Tonya, Nancy to meet at Practice"] – *Newsday*. [Original in colour].

Unintentionally, the rather conservative color magazine had introduced time travel to photography. When I later explained this to an older French photographer, Edouard Boubat, he seemed anxious, imagining someone in the future tempted to alter his black-and-white photographs for another point of view. ("They will only do this to color, no?") Perhaps he was wondering why he had waited hours for a scene to unfold in the street when someone could simply fabricate a similar image. In the French context, more supportive of the moral rights of the author than the American legal system, based on copyright, such a possibility can be even more distasteful.

Geographic's rationale, contravening or even transcending the presence of the author, is reminiscent of the Grammy award – winning "duets" between Natalie Cole and her long-dead father, Nat King Cole, recorded in the 1990s, or an animated film made posthumously from László Moholy-Nagy's still photograms. Some of these are meant as tributes, while others are circumventions. Will anyone animate one of the classics of landscape photography, Ansel Adams's *Moonrise, Hernandez, New Mexico*, bringing the image to daybreak? The fractional second when the image was recorded is made to expand; the famous "decisive moment" of Henri Cartier-Bresson can occur more easily, and just as decisively, decades after the image was taken. Authorship becomes malleable, even an unintended posthumous collaboration.

If one can reach into the past why not photograph the future? On the front page of the newspaper *Newsday*, feuding Olympic skaters Tonya Harding and Nancy Kerrigan were shown at an anticipated meeting on the ice as if it were already the next day. "Fire on Ice, Tonya, Nancy to Meet at Practice," read the February 16, 1994, front page, with a smaller-type explanation of how the image was composited so that the two athletes "appear to skate together." (Figure 41.3) Photographic time, rather than the fixed moment of a privileged encounter between observer and subject, is restructured. The photographer's role, unsurprisingly, becomes less consequential.

That same year a *Time* magazine cover image – a significantly darkened, blurred version of a mug shot of O. J. Simpson upon the occasion of his arrest on suspicion of having committed a double murder – was described by the magazine's editor in a letter to readers the following week as merely an attempt to lift "a common police mug shot to the level of art, with no sacrifice to truth." Widely viewed as racist – why darken a celebrity's skin tone upon his arrest, but not when he is selling Hertz rental cars on television? – the ability to revise a key historical document almost simultaneously with its creation was an exercise that the magazine's editors, at that time, undoubtedly would have criticized anybody else for undertaking. It is difficult to imagine anyone similarly tampering with Abraham Zapruder's amateur film of the John F. Kennedy assassination when it surfaced, although decades later filmmaker Oliver Stone did exactly that.

Similarly, a news photograph of a Swedish plane crash appeared in Finnish newspapers, even though there was no photographer present and no camera. After talking to eyewitnesses, the image was composited (and was later said to be rather accurate according to video footage that was uncovered of the scene). Imagine then the famous Clinton-Lewinsky tryst being retroactively "photographed" according to one of their accounts, presumably Lewinsky's. The media might finally have been able to stop obsessing about what had happened and, as a result, the U.S. government might then have been able to proceed with other more important business. Does the photograph still require a photographer, or even a camera?

While placing facts and their own *raison d'être* as authoritative sources into question, these corporate entities were also unconsciously playing the role of an avant-garde,

pioneering new forms of imaging considerably ahead of most artists and documentarians. Their unintentional playfulness, while destructive, can also be seen as inspiring new, as of yet unrealized, potentials.

In 1984, two years after the *National Geographic* cover had been manipulated, I found myself in Boston working with a technician to create an illustration for an article on new photographic possibilities. We manipulated a color photograph of the New York City skyline using a very costly and complex Scitex system, adding an image of the Eiffel Tower, Transamerica Pyramid, and Statue of Liberty, turning on lights in an office building, creating a traffic jam around the newly arrived Statue of Liberty, and moving a taller Empire State Building a few blocks uptown. Later that day I flew back to New York and, riding in a taxi and looking at the same skyline, I had a sensation reminiscent of a God complex, as if I had actually been able to move tall buildings. For me, photography had irrevocably been changed. For today's generation raised on Photoshop, the experience would probably seem mundane.

When, as a college freshman, I had first watched a piece of exposed paper in a chemical bath mysteriously turn into a photograph, the encounter seemed magical, a kind of alchemy. Now, in the nascent digital era, the photograph was already extant and the magic was in modifying it. No longer was it the slow emergence of the "trace" or "footprint" that was "directly stenciled off the real," as Sontag had put it, which was captivating, but the manipulation of the images themselves.

A few years after the skyline manipulation, sitting on a New York City subway and looking at the photographs posted throughout the car, particularly those above the passengers across from me, I began to doubt that what they represented actually existed. Was the man photographed speaking at the podium ever there? Did he ever exist? What of the people depicted in business suits, in a taxi, or on a picnic? Were they complete fantasies? The question for me was not whether the image had adequately and accurately interpreted the person or the scene depicted but whether in fact the person or the scene had even existed.

I began to sweat, unsure as to whether this entire system of referents was functioning. Seeing certainly was not believing, and the photographs seemed to represent openings to an alternative universe synthesized according to discordant goals, which I could only assume were commercial and subversive. Two decades later my response seems hopelessly naïve.

Certainly, photographs were retouched and staged since the beginning of the medium's history, Hippolyte Bayard's 1840 faked *Self-Portrait as a Drowned Man* serving as a very early example. But the frequency of the occurrences and the fact that image alteration can be accomplished by nearly anyone with basic computer skills has triggered mounting societal skepticism. According to a 2005 Consumer Reports Web-Watch national poll, 30 percent of Internet users said they had little or no trust in news sites to use pictures that had not been altered. Given that such sites are the flagships for photography as a documentary medium, one can hardly claim a generalized confidence in the medium's ability to cause the reader "to confront in it the wakening of intractable reality," as Roland Barthes put it at the end of *Camera Lucida*.

If photography's stenographic function is doubted, its recording fidelity no longer a given, then using it to give credibility to the stage-directed dictates of leaders and celebrities or constraining it to the generic images that make up journalistic shorthand (solemn leader, grieving widow, starving child, fiery explosion, etc.) will make its purpose transparently ceremonial. If documentary photographs cannot be trusted at

least as a quotation from appearances, then photography will have lost its currency as a useful if highly imperfect societal arbiter of occurrences, including the accidental and the spontaneous, and have become a mere symbol of spin.

A generalized skepticism, of course, can also be advantageous. Photography will have a chance to mature as a language, not relying so heavily upon its stenographic function but upon its expanded linguistic fluency. Its role becomes that of a less proximate signifier like words, paintings, or drawings, but with the background duality of its surviving role as direct trace. Its author, rather than being ignored or circumvented as the one who merely holds the camera, can emerge as central, with a point of view like other creators. And those in power will not be as able to use photography to "prove" what the medium will no longer be able to confirm.

Why stage an event when few will believe its depiction anyway? For example, a photographer known for his risk-taking recounted how, early in the digital era, he had passed around to his friends a dummy version of a forthcoming book featuring his photographs of models posing somewhat perilously on the tops of buildings and bridges, at times in high winds. The reaction of those who saw it was to compliment him on being extremely adept, but with software – much to his chagrin no one would believe that either he or the models had been foolish enough to take the risks depicted.

Now when I sit on the New York City subway I no longer even imagine that the imagery refers to anything that exists. I think of the "photographs" not as referents but as "desirents." Each image exists to make me want to find out something that is probably useless, to purchase the product described no matter how unnecessary, or to brand it so it will seem familiar each time I see the image or name again. There is no relationship for me, the viewer, with an actuality that exists independently of the intended transaction. There is not even any room to dream.

Sontag admonished: "To photograph is to appropriate the thing photographed. It means putting oneself into a certain relation to the world that feels like knowledge – and, therefore, like power." In the digital realm, where each image is a malleable mosaic, the distance is magnified. The photograph, no longer automatically a recording mechanism, is not as able to "appropriate the thing photographed" as much as to simulate it. In the age of image, the relation to the world it offers may not be knowledge or power but something like conceit.

What is appropriated is often someone else's photograph, one of several postmodern strategies to which the digital lends itself. Numerous photographers have become embroiled over disputes not only when others use their photographs without permission but also when they change them. For example, Susan Meiselas, who covered the Nicaraguan revolution nearly thirty years ago, was trying to protect the historical contextualization of one of her photographs that has become iconic – a man throwing a Molotov cocktail – after she found that a painter, Joy Garnett, had used the image as the basis for one of her own works in a series entitled "Riot." (Garnett defines herself as a painter for whom "all of my paintings are based on photographs" that she finds, many on the Internet.)

Feeling that Meiselas should not be able to exercise proprietary control over the uses of her own photograph, Garnett went public with the conflict on the Internet. Many sided with Garnett in what was soon called "Joywar," putting up mirror sites to support her in case her own site would be shut down, as well as creating and publishing even more derivative imagery. Meiselas, who has long found it difficult to establish a

point of view in mainstream media, was marginalized again, this time judged to be too controlling and old school by denizens of the Web.

They appeared together to publicly discuss the issue, and then published their remarks in *Harper's* magazine. Garnett, who is also arts editor of the journal *Cultural Politics*, cited provocative questions raised by Internet posts: "Does the author of a documentary photograph – a document whose mission is, in part, to provide the public with a record of events of social and historical value – have the right to control the content of this document for all time? Should artists be allowed to decide who can comment on their work and how? Can copyright law, as it stands, function in any way except as a gag order?"

Meiselas responded by warning that "technology allows us to do many things, but that does not mean we must do them. Indeed, it seems to me that if history is working against context, then we must, as artists, work all the harder to reclaim that context. We owe this debt of specificity not just to one another but to our subjects, with whom we have an implicit contract." The author, who risked her life to witness the Sandinista revolution (not "riot," as Garnett contextualized it), found that all she could do, in the age of mass appropriation, was plead her case. Garnett did promise to credit the photo along with her painting.

"If God died in the nineteenth century, according to Nietzsche," wrote Paul Virilio, "what is the bet that the victim of the twentieth century will not turn out to be the *creator*, the author, this heresy of the historical materialism of this century of the machines?" In fact, what happened to Meiselas's photograph has happened to countless others. The "content provider" is often just that.

Some of the most historically significant photographs are being remade by artists who reconfigure the images or place themselves within them. Polish artist Zbigniew Libera, for example, has taken well-known images of suffering, such as of a concentration camp, the Vietnamese girl fleeing from a napalm attack, or the death of Che Guevara, and modified them to show smiling prisoners behind barbed wire, a nude Caucasian woman smiling near a man in a hang-glider suit, or an apparently resurrected Che rising from his deathbed. History becomes fluid, with a happier ending just around the corner. In his 1994 series of forty manipulated images that he calls "Man Without Qualities," Matthias Wähner, a German artist, inserted himself into famous photographs such as that of President John F. Kennedy in a motorcade or, again, the young girl fleeing a napalm attack on a Vietnamese road. The past is revised and questioned, and some of history's iconic images are made to seem silly.

Given the increasing manipulation of the past, Barthes's famous observation from another era now seems nostalgic, even hopeful: "One day, quite some time ago, I happened on a photograph of Napoleon's youngest brother, Jerome, taken in 1852. And I realized then, with an amazement I have not been able to lessen since: 'I am looking at eyes that looked at the Emperor.'"

Families are also revising their photographic histories, retouching albums, removing ex-spouses. Looking at these albums, children may have difficulty knowing who was actually present at their parents' wedding, or what their parents were wearing at their own. Why buy an expensive dress when an "image stylist" can add it to the photograph later? One commercial service, by selecting from a variety of photographs, promises group portraits in which "We combine the best expressions into a single 'perfect portrait.'"

Increasingly, much of the photographic process will occur after the shutter is released. The photograph becomes the initial research, an image draft, as vulnerable to modification as it has always been to recontextualization.

In recognition of the new characteristics of digital media, the concept of copyright has already become more nuanced (and perhaps more realistic) with the new licensing system Creative Commons. As the non-profit's Web site suggests, "You can use CC to change your copyright terms from 'All Rights Reserved' to 'Some Rights Reserved.'" Choices can be made by the initial author concerning whether the work should be copied, distributed, displayed, or performed with a specific credit, whether derivative works can be made from it, whether it can be used only non-commercially, and so on. In the fluid digital environment copyright may be for some too static and all-inclusive a concept.

[. . .]

It is a potentially calamitous pursuit. Did the millions of romanticized and appropriately beautiful images of nature that serve as an image archive, on calendars, in textbooks and magazines, on the Internet and elsewhere, help us to ignore the realities of environmental destruction? Might this proliferation of celebratory imagery turn out to be a facade that has served to disconnect us from the disappearance of the natural? We can always make more images, since in the digital realm they can be synthesized ad infinitum whether or not the putative subject continues to exist.

In our acquisitive mode, it may be fool's gold that we have attained. Transforming the world into photographic currency substitutes a "sense of the universal equality of things," wrote Walter Benjamin in the 1930s. He argued, "Every day the urge grows stronger to get hold of an object at very close range by way of its likeness, its reproduction." But, Benjamin continued, "reproduction as offered by picture magazines and newsreels differs from the image seen by the unarmed eye. Uniqueness and permanence are as closely linked in the latter as are transitory and reproducibility in the former. To pry an object from its shell, to destroy its aura, is the mark of a perception whose 'sense of the universal equality of things' has increased to such a degree that it extracts it even from a unique object by means of reproduction." The more than three billion photographs that Photobucket claims are available online at the user-generated site, or the more than three billion video clips that market research firms say are served up monthly on YouTube, are more than able, by sheer volume alone, to "pry an object from its shell," as well as eliminate any aura of the original or a sense of uniqueness.

In a university classroom I often ask students if there is anything in the room, other than the students themselves, which is one-of-a-kind and not mass-produced; we can usually count many dozens of rectangular shapes – desks, computers, books, pads, blackboard, screens, windows, doors, etc. – yet we rarely ever come up with more than one or two custom-designed pieces of jewelry as the only unique objects in the room. It is often the first time the students realize that for much of their lives they are surrounded almost exclusively by the non-original, which many find reassuring. After all, who wants a one-of-a-kind car, and who does not want to bond in the consumerist ethos of nearly infinite replication?

Photography itself is, in this context, an appropriately shaped medium with which to communicate. The plethora of rectangular photographic images that reinforce the generic and mass reproduced as a means to consumer acceptance diminishes our sense of the possible and the sublime. They insidiously and casually substitute

easily reproducible image-friendly paradigms – the synthetic human, the paradise-like environment – for the rawness of existence. Accustomed to relying on the photograph as trace, we hardly know (or want to know) to what extent and how quickly we are leading ourselves down such an essentially compromised path.

In the digital image world the universal equality of things also lends itself to easy categorization under the most banal keywords in the ever-growing archives of 0's and 1's. The photograph, no longer visible on paper or film, generally requires that keywords be assigned in order for the image to be quickly retrieved – an experience quite different than perusing prints. By assigning keywords, the ambiguity of the photograph is often arbitrarily concretized, the photograph's multiple meanings denied, reifying the challenging mysteriousness of existence that the photograph can sometimes evoke. "Sunsets" and "babies" become keywords that belie any remaining complexity in the image; "sexy" is a keyword that is frequently assigned as a ploy in search of a larger audience, a form of consumer branding. As of now there is very little sense of play in keywording, of a poetic dissonance between the word and the image.

Eventually the assigning of keywords will become more subtle, and other strategies will be widely employed to find a digital photograph – geo-tagging, matching image algorithms, various ways of linking from other images and image fragments, etc. A more intuitive associative retrieval system, like Vannevar Bush's visionary memex ("a device in which an individual stores all his books, records, and communications, and which is mechanized so that it may be consulted with exceeding speed and flexibility. It is an enlarged intimate supplement to his memory"), first broadly outlined in the July 1945 issue of *Atlantic Monthly*, would be particularly helpful if it could treat photographs in the digital environment with more subtlety as neither generic nor confined by the information in their captions.

Meanwhile, photographic prints are sold for booming prices at auctions from what is beginning to resemble a photographic graveyard. Earlier this decade the *New York Times* reported that some 98 percent of the Bettmann photographic archive, personally owned by Bill Gates, was taken from its file cabinets in Manhattan and buried in a refrigerated Pennsylvania limestone mine for safekeeping, as the prints were deteriorating. Only the more commercially popular images from among the seventeen million going into storage had been digitized (it was said to be too expensive to scan all the rest) and would remain generally available. The collection, a great paper-based idiosyncratic cultural legacy containing some of the most riveting news and documentary photographs of the twentieth century – which grew from a cache of photographs brought to the United States in 1935 by Otto Bettmann during the Nazis' rise to power – was rendered much less accessible. A readily salable version of history – Einstein sticking out his tongue, for example – was kept in circulation as a digital file. Prints become the collector's domain; for reproduction in today's media, digital files are generally preferred.

The moldering photographs, palpable testimony to time's passing, are refrigerated and remote. The original photograph, its presence in time and space, yellowing and with all the markings on the back, is disallowed. The mechanically reproduced photograph attains a new status as a scarce and at times unique object, with a preciousness more like a painting: one of only three known prints of Edward Steichen's *The Pond-Moonlight* sold in 2006 for $2.9 million. The scanned and smoothed digital images enter an eternal present in which they are distributable over wires and through the

air, ephemeral, omnipresent, never decaying, gratuitously bestowing a facile attempt at immortality.

Certainly, the aging of the digital photograph is not the same as a software engineer's offer to program a paper-like "browning" according to the computer's clock. The digital, as we shall see, offers a much more dynamic version of time than that.

[. . .]

And why not? Even one of the great constants, the speed of light, has changed. In 1999, on the cusp of the millennium, this article, "Physicists Slow Speed of Light," appeared in the *Harvard University Gazette*:

> Light, which normally travels the 240,000 miles from the Moon to Earth in less than two seconds, has been slowed to the speed of a minivan in rush-hour traffic – 38 miles an hour.
>
> An entirely new state of matter, first observed four years ago, has made this possible. When atoms become packed super-closely together at super-low temperatures and super-high vacuum, they lose their identity as individual particles and act like a single super-atom with characteristics similar to a laser.
>
> Such an exotic medium can be engineered to slow a light beam 20 million-fold from 186,282 miles a second to a pokey 38 miles an hour.
>
> "In this odd state of matter, light takes on a more human dimension; you can almost touch it," says Lene Hau, a Harvard University physicist.

In the past few years speeds have been slowed down even more. "In a quantum mechanical sleight of hand," the *New York Times* reported in 2007, "Harvard physicists have shown that they can not only bring a pulse of light, the fleetest of nature's particles, to a complete halt, but also resuscitate the light at a different location and let it continue on its way."

The word "photography," coming from the Greek, means writing or drawing with light. If the light changes the writing should as well.

Original publication

Extracts from 'Of Pixels and Paradox' in *After Photography* (2009).

Martin Lister

INTRODUCTION TO *THE PHOTOGRAPHIC IMAGE IN DIGITAL CULTURE*

THE FIRST EDITION OF THIS BOOK was published in 1995 as rapid and startling technological developments took place and the emergent implications of computation and digitisation for photography began to be glimpsed. Since that date the changes in photographic production, distribution and consumption to which the book first pointed have been enormous. For some contributors to this edition the changes are ontological, they strike at the very heart of what the photographic image is or is becoming (see Rubinstein and Sluis, this volume) while for others change, even if marked, is seen to take place within existing structures and continuities (see, for instance, Frosh and Murray, this volume). Over the same period, what constitutes digital culture has also changed. Commensurately, research and debate about the cultural meaning of digital photography, its significance for the historical practice of photography, the emergence of a 'post-photographic era' and subsequently a time of networked and computed photography, have been considerably elaborated. Further, dramatic changes have taken place that were unforeseen in the mid-nineties and hence found no mention in that first edition; not least the development from 2002 of the Web 2.0 with its user-generated and editable content, the spectacular growth from the mid 2000s of social network sites, the massive accumulation of personal, corporate and historical bodies of photographs in online databases and archives, and the mass availability and use, within the period, of an important hybrid communication device: the camera-phone. We have also witnessed new forms of photojournalism and shifts in the practices of snapshot and personal photography. In the same time frame, the distinction between the still and the moving image has become hard to secure, the chemical photograph has become an historical artefact and its traditional means of production have become all but unavailable. In the 17 years between the first and second edition of this book, there has been an explosion of new kinds of photographic practices, technologies and institutions that, alongside apparent continuities, have raised a range of new questions.

The first edition of this book was one of the first to use the term 'digital culture' in its title, and this too has changed since 1995. The first edition opened with an image of

personal computers humming and blinking on desks in formal institutions. They are, of course, still to be found, but computers have also moved off desks and out of their beige boxes to be integrated into a range of embedded smart devices and closer to the fabric of everyday life, to be mobile, pervasive and ubiquitous. Rather than dramatic novelties, so called 'new' or 'digital' media technologies are now the stuff of habit, routine, everyday life and work. We have seen a shift in the terms we use to describe contemporary media with 'digital' and 'new' giving way to 'networked', 'mobile', 'social', 'locative' and 'pervasive' (see Kember, this volume). The politics of new communications technologies have shifted as the incorporation, institutionalisation, regulation and surveillance of global information systems presents a less utopian picture than some saw, perhaps naively, 17 years ago. There are fierce and relentless attempts to police and legislate over access and control of the information passing through and stored on the internet and the web. Forms of social media that once seemed best described in terms of their folksy grass roots and bottom-up organisation are now also recognised as ways of 'monetising' the labour of amateurs and selling it back to them. The vast server farms that feed the internet have become a major consumer of fossil fuels and the earth is scoured in a race to monopolise the rare metals essential in the fabrication of microelectronics. The once proclaimed light touch of digital technologies on the environment – the sustainability of the virtual (the paperless office!) in contrast to energy devouring and polluting real world industries – is appearing to be hubristic (Taffel 2012). The 'loss of the real' takes on a new meaning. This time, more than a semiotic equation is at stake; it is the real in the most material and physical sense that could be lost.

The first edition

If these are some of the main changes that have taken place with respect to the photographic image *and* with respect to digital culture in the period between the first and second editions of this book, it may be worth briefly revisiting the introduction to the first edition in order to gauge the difference between the questions that faced us then and those that face us now.

Looking back at the introductory essay in the first edition it is clear how much it was concerned with teasing out the continuities in the practice and culture of photography that ran across technological change and tempered the often hyperbolic terms in which it was conceived. It is also clear that it sought clarity and grounded argument amid wild and bewildering speculation. Noting the 'startling' and 'dramatic' technological changes in 'the means of image production' that had taken place from the end of the 1980s, it saw widespread critical chaos. This essay saw the sheer scale of the intellectual entities that clamoured for attention; a 'postphotographic age' was only one among hyperreality, virtuality, cyberspace, nano-technology, artificial intelligence and genetic engineering, and it warned that we faced a situation in which 'focused thought' could become impossible. The book intended to be 'a contribution to gaining such a focus'. It promised to eschew generalisation and abstraction to look instead at the concrete 'social sites of photographic production and consumption' (1995: 2) which, it suggested, were precisely the sites in which the new technologies of the image were being put to work. A key task that it set itself was to insist that the new discourses of the digital image should engage with the body of historical and theoretical

knowledge about photography that we already possessed and to which they seemed blind (1995: 5). Rather than a caricature of photography set in a crude opposition to 'millenarian futurology', it called for a taking into account of 'a body of critical thought about nineteenth and twentieth-century technological forms of visual representation' (1995: 5). On this basis the introduction took issue with monolithic and essentialist conceptions of photography; it advocated instead, following Tagg (1988), the concept of 'photographies', which decentres the technology employed in the medium and fore-grounds its plural social uses. It warned of an equivalent essentialism being applied to digital technology, and was highly critical of the view that digital photography simply broke the photograph's indexical connection to its referent and that a digital photo-graph was not (or could not be) indexical. This introductory essay reminded us that photographic representation was part of a wider Cartesian scopic regime that, far from being disrupted, was being engineered into the new image technologies, includ-ing digital cameras. It insisted on the hybrid nature of photography prior to its digital form by recalling its past relationships with other technologies: print, graphic, elec-tronic, televisual and telegraphic. It saw the convergence between photography and digital media as an acceleration of this longer history, and insisted that analogue pho-tographs were intertextual and polysemous and that these were not newly defining or distinguishing qualities of digital images.

I think that these points still stand. Indeed, they might be due for a little rein-forcing. In short, where photography is concerned, analogue or digital, we should remember to keep its plurality or multiplicity of forms and uses in view; we should keep its indexicality within strict critical limits; we should be aware of the enor-mous weight of the representational conventions that it embodies while insisting on its (historical as well as current) hybridity and promiscuity with other technologies and practices.

The second edition: from image to network

Much has changed since these positions were formulated. When these arguments were made certain developments were yet to take place. As Daniel Palmer observes (this volume), in 1995 the World Wide Web was in its infancy with the first images having been uploaded in 1992, and its traffic in images was slow and cumbersome. What has become the 'networked' image was not an object of attention at that time. Interest was exercised at the level of the discrete image itself, and its newly acquired 'interactivity' in 'stand alone' forms of media storage, such as the CD Rom, and 'rich media' software such as Photoshop and Macromedia Director. Now, in 2013, atten-tion has shifted from the digitally encoded image to the dispersed life of images online and to what is increasingly referred to (in the somewhat ominous and singular noun) as 'the network'; such that we now routinely affix 'networked' to 'digital image'.[1] The 'network image' has demanded new kinds of attention and it is this that most strongly marks out this second edition from the first, especially the perception of a new tran-sience of the photographic image as it is assimilated to a global flow of data and information.

It is also true that the intellectual project of the first edition, with its confident tone of 'clearing the ground' and reinstating 'focus' by engaging 'the body of historical

and theoretical knowledge about photography', has become less straightforward. The idea that the intellectual challenge was to use the history and theory of photography and media and cultural theory to qualify and inject some rigour into the wild discourses of the digital revolution no longer holds in quite the same way. Both digital photography and the World Wide Web were emergent in 1995. In this sense there was some equivalence between them; they were broadly coeval developments. Now, in 2013, the network and its institutions have grown enormously and have come, in many ways, to characterise the era we live in, while strange things have happened to photography. We now live with the paradox, expressed repeatedly but in different ways throughout the chapters of this edition, that 'photo-graphy', the technology about which there was so much anxiety in the 1990s, has all but ceased to exist, yet there has been an exponential increase in photographic images: there is more 'photography' than ever. As the network has come to constitute a second nature, photography has become harder to grasp.

In the period between the two editions there has also, I believe, been a growing awareness of the way that photography (perhaps, more specifically, the camera) has extended outwards from its traditional centre, to interface or become part of other technologies, practices and cultural forms, and this is a work in progress (see Kember, and Giddings, this volume). There is an awareness that '(d)igital photography is a complex technological network in the making rather than a single fixed technology' (Larsen 2008: 142) or that we should approach photography as a 'socio-technical object' (Gómez Cruz and Meyer 2012: 210). Traditionally, photography has been studied as one of a number of kinds of object, each in relative isolation: most frequently as a form of visual representation, but also as a technology of mass reproduction and hence sociological significance, or as an object of social and anthropological interest. Its study, particularly when situated in a philosophical milieu, has repeatedly taken the form of a search for its ontological essence; its true and singular nature. The concept of a 'socio-technical object' arose within Science and Technology Studies and, appropriately, in respect to the way photography has changed, it seeks to understand things as the product of networks of agencies. It acknowledges non-human as well as human agency and in doing so has enabled us to think beyond both technological determinism and the humanist restriction of agency and causality to only human intention and reason. Within Science and Technology Studies, and the version known as 'actor network theory', photography is understood as an always provisional outcome of a (possibly changing) alignment of factors, 'involving the creative presence of organic beings, technological devices and discursive codes, as well as people, in the fabrics of everyday living' (Whatmore 1999, quoted in Larsen 2008: 144).

Such a way of conceiving of photography, as hybrid and relational, as stabilising at moments in history, before changing again, also has implications for how we view how we may write its history (see Giddings, this volume). For instance, given our consciousness of the importance of the internet and the World Wide Web, Wi-Fi-equipped camera-phones and social media institutions such as Flickr to current photography, we are newly sensitised to a seldom mentioned aspect of photographic history: the postal service in the early twentieth century. Here a network of post offices, mail carriers (the internal combustion engine, the bicycle) and manual and mechanical sorting facilities were crucial to the viability of the Kodak system of snapshot photography even though the existence of this network owed nothing at all to 'any intention of

supporting mass-market image creation' (Gómez Cruz and Meyer 2012: 210). It was an enabling alignment.

Photography as residual

The changes photography has undergone in the last two decades have created a degree of uncertainty about how we understand its contemporary status or condition. Indeed, that last phrase, 'contemporary status or condition', begs the question, is the photography we now have truly photography? Maybe it is photography, but photography by other (digital) means? If it is the latter, does this matter? Or, should we respect that 'photography' only makes sense as a now-displaced practice based uniquely on light and chemistry? In what sense does photography continue to exist? No doubt, these largely unanswered questions (we quickly tire of asking them, they become 'academic' and convoluted, and we move on – to make and consume) contribute to the way that photography is now frequently spoken about in paradoxical and quasi-supernatural terms. Photography appears to be everywhere and nowhere simultaneously. It is *everywhere* in that its ubiquity – so often noted with regard to its reach into every corner of life during the twentieth century – has become supercharged in the twenty-first as we struggle to comprehend mind-boggling statistics about digital photographic production, storage and display. If, in the 1970s, a pioneering curator of photography felt able to make the unverifiable observation that there were more photographs than there were bricks in the world (Szarkowski 1976, unpaginated), what analogy would serve us to characterise a time when 300 million photographs are uploaded daily to a single social network site (Murray, this volume) and a trillion JPEGs have been made (Palmer, this volume), and when, it is claimed, that in less than a decade the camera-phone has put more cameras in people's hands than in the whole history of photography? But, photography is *nowhere* in the sense that it has mutated or morphed; it is a shape shifter. It has become a ghost medium that haunts us. As Nina Lager Vestberg writes (in this volume) it is a medium that has died many deaths but refuses to die. We might say that photography exemplifies the state of the 'undead' that the OED concisely defines as something that is technically dead but still animate. This is a language (echoing throughout chapters in this volume) that strives to catch something of the powerful continuities in photographic conventions, and its uses and values, while acknowledging that, strictly speaking, the historic means of photographic production now hardly exist and are practically unobtainable. As Andrew Dewdney puts it (this volume), 'the photograph is now apparently produced without photography?' Yet, as Paul Frosh warns, even to talk of 'transformation' could be 'to speak the language of alchemy, of magical alteration' (this volume).

Nina Lager Vestberg (this volume) reminds us that there is another, less melodramatic, term that we might use to speak of photography's condition, one that has held an important place in cultural theory: this is the idea of the 'residual' cultural form. This is one term in Raymond Williams' dynamic, tri-partite characterisation of cultural forms, which, he suggests, always need to be thought of as either dominant, residual or emergent. He distinguishes the 'residual' from the merely 'archaic' with its simpler connotations of very old things: the embalmed products or practices of another time. The residual, he explains, 'has been effectively formed in the past, but is still active in the

cultural process', it is not simply an element of a past age, as it remains 'an effective element in the present' (Williams 1977: 122). Photography as 'one of the great emblematic artefacts of modernity' (Tomlinson 2007: 73) was overwhelmingly dominant as a means of image production throughout much of the nineteenth and twentieth centuries and may now be thought of as residual in this way. It is a 'flexible territory where the past overlaps with the present' (Lager Vestberg, this volume). Formed in the past yet displaced in many ways, it continues to be a kind of force field that pulls and tugs at practices even as they change or, indeed, as part of *how* they change. This is certainly a concept that could help us understand why the history of analogue photography might still interest 'digital natives', the generation who have no lived experience of loading film and long hours in darkrooms. Analogue photography may have been formed in the past but it exerts its influence in the present.

Thinking of photography as a ghostly medium or a residual cultural practice resonates with yet another way in which photography is currently being understood: as a simulation or a simulacrum of the thing that it once was. Invisible simulation machines (the work of computer software and the agency of algorithms) produce what we take as photography. They make images that have all the appearance and hallmarks of photographs without using photography's historical and physical apparatus. Hence, it is argued, the theory of photography must be drawn into a theory of software and computation, as they are the agents that are responsible for the dissolution of all physical media while ensuring their continuation; this surely is the state that invites the talk of the 'undead' and its many versions. This will be taken up shortly, but before that we should recognise that the photographs that we meet in this 'continuation' are not identical to the products of the older, originary technology of optics, chemistry and mechanics.

Transient photographs

The methods and underpinning theories with which we have analysed or interpreted photographic images are no longer adequate for thinking about networked digital photographs. The kind of visual, textual or semiotic analysis that has dominated the theory of photography (and art history and visual cultural studies more generally) assumes that its objects of study are rich and complex artifacts attended to by viewers who scrutinise them with concentrated interest. They are grounded in conceptions of photography and its reception that assume framed, fixed and stable images viewed (or 'read') by equally centred and motivated viewers.

Remembering that there are plural photographies serves to remind us that there are enclaves of photographic images where such a paradigm is maintained. This is particularly the case where photographs are made and constituted as works of art, which become ever more monumental and spectacular as artifacts. Such images continue to attract the concentrated attention of art collectors and semiotically sophisticated art critics (see Dewdney in this volume). Indeed, an artist such as Thomas Ruff uses the gallery exhibit to draw the (concentrated) attention of the art-consuming public to the wider condition of the digital photographic image (see Palmer, this volume). An international festival of photojournalism, such as 'Visa: Pour L'Image' as is held annually in the city of Perpignan, testifies to the tenacity with which the historical documentary

project of photography is held to in the face of overwhelming economic odds.[2] The 'slow photography' movement described by Susan Murray (this volume) speaks of a desire to return to a more deliberative practice, and is an example of where 'the residual' might just promise to return as 'the emergent' in Williams' terms (although he is wary of such tendencies and sets the bar very high for qualification as a genuinely emergent form). The question remains, as David Bate puts it (in this volume),

> How *do* we talk about the distinct institutional and discursive practices of fashion photography, news photography, advertising images, tourist iconography, public displays of private photographs, the specious genres of the pornographic image, tabloid and paparazzi photography, generic 'stock' images, art photographs or portraits of public figures all as simply 'digital photography'?

Indeed! Yet, as he suggests, 'digital' (or, as we meet in this book, 'algorithmic', 'simulated' photography or 'photography after photography') are abstractions for processes that have effects on all of these practices. This is important, because as Paul Frosh observes (in this volume and Frosh 2003: 195–97), digital technologies in the hands of the 'visual content industry' work to dismantle the discursive and organisational boundaries between even 'the three great photographic fields of art photography, advertising photography and documentary photojournalism'.

It is now the case that the vast generality of photographic images enter fibre optic and telecommunication networks as numeric data and are transmitted, stored, and shared in this coded form. Invisible to human beings but readable by machines (computers), these images only rarely, if at all, take the form or 'output' of a stable physical print. The most common way of viewing such networked images is on the light emitting screens of cameras, camera-phones, PDAs of various kinds and laptop computers. These, of course, can be switched on and off, hence such images have duration; a quality new to photographs (Nardelli 2012: 159–78). Many such screens will be interactive and the images they display can be moved, resized and reformatted by a tap or stroke of a finger. We may say, then, that it is in the nature of digital networked images to exist in a number of states that are potential rather than actual in a fixed and physical kind of way. Such images are fugitive and transient, they come and they go, they may endure for only short periods of time and in different places, maybe many places simultaneously. Characteristically they exist in multiples; as strings, threads, sets, grids (see Frosh's thoughts on the 'thumbnail', this volume). We anticipate that behind an image we have alighted on there is another waiting or there is one, seen earlier, to be returned to. Rather than absorbing us in a singular manner each image seems to nudge us toward another. They have a kind of mobility as we scroll across them, clicking one or another in and out of the foreground of the screen's shallow space. We pay attention to such photographs in different, more fleeting or distracted ways than the kind of viewer that is imagined by traditional theories of photography, embodied now as the minority audiences of gallery-installed prints. (For further consideration of this transient image in respect of photographic exhibition and display, see Andrew Dewdney, in commercial and advertising contexts see Paul Frosh and for the way that the value of images now lies in their very depiction of transient states, see Murray, all in this volume).

Photography, information and attention

This fugitive and transient networked photograph and its restless viewer (or user) is more than an aesthetic form. It is part of a larger reconfiguration of experience and mediation of the world by information technologies. We may see what is at stake here if we think about what is meant when we say that photographs have become information. This does not mean that there is a proliferation of images that carry information of the kind that we might once have taken a traditional documentary photograph to give us; as a report on a specific event, thing or situation. The different kind of information that photographs have become had been laying in wait for some time, at least since 1949 when a theory of information as the transmission of unambiguous signals in telecommunication systems was outlined in Shannon and Weaver's foundational 'A Mathematical Theory of Communication'.[3] By the early 1950s, such a theory began to be operational with regard to photographs as it became possible to scan and convert them into arrays of binary digits, and hence they became 'electronically processable digital information' (Mitchell 1992: 1) However, it was not until considerably later, in the early 2000s, that digital cameras supplied such 'processable' information automatically and fed it into the internet. The conversion of photography to information was complete: it became a default operation.

In his etymology of the word, Geoffrey Nunberg describes this kind of 'information' as a new kind of abstract, generic and intentional *substance* that is 'at large' in the world (Nunberg 1996: 110–11, see also Frosh 2003: 195–200). It can be moved around the world at high speed, it is a quantifiable, it is a commodity that can be traded in and it is separable from its instantiation in a medium (it is detachable from its substrates). As Bruno Latour (2004) wryly observes, this is information that can be weighed in kilobytes, that clogs email accounts and can make 'computers heat up'. The history of this release of information from the material substrates on which it was once inscribed has been described as the story of 'how information lost its body', a story that was not inevitable but was the product of selective research programmes (Hayles 1999: 22). Digital photography is part of that story; as a seamless analogue configuration bound to a physical surface is rendered into bits, having the physical form of electronic charges and the symbolic form of numbers. The chemical photograph, continuous tonal alterations to a field of silver salts carried on a physical and bounded substrate, became assimilated to a generic code. This, of course, is the kind of information indicated in a phrase like the 'information economy'.

There is a problem with the concept of such an information economy that arises with the vast scale of its production and includes digital photographic production that defeats comprehension as we count photographs and image files in their billions and trillions. The question has been asked as to what kind of economy this is: an economy that trades in a commodity of which there is an unmanageable and unimaginable excess. A key statement of the problem is Goldhaber's:

> (O)urs is not truly an information economy. By definition, economics is the study of how a society uses its scarce resources. . . . We are drowning in information, yet constantly increasing our generation of it. . . . There is something else that moves through the Net, flowing in the opposite direction from information, namely attention.
>
> (Goldhaber 1997)

This sense of the massive and continuing production of information (including, since the mid 1990s, the visual and the photographic) has a much longer history in an anxiety about 'information overload'. It was broached, albeit in different terms, with regard to photography, as early as 1926 by Siegried Kracauer in his essay on photography as 'mass ornament' (Kracauer 1995). In 1945, Vannevar Bush, the pioneering electrical engineer and information scientist, envisaged an interactive, networked machine utilising a mobile camera and a 'dry' form of photography that he hoped would play a major role in solving the problem.[4] He wrote, almost 70 years ago,

> There is a growing mountain of research . . . there is increased evidence that we are being bogged down . . . The investigator is staggered by the findings and conclusions of thousands of other workers – conclusions which he cannot find time to grasp, much less to remember . . . publication has been extended far beyond our present ability to make real use of the record. The summation of human experience is being expanded at a prodigious rate, and the means we use for threading through the consequent maze . . . is the same as was used in the days of square-rigged ships.
>
> (Bush 1945)

The continuing problem, a problem for the informational mode of capitalism (Castells 2000: 77–147) is that the massive (over)production of information places demands on the ability of people to attend to it. As Simon (1971: 40) put it, 'What information consumes is rather obvious . . . the attention of its recipients. . . . a wealth of information creates a poverty of attention' (Simon 1971: 40).

The question has become, how does any particular enterprise, owner or provider of information, corporate or public, commercial or educational, scientific or artistic, gain attention to 'their' information? How is a supply or measure of the scarce commodity that is human attention to be obtained? In the twentieth century the obvious site of this competition for attention was advertising and the selling of 'eyeballs' by commercial television channels. The predominant forms of twentieth-century 'mass media', the printed press (in which photography was paramount) and television, continue to battle for ratings and sales but the real ground has moved to networked digital media with its interactive push-pull strategies, niche markets, pop-ups, cookies and predictive operations. This is a complex issue, politically, within which photography continues to be centrally involved. Suffice it to say that what is at stake is a competition for the human capacity for paying attention; a commodification of our cognitive capacities (for a comprehensive discussion, see 'Paying Attention', the special issue of *Culture Machine* Vol 13, 2012 at www.culturemachine. net/index.php/cm).

An example of what this means for photography is given by Paul Frosh (in this volume). Companies whose aim is to sell stock photographs for advertising purposes through online image-banks face a conundrum.

> The challenge for photographers and stock agencies is to make every image an 'arresting' image . . . amid the 'clutter' generated by all other images. Every image . . . cries out for attention, and yet in so doing every image also threatens to become 'noise', distracting the viewer from neighbouring images.

As Frosh then suggests, the 'thumbnail' reduces this image noise and clutter to 'an instrumental grid on a screen'. The hope is that the viewer, whose gaze is distracted by the many competing images that surround and confront them, can be helped to more effectively scan and choose, and hence be returned, to a degree, to the ideal (if now mythological) position of the attentive viewer. Another example, noted in several chapters in this book (see, for instance, Palmer and Murray, in this volume) might be the Instagram and Hipster applications whereby algorithms turn 'run of the mill' snapshots into retro-images, photographs bearing the characteristics of old photographs. This is a means of attaching the connotations of a 'look' with cultish values, to otherwise unremarkable images. The function and appeal of such applications is surely to distinguish some images within a sea of others. It is, ultimately, a self-defeating exercise but not perhaps until a temporarily profitable market becomes exhausted and a point is reached when no distinction is any longer offered.

Software, algorithm, automation

I noted above, in the discussion of photography as a residual cultural form, that a related view is to see photography as simulated; something that is achieved by computer software. In their informational state, photographs are processed and shaped by bodies of code in the form of software and its operative components: algorithms. Since the first edition of this book there has been a growing demand for theorists of media to take the social and cultural role of software seriously, hence some consideration is due in this introduction. Such 'Software Studies', urges Lev Manovich, should 'investigate both the role of software in forming contemporary culture, and (the) cultural, social, and economic forces which are shaping development of software itself' (2011 introduction to *Software Takes Command* www.manovich.net/DOCS/Manovich. Cultural_Software.2011.pdf).

Such a discipline is in its infancy and broad statements about its importance are easier to find than actual case studies (Fuller 2008). Rather like photography itself, we hear a good deal about the ubiquity of software and its place in running the world. However, where photography is concerned, software as an object of critical study will not be easy to access. The software and algorithms embedded in the cameras of Nikon or Canon or used by Flickr or Facebook to organise their business (and 'our' practice) are closely guarded corporate secrets and subject to policing by patents.

A claim that accompanies the call to study 'software' is that we (may) now live in a post-media age.

> 'What happens', asks Lev Manovich, 'to the idea of a "medium" after previously media-specific tools have been simulated and extended in software? Is it still meaningful to talk about different mediums at all? Or do we find ourselves in a brave new world of one single monomedium, or metamedium?'
>
> (Software Studies Initiative 2012)

This requires some thought, if only because it should be admitted that a 'medium' has always been a slippery and precarious concept. Its origins lie in an almost

metaphysical sense of 'an intervening substance' between a sense organ and an object (Williams 1976: 167–73); there is a mechanistic sense of a channel through which something (such as information) simply flows. In some hands, Marshal MacLuhan's for instance, it is little more than a synonym for technology (Lister *et al.* 2009: 81–88); and for yet others it is one element in something more complex: a practice. If we are to substitute 'medium' with 'software' then the sense of a medium as a 'channel' or a 'technology' makes that relatively easy to do, or think about. But, if a medium refers to an element of a practice, specifically the material that is worked by the skills of the producer, in relation to intentions and within institutions, the substitution is less readily made. As we will see, a software application that simulates a medium does so by borrowing or inheriting the work processes, decision making, conventions and procedures that constituted a media practice whether that be making a photograph, editing a video, designing a 3D structure or space, or writing and producing music. While we are clearly in a world where we can simulate and extend all older media through a single kind of machine, the computer and its software(s), we are surely a long way from being in a state where we have one metamedium. (See Kember, this volume, for the view that 'software study' is a kind of 'substitution trap'). We should, I suggest, stop well short of such a wholesale substitution while recognising that the study of software has an important role to play in figuring out the condition of photography now.

Algorithms predate computing, having a long history in mathematics. If an algorithm is a set of instructions for a sequence of procedures that will achieve a specified result then we can reasonably suggest that photography has long been algorithmic-like (see also Rubinstein and Sluis, in this volume). This is the case in at least two ways; first, in the learnt and systematic technical expertise of professional and serious amateur photographers and, second, in the technology hidden inside automatic, consumer level cameras.

The algorithmic nature of professional (analogue) photography can be seen in the following notes made by Ansel Adams about the exposure and development of his famous photograph of 1941, 'Moonrise, Hernandez, New Mexico'. At each stage of the exposure calculations are made, even ones that anticipate future actions in the darkroom. Whether we are able to fully understand Ansel Adams' recall of these 'instructions to himself' is not the point, it is the sequence of precise stages in a process that results in a particular (pre-visualised) image that is of interest here.

> I set up the 10×8 camera . . . while visualising the image. I had to exchange the front and back elements of my Cooke lens, attaching the 23-inch element in the front, with a glass G filter (#15) behind the shutter . . . I knew that because of the focus shift of the single lens component, I had to advance the focus about 3/32 inch when I used f/32 . . . I remembered that the luminance of the moon at that position was about 250 c/ft^2 . . . With a film of ASA 64, the exposure would be 1/60 second at f/8. Allowing a 3x exposure factor for the filter, the basic exposure was 1/20 second at f/8 . . . I indicated water bath development . . . and (the negative) was locally strengthened by intensification in the Kodak IN-5 formula . . .
>
> (Adams 1981: 127)

A second way in which photography is algorithmic-like is in the manner that processes or events may take place automatically and behind 'the scenes'. The much-cited

example here is the famous Kodak Brownie, which hid even its quite simple operations from its user, to the complex electro-mechanical, sensor equipped but pre-digital automatic 'point and shoot' cameras of the 1980s (see Maynard 1997: 3–4). These cameras offered their users a set of simplified controls for more complex operations, usually in the form of small pictograms. Behind these graphic 'interfaces' lay the invisible internal working of the camera (see Slater 1995: 134, 141; Palmer, in this volume). Computational software and algorithms that carry out specific tasks and operations are now not only built into cameras but also into the extended apparatus of photography: the online organisations, social media sites, data-bases and post-production 'lightrooms' where photographs are made, stored, organised, classified and shared. As we have seen, these software 'machines' (Rubinstein and Sluis, this volume) did not enter a vacuum. They take the place of older technologies and procedures and as they do they simulate and emulate them while bringing new capacities to the medium of photography.

In an attempt to show what software study might look like, Manovich has recently offered a model in his study of the software package Photoshop (Photoshop Computational Culture, 2011. http://computationalculture.net/article/inside-photoshop. Accessed 19.01.13).

It may seem fortuitous (given we are interested in photography) that in his advocacy of a wider discipline of 'Software Studies' Manovich has chosen a 'photographic' package as his example. But, where Photoshop is concerned, there is a danger we will be returned to thinking about software only in terms of image manipulation as Photoshop was closely associated with the anxiety of the 1990s about the threat to photographic 'truth'. We still have the pejorative phrase 'it has been photo-shopped'. However, bearing this in mind, Manovich's study yields some useful general points about the work of software.

He proposes that software achieves four things: it automates, simulates, and augments an existing medium, while adding its own functionality. Software, almost without exception, simulates what were once physical media, 'every element of computational media comes from some place outside of digital computers' (2011: 5). These 'places' may be prior forms of physical media, or they may borrow from the processes that were designed for earlier forms of telecommunication or television transmission etc. The operations and structures that software simulates can be traced 'to previous physical or mechanical operations and to strategies of data, knowledge and memory management that were already in place before the 1940s' (2011: 5). Given that these simulations are quite real (they *do* produce images that fulfil the role of photographs) and are in no way 'illusions' then photography is, we might say, in safe hands. (For a fuller discussion of the several meanings of 'simulation' and the need to free the concept from connotations of 'illusion', see Lister *et al.* 2009: 38–43)

However, software is not passive or neutral. It does not only simulate, it also automates and augments the processes that it simulates. The software contained in upmarket 'compact' digital cameras, such as that which is put to work when I select the 'intelligent auto' setting on my small camera (itself only one of 25 computed options it offers me), harnesses a range of sensors and algorithms to compute an image, the production of which would be beyond a human photographer whose standards fell much short of the technical wizardry of an Anselm Adams. The camera has indeed become a computer (see David Bate, this volume) yet the camera manufacturers have also sought

to reassure me, as I trigger invisible algorithms, that I am a real photographer by retro-designing the camera body that I hold to resemble the iconic Leica.

The automation of complex procedures is a standard feature of digital cameras. As Michelle Henning observes, digital cameras have been constructed to replace analogue ones when they might have explored this alternative technology and its own qualities (in Acland 2007: 53). She suggests that this is in many ways a loss, as

> Downmarket and early digital cameras can produce digital effects different to film . . . but these qualities . . . are played down in camera design. The more upmarket cameras remediate photography so successfully that these distinctive characteristics are hardly noticeable.
>
> (2007: 53)

The 'loss' that Michelle Henning notes here, the opportunity to explore new and unfamiliar features of image making (if largely unknown due to the very simulation of photographic orthodoxy that supresses them) may, or may not, interest us; there is no imperative to experiment with lo-fi techniques. But, far more importantly, it alerts us to the active shaping of photographic practices and the potential for affording some options and closing down others by software.

Finally, software brings something of its own to the world of (simulated) photography. These are software functions that have nothing to do with the media that they simulate and automate but have everything to do with the traditions of software engineering itself. In exactly the same way as we can trace a genealogy for the photographic image, we can trace another for computing and software. All software for media creation and editing, no matter how successfully they simulate older physical media, also have a functionality that derives from modern software engineering in general. Manovich's example is the provision of the 'History' window in the menu bars of many software applications. Here numerical control of the various tools provided by the software (usually itself an augmentation or increase of the degree of control that is possible manually) and the settings chosen for the manner and degree of their use, can be saved and retrieved at will. The point is that such provisions (or 'functions') are significantly different from anything found in the media 'predecessor' that the software simulates. They belong to the world of computing with which photography has converged. The some 1,300 differently exposed and 'dodged and burned' prints that Ansel Adams reputedly made from his 'Moonrise' negative would be 'saved as' versions in a computer/camera's memory. Therefore, in Manovich's view, when a photographer uses a digital camera they use 'new media'. Hidden, but no doubt lively, algorithms automate and augment across the complex technological network that is now photography: they do so 'in-camera', in post-production applications, and, in the words of Jonas Larsen, they do so as photographs 'travel through and take (momentarily) hold in the wires, databases, emails, screens, photo albums and potentially many other places' (2008: 143).

Original publication

Introduction to *The Photographic Image in Digital Culture* (2013).

Notes

1 It seems to me that this generic term 'the network' is used to avoid the greater specificity of 'the internet' or 'the world wide web', and other networks such as 'intranets' for example. It has evolved as an abstract concept to denote a *condition*.
2 www.nytimes.com/2009/08/10/business/media/10photo.html?pagewanted=1&_r = 3& sq = photojournalism& st = cse& scp = 1.
3 This section draws upon a fuller discussion in my article 'A Sack in the Sand: Photography in the Age of Information' *Convergence: The International Journal of Research into New Media Technologies* Copyright © 2007 Sage Publications London, Los Angeles, New Delhi and Singapore Vol 13(3): 251–74.
4 This refers to Vannevar Bush's proposed machine, the Memex. See Bush (1954) 'As We May Think', *Atlantic Monthly,* and again, my article 'A Sack in the Sand: Photography in the Age of Information' (note 2).

Bibliography

Acland, C. (2007) *Residual Media*, Minneapolis and London, University of Minnesota Press.

Adams, A. (1981) *The Negative*, Boston, Little, Brown and Company.

Bush, V. (1999) 'As We May Think' [*Atlantic Monthly*, 1945], in P. Mayer (ed.) *Computer Media and Communication: A Reader*, Oxford, Oxford University Press.

Castells (2000) *The Rise of the Network Society*, 2nd edition, Vol 1, Oxford, Blackwell Publishers Ltd.

Frosh, P. (2003) *The Image Factory: Consumer Culture, Photography and the Visual Content Industry*, Oxford and New York, Berg.

Fuller, M. (2008) *Software Studies: A Lexicon*, Cambridge, Massachusetts, London, The MIT Press.

Goldhaber, M. (1997) 'The Attention Economy and the Net', *First Monday* Vol 4, at http://firstmonday.org/article/view/519/440 Accessed 15 April 2013.

Gómez Cruz, E. and Meyer, E. (2012) 'Creation and Control in the Photographic Process: iPhones and the Emerging Fifth Moment of Photography', *Photographies* Vol 5, No 2, 203–21.

Hayles, N. K. (1999) *How We Became Posthuman: Virtual Bodies in Cybernetics, Literature, and Informatics*, Chicago, University of Chicago Press.

Kracauer, S. (1995) *Photography: The Mass Ornamaet* (translated Levin, T.Y.), Cambridge, Masachusetts and London, Harvard University Press.

Larsen, J. (2008) 'Practices and Flows of Digital Photography: An Ethnographic Framework', *Mobilities* Vol 3, No 1, 141–60.

Latour, B. (2004) 'Alternative Digitality', at www.ensmp.fr/~latour/presse/presse_art/GB-05%20 DOMUS%2005–04.html.

Lister, M., Dovey, J., Giddings, S., Grant, I. and Kelly, K. (2009) *New Media: A Critical Introduction*, 2nd edition, London, Routledge.

Manovich, L. (2011) 'Cultural Software', at www.manovich.net/DOCS/Manoich.Cultural_ Software.2011.pdf Accessed 14 April 2013.

Maynard, P. (1997) *The Engine of Visualisation: Thinking through Photography*, Ithica and London, Cornell University.

Mitchell, W. J. (1992) *The Reconfigured Eye: Visual Truth in the Post-photographic Era*, Cambridge, MA, The MIT Press.

Nardelli, M. (2012) 'End(ur)ing Photography', *Photographies* Vol 5, No 2, 159–77.

Simon, H. A. (1971) 'Designing Organizations for an Information-Rich World', in Greenberger, M. (ed.) *Computers, Communication and the Public Interest*, Baltimore, MD: Johns Hopkins Press.

Slater, D. (1995) 'Domestic Photography and Digital Culture' in M. Lister (ed.) *The Photographic Image in Digital Culture*, London, Routledge, pp. 129–46.

Software Studies Initiative (2012) 'Does "Media" Still Exist?', The Graduate Center, City University of New York, at http://lab.softwarestudies.com/2012/09/does-media-still-exist.html Accessed 1 February 2013.

Szarkowski, J. (1976) 'Introduction to William Eggleston's Guide', at www.egglestontrust.com/ Accessed 21 March 2013.

Taffel, S. (2012) 'Escaping Attention: Digital Media Hardware, Materiality and Ecological Cost', *Culture Machine* Vol 13, at www.culturemachine.net/index.php/cm Accessed 21 March 2013.

Tagg, J. (1988) *The Burden of Representation*, Basingstoke and New York, Palgrave MacMillan.

Tomlinson, J. (2007) *The Culture of Speed*, London, Sage.

Whatmore, S. (1999) *Hybrid Geographies: Natures, Cultures and Spaces*, London, Sage.

Williams, R. (1976) *Keywords: A Vocabulary of Culture and Society*, Glasgow, Fontana.

———— (1977) *Marxism and Literature*, Oxford, Oxford University Press.

Matthew Biro

FROM ANALOGUE TO DIGITAL PHOTOGRAPHY
Bernd and Hilla Becher and Andreas Gursky

TODAY, one of the central oppositions structuring our understanding of contemporary photography is the distinction between analogue – or film-based – practices and digital ones. In particular, the rise of digital recording and manipulation techniques have called into question the photograph's traditional claims to truthful documentary representation to such an extent that, according to certain scholars and contemporary critics, digital photography is in essence an entirely new medium, an unprecedented form of representation that will create profound changes in human thought and understanding.[1] While it is good to be suspicious of radical claims to this effect, it is true that the rapid adoption of digital technologies in photography since the 1990s has led to a greater erosion of the public trust in the truth of the photographic image than ever before, as well as a more broadly based awareness of the photograph's ability to lie – its capacity, in other words, to help propagate mythologies when functioning as a component within the system of the global mass media. For this reason, asking why we often still see 'truth' and 'objectivity' in analogue photographic practices – and why we ascribe 'untruth' and 'subjectivism' to digital photography – continues to be of pressing concern, for what at first appears to be a clear-cut distinction between analogue and digital photography soon turns out to be far less cleanly divided.

At first glance, the radical differences between digital and analogue practices seem openly on display when comparing the work of Bernd and Hilla Becher, on the one hand, with Andreas Gursky, on the other.[2] As was already suggested by their first book of photographs, *Framework Houses of the Siegen Industrial Region* in 1977, the Bechers were engaged in a rigorous and uncompromising documentary project – one that stressed the objective analogue truth of the photographic medium.[3] *Eight Views, Hauptstrasse 3, Birken* (1971) for example, is a set of eight equally sized photographs, sometimes displayed as a grid, presenting the front, back, sides, and individual corners of a single framework house in the industrial Siegen district of Germany (Figure 43.1). Characteristic of the Bechers' 'truthful' or 'objective' approach is their consistent

choice of angles and viewing distances, which de-emphasise subjective shot decisions and permit easy comparisons between different photographs and photographic groupings. Everything is done to reject the personality or particular sensibility of the photographer: the camera is consistently level with the middle of the subject; lighting is even and diffused; contrast is reduced to give all parts of the structure a similar weight and impact; and the background is de-emphasised in order to direct the spectator's attention to the architecture itself – its iconic form and its indexical connection to a specific construction existing at a particular moment of historical time (Figure 43.2). The Bechers accentuate the truthful qualities of their analogue practice through the use of a large-format Plaubel Peco camera; it allows them to delineate their subjects with sharp focus, fine detail, and a wide depth of field – qualities that increase the iconic sensuousness of the image and that also help to maximise its informational qualities.[4] Their choice of black and white film is likewise informative; it directs the viewer to concentrate on the architectural subject's specific physical and structural characteristics.

The 'truthfulness' – that is, the objectivity and the informational qualities – apparent in the Bechers' documentary practice rests not only in the analogue character of its photographic technologies but also in their photographs' natures as indexes their status as traced or caused by unique events in space, time, and consciousness.[5] The indexical character of the analogue photograph emerges from its material basis as a chemically sensitised surface upon which light reflected off real people and objects has been captured in a direct and unmediated way. As indexes, the Bechers' editioned prints accrue an aura, a sense of value that often grows stronger, particularly if the original architectural subject is destroyed. Indexicality conditions the viewer to

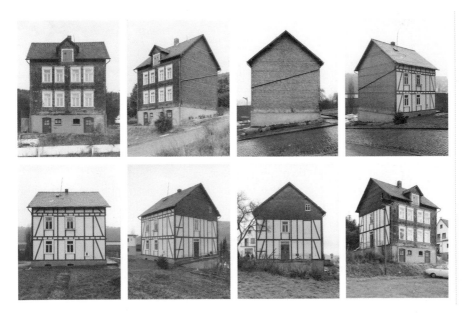

Figure 43.1 Bernd and Hilla Becher, *Eight Views, Hauptstrasse 3, Birken, Germany,* 1971. Eight gelatin silver prints, 23.81 cm × 17.94 cm each. The J. Paul Getty Museum, Los Angeles, CA. Image © 2012 Hilla Becher.

MATTHEW BIRO

Figure 43.2 Bernd and Hilla Becher, *Framework House, Corner View, Hauptstrasse 3, Birken, Germany,* 1971. Gelatin silver print, 23.81 cm × 17.94 cm. The J. Paul Getty Museum, Los Angeles, CA. Image © 2012 Hilla Becher.

anthropomorphise photographs: to attribute human qualities such as intentionality and uniqueness to them as we also do to painting and sculpture. And, as the historical time grows between the moment when the Bechers made their photographs and the moment when the contemporary viewer apprehends them, their indexical qualities seem undiminished. Indeed, the passage of time seems to produce an unexpected effect: the older the print, the stronger the indexical connection appears between the Bechers' representation and the original object.

A third aspect of the truthfulness of the Bechers' photography lies in its rigorous archival method.[6] For the past forty years, the Bechers have documented the vanishing industrial architecture of Germany, Western Europe, and the USA, producing a large typological databank of what they at one time called 'anonymous sculptures': structures such as winding towers, processing plants, framework houses, factory halls, silos, blast furnaces, lime kilns, cooling towers, water towers, and gas tanks.[7] By preserving numerous well-documented instances of these buildings constructed between the 1870s and the 1950s, they created a significant archive that today exists as an important source of historical information.[8] And because of their clarity, extent, and comparability, among other qualities, we still assume that we can investigate and discover 'truths' about the modern industrial past through the Bechers' photographs.

Another aspect of the truthfulness of the Bechers' work comes from its conscious relationship to the photographic past; specifically, its links to 'new objectivity' (*Neue Sachlichkeit*) photography: figures such as Karl Blossfeldt, August Sander, and Albert Renger-Patzsch, whose documentary practices connected careful analogue and often large-format camera techniques to archival and typological methodologies. Like the Bechers' work, Sander's portraits are straight on, neutral, 'cool', and objective.[9] Part of Sander's archive of portraits documenting the diverse social strata of German society in the pre-Nazi period, *Blind Miner and Blind Soldier* (ca. 1930), seems to present a clear picture of German men traumatised by either World War I or heavy industry (Figure 43.3). Presenting two examples of the same 'type', the disabled male proletariat, the photograph suggests both similarities and differences. Despite their worn clothing and oppressive external location, details that attest to economic hardship and privation, both figures remain buttoned up and orderly, perhaps a sign of their continuing allegiance to traditional German and military values, despite the poverty suffered by many former workers and combatants during the Weimar Republic, particularly in its waning years. On the other hand, possibly because of his more collapsed body language, the disabled man on the left seems closer to death, reminding the viewer that our fates are individual, even if our circumstances are similar. Even the slight angle and off-centredness of the viewpoint strengthens the photograph's rich documentary character by making it seem slightly less staged or set up.

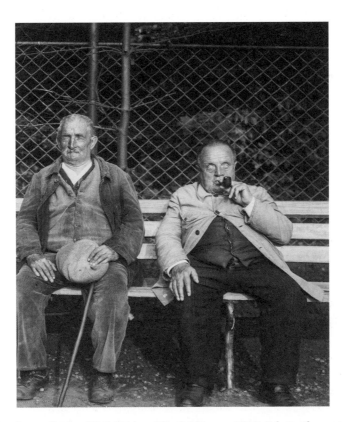

Figure 43.3 August Sander, *Blind Miner and Blind Soldier*, ca. 1930. Gelatin silver print, 25.4 cm × 20.48 cm. © Die Photographische Sammlung/SK Stiftung Kultur – August Sander Archiv, Cologne/ VG Bild-Kunst, Bonn and DACS, London 2018.

Because of their directness and rich detail, we get a sense from Sander's photographs that we see the subjects as they are and not as the photographer interprets them to be. The Bechers evoked the 'objective' photography of the 1910s, 1920s, and 1930s in part as a way of distancing themselves from the 'subjective' photography of Otto Steinert and others in the 1950s. In opposition to Sander, Steinert's photographs emphasised the photographer's subjective and transformative vision. This can be seen, for example, in the unsettled and momentary character of Steinert's *Call* (1950), the formal qualities of which evoke a type of looking receptive to chance and experiment (Figure 43.4). Steinert's subjective attitude in photography is suggested by the figure's mobile stance, lack of detail, and motion blur; the slightly low angle of the shot; and the photograph's overall emphasis on the process of human vision through its focus on the man's relationship to the street posters. Here reality is selected and manipulated so that it can stand as an easily readable symbol of modern vision.[10] As a result of this change, the photograph functions less as document and more as art.[11] And by rejecting Steinert's subjectivism as well as by emphasising their associations with the tradition of German objectivity exemplified by Sander, the Bechers stress the connections between their practices and an older mode of photographic comportment with strong documentary and matter-of-fact associations.

In comparison with the Bechers, Gursky's work seems altogether different. His photographs are intended and presented as artworks, not as documents; and although they are formally rigorous, there is little or nothing of the Bechers' focus on objective

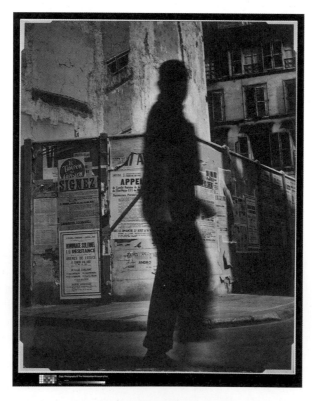

Figure 43.4 Otto Steinert, *Call*, 1950. Gelatin silver print, 60 cm × 46.8 cm. © 2017. Image copyright The Metropolitan Museum of Art/Art Resource/Scala, Florence.

method, a largely unvarying format and set of practices that allow for individual structures to be documented as well as interrelated typologically. Instead, Gursky's photographs seem much more symbolic and subjective, qualities that appear to reflect an awareness of the manipulability of the photographic medium, which in turn can be linked to the untruthfulness and lack of objectivity associated with digital processes.[12]

Gursky's *Rhine II* (1999), for example, presents an image of something that does not exist in real life (Figure 43.5). Here we are presented with a slightly elevated view of a section of the river running parallel to the picture plane, flanked by swaths of green grass and, in the foreground, a paved roadway, a man-made structure that echoes in form and function the natural avenue of transportation that flows behind it. Nature is doubly flattened in these images: depth of field is compressed through Gursky's lens and he has employed Paintbox software to remove a few buildings from the far side of the river, thereby accentuating the motif's horizontality. A photographic representation of the world has thus been transformed into an abstract artwork, 'a natural Newman', as one critic called it.[13] Its indexical qualities have been weakened; and we perceive it as a metaphor for the dialectic between nature and technology, rather than a depiction of a particular geographic location. Through its digital manipulation, moreover, which renders the picture more abstract and mechanised, the iconic quality of the river motif is emphasised, thus strengthening the beholder's sense that landscape's form has been idealised.[14]

Atlanta (1996) also seems manipulated in this sense (Figure 43.6). Here Gursky has used the computer to merge two disparate viewpoints of the John-Portman-designed hotel: shots of the Atlanta Hyatt Regency's atrium taken from the same vantage point but at a distance of 180° from one another. Somewhere near the vertical centre of our vision, in other words, Gursky has merged opposite ends of the same hallways, creating a back wall that was never really there. Like the *Rhine, Atlanta* looks in certain ways like an abstract painting; and, on a thematic level, like many of Gursky's photographs, it envisions a world of global migration and flow: a space in which travel, leisure, and labour are systematically interrelated and organic forms seem to be channelled as if they were materials being processed within a giant machine. Although cool and 'deadpan', the image seems ominous; what is most disturbing about it are its formal qualities.[15] Although the sensuousness of the work engages us, if we stare at the picture long enough, we come to mistrust it. Intuitively, the spectator knows that landscape is false in some way and that, whatever reality the photograph still points to, what we see in front of us is not the world as it existed before Gursky's lens. When the spectator learns how Gursky digitally manipulated the photograph, the view seems even more uncanny. We suddenly recognise that what we see is physically impossible, because it encompasses more than twice the normal range of human vision – and yet, strangely, it looks like our everyday field of view. Reality, here, is rendered both familiar and strange. Thus, despite its clarity and detail, *Atlanta* does not emphasise its documentary character; instead, it foregrounds its digital manipulation and thus sows seeds of doubt about its own truthful nature as well as the viewer's ability to comprehend the objective world.

It is even characteristic of Gursky's work that his 'straight' or non-doctored images look digitally manipulated. *Untitled I* (1993) presents an elevated and oblique view of the grey institutionally carpeted floor of the Düsseldorf Kunsthalle (Figure 43.7).[16] The realism of the image changes from the bottom edge or front plane, where the texture

Figure 43.5 Andreas Gursky, *Rhine II*, 1999. Chromogenic colour print, 155.6 cm × 308.6 cm. [Original in colour] © 2018. Christie's Images, London/Scala, Florence. © Andreas Gursky. Courtesy: Sprüth Magers Berlin London/ DACS 2018.

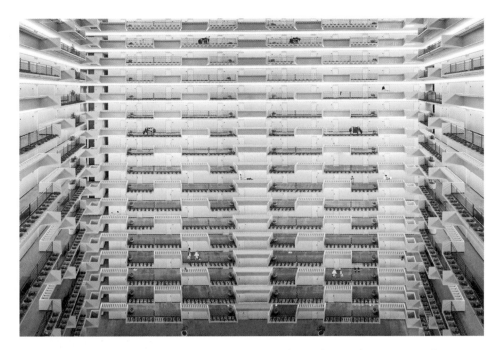

Figure 43.6 Andreas Gursky, *Atlanta*, 1996 [original in colour]. Chromogenic colour print, 187.96 cm × 260.35 cm. © Andreas Gursky. Courtesy: Sprüth Magers Berlin London/ DACS 2018.

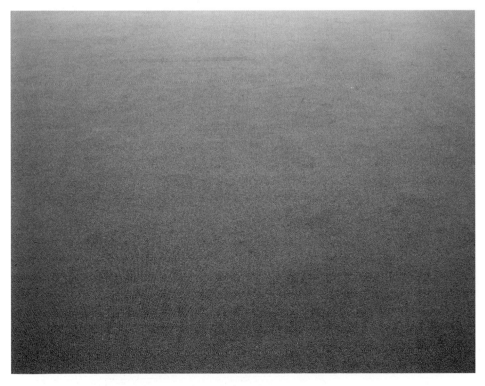

Figure 43.7 Andreas Gursky, *Untitled 1 (Carpet)*, 1993. Chromogenic colour print, 174.5 cm × 210 cm. © Andreas Gursky. Courtesy: Sprüth Magers Berlin London/ DACS 2018.

of the carpet is clearly apparent, to the top edge or rear plane, where the carpet is out of focus. On the bottom and across most of the photograph Gursky's image is true and informative; in the top one-tenth of the representation, where shallow depth of field plus distance creates abstraction, the photograph could be anything: a response, perhaps, to recent German painting's dialogue with photography in the 1960s and 1970s or to global conceptualism's tradition of institutional critique during the same time.[17]

While the photographic surface depicting the museum carpet cannot offer the richness and sensuous presence of the textured and complexly worked face of Gerhard Richter's canvas *Grey* (1974), for example, the photograph's size and sumptuous printing indicate that it does aspire to the condition of abstract painting (Figure 43.8). Furthermore, by potentially referring to Richter's famous series of grey monochromes created between 1970 and 1975, Gursky's depiction of the Kunsthalle's floor suggests an interest in engaging with the early abstract work of a German artist, who, in the 1960s, was well known for his pioneering melding of painting with photography.[18] And in retrospect, as suggested by Gursky, Richter's complex mechanisation of his daily practices of painting seems to have prepared the ground for an increased reflexivity in contemporary photography about nearly abstract forms of photomechanical reproduction.

The photograph also appears to respond to the long history of conceptual art. When compared with the floor and wall removals of Lawrence Weiner, for example, Gursky's image does not seem to be as rigorously conceptualist in its institutional critique as the US artist's work. However, as is the case with Weiner's interventions in the museum's

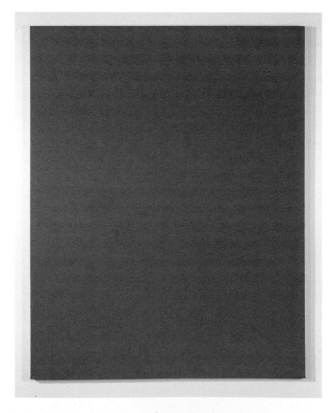

Figure 43.8 Gerhard Richter, *Grey*, 1974. Oil on canvas, 250 cm × 195 cm. Courtesy of the artist.

architecture, the Düsseldorf floor speaks to an interest in directing the viewer's atten-
tion to the museum as a space of social, structural, and spectatorial experience — an
interest that is also characteristic of some of fellow Becher-student Thomas Struth's
large-scale photographs.[19] Thus, on multiple levels, *Untitled I* dissociates itself from
its specific documentary functions and instead emphasises its formal dialogue with
the tradition of twentieth-century art through its nature as an instance of one or
more inter-subjectively agreed upon aesthetic types; in this case, either the form of the
monochrome or the strategy of institutional critique.[20]

By raising the question of general types, Gursky's museum floor impels a return
to the concept of typology that emerges in the Bechers' work. This is particularly
important since it is through the typologies that the Bechers' photographs begin to
separate themselves from their purely indexical documentary functions. Unlike *Haupt-
strasse 3, Birken* discussed previously, *Water Towers* (1967–80) is a typology and not a set
(Figure 43.9). A set, according to the Bechers, documents a particular structure from
different angles, while a typology, on the other hand, presents a group of photographs
that are different instances of the same type or ideal form.[21] Sets, in other words, refer
indexically to one actual structure, while typologies refer indexically to a number of
different individual structures. The Bechers' typologies thus use a group of specific
instances to suggest a generic type, and, as is the case with all forms of representation

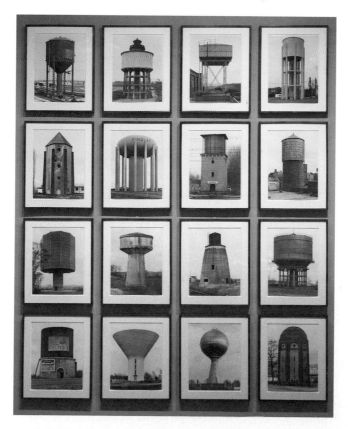

Figure 43.9 Bernd and Hilla Becher, *Water Towers*, 1967–80. Sixteen gelatin silver prints,
257.5 cm × 82 cm. Courtesy of Sonnabend and the artist's estate.

that help us to group and separate specific things or beings in the world, they are conceptual and thus open to metaphoric and symbolic appropriation.

It was the Bechers' typologies, moreover, that allowed their photographs to be understood as works of art. Although they have often denied an interest in making art photography, their work was assimilated into the gallery and museum system during the late 1960s and early 1970s. Responding to the literalness and seriality of their photographs, curators and critics in the USA (as well as a number of prominent artists such as Carl Andre) found a common ground between the Bechers' work and the minimalist and conceptualist art that had recently come to prominence.[22] Brought into the museum, the Bechers' typologies became works about ideas of industrial structures; and as Alexander Alberro put it, their serial arrays provoked a 'rigorous dismantling of the autonomous, auratic art object'.[23] As evocations of formal concepts (which in turn were based on the assumption that built forms arise naturally out of industrial functions), the Bechers' photographs became less about the actual structures that they documented and more about abstract ideas or types. Andre perhaps best described the specific concept that informed all the Bechers' work when he noted that: 'The photographs of the Bechers record the transient existence of purely functional structures and reveal the degree to which form is determined by the invariant requirements of function'.[24] Consequently, despite their avowed documentary intentions, the Bechers' photographs also became understood as conceptual art.

In light of the Bechers' partial assimilation into the sphere of contemporary art, the artistic focus of many of their students – Gursky included – is easy to understand. Gursky saw first-hand that documentary and art did not have to be separated, and as a result his photographic practice became a kind of social documentation designed to circulate within the institutions of fine art. Perhaps because of his primary location within the gallery and museum sphere, however, the visual dialogue in which he engages seems most focused on the history of painting; there is less dialogue with the history of photography. On the other hand, the concept of objectivity or *Sachlichkeit* – like that of documentary – has always contained multiple meanings.[25] Although Gursky's photographs clearly land on the side of metaphor, even the rigorous documentary practice of the Bechers always possessed symbolic aspects. As is the case with the Bechers' project, it is probably best to see Gursky's work as playing between the two poles of documentary and art. The question is not whether Gursky's works diverge from objective representation, but rather whether the metaphors he constructs still document something about the contemporary world.

To answer this question, it behooves us to explore the metaphorics of the Bechers' typologies in greater depth. As a number of critics and historians have argued, a sense of melancholy pervades the Bechers' oeuvre.[26] The photographers preserved and archived the built remnants of industries that are now in decline in the West; and the strategies that they used – analogue technologies, objective representation, typological structure, and archival method – are all products of a past that grows more remote every day. Their photographs, moreover, possess pronounced modernist characteristics: a sense that form follows function, that architects and engineers can learn from nature, and that artists must take technology as their subject so as to show their audiences how best to live in the modern world.

Finally, their work also channels the positivist philosophies of the nineteenth century upon which a number of modernist positions were built.[27] This positivism can be

discovered in the Bechers' emphasis on empirical observation, their use of comparison to reveal both identity and difference, and, above all, their 'physiognomic' approach to phenomena, which assumes that, when properly organised, individual instances will reveal the ideal forms that stand behind them as their ultimate causes. And by evoking these positivist and modernist ideas so consistently, the Bechers underscore the divide that separates the Germany in which these ideas still made sense from the Germany in which they produced their memorialising archive. For this reason, their work is in some ways — like Gursky's — 'postmodernist' in that it is about the waning of certain forms of modern technology and about the loss of objectivity. It can remind us, in other words, that seeing things clearly does not necessarily translate into a deeper understanding of the world.

In light of the metaphorical reading of the Bechers' analogue mode of photographic comportment, which sees it as a subtle critique of positivism, modernism, and technological utopianism in the post-1950s world, Gursky's by no means exclusive turn to digital photography does not indicate a rejection of photography's documentary function. Instead, Gursky's embrace of non-analogue methods suggests a desire to develop a practice of photography that is adequate to his contemporary moment. This world, as works like *Klitschko* (1999) suggest, is a context in which form has become separated from function, where the body has no centred or unified point of view, and where people, commodities, and the environment have become enmeshed in a global network of exchange in which everything can be translated into everything else (Figure 43.10).

Klitschko includes many of Gursky's favourite motifs: crowds, geometricised spaces of contemporary mass entertainment, and representations of representation (in this

Figure 43.10 Andreas Gursky, *Klitschko*, 1999 [original in colour]. Chromogenic colour print, 206.53 cm × 261.62 cm. © Andreas Gursky. Courtesy: Sprüth Magers Berlin London/DACS 2018.

case, the television lighting and cameras as well as the repetition of human figures – clusters of men in the ring and in the broadcast centre on the right – in the two central screens overhead). Already in the 1990s Gursky had a prescient sense of the shape of the world to come, and he expressed this intuition by constructing compelling metaphors for his rapidly developing moment, images that ten and twenty years later continue to inspire conviction. Although Gursky's work often relies on digital technologies, he has made some of the most iconic social documents of his time.

In terms of form, Gursky has been equally innovative. As Michael Fried argues, Gursky is one of the key photographers exemplifying the re-emergence of an 'absorptive' or anti-theatrical tradition in contemporary art. Fried isolates a number of formal and representational strategies that operate in Gursky's photographs to distance or 'sever' the viewer from the picture's natural, architectural, or human subjects, including a regular combining of microscopic and macroscopic perspectives as a well as a non-fixed, 'hovering', quasi-aerial point of view.[28] The digital manipulation that underlies these and other aspects of Gursky's photographic practice thus has, according to Fried, an important (and positive) effect. Although it undermines the photograph's indexicality, digital manipulation makes what appears within the frame seem more controlled or intentional, more determined by the photographer.[29] And for this reason, Gursky's digital manipulations help to redeem photography for Fried, to make it matter as art as never before.

The analogue age is over – in photography as well as everywhere else. Although analogue processes may survive as specialised technologies embraced by a select few, most new images made in the world will be captured, transmitted, and consumed digitally. Moreover, even if a greater percentage of 'great' photographers continue to work with analogue technologies in comparison with working photographers in general (something that may remain true in art, but probably not in documentary photography), more and more of the world's most important photographers will nonetheless slowly become digital ones. Today, the sheer ratio of digital to analogue equipment points to the ultimate triumph of digital photography. For this reason, it is safe to say that we have witnessed a seismic shift over the past twenty years, a radical transformation of photography, a primary medium through which we continue to understand both our environments and ourselves.

At the same time, it is important not to overemphasise the division between analogue and digital photography. As suggested by the long history of photomontage in the nineteenth and twentieth centuries, analogue photographs have always had the power to manipulate and transform reality.[30] Indeed, because the camera always selects – or edits – and otherwise changes the world that exists before its lens, no photograph – analogue or digital – can be said to represent the complete 'truth' of its subjects or objects.[31] Digital images, moreover, still have importance as documents. For example, as suggested by the amateur snapshots of torture at Abu Ghraib in 2003, digital photographs continue to possess a great deal of evidentiary (as well as propagandistic) power.

As this comparison of Gursky with the Bechers demonstrates, the photograph is always profoundly heterogeneous. It is, simultaneously, both document and art, the product of multiple authors, and the locus of numerous, sometimes contradictory signifying relations. A sometimes seemingly transparent avenue of communication that is anything but clear and non-distorting, the photograph possesses a complex history

that – in both its analogue and its digital phases – reveals contours of human knowledge that remain imperceptible in everyday life.

Original publication

'From Analogue to Digital Photography: Bernd and Hilla Becher and Andreas Gursky' in *History of Photography*, vol 36:3 (2012).

Notes

1 See Fred Ritchin, *In Our Own Image: The Coming Revolution in Photography*, 2nd rev. ed., New York: Aperture Foundation 1999; and Fred Ritchin, *After Photography*, New York: W. W. Norton 2009.

2 On the Bechers, see Bernd and Hilla Becher, *Water Towers*, Cambridge, MA: The MIT Press 1988; Bernd and Hilla Becher, *Blast Furnaces*, Cambridge, MA: The MIT Press 1990; Bernd and Hilla Becher, *Pennsylvania Coal Mine Tipples*, New York: DIA Art Foundation 1991; Bernd and Hilla Becher, *Gas Tanks*, Cambridge, MA: The MIT Press 1993; Bernd and Hilla Becher, *Industrial Facades*, Cambridge, MA: The MIT Press 1995; Bernd and Hilla Becher, *Mine Heads*, Cambridge, MA: The MIT Press 1997; Bernd and Hilla Becher, *Basic Forms*, with an essay by Thierry de Duve, Munich: Schirmer/Mosel 1999; Bernd and Hilla Becher, *Zeche Hannibal*, Munich: Schirmer/Mosel 2000; Bernd and Hilla Becher, *Industrielandschaften*, Munich: Schirmer/Mosel 2002; Robert Smithson, Bernd Becher, Hilla Becher, and James Lingwood, *Field Trips*, Turin: Hopefulmonster 2002; Bernd and Hilla Becher, interview by Ulf Erdmann Ziegler, 'The Bechers' Industrial Lexicon', *Art in America*, 90:6 (June 2002), 92–101, 140–1 and 143; Bernd and Hilla Becher, interview with Cornelius Tittel, 'High Precision Industrial Age Souvenirs', *Sight and Sound* (9 February 2005), www.signandsight.com/features/338.html (accessed 14 November 2011); Bernd and Hilla Becher, *Cooling Towers*, Cambridge, MA: The MIT Press 2006; Susanne Lange, *Bernd and Hilla Becher: Life and Work*, trans. Jeremy Gaines, Cambridge, MA: The MIT Press 2007; and Hilla Becher, interview by Tobias Haberl and Dominik Wichmann, 'Klar waren wir Freaks', *Süddeutsche Zeitung Magazin*, 20 (2008), http://sz-magazin.sueddeutsche.de/texte/anzeigen/24539/ (accessed 2 September 2011). On Gursky's relationship to the Bechers, who were his teachers in the early 1980s, see Peter Galassi, *Andreas Gursky*, New York: The Museum of Modern Art 2001, 15–19; see also Stefan Gronert, *The Dusseldorf School of Photography*, New York: Aperture 2010, 21 and 53–8.

3 Bernd and Hilla Becher, *Framework Houses of the Siegen Industrial Region*, Cambridge, MA: MIT Press 2001, plates 209, 105 and 255. The first edition was published by Schirmer/Mosel in 1977.

4 The Bechers always worked with large-format cameras. Between 1959 and 1962, they used a Linhof 6 cm × 9 cm camera; since 1963, they used a Plaubel Peco 13 cm × 18 cm camera. On the Bechers' cameras, lenses, and papers, see Lange, *Bernd and Hilla Becher*, 30–4 and 89.

5 'An index', Peirce wrote, 'is a sign which refers to the object that it denotes by virtue of being really affected by that object'. Charles S. Peirce, 'Logic as Semiotic: The Theory of Signs', in *Philosophical Writings of Peirce*, ed. Justus Buchler, New York: Dover 1955, 102. In reference to photography, Roland Barthes called this indexical character of certain representations, their 'that-has-been', which, for him, was ultimately a physical relationship

between signifier and signified, a connection mediated by an awareness of death. 'The photograph', he wrote, 'is literally an emanation of the referent'. Roland Barthes, *Camera Lucida: Reflections on Photography*, trans. Richard Howard, New York: Hill and Wang 1981, 80.

6 A photographic archive is a collection of historical records that include photographs as one of their primary elements; typically, photographic archives also include texts, as well as (sometimes) plans, fingerprint records, and other types of evidentiary or explanatory representation. On the concept of the photographic archive and its close relationship to the concept of typology, see David Green, 'Veins of Resemblance: Photography and Eugenics', *Oxford Art Journal*, 7:2 (1984), 3–16; Allan Sekula, 'The Body and the Archive', in *The Contest of Meaning: Critical Histories of Photography*, ed. Richard Bolton, Cambridge, MA: The MIT Press 1989, 343–88; Karin Becker, 'Picturing Our Past: An Archive Constructs a National Culture', *The Journal of American Folklore*, 105:415 (Winter 1992), 3–18; Carol Armstrong, 'Biology, Destiny, Photography: Difference According to Diane Arbus', *October*, 66 (Autumn 1993), 28–54; Lauri Firstenberg, 'Representing the Body Archivally in South African Photography', *Art Journal*, 61:1 (Spring 2002), 58–67; and Lauri Firstenberg, 'Autonomy and Archive in America: Reexamining the Intersection of Photography and Stereotype', in *Only Skin Deep: Changing Visions of the American Self*, ed. Coco Fusco and Brian Wallis, New York: Abrams 2003, 312–33.

7 On the different types of structures that the Bechers organised into 'work groups' and 'object families', see Lange, *Bernd and Hilla Becher*, 51 and 55–63. The Bechers' famous exhibition at the Städtische Kunsthalle in Düsseldorf in 1969 was entitled 'Anonymous Sculptures' (*Anonyme Skulpturen*); and the term marked their close connection with minimal and conceptual art at the time; see Lange, *Bernd and Hilla Becher,* 65. As Michael Fried notes, however, the Bechers quickly moved away from the appellation, preferring the word 'object' to terms with more artistic connotations such as 'sculpture' or 'motif'. Michael Fried, *Why Photography Matters as Art as Never Before*, New Haven: Yale University Press 2008, 321–4.

8 On the moment of industrial architecture documented by the Bechers' archive, see Lange, *Bernd and Hilla Becher*, 25–9.

9 On Sander, see Susanne Lange and Gabriele Conrath-Scholl, *August Sander: People of the 20th Century*, New York: Harry N. Abrams 2002, 1–7; George Baker, 'Photography Between Narrativity and Stasis: August Sander, Degeneration, and the Decay of the Portrait', *October*, 76 (Spring 1996), 72–113; and Ulrich Keller, *August Sander: Citizens of the Twentieth Century, Portrait Photographs, 1892–1952*, ed. Gunther Sander, trans. Linda Keller, Cambridge, MA: The MIT Press 1986.

10 For Peirce, symbols are always arbitrary and conventional as well as dependent on the beholder. There is no more fundamental connection – as is the case with icons or indexes – between the signifier and the signified. The primary examples of symbolic relationships are the arbitrary connections between linguistic signs – either words or phrases – and their denotative and connotative meanings: connections that are far more conventional and abstract than those of realistic painterly or sculptural representations, let alone photographs. Peirce called the symbol a 'conventional sign, or one depending on habit'. 'The symbol', he noted, 'is connected with its object by virtue of the idea of the symbol-using mind, without which no such connection would exist'. See Peirce, 'Logic as Semiotic', 113–14.

11 Steinert accepted all genres of photography into subjective photography, so long as they were individualistic. Furthermore, he did not reject new objectivity photography altogether; indeed, he saw subjective photography as continuing and developing the *avant-garde* photographers' emphasis on experimentation. He did, however, see subjective photography as 'humanized, individualized photography', a mode of photographic practice that employed the camera 'in order to win from the single object images [*Bildsichten*] corresponding to its essence [*Wesen*]'. Otto Steinert, *Subjektive Fotografie,* Bonn/Rein: Brüder Auer Verlag 1952, 6.

12 On Gursky, see Andreas Gursky, *Images*, London: Tate Gallery Liverpool 1995; Andreas
 Gursky, *Fotografien, 1994–1998*, Kunstmuseum Wolfsburg and Cantz 1998; Peter Galassi,
 Andreas Gursky, New York: The Museum of Modern Art 2001; Calvin Tomkins, 'The Big
 Picture', *The New Yorker* (22 January 2001), 62–71; Edward Leffingwell, 'Andreas Gursky:
 Making Things Clear', *Art in America*, 89:6 (June 2001), 76–85; Alix Ohlin, 'Andreas Gur-
 sky and the Contemporary Sublime', *Art Journal*, 61:4 (Winter 2002), 23–35; Jill Conner,
 'Andreas Gursky at Matthew Marks', *Flash Art*, 37 (July/September 2004), 64; Charlotte
 Edwards, 'Still a Classifying Act', *Art Review* (Spring 2004), 24; Paul Mattick, 'Andreas Gur-
 sky at Matthew Marks', *Art in America*, 93:1 (January 2005), 121; Thomas Weski (ed.),
 Andreas Gursky, Cologne: Snoeck 2007; Jeremy Millar, 'In Praise of Blandness: Finding Per-
 fection in the Neutrality of Andreas Gursky's Photographs', *Modern Painters* (April 2007),
 66–73; Paul McCann, 'Jong Love', *Wallpaper* (March 2007), 98–107; Ralf Beil and Sonja
 Fessel (eds.), *Andreas Gursky: Architecture*, Darmstadt: Hatje Cantz 2008; Kunstmuseum
 Basel (ed.), *Andreas Gursky*, Ostfildern: Hatje Cantz, 2008; and Martin Hentschel (ed.),
 Andreas Gursky:Works 80–08, Ostfildern: Kunstmuseen Krefeld and Hatje Cantz 2008.

13 Katy Siegel, 'Consuming Vision', *Artforum*, 39:5 (January 2001), 110. Although concur-
 ring with critics who find conscious references to the tradition of abstract painting in
 Gursky's work, Fried criticises what he sees as the consistent elision of references to
 the body of abstract painting that he sees as formally closest to Gursky's photographs;
 namely, 'the high modernist colour field painting of Morris Louis, Kenneth Noland, and
 Jules Olitski'. See Fried, *Why Photography Matters*, 180. Thus, for example, Fried sees
 Gursky's *Rhine* series as closer to Noland's horizontal stripe paintings of the late 1960s
 and early 1970s. Martin Hentschel also connects Gursky's *Rhine* series to the work of
 Noland and Ellsworth Kelly; see Martin Hentschel, 'The Totality of the World, Viewed in
 its Component Forms: Andreas Gursky's Photographs, 1980–2008', in Hentschel (ed.),
 Andreas Gursky:Works 80–08, 30–1.

14 For Peirce, an iconic relationship between signifier and signified is a mimetic one, like
 the connection between a visual likeness produced in a non-linguistic medium – for
 example, painting or sculpture – and the real-world object that this copy signifies. Peirce
 emphasised that such a signifying relation makes no assertion about the actual existence
 of that which it represents: 'The icon has no dynamical connection with the object it
 represents; it simply happens that its qualities resemble those of the object, and excite
 analogous sensations in the mind for which it is a likeness'. See Peirce, 'Logic as Semiotic',
 114. As it has later been used in relationship to photography and film, to say that an
 image has 'iconic qualities' also means to suggest that it embodies its motif or type in a
 particularly rich or significant way.

15 Charlotte Cotton uses 'deadpan' as a stylistic term to mean cool, detached, sharp, objec-
 tive, and non-emotional; and she employs it to characterise the work of the Bechers and
 the Dusseldorf School among other photographers. See Charlotte Cotton, *The Photograph
 as Contemporary Art*, London: Thames and Hudson 2004, 81–112. Although the photo-
 graphs of Gursky and the others contain none of the farce intended by deadpan's origi-
 nal meaning as dry humour or disguised comic delivery, the adjective does point to the
 matter-of-fact, detached, or expressionless character of their photographs, the fact that
 they all initially seem not to take a stance on – or advocate a position about – reality. That
 all these supposedly neutral photographers are, of course, making an interpretation of the
 world does not invalidate the adjective, which points to a kind of surface objectivity.

16 Other works in Gursky's highly abstract *Untitled* series include a sunset, sandy soil, a
 cloud, a shoe-rack, a painting by Jackson Pollock, and a dust-covered surface. Marie
 Luise Syring, 'Where Is "Untitled"? On Locations and the Lack of Them in Gursky's
 Photography', in Marie Luise Syring (ed.), *Andreas Gursky: Photographs From 1984 to the
 Present*, Munich: Schirmer/Mosel 1998, 5.

17 On the concept of institutional critique, see Benjamin H. D. Buchloh, 'Conceptual Art 1962–1969, From the Aesthetic of Administration to the Critique of Institutions', *October*, 55 (1990), 105–43.

18 Richter began making fully abstract works around 1968–69; see Benjamin H. D. Buchloh, Peter Gidal, and Birgit Pelzer, *Gerhard Richter, Volume 3: Werkübersicht / Catalogue Raisonne 1962–1993*, Ostfildern: Edition Cantz 1993. Syring connects Gursky's *Untitled I* with Richter's grey paintings; see Syring, 'Where Is "Untitled"?', 5.

19 See Thomas Struth, *Museum Photographs*, Munich: Schirmer/Mosel 2005.

20 When looked at from the point of view of the history of photography, works like Gursky's *Untitled 1 (Carpet)* also seem to engage with the tradition of seascapes begun by Gustave Le Gray in the 1850s and practiced powerfully since the 1980s and 1990s by photographers such as Hiroshi Sugimoto and Thomas Joshua Cooper.

21 On sets and typologies in the Bechers' work, see Lange, *Bernd and Hilla Becher*, 35, 44–5 and 51–4.

22 See Armin Zweite, 'Bernd and Hilla Becher's "Suggestion for a Way of Seeing", in Bernd and Hilla Becher (eds.), *Typologies*, Cambridge, MA: The MIT Press 2004, 21–3. In his 1972 essay on the Bechers, Carl Andre clearly emphasises the Bechers' conceptualism (their focus on 'variations within limits determined by function'), and he describes the evolution of their practice in terms of a movement away from painting; see Carl Andre, 'A Note on Bernhard and Hilla Becher', *Artforum* 11:4 (December 1972), 59. See also Lange, *Bernd and Hilla Becher*, 65–6.

23 Alex Alberro, 'Blind Ambition', *Artforum*, 39:5 (January 2001), 109.

24 Andre, 'A Note on Bernhard and Hilla Becher', 59.

25 Fritz Schmalenbach, 'The Term *Neue Sachlichkeit*', *Art Bulletin*, 22:3 (September 1940), 161–5; and Joel Eisinger, *Trace and Transformation: American Criticism of Photography in the Modernist Period*, Albuquerque: University of New Mexico Press 1999.

26 See, for example, Blake Stimson, *The Pivot of the World: Photography and Its Nation*, Cambridge, MA: The MIT Press 2006, 137–75.

27 On the relationship between photography and positivism, see Carol Armstrong, *Scenes in a Library: Reading the Photograph in the Book, 1843–1875*, Cambridge, MA: The MIT Press 1998.

28 As we view Gursky's photographs, Fried argues, we feel separated from his worlds – they seem like mental pictures or concepts. There appears to be no point of view; and the scope and detail of the images seem outside of normal human perceptual experience. When human subjects are visible, moreover, they appear absorbed; they do not acknowledge the viewer, and hence prevent us from identifying with them. Furthermore, because they are shot from afar, they most often seem emotionally flat, betraying little inwardness or psychic depth. A desire to distance the beholder is also behind Gursky's photography of barriers that come between the viewer and the scene. Michael Fried, *Why Photography Matters*, 156–82.

29 On how the medium of photography raises the question of the intentionality of the image in a particularly important way, see Walter Benn Michaels, 'Photographs and Fossils', in James Elkins, *Photography Theory*, London: Routledge 2006, 431–50.

30 On photomontage, see Dawn Ades, *Photomontage*, New York: Pantheon Books 1976. On the non-digital falsification of photographic images, see David King, *The Commissar Vanishes: The Falsification of Photographs and Art in Stalin's Russia*, New York: Metropolitan Books 1997.

31 The exhibition *The Camera Always Lies, the 2008 Regional Triennial of the Photographic Arts*, at the Center for Photography at Woodstock, made a similar point a few years ago, demonstrating a widespread awareness on the part of curators and photographers that the camera already changed reality and shaped experience long before the digital age.

Steven Skopik

DIGITAL PHOTOGRAPHY
Truth, meaning, aesthetics

O NE OF THE PERENNIAL THEMES in the history of photography is the
introduction, application and reception of new technology. Be it the dry-plate or
the Polaroid, upon introduction, the practical and aesthetic potential of every innova-
tion has been vigorously debated by photographers, journalists and critics. It is not
surprising, then, that the emergence of digital photography has generated fraught
proclamations, each announcing the dire effect of electronic imaging upon the prac-
tice and understanding of still photography, as we have known it. The current dialogue
is often framed in terms that historians of photography have long applied in other
contexts: truth and primacy. The first discussion explores the impact of the digitally
mediated image on our perception of the 'truth value' of photography. The second dis-
cussion, regarding 'primacy', compares the influence of photography on existing modes
of visual representation (printmaking, painting) in the mid-nineteenth century, with
the forecasted effect of digital media on photography in the early twenty-first century.
The contention, in this case, is that as photography toppled the representational pre-
eminence of painting, so too digital picture-making will undermine and, eventually,
supplant the chemically produced image. A critical examination of the ideas surround-
ing these discussions leads to a wider and richer understanding of digital imaging, its
artistic possibilities and its place in the ongoing history of photography.

Truth and the photograph

Much of the writing on digital imaging concerns itself with the erosion of the reporto-
rial value of the photograph in the face of the capacity of the computer for seamless or
invisible alteration. Max Kozloff, an articulate partisan for the chemical photograph,
concedes that the digital image is a 'big deal . . . If . . . certainly not a clean break with
our past visual culture, computer generated imaging bids to undermine it'. The intel-
lectual basis of Kozloff's opinion is a familiar one. The conventionally made photograph

enjoys, what film theorist André Bazin termed in the 1940s, an 'indexical' tie to its subject. That is to say, in order for a photographic image to exist, some pre-photographic scene, object or event must first have impressed its features on the film's emulsion. This must happen regardless of the mediating activities of the photographer, who determines point of view, framing, focus and a host of other important, but ultimately tertiary, qualities. This is not to claim that traditionally made photographs are completely free of the imprint and subjective decisions of the image maker, but the chief effect of the photograph, that quality that distinguishes it from all other modes of representation, is this decal-like relationship back to the subject.

Digital imaging, which allows image alteration without detection, stimulates some to question the photograph's tether to actuality. Writers in the popular press, but also many informed authors of theoretical studies, highlight the capacity of the digitally revised image to subvert our 'faith in the photographic image', to use Bazin's phrase. Review a dozen or so essays on the subject, and one is variously informed that the digital image 'challenges, nullifies, damages, undermines, subverts, and perturbs' the veracity of the chemical photograph.

The pitched rhetoric that often characterizes such discussions would certainly be justified, were it not for the fact that a reassessment of the photograph's authority as objective witness has dominated critical and creative work of the past twenty or so years. Historically speaking, the proposition that the digital manipulation of the photograph undermines its tie to objectivity is really little more than an intriguing coda to what has, after all, been an ongoing withering assault on the notion of photographic certainty. Even if we accept the concept of the indexical nature of the photographic representation, recent commentary on photography concerns itself more with issues of representation, than with ontological essence. As Roland Barthes pointed out as long ago as the 1960s, no photograph operates purely in terms of its denoted, literal content. Always and simultaneously, an entire constellation of connotative meanings attend the image, and at this second level of signification, all interpretation is culturally (and therefore, situationally) coded. The 'truth' offered by images is, in fact, highly contingent. Any emphatically fixed notion of photographic veracity must be regarded as highly suspect.

A look at some recent photographs, digital and conventional, makes the point. Nancy Burson's well-known digital composite portraits of the 1980s have no referent and no index back to a real object or being. In contemporary theoretical terms, this feature of her work passes without argument (Figure 44.1). Here, as in any conventional photograph, if we accept the proposition of the photograph's complex commerce with truth, the idea that we have been distanced from a reassuringly stable actuality, fails to astound. Burson's images force us to question our intuitive, and often erroneous, presupposition of photographic reliability, but so too, does the work of others using conventional photographic technique. For example, John Pfahl's work of the 1970s and 80s, his deadpan, often witty interrupted landscapes, subvert notions of absolute photographic space. Robert Cumming's false documentary scenes call into question the often uncontested use of the photograph as an evidentiary tool. Sherrie Levine's notorious photographs of photographs, often remarked upon for their interrogation of notions of authorship, also produce a dizzying 'mirror in the mirror effect', telescoping the distance between photographic referent and image to the point, perhaps, of breaking Bazin's confidently declared tether to the pre-photographic subject.

Figure 44.1 Nancy Burson, *Beauty Composite (Jane Fonda, Jacqueline Bisset, Diane Keaton, Brooke Shields, and Meryl Streep)*, digitally produced from a gelatin silver negative shot from the computer screen, 1981. © Nancy Burson.

There are many other examples of contemporary artists using conventional techniques exploring the medium's relationship to fact, including the efforts of Sarah Charlseworth, Christopher Williams, and Vic Muniz. While the example of the digitally altered photograph does much to complete the argument for photography's suspect status as an arbiter of truth, such qualities are hardly unique to photography's digital incarnation and contribute little to establishing the wider importance of electronic imaging.

A taxonomy of the digital image

If the supposed epochal effect of digital imaging on photography cannot be found in the realm of the 'truth value' of the image, what then are the factors inherent in the new technology poised to transform photography's material and conceptual framework? For the convinced – critics and practitioners alike – who embrace this notion, it becomes necessary to identify the essential, distinguishing characteristics of the digitally altered photograph. Such arguments issue from a critical point of view that most values artworks' medium-specific attributes. The foundation for these commentators is

the art historical notion that all new media begin by imitating some earlier established form, and then proceed to differentiate themselves by exploring and charting their own unique ontological and epistemological terrain. A.D. Coleman's remarks epitomize this thinking when he writes that 'some new and very medium-specific forms are going to emerge. . . . I think you'll see self-referential stuff . . . that will be very computer specific. . . . It is just a matter of time'.

Proponents of the idea that the computer mediated image represents a fundamental revision of our understanding of the photograph, suggest several characteristics that distinguish electronic picture-making from its analogue predecessor. The digital photograph, we are told, is unique by virtue of its easy malleability. The electronic picture, at least in principal, is always unfinished. An image file, thought of one way, exists in a nearly Heisenburgian state of pure possibility. When we situate the digital image in the process of construction, display and observation, its effervescent electronic status is temporarily arrested. However, the source file remains intangible, always open to further duplication and alteration. Taking this idea to the logical extreme, one could argue that the digitization of photography leads to the dematerialization of the photographic object. Can one speak of a finished product, when the essence of the image-as-computer-file is its transient screen presence or an ever-mutating series of versions?

Upon accepting the characteristic of alterability, two sub-types of digital pictures immediately assert themselves – the 'seamlessly manipulated photo-like' image, and what can be termed, the 'collage aesthetic' photograph. The ability to revise an image using digital technology is unprecedented. William Mitchell notes the digital photograph has 'none of the fragility and recalcitrance of the photograph's emulsion-coated surface. . . . The essential characteristic of digital information is that it can be manipulated easily and very rapidly by computer'. According to Mitchell, the chief activities of the digital artist revolve around gestures of 'appropriation, transformation, reprocessing, and recombination; we have entered', he claims, 'the age of electrobricollage'.

Two examples illustrate the extreme points on a continuum of digital photo-collage, ranging from a cut-and-paste painting technique to a wholesale immersion in the sensibility of assemblage. The work of Martina Lopez creates a relatively realistic impression of pictorial space, although the illusion is purposefully imperfect (Figure 44.2). While scale and placement is fairly rational, the viewer easily recognizes an artistic invention. The pictures are peopled by paper doll-like cut-out figures; sharp edges, lighting and shadow mismatches, colour cast discontinuities and a host of other obvious, and not-so-obvious, features cue the viewer to the fiction. Such images are coherent, to a point, but as with paintings, we are never unaware of their conventionalized status.

In contrast, the electronically collaged image by Paul Berger refuses any sense of the Euclidian spatial rationality we associate with conventional photographic representations (Figure 44.3). While deliberately structured, this picture is dominated by fragmentation and discontinuity. The nature of this image is certainly far from any notion of the photographic frame as a transparent 'window on the world'. The constituent elements of this image began as photographs, and within any passage or sub-unit, it has the rigid spatial and descriptive continuity of the traditional image. Globally, however, the space is emphatically interrupted, abstracted and expressionistic.

The work of Lopez and Berger is carefully wrought, skilfully crafted and sustains a notable level of serious attention and consideration. The vast majority of similar images

Figure 44.2 Martina Lopez, *Bearing in Mind 1*, 1998. Cibachrome print, 1998. [Original in colour] © Martina Lopez.

produced by contemporary digital artists, though, fails to compel; there is a vague 'already-been-done' sensibility about most digital assemblage. To address the ennui such pictures provoke, we need to acknowledge that collage as a structural synthetic technique is, after about ninety years of exploration, a thoroughly familiar visual strategy in other two-dimensional media. The digital photo-collage pieces presently produced give the mannered impression one might imagine on hypothetically encountering a contemporary poem presented as a sonnet. It is not that doing either would not take an admirable level of technical and imaginative skill; it is just that both the collage and the sonnet are thoroughly rooted in the concerns of historically remote aesthetic movements. Today, it would be almost impossible not to experience these forms in a manner that is either inflected by nostalgia, or perhaps in some postmodern context, ironic distance. The use of collage by a great many present day digital artists operates not in the context of some subtly signalled postmodern quotation or appropriation; the technique is employed with a slightly disconcerting, naïve sincerity.

For those advocating a medium-specific path for digital photographic exploration, we reach an interesting – perhaps intractable – problem. One of the defining characteristics of digital photography is its capacity for easy combination and reassembly of images. The problem is, discounting a few historical appearances, while assemblage may be new to photography, it is distinctly 'old news' elsewhere. If one's task as a digital

Figure 44.3 Paul Berger, *Warp & Weft: Duck*. Iris inkjet print; 2000 [original in colour]. 35" × 47".
Courtesy of Paul Berger.

artist is, as suggested by Coleman and others, to investigate, employ and foreground
those characteristics most properly digital, many electronically collaged images are
bound to disappoint. This is because something critical is lacking. An aesthetics based
on medium specificity stresses those essential characteristics *unique* to a given art
form. Mutability may be a central quality of the digital photograph, but it is by no
means a specific characteristic. Paintings, drawings and prints all share this capacity of
synthetic open-endedness.

Seamless digital photography

If the 'collage' represents one boundary of digital photography's trajectory, then what
one might term the 'seamless' image figures as its opposite. The seamlessly manipulated
digital photograph, unlike its collage counterpart, attempts to efface all obvious evi-
dence of revision and alteration. The seamless virtual photograph may be extensively
worked, reconfigured and modified, but, crucially, the image bears no visible trace of
revision. No contextual cues forthcoming, the virtual photograph could be mistaken for
a conventionally executed image. Of the seamless variety of digital pictures, two subcat-
egories may be designated: the 'virtual photograph' and the 'plausibly fantastical' image.

The well-known work of Pedro Meyer falls into the virtual photograph category. The image, 'Biblical Times', appears on Meyer's *Truth and Fictions* CD-ROM (Figure 44.4). The picture depicts a scene of a New York City sidewalk. The content here is fairly prosaic – pedestrians, aloof and grim faced, are arrested in mid-stride by the compressed temporality common to all conventionally made photographs. Much of the composition is dominated by the figure of a gaunt, bible wielding street preacher who occupies the picture's left foreground. The image is lent an extra note of drama by the steam that erupts through sidewalk vents viewable in the central area of the frame. Given the combination of these elements, a 'fire-and-brimstone' connotation serves as the motivation for the street cleric's electronic inclusion within the piece.

Critic Jonathan Green states that digital pictures of this variety 'remain essentially photographic. They draw their strength from a direct relationship to "photographic reality", that surface world of reflected light that the camera has so precisely described throughout its history'. Viewed as a traditionally wrought image, we are predisposed to understand Meyer's picture as accidentally ironic in the manner that fortuitously captured photographs often achieve. The image maker captures for us a situation provided both by his or her organization of the frame and the external world that imposes its own stamp on the picture – the vagaries of circumstance and chance encounter. In the traditional documentary shot, meaning acquires an extra weight, because we understand that it is both planned and the result of chance, structured and to some degree accidental.

Knowing the preacher has been layered into Meyer's picture, we are primed to seek directly after the artist's intent. The effect is to move us from an impression of lucky irony, tinged by melancholy, to the different valence of arch commentary. The

Figure 44.4 Pedro Meyer, *Biblical Times*, digital image on CD-ROM, 1995. Courtesy of Pedro Meyer ©.

nuance of the virtual photograph is that a full understanding of its meaning and effect depends on our awareness of its digitally contrived origin, despite the invisible modifying techniques employed in its synthesis. Since, by definition, we can't know this through the picture, we rely on explanatory text or a 'before and after' comparison to foreground the level of computer intervention used to create the image. Such, for instance, is the case with Matthias Wähner's 'Man without Qualities' series. Here, it is only through our prior acquaintance with the canonical originals that we recognize the artist's *Zelig*-like appearance throughout. The series' rhetorical point — the assertion that photographs and historical narratives are constructs of equivalent contingency — flounders without a clear awareness of Wähner's fairly skilled gesture of forgery.

All conventional photographs are charged with a bereft, empty sadness, as the subject and moment represented is forever beyond spatial and temporal recovery. Some modicum of solace might be offered, in principal at least, by the possibility that we could revisit the subject, assuming that it, he, or she is living or extant. The digital 'virtual image' offer us no such hope. Aware of its synthesized status, we long after a perfectly described, yet unattainably tantalizing hallucination, made seemingly real. Our critical spirit may refuse the credibility lent the image by its compelling resemblance to an indexical image, but intuitively, we are nonetheless swayed.

Another form of digital artwork also takes advantage of the capacity of the computer to seamlessly alter the photograph — the 'plausibly fantastical' image. *Disintegration #8,* by Eva Sutton illustrates this category (Figure 44.5). The image requires

Figure 44.5 Eva Sutton, *Disintegration #8*, 1991, digital electrostatic print. Courtesy Eva Sutton ©.

careful viewing. At first glance, the subject of the photograph appears to be medical research apparatus. A human hand hangs suspended from an unidentified electrical armature; the antiquated industrial design of the stand and support structure, and the sepia colour tone, suggest that this is an old photograph. The whole assembly is bluntly described, much in the manner of a simple documentary record. Are we examining the result of an anonymous nineteenth century dissection, its original investigatory purpose now unknowable and ominous?

On closer examination, we realize this is an impossible picture. The hand is not skewered onto the central poles descending from the top of the frame. Instead it blends imperceptibly into them, creating confusion between negative and positive space. The effect is similar to that of an Escher print, and immediately, perceptually, we understand an abstract idea. Projecting three-dimensional objects onto two-dimensional surfaces, forces an abstraction that normally goes unnoticed. Sutton's image exposes the spatial trickery of the two-dimensional representation. Such gestures, to the extent that they force one to question the image on such a rudimentary perceptual level, also prompt a sceptical attitude towards the content and meaning of illusionistic pictures.

Beyond the perceptual play, Sutton is using a time honoured surrealist tactic – the chance, irrational collision of familiar objects, producing a reaction of simultaneous fascination and revulsion. We move beyond the literal topographical veracity of the photograph, contacting instead normally forbidden areas of the mind. The quality which gives such images the capacity to astonish and shock is the ability to join normally unremarkable, unrelated objects with a unexpected, seamless inevitability. The psychic equivalent would be the dream (or subconscious mind) that creates its own irrational synthesis of reality fragments. The effect is that the fundamentally illogical begins to make a revealing, and often upsetting, sense. Coupled to the digital photograph's false 'reality effect' these perverse impossibilities are rendered disturbingly lucid – achieving the status of a waking nightmare.

It is instructive to compare Sutton's work with examples of well-known Dada pieces, such as Max Ernst's collage 'Murdering Aeroplane' of 1920 (Figure 44.6). The 'plausibly fantastical' photograph shares many of the same goals and methods of Dada

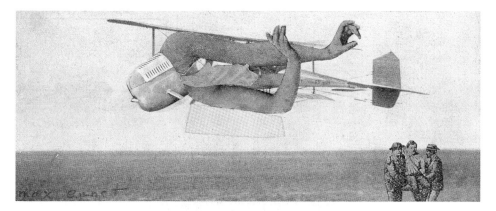

Figure 44.6 Max Ernst, *Murdering Aeroplane*, collage, 1920. [Original in colour]. Menil Collection, Houston, TX, USA/Bridgeman Images. © ADAGP, Paris and DACS, London 2018.

and Surrealism. The fantastical, photo-realistic image is the ideal Surrealist's tool, invented about seventy years too late, but what Ernst would have used had it been available. This is the inescapable problem. 'The problem with much . . . computer imagery is that it attempts to duplicate the visual tropes of painting and photography. There are swooping landscapes formed from fractal equations, and there are surrealistic conjunctions of incongruous elements. But none of this is truly revolutionary'.

The primacy of the photographic image

The seamless digital picture – in both its 'virtual' and 'plausibly fantastical' incarnations – deliberately, even strategically, exploits a resemblance to the traditional photograph. This is not just a matter of a new medium borrowing creative distinction and art world legitimacy from an immediately preceding form. These types of digital images depend on a level of photographically inspired believability to create the effects described, and in so doing, continue the formal imperatives, interpretive codes and historical traditions of the conventional image. The digital picture productively *mimics* the indexical photograph, in an unanticipated manner, ensuring the latter's continued primacy as a vital aesthetic form.

Some critics mistakenly predict a renewed interest in pictorial synthesis, given the electronic photograph's capacity for easy revision. A number of historical precedents of this form are offered. Henry Peach Robinson's synthesized images of the 1860s anticipate what here has been termed the 'virtual' photograph. Moholy-Nagy's use of assemblage and mixed media suggests the digitally collaged image. Jerry Uelsmann's experimentations with solarization, masking and composite printing presage the 'plausibly fantastical' image. Certainly the comparisons are suggestive, but the real relationship between these past and present aesthetic strategies is not one of analogy, but of identity.

In his 1989 essay, 'Photography in the Age of Electronic Simulation', Andy Grundberg laments the overall 'banality' of most computer-altered photography. Now, over a decade later, little has been produced that would contradict his initial gloomy assessment. Perhaps one reason that digital artists have thus far produced so little of enduring interest is that much of their work engages in a recapitulation of ideas from the history of art, concerns that have been disinterred, electronically reanimated, and given a peculiar posthumous existence. We might profitably compare these digital practices to the efforts of contemporary photographic antiquarians whose images also reference archaic visual styles. While it may be true that artists such as Adam Fuss, James Fee, and Jayne Hinds Bidaut employ photograms, elaborate toning techniques, and non-silver processes, the conceptual underpinnings of their work are of a decidedly contemporary character. Fuss's use of abstract photograms, for example, functions rather similarly to Sheri Levine's neo-abstract paintings of the 1980s. Levine's and Fuss's images do not further the traditions in which, at first glance, they appear to participate. Instead, they draw attention to a moribund academism. By exploiting the visual forms that once connoted its relevance and vitality, there is no better means to proclaim the end of a movement than to quote it ironically. 'Thus re-deployed, the now emptied style stands as a kind of cultural grave-marker, a subversion of the very intellectual and creative projects that originally produced it'. Most current digital work, however, lacks such metalogical perspective, inclining instead towards mere nostalgia.

Medium-specific arguments cite the tenuous relationship of the digital image to the physical print as one of its signal features. Writing as early as 1983, A.D. Coleman asserts that the digitally formatted image may eventually 'help move us away . . . from our addiction to the photograph as a precious object. The new technology de-emphasizes the photograph as object and re-emphasizes it as image and idea'. Considered generously, the notion that the work of art may dematerialize, promises the liberation of the image from the sullied concerns of commerce. The picture serves purely as a prompt for intellectual enlightenment, a catalyst for emotional reverie, or a goad to political action. Noble motivations all, but given the historical capacity of the market to enfold and digest even the most radically attenuated, anti-aesthetic art gestures and objects, such a goal is hopelessly naïve. In the effort to absent themselves from the inevitable wages of commodification, these attempts 'spawn a kind of cynical conservatism'. Even the elusive digital image that refuses its own fixity in paper and silver is vulnerable to the predations of capital.

In addition to the dismantling the photograph as object, current commentary on the digital image is characterized by a pervasive tone of uncritical futurist zeal. Such rhetoric speaks to the Platonic longing deep in Western culture that seeks to transcend physicality. Fantasies like this one are the product of a host of failed utopian visions. People take pleasure in the appreciation and display of well-wrought things. Minimalism and Conceptual Art may exert considerable influence on contemporary art practices, but their anti-object or anti-commodity missions never achieved general acceptance for a reason: objects continue to compel our interest. The argument declaring the end of the tangible photograph-as-art-object is unconvincing.

Summary and conclusions

This discussion has considered the impact of electronic image manipulation on our perception of the photograph's truth value, surveyed several distinct categories of digital picture-making, and addressed some of the aesthetic problems posed by emerging computer-based technologies. In addition, the digital image's effect on photography's primacy as one of our era's dominant visual forms has been explored.

While at first glance digital intervention in and revision of the photographic image appears to fundamentally call into question its truth bearing function, on closer inspection this issue proves to be something of a canard. In some cases (recall our discussions of the varieties of 'collage aesthetic' pictures), the digitally altered image is stylized to the point of instantly proclaiming its own artifice. While the 'plausibly fantastical' picture employs a startling photo-like realism, its rational impossibility inevitably summons up a reaction of scepticism. Finally, while the 'seamless' picture may have the potential to deceive, because we presently inhabit a critical environment of considerable epistemological doubt, we come to the image primed to question even the most seemingly 'neutral' photographic representations.

As sketched out above, a crucial feature of the computer-mediated image is that it rests upon ontologically unstable ground. An investigation of the digital photograph leads one to conclude that the 'uniqueness' of the electronic picture is, paradoxically, that it lacks a distinct material or conceptual essence. Technically, a digital photograph can look like anything. Given the range of output technologies, it can appear as

a conventional photograph (dye sublimation print), a lithograph (Iris print), a painting (inkjet on canvas), or a television image (CRT display). Stylistically, as we have seen, the translation of photographs into the digital domain has encouraged image makers to re-deploy their source material within the well-established boundaries of prior art historical concerns. The 'novelty' of digital photography, then, resides in its conventional reiteration of older categories of visual practice.

The predisposition of the computer-altered image to imitate the look of antecedent traditions has profound implications for the possibility of asserting a coherent digital photographic aesthetic. Despite ongoing efforts to the contrary, it has thus far proven impossible to develop a visual sensibility rooted in medium-specific values. No firm foundation for evaluative criteria is possible because in classical terms, digital photography is not a medium at all, but rather any number of simultaneously possible media.

To end on the issue of primacy, scholar Geoffrey Batchen has persuasively argued that photography should be understood not simply as a material technology, but rather a complex cultural formation. In other words, we should regard the medium not as a mechanical process, but as a nexus of *ideas* about how we might describe and understand the world. From this point of view, the photograph's fortunes remain ascendant so long as the constellation of socio-cultural conditions that summon up our need for such a system of representation remain in place. To be sure, for practitioners, digital technologies may hold considerable instrumental advantages over those image making systems based in the chemistry of silver salts. Electronic photographs can be made more quickly and manipulated much more easily than their conventional counterparts. In the broader sense, however, whether the image is encoded in pixels or fixed in grains of silver is of secondary importance. At least for the time being, photography's peculiar representational effect continues to sustain the medium's centrality as our culture's most pervasive and important visual form.

Original publication

'Digital Photography: Truth, Meaning, Aesthetics' in *History of Photography* (2003).

Index

Note: Page numbers in *italics* refer to illustrations.